ART
THAT CHANGED
THE WORLD

ART
THAT CHANGED
THE WORLD

**LONDON, NEW YORK, MELBOURNE,
MUNICH, AND DELHI**

DK LONDON

Senior Art Editor
Gadi Farfour

Senior Editor
Sam Atkinson

Managing Art Editor
Karen Self

Managing Editor
Esther Ripley

Producer, Pre-Production
Rebekah Parsons-King

US Senior Editor
Rebecca Warren

Senior Producer
Gemma Sharpe

US Editor
Kate Johnsen

Jacket Designer
Laura Brim

Publishers
Laura Buller, Sarah Larter

**Jacket Design
Development Manager**
Sophia MTT

Art Director
Phil Ormerod

**Associate Publishing
Director**
Liz Wheeler

Publishing Director
Jonathan Metcalf

Jacket Editor
Manisha Majithia

DK INDIA

Senior Art Editor
Anjana Nair

Senior Editor
Sreshtha Bhattacharya

Art Editors
Supriya Mahajan, Nidhi
Mehra, Neha Sharma

Editor
Suparna Sengupta

Assistant Art Editors
Niyati Gosain, Ankita
Mukherjee, Gazal Roongta,
Vidit Vashisht

Managing Editor
Pakshalika Jayaprakash

Production Manager
Pankaj Sharma

Managing Art Editor
Arunesh Talapatra

DTP Designers
Syed Md Farhan,
Sachin Singh

cobaltid

The Stables, Wood Farm, Deopham Road,
Attleborough, Norfolk NR17 1AJ
www.cobaltid.co.uk

Art Editors
Paul Reid, Lloyd Tilbury,
Darren Bland,
Rebecca Johns,
Shane Whiting

Editors
Marek Walisiewicz,
Richard Gilbert,
Neil Lockley

Picture Researcher
Louise Thomas

First American Edition, 2013

Published in the United States by
DK Publishing
345 Hudson Street
New York, New York 10014

13 10 9 8 7 6 5 4 3 2 1

001-184794—Sep/2013

Copyright © 2013 Dorling Kindersley Limited

All rights reserved

Without limiting the rights under copyright reserved above,
no part of this publication may be reproduced, stored
in or introduced into a retrieval system, or transmitted,
in any form, or by any means (electronic, mechanical,
photocopying, recording, or otherwise), without the prior
written permission of both the copyright owner and
the above publisher of this book.

A catalog record for this book is available from the
Library of Congress.

ISBN: 9781465414359

DK books are available at special discounts when purchased
in bulk for sales promotions, premiums, fund-raising, or
educational use. For details, contact: DK Publishing Special
Markets, 345 Hudson Street, New York, New York 10014
or SpecialSales@dk.com.

Color reproduction by Altaimage Ltd., London, UK
Printed and bound in China by South China

Discover more at
www.dk.com

Chief consultant
Ian Chilvers

Ian studied history of art at the Courtauld Institute,
London. He has written numerous books on art,
including *The Oxford Dictionary of Art and Artists*
and *The Baroque and Neoclassical Age*, and he
was chief consultant on DK's acclaimed *Art: The
Definitive Visual Guide*. Ian is the author of the
Baroque and Rococo sections of this book.

Contributors

ANCIENT AND MEDIEVAL
Iain Zaczek

Iain studied at Oxford University and the
Courtauld Institute. A specialist in Celtic and
Pre-Raphaelite art, he has authored more than
30 books. As well as writing chapter one of this
book, Iain also wrote the Neoclassicism section.

RENAISSANCE AND MANNERISM
Jude Welton

With a degree in art history and English,
Jude has authored and contributed to
many popular works on art history. Her
books for DK include *Impressionism*, *Monet*,
and *Looking at Paintings*.

THE 19TH CENTURY
Caroline Bugler

With a degree in history of art from Cambridge
University and an MA from the Courtauld
Institute, Caroline has written several books and
articles. She has also worked as an editor at The
National Gallery, London, and at the Art Fund.

THE MODERN AGE
Lorrie Mack

Lorrie is a highly experienced author and editor in
the fields of design and the arts. She contributed
to DK's *My Art Book* and *The Children's Book of
Art* and wrote *The Book of Dance*, and managed
a large art-history periodical for several years.

CONTENTS

8 INTRODUCTION

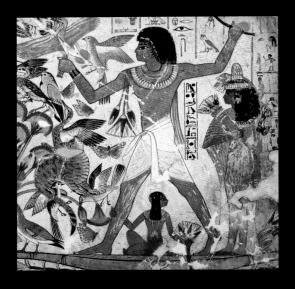

ANCIENT AND MEDIEVAL

RENAISSANCE AND MANNERISM

12 PREHISTORIC ART

22 EGYPTIAN ART

32 GREEK AND ROMAN ART

42 EARLY CHRISTIAN AND
 BYZANTINE

54 THE DARK AGES

64 ROMANESQUE AND GOTHIC

78 BIRTH OF THE RENAISSANCE

88 FLOWERING OF THE
 RENAISSANCE

100 HIGH RENAISSANCE

110 VENETIAN RENAISSANCE

120 NORTHERN RENAISSANCE

132 ITALIAN MANNERISM

142 MANNERISM OUTSIDE ITALY

BAROQUE TO NEOCLASSICISM

THE 19TH CENTURY

THE MODERN AGE

156 ITALIAN BAROQUE

166 FLEMISH AND SPANISH BAROQUE

178 DUTCH BAROQUE

190 FRENCH BAROQUE

200 FRENCH ROCOCO

210 ROCOCO OUTSIDE FRANCE

220 NEOCLASSICISM

234 ROMANTICISM

246 ROMANTIC LANDSCAPE

256 PRE-RAPHAELITES

266 REALISM

276 IMPRESSIONISM

288 POST-IMPRESSIONISM

298 SYMBOLISM

312 EXPRESSIONISM

322 CUBISM

332 BIRTH OF ABSTRACT ART

340 DADA AND SURREALISM

350 ABSTRACT EXPRESSIONISM

358 POP AND OP ART

366 RECENT ABSTRACTION

374 THE FIGURATIVE TRADITION

384 GLOSSARY

386 INDEX OF ARTISTS

392 GENERAL INDEX

399 ACKNOWLEDGMENTS

INTRODUCTION

Art is always evolving. From the moment when prehistoric artists first began to decorate their caves, painters have always looked for fresh ways of portraying the world around them. Sometimes, a solitary genius—a Giotto, a Leonardo, a Picasso—leads the way into uncharted artistic territory. At other times, groups of like-minded painters explore a new style or idea, creating an entire artistic movement.

This book traces the full development of the most significant movements, from the earliest sources of inspiration to a supreme masterpiece that is the crowning glory. Beginning with a crucial Turning Point—a painting that shaped the course of the movement or epitomized many of its most distinctive features—a variety of other influences are explored, from a chemist who concocts a brand new pigment, to an archaeologist who unearths a forgotten treasure, or a patron who challenges existing conventions. In a broader sense, social and political events were also influential. The French Revolution inspired both Neoclassical and Romantic painters; the invention of printing increased the flow of ideas during the Renaissance; and the growth of the railways enabled travel to new locations and transformed the way that the Impressionists worked.

The pace of change differed sharply from one era to the next. Some aspects of Egyptian art remained unaltered for centuries, while the last few years before World War I were marked by feverish artistic activity. This richly illustrated guide encapsulates each movement, taking the reader on an exhilarating journey through the history of art from its earliest manifestations to the present day.

ANCIENT
AND MEDIEVAL

12 PREHISTORIC ART

22 EGYPTIAN ART

32 GREEK AND ROMAN ART

42 EARLY CHRISTIAN AND BYZANTINE

54 THE DARK AGES

64 ROMANESQUE AND GOTHIC

Painting is one of the oldest art forms, dating back to the Ice Age. Its purpose has changed over the course of the centuries, but any notions about creative genius or self-expression would have seemed very alien to the first artists. Many paintings were functional—they were used in rituals, they honored the dead, they glorified God. Their appearance varied considerably: some cave paintings and Roman still lifes seem very realistic, but the art of other civilizations, such as the Egyptians, the Byzantines, and the Celts, found symbols and stylizations a more powerful way of representing the everyday world. Perhaps the greatest difference lies in the status of the artists themselves. Painting did not offer a path to fame or riches—in the ancient world, most artists were regarded as craftsmen. The identities of the greatest Christian artists are unknown to us while, ironically, ancient Greek artists are well documented, but their finest paintings have not survived.

PREHISTORIC ART

▷ **The Great Hall of the Bulls**
c.15,000–13,000 BCE
Lascaux Cave, nr. Montignac, France
Lascaux is both the most famous and the most richly decorated of all the painted caves. In all, more than 900 figures of animals have been identified. The most spectacular examples are located in a chamber dominated by six huge bulls, the largest of which is more than 17ft (5.2m) long.

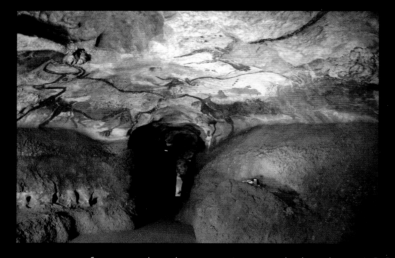

When the cave paintings at Lascaux were revealed to the public in 1948, the overriding reaction was astonishment. How could primitive people with so few resources have produced pictures of such sophistication? With each new discovery, this sense of wonder has returned. In the 1990s, the age of the oldest painted cave was pushed back to around 30,000 BCE and there is every likelihood that, in the future, this boundary may go back even further. Meanwhile, scientific advances—radiocarbon dating, accelerator mass spectrometry, and DNA analysis—are providing an increasingly detailed understanding of both the paintings and their archaeological settings. The sheer number of surviving decorated caves also continues to grow. At present, more than 360 have been recorded in Western Europe alone. Comparable sites have also been found in many other parts of the world, confirming that cave art was a truly global phenomenon.

◎ CONTEXT

Artists from the Ice Age

Cave paintings in Europe were produced by hunter-gatherer communities in the later stages of the Ice Age. When the paintings were first studied, it was assumed that the images simply reflected the everyday lives of these people. It soon became clear, however, that many of these caves were not normally inhabited and, in addition, that the paintings were executed in places where they could not be seen. As a result, it was suggested that some caves were sanctuaries and that the act of painting served some ritual purpose.

For many years, the most popular theory was that the paintings were associated with hunting magic. By depicting large, healthy creatures— their ideal food source—the cavemen were hoping to ensure the future supply of these animals for their hunters. Gradually though, as more paintings were discovered, a flaw in this theory became apparent. The study of food

deposits showed that, in many cases, the cave artists were not portraying the beasts they actually ate. At Lascaux, for instance, 90 percent of the food remains were reindeer bones, but this animal was depicted only once.

In recent years, new theories have proliferated. Some scholars have argued that individual animals should not be viewed in isolation. They believe that it is more helpful to look at the entire panel, including its various signs (hands, arrows, grids). The hypotheses arising from the *Chinese Horse* (*see pp.20–21*) illustrate this approach.

There is also great interest in the links with shamanism. In the 19th and 20th centuries, European anthropologists gained important insights into the rock art of southern Africa by studying the shamanistic practices of local Bushmen. Since then, scholars have explored parallels with European cave painting.

KEY EVENTS

◎ Landmarks in rock art

▷ **c.38,000 BCE** Start of the Upper Paleolithic Period, the final phase of the Paleolithic Age. It is subdivided into toolmaking phases known as "industries."

▷ **c.34,000 BCE** The Aurignacian industry, named after a site in Aurignac, emerges in France. The earliest cave paintings are produced.

▷ **c.28,000–20,000 BCE** The time of the Gravettian industry, named after a site at La Gravette in the Dordogne area of France. The Venus figurines date from this period.

▷ **c.16,000–10,000 BCE** The closing phase of the Upper Paleolithic era is the Magdalenian industry, named after the site of La Madeleine in France. The finest cave paintings are created during this era.

▷ **c.13,000–8500 BCE** The Late Glacial period, when the ice sheets gradually begin their retreat.

▷ **c.8000–3000 BCE** The Neolithic Wet Phase, a milder period when Saharan north Africa is habitable.

> **SUDDENLY**, [A PAINTING OF] **A BIG RED BEAR** ROSE UP BEFORE US. **TRANSFIXED**, WE **STAYED FOR A MOMENT** TO **ADMIRE IT** 〟

1995 | Eliette Brunel Deschamps
French speleologist, on discovering Chauvet

A precarious existence
Some of the masterpieces of prehistoric art were produced in the harshest of conditions. Hunter-gatherers struggled to survive during the final phases of the Ice Age. Their standard environment was usually a frozen landscape or a bleak tundra. When the climate was at its worst, they took refuge in caves.

◎ BEGINNINGS
A SHOCKING DISCOVERY

In December 1994, three spelunkers were exploring a cave in the Ardèche Valley in France, when they came across a series of painted chambers. After radiocarbon tests were carried out, archaeologists were astonished to discover that the paintings were far older than other known examples. The earliest section dates to around 30,000 BCE, while a second period of habitation dates from about 25,000 BCE. The cave has been named after one of the speleologists, Jean-Marie Chauvet, while his companions,

Eliette Brunel and Christian Hillaire, have given their names to individual chambers. The discovery of the Chauvet Cave made experts revise their views on the Aurignacian period and on the nature and purpose of cave painting itself. The animals depicted are different from those in later caves. Alongside the usual herbivores, there are images of dangerous creatures that were rarely pursued—bears, lions, and woolly rhinos. This undermined the theory that cave paintings were designed solely for hunting rituals.

I POINTED THE PICTURES OUT TO MY FATHER, BUT HE JUST **LAUGHED**. SOON, HOWEVER, HE **GOT MORE INTERESTED**... HE WAS **SO EXCITED** HE **COULD HARDLY** SPEAK

c.1923 | Maria de Sautuola
Daughter of local landowner Marcelino de Sautuola, on the discovery of the Altamira cave paintings

◉ ARTISTIC INFLUENCES

Historians have long been skeptical of the idea that cave paintings are straightforward reflections of the daily life of the hunter-gatherer. As more and more images have become available for study, they have analyzed every symbol and every unusual pose for hints about their purpose. Increasingly, it seems likely that the cave artists were influenced by their ritual practices and beliefs.

Painted symbols are found in many caves. Hands are particularly common, taking the form of handprints, palm prints, or stenciled outlines. Often, they are combined with an animal image. In this case, the charcoal line to the left is part of a mammoth.

The Panel of the Hand Stencils, c.30,000 BCE, is situated deep inside Chauvet Cave, near the entrance to the Candle Gallery. *Nr. Vallon-Pont-d'Arc, France*

Red ocher is one of the most common pigments found in cave painting. It also appears to have had a deeper, symbolic significance. It was daubed on cult figurines, as well as on the bodies of the dead and their grave goods.

Himba women grinding red ocher that is then mixed with butter, ash, and a perfumed resin to produce a balm that protects the skin.

Shamanistic practices may be linked with many of the cave paintings. This strange scene, unparalleled in Paleolithic art, shows a bird man, who may be dead or in a trance, lying next to a bird stick that may be either a spear thrower or a ritual implement.

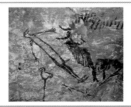

Bird-headed Man with a disemboweled bison, c.15,000–13,000 BCE, in a barely accessible sanctuary called the Shaft at Lascaux. *Nr. Montignac, France*

Unusual poses in the animal paintings have taxed the ingenuity of archaeologists. The favored theory is that this bison is rolling in its urine, in order to create territorial markings. However, it has also been interpreted as dying, sleeping, or giving birth.

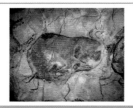

A curled-up bison, c.16,000–14,000 BCE, follows the rounded contours of a roof boss on the ceiling at the Altamira cave. *Nr. Santillana del Mar, Spain*

◎ TURNING POINT

Bison

c.16,000–14,000 BCE *Altamira Cave, nr. Santillana del Mar, Spain*

The extraordinary paintings at Altamira were discovered in 1879, and information about them was first published in 1880. However, more than 20 years passed before they were generally accepted as genuine examples of Paleolithic art. Initially, experts had dismissed Altamira as an elaborate, modern forgery, arguing that the colors were too vivid and the techniques too sophisticated for such an early date. Their amazement is understandable. This remarkable bison was outlined in black and then colored in. Shading was achieved by scraping away small areas of paint, and engraved lines were added at key points—the eyes, the horns, and the hooves—to sharpen up the detail.

HENRI BREUIL

A pioneering figure in the study of the Paleolithic era, Henri Breuil (1877–1961) was ordained as a priest but never took up his duties. Instead, he devoted himself to recording and analyzing the latest discoveries in cave art. He visited sites throughout Europe, Africa, and China, and his encyclopedic knowledge on the subject enabled him to calculate a more accurate chronology for the Palaeolithic age.

Henri Breuil, French archaeologist and authority on prehistoric cave art

CONTEXT

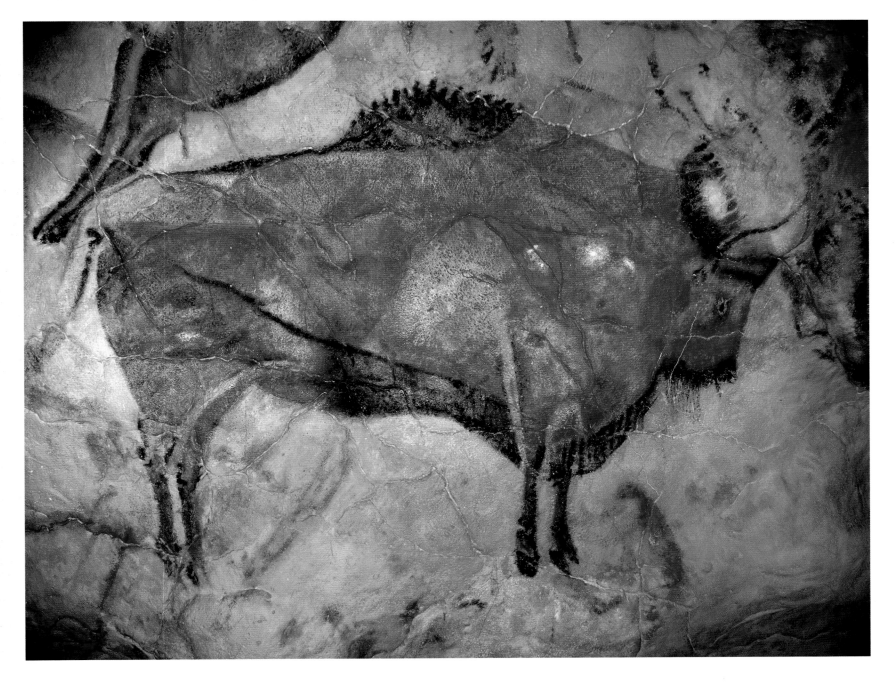

◎ TIMELINE

It is just over a century since historians accepted the idea that cave paintings dated back to the Upper Paleolithic era. The earliest European examples appear to date from around 30,000 BCE. However, as new discoveries are made and dating techniques become more sophisticated, this situation may change. Many of the European paintings were produced inside deep, barely accessible caves, which has aided their survival. Similar images have been found in Africa and Australia, where the practice of creating them continued for far longer.

> ❝ WE NOW **SHOULDERED** A HEAVY **BURDEN** OF **RESPONSIBILITY**. THIS **INTACT SITE**... MUST BE **PROTECTED** AT **ALL COSTS** ❞
>
> 1995 | Eliette Brunel Deschamps
> *French speleologist, on the discovery of Chauvet*

Megaceros Deer Running ▷
c.30,000 BCE *Chauvet Cave, Ardèche, France*
The megaceros was a giant deer, which is now extinct. It did not return to southern Europe after the Late Glacial Period and paintings of it are only found in very old caves, such as Chauvet and Cougnac.

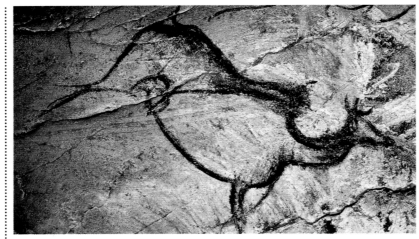

Candamo Cave
The oldest cave paintings in Spain may have been produced c.23,000 BCE, at La Peña de Candamo. These include images of bison, bulls, and aurochs (wild cattle).

30,000 BCE

27,000

Neanderthals extinct
The remains of the last Neanderthals date from c.30,000 BCE. They have dominated the Middle Paleolithic age, but are now replaced by modern humans.

Venus figurines
A number of small Venus sculptures date from c.26,000 BCE. Made from stone or mammoth tusks, the women are often obese, with few facial features and complex hair arrangements. The most famous examples are from Willendorf in Austria, and Lespugue and Brassempouy in France.

◎ REPLICA CAVES

Most cave paintings survived because they were preserved in a stable microclimate, but this changed as tourists flocked to view them. In the 1950s, officials at Lascaux noticed that algae and calcite crystals were forming on the walls and the paintings were beginning to fade. The cave was closed in 1963 and a replica—Lascaux II—was created for visitors in a nearby concrete bunker.

Replicas of cave paintings in Lascaux II

Venus of Willendorf ▷
c.25,000 BCE *Naturhistorisches Museum, Vienna, Austria*
Discovered in 1908, this is the most famous of the Venus figurines excavated from Paleolithic sites across Europe. It was found at Willendorf in Austria but must have originated elsewhere, since its material (oolitic limestone) was not locally available. Images of similar figures were produced, either as paintings or engravings, in prehistoric caves.

CONTEXT

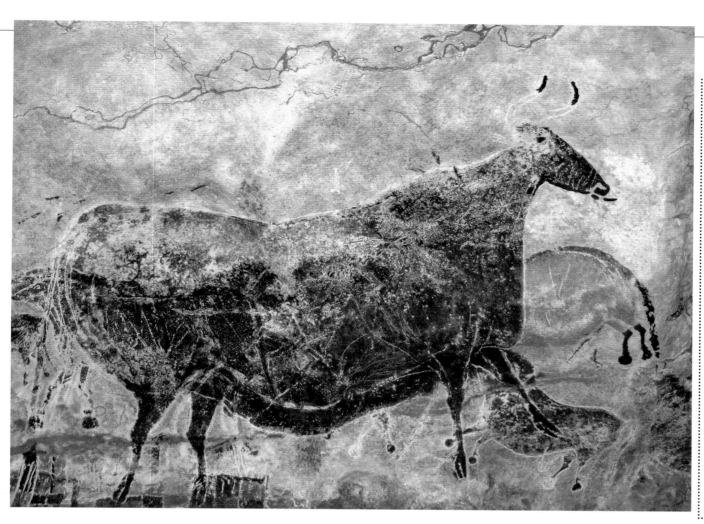

◁ Black Cow
c.15,000–13,000 BCE
Lascaux Cave, nr. Montignac, France
This superb painting was executed in a long, narrow passage called the Nave. It was superimposed on a frieze of around twenty horses, running in the opposite direction. Henri Breuil noted the "twisted perspective" of this type of image, with the body shown in profile but some details (such as the hooves and horns) pictured frontally.

21,000		18,000		15,000 BCE

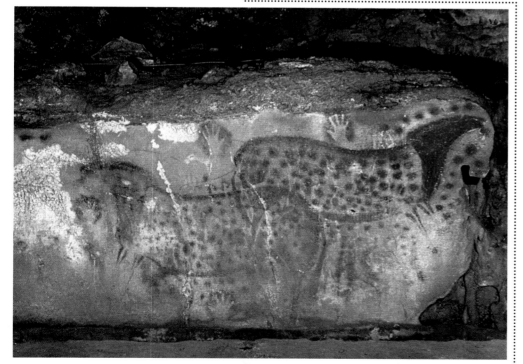

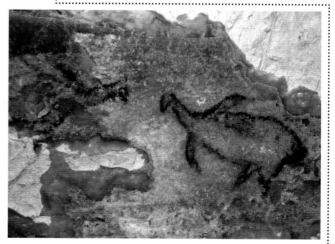

Great Auk △
c.25,000–17,000 BCE
Cosquer Cave, nr. Marseille, France
The paintings in this extraordinary cave were discovered in 1991 by Henri Cosquer, the manager of a diving center—a vital factor, since the entrance to the site is now underwater. The depictions of marine creatures include great auks, monk seals, and octopuses.

Panel of Spotted Horses △
c.26,000–20,000 BCE *Pech Merle Cave, Lot, France*
Paleolithic artists liked to exploit the contours of the surfaces that they were working on. Here, the painted heads are tiny, but the animal to the right seems more convincing, because the adjacent rock is shaped like a horse's head. In 2011, scientists found DNA evidence to suggest spotted horses like these actually existed.

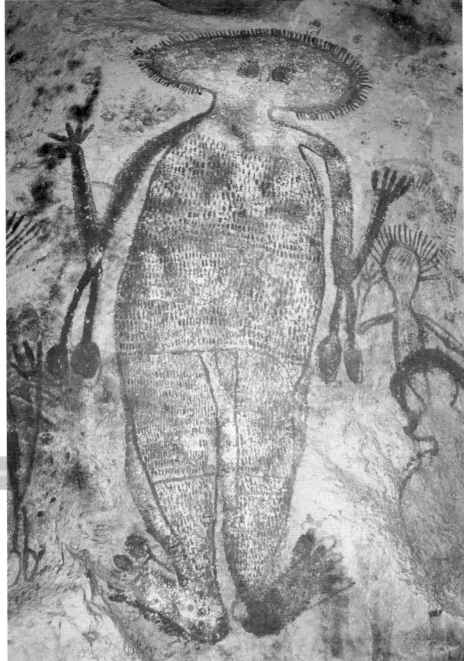

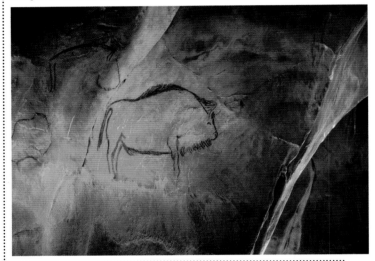

▽ **Bison**
c.11,500 BCE
Niaux Cave, nr. Tarascon-sur-Ariège, France
At Niaux, most of the animal paintings were executed in a large, domed chamber called the Salon Noir. Chemical tests have shown that the paint was made from manganese dioxide, coupled with biotite and feldspar.

15,000 BCE　　　　**12,000**

El Castillo
According to radiocarbon tests, several paintings of bison are produced at the Spanish cave of El Castillo c.13,500 BCE. In all, around 250 animal images are present here.

c.11,000 BCE
By c.11,000 BCE the Weichsel Glaciation—one of the final phases of the Great Ice Age—is drawing to a close in northern Europe.

Bradshaw Aboriginal painting △
c.15,000 BCE *Mount Elizabeth Station, Kimberley Region, Western Australia*
Bradshaw figures take their name from Joseph Bradshaw, the settler who first recorded them in 1891. These rock paintings have been exposed to the elements, but their colors have remained fresh because they are coated in a film of fungi and bacteria.

[AN EXPRESSION OF] **THE IDEAS** THAT MOST **DEEPLY MOVED** THE **BUSHMAN MIND** AND FILLED IT WITH **RELIGIOUS FEELINGS** 🙶

1874 | Wilhelm Bleek
German linguist, on the rock art of southern Africa

MASKS AND SHAMANISM

This imposing figure, with massive biceps and horns, has been nicknamed "the great god of Sefar." "Roundhead" worshippers appear to kneel before him. Some scholars regard the horns and mask as evidence of shamanistic practices among the Saharan peoples. In addition, they view some of the stranger scenes depicted at Sefar as visions brought on during trances, or alternatively by hallucinogenic substances used during the rituals.

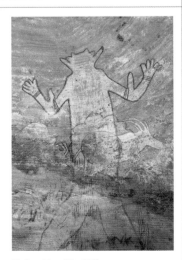

Sefar, Tassili n'Ajjer, Algeria, c.6,000 BCE

CONTEXT

Elands ▽
c.1500 BCE
Game Pass Shelter, Drakensberg, South Africa
The paintings at Game Pass Shelter provided archaeologists with the clearest evidence of the links between rock art and shamanism. Elands (large antelopes) were at the heart of ritual ceremonies, because shamans thought the animals' spiritual potency would enable them to enter a trance state.

Human Figures and Mouflon ▽
c.4500 BCE *Tan Zumaitak, Tassili n'Ajjer Plateau, Algeria*
The rock paintings at Tassili n'Ajjer were produced before the Sahara became a desert. This example dates from the early roundhead phase, when figures were depicted with few facial features. The painting shows the herdsmen tending mouflons (large-horned sheep).

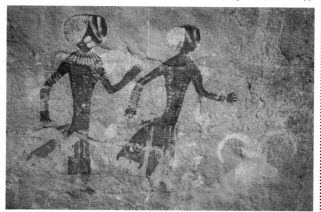

9000 6000 3000 **1000** BCE

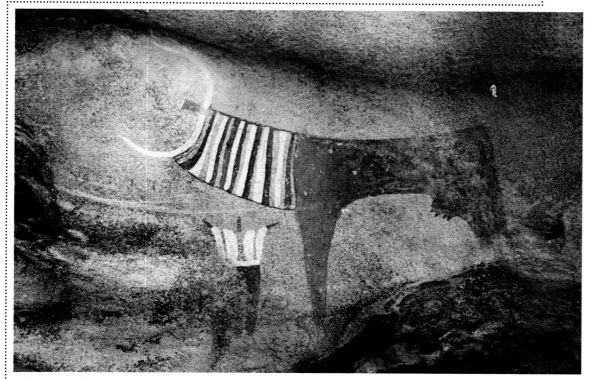

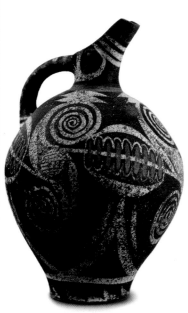

△ Ceremonial Cow
c.3000 BCE *Laas Gaal, nr. Hargeisa, Somalia*
The paintings in the rock shelters of Laas Gaal are a reminder of a time when this arid part of Africa was lush and fertile, with wild cattle roaming free. Here, a long-horned cow, portrayed as a divine spirit, is worshipped by a herdsman.

△ Kamares Ewer
c.1900 BCE
National Archaeological Museum, Iraklion, Crete
This ewer—a large jug—was made by the Minoans on Crete, one of the first European peoples to make use of a potter's wheel. This example was found at the Palace of Phaistos, but most wares of this kind were excavated at Kamares itself, a cave sanctuary on Mount Ida.

◎ MASTERWORK

Chinese Horse

c.15,000–13,000 BCE

Lascaux Cave, nr. Montignac, France

The animal paintings at Lascaux are supreme examples of Paleolithic art. One scholar has described the site as the "Sistine Chapel of Prehistory," referring not just to the beauty of the paintings, but also to the difficult conditions under which they were produced, high up on ceilings or in dark recesses.

The *Chinese Horse* is situated in the Axial Gallery, one of the most richly decorated sections. It was dubbed "Chinese" because it reminded some commentators of Song Dynasty paintings, and the closest modern-day type of horse does indeed come from that part of the world. This is the Przewalski species from Mongolia, which, like the *Chinese Horse*, has a small head and a bulky body. That combination has prompted a few unflattering comments—a leading archaeologist described the Lascaux horses as "these Basset Hound animals, all belly."

The outline of the animal was painted with a brush, while the main areas of color were sprayed on, either from the mouth or through a hollow bone serving as a tube. The signs surrounding the horse have been the subject of much debate. Some have linked these to the theories about hunting magic, interpreting the diagonal markings as weapons and the gridlike symbol as a net. For others, the details are more descriptive. The lines are ferns or grasses, bending as the horse gallops through them, while the enlarged contours simply represent the animal's thick, winter coat.

> ❝ THEIR **LEGS** ARE **VERY SHORT** AND THEIR **BODIES VERY THICK**, WHICH GIVES…THE APPEARANCE OF **ANCIENT CHINESE PAINTINGS** ❞
>
> c.1948 | Henri Breuil
> *French priest and archaeologist*

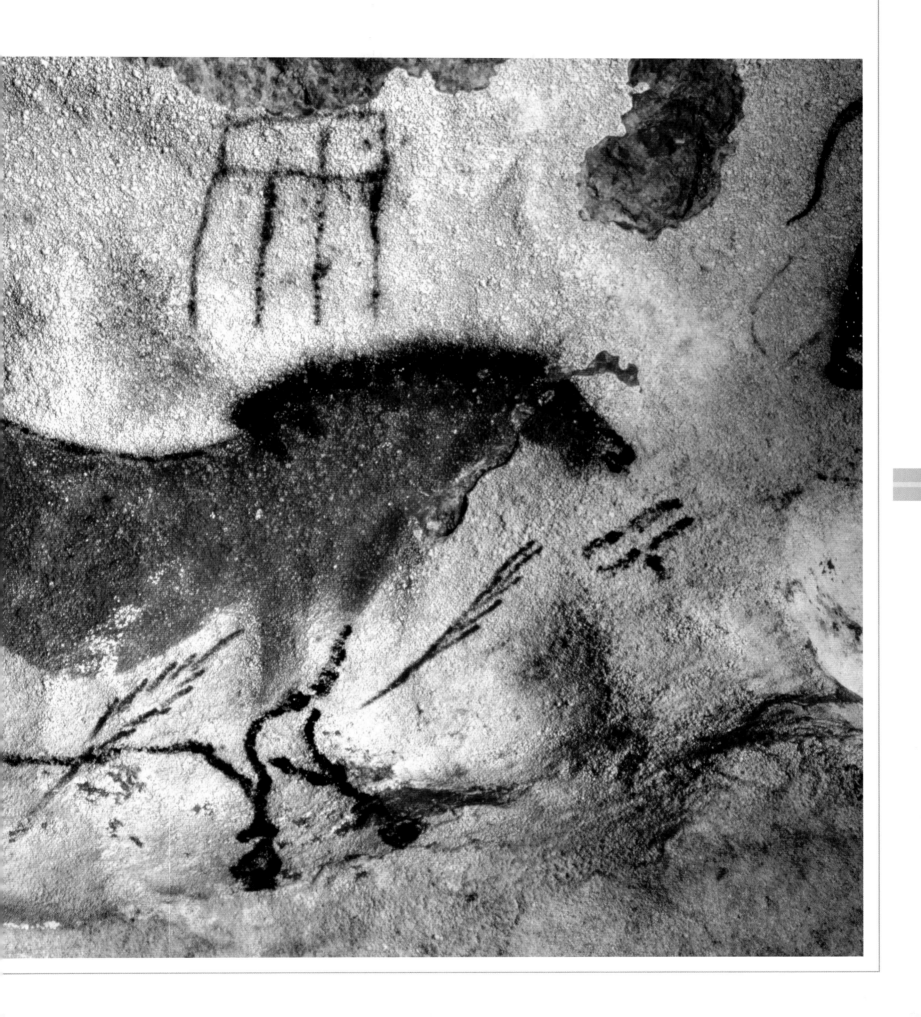

EGYPTIAN ART

▷ **Tutankhamun's Burial Mask c.1324** BCE
Egyptian Museum, Cairo, Egypt
One of the most iconic images of Egyptian art, Tutankhamun's burial mask epitomizes the care and expense that was lavished on the dead. The primary aim of the mask was to protect the pharaoh's head, which needed to be intact if he was to be reborn in the afterlife. The gold was not purely ostentatious—it was also a symbol of immortality.

Egyptian art made a significant contribution to the development of Western culture. The Greeks, in particular, were dazzled by its sheer monumentality, and through them some aspects of the Egyptian style filtered through to later ages. Even so, the aims and methods of Egyptian art are in many ways remote in spirit as well as time. Egyptian painting was entirely functional in its outlook. Artists were expected to depict their given subjects competently, according to a strictly regulated set of standards, and there was no place for originality, aesthetic considerations, or self-expression. The painters themselves had little status, certainly no better than other craftsmen, and they probably worked in teams. The Egyptians believed fervently in an afterlife and directed much of their artistic energy into providing for it. The staggering amount of care and expense that this involved can be gauged from the magnificent wall decoration and treasures found in the tomb of Tutankhamun, who reigned as king during the artistic golden age of the 18th Dynasty (c.1540–1295 BCE).

⊚ CONTEXT

Order and stability

The Egyptian civilization is remarkable both for its richness and its longevity. It survived for around 3,000 years, producing art of a consistently high quality for most of this period. The river Nile, with its annual pattern of flooding, provided the fertile conditions that allowed the country's agricultural economy to prosper. This in turn gave Egypt the financial muscle to dominate its immediate neighbors during the Old Kingdom period (c.2647–2124 BCE).

From a very early stage, Egypt's funerary beliefs were well established. The first pyramids emerged in the 3rd Dynasty, and were not straightforward tombs—they were houses for the *ka* (spirit) of the deceased, with treasures placed inside them for use in the afterlife. They were attached to large estates, which produced food and other goods for offerings, while also supporting the local community. Farming activities were often portrayed inside the tomb.

Because they were essentially religious in character, paintings were rigorously controlled. The human form had to be shown in its entirety, so artists combined a side and frontal view. This gives the figures a contorted appearance and produces some curious anomalies. In the figure of Nebamun (*see pp.30–31*), for example, the left hand is attached to the right arm. Frivolous, ephemeral features—such as emotion or movement—were banished. The size of a figure reflected its importance, and skin color was predetermined—red for men, cream for women, and yellow (symbolizing immortality) for gods.

The regulations remained in force for most of the history of ancient Egypt, though they were observed less strictly in times of political strife, such as the Intermediate periods. The Gebelein murals (*see p.26*) offer an example of this. The rules were also modified during the turbulent reign of Akhenaten, as can be seen in the painting of his daughters (*see p.28*), which displays both movement and human interaction. The old traditions only began to wane after the collapse of the New Kingdom (c.1540–1069 BCE), when waves of foreigners—Persians, Kushites, Greeks, and Romans—threatened the country.

(see pp.30–31) (see p.26) (see p.28)

⊚ A resilient nation

▷ **c.2647–2124 BCE** The Old Kingdom period comprises the 3rd to the 8th Dynasty. Chephren, the model for the Sphinx, is one of the rulers.

▷ **c.2040–1648 BCE** In the Middle Kingdom period, a revival in Egypt's political fortunes follows the reunification of the country.

▷ **c.1540–1069 BCE** In the New Kingdom period, the military triumphs of Ahmose usher in a new period of greatness.

▷ **c.1540–1295 BCE** The 18th Dynasty, regarded by many as the high point of Egyptian art, includes the eventful reigns of Akhenaten and Tutankhamun. These rulers also coincide with the Amarna period, which was arguably the most inventive phase of Egyptian art.

▷ **c.1295–1069 BCE** The Ramessides (the line of kings named "Ramses") are great builders, but their rule is threatened by the military might of the Assyrians.

▷ **525 BCE** Persian king Cambyses II conquers Egypt, which becomes a client state.

▷ **31 BCE** Mark Antony and Cleopatra are defeated by Roman forces at the Battle of Actium, effectively ending Egypt's independence.

KEY EVENTS

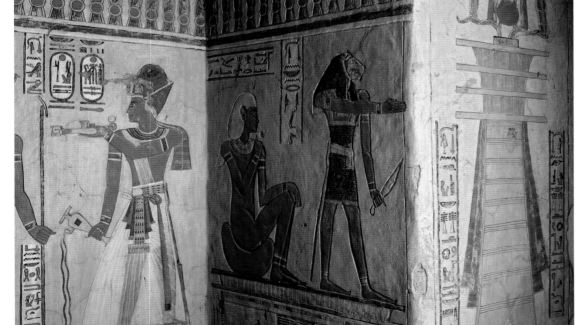

❝ [I SAW] **STRANGE ANIMALS, STATUES,** AND GOLD— **EVERYWHERE THE GLINT OF GOLD...** I WAS **STRUCK DUMB** WITH **AMAZEMENT** ❞

1922 | Howard Carter
British archaeologist, on Tutankhamun's tomb

Tomb of Prince Khaemwaset
This lavishly decorated tomb—adorned with two guardian figures, lion-headed Nebneru next to Heri-maat—was produced for one of the sons of Rameses III. *20th Dynasty, Valley of the Queens, Luxor, Egypt*

◎ BEGINNINGS
SANDS OF TIME

The origins of Egyptian painting can be traced back to prehistoric times. The artisans of the Nagada culture (c.4000–3500 BCE) produced painted pottery, using some motifs that would survive into the dynastic era. The earliest known painted tomb dates back to c.3100 BCE and was discovered at the ancient capital, Hierakonopolis. The royal cemetery at Saqqara is almost as old, with decorated tombs dating back to as early as the 1st Dynasty. These include pyramids and the more modest mastabas (mud-brick burial places).

Although the contents of Egyptian tombs may appear lavish and artistic to modern eyes, that was never the intention. Everything in the funereal traditions of ancient Egypt served a common purpose: to protect and sustain the deceased in the afterlife. Paintings were not designed to look realistic or aesthetically pleasing—they were components in a ritual framework that was organized for the benefit of the dead. These practices remained in place for virtually the entire span of Egypt's ancient history.

◉ ARTISTIC INFLUENCES

By the time Saqqara was built, the format for tomb decoration was already well established. Among the themes to feature heavily was agriculture, an activity that the deceased might have been associated with during their lifetime—Unsu the scribe, for example, had been a grain accountant. Agricultural motifs also featured because of the food and provisions that would be needed in the afterlife.

Sculpture was combined with painting in early tombs, producing colored reliefs rather than frescoes. Parades of herdsmen with animals—their sheer variety emphasized the wealth of the deceased—were a common theme.

Offering Chapel of Ptah Sekhem Ankh, c.2454–2311 BCE (5th Dynasty). *Museum of Fine Arts, Boston, MA*

Stylistic regulations dictated the way artists organized their pictures. Human figures were shown in profile, although both shoulders were turned to face the front. Scenes were arranged into long, horizontal bands known as "registers."

Tomb of Unsu, c.1479–1425 BCE (18th Dynasty), depicts an agricultural scene. *Louvre, Paris, France*

Hieroglyphs, literally "sacred words," were used to amplify the subject of the painting—images were rarely meant to be viewed in isolation. Tomb paintings tended to be personalized with a theme relating to the deceased.

Goddess Ma'at, c.1297–1185 BCE (19th Dynasty), painted with hieroglyphs alongside. *Tomb of Nefertari, Valley of the Queens, Egypt*

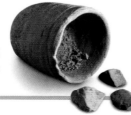

Egyptian blue or "blue frit" is often described as the first synthetic pigment. It is a calcium-copper silicate produced by fusing powdered limestone with sand and copper filings. It features in *Nebamun Hunting in the Marshes* (see pp.30–31).

Powdered mineral pigments from the tomb of Kha at Deir el-Medina (18th Dynasty). *Egyptian Museum, Turin, Italy*

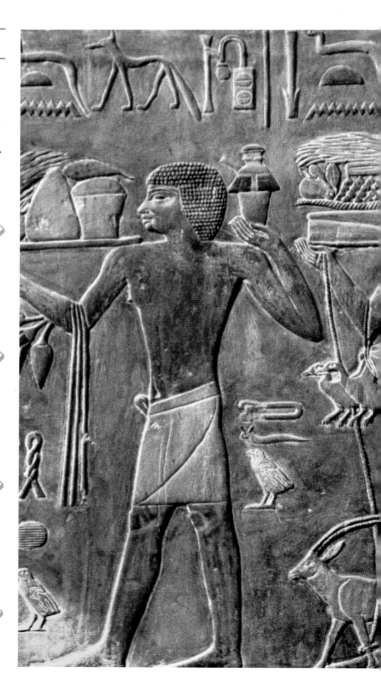

◎ TURNING POINT

Mastaba of Ty

5th Dynasty **2494–2345** BCE *Saqqara, nr. Cairo, Egypt*

This is probably the finest of the Saqqara tombs dating from the Old Kingdom era. Ty was a high-ranking court official—"Overseer of the Pyramids of Niuserre" was one of his many titles—and his status is reflected in the splendid relief decorations at the mastaba. Long parades of porters (pictured) bring food, animals, and other goods to serve as offerings, while there are also detailed illustrations of the many activities that Ty supervised, ranging from farming and brewing to making inspections and managing the accounts. Elsewhere on the reliefs there are a number of more exotic scenes, such as hunting a hippopotamus with harpoons.

◎ **SAQQARA UNCOVERED**

CONTEXT

The Saqqara tombs were discovered by French Egyptologist and archaeologist Auguste Mariette. An early passion for hieroglyphs had helped him land a job at the Louvre and, in 1850, he was sent to Egypt to purchase manuscripts for the museum. Instead, he excavated the site at Saqqara, making the sensational finds that secured his reputation. Mariette's determination to eradicate the looting that took place at excavations led to his appointment as Conservator of Egyptian Monuments and cofounder of the Cairo Museum. He even found time to supply the plot for Verdi's *Aida*, set in ancient Egypt.

Auguste Mariette, French archaeologist and Egyptologist

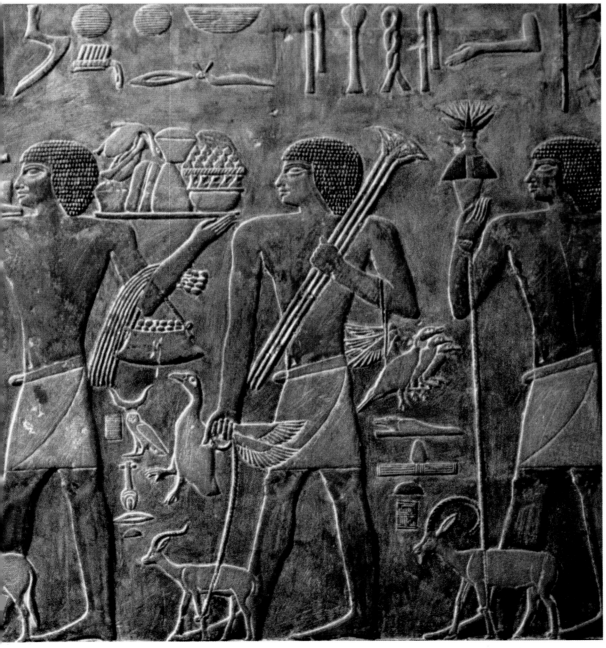

❝ **I KNEW** I WOULD **DIE OR GO MAD** IF I DID NOT **RETURN TO EGYPT IMMEDIATELY** ❞

1856 | Auguste Mariette
Speaking in Paris after discovering Saqqara

◎ TIMELINE

Throughout their history, the Egyptians used a diverse array of artifacts for funerary practices. Cult statues, such as those in Rahotep's tomb (*below*), were designed to house the *ka* of the deceased, while adornments on mummy cases were meant to ward off evil. The style of painting remained remarkably consistent, with the notable exceptions of the rebellious phase of Akhenaten's reign (*see p.28*) and the later colonial periods, under the influence of Greece and Rome.

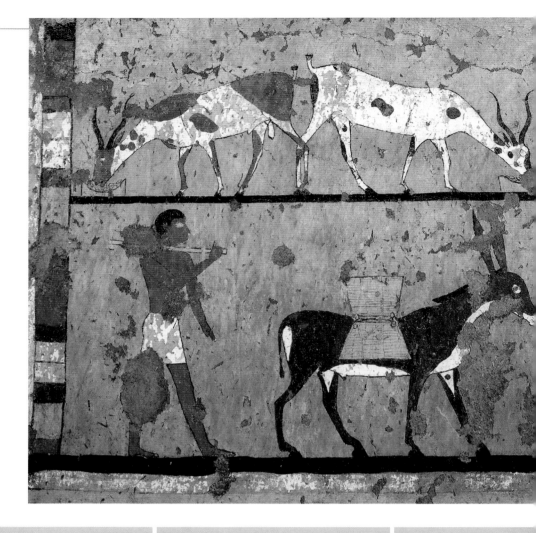

First tomb statues
In Saqqara, a royal official founds the earliest-known funerary cult chapel in c.2800 BCE. The first tomb statues belonging to the pharaonic era also date from this period.

Hieroglyphs
Hieroglyphic forms of script are in general use throughout Egypt by c.2890 BCE. They are widely employed on most paintings, sculptures, and monuments.

3000 BCE	2800	2600	2400

Early Dynastic period
The initial Early Dynastic period includes the creation of a new capital at Memphis in c.2972 BCE. The historical division into dynasties (royal houses) was devised in the 3rd century BCE by Manetho, an Egyptian priest.

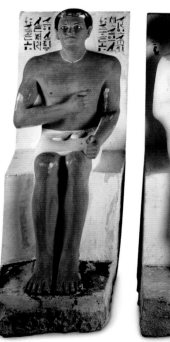
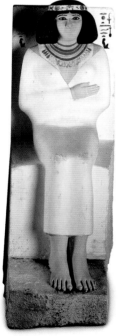

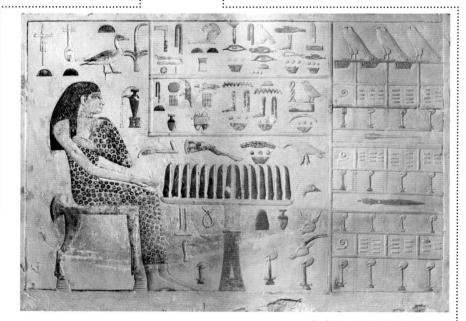

Rahotep and Nofret △
4th Dynasty, c.2570 BCE
Egyptian Museum, Cairo, Egypt
This couple were discovered in a mastaba near Meidum. The painted limestone figures are incredibly lifelike—strands of Nofret's own hair are even depicted, peeping out from under her wig.

Princess Nefertiabet △
4th Dynasty, c.2500 BCE *Louvre, Paris, France*
This limestone slab—discovered at the princess's tomb in Giza—shows Nefertiabet, a sister of King Cheops. Clothed in a panther-skin dress, she sits before the food and other offerings that she will need in the afterlife.

Building the pyramids
Construction of the magnificent pyramids at Giza begins c.2550–2500 BCE. The monuments to Khufu, Khafre, and Menkaure dominate the scene.

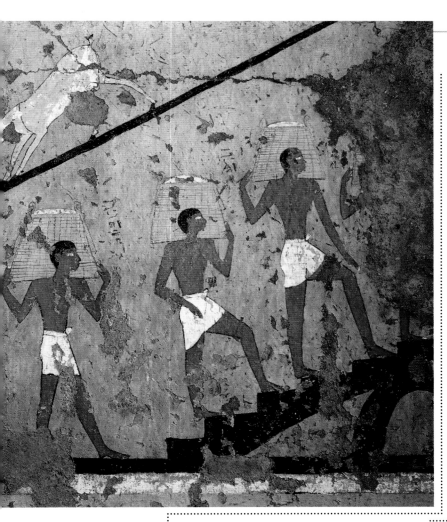

◁ **Transporting Grain Sacks**
1st Intermediate Period, c.2100 BCE
Museo Egizio, Turin, Italy
Murals from the tomb of Iti at Gebelein
reflect the fact that in that region, artistic
controls were relaxed due to political
divisions within Egypt. Colors are brighter
than normal, but the scale is erratic.

An Asiatic Caravan ▽
12th Dynasty, c.1880 BCE
Beni Hasan Necropolis, Egypt
This detail of the decorations from the
tomb of Khnumhotep II depicts
nomadic traders from Asia bringing
offerings for the deceased. The rapid
rise in immigration from Asia was a
matter of political concern in Egypt.

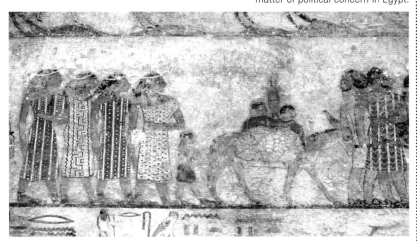

2200	2000	1800	1600 BCE

◁ **Detail of Musical
Procession**
11th Dynasty, c.2000 BCE
Cincinnati Art Museum, OH
Female attendants clap their hands
in a section of the decorations from
the tomb of Queen Neferu, one of the
wives of King Mentuhotep II. Her
tomb forms part of a large mortuary
complex at Deir el-Bahari.

The Valley of the Kings
A royal cemetery is established
around c.1560 BCE in the
area now known as the Valley
of the Kings. It will become the
most important burial site of
the New Kingdom.

CEREMONIAL PALETTES

Palettes were practical objects
used for grinding pigments, but
some early, highly decorated
examples held a deeper
significance. They were given as
offerings to temples and employed
during rituals. Scholars speculate
that they may have been used to
produce eye or body paint, which
was worn by the priest or daubed
on cult statues. In artistic terms, the
grinding bowl became a feature of the
design, used here to shape the necks
of fabulous beasts.

Palette of Narmer, c.3000 BCE,
Egyptian Museum, Cairo, Egypt

CONTEXT

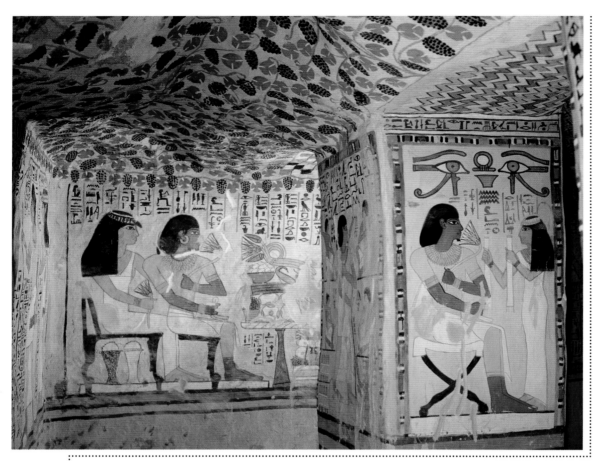

◁ **Interior of the Tomb of Sennefer**
18th Dynasty, c.1410 BCE *Sheikh Abd el-Qurna, Egypt*
Often dubbed the "Tomb of the Vines" because of the ceiling decoration, this 18th Dynasty tomb depicts Sennefer—the mayor of Thebes—on the far wall, receiving offerings with his wife.

> **WELL-BELOVED COURTIER, GREAT OF THE GREAT ONES... THE KING KNEW OF MY EXCELLENCE**
>
> c.1410 BCE | Sennefer
> *Inscription in his tomb, describing himself*

Tanis Necropolis
In c.800 BCE, the main focus of royal burials shifts away from the Valley of the Kings, and to Tanis. These tombs are more modest, though they contain golden treasures.

1400 BCE — **1200** — **1000** — **800**

Queen Hatshepsut
Work begins on the magnificent temple of Queen Hatshepsut in c.1460 BCE. Its unusual decorations include scenes of a naval expedition, and the transportation of obelisks from the quarries at Aswan.

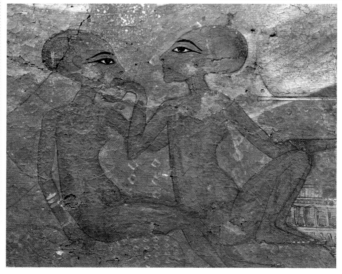

△ **The Daughters of Akhenaten**
18th Dynasty, c.1353–35 BCE
Ashmolean, Oxford, UK
Artistic styles altered radically during the reign of Akhenaten, the "heretic king." Figures appeared less static and impassive, while the human form was portrayed in a strangely stylized manner.

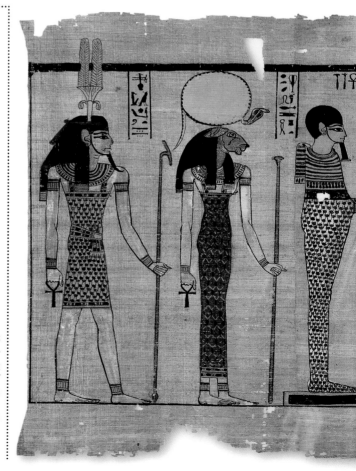

The Great Harris Papyrus ▷
20th Dynasty, c.1150 BCE
British Museum, London, UK
At 138ft (42m) in length, this is one of the largest surviving papyri. This section shows Ramses III with the principal gods of Memphis—Ptah, Sekhmet, and Nefertem.

Mummy Cartonnage of Nespanetjerenpere ▷
22nd Dynasty, c.945–718 BCE *Brooklyn Museum of Art, New York, NY*
Cartonnage was a material composed of linen or papyrus mixed with plaster and water, and was used to cover a mummy. Various symbols and spells were painted on the surface, designed to aid the deceased—in this case a priest—in their journey to the afterlife.

Fayum Portrait of a Young woman ▷
Roman period, c.30 BCE–120 CE *Louvre, Paris, France*
Fayum portraits combined the realism of Roman portraiture with the burial practices of the Egyptians. This is an extremely lavish example, painted in encaustic (a molten-wax process) on imported cedar wood, and covered with gold-leaf decoration.

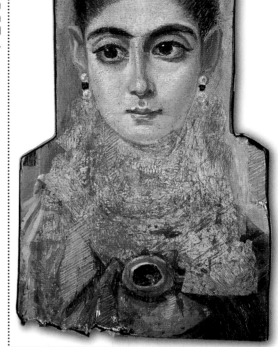

Temple of Edfu
Egyptian architecture enjoys a revival under the Ptolemies. The most impressive building is the Temple of Horus at Edfu, begun by Ptolemy III in 237 BCE and finished in 57 BCE.

The Ptolemaic Dynasty
The Ptolemaic era, when Egypt is ruled by Greeks, begins c.240 BCE. Alexandria replaces Memphis as the capital and the Hellenistic style affects most branches of the arts.

Kushite rule
From around 728 BCE, the Egyptians are ruled by the Kushites from the south (now the Republic of Sudan). This situation is ended by invading Assyrians, who sack Memphis in 671 BCE.

600 **400** **200** **1** CE

Nectanebo I
A brief period of Egyptian independence begins during the 30th Dynasty, in c.380 BCE. Nectanebo I and his successors revive earlier building programs, enlarging temples and creating avenues of sphinxes.

Rosetta Stone
A slab is carved with identical inscriptions in Greek, Demotic, and hieroglyphic script in 196 BCE. It will eventually provide scholars with the vital clues that they need in order to decipher ancient hieroglyphs.

A Roman province
Following defeat at the Battle of Actium the previous year, Mark Antony and Cleopatra commit suicide in 30 BCE. Egypt now becomes a Roman province.

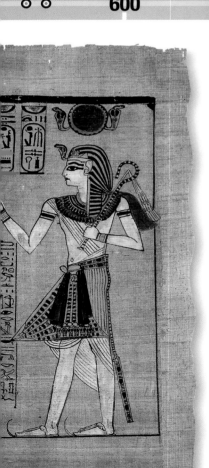

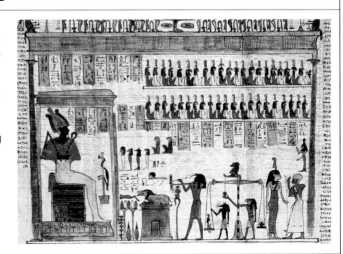

CONTEXT

THE BOOK OF THE DEAD

Designed to aid the deceased in their voyage to the afterlife, *The Book of the Dead* is the collective name given to an anthology of spells and instructions. These texts could be inscribed in tombs or on coffins, but the most elaborate were personalized for the deceased and written on long papyrus scrolls. Many featured a series of painted vignettes, culminating in the judgment of Osiris, the god of the dead.

The Judgment of Osiris, from *The Book of the Dead*, c.332–330 BCE

◎ MASTERWORK

Nebamun Hunting in the Marshes

18th Dynasty **c.1350** BCE
British Museum, London, UK

This fresco is justly considered to be one of the finest examples of Egyptian tomb painting. It belonged to a series of frescoes that decorated the resting place of the scribe Nebamun, who—according to hieroglyphs at the site—"counts the grain in the granary of divine offerings." It formed part of a larger scene that also included Nebamun spearing fish. Although that portion has not survived, a fragment of the spear can be seen in the lower left-hand corner of the painting.

At first glance, the scene may look like a faithful representation of an activity that Nebamun might have enjoyed during his lifetime. This would be misleading, though, because Egyptian art always served a deeper purpose. Nebamun would never have hunted while wearing his wig and an ornate collar, his wife would not have accompanied him dressed for a banquet, nor would their child have been present.

In fact, the scene is full of symbolic references to fertility and rebirth that are linked to a solar cult. Two lotus buds and a lotus flower are draped prominently over Nebamun's right arm. These are traditional attributes of the sun-god Re, who was often portrayed reclining on a lotus. Gold was an emblem of the sun, and a tiny speck of gold leaf (its only use in the painting) is found in the eye of the cat, an animal sacred to Re's daughter, the goddess Bastet. The cat's position— balancing improbably on a reed and gazing up at Nebamun—coupled with the presence of the gold leaf signals that its presence is symbolic.

❝❝ **TAKING RECREATION** AND **SEEING WHAT IS GOOD** IN THE **PLACE OF ETERNITY** 🙷🙷

c.1350 BCE | Unknown
Hieroglyphs inscribed beneath Nebamun's left arm

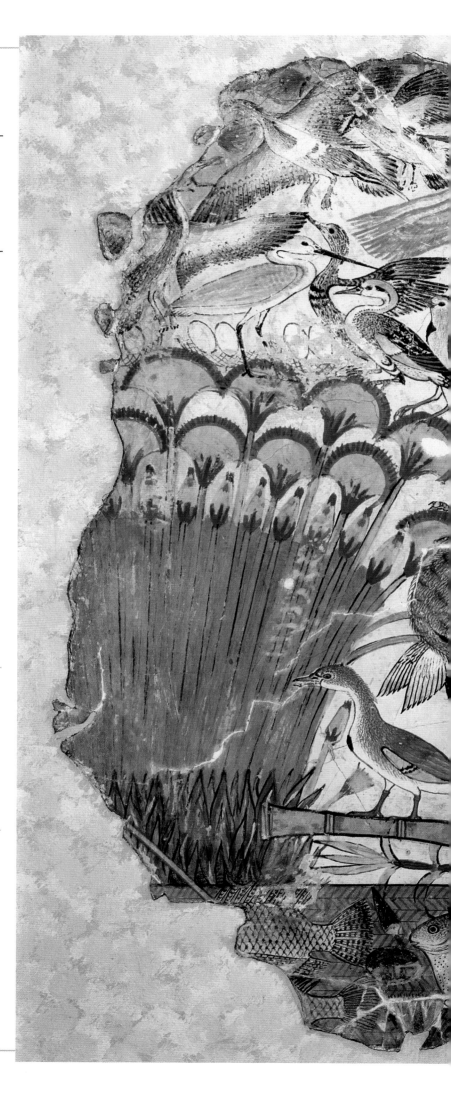

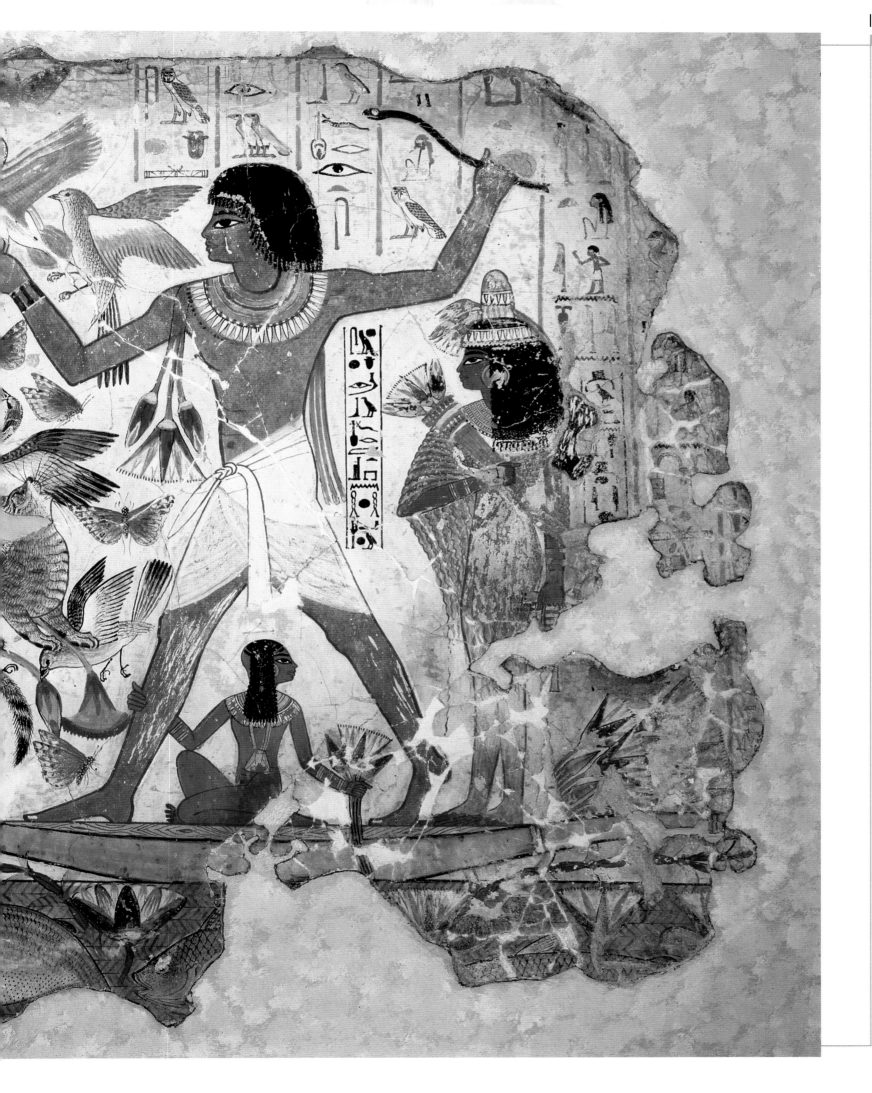

GREEK AND ROMAN ART

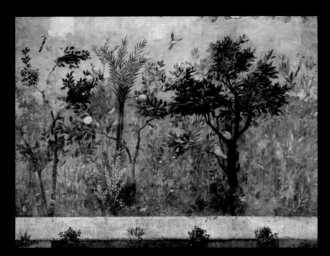

▷ **Detail of Garden Fresco**
c.20 BCE *Museo Nazionale Romano, Rome, Italy*
The Romans started a fashion for decorating their homes with scenes of gardens and orchards. The most famous fresco of this type is this example, which once adorned the Villa of Livia to the north of Rome. It was located in a subterranean chamber, which was probably used as a cool retreat in summer.

Painting and sculpture produced in the heyday of ancient Greece and Rome provided the building blocks of Western art. Later ages looked back on it as an era of supreme achievements, which they could barely hope to emulate. The artworks of the two civilizations were both noble and imposing, yet were still produced in a manner that seemed realistic—a far cry from the clumsy stylizations that succeeded them. This admiration for classical art was based primarily on sculpture, since more of it survived, but the reputation of painting was still high. Ancient writers praised it to the skies, and as more paintings have come to light, many of these contemporary claims seem justified. The Greeks and the Romans shared a passion for capturing reality, whether in *trompe l'oeil* illusionistic effects—in which the painted object appears to be real—or in strikingly natural-looking garden scenes and still-life paintings.

⊚ CONTEXT

The age of empires

The artistic traditions of both Greece and Rome had very deep roots. The initial stimulus came from the cultures that had preceded them but, as their power and influence grew, new sources of inspiration were soon found. Both civilizations flourished through a mix of conquest and trade, which exposed them to an ever-widening circle of contacts.

In Greece, the local influences came from the waning civilizations of the Minoans (in modern-day Crete) and the Mycenaeans (in mainland Greece). The country itself developed as a group of independent city-states, which were fiercely competitive. In vase production, for example, the two main centers were Athens and Corinth, which vied continually for new foreign markets for their wares. Greek colonists also had an impact. By the 7th century BCE, settlers in North Africa returned with dazzling reports of the glories of Egyptian art.

It took time for these diverse influences to merge into a national style. This process was not completed until the Classical period (5th–4th century BCE), when Greek art and architecture reached its peak. Following the campaigns of Alexander the Great, the triumphs of Greek art were then transmitted far and wide—throughout the Mediterranean, across to North Africa, and into parts of Asia.

The course of Greek painting is harder to codify, since so little has survived. It was always in demand though—the Romans, in particular, were in awe of it. They wrote about it, they copied it, and—as the balance of power between the two civilizations shifted—they acquired it. Rome began as a kingdom, became a republic, and reached its heights as an empire. But even at the height of its pomp, it still deferred to the sheer quality of Greek painting.

The survival of Roman painting is in general almost as patchy as that of ancient Greece, but the preservation of Pompeii's artworks is a conspicuous exception. The treasures of this buried city show that the Romans continued to collect Greek easel paintings or have them copied, either as murals or as mosaics.

> I WAS **EVER OF THE OPINION** THAT THE **ANCIENT ROMANS** DID **FAR EXCEED** ALL THAT HAVE COME **AFTER THEM**

1570 | Andrea Palladio
Italian architect and writer

The Classical world

KEY EVENTS

▷ **c.900 BCE** The first Greek city-states begin to be formed.

▷ **c.620–500 BCE** The Etruscans reach the height of their power in Italy.

▷ **c.480–323 BCE** The Classical period in Greece includes a golden age of art, literature, and philosophy.

▷ **356–323 BCE** During his short life, Alexander the Great builds his nation into a huge empire, reaching as far as India.

▷ **218 BCE** Hannibal crosses the Alps into Italy with his Carthaginian army.

▷ **146 BCE** Macedonia officially becomes a Roman province, and the rest of Greece is effectively under Roman control.

▷ **27 BCE** Following his defeat of Antony and Cleopatra in 31 BCE, Octavian exercises full control over Rome's territories. Four years later, he assumes the title "Augustus" and becomes the first Roman Emperor.

▷ **79 CE** The tragic destruction of Pompeii by a volcanic eruption preserves a wealth of Roman art for the future.

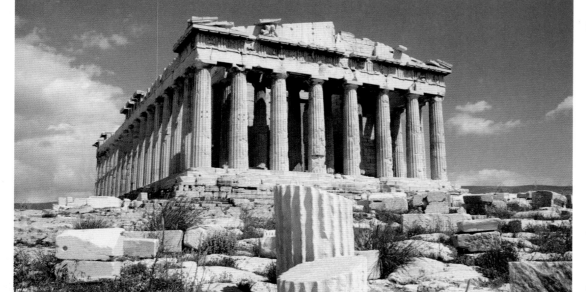

The Parthenon
Built on the highest point of the Acropolis in Athens, the Parthenon—a temple dedicated to Athena—is one of the most celebrated monuments of the Classical age in Greece.

◎ BEGINNINGS

THE GREEK HERITAGE

Only a tiny proportion of the paintings produced in the Classical world have survived, so it is hard to gain a balanced picture of their development. Easel paintings and murals were undoubtedly the more prestigious forms of art, winning extravagant praise in the writings of Pliny and other ancient writers, but painted vases have proved more durable. Most vases that have survived were retrieved from tombs and, although they were often broken, it has been possible to piece together substantial numbers of them. The Greek tradition stemmed from Mycenaean and Minoan examples, producing its first truly independent style during the Geometric phase, when abstract ornamentation was the dominant approach. Figurative elements were gradually introduced, partly through contacts with the Near East, culminating in the black-figure and red-figure vases that mark the pinnacle of Greek achievement in pottery.

◉ ARTISTIC INFLUENCES

The art of both Greece and Rome had a long pedigree, stretching back into prehistoric times. The key influences on Greek art came from the Cyclades islands, Mycenae on mainland Greece, and the Minoan civilization on Crete, while the Romans followed in the path of the Etruscans. Decorated Etruscan tombs at Tarquinia and Cerveteri—both now World Heritage sites—emphasize the importance of the art of that civilization.

The Minoans were influenced by Greek fresco-painting techniques. They flourished on Crete from around 2500 BCE, producing fine works of art with religious overtones—as well as purely decorative murals—in great palaces, especially Knossos.

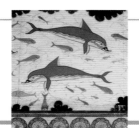

Dolphin Fresco, detail, 3rd millennium BCE, has been carefully reconstructed in the Queen's *Megaron* (great hall). *Palace of Knossos, Crete*

Greek colonists took their customs and material culture to foreign lands, spreading their painting traditions and resulting in local variations. This image is from a Greek tomb in Italy—its style is provincial, with little attempt at grandeur.

The Diver, c.480 BCE, depicts a figure that is thought to symbolize the journey from life into death. *Paestum, Campania, Italy*

The Mycenaean civilization, which flourished in Greece in the Late Bronze Age, grew out of the city of Mycenae in the northeastern Peloponnese. It is best known for pottery, which was an important inspiration for later Greek vase painters.

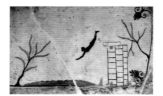

The Warrior Vase, 13th century BCE, is unique in its iconography—a phalanx of marching soldiers. *National Archaeological Museum, Athens, Greece*

The color red was made from cinnabar, one of the rarest and most expensive pigments in the ancient world. Patrons specified the amount to be used as a statement of their wealth. Pliny the Elder recommended diluting cinnabar with goat's blood or crushed berries to make it last.

Cinnabar was thought to turn black if exposed to sunlight or moonlight. To prevent this, artists coated it in a mix of oil and candle wax.

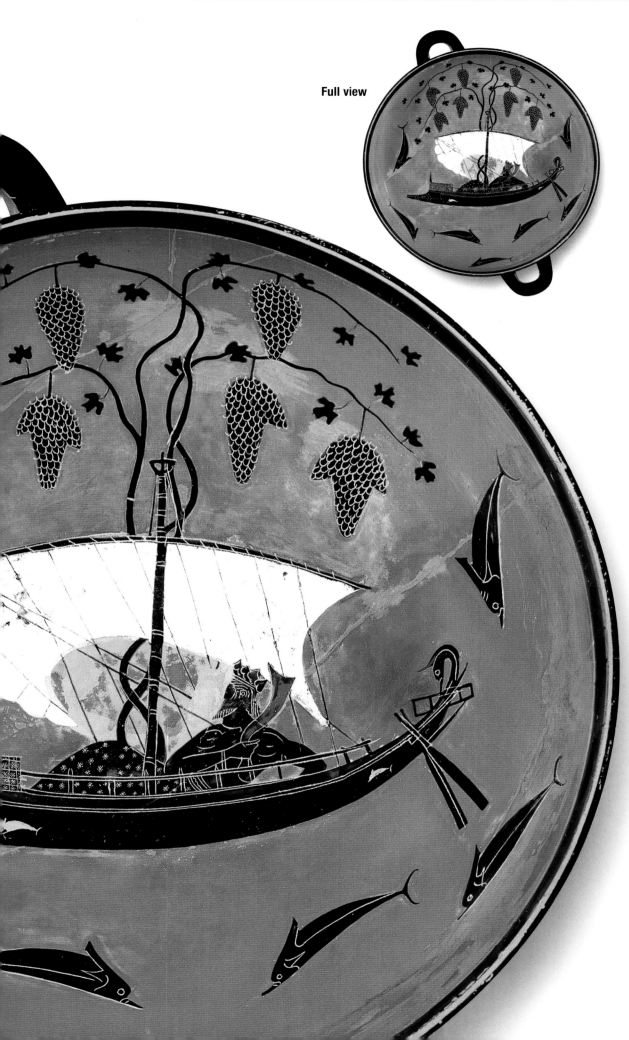

Full view

Dionysus Cup

Exekias **c.530** BCE *Staatliche Antikensammlungen, Munich, Germany*

The Dionysus Cup is a truly masterful blend of function and design in the black-figure technique, in which figures were painted in black on a red clay background. The vessel is a *kylix*—a shallow wine-cup—and would have been mainly used at *symposia* (drinking parties), where the guests reclined on couches. As they drank, the image at the bottom of the cup was revealed. Exekias has chosen as his subject an episode from a Homeric hymn about Dionysus, the wine-god, who was captured by pirates in his youth. To escape, he turned the mast into a vine, complete with clusters of grapes. Terrified, the pirates jumped overboard, where they were transformed into dolphins. Dionysus reclines like one at a symposium, enjoying the scene that he has created. The narrative is condensed into a single, harmonious image, with the seven dolphins balanced by the seven bunches of grapes.

Exekias

active Athens, Greece, c.550–520 BCE

Exekias was the greatest of the Greek vase painters working in the black-figure technique. A potter and a painter, he was highly inventive in both fields. Sixteen signed pieces have survived and, in all, around 40 paintings are attributed to him. He combined great precision and naturalism with imaginative flair, choosing unusual subjects and often endowing them with genuine psychological depth. He also excelled at adapting his designs to the awkward surfaces of different kinds of vessels.

BIOGRAPHY

◎ TIMELINE

Painting flourished in the Classical world, though it is hard to appreciate this, since so little remains. The most famous painters of antiquity—Zeuxis, Apelles, Parrhasius, Apollodorus—were all active during the 5th or 4th century BCE, but not a single original work has survived. The wall paintings that were preserved in and around Pompeii offer a tantalizing glimpse of the Greek and Roman artistic heritage that was destroyed.

▽ Corinthian Aryballos
c.650 BCE
Louvre, Paris, France
This type of perfume flask, with a human or animal head, was extremely popular throughout the Mediterranean. The battle scene indicates that it was designed for use by a man.

◎ ETRUSCAN ART

The Etruscans emerged in northern Italy in around the 8th century BCE and remained a potent force for the next 500 years. Their artistic style contains a mix of Greek, Phoenician, and Asian influences. The Romans drew inspiration from their art, which is typified by the painted tombs at Tarquinia and Cerveteri. The wrestling bouts pictured here were staged at funeral games.

Detail of Wrestlers, **Tomb of the Augurs, Italy**

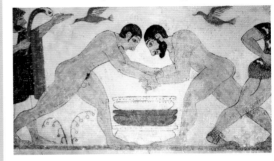

CONTEXT

Vase painting styles
The Greeks move into northern Syria in the 9th century BCE. This affects the style of vase painting, with Asian motifs now being featured alongside the more traditional geometric patterns. Corinth remains the most important center of pottery production.

Archaic period
The Archaic age begins to blossom in ancient Greece from c.730 BCE. New city-states are founded, trading contacts are extended, and colonies are set up in many parts of the Mediterranean.

Roman republic
Rome becomes a republic in 510 BCE. The last king is expelled and his place is taken by two officials called *praetors* (later consuls), who are elected each year.

800 BCE	750	700	650	600	550	500

Etruscan origins
The Etruscans emerge on the Italian mainland c.690 BCE, rapidly superseding the Villanovan people. They produce remarkable tomb paintings as part of an elaborate cult of the dead.

△ Geometric Amphora
c.800 BCE
Large, geometric amphorae were often used as grave markers at this time. Precise bands of zigzag or interlocking patterns were combined with friezes of grazing animals or, occasionally, mourners and burial carts.

Winged Gorgon ▷
c.7th century BCE
Museo Archeologico Regionale Paolo Orsi, Syracuse, Sicily, Italy
This colorful clay relief was probably used to decorate the side of an altar. It displays the fearsome Medusa carrying her offspring, the winged horse Pegasus. The distinctive kneeling pose was a standard way of representing a figure that was either running or flying.

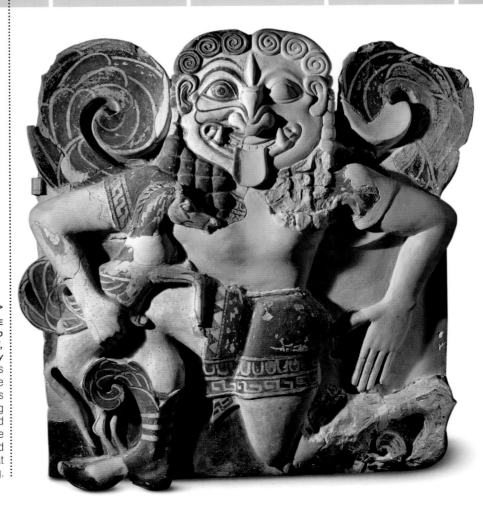

▽ Artemis and Actaeon Bell Krater
Pan Painter c.470 BCE
Museum of Fine Arts, Boston, MA

This is the opposite side of the Pan Painter's name piece, portraying a tragic episode from Greek legend. While out hunting, Actaeon surprises Artemis in her secluded grotto. In revenge, the virgin goddess sets his own hounds upon him, watching as they tear him apart.

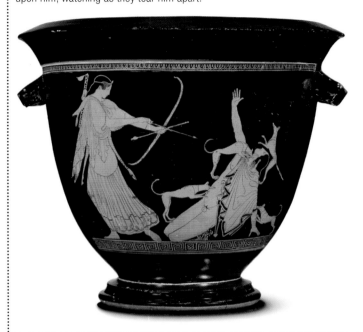

Pan Painter

active Athens, Greece c.480–450 BCE

One of the greatest of the red-figure vase painters, the Pan Painter worked in a lively, theatrical style. More than 160 of his works have survived. He was probably trained by Myson, a leading artist of the preceding generation, and he developed a sizable repertoire, ranging from religious and mythological themes to scenes of everyday life. The artist takes his name from a spirited depiction of the Greek god Pan, who chases a startled goatherd (on the reverse of the vessel illustrated *left*).

BIOGRAPHY

450 **400** **350** BCE

Temple of Zeus
The temple of Zeus at Olympia is completed in 456 BCE. Built to house a magnificent statue of the god, it is acclaimed as one of the Seven Wonders of the Ancient World.

Parthenon completed
Begun in 447 BCE, the Parthenon—the temple dedicated to Athena on the Acropolis in Athens— is completed in 432 BCE. The building is richly adorned with sculpture, much of which survives today.

Apelles

born Colophon, Ionia [now Turkey]; **active** 4th century BCE

Hailed as the greatest painter of ancient Greece, Apelles was a native of Ionia, in Asia Minor. He became court painter to Philip of Macedon and his son, Alexander the Great. Apelles was famed for his portraits and his graceful depictions of Aphrodite, but sadly none of them have survived to the present day.

BIOGRAPHY

Alexander the Great as Zeus ▷
After Apelles c.350 BCE
Casa dei Vetti, Pompeii, Italy
This small but majestic wall painting was discovered at Pompeii. It is a 1st century BCE Roman copy of a lost Greek original from c.350 BCE. Scholars speculate that it derives from a portrait by Apelles, since it corresponds very closely to a description by Pliny the Elder, the Roman writer.

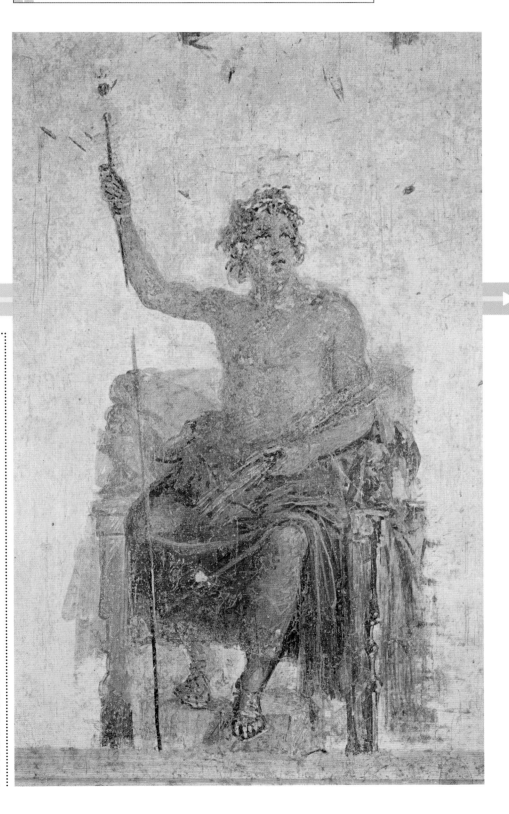

Dioskurides of Samos

born Samos?, Asia Minor **active** c.1st century BCE

Little is known about Dioskurides, a mosaicist who produced a pair of theatrical scenes for the Villa of Cicero. He was evidently working from a pattern book, since later, painted copies of his *Street Musicians* have survived. He was highly skilled, using minute *tesserae* and even painting the mortar between the stones.

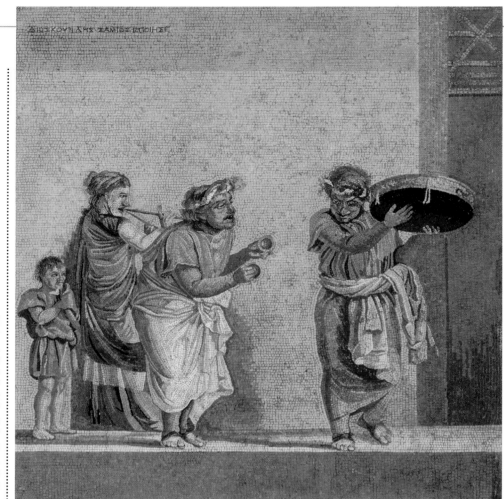

Mosaic of Street Musicians ▷
Dioskurides of Samos,
1st century BCE
Museo Archeologico Nazionale, Naples, Italy
This striking mosaic was recovered from the Villa of Cicero in Pompeii. It is probably a copy of a Greek painting from the 3rd century BCE. The theatrical masks suggest that it represents a scene from a comedy.

Lost work
A famous painting celebrating the military prowess of Alexander the Great is produced c.300 BCE. Although the picture itself has not survived, it is known through a Roman copy found at Pompeii, the *Alexander Mosaic*.

300 BCE **250** **200** **150** **100**

Carthage rises
From c.310 BCE, Carthage rises to dominance in the Mediterranean, embarking on a struggle with the Greeks for control of Sicily.

Rome conquers
Rome extends its power and influence throughout the 2nd century BCE. The capture of Numantia in 133 BCE brings most of Spain under its rule, while the province of Asia Minor (modern-day Turkey) is established.

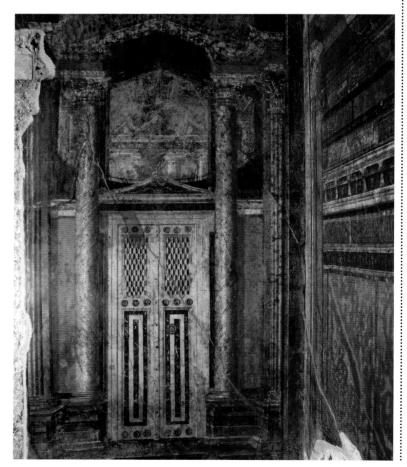

◁ **Trompe l'Oeil Doorway**
2nd century BCE
Pompeii, Italy
One of the chief traits that the Romans inherited from the Greeks was a love of illusionistic effects. Many of the wall paintings at Pompeii feature remarkably convincing *trompe l'oeils* of doors, columns, and architectural details. This arch and doorway, for example, are entirely painted.

▽ The Aldobrandini Wedding

c.27 BCE**–14** CE *Vatican Museum, Vatican City*
This fresco was discovered in 1601 in the remains of a Roman mansion. It takes its name from its first owner, Cardinal Aldobrandini. It has a mythological theme, with Venus attending to the bride in the center.

CONTEXT

PERFECTLY PRESERVED

Pompeii has become a crucial site for the study of Roman painting. In 79 CE Mount Vesuvius erupted, killing thousands and burying the thriving port under thick layers of ash and pumice. The dry, airless conditions helped preserve scores of wall paintings, providing a unique insight into Roman culture.

Ruins at Pompeii

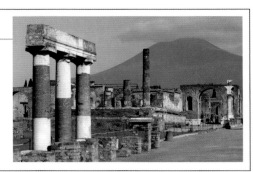

Revolt of Spartacus

A far-reaching slave rebellion in 73 BCE shakes Roman confidence. Spartacus, a Thracian captive, escapes from a gladiator school in Capua and raises a huge army that inflicts a string of humiliating defeats on Roman forces. He is eventually defeated by Marcus Crassus in 71 BCE.

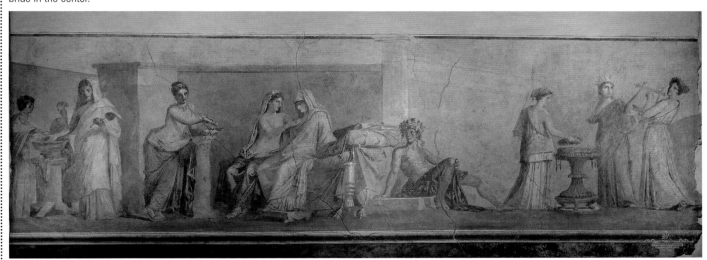

50 1 CE 50 100 CE

Colosseum opens

Rome's first permanent amphitheater, the Colosseum, opens in 80 CE. The dedication ceremony is followed by 100 days of games.

Trajan's Column

In c.107 CE work begins on Trajan's Column, a spectacular monument with relief carvings celebrating the achievements of Emperor Trajan. In particular, it commemorates his victorious campaigns in Dacia (in modern-day Romania).

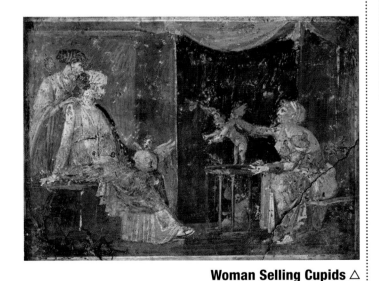

Woman Selling Cupids △

1st century BCE**–79** CE
Museo Archeologico Nazionale, Naples, Italy
The Romans loved portraying cupids in humorous vignettes—drinking wine, playing children's games, or even performing household chores. Several Neoclassical artists were fond of this particular theme, producing their own versions (*see p.223*).

◁ Woman Playing a Kithara

c.50–40 BCE
Metropolitan Museum of Art, New York, NY
This sumptuous fresco was designed for the villa of P. Fannius Synistor at Boscoreale. The woman's rich attire has given rise to suggestions that she may be a Macedonian queen, pictured with her daughter or sister.

 # MASTERWORK

Villa of the Mysteries Frescoes

c.60–50 BCE
Pompeii, Italy

This unparalleled example of a monumental cycle of Roman paintings was discovered in the Villa of the Mysteries, situated on the outskirts of Pompeii. By good fortune, the building sustained relatively little damage during the eruption of Mount Vesuvius in 79 CE, and most of the paintings have survived in reasonable condition.

The frescoes take the form of a frieze, covering three walls of an *oecus* (large saloon) at the southwestern corner of the villa. The precise details of the imagery are still disputed, but most critics agree that the paintings relate to the initiation rites for a cult of Dionysus reserved solely for women. At the heart of the frieze, the god reclines with his satyrs and other woodland companions. These mingle with the women taking part in the ceremonies, which appear to include a symbolic marriage and a ritual scourging. The figures in the detail pictured here include a child reading from a scroll, a woman bearing a tray of food, and a seated priestess unveiling an unseen object that will be used in the rites.

The patron of these paintings is unknown, but was clearly a person of considerable means. This is evident from the lavish use of cinnabar, a prohibitively expensive red pigment.

> **„„** ...FOR **THE EYE** IS **ALWAYS IN SEARCH** OF **BEAUTY** **„„**

c.20 BCE | Vitruvius Pollio
Roman architect and engineer, author of De Architectura

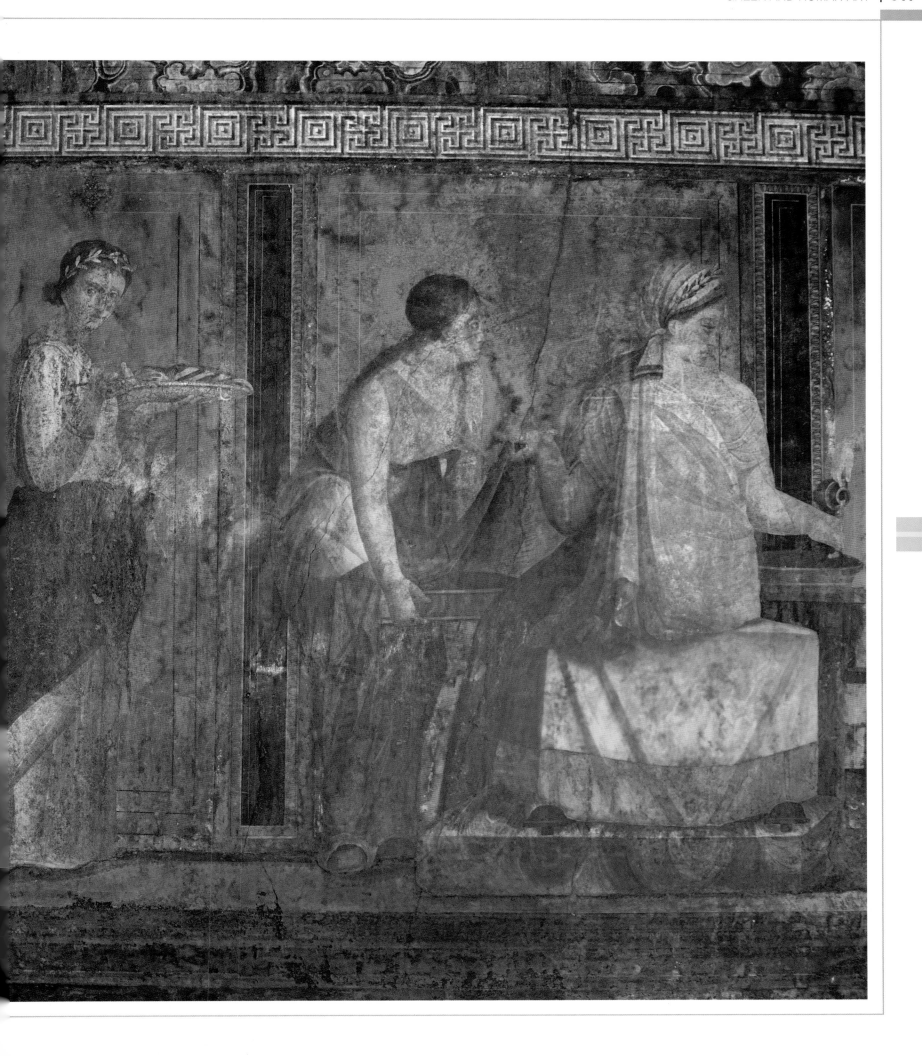

EARLY CHRISTIAN AND BYZANTINE

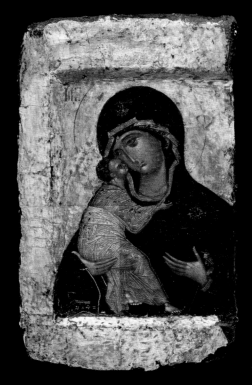

▷ **The Virgin of Vladimir**
Circle of Andrei Rublev,
15th century *Russian Museum,*
St. Petersburg, Russia
The original version of this icon
was painted in Constantinople in
the early 12th century and was
sent to Vladimir in 1155. It typifies
the Byzantine practice of arranging
subjects in very specific formats:
this example depicts the *Eleousa*
(compassionate) aspect of the
Virgin. The Infant is affectionate,
but Mary appears sorrowful, as
if she already knows Christ's
painful destiny.

In 330 CE, the Roman emperor Constantine the Great took the momentous step of transferring his capital to the East. This move had huge consequences, not only in the realm of politics but also for the future development of religion and art. In the West, Christian painters would eventually glorify their faith with artworks that brought the Holy Scriptures to life, displaying naturalism, emotion, and imaginative power. In the East, the approach could hardly have been more different. Christian art was solemn and stylized, a means of communing directly with the Lord. As such, it was carefully regulated. There was no interest in producing realistic images of the natural world. Nor were artists expected to demonstrate any signs of originality or personal expression. Instead they were encouraged to spread the influence of the finest icons by imitating them as precisely as possible. This was the case with *The Virgin of Vladimir* (*see above*), the holiest icon in Russia, which was copied repeatedly over the centuries.

 CONTEXT

The path to Orthodoxy

Early Christian art developed in an era of crisis. In 324 CE, Constantine reunited the empire after a period of civil war, but he recognized that Rome was no longer suitable as its capital. Instead, he opted for the old Greek city of Byzantium, which was better situated strategically to manage his vast territories. He enlarged it, renamed it Constantinople, and encouraged the spread of Christianity. In part, this was because of his own conversion, but it was also a recognition of the success of the religion in this area. The Church was already thriving in Egypt, Syria, Armenia, and Ethiopia, and their regional styles, combined with Roman and Hellenistic influences, all contributed to the early development of Byzantine art.

Rome proved as vulnerable as Constantine had feared. The city was sacked several times in the 5th century CE and the last emperor in the West was deposed in 476 CE. The Church survived these onslaughts, but its influence was restricted. During the period of the Byzantine Papacy (537–752 CE), all papal appointments had to be approved by the emperor, while the finest Christian art on Italian soil was produced at Ravenna, a provincial Byzantine capital.

In the East, the Church struggled to maintain unity and suppress heresy. A series of Ecumenical Councils were called to lay down the finer points of Orthodox doctrine, but divisions still persisted. One of the most serious problems concerned the use of icons, which some considered idolatrous. During the Iconoclastic periods, they were prohibited entirely and thousands were destroyed. Even after the ban was revoked, the content and style of icons was closely monitored, with theological precision taking precedence over any aesthetic considerations. The Byzantine Empire ended with the fall of Constantinople in 1453, but the art of icon painting continued to flourish in Russia and the Balkans.

The rise and fall of Constantinople

▷ **324–330 CE** After enlarging and embellishing the city of Byzantium, Constantine renames it Constantinople.

▷ **532–537 CE** Emperor Justinian builds the church of Hagia Sophia in Constantinople, adorning it with icons and mosaics.

▷ **726–787 CE and 814–843 CE** Eras of Iconoclasm, when many Byzantine icons are prohibited and destroyed.

▷ **988 CE** Vladimir of Kiev marries the sister of Emperor Basil II, bringing Byzantine culture to Russia.

▷ **1155** The city of Vladimir acquires its most famous icon, the *Virgin of Vladimir*. The Assumption Cathedral will be built to house it.

▷ **1204** Soldiers on the Fourth Crusade sack Constantinople and found the Latin Empire.

▷ **1395** Theophanes the Greek, the renowned Byzantine icon painter, begins work in Moscow.

▷ **1453** Constantinople falls to the Turks, signaling the end of the Byzantine Empire.

KEY EVENTS

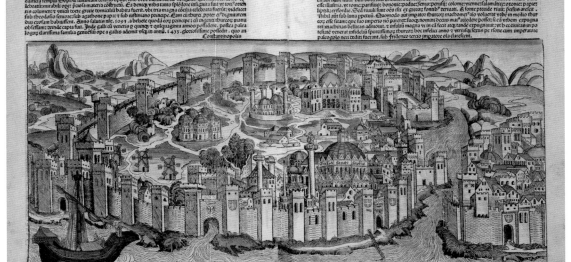

> **WE KNEW NOT** WHETHER WE WERE **IN HEAVEN** OR **ON EARTH**, FOR SURELY THERE IS **NO SUCH SPLENDOR** OR **BEAUTY ANYWHERE UPON EARTH**

988 CE | Russian emissaries
Reporting to Vladimir of Kiev, after witnessing services in Constantinople

Constantinople
This fanciful view of Constantinople is from the richly illustrated *Weltchronik* (World History) published in 1493. It is often called the *Nuremberg Chronicle*, after its place of publication.

◎ BEGINNINGS
A MELTING POT

In the West, the earliest Christian paintings were created on the walls of the catacombs, a maze of burial chambers just outside Rome. The threat of persecution still lingered, so the images were cautious, very basic, and sufficiently ambiguous to be interpreted as pagan art. In depictions of the *Good Shepherd,* for example, Christ was portrayed as a young, beardless man who could easily be mistaken for Orpheus or Apollo.

In the East, the first icons were modeled on pagan images of household gods. Surviving examples of these are reminiscent of the *Christ and Abbot Mena* painting (*see p.46*), with squat figures in a rigid, frontal pose. The Fayum portraits (*see p.29*) from Roman Egypt were also highly influential. Some icon painters even adopted the same techniques: the Sinai portrait of *St. Peter* (*see p.47*), for instance, was executed with the encaustic process favored by the Fayum artists.

◎ ST. LUKE

According to Eastern tradition, the first icon was a portrait of the Virgin holding the infant Christ, painted by St. Luke. The claim was first recorded in the *Veneration of Holy Icons,* a treatise written in the 8th century CE at the start of the iconoclastic period, and attributed to St. Andrew of Crete. Churches in Rome, Jerusalem, and Constantinople were all said to hold paintings by Luke. The most influential was at the Hodegon Monastery, Constantinople, which gave its name to the format—the *Virgin Hodegetria*—that was followed by later icon painters.

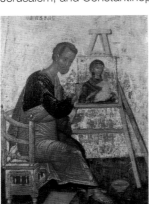

St. Luke Painting the Blessed Virgin, **early 15th century, Michael Damaskenos, Ikonen-Museum Recklinghausen, Germany**

CONTEXT

◎ TURNING POINT

Virgin Enthroned with Two Saints

6th century CE *St. Catherine's Monastery, Sinai, Egypt*

This is the most striking of the early icons preserved at Sinai. The Virgin sits in majesty, flanked by St. Theodore and St. George. Behind, two angels gaze up in wonder as the hand of God reaches down toward her. The painting anticipates the formal style that characterizes Byzantine art. Its encaustic technique gives the figures a rich glow, but the artist's concern is doctrinal rather than aesthetic. His primary aim is to stress the Virgin's role as the *Theotokos* (God-bearer).

◉ ARTISTIC INFLUENCES

The center of the Christian world lay in the East, during the early years of the religion. Together with Constantinople, the cities of Antioch, Alexandria, and Jerusalem were all important centers. Each of these had artistic traditions of their own, which contributed to the development of Byzantine art.

The Coptic Church produced a distinctive form of early Christian art, with its mix of Egyptian and Hellenistic influences. These are best seen in Coptic wall paintings and manuscripts.

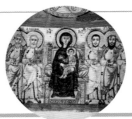

The Virgin and Child Accompanied by the Apostles, detail, 6th century CE, a fresco from the Monastery of St. Apollo, Bawit. *Coptic Museum, Cairo, Egypt*

The color purple was extremely prestigious, because of its high cost and its imperial associations, so Eastern artists often used it for the robes of Christ and the Virgin (*see Crucifixion, p.48*).

Jesus Before Pilate and the Repentance of Judas, 6th century CE, from the lavish purple pages of the *Codex Rossanensis. Museo Diocesano di Arte Sacra, Rossano, Italy*

The Roman catacombs provided inspiration for some formats of Byzantine icons. In the East, the Virgin Mary was commonly shown praying in the Orans pose, and was often pictured with the infant Christ.

Orans (praying) figure, 3rd century CE, displays the stance adopted in worship in the East: arms spread, palms facing outward. *Catacombs of Priscilla, Rome, Italy*

The Rabbula Gospels, the oldest known Syriac manuscript, introduced many ideas to early Christian iconography. The Syrian Church, centered in Antioch, was crucial in spreading the Faith.

The Ascension, detail, 586 CE, depicts Christ borne up to heaven. A composite figure bears the symbols of the four Evangelists. *Biblioteca Laurentiana, Florence, Italy*

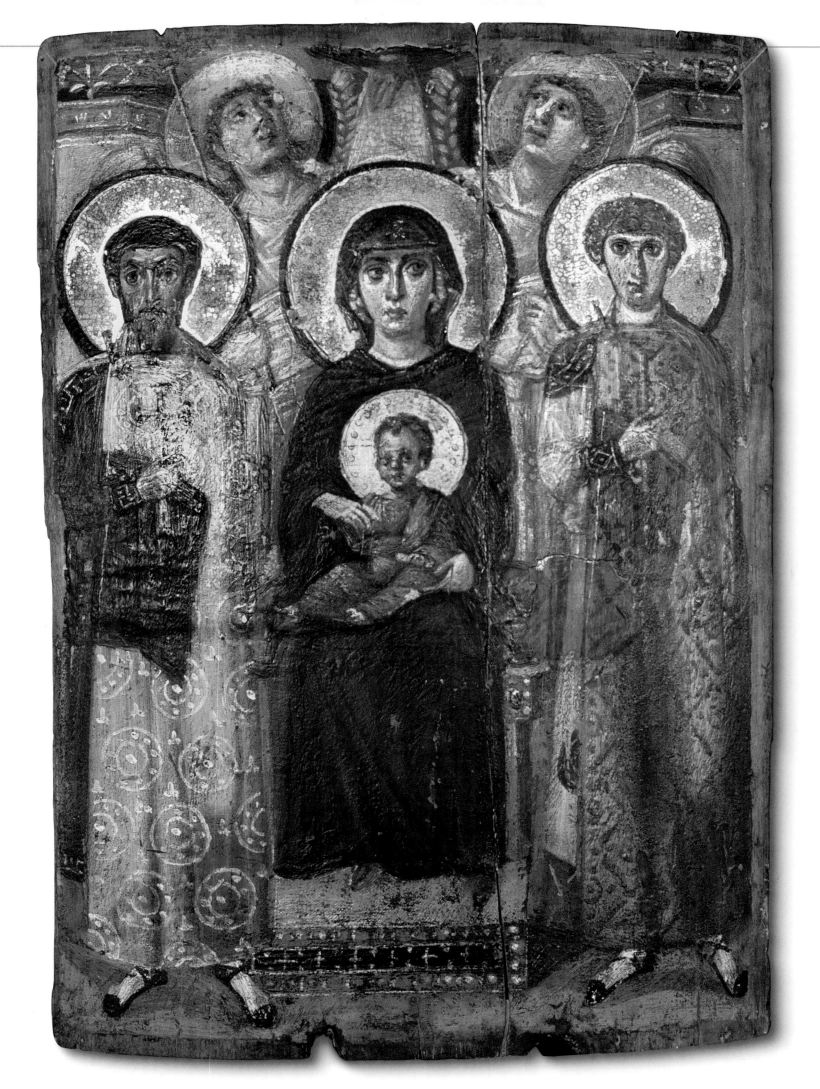

◎ TIMELINE

While the threat of persecution still lingered, the earliest Christian art remained modest. However, once Constantine had made Christianity the official religion of the Roman empire, artists became more ambitious, borrowing forms and imagery from classical antiquity. Icons developed from around the 6th century CE, but their status as sacred objects caused controversy, and for a time they were banned. Byzantine links with Russia date from the 10th century and after the fall of Constantinople, Russia became the principal center of icon painting.

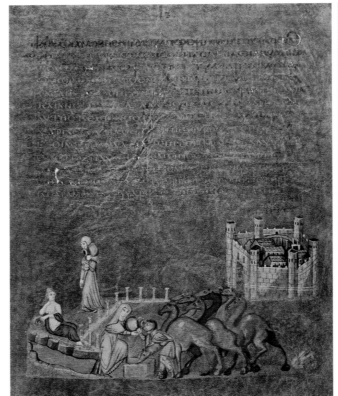

◁ **Rebecca at the Well**
Vienna Genesis, 6th century CE
Österreichische Nationalbibliothek, Vienna, Austria
This lavish manuscript of the Book of Genesis was written in silver lettering on purple vellum. The sheer expense of such a project suggests it was probably produced in Constantinople as an imperial gift. Rebecca is chosen as Jacob's bride after drawing water for his camels.

Edict of Milan
In 313 CE, Emperor Constantine and his political rival, Licinius, agree to grant religious freedom to Christians. This agreement is widely known as the Edict of Milan.

Council of Chalcedon
Held in 451 CE, the Council of Chalcedon highlights the growing divisions between East and West. The decision to elevate the see of Jerusalem, ranking it second only to Rome, proves particularly unpopular.

Exarchate of Africa
Emperor Maurice creates the Exarchate (province) of Africa in c.590 CE, with Carthage as its capital. This form of government is designed to protect Byzantine interests in the Western Mediterranean region.

300 CE ○ ○ **400** ○ **500** ○ ○ ○ ○ **600**

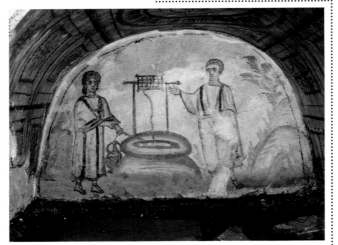

Jesus and the Samaritan Woman △
c.320–350 CE
Catacomb on Via Latina, Rome, Italy
Some of the earliest Christian paintings were produced in the Catacombs, a network of underground burial tunnels near Rome. In this New Testament episode, Christ wears a toga and is beardless.

Construction of San Vitale
The Basilica of San Vitale in Ravenna is begun by Bishop Ecclesius in c.525 CE. He does not live to see its completion, but the church is eventually consecrated in 547 CE.

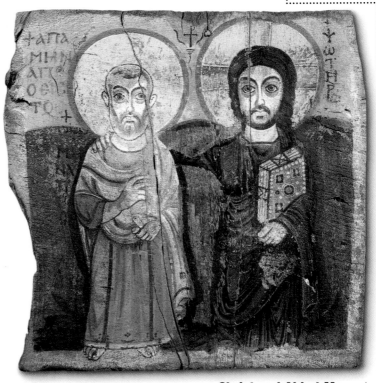

Christ and Abbot Mena △
Late 6th–early 7th century CE *Louvre, Paris, France*
This is the oldest known Coptic icon. It was excavated from the Egyptian monastery of Apollo at Bawit. Christ lays a protective arm around the shoulder of the abbot, who holds a scroll in his left hand containing the rules of the monastery.

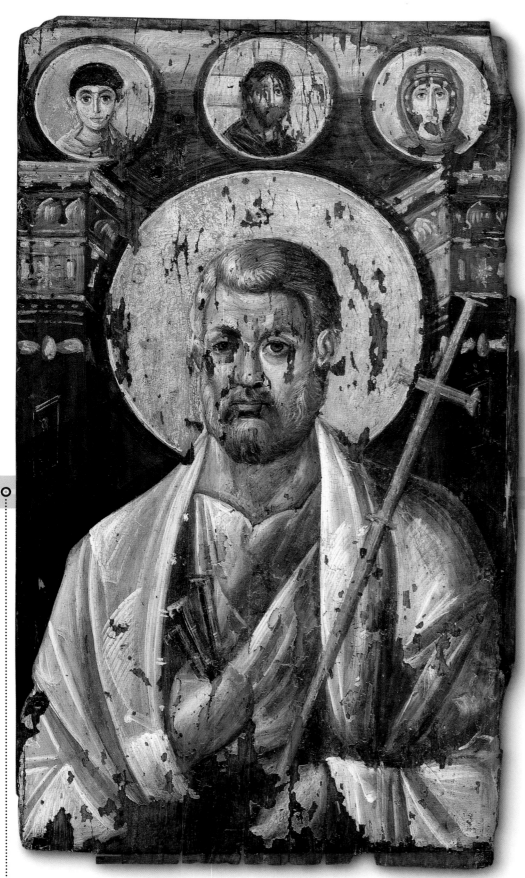

△ St. Peter
6th–7th century CE
St. Catherine's Monastery, Sinai, Egypt
In this early icon, Peter is portrayed as a figure of authority. The picture follows a format that was often found on consular diptychs, where the status of the subject was reinforced by images of higher powers in roundels—in this case, God the Father, the Virgin, and a young, beardless Christ.

Boethius Diptych ▽
7th century CE *Museo Cristiano, Brescia, Italy*
Consular diptychs were lavish status symbols. This pair of hinged, ivory panels is a writing tablet, but it was also a present, given traditionally by a newly appointed Consul to his supporters. Some were Christianized. In this instance, religious paintings were added in the 7th century CE to Boethius's original tablet of 487 CE.

700 CE ➤

Pope arrested
Martin I is the only pope to challenge the authority of the emperor during the period of the Byzantine Papacy (537–752 CE). He is arrested in 653 CE and banished to Chersonesos Taurica, in present-day Ukraine.

RAVENNA

The Byzantine empire maintained influence in Italy through its provincial capital at Ravenna. The city was captured from the Ostrogoths in 540 CE, as part of Justinian's campaign to reconquer the West. Its crowning glory was the Basilica of San Vitale, with its dazzling mosaics of Justinian and his empress, Theodora.

Emperor Justinian and his Entourage, mosaic panel, c.547 CE, S. Vitale, Ravenna, Italy

CONTEXT

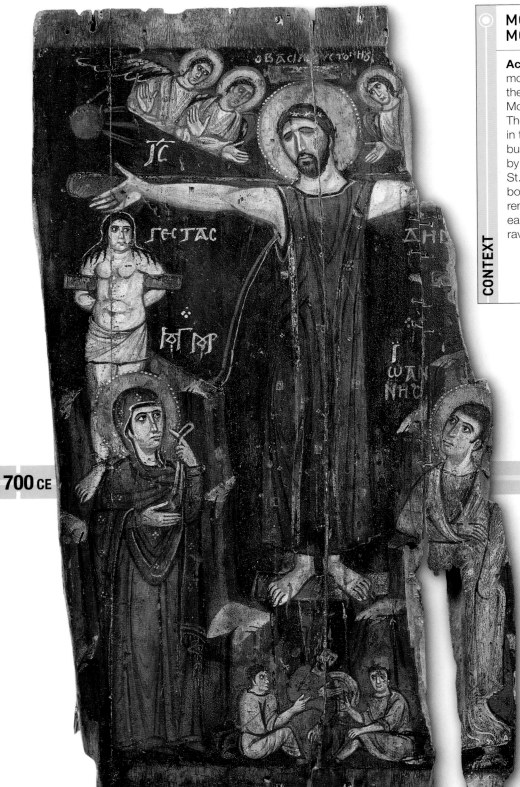

MONASTERY OF ST. CATHERINE, MOUNT SINAI, EGYPT

According to tradition, the monastery at Sinai stands on the site of the biblical event of Moses and the Burning Bush. The community was founded in the 4th century CE, but fortified buildings were commissioned by Justinian two centuries later. St. Catherine's contains many books and manuscripts, but is renowned for its collection of early icons, which escaped the ravages of the iconoclasts.

The monastery of St. Catherine stands at the foot of Mount Sinai

Iconoclasm returns
In 813 CE, the new emperor, Leo V, reawakens the debate over Iconoclasm by banning religious images. This is put into effect two years later, following a synod in Constantinople.

End of Iconoclasm
The second period of Iconoclasm draws to a close in 843 CE, marked by a procession of icons from the Blachernai Church to Hagia Sophia in Constantinople.

700 CE

800

Crucifixion △
8th century CE
St. Catherine's Monastery, Sinai, Egypt
The crucifixion was not depicted by the first Christian artists, because of the degrading nature of the punishment, which was reserved for common criminals, slaves, and non-Romans. Christ is shown standing on the Cross, rather than hanging from it, wearing an eastern tunic called a colobium. Both he and the Virgin Mary are clothed in purple, a color denoting high status.

Ezekiel's Vision in the Valley of Dry Bones △
Homilies of St. Gregory 880–882 CE
Bibliothèque Nationale, Paris, France
This is the finest miniature in a manuscript produced for Emperor Basil I. It depicts a vision prefiguring the Resurrection, in which the prophet is shown a group of skeletons that the Lord restores to life.

◁ Archangels Michael and Gabriel
10–11th century
Private Collection
This is an early icon in a provincial style, perhaps Cretan. Michael and Gabriel were often pictured together by Byzantine artists because, in addition to their own feast days, they were also celebrated on Synaxes (assemblies), when there were special services for groups of holy figures.

▽ Emperor Nicephorus III Botaneiates between St. John Chrysostom and the Archangel Michael
Homilies of St. John Chrysostom 1078
Bibliothèque Nationale, Paris, France
This stately portrait conceals a political subtext. The Chrysostom manuscript was produced for Emperor Michael VII Dukas, but in 1078 he was ousted by one of his generals, Nicephorus Botaneiates. The usurper duly had the portraits changed.

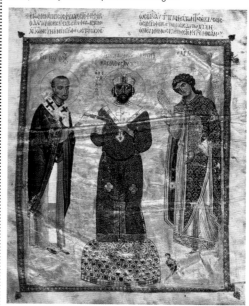

Vladimir dies
In 1015 Vladimir, Grand Prince of Kiev, the ruler who had forged new ties with the Byzantine empire, dies on the eve of battle.

900　　　　**1000**　　　　　　　　　　　**1100** ▶

Church of the Dormition
In 1080, construction work begins on the monastic Church of the Dormition at Daphni near Athens. In the following decade, it will be adorned with a remarkable series of mosaics.

◁ The Nativity
11th century
St. Catherine's Monastery, Sinai, Egypt
Byzantine versions of the Nativity differed from those in the West. Artists supplemented the meager details in the New Testament with information from the Apocryphal Gospels. These specified that the Nativity took place in a cave and that Mary was assisted by two midwives, Salome and Zelomi.

The Heavenly Ladder ▷
12th century *St. Catherine's Monastery, Sinai, Egypt*
The Heavenly Ladder was a 7th-century CE treatise by St. John Klimakos (literally John of the ladder), an abbot at St. Catherine's Monastery. In 30 chapters, his text outlined the path to spiritual perfection for monks, with each chapter representing a step on the ladder to heaven.

Norman palace in Palermo
In 1150, work continues on Roger II's palace in Palermo, Sicily. The highlight of the entire project is the Palatine Chapel, with its stunning sequence of mosaics produced by Byzantine craftsmen.

The Harrowing of Hell
c.1315–21
Chora Museum, Istanbul, Turkey
One of the finest examples of late Byzantine art, this outstanding fresco dates from a period when the empire was shrinking and funds were limited. Significantly, the commission came from a wealthy individual, Theodore Metochites, rather than the emperor. It illustrates a biblical tradition in which after his Crucifixion, Christ descended into Limbo (on the edge of Hell) where, according to a medieval belief, he raised up Adam and Eve from their graves and led them to heaven. The scene was executed in a semicircular apse, accentuating the way that all the figures seem to move toward Christ.

End of Latin Empire
Under the leadership of Michael VIII, Byzantine forces capture Constantinople in 1261. This brings to an end the Latin Empire, founded by the Crusaders in 1204.

1100 **1200** **1300**

△ The Ustyug Annunciation
Novgorod School 1130–49
Tretyakov Gallery, Moscow, Russia
This early Russian icon, one of the few that survived the Mongol invasion in the 13th century, depicts Christ cradled upon Mary's chest. She also holds a length of yarn, a reference to the legend that she made a curtain for the Temple of Jerusalem.

◁ St. George and the Dragon
Novgorod School, 14th century
Russian Museum, St. Petersburg, Russia
St. George is thought to have been a soldier, martyred in Palestine during the period of persecution under Diocletian (303–312 CE). As a warrior saint, he was popular with the Crusaders, who brought his cult back to Britain. The snakelike dragon is a symbol of the devil.

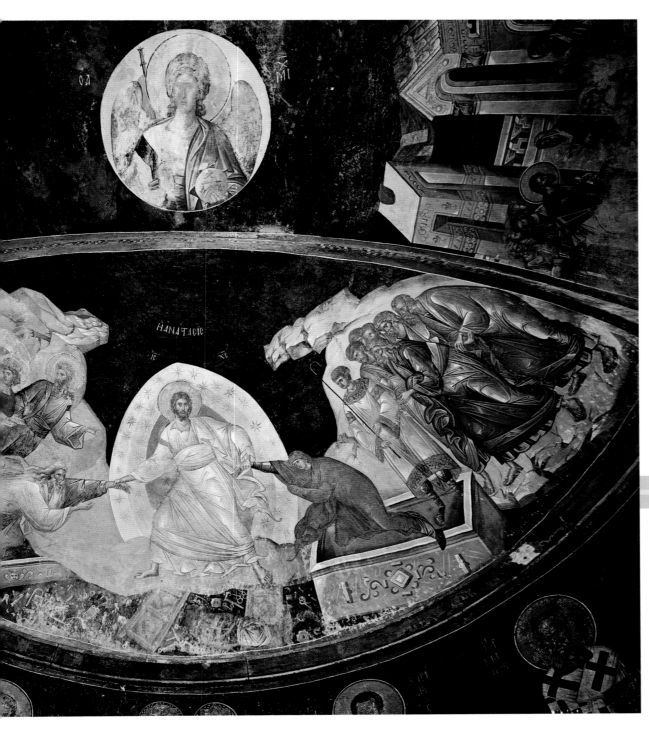

Battle of Ankara
In 1402, the Mongols under Tamburlaine the Great defeat the Ottoman army at Ankara. The resulting confusion enables Manuel II to strengthen the Byzantine position.

1400

Florus and Laurus △
Novgorod School, 15th century
Tretyakov Gallery, Moscow, Russia
These twin brothers were venerated in Russia as the patron saints of horses. Here, they intercede with St. Michael (top) for the return of some missing animals, which are rounded up by three grooms.

CONTEXT

THE ICON AS TALISMAN

All icons were regarded as sacred objects, but a few were deemed so holy that miraculous powers were attributed to them. Soldiers believed icons could help them in battle. In this depiction of a siege in 1169, the Novgorodians use an image of the Virgin to assist them against the Suzdalians. They pray to the icon and then place it on the parapets, where it shields the defenders against incoming arrows. Then they make a decisive charge, led by the haloed figures of St. Boris and St. George.

The Miracle of the Icon, c.1400–50,
Tretyakov Gallery, Moscow, Russia

◎ MASTERWORK

Old Testament Trinity

Andrei Rublev **c.1425**
Tretyakov Gallery, Moscow, Russia

This is the supreme masterpiece of Russia's finest icon painter. It illustrates a theme that was developed by Byzantine artists. In the West, depictions of the Trinity normally featured the readily identifiable figures of God the Father, the Son, and the Holy Spirit (usually in the form of a dove). By contrast, Eastern painters tended to portray three similar-looking divine figures, basing the scene on an episode from the Old Testament (Genesis 18:1–15). In this passage of Scripture, the Hebrew patriarch Abraham is visited by three otherworldly strangers. The text refers to them interchangeably as the Lord and as three men, leading later Christian theologians to conclude that this incident was the first appearance of the Trinity in the Bible. Abraham offers the visitors hospitality, giving them a meal of bread, meat, cheese, and milk. They, in turn, inform him that his aged wife, Sarah, will give birth to a son.

Rublev's *Trinity* is a huge improvement on earlier versions of this theme. He stripped away the distracting narrative content, focusing on its spiritual core. The table at which the guests eat is now an altar. On it, a chalice with the head of the sacrificial calf symbolizes the Eucharist. In front there is a recess, where relics are normally stored. Behind each of the figures, there is another symbol. The mansion is God's house, the goal of life's journey; the mountain represents the spiritual ascent that believers must make; and the oak is an emblem of the Tree of Life and Christ's Crucifixion. Finally, though aesthetic considerations were not valued highly at the time, Rublev's figures display a gracefulness and his colors a lyrical beauty that are unmatched in any other icon. According to a 17th-century tradition, the icon was painted in honor of Sergei Radonezhsky, a famous teacher and monastic reformer in medieval Russia.

> **ICONS** ARE **IN COLORS** WHAT THE **SCRIPTURES** ARE **IN WORDS**: **WITNESSES** TO THE **INCARNATION**, THE FACT THAT **GOD HAS COME AMONG US AS A PERSON** 🙶

787 CE | Seventh Ecumenical Council
On the restoration of the veneration of icons in Christian worship

◎ Andrei Rublev

born Russia, c.1360?
died Moscow, Russia, 1430

Russia's greatest and most influential icon painter, Rublev mastered the formal Byzantine style, but softened it, lending his figures an air of gentleness and serenity. Few personal details are known, though he may have been a monk at the Holy Trinity Lavra, near Moscow, and in 1405 he is documented assisting Theophanes the Greek in the Cathedral of the Annunciation, in the Kremlin. The *Old Testament Trinity* remains, by far, Rublev's most celebrated work. His reputation continues to grow. In 1988, he was canonized by the Russian Orthodox Church and he has become better known in the West through Andrei Tarkovsky's award-winning biopic of 1966.

BIOGRAPHY

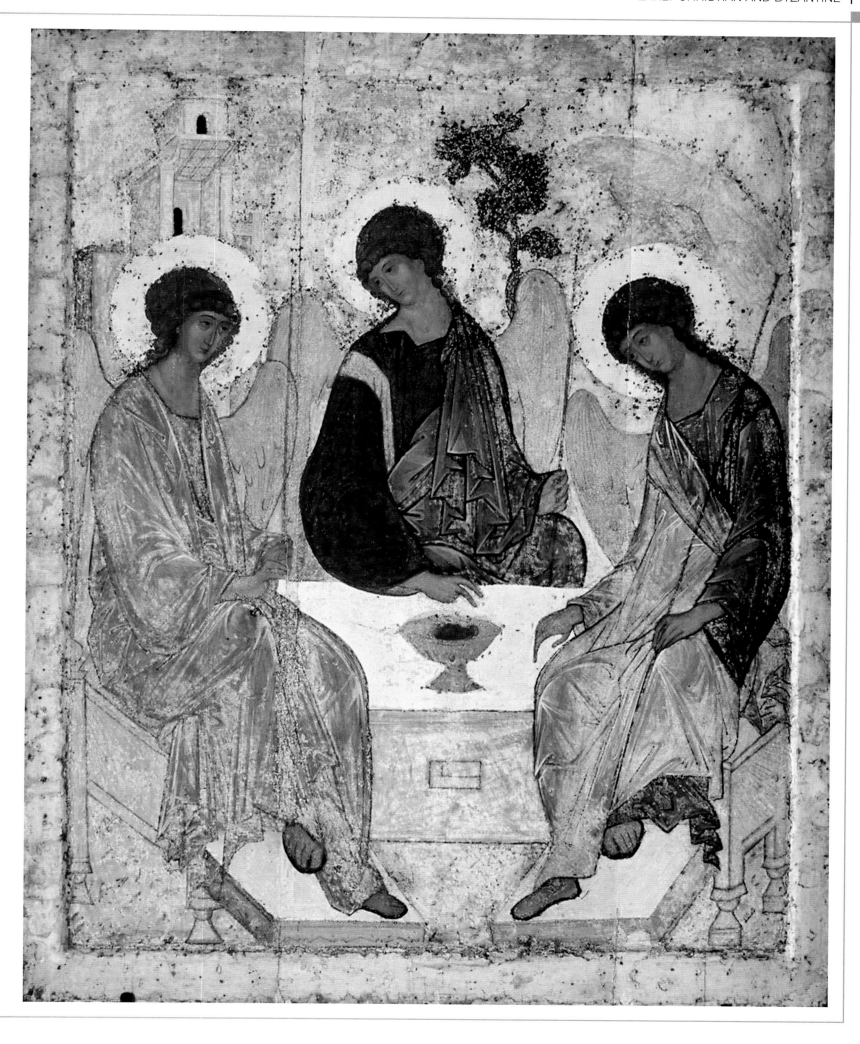

THE DARK AGES

▷ **St. Matthew**
Lindisfarne Gospels
c.698–721 CE
British Library, London, UK
In this prime example of Dark Ages painting, classical elements—the robe and even a very basic form of sandals worn by Matthew—are painted in a nonclassical, linear style. The Evangelist writes his Gospel while his symbol, the winged man, stands behind him (the third figure may possibly be Christ). The close resemblance between this *St. Matthew* and *Ezra*, in the *Codex Amiatinus* (see p.59) suggests that they were copied from a common source.

The art of manuscript illumination was the main form of painting that survived the turbulent period after the collapse of the Roman empire. Many manuscripts were designed for a very specific purpose: to assist with converting the pagan tribes of Europe to Christianity. These tribes already had flourishing artistic cultures of their own, mainly consisting of abstract or highly stylized designs executed in metalwork and stonework, rather than in paintings. Christian artists were perfectly happy to combine decorative motifs from these pagan sources with figurative images from Christian sources. For missionary purposes, a shortened form of the biblical text was preferred, focusing on the life of Jesus as described in the four Gospels—Matthew, Mark, Luke, and John. The decoration in these Gospel Books revolved around the four Evangelists and their traditional symbols. In many cases, the artist painted a portrait of the Gospel writer at the start of the book in the style of author portraits from classical manuscripts. This type of source is clearly evident in the illustrations of the *Lindisfarne Gospels*, such as *St. Matthew* (see above).

◎ CONTEXT

Spreading the Word

The final collapse of the Roman empire in the 5th century CE created a vacuum in Europe. The old areas of imperial control were overrun by marauding tribes: the Visigoths occupied parts of Gaul and Spain, the Ostrogoths and Lombards invaded Italy, while Germanic tribes —Angles, Franks, Saxons, and Jutes—spread across much of northern Europe. Often, these peoples could not settle within fixed borders, but were forced to continually migrate due to pressure from rival tribes. The Celts, for example, originated in central Europe but were eventually pushed to the western fringes of the continent —Ireland, Scotland, Wales, and Brittany.

Many pagan tribes had vibrant cultures that were far removed from the mainstream of classical art. The naturalism that was predominant in the pottery and fresco of the Greeks and Romans was rarely seen. Instead, in view of their nomadic circumstances, tribal craftsmen tended to lavish the greatest attention on small, portable objects, such as weapons and jewelry. Painting only came to the forefront during the conversion to Christianity, when religious texts were needed.

The Gospel Books and other Christian texts were created by monks, working together in a *scriptorium* ("a place for writing"). Some of the finest examples were created in Britain and Ireland by Celtic and Anglo-Saxon craftsmen. The *scriptoria* in the monasteries of Iona, Lindisfarne, Jarrow, and Wearmouth were particularly important, producing manuscripts for missionaries elsewhere in Europe.

Religious texts had to be copied precisely, but there was much more scope for invention in the illustrations. Monastic artists might borrow ideas from other Christian or classical manuscripts, but they could also copy designs that they had seen on the pagan metalwork or jewelry that was in widespread circulation. This produced the rich fusion of imagery that made the *Lindisfarne Gospels* and the *Book of Kells* such extraordinary masterpieces.

The conversion of the West

KEY EVENTS

▷ **476 CE** Romulus Augustulus, the last Roman emperor in the West, is ousted by a barbarian king, who rules in his place.

▷ **597 CE** The *Gospel of St. Augustine* is sent from Rome to England by the Pope. It is one of a number of manuscripts intended to assist in the conversion of the English.

▷ **c.700 CE** The Tara Brooch, one of the finest examples of Celtic jewelry, is created. Its intricate spiral decoration is echoed in the manuscripts of the period.

▷ **793 CE** Viking raiders launch their first attack on Lindisfarne, Northumbria.

▷ **814 CE** In Ireland, the monastery at Kells is revived. Monks from Iona begin to move to this safe haven to escape Viking attacks.

▷ **c.820–35 CE** One of the greatest Carolingian manuscripts, the *Utrecht Psalter*, is produced in France, probably at the abbey of Hautvillers.

▷ **878 CE** Following his defeat by Alfred, the Viking leader Guthrum adopts Christianity.

▷ **966 CE** With the baptism of Mieszko I, Poland becomes one of the last European nations to adopt Christianity.

MACREGOL PAINTED THIS GOSPEL BOOK. WHOEVER **READS AND UNDERSTANDS** ITS NARRATIVE, **LET HIM PRAY** FOR **MACREGOL THE SCRIBE** 🙶

c.820 CE | Macregol
Abbot of Birr, Ireland, written on colophon page in the Macregol Gospels

Island monastery
Situated off the west coast of Scotland, the island of Iona was once one of the most important Christian centers in Europe, with a *scriptorium* producing manuscripts of unparalleled beauty.

◎ BEGINNINGS
A FUSION OF STYLES

Some sources for the great decorated Christian manuscripts of the Dark Ages can be identified. The *Gospel of St. Augustine* was probably brought to the British Isles from Rome during Augustine's mission, and is still used for the swearing-in of the Archbishop of Canterbury. Its sole-surviving Evangelist portrait is classical in style.

In the *Ezra* portrait (*see p.59*), nine books are displayed in a cupboard. This is probably the *Novem Codices*, a fabled 9-volume Bible purchased from the library of Cassiodorus (a 5th-century CE Roman statesman and scholar) and sent to Northumbria. Historians have surmised that portraits in the *Lindisfarne Gospels* and the *Codex Amiatinus* were borrowed from this source. The most intriguing Celtic manuscript is the *Cathach of St. Columba*, a fragment of a Psalter. Dating from the early 7th century CE, its decorated initials provide a hint of the glories that were to come. It was long attributed to St. Columba and, as its name attests—*Cathach* means "Battler"—it was carried onto the battlefield as a relic.

◉ ARTISTIC INFLUENCES

The great Gospel Books were created against a background of change. A constant flux of raiders, settlers, and traders exposed native craftsmen to a wealth of influences. It is a testament to the skill of these Christian artists that they were able to combine a variety of decorative elements, divorce them from their pagan contexts, and use them to adorn holy texts.

Intricate interlacing was not confined to Celtic art. In this Visigothic manuscript, it adorns the arched form of a canon table—a means of cross-referencing text in the Gospel Books.

Codex Euricianus, detail, c.480 CE, from a manuscript created for Euric, a king of the Visigoths. *Biblioteca Nacional de España, Madrid, Spain*

Pagan jewelry exerted a notable influence on Celtic craftsmen. The decorative forms that were commonly used could easily be given a spiritual significance, such as the animal emblems of the Evangelists.

Visigothic fibula (brooch), c.6th century CE, resembles the eagle used to symbolize St. Mark in the *Book of Durrow.*

Pictish stonework—produced by a Celtic race in present-day Scotland—had a significant impact on the manuscripts of Northumbria. This is particularly evident in the stylized forms of animals.

Pictish Symbol Stone, detail of a slab thought to have been a grave marker, 8th century CE. *Brough of Birsay, Orkney, Scotland*

Viking raiders borrowed artistic ideas from looted items and also influenced native styles. Biting creatures, ribbon snakes, and tight interlacing became popular in Celtic and Anglo-Saxon art.

Deer eating a branch of Yggdrasil, the world tree, detail, 11th century. *Urnes stave church, Sogn og Fjordane, Norway*

◎ TURNING POINT

Symbols of the Gospel Writers

Book of Durrow **c.675** CE *Trinity College Library, Dublin, Ireland*

The decoration in Gospel Books often included images of the four authors and their respective symbols. These mystical emblems—a lion, a calf, an eagle, and a man—were drawn from two passages in the Bible, describing apocalyptic beasts worshipping before the throne of God (Ezekiel 1:10 and Revelation 4:6–9). Each of the creatures was thought to represent a different aspect of Christ's divine persona. The lion represented his royal and majestic role as the King of Heaven, while the man referred to his incarnation as a human being. The Durrow lion resembles Pictish stonework, suggesting that the manuscript was produced in Northumbria.

CONTEXT

◎ ST. COLUMBA

Following a violent dispute in 563 CE that forced him to leave his native Ireland, Columba vowed to redeem himself through missionary work. He founded a monastery on the island of Iona, using it as a base to launch an expedition to convert the Picts in Scotland. Iona became his center of operations for founding a network of monasteries, organizing missions to Europe, and running a remarkable *scriptorium*, which produced a succession of fine manuscripts, possibly including the *Book of Kells* itself.

St. Columba, Dunkeld Cathedral, Scotland

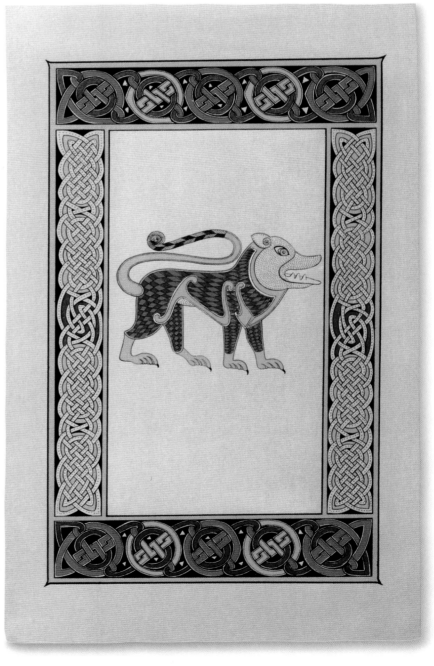

◎ TIMELINE

Manuscripts mirrored the dangers and uncertainties of the Dark Ages: occasionally cryptic marginal notes hint at violence and theft, the *Lichfield Gospels* (*opposite*) was exchanged for a horse, while the *Canterbury Codex Aureus* (*see p.60*) was stolen by Norsemen then ransomed by a dignitary called Aelfred. Politics, too, was reflected: in both the Canterbury manuscript and *Imago Hominis* (*opposite*) the figures' heads are shaved like a Roman monk in a bid to promote papal authority. In stylistic terms, pagan influences—complex interlacing, stylized robes, and ferocious beasts—gradually diminished over time.

SUTTON HOO

The royal cemetery at Sutton Hoo is the most important Anglo-Saxon site in Britain. The main grave—a ship burial—is often associated with Raedwald (died c.625 CE), who ruled when East Anglia was converting to Christianity. There are exotic items, such as Byzantine bowls and Merovingian coins, but also buckles and clasps with patterns that closely resemble decorations in the *Book of Durrow*. The prize piece is this helmet, with its ornate face mask and dragonhead details.

Helmet from Sutton Hoo

The rise of the Franks
By 500 CE, Clovis I has largely succeeded in his quest to subjugate the Alemanni (a confederation of Germanic tribes) and unite the Franks under his leadership.

500 CE ○ **600** ○ ○

Battle of Mount Badon
In c.510 CE, the Britons, supposedly led by King Arthur, are said to have won a great victory over Anglo-Saxon invaders at the Battle of Mount Badon.

Foundation of Lindisfarne
The monastery of Lindisfarne is founded in c.635 CE by Aidan, a monk from Iona. It rapidly becomes a key center for the spread of Christianity in northern England.

◁ The Story of Adam
Ashburnham Pentateuch c.580–620 CE *Bibliothèque Nationale, Paris, France*
Unique in both style and iconography, this manuscript contains 19 narrative illustrations, running from the creation of the world to the exodus of the Israelites. The sequence on this page concludes with the image of Cain murdering Abel.

◁ Imago Hominis
Echternach Gospels, late 7th century CE
Bibliothèque Nationale, Paris, France
Depictions of St. Matthew's symbol often resemble an angel (*see p.54*), but the Echternach artist took the unusual step of portraying him as a monk. This symbolism has political overtones, since the man wears a tonsure— a partial shaving of the head —in the Roman rather than the Celtic style.

▽ Ezra
Codex Amiatinus, before 716 CE
Bibliotheca Medicea Laurenziana, Florence, Italy
This illustration of the Old Testament scribe is from a Bible copied at the Wearmouth-Jarrow scriptorium and sent to Rome in 716 CE, as a gift for the Pope. It closely resembles *St. Matthew* (*see p.54*) in the *Lindisfarne Gospels*.

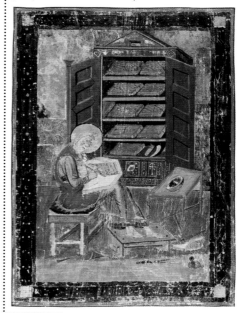

Battle of Tertry
Pepin II, an ancestor of Charlemagne, wins a crucial victory over the Neustrians at the Battle of Tertry (687 CE). This brings most Frankish territories under his control.

Death of Venerable Bede
Bede dies in 735 CE. His *Ecclesiastical History of the English People* is one of the primary sources for this period.

650 **700** **750** CE

Carpet Page ▷
Lindisfarne Gospels c.698–721 CE
British Library, London, UK
As the name suggests, carpet pages may originally have been inspired by the designs on prayer mats. The interlacing here positively teems with life, as fierce-looking birds and dogs confront each other.

LINDISFARNE GOSPELS

The *Lindisfarne Gospels* is one of the outstanding manuscripts of the period. It was created as part of the cult of St. Cuthbert, a former Bishop of Lindisfarne. A later inscription provides an unusual amount of detail about the making of the book, stating that the artist and scribe was Eadfrith, another Bishop of Lindisfarne (c.698–721 CE). As to the decorations, the carpet pages and calligraphy are mesmerizing, while the artist's quirky treatment of birds—a jumble of snakelike bodies and vicious beaks—has won particular praise.

CONTEXT

St. Luke ▷
Lichfield Gospels c.720 CE
Lichfield Cathedral, UK
The evangelist is shown with his symbol —the winged ox—above his head, and he holds two ceremonial staves in his tiny hands. The manuscript was probably produced in Northumbria.

The Incarnation Page ▷
Canterbury Codex Aureus
c.750–755 CE *Kungliga BibliIoteket, Stockholm, Sweden*
This lavish manuscript, with its golden decorations, was probably produced in Canterbury. Even so, there are strong Northumbrian influences in the calligraphy. *The Incarnation Page* is so called because it describes the birth of Christ.

> THEY **BROUGHT** WITH THEM **EVERYTHING NECESSARY**... **SACRED VESSELS**, CHURCH ORNAMENTS... **RELICS** OF THE **HOLY APOSTLES**, AND **MANY BOOKS**

c.731 CE | The Venerable Bede
Anglo-Saxon chronicler, in Ecclesiastical History of the English People

Lombards seize Ravenna
In 751 CE, Aistulf, King of the Lombards, continues his expansion, seizing the city of Ravenna. This is the last Byzantine stronghold on Italian soil.

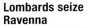

Alfred becomes king
In 871 CE, Alfred the Great becomes king of Wessex. In the same year, he gains a notable victory over the Danes at the Battle of Ashdown.

750 CE **800** **850**

Viking raids on Bangor
Vikings plunder the monastery of Bangor, in County Down, Ireland, in successive years. In 824 CE, they break open the shrine of St. Comgall and carry off his relics.

Treaty of Verdun
The Treaty of Verdun (843 CE) brings the Carolingian Civil War to a close. Through it, Charlemagne's empire is divided up between the sons of Louis the Pious.

◁ King David Playing the Harp
Vespasian Psalter,
mid-8th century CE
British Library, London, UK
The *Vespasian Psalter* is one of the earliest treasures from Canterbury, where the monks believed (incorrectly) that it had belonged to St. Augustine himself. King David was often portrayed in Psalters, because he was traditionally regarded as the author of the Old Testament Book of Psalms.

ST. AUGUSTINE OF CANTERBURY

Although he was a leading figure in the conversion of the English, nothing is known of the early life of Augustine of Canterbury. He was probably born and raised in Italy, and became a Benedictine monk at the monastery of St. Andrew in Rome, where he soon impressed Pope Gregory I. In 597 CE, Gregory chose him to lead a mission to evangelize the Anglo-Saxons. Augustine arrived at Thanet in England on Easter Day, and was welcomed by the local king, Ethelbert. He founded his see at Canterbury, becoming the first Archbishop there. Augustine also made good progress in establishing papal supremacy in England, but full recognition was not achieved until after the Synod of Whitby in 664 CE, long after his death.

CONTEXT

THE CUMDACH

In an age when most people were illiterate, the sumptuously produced Gospel Books were objects of wonder. They were revered in the same way as relics and were stored in a *cumdach*—a specifically designed, boxlike shrine. Such caskets were often highly ornate, with precious metals and stones set into the lid. The pictured example, the *Soiscél Molaise*, is decorated with images of the Evangelists' symbols. The disadvantage of the *cumdach*, however, was that it became a tempting prize for thieves.

Soiscél Molaise, **11th century, National Museum of Ireland, Dublin, Ireland**

CONTEXT

◁ Kings and Scribes
Codex Vigilanus 976 CE
Escorial Library, Spain
This is an example of Mozarabic art, the style of work produced by Christians living in Spain during the period of Muslim rule. This page includes depictions of three scribes, one of whom is Vigila, the monk who gave his name to the manuscript.

Eric Bloodaxe in York
In 947 CE, Eric Bloodaxe begins his reign as king of Jorvik (York and the surrounding area). He is the last Viking king of the region, and is expelled by the Northumbrians in 954 CE.

900 **◦950** **1000**

Capetian dynasty
Hugh Capet is elected to the French throne in 987 CE, succeeding the Carolingian line. The Capetian dynasty will rule France from 987 CE to 1328.

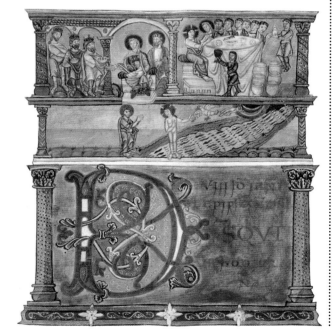

◁ Liber Sacramentorum
10th century
Biblioteca del Seminario Arcivescovile, Udine, Italy
This is a Sacramentary, a book containing the texts that were used during Mass. The miniature scenes depict the Adoration of the Magi, the Marriage at Cana, and the Baptism of Christ.

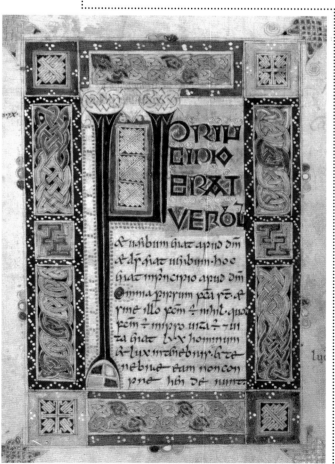

◁ Opening Page of St. John's Gospel
MacDurnan Gospels, late 9th century CE
Lambeth Palace Library, London, UK
This is one of the last decorated Gospel Books. An inscription suggests that it was either ordered or written out by Mac Durnan, the abbot of Armagh. In the 10th century, it was presented by King Athelstan to Canterbury Cathedral.

◎ MASTERWORK

The Monogram Page

Book of Kells **c.800** CE
Trinity College Library, Dublin, Ireland

This is the most important page in the finest of all the Gospel Books. Almost the entire design is devoted to the two Greek letters *Chi* and *Rho* (written as "XP"), which form Christ's monogram. In the elaborate Celtic manuscripts, there were usually five major pages of calligraphy—one at the beginning of each of the four Gospels, and the Monogram Page. The latter was seen as the most significant, since it marked the beginning of the passage describing Christ's birth (Matthew 1:18), so most artists gave it special treatment. The illustration of the same passage in the *Canterbury Codex Aureus* (*see p.60*) is typically ornate, but the Kells example eclipses all others. It was preceded by two full-page illustrations in the manuscript—a portrait of Christ and a carpet-page.

Celtic artists excelled at calligraphy, because it was compatible with the swirling, abstract designs that had featured on their metalwork and jewelry for centuries.

The complexity and variety of the tightly coiled spirals and knotwork are phenomenal. In addition, there are several tiny figurative details hidden away in the design, including three angels on the left side of the "X," an otter with a salmon (*bottom*), and two mice nibbling a communion wafer (*bottom, left*). There has been much debate about these animals—some believe that they are related to the symbols of the Eucharist that appear frequently throughout the manuscript.

There is an element of mystery about the manuscript. The *Book of Kells* was an extremely ambitious undertaking—it had more illustrations than other Gospel Books and would have been both costly and time-consuming to produce. Yet it was never finished. The reason is unknown, though it is tempting to link the incomplete state of the book with the Viking attacks of the time, when many monks were slaughtered.

❝❝ YOU WILL SEE **INTRICACIES SO FINE** AND **SUBTLE**…YOU HAVE GAZED UPON THE WORK, **NOT OF MEN** BUT OF **ANGELS** ❞❞

c.1188 | Giraldus Cambrensis
Clergyman and chronicler, description of an illuminated Gospel Book from Topographia Hiberniae

◎ ORNAMENTAL DETAILS

In addition to its celebrated full-page decorations, the *Book of Kells* features ornamental details scattered liberally throughout the text. Many of these served a practical purpose, highlighting important passages or helping the scribes to save space. Vellum was an expensive commodity, so there was a natural reluctance to leave lines unfinished. Scribes solved this problem by allowing sentences to run over, finishing on the line above or below, known as a "turn in the path" or "head under the wing." In the *Book of Kells*, the point was marked with a "C" symbol. Often, a small animal—such as the dog pictured below—was included with a tail or paw extended to show the direction that the text should be read.

Folio 19, Verso, *Book of Kells*, detail, c.800 CE.
A dog and "C" symbol mark the turn in the path.

CONTEXT

ROMANESQUE AND GOTHIC

▷ **Bayeux Tapestry**
c.1070–80 *Musée de la Tapisserie, Bayeux, France*
Probably commissioned by Bishop Odo of Bayeux, the half brother of William the Conqueror, this remarkable wall hanging tells the story of the Norman invasion of England. The format is similar to contemporary frescoes, such as those at Saint-Savin and Nohant-Vicq (*see p.69*). Episodes run into each other and there is a bare minimum of detail, but the narrative is forceful and dynamic.

Art in the Middle Ages was dominated by two great styles: Romanesque and Gothic. Both terms derived from ancient peoples—the Romans and the Goths—and both relate primarily to architecture. Romanesque architecture is massive and robust in appearance, qualities that are reflected in the wall paintings that were commissioned for buildings in the style. Figures appear solid and rounded, and are sometimes simplified, but any stylization is far less pronounced than that of Celtic manuscripts. Many aspects of the Romanesque style were spread by the Normans in the wake of their victorious military campaigns. These included the conquest of England, southern Italy and Sicily, and the Crusader territories in the Middle East. The most famous Norman artwork, the *Bayeux Tapestry (above)*, typifies their vigorous version of the Romanesque style. The Gothic style was an evolution of Romanesque, with a greater emphasis on grace and elegance. Figures are tall, slender, and have a distinctive sway in their posture.

◎ CONTEXT

An age of reform

After the mass migrations and political upheavals of the Dark Ages, the Middle Ages ushered in a period of relative stability in Europe. Cities grew, universities were founded, and the feudal system developed. In the arts, the main patron was still the Church, although change was under way. A reform movement was in full swing, rooting out corruption and strengthening the monasteries. Several orders—such as the Cluniacs, Cistercians, and Carthusians—were founded, and a host of churches were built.

The ecclesiastical reforms increased the demand for paintings—both murals and manuscripts—but the role of artists remained unchanged. Almost without exception, their names and lives are unknown. To some extent, this was because the Church was wary about decoration. Bernard of Clairvaux, a leading Cistercian, famously criticized Romanesque sculptors for their distracting carvings, fearing that his monks would be "more tempted to read in the marble than in our books." Other high-ranking clerics followed this lead.

By the latter part of the 12th century, the transition to the Gothic style was under way. In place of sheer bulk, architects now wanted their churches to appear light, airy, and—above all—tall, with towers and spires that seemed to soar toward the heavens.

An increasing emphasis on stained-glass windows meant that there was far less room for wall paintings, but manuscripts remained in high demand. New sources of patronage emerged, particularly from the courts of wealthy aristocrats. They wanted a broader range of secular subjects, including histories and romances, together with a different kind of devotional text: Books of Hours, designed for use by laymen.

◎ Church and Crown

▷ **966 CE** The *New Minster Charter* is the first major artwork produced by the Winchester School of manuscript painting.

▷ **1066** William, Duke of Normandy, triumphs at the Battle of Hastings. His victory signals the end of the Anglo-Saxon era in England.

▷ **1088** The oldest university in the West is founded at Bologna in Italy. The universities of Paris and Oxford follow during the 12th century.

▷ **c.1100** Work begins on a series of wall paintings at the chapel of Berzé-la-Ville. These prove to be outstanding examples of the French Romanesque style.

▷ **1291** Following a protracted siege, the city of Acre falls to Muslim forces. The loss of this final Christian stronghold in the Holy Land effectively brings the Crusades to an end.

▷ **1309–76** After a bitter political dispute, the papacy takes refuge at Avignon in France. Seven popes rule from here, until Gregory XI ends the exile from Rome.

▷ **c.1400–05** The *Ellesmere Chaucer*, a beautifully illustrated manuscript of the *Canterbury Tales*, is produced shortly after the author Geoffrey Chaucer's death.

KEY EVENTS

> **IT WAS** AS THOUGH THE **WHOLE EARTH** …WAS **CLOTHING ITSELF EVERYWHERE** IN A **WHITE ROBE OF CHURCHES** "

Raul Glaber
Cluniac monk and chronicler (c.985 CE–c.1046)

Early Gothic architecture
Notre Dame cathedral in Paris, begun in 1163, is one of the earliest Gothic cathedrals. The new architecture emphasized height, accentuated by slender windows with pointed tops. Rose windows also became a major feature.

◎ BEGINNINGS
THE WINCHESTER SCHOOL

The Romanesque tradition was built up from a variety of sources. Many wall paintings in this style have a discernible Byzantine influence. This is most evident in Italy, where political and trading contacts with the East were strongest but, as the mural of *St. Paul and the Viper* (*see p.71*) demonstrates, traces of the Byzantine style traveled as far as Britain.

In northern Europe, the key influences came from the two great imperial dynasties, the Carolingians and the Ottonians. Both courts offered generous patronage, encouraging the growth of a network of wealthy monastic centers with highly productive workshops.

In England, the movement reached a watershed with the Winchester School of manuscript illumination. The term is a slight misnomer, since manuscripts in the distinctive Winchester style were produced in *scriptoria* in other centers, such as Canterbury and Bury St. Edmunds, not just in Winchester itself.

◎ TURNING POINT

Christ's Entry into Jerusalem
Benedictional of St. Aethelwold **c.980** CE *British Library, London, UK*

This is the most celebrated of the manuscripts produced by the Winchester School. With 28 full-page illustrations, it is also one of the pinnacles of Anglo-Saxon art during its most productive phase. The most spectacular aspect is the decoration of the borders—elaborate trellises are covered in winding acanthus leaves, while some of the corners are dominated by large rosettes or roundels. Figures from biblical stories interact with the borders, climbing up them or emerging from behind them, creating a rudimentary sense of depth.

◉ ARTISTIC INFLUENCES

In the early medieval period, the Dark Age taste for abstract or highly stylized decoration was gradually reversed. The Carolingians and Ottonians were ruled by Holy Roman Emperors, who strove to restore their Roman legacy. In England, this policy was echoed by Anglo-Saxon kings seeking to create a national identity.

Carolingian art was a prime source of the Romanesque style. During the era of Charlemagne (r.768–814 CE) and his heirs, illuminators adapted ideas from Late Antique, Classical, and Byzantine models.

St. Mark, detail from the *Ebbo Gospels*, c.820–830 CE, reveals a more expressive approach that replaced earlier stylization. *Bibliothèque Municipale, Epernay, France*

Anglo-Saxon art, such as the Alfred Jewel, is evidence that the achievements of the Winchester School were part of a broader resurgence of the arts. The figure may be Christ or Alfred the Great.

The Alfred Jewel, c.871–899 CE, made of gold and cloisonné enamel, may be an *aestel*, a pointer for reading manuscripts. *Ashmolean Museum, Oxford, UK*

The Ottonians provided a bridge between Carolingian culture and the Romanesque style. Their manuscript tradition, from centers including Trier, Cologne, and Reichenau, proved particularly influential.

Decorative calligraphy from the *Wernigerode Gospels* produced at Korvei monastery echoes the style at Winchester. *Morgan Library & Museum, New York, NY*

Vellum was the standard material for manuscripts. It was traditionally made from calf skin, although skins of other animals were also suitable. The hides were dried, scraped, and stretched prior to use.

Decorated initial from a Bible, 1255, shows a scribe holding prepared vellum sheets, in front of a skin stretched on a frame. *Kongelige Bibliotek, Copenhagen, Denmark*

◎ AETHELWOLD OF WINCHESTER

A key figure in the 10th-century reform movement in the English Church, Aethelwold was for a time a monk at Glastonbury under the reformer, St. Dunstan. Aethelwold became Abbot of Abingdon in 955 CE and Bishop of Winchester in 963 CE, improving monastic standards in both places. He also took a strong interest in the arts. Aethelwold was skilled at metalwork himself, and there is little doubt that the lavish decorations in his *Benedictional* were created under his personal supervision.

Aethelwold, from the Benedictional of St. Aethelwold, c.980 CE, **British Library, London, UK**

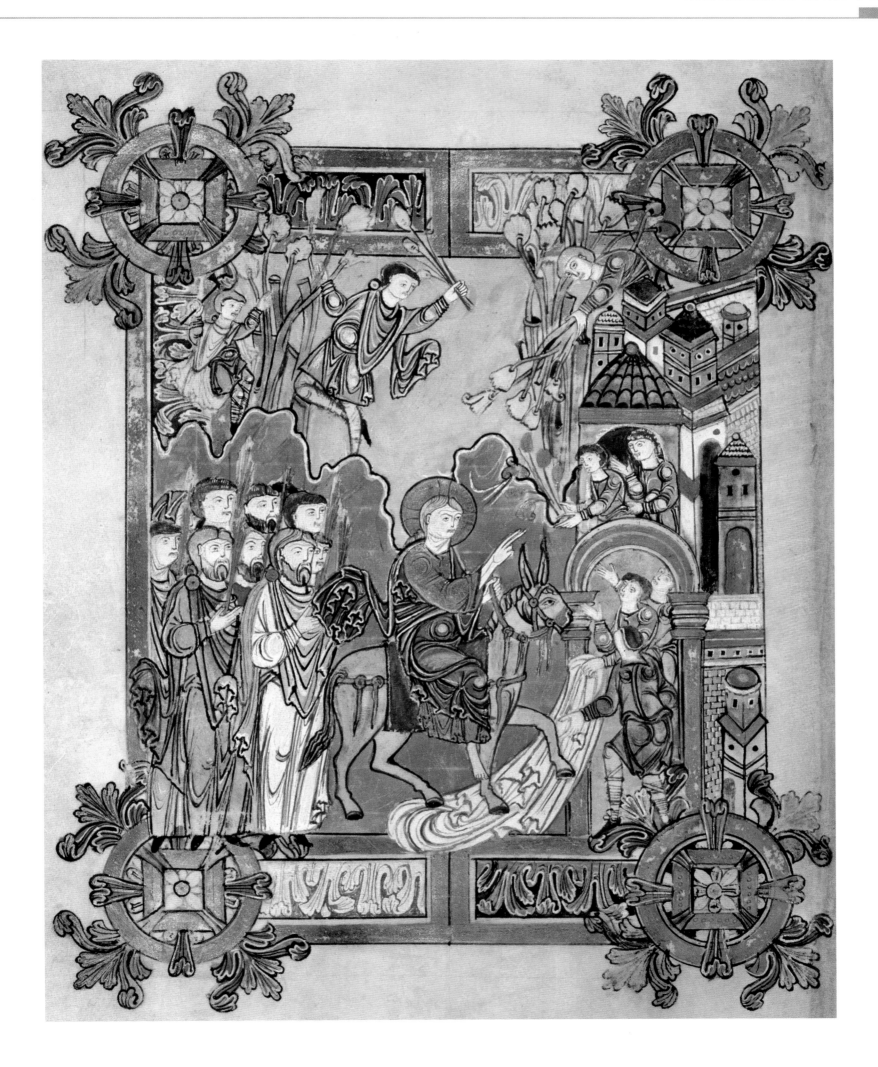

TIMELINE

Throughout the Romanesque period, the Church remained the dominant patron. The finest surviving examples of painting are illuminated manuscripts and murals, although a leap of the imagination is often required to visualize the bright, original coloring of the latter. By the later Middle Ages, royal and aristocratic taste came to the forefront—demand for images of leisure and romance increased. However, as the Avignon frescoes demonstrate (*see p. 72*), even the Pope was capable of enjoying secular subjects.

◁ **King Rothari**
Madrid Codex, 11th century
Biblioteca Nacional, Madrid, Spain
By the 11th century, manuscripts were covering a much broader range of subjects. This example, also known as the *Edictum Rothari*, is a historical record of the laws proclaimed by Rothari, king of the Lombards (r.636–652 CE).

Otto crowned Emperor
In 962 CE, Otto I is crowned Holy Roman Emperor by Pope John XII in Rome. This heralds the start of an artistic revival in Germany, particularly in the fields of ivory and metalwork.

Erik the Red in Greenland
Erik Thorvaldsson, better known as Erik the Red, continues his exploration of Greenland. In 986 CE, he founds the first Norse settlements there.

Crowning of Canute
Canute becomes king of Denmark in 1018, two years after gaining the throne of England. In time, he will also rule Norway.

970 CE **990** **1010** **1030**

Abraham and the Sacrifice of Isaac ▷
The Aelfric Hexateuch
c.1025–50
British Library, London, UK
Produced in Canterbury, perhaps for a lay client, this manuscript contains the earliest surviving translation of Old Testament text into Anglo-Saxon. The style of the illustrations is primitive, almost naive, quite unlike conventional treatments of biblical themes. Aelfric of Eynsham was one of the translators.

◁ **The Angel Battles the Beast**
Apocalypse of Beatus of Liebana,
10th century *Escorial Library, Spain*
With its bright colors and simplified forms, the Mozarabic style resembles folk art. It is frequently found in manuscripts of the *Commentary on the Apocalypse* by a Spanish monk, Beatus of Liebana.

◁ **The Kiss of Judas**
Early 12th century *Church of St. Martin, Nohant-Vic, France*
There is an extraordinary sense of movement in this remarkable cycle of wall paintings. Christ is swept away to the right, while Peter pulls in the opposite direction as he slices off Malchus's ear.

> ❝ **A CLOISTER** WITHOUT A **BOOK ROOM** IS LIKE A **MILITARY CAMP** WITHOUT **WEAPONS** ❞
>
> Medieval saying
> *From a Latin pun:* "claustrum sine armario est quasi castrum sine armamentario"

1050　　　**1070**　　　**1090**　　　**1110** ▶

△ **The Building of the Tower of Babel**
c.1060–1115 *Saint-Savin Abbey, France*
One of a series of 30 Old Testament scenes painted on the barrel-vaulted ceiling, this episode appears particularly fresh and animated. This is probably because construction work on Saint-Savin was still in progress, so the artist was able to observe the masons at close quarters.

The First Crusade
Pope Urban II launches the First Crusade in 1095, in response to a call for aid from the Byzantine emperor. The campaign will eventually lead to the capture of Jerusalem, but most of the territorial gains are short-lived.

Creation of the Cistercian Order
In 1098, a group of monks led by Robert of Molesme found the Abbey of Cîteaux, the main base of the Cistercian Order.

HELLMOUTH

CONTEXT

Medieval artists often portrayed Hell as the gaping maw of a huge creature, waiting to consume the damned. The original source for this image was the biblical beast Leviathan, whose "breath sets burning coals ablaze" (Job 41:21). The concept was popular in scenes of the Last Judgment, but it was rarely depicted more imaginatively than here, where an angel simply locks shut the gates of Hell.

The Jaws of Hell Fastened by an Angel, *Winchester Psalter,* **early 12th century, British Library, London, UK**

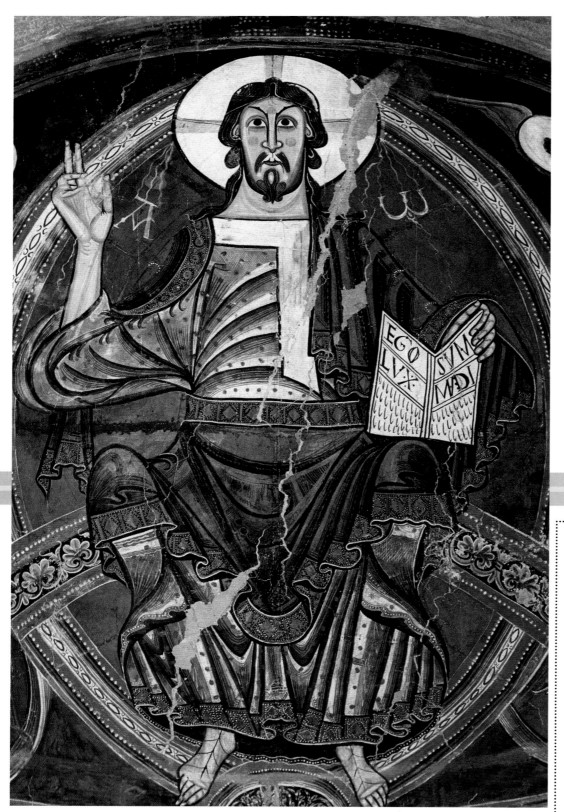

BIOGRAPHY

Winchester Bible artists

By the 12th century, manuscripts were no longer decorated solely by monks. Some illuminators were laymen who made their living as itinerant, professional artists, lodging at the monastery while they worked. Their names are seldom known. Often, artists worked in teams. In the case of the *Winchester Bible*, for example, six different hands have been identified. The "Master of the Leaping Figures" (so-called because of the exaggerated sense of movement in his scenes) was a dominant member of this anonymous group, designing around 40 of the initials.

Vézelay Tympanum
Around 1130 work nears completion on the nave and tympanum of Sainte-Madeleine, Vézelay in France. *The Mission of the Apostles* on the tympanum is one of the finest examples of Romanesque sculpture.

1130 **1150**

Christ in Majesty △
1123 *Museu Nacional d'Art de Catalunya, Barcelona, Spain*
This imposing mural was painted in the church of San Clemente in Tahull, Spain. With its strong contours, its stiff, linear folds, and its powerful, stylized features, it is one of the finest examples of Romanesque painting in Catalonia. Christ's text is from the Gospel of John: "I am the light of the world" (John 8:12).

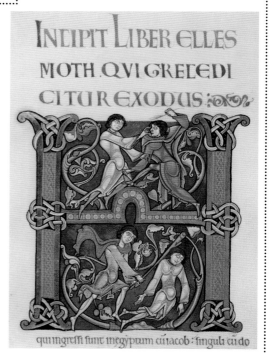

Page from the Winchester Bible △
c.1150–80 *Winchester Cathedral, UK*
No expense was spared in creating this huge manuscript, the largest surviving English Bible from the period. Its chief glory is the set of decorated initials at the beginning and end of each chapter. This example comes from the start of the Book of Exodus.

▽ A Scribe, an Astronomer With an Astrolabe, and a Mathematician
Psalter of St. Louis and Queen Blanche c.1225–50 *Bibliothèque de l'Arsénal, Paris, France*
This page formed the frontispiece to a calendar, which explains the unusual, scientific subject. However, the strange vegetation, the figures' elongated arms, and the lyrical depiction of the night sky give this image a mystical quality.

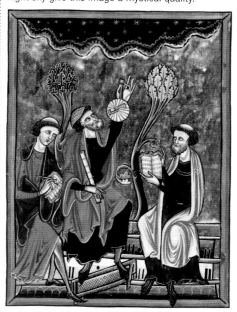

◁ The Crucifixion
Evesham Psalter, after 1246 *British Library, London, UK*
There is a curiously topical element here. In 1238, Louis IX acquired a relic of the Crown of Thorns and built the Sainte-Chapelle in Paris (completed in 1248) to house it. In the wake of the publicity, artists began to include this item in scenes of the Crucifixion for the first time.

Murder in the cathedral
On December 29, 1170, the controversial Archbishop of Canterbury, Thomas à Becket, is murdered in his cathedral. He is canonized by Pope Alexander III just three years later.

1170 **1190** **1210** **1230** **1250** **1270**

◁ St. Paul and the Viper
c.1180 *St. Anselm's Chapel, Canterbury Cathedral, UK*
This fresco pictures an episode from Paul's mission in Malta (Acts 28:1–6). Its style has a Byzantine flavor and is strongly reminiscent of a mosaic in Palermo. Medieval images of snakes always carry overtones of Satan.

Death of Frederick II
The Holy Roman Emperor Frederick II dies on December 13, 1250. He had been an enthusiastic patron of the arts and also wrote the first treatise on falconry, *De arte venandi cum avibus.*

BESTIARY

Bestiaries were books of animal lore. They were extremely popular in the Middle Ages, spawning dozens of colorful manuscripts. Although the descriptions of the creatures were presented as scientific fact, the bulk of the text consisted of moral lessons, myths, and Christian allegories. The camel, for example, was regarded as a symbol of prudence, because of its ability to store water, but also as an emblem of lust. Legendary creatures, such as unicorns and basilisks, were also included.

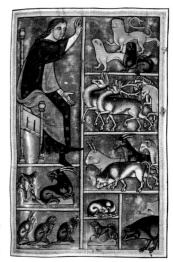

Adam Naming the Animals, *Aberdeen Bestiary,* 12th century, Aberdeen University Library, Scotland, UK

CONTEXT

▽ Scythian Women Besieging Their Enemies

Histoire Universelle c.1268
Bibliothèque Nationale, Paris, France
The impact of Western manuscripts outside Europe was considerable.
This example was produced at Acre, a Christian stronghold in the Holy
Land, during the Crusader period. The local artist developed a style that
combined elements of French, Byzantine, and Arab influences.

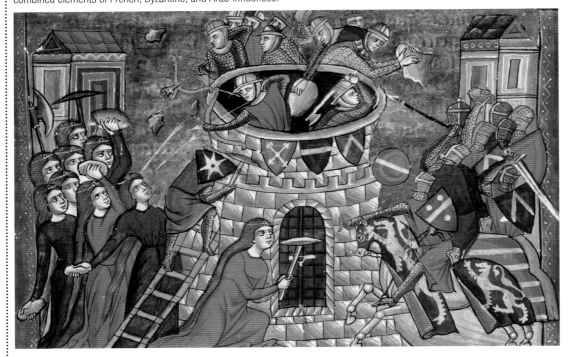

▽ Falconry

Matteo Giovanetti 1343–45
Papal Palace, Avignon, France
This is part of a series of elegant hunting
scenes that were commissioned for the
private apartments of the Pope. The design
was supervised by an Italian artist, Matteo
Giovanetti, although he probably did not
paint this section. The frescoes resemble
contemporary tapestries.

1270 **1290** **1310** **1330** **1350**

Marco Polo in China
In 1275, Marco Polo arrives in China
at the summer court of Kublai Khan,
staying until 1292. He travels with his
father and uncle, both jewel merchants
who have made the journey before.

LE ROMAN DE LA ROSE

This lengthy 13th-
century poem was a
bestseller. It is a romantic
allegory, describing the
dream-vision of the
narrator, who courts his
image of ideal beauty in
the Garden of Love. The
book had a slightly racy
reputation, creating a
sizable demand for
manuscripts. More than
200 have survived, many
with lavish illustrations.

*Scenes from the Lover's
Dream, French School,
14th century, Musée
Condé, Chantilly, France*

The Black Death
By 1340, the bubonic
plague wreaks havoc in
China. Often known as
the Black Death, it
spreads to Europe in
the late 1340s, killing
millions of victims.

◁ Kristan von Hamle Visits His Lover

Codex Manesse c.1304
*University Library,
Heidelberg, Germany*
There is a fairy-tale simplicity
about the miniatures in this
charming manuscript—
produced in Zurich for the
Manesse family—which is
devoted to the love poems
of German *Minnesänger*
(minstrels). Knights
perform chivalrous deeds
to win their lady.

The Limbourg brothers

died Bourges, France 1416

Netherlandish illuminators Herman, Jean, and Pol Limbourg were the supreme exponents of the International Gothic style. They came from Nijmegen, where their father was a sculptor. Their links with Jean, Duc de Berry, date from 1405, and they began work on his *Très Riches Heures* around 1413. Its jewel-like miniatures capture both the refinement of the court and the hardships of peasant life. The brothers did not complete the manuscript, however, because all three died in 1416, probably from the plague.

BIOGRAPHY

Peasants' Revolt
The first great challenge of Richard II's reign occurs in 1381, when a widespread Peasants' Revolt breaks out. Rebels storm the Tower of London, but the young king is able to defuse the situation.

The Battle of Agincourt
Henry V's victory at the Battle of Agincourt, in 1415, marks a crucial phase in the Hundred Years' War. It brings fresh impetus to the English in their campaigns against the French, though the successes of Joan of Arc soon reverse any gains.

1390 **1410**

July △
Limbourg Brothers, before 1416
Musée Condé, Chantilly, France
The calendar illustrations in *Les Très Riches Heures du Duc de Berry* cover a range of activities on the ducal estates. Here, sheepshearing and harvesting are combined with a view of the chateau at Poitiers. The miniature includes quirky details characteristic of the work of the Limbourgs, such as a rickety wooden footbridge resting precariously on two stone blocks.

The Virgin in the Garden of Paradise △
German School c.1420
Städelsches Kunstinstitut, Frankfurt, Germany
This is a transitional work: the inconsistent use of scale and perspective is typically medieval, but the interest in nature and the precise depiction of numerous plants herald the Renaissance. The Virgin is surrounded by various saints, among them St. George with a vanquished miniature dragon.

> **THE VERY PURPOSE OF A KNIGHT IS TO FIGHT ON BEHALF OF A LADY**
>
> c.1470 | Sir Thomas Malory
> *English writer, in Le Morte d'Arthur*

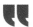 # MASTERWORK

The Wilton Diptych

c.1395–99
National Gallery, London, UK

A crowning example of the International Gothic style, the *Wilton Diptych* is a portable altarpiece that features a portrait of Richard II (r.1377–99), the young king who kneels in the left-hand panel. He is accompanied by John the Baptist and two saintly English kings, Edmund and Edward the Confessor.

The picture takes the form of a diptych, with two hinged panels that had a practical purpose—the panels can be closed together, protecting the surface of the painting when it is transported. However, the format also enabled the artist to create an extraordinarily flattering image of the monarch. It was not unusual for patrons to appear alongside sacred figures, but their presence was usually fairly discreet. In the *Evesham Psalter* (*see p.71*), for instance, the Abbot of Evesham is included at the foot of the Crucifixion, meditating on Christ's sacrifice. The portrait is so small that it would be easy to miss it. In the *Wilton Diptych*, however, it seems as if the king has been granted a private audience with the Virgin. The Infant Christ appears to be reaching out toward him, and the angels are wearing badges with a white hart, Richard's personal emblem. Only the flowers beneath Mary's feet confirm that they are in separate planes: she is holding court in the gardens of Paradise.

Nothing is known about the origins of the painting, although it is safe to assume Richard commissioned it for his own use. It takes its name from Wilton House, the home of the Earls of Pembroke, who owned the picture for about 200 years.

> NOT ALL THE **WATER** IN THE **ROUGH RUDE SEA** CAN **WASH THE BALM** FROM AN **ANOINTED KING**
>
> c.1595 | William Shakespeare
> *English playwright, describing the king in* Richard II

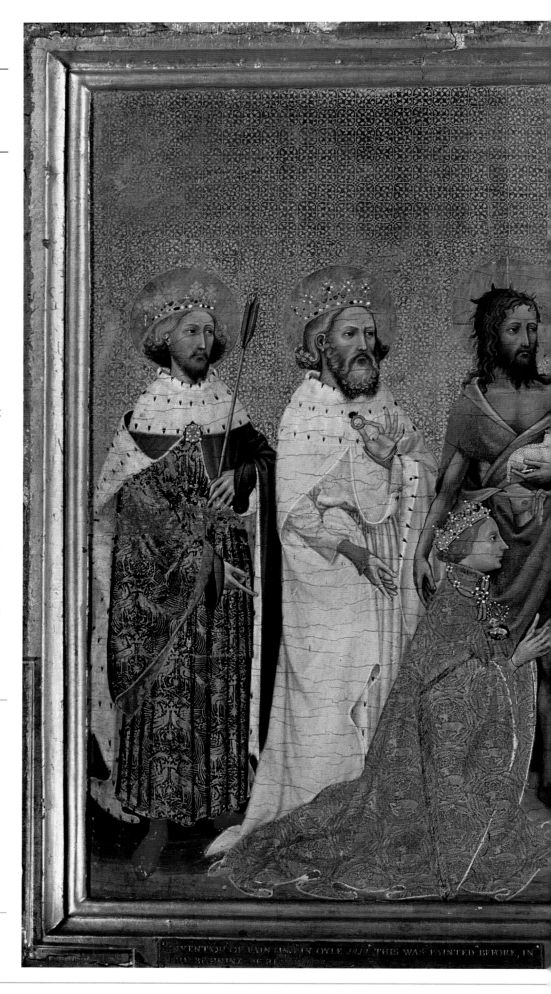

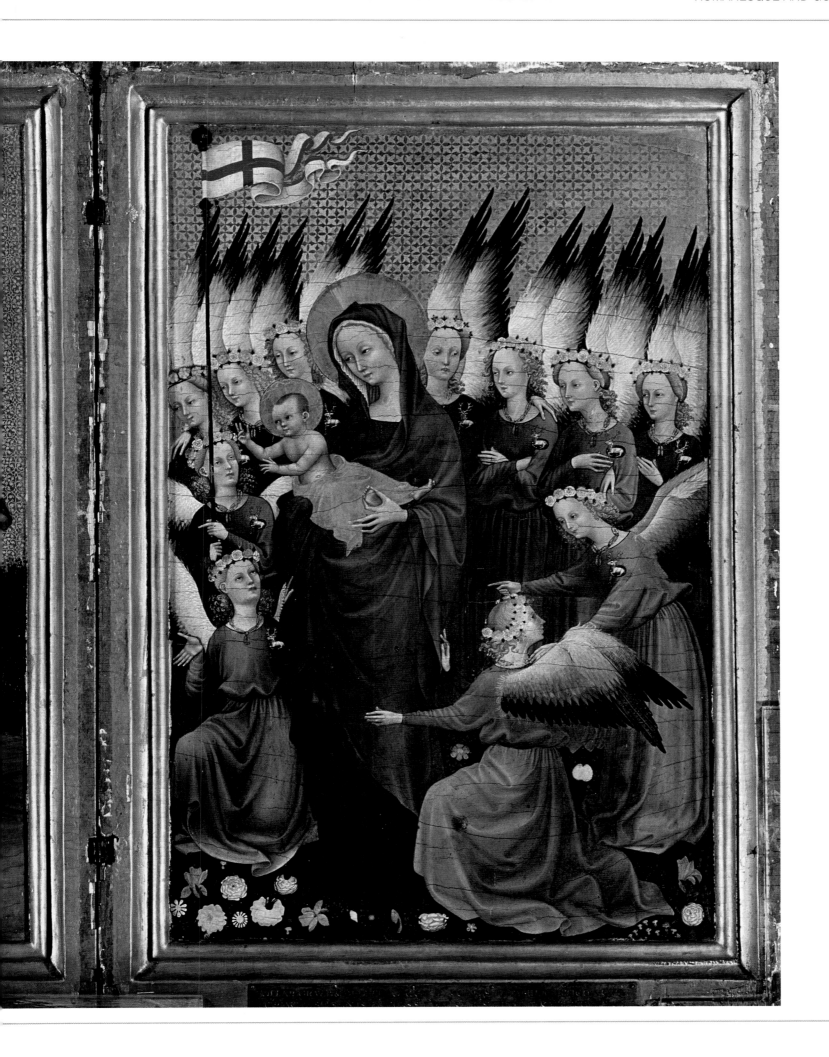

RENAISSANCE AND MANNERISM

78 BIRTH OF THE RENAISSANCE

88 FLOWERING OF THE RENAISSANCE

100 HIGH RENAISSANCE

110 VENETIAN RENAISSANCE

120 NORTHERN RENAISSANCE

132 ITALIAN MANNERISM

142 MANNERISM OUTSIDE ITALY

Emerging in 14th-century Italy, the dawning of the Renaissance—a revival of the cultural ideals of classical antiquity—is clearly visible in the frescoes of Giotto, which display a new humanity and realism. Italian Renaissance art blossomed fully in the 15th century, in paintings characterized by clarity, harmony, and perspective. Florentine artists were at the forefront, but in Venice an equally significant, more painterly tradition evolved as artists exploited the oil painting technique learned from painters in northern Europe. Northern Renaissance artists shared the drive toward naturalism of their Italian counterparts, but it was based on meticulous observation rather than on classical antiquity. In the early 16th century, artistic developments in Italy culminated in High Renaissance art, renowned for its grace and skillful complexity. These qualities were refined and exaggerated in the sophisticated style known as Mannerism, which emerged first in Italy and soon spread throughout Europe.

BIRTH OF THE RENAISSANCE

▷ **The Lamentation of Christ**
Giotto di Bondone c.1303–06
Arena Chapel, Padua, Italy
One of the most celebrated of Giotto's Arena Chapel frescoes depicts the crucified Christ, cradled in his grieving mother's arms. Dramatic gestures and the diagonal of the stone ridge lead the eye to the emotional core of the scene, where Mary stares in mournful intensity at her dead son.

The Renaissance (meaning "rebirth") was an intellectual and artistic movement that began in Italy in the 14th century, inspired by a revival of classical learning. In the visual arts, the work of the Florentine master Giotto di Bondone has long been regarded as a turning point that heralded the emergence of the Renaissance. Giotto's paintings, such as the frescoes in the Arena Chapel (*left*), mark a departure from the stylized, otherworldly images of Byzantine art. They introduced emotional drama, a naturalism then associated with ancient Roman art, and a convincing sense of three-dimensional space. Although Giotto's art influenced Florentine painters of the next generation, its full impact came later. Distinctively different styles developed in 14th-century Italy, notably in the city-state of Siena through artists including Duccio and Simone Martini. An elegant, courtly style known as International Gothic also flourished. It was more than a century after Giotto created his groundbreaking paintings that his true artistic heir emerged—another great Florentine master, Masaccio.

◎ CONTEXT

A new humanity

In the 14th century, Italy did not exist as a unified country. To the south was the Kingdom of Naples, while the Papal States around Rome were nominally under the Pope's rule, although the papal court had transferred to Avignon, France, in 1309. In central and northern Italy, commerce had enriched and empowered cities such as Florence, Siena, Venice, and Milan, which grew into self-governing city-states. It was in this political climate of proud city-states vying with each other for power and prestige that the Italian Renaissance was born.

With the growth of banking, textiles, and trade, Italy had become more urbanized than the rest of Europe, and artists were commissioned to provide paintings for specific churches and civic buildings. Some of these secular commissions were highly ambitious works, such as Ambrogio Lorenzetti's *Allegory of Good and Bad Government* frescoes (*see p.83*) painted for Siena's Palazzo Pubblico (town hall). However, the majority of paintings commissioned in the early Renaissance were Christian images.

A driving force of the Renaissance was the revival of interest in the literature and art of ancient Rome. Italy's classical past was visible in ruins and ancient artifacts, and the classical revival had a major influence on pictorial naturalism. Interest in the classical past was also linked with the rise of humanism, a philosophy that emphasized the individual achievements of man in this life rather than the next, and marked a significant move away from the spirit of medieval Christianity.

Another important change in religious sensibility was triggered by the 13th-century friar St. Francis of Assisi and his followers, whose preaching stressed Christ's suffering and humanity. The combination of the classical revival and this new style of Christianity provided the foundation for a new type of art— one that not only looked more realistic, but that also inspired sympathy for the real, human qualities of Christ, rather than creating a sense of awe and mystery, which was the function of the stylized Byzantine images of God.

(*see p.83*)

◎ Europe during the birth of the Renaissance

KEY EVENTS

▷ **1301** Halley's Comet makes one of its rare appearances. Many saw it as a bad omen, but Giotto incorporated the comet into the *Adoration of the Magi* fresco in the Arena Chapel. Instead of the traditional star of Bethlehem, he depicts a flaming comet.

▷ **1308** Dante, Italy's most celebrated writer, begins his famous poem *The Divine Comedy*. In it, he expresses keen admiration of Giotto's naturalism.

▷ **1309** The Papacy moves from Rome to Avignon. The Sienese painter Simone Martini works at the papal court there from about 1335 until his death.

▷ **1348** The Black Death devastates Europe. About half the inhabitants of Florence and Siena are killed by the plague, possibly including the Lorenzetti brothers (*see p.83*).

▷ **1427** Florence imposes a new tax system on its citizens to raise money for the war against its powerful rival, Milan. Masaccio's *Tribute Money* may be an allusion to this.

> GIOTTO **TRANSLATED** THE ART OF PAINTING **FROM GREEK INTO LATIN** AND **MADE IT MODERN** "

c.1400 | Cennino Cennini
Florentine painter and writer

A patchwork of city-states
The Tuscan city of Siena is dominated by the bell tower (*campanile*) of the Palazzo Pubblico, which housed the city's republican government. City-states like Siena were characterized by intense civic pride (*campanilismo*), and were often at war with each other.

◎ BEGINNINGS
THE CHRISTIAN STORY

One of the defining characteristics of Renaissance painting was a drive toward realism. Artists moved away from the flat, linear style of Byzantine art, creating more realistic, sculpturally rounded forms and figures that appeared to exist in real space. The Christian imagery of Byzantine art was intentionally mysterious and distanced from the real world of humankind, but Giotto, Duccio, and their followers began to tell the Christian story in real, human terms. In narrative scenes, the increasingly realistic portrayal of the physical world was paralleled by a new sense of emotional and dramatic realism.

◉ ARTISTIC INFLUENCES

Numerous factors influenced the Arena Chapel frescoes. Giotto's dramatic storytelling style was influenced by Franciscan preaching and miracle plays, as well as by earlier contemporary artists and classical art. The powerful simplicity of his monumental realism is partly a function of the fresco technique, which involved working methodically and rapidly on sections of wall prepared daily with wet plaster.

The teachings of St. Francis (c.1182–1226) and his Order had a humanizing influence on Italian painting: Christ was portrayed as a suffering man rather than a triumphant, distant deity. St. Francis was also a subject for Italian Renaissance art.

St. Francis and Angels, detail, c.1250–1300, from the town of Francis's birth. *S. Maria degli Angeli, Assisi, Italy*

The paintings of Cimabue (Cenni di Peppi), who may have been Giotto's teacher, display a softening of the rigidity of Byzantine art. The figures have gentler expressions and more natural gestures, and the curved throne conveys volume and receding space.

Madonna and Child Enthroned, c.1280–90, by Cimabue was painted for the altar of S. Trinità in Florence. *Uffizi, Florence, Italy*

Pietro Cavallini was inspired by classical Roman art to develop a more naturalistic style. His innovative way of painting the human figure with solidity and humanity influenced artists including Giotto, who would have seen his work in Rome.

The Last Judgment, detail, 1290s, Cavallini, portrays Christ with weighty three-dimensionality. *S. Cecilia in Trastevere, Rome, Italy*

Nicola and Giovanni Pisano were almost as significant in sculpture as Giotto was in painting. Inspired by antique art, father and son imparted a powerful sense of emotional drama into crowded narrative scenes, which show strong links with Giotto's frescoes.

The Crucifixion, detail, 1265–68, from a carved pulpit relief by Nicola Pisano, shows drama and expressive emotion. *Siena Cathedral, Italy*

◎ TURNING POINT

The Betrayal of Christ

Giotto di Bondone **c.1303–06**
Arena Chapel, Padua, Italy

This intensely dramatic scene from Giotto's Arena Chapel frescoes illustrates the moment when Judas Iscariot betrays Jesus by identifying him with a kiss of greeting. As the treacherous disciple envelops Christ in his cloak, the focus of the scene is on their contrasting faces, pressed dramatically together against a bristling backdrop of weapons. There is an intense psychological force in Christ's unflinching gaze as he stares calmly into Judas's tense face. Renowned for their revolutionary naturalism, monumental grandeur, powerful storytelling, and emotional impact, the Arena Chapel frescoes were recognized even by Giotto's contemporaries as ushering in a new artistic era.

◎ Giotto di Bondone

born Colle di Vespignano?, nr. Florence, Italy c.1270; **died** Florence, January 8, 1337

Giotto was the first artist since antiquity to become a famous name. Major figures of the time—including Dante, Boccaccio, and Petrarch—praised him, and he was in demand all over Italy. He is thought to have trained with Cimabue. There is often dispute about the attribution of his work, but the frescoes in the Arena Chapel, Padua, and the Bardi and Peruzzi Chapels in S. Croce, Florence, are certainly by his hand. He may have been involved with the fresco cycles at San Francesco in Assisi. Several altarpieces bear his signature, but may be by his workshop. Although unsigned, the *Ognissanti Madonna* has a similar solemn grandeur and humanity to the Arena Chapel frescoes, and is universally considered to be by Giotto himself.

BIOGRAPHY

◎ TIMELINE

Italian painting in the 14th and early 15th century was not marked by one single style. Compared to the weighty naturalism of the Florentine tradition, Duccio and other Sienese artists developed a more decorative style. But both schools continued to move away from the aloofness and rigidity of Byzantine art and toward a greater naturalism, expressiveness, and humanity. At the end of the 14th century, as communication between European courts improved, a new courtly style emerged known as International Gothic.

Simone's first work
Simone Martini paints his earliest known work in 1315, a fresco of the *Maestà* in Siena Town Hall, combining Byzantine aloofness with the grace of Gothic art.

Scrovegni commissions Giotto
In an attempt to expiate his father's crimes of usury, in around 1303 Enrico Scrovegni commissions Giotto to paint the narrative cycle of frescoes in the Arena Chapel, Padua.

Sienese procession
On June 9, 1311, Duccio's spectacular altarpiece, the *Maestà*, is carried in triumphal procession to the sound of church bells from the artist's workshop to Siena Cathedral.

| 1300 | 1305 | 1310 | 1315 | 1320 | 1325 | 1330 |

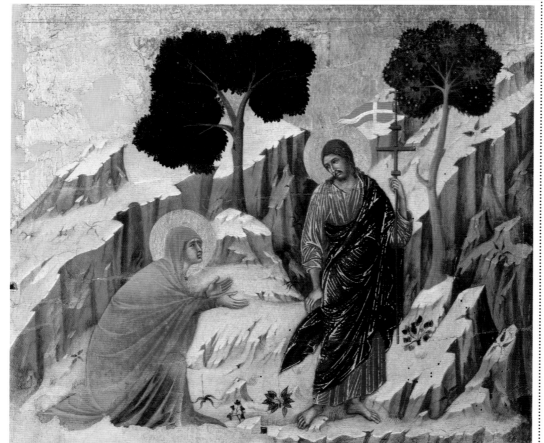

The Annunciation △
Simone Martini 1333 *Uffizi, Florence, Italy*
Exquisite craftsmanship and expressive, graceful contours characterize this Sienese altarpiece, which Simone Martini created in collaboration with his brother-in-law, Lippo Memmi. The Virgin shrinks from the Angel Gabriel as he tells her she is to be the mother of Jesus.

◁ **Noli Me Tangere**
Duccio di Buoninsegna 1308–11
Museo dell'Opera del Duomo, Siena, Italy
This panel, from Duccio's magnificent altarpiece the *Maestà*, shows the risen Christ telling Mary Magdalene not to touch him. Like Giotto, the influential Sienese master Duccio introduced a new sense of human feeling into his depiction of biblical stories.

◁ The Effect of Good Government in the City
Ambrogio Lorenzetti 1338
Palazzo Pubblico, Siena, Italy
This detail from Lorenzetti's fresco in Siena's town hall presents a remarkably naturalistic view of the bustling city and its inhabitants. It forms part of his celebrated *Allegory of Good and Bad Government*.

▽ Triumph of Death
Andrea Orcagno 1344–45 *S. Croce, Florence, Italy*
Painted by one of an important family of Florentine artists, this fresco fragment is part of a trilogy that originally included the *Last Judgment* and *Hell*. The powerfully dramatic scene features grotesque, vividly imagined demons.

The Black Death
In 1348 one of the most devastating pandemics in history, the Black Death (bubonic plague) swept through Europe. It had a profound effect on European history—millions died, and the population took 150 years to recover.

1335 **1340** **1345** **1350** **1355** **1360**

Giotto appointed architect
In 1334 Giotto is appointed city architect in Florence, and begins work on the *campanile* (bell tower) for Florence Cathedral.

The Baptistery doors
Sculptor Andrea Pisano completes the bronze doors for the Florence Baptistery in 1336. His relief scenes from the life of John the Baptist show the influence of Giotto's painting.

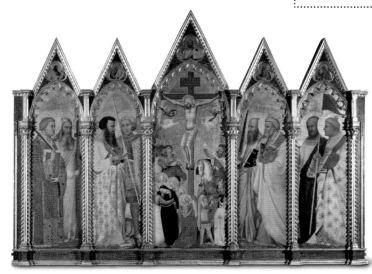

Crucifixion With Eight Saints △
Bernardo Daddi 1348
Courtauld Gallery, London, UK
Possibly Giotto's pupil, Daddi ran a busy and influential workshop in Florence after Giotto's death. This polyptych (multi-paneled painting) is his last-known work. It exemplifies his sweet, lyrical style.

△ Portrait of a Dominican Friar
Tomaso da Modena 1352
Chapter House of S. Niccolò, Treviso, Italy
This beautifully observed portrait by one of the leading artists in northern Italy is one of a series of signed and dated frescoes of celebrated members of the Dominican order, showing the friars reading, writing, and meditating.

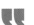

❝ DUCCIO...TRIED SUCCESSFULLY...
TO **BREATHE NEW LIFE** INTO OLD
BYZANTINE FORMS **INSTEAD OF**
DISCARDING THEM ALTOGETHER ❞

1950 | EH Gombrich
Austrian-born British art historian

▽ **Coronation of Alexander III**
Spinello Aretino 1408–10
Palazzo Pubblico, Siena, Italy
Spinello was the first non-Sienese painter to provide paintings for Siena's Palazzo Pubblico, where this fresco forms part of a cycle dedicated to Pope Alexander III. Spinello probably trained in Florence— his voluminous figures and powerful outlines owe much to Giotto.

The Great Schism
In 1378 the Western Church is divided when two rival lines of popes are elected, one based in Rome, and one in Avignon, France. This division, known as the Great Schism, continues until 1417.

▽ **The Church Militant and The Church Triumphant**
Andrea da Firenze 1366–68
S. Maria Novella, Florence, Italy
This is a detail from Andrea's most famous work, a cycle of frescoes glorifying the Dominican order. The pack of dogs protecting the Christian flock is a pun on "Dominicans" (the Latin *domini canes* means "dogs of the Lord").

Anonymous masterpiece
As the International Gothic style emerges in Europe, the Wilton Diptych (see *pp.74–75*) is created around 1395 by an unknown artist. Experts cannot agree on the artist's country of origin, testifying to the truly international nature of the style.

| 1370 | 1380 | 1390 | 1400 | 1410 | 1420 |

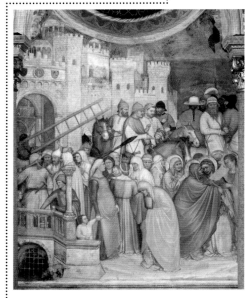

△ **The Crucifixion**
Altichiero c.1376–79
S. Antonio, Padua, Italy
This detail from a fresco of the Crucifixion characterizes Altichiero's style. Inspired by Giotto and Roman relief sculpture, the colorful narrative combines grandeur with lively incident and closely observed details.

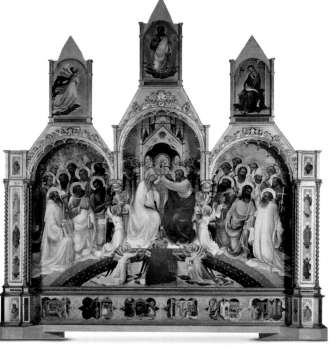

△ **Coronation of the Virgin**
Lorenzo Monaco 1414
Uffizi, Florence, Italy
This altarpiece was painted for the Florentine monastery where Lorenzo took his vows (Lorenzo Monaco is Italian for "Laurence the Monk"). With its brilliant colors and sinuous lines, it represents the pinnacle of Late Gothic art in Florence.

△ **Madonna of the Quail**
Pisanello c.1420
Castelvecchio, Verona, Italy
Thought to be an early work by Pisanello ("the little Pisan"), this unusual Madonna is a lovely example of the International Gothic style. The sensuous lines and decorative use of naturalistic details of birds and fruit add to the small painting's charm.

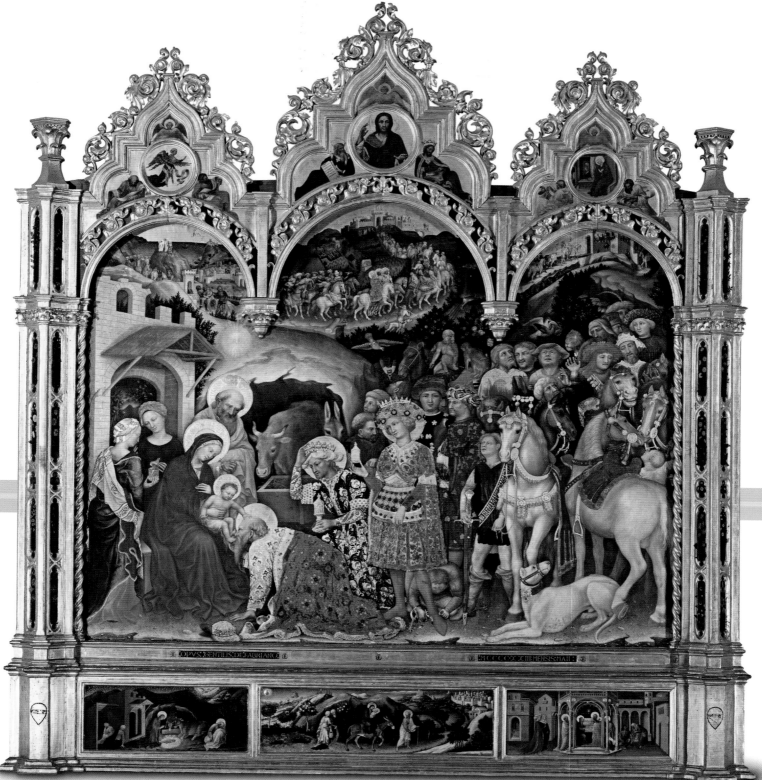

1430

△ Adoration of the Magi
Gentile da Fabriano 1423 *Uffizi, Florence, Italy*
Painted for one of the wealthiest citizens in Florence, Palla Strozzi, this spectacular altarpiece is a masterpiece of the International Gothic style. It displays a courtly elegance designed to underline Strozzi's own wealth and rank. Set in a magnificently ornate frame, the painting blends natural-looking and decorative detail, and shows the Magi dressed in splendidly luxurious garments. The natural treatment of lighting, especially in the night scene of the *predella* (the small images beneath the main panel), is remarkable.

⊚ Gentile da Fabriano

born Fabriano, Italy, 1385?; **died** Rome, Italy, before October 14, 1427

The consummate master of the International Gothic style, Gentile da Fabriano is named after his birthplace, Fabriano, a town in the Marches region of central Italy. Throughout the two decades of his career, he worked in major Italian art centers including Venice, where he painted for the Doge's Palace, and in Rome, Siena, Orvieto, and Florence, where he painted the *Adoration of the Magi*. Renowned for its decorative beauty, narrative detail, and natural treatment of light and shade, his work influenced artists including Pisanello, Jacopo Bellini, Masolino, and Fra Angelico.

BIOGRAPHY

◎ MASTERWORK

The Tribute Money

Masaccio **c.1426–28**
Brancacci Chapel, S. Maria del Carmine, Florence, Italy

In his short life, Tommaso di Ser Giovanni di Mone Cassai (1401–28) became one of the most important artists of his time, and was a founding father of Renaissance art. His nickname Masaccio, by which he is now known, may be translated as "Sloppy Tom"—he is said to have earned the name because he was so absorbed by his art that he had no time for worldly matters, such as looking after his appearance.

This magnificent fresco is one of his most famous works. It is part of a cycle painted for the Brancacci Chapel in Florence by Masaccio and his colleague Masolino di Panicale. The fresco depicts a rarely painted biblical story that Masaccio portrays with great clarity, dividing the narrative into three sections. In the center, Christ and his disciples stand outside a town, indicated by contemporary architecture. Confronted by a tax collector demanding a toll, Christ tells Peter to go to the lake, where he will find a fish containing a coin. On the left, Peter finds the coin; on the right he pays the tax collector the "tribute money."

The solemn, unadorned grandeur of Masaccio's monumental style differs from the ornate elegance of contemporary painters, such as Lorenzo Monaco or Gentile da Fabriano. Instead, it shows a profound debt to the paintings of Giotto from more than a century earlier. However, where Giotto's depiction of three-dimensional space was largely intuitive, Masaccio constructs his pictorial space in accordance with the scientific laws of perspective, as developed by contemporaries Leon Battista Alberti and Filippo Brunelleschi. The figures in the painting also show links with the Florentine Renaissance sculptor Donatello, and with antique art. A single, unifying light source helps to create a convincing sense of volume and space as light falls and shadows are formed on the draped figures, the building, and the barren landscape.

GIOTTO BORN AGAIN, STARTING WHERE DEATH HAD CUT SHORT HIS ADVANCE

1896 | Bernard Berenson
American art historian, on Masaccio

FLOWERING OF THE RENAISSANCE

▷ **The Baptism of Christ**
Piero della Francesca 1440–60
National Gallery, London, UK
The calm grandeur of Piero's perfectly balanced masterpiece derives partly from the precise mathematical proportions and pure geometric shapes that underlie the composition. Although Piero worked mainly outside Florence, he was influenced by artistic developments there, and was inspired by artists such as Masaccio and Fra Angelico.

Paintings in 15th-century Italy, such as Piero della Francesca's *The Baptism of Christ* (*left*), achieved a powerful sense of monumentality, clarity, and order. These distinctive qualities were founded on the study of ancient art, modern scientific principles of perspective, and Renaissance notions of divine geometry and proportion. Florence was at the center of quattrocento (15th-century) developments in the fields of painting, sculpture, and architecture. However, artists created many significant works in other cities—such as Siena and Arezzo—and in cultured courts including those of Federico da Montefeltro in Urbino, the Este family in Ferrara, and the Gonzagas in Mantua. It was in Mantua that Mantegna's classically inspired painting took the illusionistic possibilities of perspective to a new level. While Christian subjects still dominated, artists were also commissioned to paint portraits, battle scenes, and sophisticated mythologies, such as Botticelli's masterpiece, *Primavera* (*see pp.98–99*).

◉ CONTEXT

Florence and the Medici

Often called "the cradle of the Renaissance," the city of Florence was home to many of the innovations and cultural achievements of the 15th century. Despite the plagues of the mid-14th century, which had devastated its population, Florence was the most prosperous city in Italy, with its own gold currency, the florin. Developments in architecture, science, art, philosophy, and literature thrived there as politicians, architects, artists, and scholars exchanged and explored ideas.

Although technically a republic, 15th-century Florence was dominated by a single family— the Medici, who were great patrons of classical learning and the arts. A wealthy family of bankers and merchants, they gained power through political astuteness rather than force. They ousted rival ruling families the Albizzi and the Strozzi in 1434 and remained in power until exiled in 1494, later returning to power in 1512. Lorenzo de' Medici, known as Lorenzo the Magnificent (1449–92), played a pivotal role in Renaissance Florence: diplomat, poet,

scholar, and collector of antiquities, he maintained relative political stability and patronized major artists.

Science and art came together in one of the lasting legacies of the Renaissance—perspective. A mathematical system for representing three-dimensional space on a flat surface, linear perspective was developed by the Florentine architect Filippo Brunelleschi and fellow-architect and writer Leon Battista Alberti. While mathematics was the basis of linear perspective, it also underpinned the ideal of beauty that found expression in quattrocento painting. The ancient idea of "divine proportion" was revived at this time, and mathematical ratios (based on the human body) were used to create architecture and paintings with harmonious proportions that were thought to echo the God-given geometry of the universe. Quattrocento artists, including Paolo Uccello and Piero della Francesca, were fascinated by mathematical perspective, and Piero wrote treatises on both perspective and the science of optics.

◉ A powerful dynasty

KEY EVENTS

▷ **1434** Cosimo de' Medici returns from exile in Venice and assumes power in Florence. He funds many public building projects in Florence, earning him the title *pater patriae* (father of his country).

▷ **1444** Having amassed a fortune as a *condottiere* (mercenary commander), Federico da Montefeltro becomes Duke of Urbino, establishing a cultured ideal city that attracts scholars and artists including Alberti and Piero della Francesca.

▷ **1469** Lorenzo de' Medici assumes power in Florence. He rules until his death in 1492, when his son Piero succeeds him.

▷ **1494** French troops under Charles VIII invade Italy, beginning a period of warfare that lasts until 1559. The Medici are expelled from Florence.

▷ **1498** The influential preacher Girolamo Savonarola, an outspoken critic of the Medici and of Church corruption, is executed in Florence for heresy. Savonarola's preaching about the role of art influenced many artists including Botticelli, Fra Bartolommeo, and Michelangelo.

THE **MOST GLORIOUS CITY**, RENOWNED FOR ITS **WEALTH, VICTORIES, ARTS,** AND **ARCHITECTURE,** ENJOYED **SALUBRITY** AND **PEACE** ❞

Unknown
Description of Florence, inscribed on a fresco by Domenico Ghirlandaio

Quattrocento Florence
This bird's-eye view shows Florence dominated by the huge Cathedral dome designed by Brunelleschi. Alberti wrote that it was "a structure so immense... that it covers all Tuscans with its shadow."

◎ BEGINNINGS
A NEW PERSPECTIVE

The blossoming of art in early 15th-century Italy was to a great extent triggered by four men: the architect, Brunelleschi; the architect and writer, Alberti; the painter, Masaccio; and the sculptor, Donatello. Brunelleschi pioneered the understanding of linear, single-point perspective, the mathematical system that allows artists to create a convincing illusion of space and sculptural form on a flat surface. Alberti formulated the rules of perspective and wrote an influential treatise, *On Painting* (1435), setting out the method that an artist should follow.

The first artist to put the principles of perspective into practice with complete consistency was Masaccio. His frescoes of the *Holy Trinity* in S. Maria Novella and in the Brancacci Chapel (*see pp.86–87*) achieved an unprecedented illusion of space and monumental, sculptural realism. Masaccio's paintings are close in spirit to the sculptures of Donatello, whose realistic freestanding sculptures and reliefs were inspired by antique art. Like Masaccio, Donatello had a huge influence on the development of quattrocento painting.

> HE WOULD NEVER TAKE THE **PENCIL IN HAND** UNTIL HE HAD FIRST **OFFERED A PRAYER**

1568 | Giorgio Vasari
Italian writer and artist, on Fra Angelico in Lives of the Artists

◉ ARTISTIC INFLUENCES

In early 15th-century Italy, two contrasting approaches to painting coexisted — the elegantly decorative International Gothic style, and the solid, sculptural style of Masaccio. These two strands are blended in the early work of Fra Angelico, and in that of Sienese artists including Sassetta. As the century progressed, a monumental sense of space and form took hold in Italian art.

Gold halos as used here and in Simone Martini's earlier *Annunciation* were punched with decorative patterns. Alberti's Renaissance treatise, *On Painting*, recommends that artists "represent the glitter of gold with plain colors" rather than use gold itself.

Angel Gabriel, detail from *The Annunciation*, 1333, by Simone Martini and Lippo Memmi, features the use of gold leaf. *Uffizi, Florence, Italy*

Masaccio's pioneering use of perspective influenced Fra Angelico and later painters. His *Holy Trinity* is one of the earliest paintings to use linear perspective systematically to create a convincing illusion that the image receded into the wall.

Holy Trinity With the Virgin, St. John, and Donors, c.1425–28, places figures in a classical setting. *S. Maria Novella, Florence, Italy*

Brunelleschi's influence is apparent in the perspective and setting of Angelico's *Annunciation*. Placing figures in an arcade of Corinthian columns and semicircular arches, as seen in Brunelleschi's architecture, forms a convincing sense of space and solidity.

The Foundling Hospital (begun 1419), by Brunelleschi was the first building since antiquity to master the language of classical architecture.

The sculptor Donatello was highly influential. Taking inspiration from antique art, he was renowned for the inventiveness and emotional power of his work. In this elegant Annunciation, the echoing poses and gestures establish a dynamic relationship between Gabriel and Mary.

The Annunciation, c.1435. Vasari noted that it brought Donatello recognition for its grace and emotional drama. *S. Croce, Florence, Italy*

◎ TURNING POINT

The Annunciation

Fra Angelico **1432–33** *Museo Diocesano, Cortona, Italy*

Fra Angelico's early masterpiece combines a knowledge of Masaccio's monumental style with a decorative lyricism that links it to Gothic art. Seated in a classical *loggia*, the Virgin responds with humility to the Angel Gabriel's news that she will give birth to the Son of God. Their verbal exchange: "the Holy Ghost shall come upon thee…Behold the handmaid of the Lord…" is written in gold lettering. The receding architecture leads the eye back toward the scene of Adam and Eve being expelled from Eden— a reference to mankind's sin, which will be redeemed by Christ, whose coming birth Gabriel announces.

◎ Fra Angelico

born nr. Vicchio, Italy c.1395–1400;
died Rome, Italy, February 18, 1455

BIOGRAPHY

Fra Angelico's real name was Guido di Piero, although after he became a Dominican friar he was known as Fra Giovanni. His nickname "the angelic brother" reflects his saintly reputation. Trained as a manuscript illuminator, he went on to become one of the most important artists in Florence, and also in Rome. Based mainly in Fiesole, he is most associated with his series of frescoes in the monastery of S. Marco in Florence, which were designed to aid the monks' spiritual contemplation.

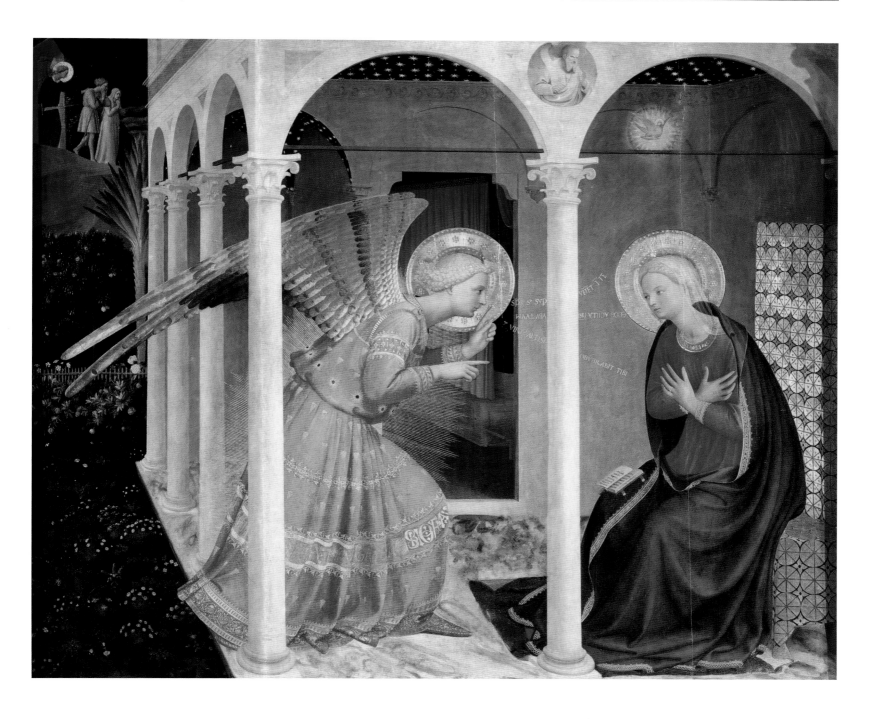

◎ TIMELINE

Throughout the quattrocento (15th century) Italian artists progressed toward a greater sense of naturalism and monumentality, which was underpinned by an awareness of antique art and advances in mathematics and perspective. In the second half of the century, artists created stunningly convincing illusions of reality, aided by the use of the oil painting technique. The grand mythologies of Botticelli and Mantegna, the anatomical studies of Antonio Pollaiuolo, and the harmonious, idealized paintings of Perugino looked forward to the High Renaissance.

CONTEXT

◎ ALBERTI ON PERSPECTIVE

In his influential treatise *On Painting*, published in Latin in 1435 and translated into Italian the following year, Alberti explained the principles of perspective. Parallel lines appear to converge as they move further away from the viewer and meet at a vanishing point. By showing painters how to use converging lines to create a mathematically constructed sense of space and depth on a flat surface, he helped to transform Western art.

St. Francis Renounces His Earthly Father ▷
Sassetta 1437–44
National Gallery, London, UK
Sassetta (Stefano di Giovanni) was one of 15th-century Siena's leading artists. This scene from an altarpiece dedicated to St. Francis blends the decorative Sienese tradition with Florentine developments in perspective and naturalism.

Ghiberti's doors
In 1425, Lorenzo Ghiberti finishes one set of bronze doors for Florence's Baptistery, and begins a second; their sculpted relief scenes are renowned for their advanced use of perspective.

Death of Masaccio
Masaccio moves to Rome in 1428, leaving the Brancacci frescoes unfinished. He dies soon afterward, aged 26 or 27—so suddenly that some suspect poisoning.

1425 **1428** **1431** **1434** **1437**

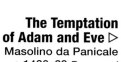

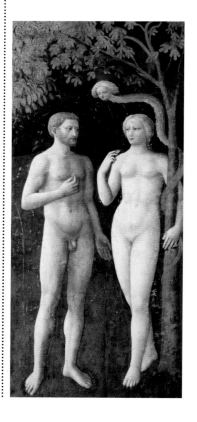

The Temptation of Adam and Eve ▷
Masolino da Panicale
c.1426–28 *Brancacci Chapel, S. Maria del Carmine, Florence, Italy*
This fresco appears on the wall opposite Masaccio's *Tribute Money* (see pp.86–87). Masaccio collaborated on the neighboring piece, *The Raising of Tabitha*, but this scene—showing a slender, elegant Adam and Eve—is by Masolino alone. Almost 20 years older than Masaccio, Masolino had a more graceful, less monumental style.

▽ The Care of the Sick
Domenico di Bartolo 1440–44
Hospital of S. Maria della Scala,
Siena, Italy
One of a remarkable series of frescoes painted for a hospital in Siena, this secular subject is unusual. In vivid—sometimes gory—detail, Bartolo depicts the sick being cared for by friars, observed by wealthy visitors.

St. Lucy Altarpiece ▷
Domenico Veneziano
c.1445–47 *Uffizi,*
Florence, Italy
In this luminous altarpiece—named after the church in Florence for which it was painted—Domenico echoes the traditional triptych format of the Virgin and Child flanked by Saints by dividing the scene into three using the arches of a *loggia*.

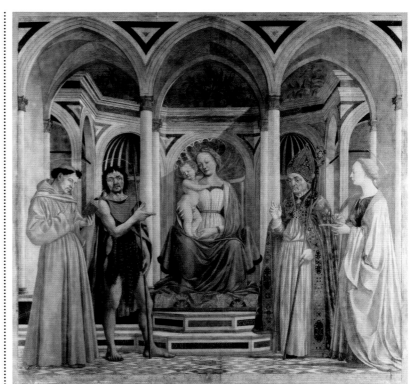

Sienese preacher
When Franciscan preacher Bernardino of Siena dies in 1444, the Company of the Virgin commissions an altarpiece featuring Bernardino preaching outdoors to crowds.

1440 ○ **1443** ○ ○ **1446** ○ **1449** ○ **1452** ▶

◁ Battle of San Romano
Paolo Uccello c.1440–50
National Gallery, London, UK
Renaissance geometry and medieval pageantry combine in this painting commemorating a Florentine victory against the Sienese in 1432. It was once hung in the Medici Palace. Florentine leader Niccolò da Tolentino appears at the center of the stagelike foreground in a gorgeously decorated, geometrically shaped hat. Lines created by broken lances strewn on the ground converge at the vanishing point on the head of Niccolò's horse.

Humanist Pope
Tommaso Parentucelli, a humanist scholar, is elected Pope Nicolas V in 1447. Fra Angelico frescoes the Pope's private chapel in the Vatican with scenes from the lives of St. Stephen and St. Lawrence.

Paolo Uccello

born Florence, Italy c.1397;
died Florence, December 10, 1475

Paolo di Dono was nicknamed *Uccello* ("bird" in Italian) because of his love of animals, in particular birds. Long regarded as a curiosity, he is now one of the most popular Renaissance artists. After a brief stint as a mosaicist in Venice, Uccello spent most of his life in Florence. His idiosyncratic work combines the decorative appeal of the International Gothic tradition with enthusiastic displays of mathematical perspective. Vasari claims his enthusiasm was such that he worked late into the night, telling his wife: "What a sweet mistress is this perspective!"

BIOGRAPHY

△ The Youthful David
Andrea del Castagno c.1450
National Gallery of Art,
Washington, DC
This painted leather shield would have been carried at a Florentine pageant or joust. David's heroic bravery in slaying the giant Goliath made him a popular, inspirational subject in Renaissance Florence, which saw itself as standing up to giants of the day, such as the Duke of Milan.

◁ **Procession of the Magi, detail**
Benozzo Gozzoli c.1459–61
Chapel of the Medici Palace, Florence, Italy
This splendid fresco is Gozzoli's masterpiece.
Commissioned by Piero de' Medici, it deliberately
echoes Gentile da Fabriano's *Adoration of the
Magi* and features portraits of Medici family
members and their allies.

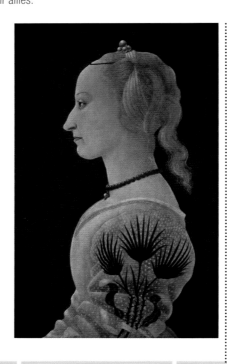

◁ **Portrait of a Lady**
Alesso Baldovinetti c.1465
National Gallery, London, UK
Profile portraits, echoing the
heads on antique coins, were
popular in 15th-century Italy.
This noblewoman has not been
identified, but the decorative
device on her sleeve probably
relates to her family's coat of arms.

Donatello dies
The Florentine sculptor
Donatello (Donato di
Niccolo), the greatest
sculptor and the most
influential artist of the
time—in any medium
—dies in Florence on
December 13, 1466.

1452 ◦ **1455** **1458** ◦ ◦ **1461** **1464** ◦ ◦ **1467** ◦

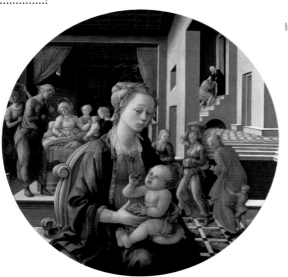

△ **Virgin and Child With Scenes
From the Life of St. Anne**
Fra Filippo Lippi c.1453
Palazzo Pitti, Florence, Italy
Fra Filippo Lippi's early paintings were
influenced by Masaccio, but later work such
as this was more decoratively linear. Lippi
influenced Botticelli, who was probably a
pupil. He was among the first Renaissance
artists to use the *tondo* (circular) format.

Mantegna to Mantua
In 1460, Andrea Mantegna
arrives in Mantua and
becomes court painter to
Ludovico Gonzaga. He
remains in service to the
Gonzaga family for the
rest of his life.

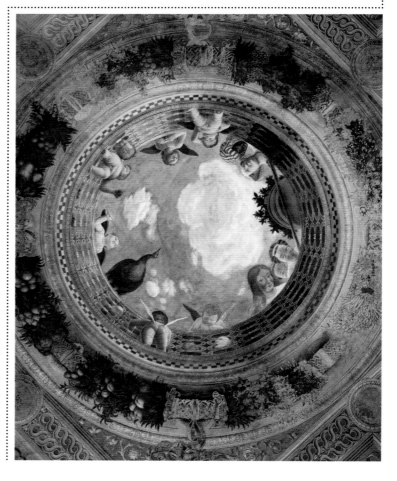

**Oculus from the Painted
Room (*Camera Picta*)** ▷
Andrea Mantegna c.1465–74
Gonzaga Palace, Mantua, Italy
In a virtuoso display of perspective,
Mantegna creates the illusion that the
ceiling of the "Painted Room" opens on
to the sky: servants and ladies peep
down over a parapet, accompanied by
cleverly foreshortened *putti*.

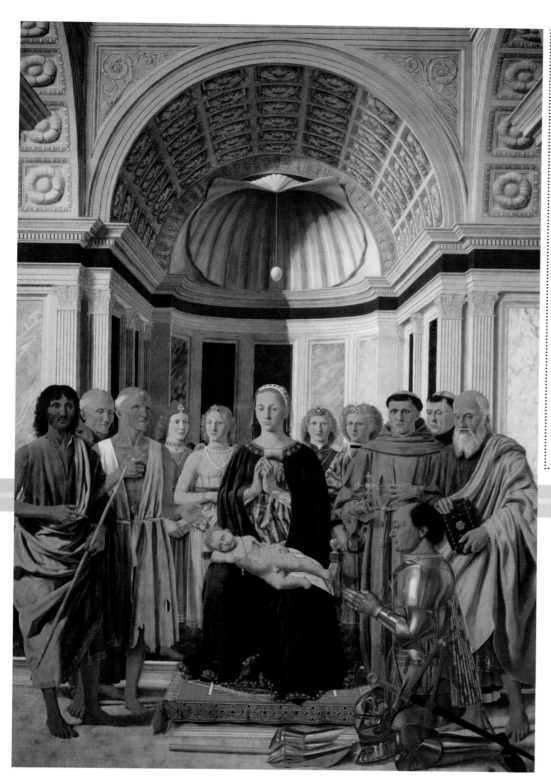

◁ **The Montefeltro Altarpiece**
Piero della Francesca c.1472–74
Pinacoteca di Brera, Milan, Italy
Resplendent in armor, Federico da Montefeltro, who commissioned the painting, kneels in a Renaissance church before the Madonna and Child with attendant saints and angels. Above the Madonna's oval-shaped head hangs an ostrich egg—symbol of the miraculous Virgin birth.

❝ **PAINTING** IS NOTHING BUT A **REPRESENTATION OF SURFACES** AND **SOLIDS FORESHORTENED** OR **ENLARGED**... ❞

c.1480–90 | Piero della Francesca
Writing in On Perspective in Painting

Netherlandish influence
From 1472 to 1474, Netherlandish artist Joos van Ghent stays at the court of Federico da Montefeltro in Urbino. His oil painting technique influences fellow artists, such as Piero della Francesca.

1470 **1473**

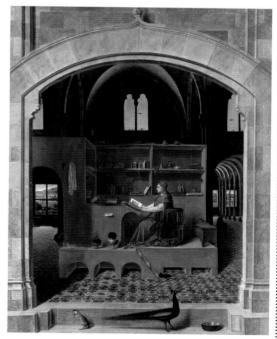

St. Jerome in His Study △
Antonello da Messina c.1475
National Gallery, London, UK
Antonello combines meticulously planned perspective with the oil painting technique to create a stunningly illusionistic image: the stone ledge appears to project toward us, while the floor tiles' converging lines lead deep into the picture.

BIOGRAPHY

Piero della Francesca

born Borgo San Sepolcro (now Sansepolcro), Umbria, Italy, c.1415;
died Borgo San Sepolcro, October 12, 1492

One of the great theorists of the Renaissance, Piero della Francesca was remembered chiefly as a mathematician until the 19th century. Now he ranks as one of the greatest of all quattrocento artists, admired for the clarity and solemn grandeur of his works, which are underpinned by his profound understanding of perspective, geometry, and harmonious proportion. He lived mainly in Borgo San Sepolcro, but painted in various other places, notably Arezzo, where he created a magnificent fresco cycle on the *Legend of the True Cross*, and Urbino, where he worked at the court of Federico da Montefeltro.

> **ANTONIO'S** TREATMENT OF **THE NUDE** IS **MORE MODERN** THAN THAT OF **ANY OF THE MASTERS** WHO PRECEDED HIM

1568 | Giorgio Vasari
Writing in Lives Of The Artists

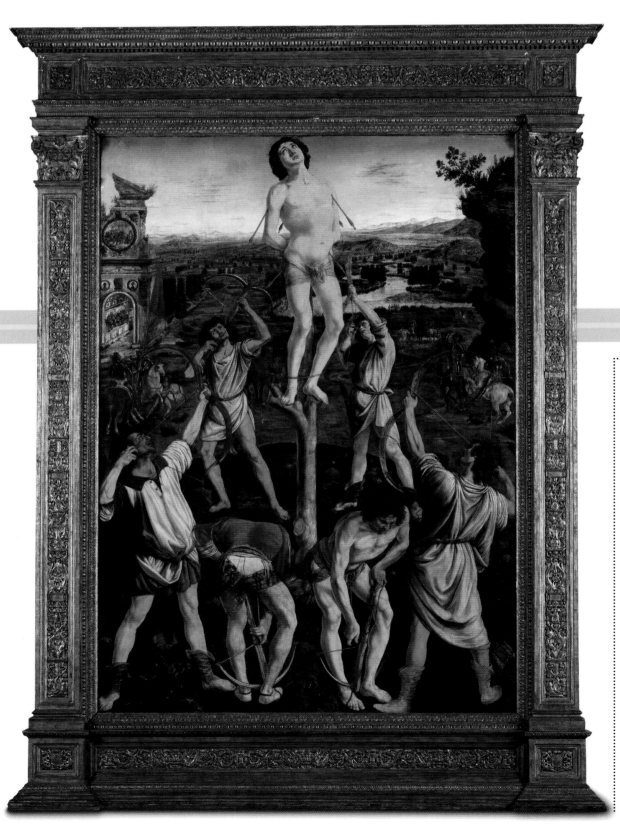

BIOGRAPHY

Pietro Perugino

born Castello della Pieve (now Città della Pieve), Italy c.1450;
died Fontignano, nr. Perugia, Italy February or March 1523

Pietro Vannucci was nicknamed after Perugia, where he settled. His early years are obscure, but he worked in Florence before making his reputation painting frescoes for the Sistine Chapel in 1481. He was later hailed the "best painter in Italy" by wealthy patron Agostino Chigi. Perugino ran workshops in Florence and Perugia, and his sweetly harmonious, idealized art was a formative influence on the young Raphael.

Birth and death
In 1475, Michelangelo Buonarotti is born on March 6 in Caprese, near Arezzo: he becomes a giant of the High Renaissance. On December 10 Paolo Uccello dies in Florence.

1475

Murder in the cathedral
In an unsuccessful attempt to seize power in Florence, the Pazzi family and others conspire to murder Lorenzo de' Medici and his younger brother Giuliano on April 26, 1478, during High Mass at the Cathedral. Giuliano is stabbed to death, Lorenzo wounded. Botticelli paints frescoes of the hanged conspirators.

◁ **The Martyrdom of St. Sebastion**
Antonio and Piero Pollaiuolo 1475
National Gallery, London, UK
The Pollaiuolo brothers (their name means "poulterer") ran a busy workshop in Florence, and later Rome. In this powerful collaborative work, the muscular figures shown from a variety of viewpoints are probably by Antonio, who was a gifted sculptor and was fascinated by anatomy—he even dissected corpses. Piero was a pioneer of landscape, and probably painted the panoramic background, based on the Arno valley around Florence.

▽ The Crucifixion With the Virgin, St. John, St. Jerome, and St. Mary Magdalene
Pietro Perugino c.1482–85
National Gallery of Art, Washington, DC
This idealized, sweetly pious image of the Crucifixion—devoid of any suggestion of suffering—was once thought to be an early work by Raphael.

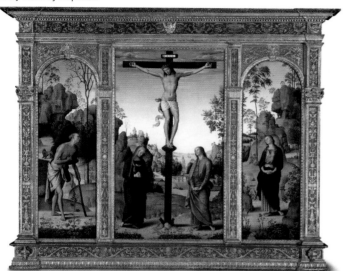

◁ The Annunciation, With St. Emidius
Carlo Crivelli 1486
National Gallery, London, UK
This unusual Annunciation shows how closely politics, religion, and art were linked in 15th-century Italy. Commissioned to commemorate the Pope's recent granting of rights of self-government to Ascoli, it shows the town's patron saint presenting Gabriel with a model of the town, while the zooming perspective leads back to a bridge where a carrier pigeon delivers the papal message—a witty parallel to the sacred message being delivered by the angel to Mary.

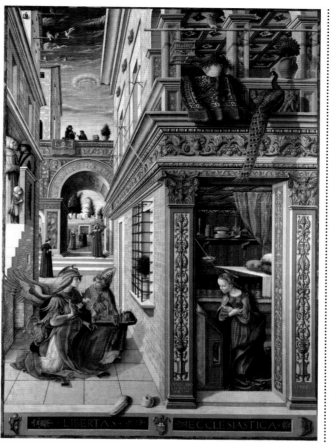

End of an era
Botticelli's frescoes of the conspirators who were hanged for their part in the Pazzi conspiracy of 1478 are destroyed in 1494, when the Medici are expelled from Florence.

1480 **1485** **1490** **1495** **1500**

An Old Man and a Boy △
Domenico Ghirlandaio c.1485
Louvre, Paris, France
In this tender, poignant portrait, the old man's disfigured face contrasts with the unsullied features of the little boy, who gazes up at him with touching intensity.

△ A Satyr Mourning Over a Nymph
Piero di Cosimo c.1495
National Gallery, London, UK
Possibly a warning against marital jealousy, this enigmatic mythological scene may depict Procris, who was accidentally killed by her husband Cephalus while spying on him. The sorrowful dog reflects Piero's sensitivity to animals.

ISABELLA D'ESTE

One of the most passionate art patrons of her time, Isabella d'Este amassed a fine collection of ancient art. She commissioned leading artists, including Mantegna and Perugino, to provide allegorical paintings for her *studiolo* in the Ducal Palace in Mantua. She inspired her brother Alfonso to create his *camerino*, a marble-walled gallery for the display of paintings, including Titian's *Bacchus and Ariadne* (see pp.118–19).

CONTEXT

Drawing of Isabella d'Este by Leonardo da Vinci, 1499–1500

 # MASTERWORK

Primavera

Sandro Botticelli **c.1482**
Uffizi, Florence, Italy

***Primavera* is one of the most celebrated** of all Renaissance paintings. Botticelli was the first artist since antiquity to paint mythological subjects such as this on a large scale, and to treat them with a seriousness previously reserved for religious subjects. This new type of painting was highly valued in cultured Renaissance circles: like a painted allegorical poem, it uses complex symbolism to bring together classical and Renaissance ideas about love, beauty, and nature. Vasari describes it as "Venus as a symbol of spring [*Primavera* is Italian for spring] being adorned with flowers by the Graces." Scholars continue to debate its precise meaning, but it draws on various Greek and Roman myths, and seems to be linked to the Medici festivals for which Botticelli painted fabrics and banners.

Painted in tempera on a wooden panel, it was commissioned for one of the Medici residences in Florence, by or for Lorenzo the Magnificent's young cousin, Lorenzo di Pierfrancesco de' Medici. At the center of the composition stands the life-size figure of Venus, attended by Cupid; to her left, the three Graces (goddesses of charm, grace, and beauty) dance, while Mercury stirs the clouds with his wand. To Venus's right, the Greek nymph Chloris is accosted by Zephyr. She transforms into Flora, the goddess of flowers, who wears an exquisite gown matching the description of one worn at a Medici tournament of 1475, which was "painted with roses and flowers and greenery."

> " WHEREVER MY LADY TURNS HER **BEAUTIFUL EYES**...DOES THIS **NEW FLORA** CAUSE THE EARTH ...TO PUT FORTH **NEW FLOWERS** IN A **THOUSAND VARIOUS COLORS** "

Lorenzo de' Medici
Florentine statesman, writing in a sonnet

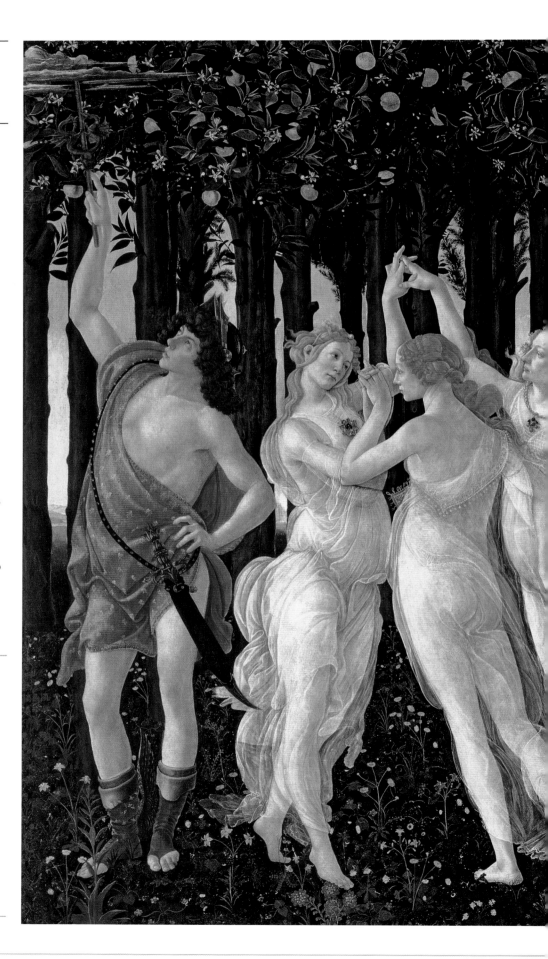

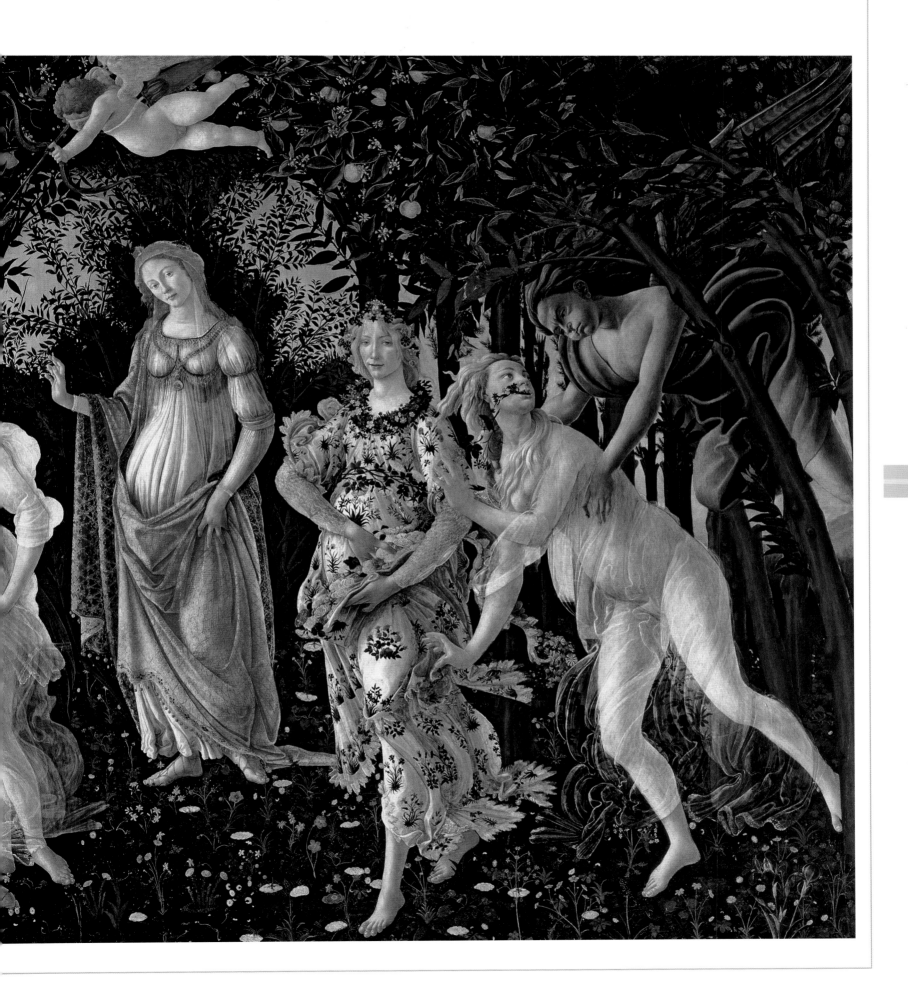

HIGH RENAISSANCE

c.1500–1530 TOUCHSTONES OF PERFECTION

▷ **Sistine Madonna**
Raphael 1513–14
Gemäldegalerie,
Dresden, Germany
This celebrated painting epitomizes
the grandeur and grace of High
Renaissance painting. It was
commissioned by Pope Julius II,
and depicts the Virgin and Child
flanked by two saints, Sixtus and
Barbara. St. Sixtus gestures the
Virgin forward as she appears
on clouds through parted curtains,
while St. Barbara glances down at
two winged *putti* who gaze up at
the heavenly scene.

The culmination of the Italian Renaissance came in the first few decades of the 16th century. It was a period dominated by three giants of Italian art—Leonardo (1452–1519), Michelangelo (1475–1564), and Raphael (1483–1520). According to the artist and biographer Giorgio Vasari, writing in his *Lives of the Artists* in 1568, this period represented the pinnacle of artistic achievement. Works such as Raphael's *Sistine Madonna* (*left*)— admired for its grandeur, idealized beauty, and refined grace (*grazia*)—came to be seen as touchstones of perfection for centuries. Many of the key works of the High Renaissance were frescoes, but artists also exploited the particular qualities of oil paint to achieve the subtle, softening effects that were characteristic of the period. High Renaissance artists were valued for their individuality and imaginative powers as well as for their ability to depict idealized figures in complex (often twisting) poses, frequently derived from antique sculpture.

◎ CONTEXT

The patronage of popes

While Florence had been the cradle of the early Renaissance, papal Rome is the city most associated with the masterpieces of the High Renaissance. At the end of the 15th century, the stability of Florence had been shaken by the invasion of Charles VIII of France and the flight of the ruling Medici family. Its position as the focus of artistic innovation waned, and Rome took center stage. With its Christian and classical heritage, the city attracted artists, architects, and scholars from across Europe. In this climate of confidence, artists shared the humanist philosophy of the period that saw man as "the measure of all things."

Unlike Florence or Venice, Rome was not a center of banking, manufacturing, or trade—it needed the papacy to draw pilgrims to the city and create wealth. In the words of Pope Martin V, Rome had become "dilapidated and deserted" after the papal court moved to Avignon in 1309. But in the 15th century, after Rome had become the permanent papal base

once again, the city began to prosper. A succession of popes set about restoring Rome to its former, ancient glory.

The area around the Vatican and St. Peter's was the focus of redevelopment. In 1475, Pope Sixtus IV ordered the rebuilding of an old chapel to take on a new ceremonial role—it became the Sistine Chapel. New churches rose throughout Rome, and tax concessions on property led to a flurry of building, giving rise to splendid palaces and villas such as the Villa Farnesina. This brought countless commissions for artists, who decorated the new sites.

Construction work unearthed ancient Roman remains, such as the celebrated sculptures the *Laocoön* and *Apollo Belvedere*. These examples of antique art were admired by High Renaissance artists and others, including Pope Julius II, who founded the Belvedere collection of sculpture. Of all the popes, Julius II (r.1503–13) played the most significant role in the achievements of the High Renaissance.

Among his many commissions were the rebuilding of St. Peter's, Michelangelo's Sistine Chapel frescoes, and Raphael's *Stanze*.

Everything changed on May 6, 1527, when mutinous imperial forces of the Holy Roman Emperor Charles V entered Rome. Fueled partly by religious sectarianism, they raped, tortured, and slaughtered thousands of inhabitants. Martin Luther's name was carved with a spear tip across Raphael's fresco the *Disputa*. The golden age of the High Renaissance came to a sudden, bloody end.

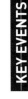

Harmony and balance
Inspired by circular Roman temples, Bramante's perfectly proportioned *Tempietto* (c.1502–10) epitomizes High Renaissance ideals of classical harmony and balance. *S. Pietro in Montorio, Rome, Italy*

◎ A city restored and ransacked

KEY EVENTS

▷ **1500** Pope Alexander VI declares 1500 a Jubilee year. Pilgrims flock to Rome in the hope of "buying" salvation. In the same year, Juan de la Cosa, Christopher Columbus's pilot, draws one of the earliest surviving maps depicting the Americas.

▷ **1503** Julius II becomes pope. In his reign, he commissions many major artistic works.

▷ **1506** The ancient sculpture the *Laocoön* is discovered in Rome. In the same year, the foundation stone is laid for the new St. Peter's Basilica.

▷ **1513** The Medici family is restored to power in Florence. Pope Julius II dies, and Pope Leo X is elected in his place.

▷ **1517** Religious reformer Martin Luther posts his *95 Theses* denouncing the decadence of the Catholic Church, marking the start of the Protestant Reformation.

▷ **1519** Charles I of Spain becomes Holy Roman Emperor, as Charles V.

▷ **1527** Rome is ravaged by imperial forces of Charles V in an event that comes to be known as The Sack of Rome. Inhabitants are murdered and art treasures looted.

> **I MYSELF TURN TO AN IDEAL** WHICH I AM **ABLE TO CREATE** IN MY **OWN IMAGINATION**
>
> Raphael

◎ BEGINNINGS
ATMOSPHERE AND GRACE

While Early Renaissance artists aimed to create lucid, ordered depictions of nature, paintings of the High Renaissance show nature observed, but refined and idealized. Hard-edged naturalism was softened and replaced by an emphasis on grace and subtlety expressed through smooth transitions of form and color. Initiating this change, Leonardo developed an oil painting technique called *sfumato* ("in the manner of smoke") in which he blurred edges and contours. While mathematically plotted linear perspective was central to early Renaissance art, "aerial" (atmospheric) perspective became a feature of the High Renaissance. Atmospheric effects that cause distant objects to appear increasingly hazy and blue toward the horizon had long been mimicked by artists, but Leonardo invented the term "aerial perspective" and fully developed its use in painting.

◎ TURNING POINT

The Virgin of the Rocks
Leonardo da Vinci **c.1483** *Louvre, Paris, France*

Leonardo's early masterpiece uses a pyramidal composition, which became a prototype for High Renaissance painters. It shows the Virgin and Child with St. John and an angel in a remote, cavelike setting, with a strange rocky landscape receding into a pale, bluish haze in the far distance (darkened varnish has obscured the original colors). The painting is imbued with a lyrical air of mystery. Departing from the clarity and precision of earlier quattrocento painting, Leonardo makes his graceful figures emerge from the shadows, softening features and blurring contours with *sfumato*. Unlike any figure painted before this, the exquisite angel who turns to gaze out of the picture seems almost to breathe with life.

◉ ARTISTIC INFLUENCES

Leonardo's genius was unique, and his skillful modeling of figures using blended gradations of light and shade originated in his own scientific investigations. But the work of earlier Italian and Northern Renaissance artists show precedents to several aspects of this groundbreaking painting, looking forward to the gracious refinements and mastery of atmosphere that are hallmarks of the High Renaissance.

◎ Leonardo da Vinci

born Anchiano or Vinci, Italy, April 15, 1452;
died nr. Amboise, France, May 2, 1519

A complex and versatile creative genius, Leonardo da Vinci was one of the most outstanding figures of the Italian Renaissance, and of all time. The illegitimate son of a notary and a peasant girl, he was apprenticed to the sculptor and painter Andrea del Verrocchio in Florence, then settled in Milan in 1482. His drawings and notebooks reveal the breadth and depth of his intellectual curiosity, which included research into areas as diverse as anatomy (he dissected more than 30 bodies), engineering (he designed flying machines, armored vehicles, and canal systems), mathematics, optics, botany, sculpture, architecture, and music. He researched every aspect of light and color. Painting was only one of his interests, and although he was one of the greatest and most influential artists of his time, he completed few pictures. His career was mainly divided between Florence and Milan, but he spent his final years in France as the honored guest of Francis I.

BIOGRAPHY

Pictorial grace was central to High Renaissance style. This lovely drawing by Leonardo's master, the sculptor and painter Andrea del Verrocchio, shows similarities to Leonardo's Virgin and angel.

Head of a Woman, c.1475, is evidence of Verrocchio's strong feeling for three-dimensional form. *British Museum, London, UK*

Atmospheric—or aerial— perspective had been observed since ancient Roman times. Its effects were imitated by many artists including Dutch 15th-century painter Hans Memling.

Passion of Christ, detail, c.1470. Memling's work often featured distant blue hills to create depth in a landscape. *Galleria Saubada, Turin, Italy*

Depictions of the natural world evolved during the Renaissance. Botticelli's *Primavera* (see pp.98–99) features a tapestrylike effect of flowers, while Leonardo's flowering plants reflect his interest in botany.

Primavera, detail, c.1482. Flowers and fruit are strewn across Botticelli's painting, emphasizing its decorative surface. *Uffizi, Florence, Italy*

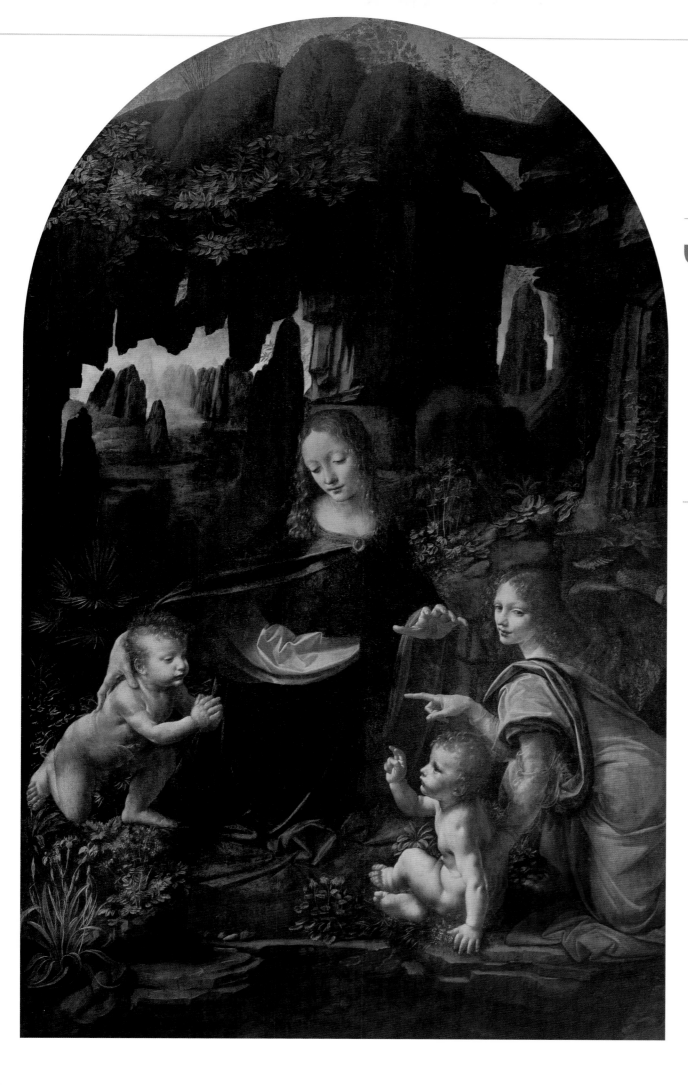

" FROM THIS **HEIGHTENING** OF **LIGHT AND SHADE** THE FACE **GAINS GREATLY IN RELIEF**...AND IN **BEAUTY "**

Leonardo da Vinci
Writing in Treatise on Painting

◎ TIMELINE

The High Renaissance is usually dated from around 1500 until around 1530. However, the move toward the High Renaissance style can be seen in Leonardo's art in the decades before 1500. His innovative *Virgin of the Rocks* (*see pp.102–03*) dates from c.1483—the year that Raphael was born. While Leonardo worked mainly in Florence and Milan, it was in Rome—where Michelangelo and Raphael produced their most influential works in the first decades of the 16th century—that the High Renaissance chiefly flourished.

Artistic giants
In 1501, artists line up to admire a cartoon—a full-size preparatory drawing—by Leonardo in Florence. Michelangelo begins his huge sculpture of David, the largest freestanding sculpture since ancient times.

▽ The Damned Consigned to Hell
Luca Signorelli 1500–03
Orvieto Cathedral, Italy
One of a series of frescoes based on the biblical Apocalypse, this powerful scene shows Signorelli's ability to depict the male nude in vigorous, complex poses. According to Vasari, Michelangelo admired Signorelli's work.

1500	1502	1504	1506	1508	1510

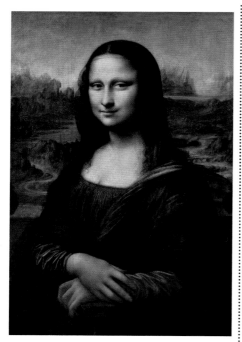

Mona Lisa △
Leonardo da Vinci c.1503–06
Louvre, Paris, France
This portrait of a fashionable Florentine woman set against a mysterious, mountainous landscape is probably the world's most famous painting. Its timeless appeal comes partly from the enigmatic quality of the sitter's smile, which Leonardo achieved by blurring the contours of lips and eyes, using the *sfumato* technique.

Vatican commissions
Michelangelo begins painting the Sistine Chapel ceiling in the Vatican in 1508. Raphael moves to Rome, where Pope Julius II commissions him to paint the Vatican's *Stanza della Segnatura* (*see pp.108–09*).

Sistine Chapel Ceiling ▷
Michelangelo 1508–12
Apostolic Palace, Vatican
The painting of the vaulted ceiling of the Sistine Chapel is one of the greatest achievements in the history of art. Michelangelo completed the work virtually unaided, dismissing assistants and refusing to admit anyone while he worked. Paintings of prophets and sybils who foretold Christ's birth flank the central series of frescoes, which depict events from the Creation to Noah.

THE LAOCOÖN

A spectacular masterpiece of ancient art was discovered in a vineyard in Rome on January 14, 1506. This dramatic ancient marble sculpture shows the Trojan priest Laocoön and his sons being crushed to death by sea serpents. Michelangelo was among those who went to see it immediately. By June 1506, it was the star attraction in Pope Julius II's collection of ancient sculpture, the Belvedere collection. It became the most influential and copied of all ancient works of art.

Laocoön,
Vatican Museum, Vatican

CONTEXT

BIOGRAPHY

◎ Michelangelo

born Caprese, Italy, March 6, 1475;
died Rome, Italy, February 18, 1564

Sculptor, painter, architect, and poet, Michelangelo Buonarroti was one of the greatest and most influential artists of the Renaissance. The almost superhuman nature of his work inspired awe in his contemporaries, who called him "the divine Michelangelo." An intense, brooding character, he was briefly apprenticed to painter Domenico Ghirlandaio before turning mainly to sculpture. He developed a heroic style based on the expressive qualities of the male nude. Most of his long career, which spanned some 70 years, was spent in Florence and Rome, where his late work inspired Mannerism.

Mythological masterpiece
Raphael paints his celebrated fresco the *Triumph of Galatea* for the wealthy banker Agostino Chigi's Villa Farnesina from 1511 to 1512. It shows the sea nymph Galatea riding on a shell pulled by dolphins.

1512 **1514** ○ ▶

The Annunciation With Six Saints △
Fra Bartolommeo 1515
Louvre, Paris, France
Strongly influenced by Leonardo, Bartolommeo was the leading High Renaissance painter in Florence after Leonardo, Michelangelo, and Raphael had left the city. Calm, balanced compositions such as this, featuring the Virgin with saints, are typical of his work.

▽ Portrait of Baldassare Castiglione
Raphael c.1515
Louvre, Paris, France
Raphael's portraits were hugely influential, admired for the beauty of their technique, their bold compositions, and their subtle revelation of character. Raphael's friend Castiglione was author of *The Courtier* (1528), a famous treatise describing ideal courtly behavior.

◁ The Raising of Lazarus
Sebastiano del Piombo 1517–19
National Gallery, London, UK
Sebastiano's grand, boldly colored altarpiece was commissioned as a rival companion piece to Raphael's last, unfinished masterpiece *The Transfiguration*. The Venetian-born Sebastiano was a friend of Michelangelo who may have negotiated the commission, and even helped with some preliminary drawings.

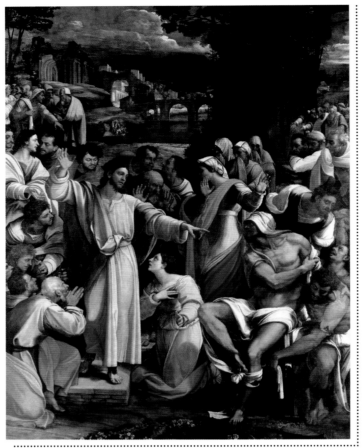

Cathedral commission
In 1522 Correggio receives a major commission—to fresco the dome, apse, and choir vault of Parma Cathedral. He eventually completes only the dome with the staggeringly bold, illusionistic *Assumption of the Virgin*.

1515	1517	1519	1521	1523

Leonardo leaves Italy
Leonardo leaves Italy for good in 1516 or 1517, invited to France by King Francis I. Officially he is "first painter, architect, and mechanic to the king." He dies in France in 1519.

Raphael

born Urbino, Italy, March 28 or April 6, 1483; **died** Rome, Italy, April 6, 1520

Painter, draftsman, and architect, Raphael (Raffaello Santi) was the supreme synthesizer of the High Renaissance: he absorbed the ideas of Leonardo and Michelangelo and combined them to create an art of unmatched grace and grandeur. Raphael was brought up in the cultured world of Urbino, where his father was a painter. His formative influence was the sweet, graceful art of Perugino, but his style grew grander under the influence of Leonardo and Michelangelo. Precociously talented and socially charming, Raphael quickly achieved success and fame. He worked in Rome from the age of 25 until his early death, aged 37.

BIOGRAPHY

△ Madonna of the Harpies
Andrea del Sarto 1517 *Uffizi, Florence, Italy*
Influenced by Leonardo, Raphael, and Fra Bartolommeo, Andrea developed a serene, stately style that was described by Vasari as "faultless." This is one of his most celebrated paintings. Its lovely colors were revealed by restoration in the 1980s.

△ Melissa
Dosso Dossi c.1520
Galleria Borghese, Rome, Italy
Working at the court of the Este family in Ferrara, Dosso (real name Giovanni di Luteri) painted mythological and religious works as well as portraits. His atmospheric feel for landscape, which suggests the influence of Giorgione and Titian, is evident in this splendidly opulent work.

Death of Raphael
On April 6, 1520, Raphael dies of a fever in Rome. According to Vasari, the entire papal court "is plunged into grief."

Correggio

born Correggio, Italy, c.1490;
died Correggio, Italy, March 6, 1534

The northern Italian artist Correggio (Antonio Allegri da) is most admired for his spectacular illusionistic frescoes in the domes of S. Giovanni Evangelista and the cathedral in Parma, and for his paintings of mythological subjects, whose soft sensuality foreshadows Rococo art. Correggio gained only a modest reputation in his lifetime, but he had enormous posthumous fame: in the 17th and 18th centuries, he was revered almost as much as Raphael.

The Sack of Rome

The city is invaded by the imperial forces of the Holy Roman Emperor Charles V in 1527. Mass slaughter depopulates the city. Martin Luther's name is carved on Raphael's *Disputa*.

1525 1527

LIVES OF THE ARTISTS

Vasari's *Lives of the Artists* (1550 and 1568), the primary source of information on Renaissance art, influenced attitudes for centuries. It expresses the view that after the golden age of classical antiquity, art declined in the Middle Ages, was revived in the 14th century, and reached its peak in the author's time, in the art of Michelangelo, whom Vasari idolized.

Michelangelo's tomb, designed by Vasari, S. Croce, Florence, Italy

◁ Jupiter and Io

Correggio c.1530
Kunsthistorisches Museum, Vienna, Austria

This is the most famous of Correggio's series of mythological paintings depicting the loves of Jupiter, commissioned by Federico II Gonzaga. It shows the nymph Io being seduced by the Greek god Jupiter, who has transformed himself into a cloud in order to ravish her. Her head thrown back in erotic abandon, the nymph succumbs to the caresses of the god, whose face and hands can just be discerned in the cloud. Correggio's assimilation of Leonardo's *sfumato* technique is evident in the soft, sensuous rendering of Io's flesh and facial features.

A celebrated series

Correggio begins a series of the *Loves of Jupiter* in 1530 for Federico II Gonzaga, 5th Marchese of Mantua, as a gift for Emperor Charles V.

1529

Michelangelo as engineer

While Michelangelo is in Florence working on the Medici Chapel, Florence is besieged. Michelangelo is appointed military engineer in 1529 and sets to work fortifying the city walls.

> ❝ ART'S REBIRTH, AND THE STATE OF PERFECTION TO WHICH IT HAS AGAIN ASCENDED ❞

1568 | Giorgio Vasari
On High Renaissance art, writing in Lives of the Artists

 MASTERWORK

The School of Athens

Raphael **c.1510–12**
Stanza della Segnatura, Vatican

Not long after he arrived in Rome in 1508, Raphael was commissioned by Pope Julius II to decorate a suite of rooms (*stanze* in Italian) in the Vatican palace. While Michelangelo labored nearby on his own masterpiece—the Sistine Chapel ceiling—Raphael began work on this fresco in the *Stanza della Segnatura* (the room in which papal documents were signed). The room is thought to have been used as the Pope's private library: the overall theme of the decorative scheme is the relationship between Christian thought and classical learning.

Painted medallions on the ceiling depict the four branches of learning that formed an enlightened Renaissance education: Philosophy, Theology, Poetry, and Jurisprudence. Under each medallion is a wall fresco illustrating that discipline. Beneath "Theology," Raphael painted the *Disputa*, in which Christian theologians discuss the mystery of the Sacrament. On the opposite wall, beneath "Philosophy," Raphael painted his most famous fresco—which later became known as *The School of Athens*—in which he brought together the great thinkers of the ancient world.

Raphael creates a majestic composition of great clarity, harmony, and rhythmic power. In a classical architectural setting—possibly linked to Bramante's design for the new St. Peter's—Plato and Aristotle discuss their philosophical ideas, surrounded by other ancient philosophers and scientists who debate ideas and pass on knowledge. Gathered in dynamic groups, the gesturing figures are arranged in harmonious rhythm throughout the composition. The powerful perspective of the architectural framework leads the eye deep into the painting, toward and beyond the central pair.

Raphael includes portraits of his contemporaries. Plato is modeled on Leonardo, while Euclid, bending down to demonstrate a mathematical concept, has been identified as Bramante. In the foreground, the self-absorbed figure of Heraclitus may be a portrait of Michelangelo. Raphael also included a self-portrait on the far right.

 OF THE **THREE MAJOR CREATORS** OF HIGH RENAISSANCE PAINTING...**RAPHAEL** WAS **THE GREAT SYNTHESIZER** 🙷

1997 | Ralph E Lieberman
American art historian

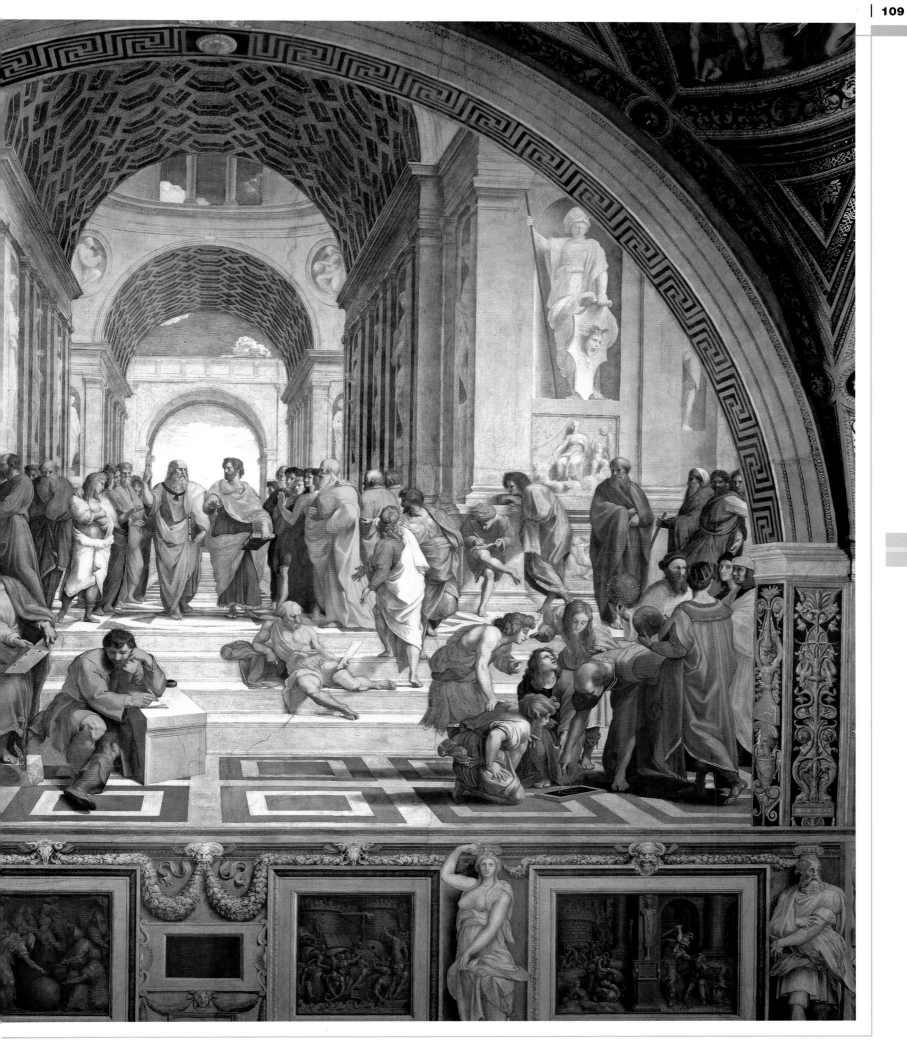

◎ BEGINNINGS
LUMINOUS VISIONS

Painting in early 15th-century Venice lagged behind the innovative art of Renaissance Florence, and was still essentially decorative and Gothic in character. The distinctive Venetian Renaissance style developed mainly through the art of one man, Giovanni Bellini. Giovanni's father, Jacopo Bellini, had been taught by the International Gothic master Gentile da Fabriano. Giovanni's early paintings of the Madonna and Child show him adapting his father's style, softening its linear formality and increasing both grandeur and naturalism.

Under the influence of his brother-in-law Andrea Mantegna—who had trained in Padua rather than Venice, and was a master of perspective—Bellini developed a new sense of pictorial space. However, unlike Mantegna's landscapes, Bellini's are suffused with an atmospheric lyricism. In 1475–76, Antonello da Messina visited Venice, bringing his expertise in oil paint. Bellini became a leading expert in oil painting, a medium that allowed him to achieve atmospheric and coloristic effects that were unattainable in tempera.

◉ ARTISTIC INFLUENCES

Venice's Byzantine and Gothic heritage, the taste for rich colorful textiles and textures, and even the local craft of glassblowing all influenced Venetian Renaissance art. A sensuous, painterly style evolved when Venetian traditions mixed with outside innovations, such as the use of perspective and oil painting.

Venetian glass, one of the area's most celebrated crafts, had an impact on Bellini's work. This painting's molten gold landscape has been compared to the flowing color of Venetian glass of the period, while the angel in the sky has the appearance of blown glass.

Late 15th-century Venetian glass reliquary, sprayed with gold decoration, has echoes in the chalice held by the angel.

Jacopo Bellini's drawings were used as sources for paintings. The sketch probably used by Giovanni and Mantegna is too faint to reproduce, but many also feature spacious rocky landscapes.

The Adoration of the Magi, c.1450, from Jacopo's album of drawings, in pen and leadpoint on vellum. *Louvre, Paris, France*

Exotic imports to Venice included minerals such as lapis lazuli, which created ultramarine, realgar (orange), and orpiment (yellow). The minerals were ground into pigments, and mixed with egg to create egg tempera, or with oil.

Pigments made from arsenic-based realgar and orpiment were popular with Venetian painters. They created glowing golden colors.

Bellini's brother-in-law Andrea Mantegna painted this version of the *Agony in the Garden*, perhaps using the same Jacopo drawing. It may have been painted a few years earlier than that by Bellini.

The Agony in the Garden, c.1458–60, by Mantegna has a precise, linear, hard-edged style unlike Bellini's. *National Gallery, London, UK*

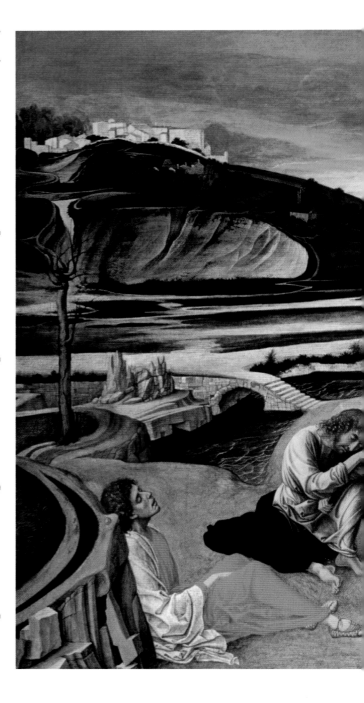

⊙ TURNING POINT

The Agony in the Garden

Giovanni Bellini c.1460–65 *National Gallery, London, UK*

This biblical scene shows Jesus after a long night of prayer before his crucifixion. His disciples sleep and his enemies arrive to arrest him. Bellini's early masterpiece is painted in egg tempera, which does not allow the artist to achieve the luminosity that became possible with oil paint. However, Bellini achieves a breathtakingly atmospheric evocation of mood. Unlike Mantegna (*below left*), he sets the scene as day is breaking: the sky glows pink, and the golden light of dawn envelops the landscape and figures. The first known dawn in Italian painting, Bellini's creation of a unifying light and atmosphere represents a revolutionary change in Venetian art.

⊙ Giovanni Bellini

born Venice, Italy, c.1430–35; **died** Venice November 29, 1516?

BIOGRAPHY

Bellini belonged to a family of painters who ran the most influential workshop in Venice. Art historian Kenneth Clark wrote of his influence on Venetian painting: "No other school of painting is to the same extent the creation of one man." Although he earned great fame, his long life and prolific career are poorly documented. Most of his work is religious, but he also painted portraits, mythological paintings, and allegories, and is renowned for his development of the atmospheric landscape. He trained and inspired the next generation of major Venetian painters, including Giorgione and Titian.

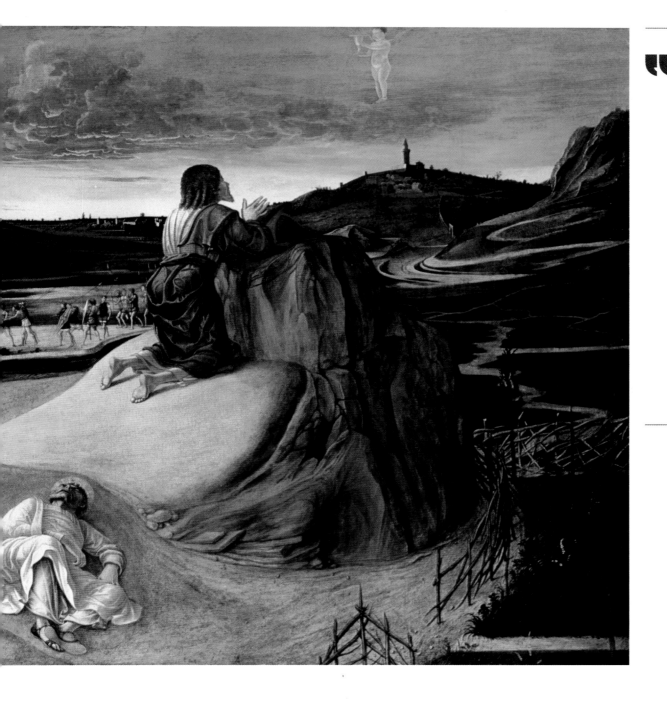

❝ THE DISTINCTIVENESS OF **BELLINI'S LANDSCAPE** LIES MORE IN THE **REALMS OF POETRY** THAN **SCIENCE**... DRIVEN...BY THE **FORCE OF RELIGIOUS EMOTION** ❞

1999 | Andrew Graham-Dixon
British art historian

◎ TIMELINE

A distinctive Venetian Renaissance style emerged around 1460. Giovanni Bellini absorbed the Gothic tradition from his father, drawing on developments in Florence and Padua to create a Renaissance style that gave primacy to color and atmosphere. When Bellini died in 1516, Titian became Venice's leading painter. An artist of international stature, he spread the reputation of Venetian art throughout Europe. His painterly style influenced Veronese and Tintoretto, who dominated Venetian painting at the end of the 16th century.

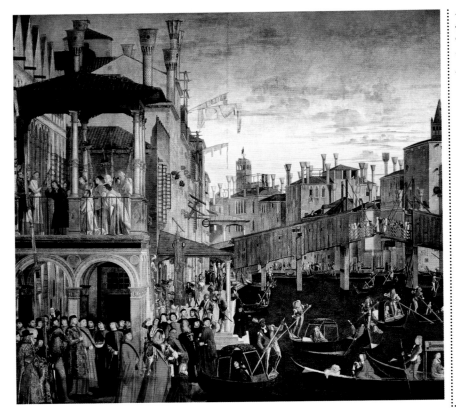

◁ **Miracle of the Relic of the True Cross**
Vittore Carpaccio 1494
Accademia, Venice, Italy
Many large narrative scenes like this were commissioned by Venice's *scuole*. Carpaccio depicts the legend of a 14th-century miracle when a relic of the True Cross (Christ's cross) was rescued after falling into the Grand Canal at the Rialto Bridge. Bristling with incidental detail, the painting features portraits of the *scuola* members.

Family connections
In 1453 Andrea Mantegna marries Giovanni Bellini's sister, Nicolosia. This family connection influences the development of Venetian painting.

1440 1460 **1480** **1500**

Doge abdicates
In October 1457, Doge Francesco Foscari is forced to abdicate by Venice's Council of Ten, but dies the following week and is given a State funeral.

△ **Virgin of Humility Adored by a Prince of the House of Este**
Jacopo Bellini c.1440 *Louvre, Paris, France*
With its refined details and gold highlights, this devotional painting reveals Jacopo's training by the International Gothic master Gentile da Fabriano.

◎ Antonello da Messina

born Messina, Sicily, c.1430;
died Messina, Sicily, February 14–25, 1479

The Sicilian painter Antonello da Messina was one of the pioneers of oil painting in Italy, and is traditionally credited with introducing the "secret" of oil painting to Venice when he visited in 1475–76. Paintings such as this *Portrait of a Man* c.1475 (National Gallery, London, UK) show him using transparent glazes and exploiting the light-reflecting properties of oil paint to create stunningly naturalistic effects. His paintings were popular in Venice, and inspired Giovanni Bellini and others to explore the possibilities of oil painting.

BIOGRAPHY

△ **Seated Scribe**
Gentile Bellini 1480
Isabella Stewart Gardner Museum, Boston, MA
This exquisite watercolor was painted by Giovanni's brother Gentile, who was sent by the Venetian State to the court of the Ottoman Sultan Mehmed II in Constantinople.

▽ The Tempest
Giorgione c.1505
Accademia, Venice, Italy
One of the most original and influential painters of the Venetian Renaissance, Giorgione specialized in paintings for private collectors. The theme of this poetic masterpiece remains a mystery; its importance lies in Giorgione's creation of an imaginative "landscape of mood."

1520

Dürer visits Venice
In 1505–07 Dürer visits Venice, meeting the elderly Bellini, whom he judged the "best painter" there. Other artists resent Dürer's presence, but Bellini treats him courteously.

> **GIORGIONE,** YOU WERE THE **FIRST TO LEARN** HOW TO **CREATE MARVELS IN PAINTING**

1660 | Marco Boschini
Venetian painter and writer

The Assumption of the Virgin ▷
Titian 1516–18
S. Maria Gloriosa dei Frari, Venice, Italy
In this grand, gigantic altarpiece—almost 23ft (7m) in height—Titian uses color to clarify the composition and intensify emotional impact. A triangle of red leads the eye up through the vermilion robes of the apostles, who reach toward the Virgin as she rises into heaven after her death. Her swirling red robes, uplifted arms, and upward gaze lead the eye heavenward to God, in a red cloak, who prepares to crown her.

▽ Judith
Palma Vecchio c.1525–28
Uffizi, Florence, Italy
Giacomo Palma (called "Old Palma" to distinguish him from his great-nephew) specialized in portraits such as this, showing opulently dressed women, sometimes in mythological or religious guise. Holofernes's severed head is overshadowed by Judith's gloriously pink satin sleeve.

Charles V on Horseback ▽
Titian 1548 *Prado, Madrid, Spain*
This influential equestrian portrait was painted when Titian visited Charles V's court at Augsburg, Germany. For the lush reds, Titian ordered half a pound of "burning ... splendid" crimson lake pigment from Venice.

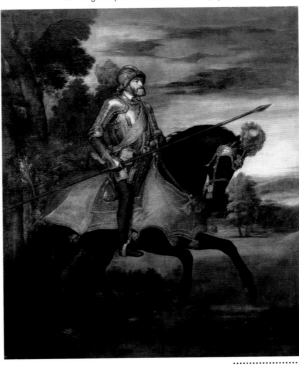

CONTEXT

COLOR VERSUS LINE

In 16th-century Italy, a dispute arose about which of the two dominant traditions in Italian painting was superior—Florentine or Venetian. What the debate came down to was whose style was best—Michelangelo's or Titian's. Florentine and other central Italian artists valued painting based on *disegno*, a term that referred to the intellectual capacity involved in inventing a design that could be worked out through preliminary drawings. In contrast, color (*colore*) was central to the Venetian approach to painting, in which the process of applying and handling paint assumed greater significance.

Scuola series
Tintoretto completes his first work for the Scuola di San Rocco in 1564. His magnificent series of paintings from 1564 to 1587 includes a huge, awe-inspiring *Crucifixion*.

1530 **1540** **1550** **1560**

Lotto at Loreto
After years of an unsettled existence, working in Venice and many other places, in 1554 Lorenzo Lotto settles in the pilgrimage town of Loreto, where he becomes a lay brother. He dies there two years later.

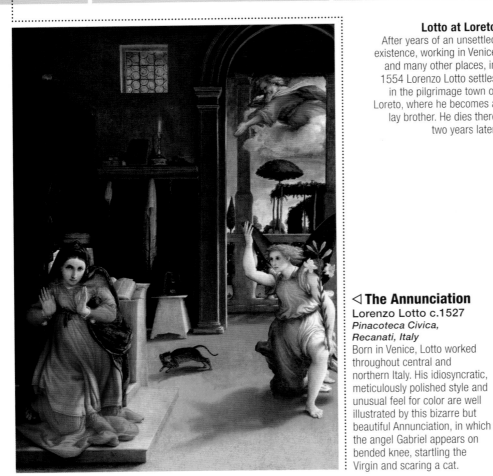

◁ The Annunciation
Lorenzo Lotto c.1527
Pinacoteca Civica, Recanati, Italy
Born in Venice, Lotto worked throughout central and northern Italy. His idiosyncratic, meticulously polished style and unusual feel for color are well illustrated by this bizarre but beautiful Annunciation, in which the angel Gabriel appears on bended knee, startling the Virgin and scaring a cat.

Parable of the Sower △
Jacopo Bassano c.1564 *Museo Thyssen-Bornemisza, Madrid, Spain*
Trained in Venice, but based around 40 miles (65km) away in the town of Bassano, Jacopo was renowned for paintings such as this. An everyday scene from rural life, it suggests rather than illustrates a biblical parable.

Mars and Venus United By Love ▷
Veronese c.1575
Metropolitan Museum of Art, New York, NY
In this splendidly sensuous mythological painting, one winged *putto* binds the gods Mars and Venus together, while another restrains Mars's horse. The painting suggests various themes, including the nurturing effects of love (Venus's breast milk) and the uniting of opposites. X-rays have revealed that Veronese made major alterations to the composition as he painted.

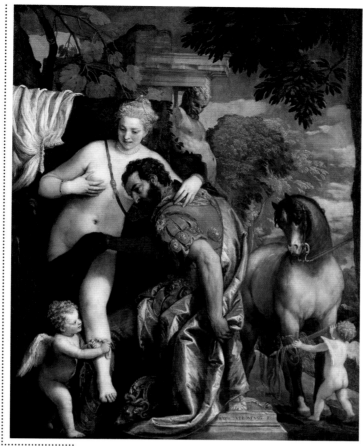

Veronese

born Verona, Italy, 1528?;
died Venice, Italy, April 19, 1588

Paolo Caliari's nickname Veronese derives from his birthplace, but he worked in Venice. Unlike his friend Tintoretto, whose paintings (*see below*) are characterized by religious intensity and dramatic light and shade, Veronese was a supreme colorist, and his sunlit paintings are concerned with pictorial beauty and decorative color. One of the greatest of all decorative artists, Veronese is renowned for his illusionistic works and his lively, large-scale paintings of biblical feasts, as well as for altarpieces, portraits, and mythological paintings. His gloriously confident decorative works inspired later Venetian artists, in particular Tiepolo (1696–1770).

BIOGRAPHY

THE **DRAWING OF MICHELANGELO** AND **THE COLORING OF TITIAN** 🙶

Tintoretto
Motto written on the artist's studio wall

1570 **1580** **1590** **1600**

Veronese interrogated
In 1573 Veronese is interrogated by the Inquisition for including figures such as a buffoon with a parrot in his work *The Last Supper*. Veronese famously replies that artists have "poetic license."

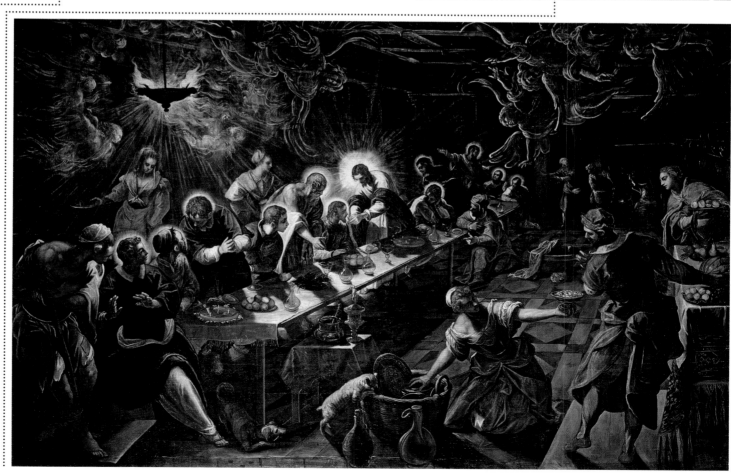

The Last Supper ▷
Tintoretto 1594
S. Giorgio Maggiore, Venice, Italy
Tintoretto completed this incandescent masterpiece in the year of his death. Typically, it features figures in complex poses, dramatic lighting, and an equally dramatic use of perspective created by angling the table so that it zooms into the dark depths of the picture.

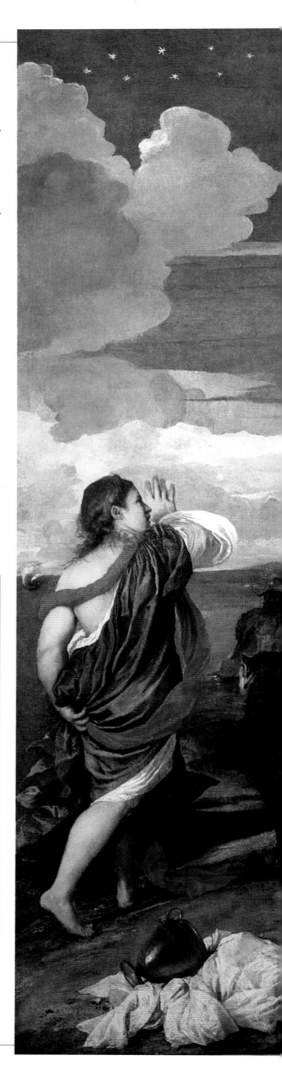

◎ MASTERWORK

Bacchus and Ariadne

Titian **1520–23**
National Gallery, London, UK

Titian's colorful masterpiece is one of three mythological works he painted for the study of Alfonso d'Este, Duke of Ferrara. Based on stories told by the Latin poets Ovid and Catullus, it depicts the first meeting of the wine god Bacchus and Ariadne. Daughter of King Minos, Ariadne had been abandoned by her lover Theseus on the island of Naxos (his ship sails away into the distance on the far left), when Bacchus and his noisy, drunken retinue burst upon her with a clash of cymbals. As the startled Ariadne turns to see the wine god leaping from his chariot, it is love at first sight. Bacchus and Ariadne gaze at each other across an expanse of blue, and Bacchus flings Ariadne's crown into the heavens, where she is immortalized as a glittering constellation in the sky at the top left of the composition.

The painting is packed full of energetic movement and sensuous color. Semi-naked figures turn, twist, and writhe, their poses originating from ancient sculpture—the foreground figure with the snakes clearly based on the *Laocoön* (*see p.104*). A strong diagonal cuts across the painting, emphasizing Bacchus's forward motion. Contrasting with the lush golds and greens of the landscape setting, a vast expanse of ultramarine blue dominates the top left of the painting. Ultramarine, made by grinding the mineral lapis lazuli, was then available only from Afghanistan. More costly than gold, it is used here with conspicuous extravagance and dramatic effect. Exploiting bold color contrasts, Titian sets the red of Ariadne's sweeping sash and the dazzling pink of Bacchus's billowing cloak against the blue.

 TITIAN IS **WORTHY OF BEING SERVED** BY **CAESAR**

Charles V
Holy Roman Emperor, supposed remark upon picking up a brush dropped by the artist

◎ Titian

born Pieve di Cadore, Italy, c.1480–85;
died Venice, Italy, August 27, 1576

Tiziano Vecello, better known as Titian, dominated Venetian art for 60 years and enjoyed the patronage of Europe's most powerful rulers, including Holy Roman Emperor Charles V and his son Philip II of Spain. He had his main training in the workshop of Giovanni Bellini, and came under the influence of another of Bellini's pupils, Giorgione. Titian revolutionized virtually every genre of painting from altarpieces to portraits, the nude, and classical mythologies, which included the *poesie*—painted "poems" he created for Philip II of Spain. He also explored and extended the possibilities of oil painting to develop a free and expressive style of broken brushwork that suggested rather than described form, which influenced artists from Rubens to Velázquez.

 BIOGRAPHY

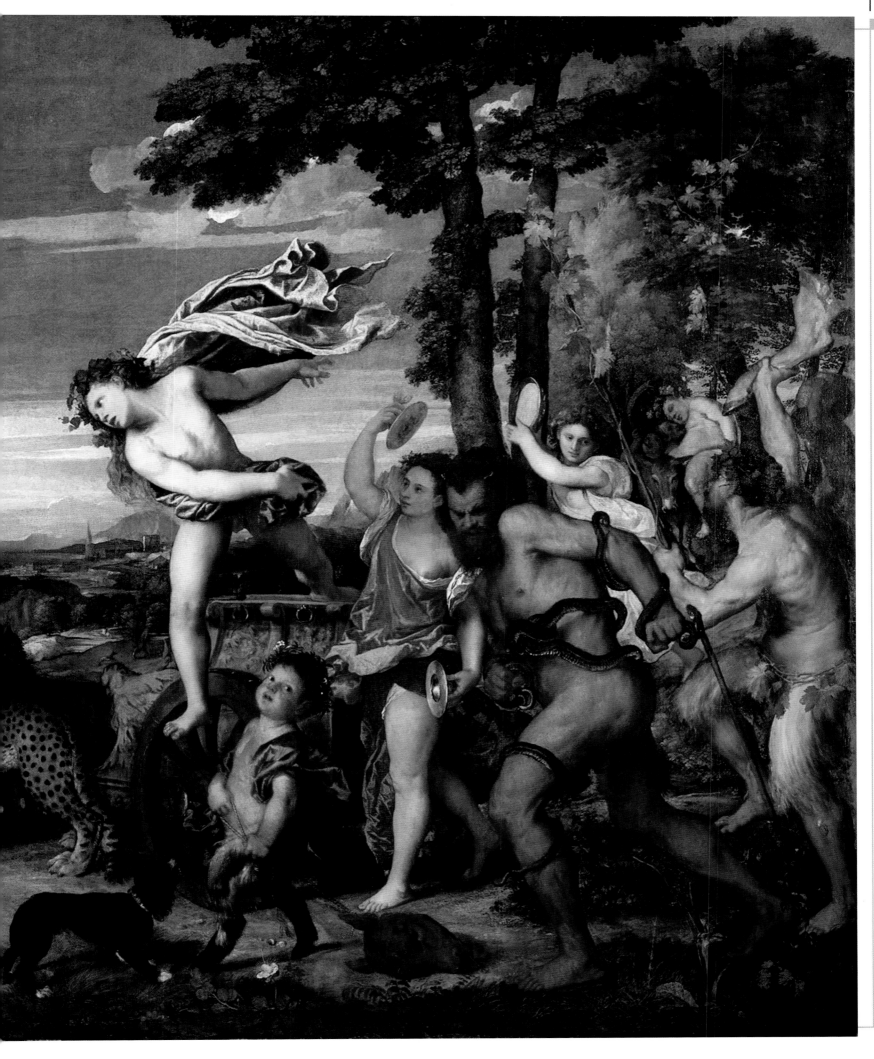

NORTHERN RENAISSANCE

▷ A Goldsmith in His Shop

Petrus Christus 1449
Metropolitan Museum of Art, New York City, NY
Painted for the Goldsmiths' Guild of Bruges, Christus's object-filled image reflects the material wealth of such mercantile cities, which underpinned artistic patronage. Its naturalistic rendering of textured and reflective surfaces—including a gleaming convex mirror— could only be achieved by using translucent glazes of oil paint.

The term Northern Renaissance refers to art that was produced over a wide area of northern Europe between about 1400 and 1580. It includes artists as diverse as Jan van Eyck, who worked mainly in Bruges, Albrecht Dürer from Nuremberg, and Hans Holbein, who was born in Germany, established his reputation in Switzerland, and painted his most celebrated works in England. Northern Renaissance artists shared their Italian contemporaries' drive toward an increasing naturalism. However, it was a naturalism characterized by minute attention to detail, based on fascination with the natural world and the individual, rather than on the revival of ancient art. The sometimes breathtakingly realistic detail of Northern Renaissance art is inextricably linked with advances in the oil painting technique in the 15th century: paintings such as Petrus Christus's *A Goldsmith in His Shop* (*above*) display a degree of illusionism that only became technically possible with oil paint.

◎ CONTEXT

Revolution and reform

Dramatic changes occurred at the time of the Northern Renaissance, as monarchs in northern Europe battled for power, and religious divisions tore through society. Europe consisted of a complex patchwork of competing territories, and trade routes facilitated commercial and cultural links between cities north and south of the Alps. Far from being a one-way flow of Renaissance ideas from Italy into northern Europe, a dynamic interchange took place between north and south.

One of the most significant developments was the rise of printmaking and printed books, which originated in Germany in the mid-15th century. Johann Gutenberg's invention of movable type, allied to the development of the printing press, led to one of the world's great technological revolutions. Printed books with woodcut illustrations transformed the way images and ideas could be spread and shared. Being able to make and sell multiple copies of their work could also transform artists' fortunes.

In the 16th century, the religious revolution known as the Protestant Reformation had a profound impact on art in northern Europe. Disillusioned with the worldliness of Catholic Church leaders, German priest and theologian Martin Luther developed a new doctrine based on the belief that salvation came from faith alone. His ideas spread throughout Germany and beyond, and Western Christendom was split in two. Many artists were affected by the turmoil. Grünewald had Lutheran sympathies—when he left his Catholic patron, his career was essentially finished. Holbein fared better—when Lutheran iconoclasts destroyed religious art in Basle, and patronage declined, he settled in England and became court artist for Henry VIII. As the market for altarpieces and paintings of saints dwindled in Protestant Europe, there was a rise in secular painting: genre scenes with moral rather than overtly religious subjects; landscapes; and portraits such as Holbein's *Ambassadors* (see pp.130–31), which refers discreetly to religion while advertising Renaissance achievements in scientific discovery and exploration.

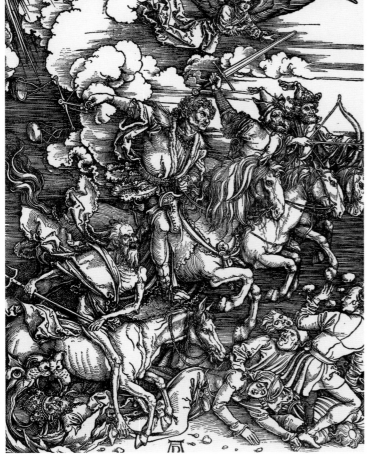

Printing revolution
Printmaking transformed the way images were made and viewed. The German artist Albrecht Dürer earned international renown through masterful prints, such as this woodcut *Four Horsemen of the Apocalypse*. It was published in 1498 in a set of 15 prints on the Apocalypse.

◎ A shifting political canvas

KEY EVENTS

▷ **1419** Philip III (Philip the Good) becomes Duke of Burgundy (until 1467), and ruler of Flanders, Brabant, Namur, and Limburg.

▷ **1453** The Hundred Years War between France and England ends. Printing of the Gutenberg Bible, the first full-length book ever produced with movable type, is in progress (it is completed by 1456).

▷ **1492** Christopher Columbus inadvertently discovers the Americas, having set out to find a route to the Far East.

▷ **1517** Martin Luther fixes his *Ninety-Five Theses*—a document in which he protests against the sale of Indulgences by the Catholic Church—to the door of a church in Wittenberg, Germany. This act marks the start of the Reformation and the birth of the Protestant faith.

▷ **1522** First acts of iconoclasm—the destruction of religious images—by Reformers in Wittenberg.

▷ **1534** Act of Supremacy establishes the Church of England, with Henry VIII as its head, marking the split from the Roman Catholic Church, and the start of the English Reformation.

❝ ART IS TRULY IN NATURE—HE WHO IS ABLE TO EXTRACT IT, POSSESSES IT ❞

Albrecht Dürer

◎ BEGINNINGS

FLEMISH NATURALISM

A new type of painting developed in 15th-century Flanders, the region (roughly equivalent to modern-day Belgium) also known as the Southern Netherlands. As Flemish artists moved away from the decorative extravagance of International Gothic, a natural-looking style evolved that blended realistic detail with spiritual symbolism. (The terms "Flemish" and "Netherlandish" tend to be used interchangably).

The founders of the Netherlandish School were the "Master of Flémalle" (probably Robert Campin) and Jan van Eyck. The Master of Flémalle's paintings display a powerful sense of physicality, while Van Eyck's mastery of the oil painting technique allowed him to achieve luminous, jewel-like colors and an extraordinary clarity akin to today's high-definition images. Van Eyck's successor in Bruges was Petrus Christus, but it was Rogier van der Weyden's combination of minutely observed naturalism and emotional expression that had the biggest influence on the development of Netherlandish art.

◎ TURNING POINT

The Arnolfini Portrait

Jan van Eyck **1434** *National Gallery, London, UK*

This celebrated double portrait shows a wealthy couple in a domestic interior, and may commemorate the marriage of the Italian merchant Giovanni di Nicolao Arnolfini and his wife. Scholars debate the painting's subject, and question the extent to which the meticulously painted objects have symbolic significance. However, all agree that this ravishing masterpiece displays an unprecedented level of realism and detail made possible by van Eyck's perfection of the oil painting technique.

◉ ARTISTIC INFLUENCES

Works by Flemish artists Sluter and Broederlam at a monastery in the Burgundian capital Dijon prefigured the robust realism of the Master of Flémalle. His detailed depiction of (often symbolic) objects and van Eyck's technical advances in oil painting became hallmarks of a new Flemish style.

Jan van Eyck

born c.1380/90;
died Bruges, Flanders, June 1441

The most famous of all Early Netherlandish artists, Jan van Eyck is now known through about two dozen paintings—religious works and portraits. His supreme skill in oil painting gained him renown north and south of the Alps. Little is known of his early life, but by 1422 he was working for the Count of Holland. Three years later, he became court painter to Philip the Good, Duke of Burgundy, in Bruges, with an official, salaried role. He remained in the Duke's service for the rest of his life, going on several diplomatic missions on his behalf. One of his earliest dated paintings, the *Ghent Altarpiece* of 1432, bears an inscription suggesting that this "stupendous painting" (as Dürer called it) was painted by both Jan and his brother Hubert (died 1426). However, Hubert is a shadowy figure, and his contribution to the painting is unknown.

BIOGRAPHY

Sculptor Claus Sluter developed a naturalistic style that was new to northern European sculpture: he seems to have influenced the paintings of the Early Netherlandish painter the Master of Flémalle.

The Well of Moses, detail, 1395–1403, by Claus Sluter features highly individualized, realistic portraits of six prophets. *Chartreuse de Champmol, Dijon, France*

Naturalism is evident in Melchior Broederlam's *Dijon Altarpiece*. The painting includes naturalistic touches, notably a peasant Joseph, that look forward to the realism of the Netherlandish school.

St. Joseph, detail, 1394–95, by Broederlam from the *Dijon Altarpiece*, created for the Chartreuse de Champmol. *Musée des Beaux-Arts, Dijon, France*

Symbolic objects became a feature of 15th-century Netherlandish art. The three blossoms of this lily symbolize Mary's virginity before the Annunciation, after conception, and perpetually after Christ's birth.

Lily, detail, c.1425–30 from the *Mérode Altarpiece*, workshop of the Master of Flémalle. *Metropolitan Museum of Art, New York City, NY*

Oil painting transformed art in the Netherlands. Van Eyck perfected the use of layers of transparent glazes to create luminous, illusionistic effects, brilliant colors, and an enamel-like finish.

Thamar Painting, c.1403 from *De Claris Mulieribus*, shows an artist's assistant grinding pigment into oil with a muller. *Bibliothèque Nationale, Paris, France*

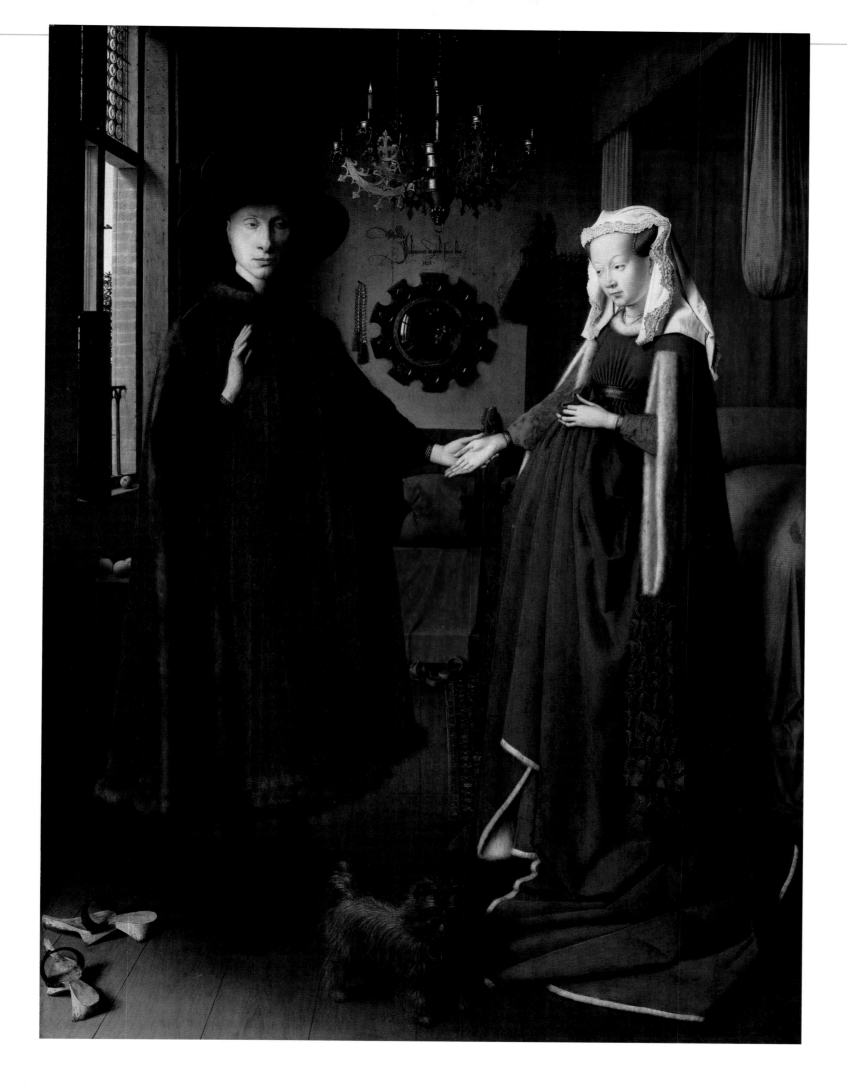

◎ TIMELINE

The Northern Renaissance emerged in the 15th century in the Netherlands, with the pioneering works of van Eyck, the Master of Flémalle, and van der Weyden. In the 16th century this early Flemish style evolved into what could be termed the flowering of the Northern Renaissance. German artists—such as Dürer and Grünewald—and a new generation of Netherlandish artists—such as Bosch and Bruegel—developed fresh styles and subjects, including landscapes and scenes from everyday life.

The Mérode Altarpiece ▽
Master of Flémalle/Robert Campin (workshop of)
c.1427–32 *Metropolitan Museum of Art, New York City, NY*
In this famous triptych the Annunciation occurs in a Flemish domestic interior. The donors may have bought the central Annunciation painting, then commissioned two side panels, in the left of which they appear. Many objects have symbolic significance: the mousetrap in Joseph's workshop symbolizes Christ's incarnation as a snare for the devil.

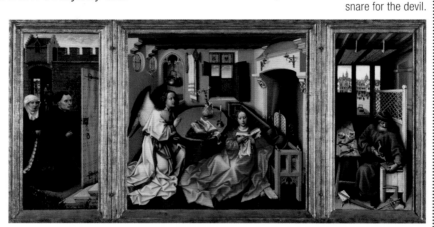

Citizen of Tournai
In 1410, the artist Robert Campin purchases citizenship in Tournai, suggesting he was born elsewhere. *The Entombment* attributed to him dates from around this time. It combines a medieval gold background with realistic, sculptural figures influenced by the sculptor Claus Sluter.

| 1410 | 1415 | 1420 | 1425 | 1430 |

Van Eyck in The Hague
The first record of Jan van Eyck is in August 1422, when documents describe him as a master with an assistant, working at the court of John of Bavaria, Count of Holland, in The Hague.

BIOGRAPHY

◎ Rogier van der Weyden

born Tournai, Flanders, 1399?;
died Brussels, Flanders, June 18, 1464

The greatest Netherlandish artist of the mid-15th century, Rogier van der Weyden was born Rogier de la Pasture ("Roger of the Meadow"), but is known by the Dutch version of his name. The son of a cutler, he was apprenticed to Robert Campin in Tournai. By 1435, he had moved to Brussels, and in 1436 he was appointed official painter to the city. He painted portraits and religious subjects, and ran a thriving workshop. After van Eyck's death in 1444, he became the leading painter at the court of Philip the Good. His fame spread through France, Germany, Italy, and Spain, and his naturalistic, emotionally sensitive style had a huge influence on European painting.

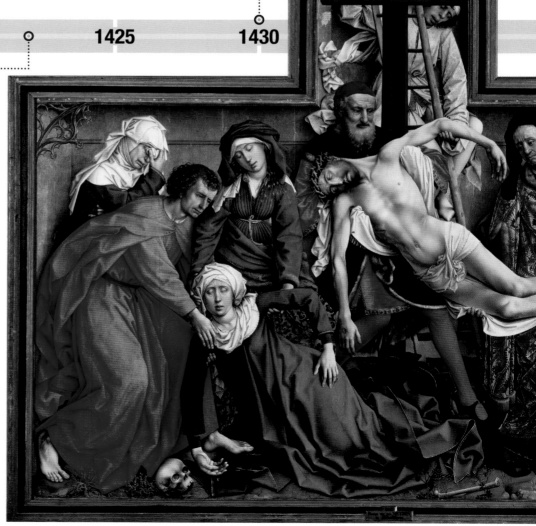

Etienne Chevalier and St. Stephen (Melun Diptych) ▽

Jean Fouquet, c.1455–60 *Gemäldegalerie, Berlin, Germany*
This panel originally formed a diptych with the Virgin and Child (*right*). Fouquet, painter to King Charles VII of France, depicts the King's treasurer and his name saint in a realistic, perspectival space.

◁ Virgin and Child (Melun Diptych)

Jean Fouquet c.1455–60
Koninklijk Museum, Antwerp, Belgium
While the donor and his saint are in a precisely realized Italianate interior, the Virgin and Child are in an unrealistic, heavenly space, surrounded by blue and red cherubim and seraphim. The unnaturally smooth, white, bare-breasted Virgin, dressed as a fashionable queen, is modeled on the King's mistress Agnès Sorel, who died in 1450.

Courtly commission

Between 1450 and 1460 Jean Fouquet illuminates a Book of Hours for Etienne Chevalier, his most important patron at the court of Charles VII.

1435 1440 1445 1450 1455 1460 ▶

❝❝ FLEMISH PAINTING WILL, GENERALLY SPEAKING, **PLEASE THE DEVOUT** BETTER THAN **ANY PAINTING IN ITALY** ❞❞

1548 | Michelangelo
Quoted by Francesco da Holanda, Portuguese painter

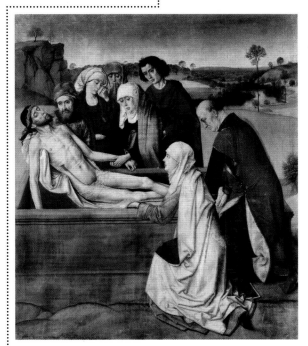

◁ Descent From the Cross

Rogier van der Weyden c.1440 *Prado, Madrid, Spain*
Imitating the sculpted altarpieces popular in Netherlandish churches, Rogier crams his almost life-size figures into a shallow, boxlike space, heightening the emotional intensity created by the anguished expressions and contorted poses. Made for the Crossbowmen's Guild in Louvain, this meticulous masterpiece features tiny crossbows in the painted tracery, and evokes the crossbow's shape in the poses of Christ and Mary.

△ The Entombment

Dirk Bouts c.1450s
National Gallery, London, UK
The subtle, muted colors of this poignant image result from the technique of applying pigments mixed with glue directly on to linen. It may have been painted for export to Italy—the linen support could be rolled and easily transported.

◎ Hieronymus Bosch

born 's-Hertogenbosch?,
Netherlands, c.1450 **buried**
's-Hertogenbosch, August 9, 1516

Born Jerome van Aken, Hieronymous
(Latin for Jerome) Bosch (after
's-Hertogenbosch) created some of
the most intriguing images in the
history of art. He lived in a town
that was far away from mainstream
Netherlandish painting, and developed
a uniquely imaginative style, depicting
the consequences of sin and folly
with fantastical, often grotesque
imagery. Little is known about his life,
except that he was wealthy, an
orthodox Catholic, and a leading
member of a religious organization
called the Brotherhood of Our Lady.

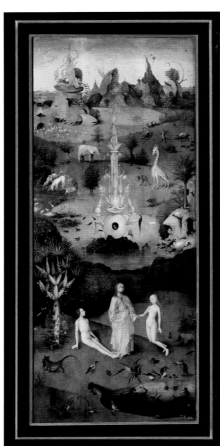
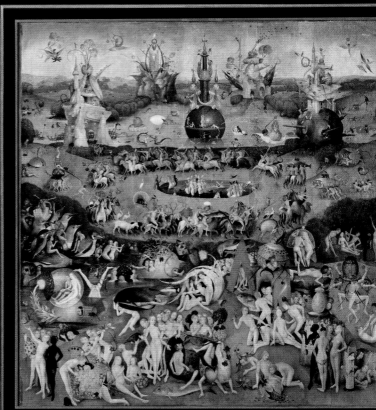

From Ghent to Bruges
In 1468, a year after Hugo
van der Goes becomes a
master in the Ghent Painters'
Guild, he assists with the
wedding decorations of
Charles the Bold in Bruges.

1460	**1470**	**1480**	**1490**

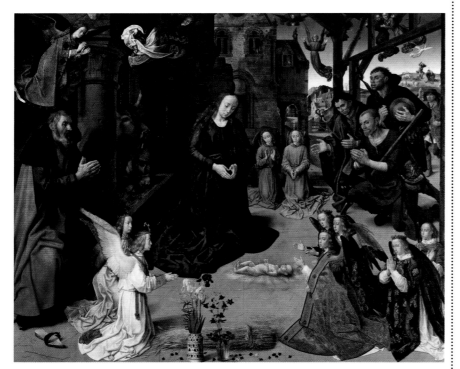

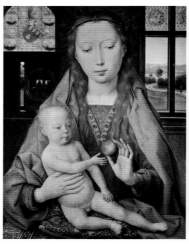
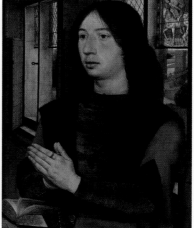

Diptych of Maarten van Nieuwenhove △
Hans Memling 1487
Sint-Janshospitaal, Memlingmuseum, Bruges, Belgium
The most popular Netherlandish painter of his day, Memling
may have been taught by Rogier van der Weyden. This quiet
devotional diptych shows the Virgin and the praying donor
in separate panels, but in the same room—both
figures are reflected in the mirror behind her.

Pontinari Altarpiece (central panel) △
Hugo van der Goes c.1475 *Uffizi, Florence, Italy*
Commissioned by Tommaso Pontinari, representative of the Medici bank in
Bruges, this altarpiece was installed in a hospital church in Florence. Its
meticulous naturalism influenced Florentine artists. Weather-beaten shepherds
gaze in awe at the infant Christ, while vases of flowers symbolize Christ's sacrifice
(red carnations representing the bloodied nails of the cross, for example).

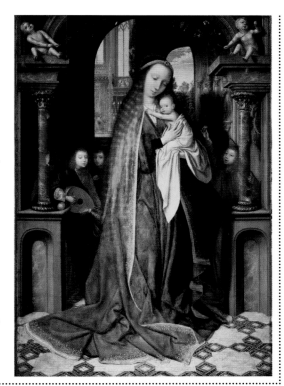

◁ The Garden of Earthly Delights
Hieronymus Bosch c.1500
Prado, Madrid, Spain
Despite its triptych format, which was traditional for altarpieces, this large painting was intended not for a church, but for an aristocrat's palace. In the left panel, God creates Adam and Eve in Eden; the landscape continues into the central panel (perhaps depicting a false paradise), where naked men and women cavort amid bizarre plants, huge birds, and fantasy fruit; in the right panel, sinners are punished with gruesome tortures in a monstrous vision of Hell.

> A **PAINTED SATIRE** ON THE **SINS** AND **RAVINGS** OF MANKIND

1605 | José de Sigüenza
Spanish monk, on Bosch's paintings

◁ The Madonna Standing With the Child and Angels
Quentin Massys c.1500–10
Courtauld Gallery, London, UK
A leading painter in Antwerp, Massys may have visited Italy. This exquisite Madonna is in the Netherlandish tradition, but the classical architecture and *putti* with garlands indicate a knowledge of Italian art.

Dürer acclaimed abroad
In 1520–21, Dürer journeys north to Aachen for the coronation of Charles V, the Holy Roman Emperor. Traveling through the Netherlands, he is feted as the greatest German artist of his time.

1500 **1510** **1520**

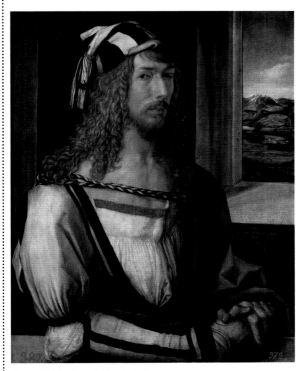

△ Self-Portrait With Gloves
Albrecht Dürer 1498
Prado, Madrid, Spain
This is one of a number of self-portraits by Dürer. One of the giants of the Northern Renaissance, he was determined to elevate the status of artists, and depicts himself as an elegant gentleman.

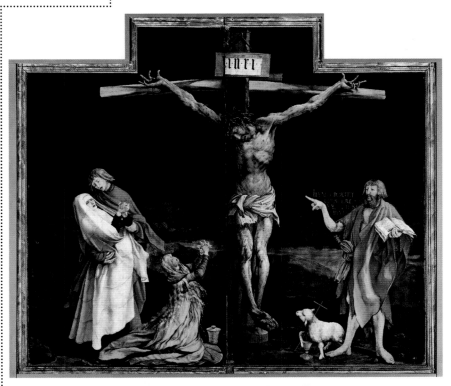

△ Crucifixion (Isenheim Altarpiece, central panel)
Mathis Grünewald c.1512–15
Musée d'Unterlinden, Colmar, France
German painter Mathis Grünewald painted this harrowing altarpiece for a plague hospital. By showing the suffering Christ in horrific detail, he hoped to inspire patients to view their own terrible suffering as part of a divine plan.

Joachim Patinir

born Dinant or Bouvignes?, Flanders, c.1480;
died Antwerp, Flanders, 1524

Patinir was the first European artist to give landscape priority over figures in a painting. He is thought to have come from the Meuse valley, in an area with a rocky landscape unusual in Flanders. It evidently inspired his works. A member of the Painters' Guild in Antwerp, he was held in high esteem by his contemporaries, including Dürer. He sometimes painted landscape backgrounds for his friend Quentin Massys (who became guardian of his children after his death).

Death and the Maiden ▷
Hans Baldung Grien
c.1520–25 *Kunstmuseum, Basle, Switzerland*

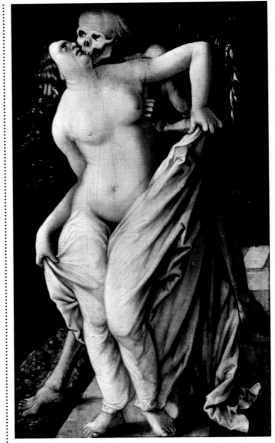

Baldung was probably a pupil of Dürer. His paintings and prints included a variety of subjects, but he is best known for macabre, erotic allegories involving witches or young women being embraced by Death. The inevitability of death was a preoccupation of many Northern Renaissance artists.

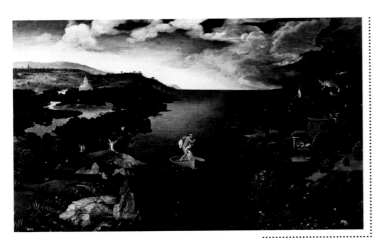

◁ Charon Crossing the Styx
Joachim Patinir c.1515–24
Prado, Madrid, Spain

In classical legend, Charon ferried souls of the dead to the underworld. Placing Charon in a panoramic landscape, midway between Paradise and Hell, Patinir transforms pagan myth into a Christian allegory about the choice between good and evil. Bosch's influence is evident in the visions of Paradise and Hell.

1520 **1525** **1530** **1535** **1540**

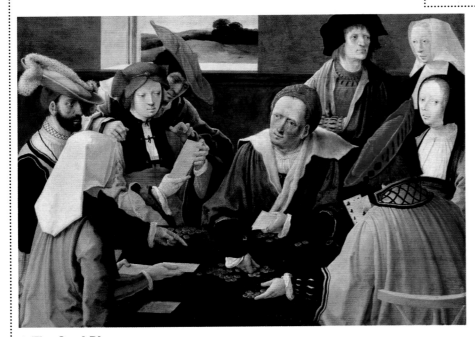

△ The Card Players
Lucas van Leyden c.1517
Wilton House, Wiltshire, UK

A renowned printmaker, Lucas was also a pioneer of genre paintings, such as this. Probably intended as a moralizing message about the ills of gambling, the scene is presented as if the viewer is at the card table.

The Battle of Issus ▷
Albrecht Altdorfer 1529
Alte Pinakothek, Munich, Germany

This spectacular battle scene, depicting one of Alexander the Great's victories, has a visionary power. Altdorfer achieves an extraordinary sense of space as the landscape stretches into the blue distance, and teeming hordes fight beneath a dazzling sunset.

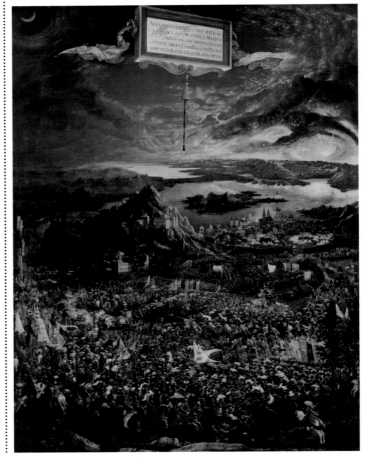

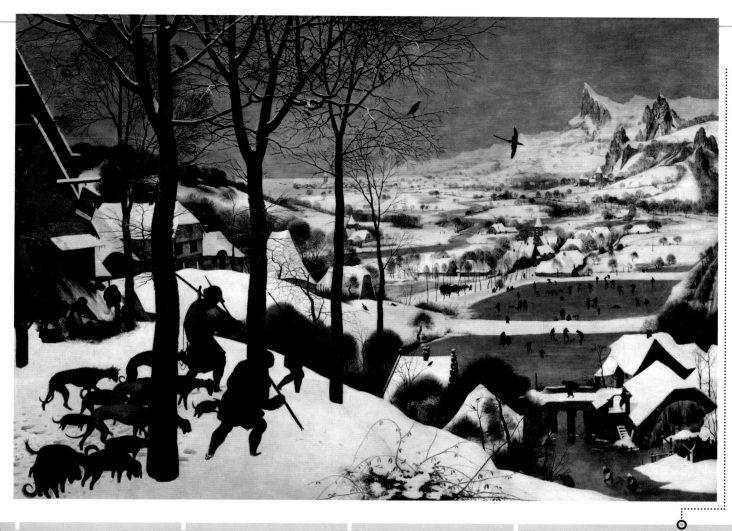

◁ **Hunters in the Snow**
Pieter Bruegel 1565
Kunsthistorisches Museum, Vienna, Austria
One of a series of six paintings of The Months, this extraordinarily skillful composition is a monumental version of the type of scene that appeared in medieval Books of Hours. As hunters trudge through the snow, bold diagonals lead across and into the painting toward icy ponds and distant Alpine mountains.

1545	1550	◉ 1555	1560	1565	◉ 1570

Pieter Bruegel (the Elder)

born nr. Breda?, Netherlands, c.1525;
died Brussels, Flanders, 1569

BIOGRAPHY

The greatest northern European artist of his time, Pieter Bruegel the Elder was a painter, draftsman, and printmaker whose lively, humane scenes of rural life (often illustrating proverbs) earned him the name "Peasant Bruegel." Despite his nickname, Bruegel spent his career in cities rather than the countryside. He visited Italy early in his career, and the experience of crossing the Alps stayed with him. His style changed significantly after moving from Antwerp to Brussels in 1563: busily crowded scenes were replaced by bold, monumental figures and powerful landscape settings.

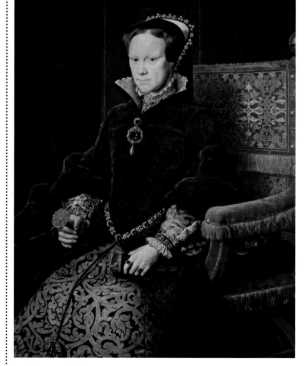

△ **Queen Mary I**
Anthonis Mor 1554 *Prado, Madrid, Spain*
Daughter of Henry VIII of England, Mary married Philip II of Spain the year this picture was painted. Mor combines regal dignity with a sense of human vulnerability: Mary sits stiffly as she turns toward the viewer, clutching a bright red Tudor rose.

Lutheranism made legal
In 1555, the Peace of Augsburg gives official recognition of Lutheranism as well as Roman Catholicism in Germany.

Bruegel dies
Pieter Bruegel dies in 1569, leaving two young sons, Jan and Pieter the Younger, who go on to become successful painters.

❝❝ WHEN HE **TRAVELED THROUGH THE ALPS…** [BRUEGEL] **SWALLOWED** ALL THE **MOUNTAINS…** AND **SPAT THEM OUT…** ON HIS **CANVASES AND PANELS** ❞❞

1604 | Karel van Mander

◎ MASTERWORK

The Ambassadors

Hans Holbein the Younger **1533**
National Gallery, London, UK

One of the earliest portraits depicting two life-size figures, this magnificent painting combines startling realism with an equally startling hidden message. The painting was commissioned by Jean de Dinteville, a French nobleman and ambassador in London. He is shown with his friend, Georges de Selves, the Bishop of Lavour, a classical scholar and diplomat, who visited him in London in the spring of 1533.

The two men stand either side of a tabletop display of immaculately painted objects signifying their learning and culture. The cylindrical dial indicates the date: April 11, 1533. The sitters' ages are recorded: Jean de Dinteville's inscribed dagger indicates that he is in his 29th year; Georges de Selve's age—25—is written on the book on which he leans his elbow. It is a moment frozen in time, when the men are shown at the height of their powers.

There are layers of meaning in this complex portrait. The terrestrial globe on the bottom shelf represents science and exploration, but also bears the name of Jean de Dinteville's chateau in France, where the picture was to hang. The lute is a symbol of music, but its broken string may signify death or the religious discord of the Reformation.

Although the painting may appear to be a glorification of man's achievements, it takes on another meaning when the distorted shape hovering over the pavement is recognized. It is a skull, painted in what is known as anamorphic perspective: only when viewed obliquely from the right does it assume its recognizable form. This reveals the painting as a *memento mori*—a reminder that whatever man's worldly achievements, we all must die. But there is yet another layer of meaning: almost hidden in the top left corner, a crucifix affirms that after death, salvation comes through Christ.

> ## IF YOU ADDED THE VOICE, THIS WOULD BE HIS VERY SELF. YOU WOULD DOUBT WHETHER THE PAINTER OR HIS FATHER MADE HIM

1533 | Hans Holbein
Inscription on his portrait Derich Born, *stressing how lifelike his portraiture appears*

Hans Holbein (the Younger)

born Augsburg, Germany, 1497
died London, England, October/November 1543

The son of a successful German artist, Holbein began his career in Basle, Switzerland, working mainly as a portraitist and designer of woodcuts and stained glass. In 1524, he visited France, where he would have seen works by Raphael. Two years later, armed with a letter of introduction from the great humanist scholar Erasmus—who noted that in Basle "the arts are not appreciated"—Holbein traveled to England, where he worked mainly as a portraitist for the statesman Sir Thomas More and his circle. In 1528, Holbein returned to Basle (where he had left his wife and family), but in 1532 he went back to England for good. Holbein was the supreme portrait painter of his time, and soon gained royal patronage, probably with the help of Henry VIII's chief minister Thomas Cromwell.

BIOGRAPHY

ITALIAN MANNERISM

c.1520–1600 "THE STYLISH STYLE"

Mannerism is a term applied to the style that flourished in the 16th century between the High Renaissance and the Baroque. It has been seen as both a rejection and a refinement of the ideals of the High Renaissance. The label derives from the word *maniera*, meaning "style" or "stylishness," which Giorgio Vasari used at the time to describe the sophisticated grace of contemporary art. But by the 18th century, the term Mannerism (*manierismo*) was being used in a pejorative sense, to describe art perceived as decadent and affected—an over-stylish decline from the balance and grandeur of the High Renaissance. Inspired by the late works of Michelangelo and Raphael, Italian Mannerist artists played with the formal language of the High Renaissance to create a deliberately artificial style, featuring elegantly elongated figures, decorative, unnatural colors, and difficult, twisting poses. Bronzino's *Portrait of Lodovico Capponi* (*above left*), with its elegant lines; acidic color; and unsettling, claustrophobic sense of space, is a striking example of the refined beauty of the best Mannerist art.

◎ CONTEXT

Crisis or confidence?

The "stylish style" that later became known as Mannerism first appeared in the work of artists in Rome and Florence. Some historians have suggested that the move away from the harmonious equilibrium of High Renaissance art toward the agitated complexities seen in many Mannerist compositions reflects a kind of neurotic response to the uncertainties of the 16th century. However, an alternative viewpoint is that Mannerism was an expression of confidence rather than crisis: authoritative confidence was undoubtedly a hallmark of Cosimo de' Medici's autocratic court in Florence, where Bronzino and Vasari were leading lights.

In the early 16th century, Europe was split in two by the Reformation, which was triggered in 1517 by Martin Luther's protest against the Pope's sale of Indulgences. The Sack of Rome in 1527, when the troops of Holy Roman Emperor Charles V slaughtered thousands in the city, was seen by many as divine punishment. Spanish power (Charles V was also king of Spain) now extended over large areas of Italy. Not only was the position of Italy in the world changing, but the belief that the Earth itself—and by extension humankind—was the center of God's universe was being challenged by astronomer Nicolaus Copernicus's revolutionary theory that the planets circled the Sun. Other theological changes were ushered in after 1545, when the Council of Trent met for the first time to formulate the Catholic Church's reaction to the Protestant Reformation: this response, known as the Counter-Reformation, led to strict censorship of religious art.

While some art historians have held the view that these religious and cultural crises are reflected in the unsettling stylistic characteristics of Mannerist art, others see the elegant exaggerations of Mannerism as an expression of self-conscious sophistication. Contemporary literature indicates that elaborate displays of wit and artifice were highly valued in cultured society—as they were in Mannerist art. This was also a time when patrons were appreciating works of art as first and foremost works of art—to be displayed and enjoyed in a gallery. This may be linked to the confident—indeed, often overconfident—virtuoso artfulness of Mannerist paintings.

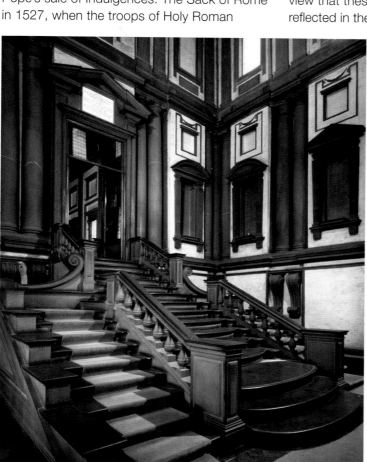

Mannerist rule breaking
Michelangelo's revolutionary design for the vestibule of the Laurentian Library in Florence replaces High Renaissance harmony with an unsettling, stylish severity: architectural elements are modified, proportions are squeezed, and giant brackets support nothing, instead appearing to hang from a molding.

KEY EVENTS

Shifting world views

▷ **1522** Following the death of the Medici Pope Leo X (a lavish art patron), Adrian VI is elected Pope. A Dutch theologian and the only Renaissance pope to come from Northern Europe, he curbed papal expenditure—including that on art.

▷ **1523** After Adrian VI dies, Cardinal Giulio de' Medici is elected Pope. As Clement VII, he revives papal patronage. He commissions Michelangelo to design the Laurentian Library in Florence to house the books of his uncle Lorenzo the Magnificent.

▷ **1543** Nicolaus Copernicus's *On the Revolutions of the Celestial Spheres* is published. The idea that the Earth was not the center of God's universe had profound religious implications.

▷ **1545** Catholic authorities meet for the first time at the Council of Trent, marking the start of the Counter-Reformation. The Council sits intermittently until 1563.

▷ **1550** The first edition of Giorgio Vasari's *Lives of the Most Eminent Italian Architects, Painters, and Sculptors* is published.

▷ **1563** Vasari, Bronzino, and others set up the first formal art academy, the Accademia del Disegno in Florence.

 THIS '**STYLISH STYLE**' HAD ITS **ROOTS DEEP** IN THE **HIGH RENAISSANCE** 🙷

1967 | John Shearman
British art historian

◎ BEGINNINGS
PAINTING AFTER PERFECTION

Around 1520, the year in which Raphael died, there was a feeling that art in Italy had reached its peak, and that the artists of the High Renaissance had achieved all there was to achieve in terms of beauty, harmony, and technical accomplishment. This could present artists with a potential quandary: how do you progress from a point of perfection? However, art cannot stand still, and the beginnings of Mannerism are evident in the mature work of the High Renaissance masters Raphael and Michelangelo. The artifice and theatricality of Raphael's late works, and the deliberate difficulty of the contorted poses in which Michelangelo painted his nudes, inspired the next generation of artists. They used the same classical-inspired forms that feature in Renaissance art, but pushed the boundaries of artful invention and broke the classical rules—replacing balance with imbalance and complexity, and rejecting compositional coherence in favor of distortions in scale and perspective, often creating an unsettling sense of space.

Pontormo

born Pontormo, nr. Empoli, Italy, May 26, 1494;
died Florence, Italy, December 31, 1556

Jacopo Carucci, known as Pontormo after his birthplace in Tuscany, was a pioneer of Mannerist painting. According to Vasari, he trained with a number of High Renaissance artists including Leonardo da Vinci and Andrea del Sarto. He had a precocious talent, and early in his career he broke away from the classicism of his teachers to create a new, distinctive style that seemed to reflect his neurotic nature. Vasari described him as "solitary beyond belief," and his diaries reveal him to have had an anxiously obsessive personality. Although his style was very personal and original, it was influenced by both Michelangelo and the prints of Albrecht Dürer. Pontormo spent almost all his working life in Florence, painting mainly religious works and some portraits. Although only nine years older than his pupil Agnolo Bronzino, he became like a father to him.

BIOGRAPHY

◉ ARTISTIC INFLUENCES

Mannerism emerged from the High Renaissance art of Michelangelo and Raphael, and like these great masters, Mannerist painters drew their inspiration ultimately from classical art. However, the characteristics of Mannerist paintings—exaggerated poses, elongated limbs, unnatural colors, artificiality, strangeness, and illogicality—reflect a drive to refine and experiment with these artistic influences in pursuit of a new sense of style.

Michelangelo influenced Mannerism in terms of both form and color. His difficult-to-draw *contrapposto* (twisting) poses—particularly in his male nudes—and his decorative, opalescent colors were emulated by Mannerist artists.

Delphic Sibyl, 1509, shows Michelangelo's mastery of complex poses, and his striking use of vivid colors. *Sistine Chapel Ceiling, Vatican*

In Raphael's late works, his refined figures look forward to Mannerism in their increasing sense of stylish artificiality. This elegant image of St. Michael slaying the dragon has a brittle poise and almost metallic smoothness.

The Archangel Michael Vanquishing Satan, 1518, by Raphael, was painted as a present from Pope Leo X to Francis I. *Louvre, Paris, France*

Elegant hands, which are characteristic of High Renaissance art, were adopted and exaggerated by Mannerist painters. This study is by Andrea del Sarto, who trained and influenced Mannerist artists Pontormo, Vasari, and probably Rosso Fiorentino.

Study of Hands, c.1510–30, by Andrea del Sarto, one of the finest draftsmen of the Renaissance. *Uffizi, Florence, Italy*

Antique sculpture continued to be a source of inspiration to Mannerist artists, as it had been throughout the Renaissance. Pontormo's painting refers to a classical relief sculpture of the dead Meleager, a hero from Greek mythology.

Death of Meleager, c.200 CE. The figure supporting Meleager's legs is echoed in Pontormo's crouching disciple. *Doria-Pamphily Collection, Rome, Italy*

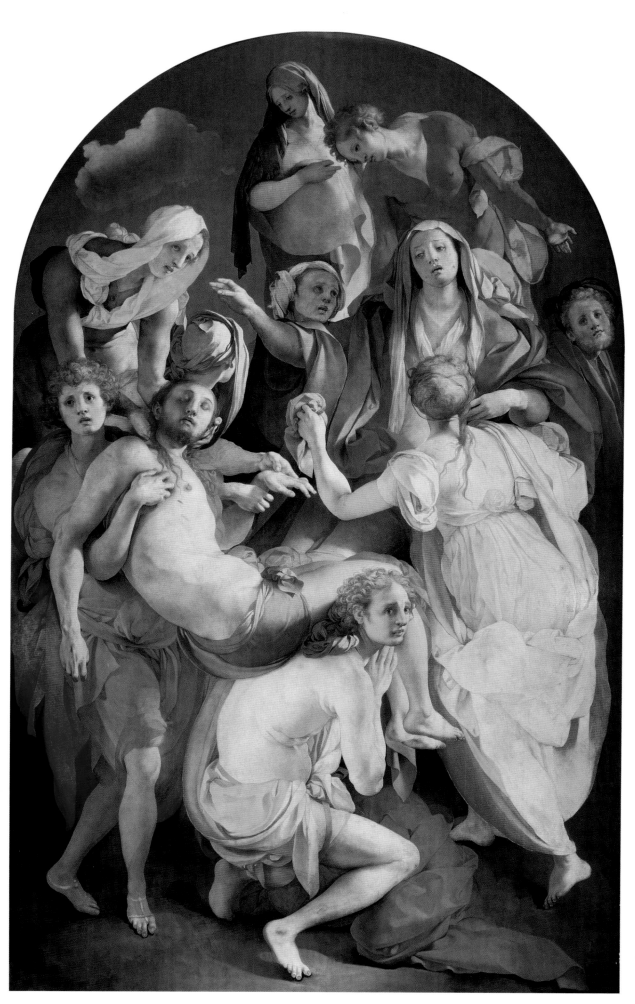

◉ TURNING POINT

The Deposition of Christ

Pontormo c.1525–28 *Capponi Chapel of S. Felicità, Florence, Italy*

This achingly beautiful image of the crucified body of Christ being borne away from his mother marks a radical departure from the serene equilibrium of High Renaissance painting. Although the painting is often known as *The Entombment*, there is no tomb visible: Pontormo paints a moment never previously depicted, when Christ's body is lifted away from his mother, who swoons with grief. Her empty lap is at the center of the fluid, deliberately unstable composition. Doing away with the logical, mathematical perspective and subtly shaded modeling of his High Renaissance masters, Pontormo presses his figures into a harshly lit, crumpled, unmeasurable space. Elegantly awkward poses and distortions, lurid lighting, and unearthly colors heighten both the painting's sense of artifice and its unnerving emotional effect.

> **HAVING PAINTED IT IN HIS OWN WAY**...IT WAS **FINALLY UNCOVERED** AND SEEN WITH **ASTONISHMENT** BY **ALL OF FLORENCE**

1568 | Giorgio Vasari
On Pontormo's
The Deposition of Christ

⊚ TIMELINE

The characteristics of Mannerism emerged in the works of Raphael and Michelangelo, as the calm balance of the High Renaissance was replaced by theatricality and exaggerated poses. From the 1520s, Italian artists developed these aspects, and an artificial "stylish style" evolved. Refinements and exaggeration led to elegance, but also to excess, when heroic poses were at times trivialized into empty posturing. Toward the end of the century a more emotionally direct and powerful energy emerged in works by painters such as Barocci.

The Marriage of the Virgin ▽
Rosso Fiorentino 1523
S. Lorenzo, Florence, Italy
Rosso created this sophisticated, elegant painting for the Medici parish church of San Lorenzo. He left Florence for Rome the year he painted it, later moving to Fontainebleau, where he established the French Mannerist school.

1515 ○ **1520** ○ **1525** ○

End of an era
The Sack of Rome in 1527 has a devastating impact on art and artists, ending the optimistic confidence that underpinned High Renaissance art and temporarily bringing to a halt Rome's preeminence as an art center.

> **ALL LASCIVIOUSNESS** MUST BE **AVOIDED**, SO THAT IMAGES SHALL NOT BE **PAINTED** OR **ADORNED** WITH A **SEDUCTIVE CHARM** 〝

1563 | Decree of the Council of Trent

◁ The Transfiguration
Raphael 1518–20 *Pinacoteca, Vatican*
Raphael was working on this great altarpiece when he died. Its agitated theatricality, particularly in the lower scene involving the healing of the possessed boy, differs from the serenity and balance of his earlier work. The exaggerated gestures, disjointed poses, and unharmonious lighting show Raphael moving away from the ideal art of the High Renaissance toward a Mannerist style.

Last Judgment ▷
Michelangelo 1536–41
Sistine Chapel, Vatican
Completed almost three decades after the Sistine Chapel ceiling (and, significantly, after the Sack of Rome), Michelangelo's powerful, pessimistic *Last Judgment* contrasts in both mood and style from the ceiling's calm, heroic grandeur. Bands of massive figures in all manner of contorted poses writhe and tumble in non-naturalistic space. Considered obscene by the Council of Trent, the nudes' genitalia were painted over with folds of drapery.

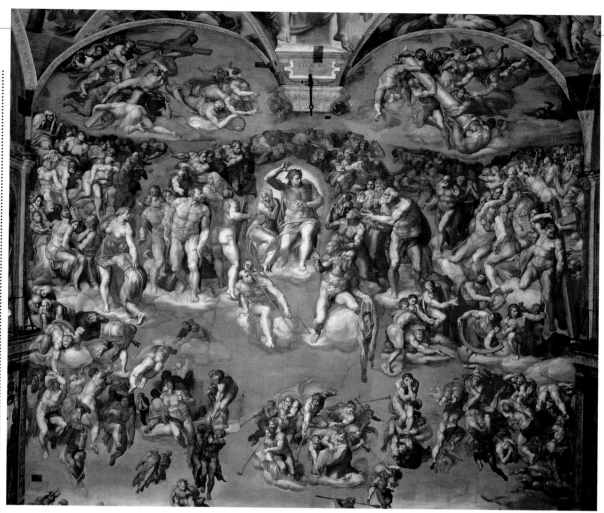

Michelangelo returns to Rome
In 1534, Michelangelo returns from Florence to settle in Rome for good. He is commissioned by Pope Paul III to paint the *Last Judgment* on the altar wall of the Sistine Chapel.

1530	1535	1540	1545	1550	1555	1560 ▶

△ Sala dei Giganti (Room of the Giants)
Guilio Romano c.1530
Palazzo del Tè, Mantua, Italy
One of the most confidently ingenious manifestations of Mannerism is the "Room of the Giants" in Mantua. In an overpowering, illusionistic tour de force, Giulio Romano covered walls and ceiling with scenes depicting the Titans' vain attempt to overthrow the gods of Olympus.

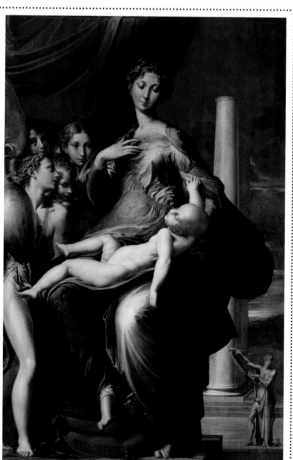

The Odyssey △
Pellegrino Tibaldi c.1555 *Palazzo Poggi (now the University), Bologna, Italy*
Tibaldi's narrative fresco cycle illustrates the adventures of Ulysses. The figures adopt athletic *contrapposto* poses, but Tibaldi leavens the grandeur with a stylish sense of humor.

◁ Madonna of the Long Neck
Parmigianino 1534–40 *Uffizi, Florence, Italy*
The artificial beauty that characterizes Mannerism is well illustrated in this celebrated painting. The Madonna's elongated neck echoes the column behind her, while her body twists into a sinuous, serpentine curve.

▽ Portrait of Don Gabriel de la Cueva y Giron

Giovanni Battista Moroni, 1560
Gemäldegalerie, Berlin, Germany
With its austere, enclosed classical setting and sharply drawn, flattened silhouette, this portrait by the northern Italian artist Moroni creates a refined but unsettling effect typical of Mannerist portraiture. The fashionable Spanish nobleman turns to the viewer with almost sneering aristocratic hauteur.

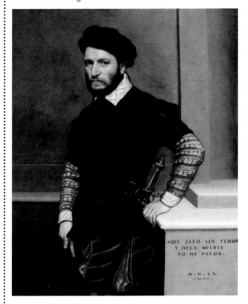

St. Luke Painting ▷ the Virgin

Giorgio Vasari c.1570
SS. Annunziata, Florence, Italy
Vasari includes a self-portrait as St. Luke—the patron saint of painters—in this traditional devotional subject. Despite being a leading figure in Mannerist art, Vasari is not now regarded as a great painter. Though indebted to his hero Michelangelo, this fresco is "mannered" in an overblown, affected way.

Grand Duke Cosimo

Cosimo de' Medici, Duke of Florence, is raised to the rank of Grand Duke of Tuscany in 1569; he is now a sovereign, one rank below royalty—and Florence is a sovereign territory.

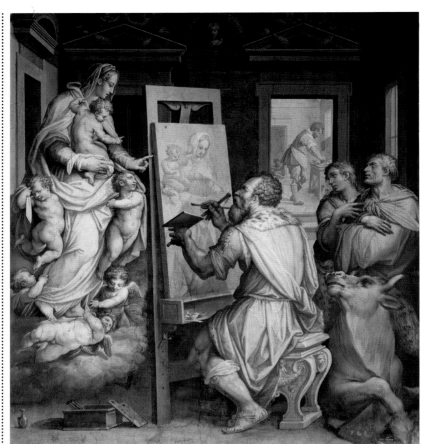

1560	1565	1570	1575	1580

The first academy

Determined to raise the status of artists, Vasari instigates the prestigious Accademia del Disegno (Academy of Design) in Florence in 1563. It served as a model for the art academies established in Europe in the following centuries.

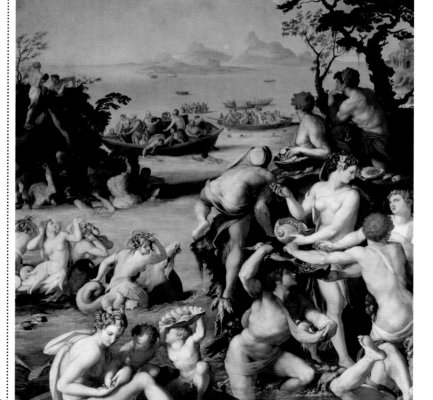

The Pearl Fishers ▷

Alessandro Allori 1570–72
Palazzo Vecchio, Florence, Italy
Allori—Bronzino's pupil and adopted son—painted this elegant scene as part of a complex decorative design for the *studiolo* of Grand Duke Francesco de' Medici. Influenced by Vasari and Bronzino, with poses taken from Michelangelo's *Battle of Cascina*, it has come to epitomize late Mannerism in Florence.

⊚ Giorgio Vasari

born Arezzo, Italy, July 30, 1511;
died Florence, Italy, June 27, 1574

Of incomparable art-historical importance as the writer of *Lives of the Artists*, Vasari was also a prolific painter, a distinguished architect, and a prominent figure in Florence and Rome. Born into a family of potters, he received a classical education, and was tutored with members of the Medici family in Florence, where he began his artistic training. Hugely ambitious, he achieved great success. His paintings are now less well regarded than his architecture: he designed the building now home to Florence's famous Uffizi Gallery, originally as government offices for his patron Cosimo de' Medici.

BIOGRAPHY

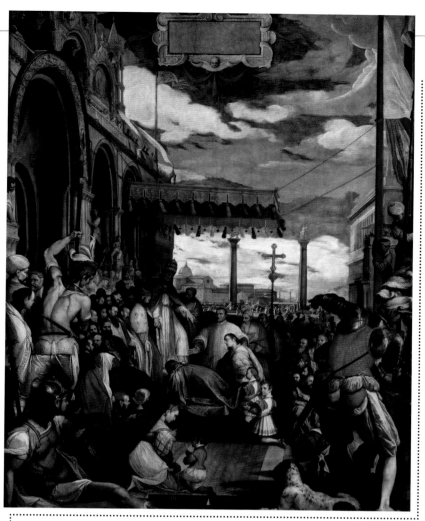

◁ **Barbarossa Pays Homage to Pope Alexander III**
Federico Zuccaro 1582
Doge's Palace, Venice, Italy
The Mannerist artist and theorist Zuccaro worked throughout Europe, becoming one of the most famous painters of his generation. This large work, painted for the Doge's Palace, contains dramatic changes in scale reminiscent of the Venetian master Tintoretto.

◁ **Adoration of the Shepherds**
Camillo Procaccini 1584
Pinacoteca Nazionale, Bologna, Italy
Procaccini came from a family of painters who worked in Bologna and Milan. This emotionally intense *Adoration* is notable for its dramatic *chiaroscuro* (strong contrasts of light and dark) and rather ostentatious gestures, including that of the muscular shepherd in the foreground who shields his eyes from the divine light.

1585	1590	1595	1600

Italians at the Escorial
From 1585 to 1588, Federico Zuccaro paints at the Escorial, Philip II's monastery-palace near Madrid. He and Pellegrino Tibaldi, who arrives at the Escorial in 1587, introduce the Italian Mannerist style to Spain.

The Baroque emerges
As the taste for the artificiality of Mannerism declines, Annibale Carracci begins work in 1597 on his Baroque masterpiece, the decoration of the Farnese Gallery in Rome. Michelangelo's Sistine Ceiling and Tibaldi's frescoes of Ulysses were inspirations.

BIOGRAPHY

Federico Barocci

born Urbino, Italy, 1535?;
died Urbino, September 30, 1612

Although Barocci spent most of his life in Urbino—not a major art center—he was among the most successful artists of his time. He abandoned his early career in Rome when he believed he was being poisoned. Plagued by a debilitating illness thereafter, he could only work in short bursts. Yet he was a productive painter—almost exclusively of religious works—and an outstanding draftsman. His style bridges the High Renaissance and the Baroque, and he influenced many artists, including Rubens.

△ **Aeneas's Flight from Troy**
Federico Barocci, 1598 *Galleria Borghese, Rome, Italy*
Apart from a few portraits, this is the only secular subject painted by the devout Barocci. In fact, he painted it twice—for Emperor Rudolph II in Prague, and then this version for Monsignor Giuliano della Rovere of Urbino. Its emotional force, robust figures, and dramatic movement and lighting look forward to the Baroque.

◎ MASTERWORK

An Allegory With Venus and Cupid

Agnolo Bronzino **c.1545**
National Gallery, London, UK

Commissioned by the Duke of Florence, Cosimo de' Medici, this coolly erotic allegory was sent as a gift to the French King Francis I, whose court at Fontainebleau was a leading center of Mannerist art outside Italy. The epitome of stylish, sophisticated artifice, it is deliberately complex and erudite, as would have appealed to a cultivated, courtly audience. It is thought to symbolize the consequences of unchaste love. Venus, goddess of love and beauty (identified by her golden apple), disarms her son Cupid by removing an arrow from his quiver as they kiss incestuously.

Other figures in the painting are personifications of concepts related to the theme. Folly showers the couple with rose petals, not noticing the pain (of love) from the thorn in his foot. Pleasure offers a sweet honeycomb, but has a sting in her tail. Time (an old man with an hourglass) draws back the curtain to reveal Fraud—represented by a head that is a hollow mask. The screaming figure may represent Jealousy and/or syphilis, a disease that was rife at the time. If so, such a gift from the Italian duke to the French king may have been a dark, sophisticated joke: syphilis was known as the "French disease" in Italy, and the "Italian disease" in France.

As his master Pontormo did in *The Deposition of Christ* (*see p.135*), Bronzino creates an irrational sense of space, with entwined and distorted figures pressed up against the picture plane. But where Pontormo's painting expressed an intense spirituality, Bronzino's exquisitely skilful Mannerist masterpiece is spiritually and emotionally as cold as alabaster. The painting's overt eroticism offended later generations, and in the Victorian era Venus's tongue was painted out, as was the nipple that protrudes between her son's fingers. In 1958 it was restored to its present sexually explicit state.

> A PICTURE OF **SINGULAR BEAUTY** ...
> WHEREIN WAS A **NUDE VENUS**, WITH
> A **CUPID** WHO WAS **KISSING HER** 〞

1568 | Giorgio Vasari

◎ Agnolo Bronzino

born Monticelli, nr. Florence, Italy, November 17, 1503
died Florence, November 23, 1572

Born Agnolo di Cosimo, Bronzino may have earned his nickname because of his dark complexion. He came from a humble background in a suburb of Florence, and as a boy was apprenticed to the young Florentine master Pontormo. According to his friend Vasari, Bronzino became like a son to Portormo, who included a portrait of him as a boy in his painting *Joseph in Egypt* (*above*) in c.1518. By the 1530s, Bronzino was sought after as a portraitist, particularly by literary patrons—he was a gifted poet himself. In 1539, he began working for the new Duke of Florence, Cosimo de' Medici, and was court artist for almost three decades, painting formal portraits, religious works, and mythologies, and creating tapestries for the Medici court. In 1563, along with Vasari, he was a founder member of Florence's new art academy, the Accademia del Disegno. Among his pupils was Alessandro Allori, who became his adopted son.

BIOGRAPHY

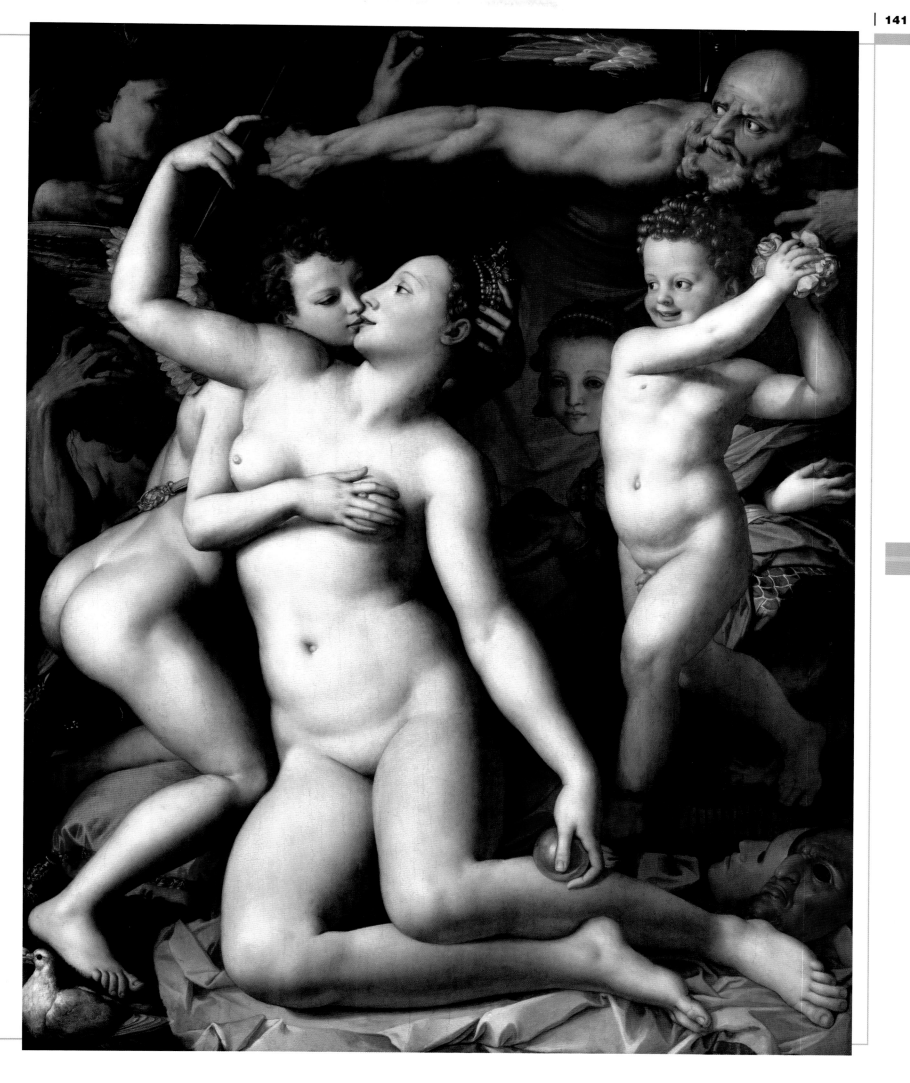

MANNERISM OUTSIDE ITALY

c.1525–1600 SOPHISTICATED BEAUTY

▷ **Allegory of Water or Allegory of Love**
Fontainebleau School c.1580
Louvre, Paris, France
Although there are numerous famous names associated with Mannerist art outside Italy, many of the paintings created at Fontainebleau are by unknown hands—including this sophisticated allegory on the theme of sacred and profane love. It features symbolic flowers in a similar way to Nicholas Hilliard's *Young Man Among Roses (see p.153)*.

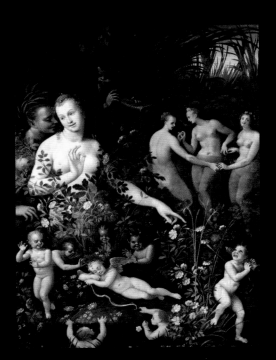

Mannerism spread outside Italy during the 16th century among a diverse array of European artists. Some of the most refined examples of Mannerist art were created at royal courts, initially at Fontainebleau in France, where *Allegory of Water or Allegory of Love (see left)* was painted. Like many paintings of the time, this deliciously sensuous work refers back to antiquity, but its esoteric cleverness and decorative, sophisticated beauty are typical of courtly Mannerist art in particular. Outside the courtly environment, another strand of Mannerism evolved in the Netherlands with the Romanist artists, who included Jan van Scorel, Maerten van Heemskerck, and Frans Floris. They all visited Rome, and blended the High Renaissance art they saw there with their own Flemish tradition to create a distinctly different Mannerist style. The German artist Lucas Cranach developed a coolly erotic, refined style that had parallels with Italian Mannerism, while the most original manifestation of Mannerism evolved in Spain, with the powerfully expressive paintings of El Greco.

◎ CONTEXT

The courts of Europe

Mannerism emerged in Italy in the early decades of the 16th century, but this "stylish style" soon began to spread abroad after the Sack of Rome (1527), when Mannerist artists who had fled the city took up invitations to work for powerful patrons in Northern Europe. Although it was not exclusively a courtly style, the virtuoso stylishness, elegant artificiality, and sophisticated novelty of Mannerism flourished particularly in royal and aristocratic environments. Italian artists Rosso Fiorentino and Francesco Primaticcio were pivotal in creating the dazzling court of Francis I at Fontainebleau, which became the center for French Mannerism. Mannerist art also had an important role to play in the sophisticated courts of Rudolf II in Prague (then in Bohemia, now the Czech Republic) and Elizabeth I in England.

The introduction of Italian artists to the French court at Fontainebleau was an integral part of Francis I's ambition to emulate the humanist rulers of Italy and bring about a national revival of the arts that would serve to advertise and promote France's cultural importance. Artists were employed not just to paint pictures but to design every visual aspect of court life—from tableware, such as Cellini's famous salt cellar (*see p.147*), to tombs.

As it was for Francis I, art was central to the vision of Rudolf II. After he became Holy Roman Emperor in 1576, he moved the imperial court from Vienna to Prague, and set about attracting artists, architects, mathematicians, astronomers, and philosophers there. Through his enthusiastic patronage of artists including Giuseppe Arcimboldo, Bartholomeus Spranger, and Hans von Aachen, Rudolf made his court a celebrated cultural center. Meanwhile, in Tudor England, the vogue for sophisticated love poetry, royal masks, and pageants, which flourished in this era, is echoed in the exquisite artificiality of works by artists such as Hans Eworth and the celebrated miniaturist Nicholas Hilliard.

(*see p.147*)

◎ Courts and patronage in 16th-century Europe

KEY EVENTS

▷ **1528** Baldassare Castiglione's famous *Book of the Courtier* is published in Italy. It mentions Francis I of France, who is already renowned outside of his own country for his love of culture.

▷ **1530** Italian Mannerist Rosso Fiorentino, who had left Rome after the Sack of Rome in 1527, is invited to Fontainebleau by Francis I.

▷ **1532** Primaticcio joins Rosso at Fontainebleau; together they establish the School of Fontainebleau.

▷ **1547** Henry II becomes King of France. Although he is married to Catherine de Médicis, his mistress Diane de Poitiers is a more influential figure.

▷ **1558** Elizabeth I becomes Queen of England, where she remains ruler until her death in 1603.

▷ **1576** Maximilian II dies, and his son Rudolf II becomes Holy Roman Emperor.

▷ **1583** Rudolf II moves the imperial court from Vienna to Prague, where he establishes himself as a major patron, and creates the world's greatest collection of Northern Mannerist art.

❝ **VARIETY** AMONG **THE ELEMENTS** IS A SOURCE OF **GREAT PLEASURE TO THE EYE** AND **SATISFACTION TO THE MIND** ❞

Sebastiano Serlio
Mannerist architect who worked at the palace of Fontainebleau

Gallery of Francis I
Italian artists Rosso and Primaticcio directed the decorations at the palace of Fontainebleau. Together they created the Gallery of Francis I (c.1533–39), which has been praised by art historian Anthony Blunt as "one of the most refined and successful products of Early Mannerism."

◎ BEGINNINGS
THE FRENCH CONNECTION

The beginning of the Mannerist style outside Italy was partly triggered by the same event that brought an end to the golden era of High Renaissance art in Italy. This was the Sack of Rome in 1527, which led Mannerist artist Rosso Fiorentino to abandon the city and search for work elsewhere. In 1530, after working in various places in central Italy and in Venice, Rosso was invited by Francis I to help transform his residence at Fontainebleau from a hunting lodge to a lavishly decorated palace. Rosso, together with fellow-Italian Primaticcio, established the First School of Fontainebleau. (The Second School of Fontainebleau flourished toward the end of the century.) The Mannerist style later spread throughout the rest of Europe, through artists who visited Italy or Fontainebleau or who saw Mannerist art in the form of engravings.

◎ TURNING POINT

Diana the Huntress
School of Fontainebleau c.1550 *Louvre, Paris, France*

This striking painting may be an allegorical portrait of Diane de Poitiers, mistress of the French King Henry II, who succeeded Francis I in 1547. Painted by an unknown artist, it reveals the profound impact of Italian Mannerist painters on French court art. One of the most famous examples of the First School of Fontainebleau, it is typical of this early manifestation of European Mannerism in its depiction of an elegant, long-limbed figure, based on an antique sculpture, within a mythological context. Looking over her shoulder in a *contrapposto* pose that derives from Michelangelo, the almost naked Diana—the Roman goddess of hunting—exhibits a sophisticated eroticism that frequently features in French Mannerist art.

◉ ARTISTIC INFLUENCES

Like Mannerist art in Italy, Mannerism outside Italy represents a refinement and exaggeration of Italian Renaissance art, and its evolution can ultimately be traced back to antique sculpture. Artists throughout Europe were influenced by Italian Mannerists, such as Rosso, Primaticcio, and Niccolò dell'Abate, whose work had a huge impact at Fontainebleau and beyond. By visiting Italy, and through engravings, European artists became familiar with the work of many Italian artists, including Michelangelo, whose *contrapposto* (twisting) poses were eagerly adopted.

◎ FRANCIS I—A ROYAL PATRON

Francis I (r.1515–47) was determined to transform the art and culture of France. Renowned for his intellectual attributes and physical prowess, he amassed a great collection of paintings, sculpture, books, and manuscripts. His taste for Italian art was stimulated during France's military campaigns in Italy, and at Fontainebleau he set out to create a court to rival any in Italy. The works he owned—including Leonardo's *Mona Lisa* (see p.104)—later formed the basis of the Louvre's collection.

Portrait of Francis I, King of France, c.1535, Jean or François Clouet, Louvre, Paris, France

Antique sculpture, such as this life-size Roman statue of the goddess Diana, influenced Mannerist imagery. Pope Paul IV presented it to Henry II, who installed it in the gardens of the palace at Fontainebleau.

Diana of Versailles, 1st or 2nd century CE, was among the first Roman sculptures to be seen in France. *Louvre, Paris, France*

Michelangelo's nude figures and their *contrapposto* (twisting) poses influenced Mannerist artists in and outside Italy. This red chalk drawing of a figure from the Sistine Chapel ceiling is by Rosso.

Ignudo, c.1525, by Rosso Fiorentino after Michelangelo. The twisting pose is echoed in *Diana the Huntress. Chatsworth House, Derbyshire, UK*

Italian Renaissance paintings of gods and goddesses have links with images by Mannerist artists working outside Italy. This painting, by one of Leonardo's followers, is closely related to an engraving after a drawing by Rosso.

Diana the Huntress, c.1530, by Milanese artist Giampietrino, has similarities to the Fontainebleau Diana. *Metropolitan Museum of Art, New York City, NY*

◎ TIMELINE

Soon after Mannerism emerged
in Italy, this "stylish style" began to
spread throughout Europe, initially
at the court of Francis I in France,
where the School of Fontainebleau
was founded in the 1530s by the
Italian artists Rosso Fiorentino and
Primaticcio. The vogue for courtly
Mannerism flourished throughout
the 16th century, and outside such
environments, generations of northern
artists were inspired by the Mannerist
art they saw in Rome. By the end of
the century, El Greco's personal style
of Mannerism stood at the head of
a new Spanish school of painting.

Italians in France
Following the Sack of Rome in 1527, Italian
artist Rosso Fiorentino accepts the invitation
from Francis I to oversee the decorations of
his palace at Fontainebleau. He arrives in
1530 and is joined by Primaticcio in 1532.

▽ Danaë
Jan Gossaert (Mabuse) 1527
Alte Pinakothek, Munich, Germany
In his delicately erotic version of the Greek
myth, Gossaert depicts the scantily clad
Danaë in an elegant Italianate classical
interior; the god Zeus is seducing her
disguised as a shower of gold, at which
she gazes in wonder. Gossaert draws on
a variety of influences, including his native
Netherlandish tradition, the German master
Dürer, and the art of Michelangelo and
Raphael to create his own distinctive,
finely delineated style.

◎ Jan Gossaert (Mabuse)
born Maubeuge?, Flanders, c.1478;
died Veere?, Flanders, October 1, 1532

BIOGRAPHY

Sometimes called "Mabuse" after his presumed
birthplace of Maubeuge (now in France), the
Netherlandish painter Jan Gossaert was a leading
exponent of what art historian Max J. Friedländer
termed "Antwerp Mannerism"—a style that flourished
in the first decades of the 16th century, characterized
by technical virtuosity and a combination of Gothic
and Renaissance elements. A trip to Italy in 1508–09,
visiting Rome as part of the retinue of Philip of
Burgundy, had a lasting impact on Gossaert's work.
Praised by Vasari for bringing "the true method of
representing nude figures and mythologies from Italy
to the Netherlands," he had a powerful influence on
the "Romanist" artists of the next generation, such
as his probable pupil Jan van Scorel, and Scorel's
own pupil Maerten van Heemskerck.

1525 **1530**

Cupid Complaining to Venus △
Lucas Cranach 1530
National Gallery, London, UK
As court painter to Frederick the Wise of Saxony
(Germany), Cranach developed a refined style
that echoed Italian Mannerism. This coquettish
Venus wears fashionable jewels and hat—
giving a sophisticated thrill to her nakedness.
She is both goddess and aristocrat—undressed.

▽ **Danaë Receiving the Shower of Gold**
Primaticcio c.1533–39 *Château de Fontainebleau, Seine-et-Marne, France*
Primaticcio's depiction of the Danaë myth makes an interesting comparison with
Gossaert's innocent-looking Danaë (*opposite*). Framed by the stucco decorations of
the Gallery of Francis I at Fontainebleau, Primaticcio's painting shows an aristocratic
Danaë receiving Zeus's shower of gold with a world-weary sensuality.

▽ **Allegorical Portrait of
Sir John Luttrell**
Hans Eworth 1550
Courtauld Gallery, London, UK
Netherlandish artist Hans Eworth settled in England,
where he painted this allegorical portrait celebrating
a peace treaty between England and France. Sir
John proclaims his devotion to Peace (with her olive
branch) by wearing her colors on his arm.

1535 **1540** **1545** **1550**

> FOR YEARS **I HAVE
> KNOWN** YOU TO BE THE
> **GREATEST GOLDSMITH
> EVER HEARD OF...**

c.1554 | Michelangelo
In a letter to Benvenuto Cellini

**Suicide at
Fontainebleau?**
In 1540, Rosso dies,
according to Vasari, by
suicide after realizing
he had wrongly accused
a friend of stealing
from him. Following
Rosso's death,
Primaticcio takes
control of decorations
at Fontainebleau.

△ **The Sermon, Arrest, and
Martyrdom of St. James (from
the polyptych of St. James the
Great and St. Stephen)**
Jan van Scorel c.1541
Musée de la Chartreuse, Douai, France
Scorel's mature Mannerist style draws on
the late works of Raphael, which he would
have seen in Rome. The muscular figure
on the right is about to behead the saint,
but his almost balletic pose and the
decorative colors serve to minimize
any real sense of violence.

CONTEXT

SALT CELLAR WITH NEPTUNE AND CERES

Made for Francis I by
Benvenuto Cellini—Florentine
goldsmith, sculptor, and writer
of one of the raciest and
most entertaining of all artists'
autobiographies—this exquisite
gold-and-enamel salt cellar
is a celebrated Mannerist
masterpiece. An allegorical
work of art rather than simply
a condiment holder, the salt
cellar depicts Neptune, god of
the sea, and Ceres, goddess
of Earth's abundance.

**Salt cellar of Francis I,
1540–43, Benvenuto Cellini**

◁ Fall of the Rebel Angels
Frans Floris 1554
Koninklijk Museum voor Schone Kunsten, Antwerp, Belgium
Witnessing the unveiling of Michelangelo's *Last Judgment* in Rome in 1541 made a lasting impression on Antwerp artist Frans Floris. Tumbling, writhing Michelangelesque bodies pack this central panel of a triptych (side panels lost), commissioned by the Antwerp fencers' guild.

Labors of Hercules
Among the many private commissions carried out in Antwerp by Frans Floris for wealthy local collectors is a series of ten paintings on the Labors of Hercules, painted in 1554–55.

1550 **1555** **1560**

◁ The Death of Eurydice
Niccolò dell'Abate c.1557
National Gallery, London, UK
This expansive landscape peopled with elegant mythological figures was probably painted while Niccolò was in France, and looks forward to the classical landscapes painted by Claude and Poussin in the 17th century. Various points of the narrative are depicted, and Eurydice is shown twice—trying to escape from her attacker, and dying from a serpent bite.

Child king
After the deaths of his father Henry II in 1559, and his brother Francis II the following year, the 10-year-old Charles IX becomes King of France in 1560. His mother Catherine de Médicis is regent.

Niccolò dell'Abate

born Modena, Italy, c.1510;
died Fontainebleau?, France, 1571

Master of the Mannerist landscape, Niccolò dell'Abate was born in Modena, northern Italy, where he trained with his father, a stuccoist. He spent much of his early career decorating secular buildings in and around his hometown before moving to Bologna in 1547. His work during this early period was particularly influenced by Parmigianino. He moved to France in 1552, and spent the rest of his life there—for much of this time working under the supervision of fellow-Italian Primaticcio at Fontainebleau, where he painted fresco decorations and independent landscapes.

BIOGRAPHY

◁ Lamentation
Maerten van Heemskerck 1566
Prinsenhof Museum, Delft, Netherlands
The restrained pathos of this elegantly
melancholic image is deeply moving.
Crowded close to the picture plane, leaving
a glimpse of the site of the Crucifixion
beyond, the well-dressed mourners gather
in a rhythmic arrangement around Christ's
pale body, which sweeps across the
painting. The influence of Michelangelo—
and in the figure of Christ, the influence
of classical sculpture—is clearly evident.

BIOGRAPHY

Maerten van Heemskerck
born Heemskerck, Netherlands, 1498; **died** Haarlem, Netherlands, October 1, 1574

Born in a Dutch village from which he took his
name, Heemskerck became the leading artist
of his day in nearby Haarlem. After training
with his near-contemporary Jan van Scorel in
Utrecht (c.1528–29), he traveled to Rome in
1532. He spent several years there studying
its ancient architectural remains—such as the
Colosseum, which he later included in his
self-portrait (*left*)—and its masterpieces of
classical sculpture. As well as painting,
Heemskerck designed hundreds of prints that
were instrumental in spreading Mannerism
throughout northern Europe.

> THE ARTIST WHO DID MOST TO MAKE
> AVAILABLE IN **NORTHERN EUROPE**
> A **DETAILED KNOWLEDGE** OF **ROMAN
> ANTIQUITIES** WAS...**HEEMSKERCK**

1972 | Alastair Smart
British art historian

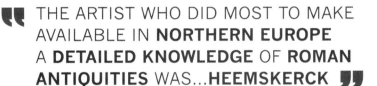

1565 **1570** **1575**

Wedding and funeral
François Clouet is given
responsibility for the
decorations of the wedding
of Margaret Valois to Henry
of Navarre (later Henry IV of
France) in 1572. Clouet
dies later that year.

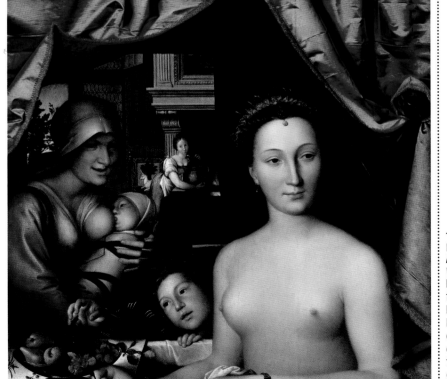

◁ A Lady in her Bath
François Clouet c.1571
*National Gallery of Art,
Washington, DC*
François Clouet succeeded his
father Jean as artist to the
French court. The family was of
Netherlandish origin, and the
distinctive character of this
enigmatic image derives partly
from the combination of Flemish
elements, such as the detailed,
naturalistic painting of the still
life, with the more Italianate
treatment of the idealized nude
—traditionally said to be Henry
II's mistress, Diane de Poitiers.

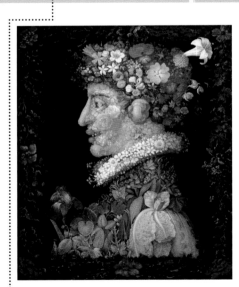

△ Spring
Giuseppe Arcimboldo 1573
Louvre, Paris, France
The Italian artist Arcimboldo was employed
at the Habsburg court from 1562 to 1587,
working for successive emperors—
Ferdinand I, Maximilian II, and Rudolf II.
This personification of Spring (painted for
Maximilian) is typical of his many fantastical
allegorical portraits created from fruit,
vegetables, and other objects.

MINIATURES

The portrait miniature
gained popularity in the time of Hans Holbein and flourished in Elizabethan England. While Holbein's miniatures were essentially scaled down Renaissance portraits, Hilliard's watercolor technique evolved from manuscript illumination. Miniatures were worn as pieces of jewelry, and often served as love tokens or signs of political loyalty.

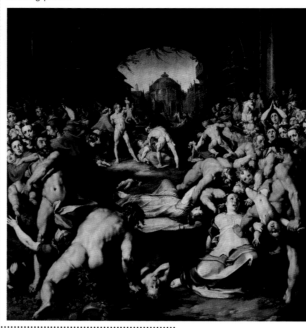

The Gresley Jewel, with miniatures by Hilliard

CONTEXT

El Greco in Toledo
In 1577 El Greco completes his first large commission in Toledo, Spain. In the same year, for Toledo Cathedral, he begins his *Disrobing of Christ,* which firmly establishes his reputation.

Spranger's court appointment
After spending five years in Vienna, Bartholomeus Spranger settles in Prague, where he is appointed court painter by the emperor Rudolf II in 1581.

▽ Massacre of the Innocents
Cornelis van Haarlem c.1590–91
Frans Halsmuseum, Haarlem, Netherlands
One of the leading Mannerists in Haarlem at the end of the 16th century, Cornelis is best known for historical and biblical paintings such as this, featuring life-size nudes in a variety of dramatic, mannered, twisting poses.

1575 **1580** **1585** **1590** **1595**

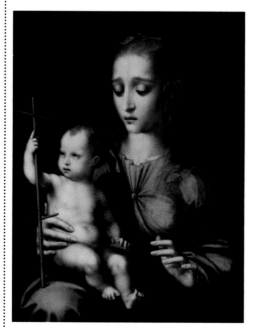

△ Madonna and Child with a Distaff
Luis de Morales c.1575
Hermitage Museum, St. Petersburg, Russia
The Spanish artist Luis de Morales was called *el Divino,* because of the spiritual intensity of his paintings: this image is typical of his style. He probably knew the work of Michelangelo and Rosso through engravings, and was also influenced by Flemish Mannerism and Leonardo's *sfumato* technique.

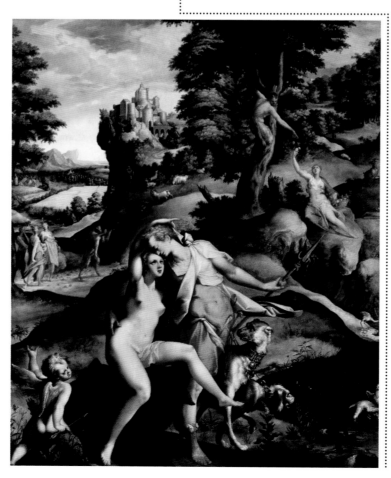

◁ Venus and Adonis
Bartholomeus Spranger
c.1585–90 *Rijksmuseum, Amsterdam, Netherlands*
Spranger was influential in the spread of Mannerism through Europe. Trained in Antwerp, he traveled to France and Italy, worked in Vienna for Emperor Maximilian II, and was one of the leading artists at the court of Rudolf II in Prague. This depiction of Venus entwined with the hunter Adonis is one of a series of paintings of mythological lovers.

◁ **Christ Driving the Traders from the Temple**
El Greco c.1600
National Gallery, London, UK
This is one of several versions El Greco painted of this dramatic biblical subject. In a rare display of anger, Jesus drives out the traders who are desecrating the Temple in Jerusalem, turning what should be a "house of prayer" into a "den of thieves." A broad, curving highlight following the line of Christ's robe accentuates his twisting motion as he sweeps forward, raising his arm to unleash his whip. Traders recoil in a tumble of tortured gestures on the left, while the righteous on the right remain calm.

The Arte of Limning
In about 1600 Nicholas Hilliard writes a treatise entitled *The Arte of Limning*, giving detailed descriptions of the technical aspects and stylistic considerations of miniature painting. He notes that "lyne without shadows showeth all good judgement, but shadowe without lyne showeth nothing."

1600

El Greco

born Candia (now Iraklion), Crete, c.1541;
died Toledo, Spain, April 7, 1614

Domenikos Theotokopoulos—known as *El Greco* ("The Greek")—was born in Crete, where he trained in the Byzantine tradition of icon painting. By 1568, he had left his native island and was in Venice, where he may have studied with the elderly Titian, but was influenced more by the dramatic, emotional works of Tintoretto. After a period in Rome, he settled in the Spanish city of Toledo in 1577, and is recognized as the first great painter of the Spanish school. His extraordinary works—featuring distorted, elongated figures, flamelike, flowing forms, and intense colors—represent the most intensely personal and original expression of Mannerism.

BIOGRAPHY

 THE **CITIZENS OF TOLEDO** NEVER **TIRE** OF SEEING HIS **PAINTING** 🙿

1588 | Alonso de Villegas
Spanish theologian and writer, on El Greco

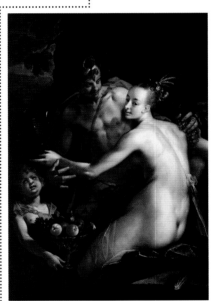

△ **Bacchus, Ceres, and Cupid**
Hans von Aachen c.1600
Kunsthistorisches Museum, Vienna, Austria
One of the leading artists at Rudolf II's court in Prague, where he was appointed as court painter in 1592, Hans von Aachen developed a sophisticated style combining meticulous detail with elegant nude figures in allegorical scenes. It was a style perfectly suited to the refined courtly taste of 16th-century Europe.

◎ MASTERWORK

Young Man Among Roses

Nicholas Hilliard **c.1587**
Victoria and Albert Museum, London, UK

Probably the best known of all English miniatures, this delicate masterpiece epitomizes the stylish sense of elegant artifice that characterized painting, poetry, and courtly relationships in the Elizabethan era. At 5⅜in (136mm) tall, it is larger than most of Hilliard's miniatures, but he created it with his usual technique: using tiny squirrel hair brushes, with watercolor paints mixed in mussel shells, he painted on vellum (calfskin) stuck on cardboard. The influence of the Mannerist style of the School of Fontainebleau is evident: Hilliard had been familiar with French court portraiture before he visited France in 1576–78, but the experience of seeing Fontainebleau art at firsthand had a profound impact on his work. The pose of the slender young man has its origins in the stucco decorations at Fontainebleau, while his position amid flowers has been linked to works by an anonymous Fontainebleau artist, the Maître de Flore.

The identity of the sitter and the meaning of the image are obscure, perhaps intentionally so. The miniature is an *impresa*, in which words and image work together to create an allegorical message intended for certain eyes only—in this case perhaps Queen Elizabeth I. Dressed in black and white, the colors worn by Elizabeth's champions in jousting and in court masks, the lovesick youth stands with hand on heart, entrapped by roses, whose beauty and thorns express the bittersweet nature of love. The rose is an eglantine, emblem of the Virgin Queen. While the man's costume proclaims loyalty to the queen, the Latin motto above his head confirms his constancy. Art historian Sir Roy Strong argues that the youth is Elizabeth's favorite, Robert Devereux, 2nd Earl of Essex. If so, the man's proclaimed constancy proved questionable: after an unsuccessful attempt to overthrow the government in 1601, Essex was executed for treason.

❝❝ DAT POENAS LAUDATA FIDES [**LOYALTY, THOUGH PRAISED**, BRINGS **SUFFERING**] ❞❞

1st century CE | Lucan
Roman poet, whose Latin motto is written on Young Man Among Roses

◎ Nicholas Hilliard

born Exeter, England, c.1547;
buried London, England, January 7, 1619

Nicholas Hilliard was a teenage apprentice to London goldsmith Robert Brandon, jeweler to Elizabeth I, before going on to establish an international reputation as the leading painter of miniatures. By 1572, he was working for Elizabeth I, but although he earned great renown, he had no fixed income, and was often in dire financial straits—losing money in a disastrous goldmining venture in Scotland, hiding from creditors, and being imprisoned for debt. In 1576–78 he was in France, and it can be assumed that he visited Fontainebleau. Certainly he was inspired by the Mannerist art of François Clouet and other Fontainebleau painters. In about 1600, he wrote *Treatise Concerning The Arte of Limning* ("limning" means painting in miniature). The treatise (not published until 1912) gives a fascinating insight into his meticulous technique. On Elizabeth I's death in 1603, Hilliard became "King's Limner" to her successor James I.

BIOGRAPHY

Actual size

BAROQUE TO NEOCLASSICISM

156 ITALIAN BAROQUE

166 FLEMISH AND SPANISH BAROQUE

178 DUTCH BAROQUE

190 FRENCH BAROQUE

200 FRENCH ROCOCO

210 ROCOCO OUTSIDE FRANCE

220 NEOCLASSICISM

Three styles successively dominated European art in the 17th and 18th centuries: Baroque, Rococo, and Neoclassicism. These styles often merged or overlapped, and the pattern of development varied from country to country, but—in very broad terms—Baroque flourished throughout the 17th century, Rococo in the first half of the 18th century, and Neoclassicism in the second half. Baroque was born in Rome and blossomed mainly in Catholic lands, its emotional qualities being well suited to expressing religious fervor. The Rococo style, which originated in France, is lighter and usually more secular in spirit. Neoclassicism marked a reaction against Rococo's frivolity and a revival of the forms and values of ancient art. Around 1800, Neoclassicism still thrived throughout Europe, but by this time its dominance was being challenged by the very different ideals of Romanticism.

ITALIAN BAROQUE

1600–1700 GRANDEUR AND RHETORIC

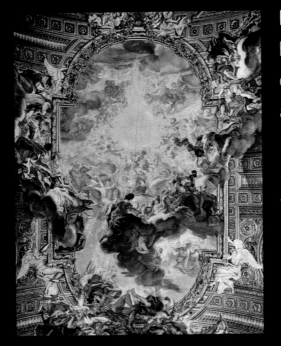

▷ **Adoration of the Name of Jesus**
Giovanni Battista Gaulli
1674–79 *Chiesa del Gesù, Rome, Italy*
This ceiling fresco adorns the Gesù church in Rome, the mother church of the Jesuit religious order. The rhetorical splendor and emotional fervor of Gaulli's painting are typical of Baroque art at its most intense, conjuring up an ecstatic, heavenly vision.

By the end of the 16th century, Italian art had generally declined since the great days of the Renaissance. There were many highly accomplished painters at work, but often their pictures are more concerned with style than substance and are lacking in real passion. In the 17th century, however, there was a revival of energy and creative fire as a new style emerged. This style, which historians later called Baroque, took some elements from High Renaissance art—particularly its grandeur and dignity—and some from Mannerism—particularly its emotionalism and sense of movement—and blended them into a dynamic synthesis. Baroque was born in Rome, where Caravaggio and Annibale Carracci created its first great landmarks in painting, and soon spread to other Italian cities and other countries. Domenichino, Guido Reni, and Pietro da Cortona were among its most illustrious representatives.

◎ CONTEXT

Piety and passion

For most of the 17th century, Italy was the leader in art and architecture, just as it had been during the Renaissance. Rome in particular was the most important center of innovative ideas, attracting artists from all over Europe. They went there both to study the great treasures of the past and to find work in the many new churches and palaces that were being erected. Such buildings were often elaborately decorated, providing employment for painters, sculptors, and many types of craftsmen. No other city had such a stimulating artistic atmosphere: it was like Paris in the 19th century or New York in the 1950s.

Although other subjects were becoming more important than they had been in earlier centuries, religion remained the dominant theme in Italian art and was often influenced by the ideas of the Counter-Reformation. This is the name given to the Catholic Church's campaign—from about the middle of the 16th century—to reassert its authority, which had

been battered by the spread of Protestantism. As part of this fight, the Catholic clergy saw art as an important form of propaganda—a direct appeal to the hearts and minds of ordinary men and women whose faith could be fortified by suitable images of the sufferings and triumphs of Christ and the saints. Consequently, Baroque religious art is often highly emotional in tone, seeking to overwhelm the spectator with a sense of spiritual passion.

Many Italian artists of the time were fervently devout and entirely in sympathy with this outlook. Among them was Gianlorenzo Bernini, who attended Mass each morning and enjoyed theological discussions with priests. One of his most famous works is the great colonnade (1656–67) that encloses the piazza in front of St. Peter's in Rome. In words that get to the heart of Baroque art, he compared the sweeping architectural forms to the motherly arms of the Church reaching out to "embrace Catholics and reinforce their belief."

Changing papal fortunes

▷ **1605** Camillo Borghese becomes pope as Paul V and reigns until 1623. He comes from a notable family of art patrons, the most illustrious member of which is his nephew, Cardinal Scipione Borghese.

▷ **1623** Maffeo Barberini becomes pope as Urban VIII and reigns until 1644. He is one of the greatest art patrons of the age, employing Gianlorenzo Bernini above all, but also Pietro da Cortona, Guido Reni, and many other artists.

▷ **1626** Consecration of St. Peter's, Rome, which had been begun in 1506. The lavish decoration of the building—the largest, most important church in Christendom—goes on long after this, keeping a small army of artists and craftsmen busy throughout the 17th century.

▷ **1665** Bernini visits Paris. The "invitation" there is in fact a summons, one of several humiliations Louis XIV inflicted on Pope Alexander VII—a sign of increasing French power and declining papal authority.

▷ **1693** The most powerful earthquake in Italian history devastates Sicily, killing an estimated 60,000 people and destroying much of the art and architecture.

KEY EVENTS

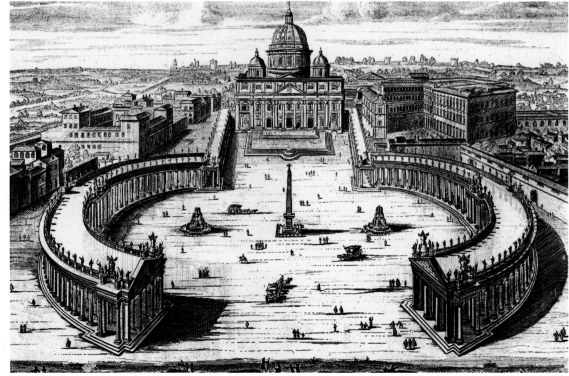

IN COMPARISON WITH THE ART OF THE HIGH RENAISSANCE, **BAROQUE ART** IS A GOOD DEAL **MORE COLORFUL**, HIGHER-PITCHED, AND 'THEATRICAL' ❞

1970 | Robert Wallace
American writer, The World of Bernini

Embracing arms
Bernini's majestic colonnades enclose the piazza in front of St. Peter's Basilica, Rome, in this 1702 engraving.

◉ BEGINNINGS

A NEW VISION

Two commanding, contrasting figures stand at the head of Italian Baroque painting—Annibale Carracci and Caravaggio. Both came from northern Italy and both did their most important work in Rome, where they were contemporaries. They are often characterized as polar opposites in style: Caravaggio the inventor of a new type of shadowy, earthy realism, Annibale the creator of heroic, idealized figures, harmonious and clearly lit. However, they respected one another, and although their means were very different, their essential artistic aims were similar: both of them broke away decisively from the graceful but rather artificial—sometimes insipid—Mannerism that prevailed when they were growing up, replacing it with energy and resounding physical presence.

◎ Caravaggio

baptized Milan, Italy, September 30, 1571;
died Porto Ercole, Italy, July 18, 1610

After training as a painter in Milan, Michelangelo Merisi da Caravaggio settled in Rome in the early 1590s. His early work was mostly secular, including intimate mythological and allegorical scenes with a strong erotic flavor. However, his career changed course in 1599 with his first church commission for a large and serious religious painting—the type of work in which he henceforth specialized.

Over the next seven years Caravaggio painted a series of major altarpieces that established him as the most influential painter in Rome. Several caused heated controversy, for some people considered his down-to-earth treatment of holy subjects sacrilegious. He also caused scandal because of his violent temperament, and in 1606 he fled Rome after killing a man in a fight. He moved to southern Italy and, after continuing his career with outstanding works in Naples, Malta, and Sicily, died—probably of fever—en route to Rome, where he hoped for a pardon. He was only 38. His work had enormous impact: although his style went out of fashion in Rome in the 1620s, in parts of Europe it survived into the 1650s.

BIOGRAPHY

◎ TURNING POINT

The Martyrdom of St. Peter

Caravaggio **1601** *S. Maria del Popolo, Rome, Italy*

This is one of a pair of pictures—the other is *The Conversion of St. Paul*—that Caravaggio painted for the Cerasi Chapel of the church of Santa Maria del Popolo in Rome. St. Peter and St. Paul are often found closely linked in art like this, since they were regarded as joint founders of the Christian Church. This was one of the first public commissions in which Caravaggio showed his revolutionary style, based not on well-worn conventions, but on observation of the ordinary people he saw in the world around him. Such realism was one trademark of his work, and another was the use of strong contrasts of light and shade to produce intensely dramatic effects. Many painters imitated these innovations, but few of them approached Caravaggio's deep solemnity or his magnificent boldness and sureness of design. The figures here are so powerful and concentrated that they seem almost to burst out of the frame.

◉ ARTISTIC INFLUENCES

Although Caravaggio was a highly original and individual painter, he was influenced by others who were active in the part of northern Italy where he grew up, and also by contemporary ideas. He lived at a time when the Catholic Church encouraged artists to produce paintings that conveyed religious ideas clearly and vigorously.

The Catholic Church met in conference at Trent, and its concerns included the role of art in worship. Artists were told to adopt a realistic style to help Catholics "love God and cultivate piety."

The Council of Trent met in 1545–47, 1551–52, and 1562–63 (pictured) to find ways to counter the Protestant Reformation.

Giovanni Girolamo Savoldo worked in Venice and other parts of northern Italy. Little is known of his career, but Caravaggio may have been influenced by his poetic night scenes.

Mary Magdalene Approaching the Sepulchre, detail, c.1540, is one of several similar works by Savoldo. *National Gallery, London, UK*

Leonardo was the outstanding pioneer of the use of expressive light and shade in painting. He spent much of his career in Milan, where Caravaggio saw paintings by him or his followers.

The Virgin of the Rocks, detail, c.1508, exhibits Leonardo's strong sense of three-dimensionality. *National Gallery, London, UK*

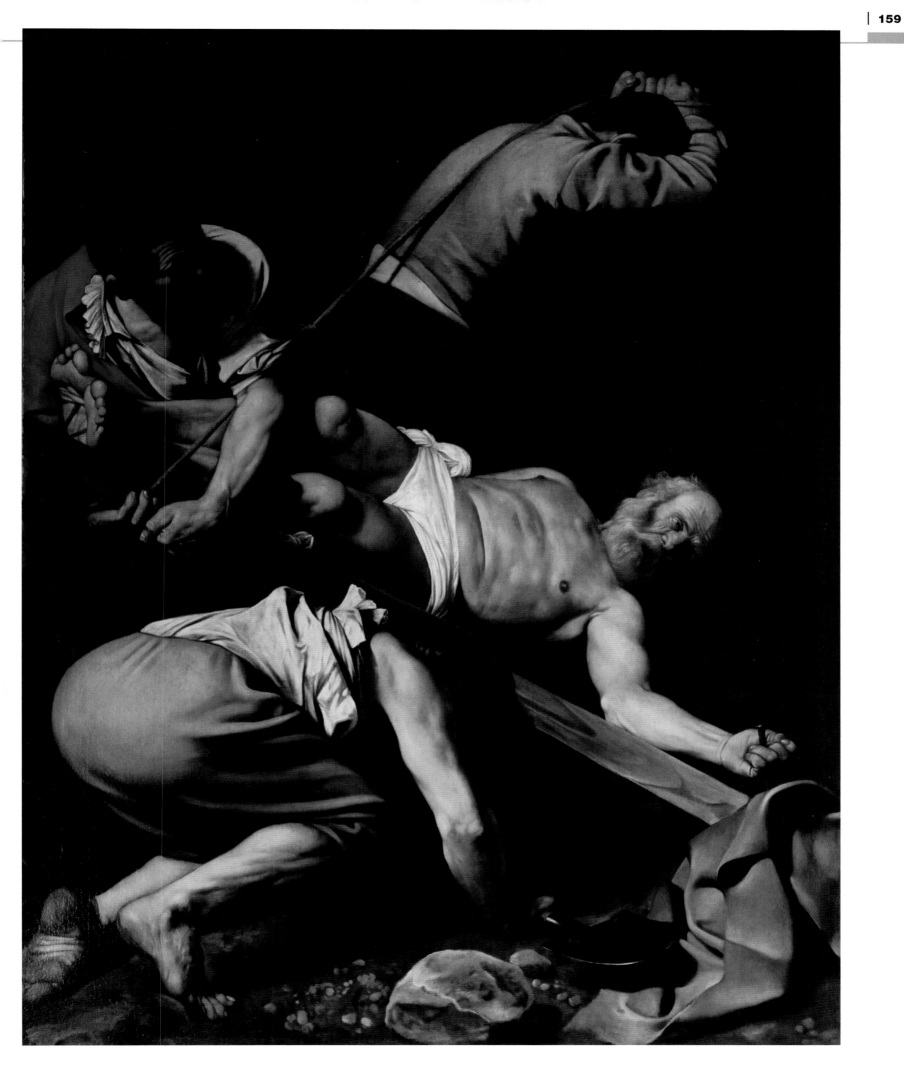

◎ TIMELINE

Much of the best 17th-century Italian painting was done in Rome, but there were several other important centers. Bologna produced many outstanding painters, including Annibale Carracci at the beginning of the century, followed by Guido Reni. Caravaggio's style took root in Naples, where Artemisia Gentileschi settled around 1630. Pietro da Cortona and Salvator Rosa both worked in Florence in the 1640s. In the later part of the 17th century, Luca Giordano had an itinerant career in Italy and Spain.

Papal chapel
Newly elected Pope Paul V begins a lavish chapel in S. Maria Maggiore, Rome in 1605. Many leading painters and sculptors are commissioned to work on it.

Family split
Agostino Carracci leaves Rome for Parma in 1599 after quarreling with his brother Annibale. Previously he had been Annibale's main assistant in his work at the Farnese Palace.

BIOGRAPHY

◎ Artemisia Gentileschi

born Rome, Italy July 8, 1593;
died Naples, Italy 1654?

Artemisia Gentileschi was one of the first female artists to gain a substantial reputation. She was trained by her painter father in Rome and also worked in Florence, Naples, and England, where she was patronized by King Charles I. A strong-minded, independent character, she was not interested in traditional "ladylike" subjects such as floral still life, but instead specialized in serious, often somber, religious paintings.

▽ Judith Beheading Holofernes
Artemesia Gentileschi c.1620
Museo di Capodimonte, Naples, Italy
Judith is a biblical Jewish heroine who infiltrates an enemy camp and kills the commander, Holofernes. The strong contrasts of light and shade and the fierce intensity with which this horrific scene is depicted show the influence of Caravaggio.

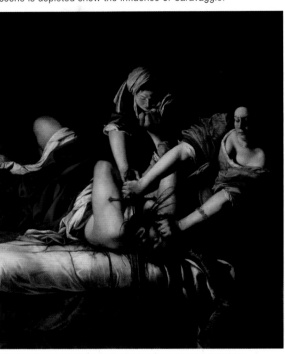

1600 **1605** **1610** **1615** **1620**

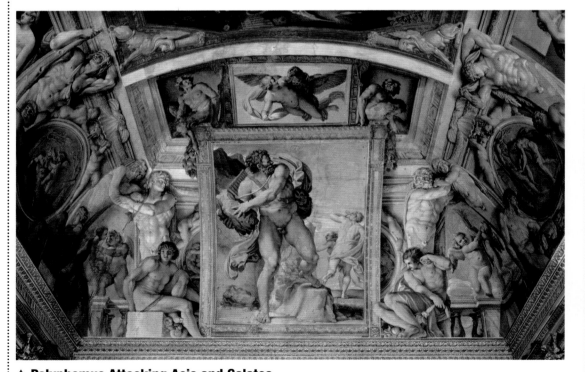

△ Polyphemus Attacking Acis and Galatea
Annibale Carracci c.1600 *Farnese Palace, Rome, Italy*
The giant Polyphemus is the most imposing single figure of Annibale's masterpiece. Contemporaries admired the way in which the strenuous torsion of his pose conveys a powerful sense of movement. Such exuberance had a great influence on Baroque painting.

△ A Sibyl
Domenichino 1617
Galleria Borghese, Rome, Italy
Domenico Zampieri, known as Domenichino ("Little Dominic"), was the most successful painter in Rome at the time he produced this refined picture. Sibyls were ancient prophetesses who were said to have foretold the coming of Christ.

Ceiling of the Apollo Room ▷
Pietro da Cortona c.1642–47
Palazzo Pitti, Florence, Italy
Between 1642 and 1647 (with various interruptions) Cortona decorated a series of rooms in the Pitti Palace in Florence, the main residence of the city's ruling Medici family. His combination of colorful, ebullient figures and rich stucco ornamentation influenced many contemporary and later artists.

Poussin altarpiece
The French artist Nicolas Poussin, who settled in Rome in 1624, completes the altarpiece *The Martyrdom of St. Erasmus* for St. Peter's in 1629.

Marvel in bronze
In 1623 Gianlorenzo Bernini begins work on the *Baldacchino*, a huge bronze canopy over the high altar in St. Peter's. It is completed in 1634.

1625 **1630** **1635** **1640** **1645**

◁ **The Archangel Michael Vanquishing Satan**
Guido Reni c.1635 *S. Maria della Concezione, Rome, Italy*
Reni had an internationally successful career and was renowned for the celestial beauty and grace of his work, which earned him the nickname "the Divine Guido." He inherited the clear, vigorous draftsmanship of the Carracci, under whom he studied.

❝ I **SHOULD HAVE LIKED** TO HAVE HAD AN **ANGELIC BRUSH**...TO **FASHION THE ARCHANGEL** ❞

c.1635 | Guido Reni

Gianlorenzo Bernini

born Naples, Italy, December 7, 1598;
died Rome, Italy, November 28, 1680

Bernini was the greatest Italian artist of the 17th century, and for much of his long career he was virtually the artistic dictator of Rome, running a large studio that was involved in most major commissions. He was mainly a sculptor and architect, but he was also—as a diversion—a brilliant painter. Most of his paintings, like this self-portrait (c.1620–25), date from early in his career, before his huge architectural and sculptural workload left no time for his "hobby."

BIOGRAPHY

▽ Bacchus and Ariadne
Luca Giordano c.1680–90
Museo Civico di Castelvecchio, Verona, Italy
Giordano was born and died in Naples, but he also worked in Florence and Venice, and in Spain in the service of Charles II for ten years from 1692. Versatile and prolific, he was famous for the speed at which he worked.

Bernini in Paris
In 1665 Bernini visits Paris, where he works for Louis XIV, but his designs for the main façade of the Louvre palace are rejected.

▽ Jacob's Dream
Salvator Rosa c.1660–70 *Chatsworth House, UK*
Rosa was a flamboyant, independent-minded character, and his work was highly varied. His most distinctive paintings were "wild" landscapes—such as this example—a type of his own invention. With their jagged forms and rough brushwork, they contrasted with the serene classical landscapes of Claude and Poussin.

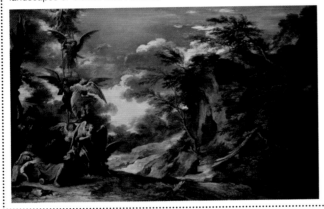

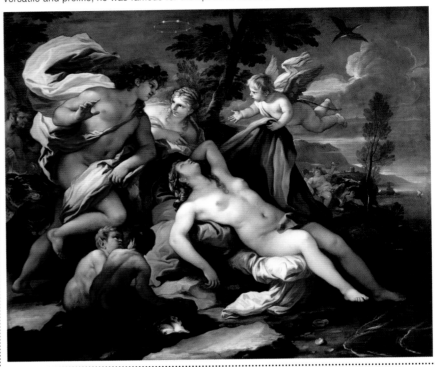

| 1650 | 1660 | 1670 | 1680 |

A brilliant debut
Carlo Maratta's altarpiece *The Adoration of the Shepherds* for the church of S. Giuseppe dei Falegnami, Rome—his first major public work—launches him on a highly successful career in 1650.

Lost lives
Plague ravages Naples and then Genoa in 1656 and 1657, killing about half the population of both cities—including virtually an entire generation of artists. Other places, including Rome, also suffer, though not to the same extent.

Grand old man
At the age of 87, the architect and sculptor Cosimo Fanzago dies in 1678 in Naples. For many years he has been the city's leading artist. His exuberant works often make use of colored marbles.

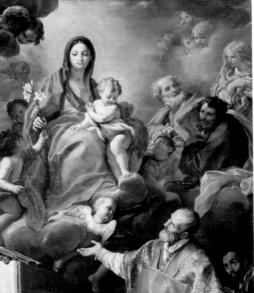

◁ The Virgin Mary Appearing to St. Philip Neri
Carlo Maratta c.1675
Palazzo Pitti, Florence, Italy
After the death of Bernini in 1682, Maratta became the dominant personality in the art world of Rome. He specialized in suave, grandiose religious paintings that often reworked High Renaissance precedents, with more movement and more overt emotion.

THE JESUITS

The Jesuit Order (or Society of Jesus) was founded in 1534 to support orthodox Catholic belief. This order of priests had a key role against Protestantism in the Counter-Reformation, and Jesuits were renowned for their zeal in missionary work and education. The order had many wealthy supporters and its churches were often richly adorned, notably the Gesù, the mother church in Rome, which was begun in 1568.

Main Altar at the Chiesa del Gesù, Rome, Italy

CONTEXT

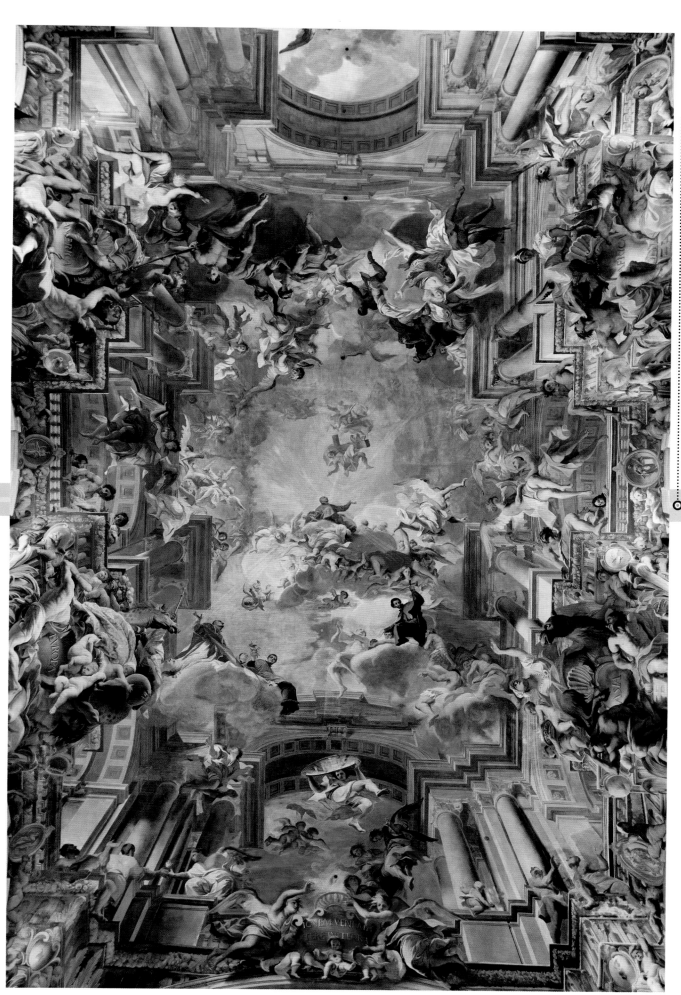

◁ **The Glory of St. Ignatius Loyola and the Missionary Work of the Jesuits**
Andrea Pozzo 1688–94
S. Ignazio, Rome, Italy
This breathtaking painting covers the ceiling of the nave of Sant'Ignazio, Rome, which is dedicated to St. Ignatius Loyola, the founder of the Jesuits, who is shown floating in ecstasy in the center. Pozzo was renowned as a virtuoso of perspective, on which he wrote a scholarly treatise (1693–1700).

Holy relic
In Turin in 1690, Guarino Guarini completes the Chapel of the Holy Shroud, a masterpiece of Baroque architecture, which houses the famous Turin Shroud.

1690

DRAW ALL THE LINES TO **THAT TRUE POINT**, THE **GLORY OF GOD**

1693 | Andrea Pozzo

◎ MASTERWORK

Aurora

Guercino **1622–23**
Casino of the Villa Ludovisi, Rome, Italy

A childhood accident to an eye earned Giovanni Francesco Barbieri (1591–1666) the nickname Guercino ("squinter"), by which he has been known ever since. He was born in Cento in northern Italy and spent most of his career there and in nearby Bologna. However, he also had a brief but significant two-year period in Rome from 1621. He moved there because one of his early patrons, Cardinal Alessandro Ludovisi, was elected pope as Gregory XV in 1621. When Gregory died only two years later, Guercino returned to his home in Cento.

Guercino received two major commissions in Rome because of his connections with the pope: a huge altarpiece for St. Peter's, and this gloriously exuberant fresco, which adorns a ceiling in the "casino"—a kind of summerhouse—of the Ludovisi family villa on the Pincian Hill. Aurora, the goddess of the dawn, rushes overhead in her chariot, dispersing the dark clouds of night. The steep recession of the painted architecture helps create the feeling that the ceiling is open to the sky. It is one of the first examples of such opening up in 17th-century painting (although the idea had been used earlier by Mantegna), and in this and in its vigorous, flowing composition, it looks forward to later Baroque ceilings by such artists as Cortona and Pozzo. Guercino had the help of a specialist collaborator, Agostino Tassi, for the architectural painting, which demanded great skill with perspective.

> ❝ THERE IS HERE AN **EXTRAORDINARY FREEDOM** OF HANDLING, **ALMOST SKETCHLIKE** IN EFFECT ❞
>
> 1958 | Rudolf Wittkower
> *Anglo-German art historian, on* Aurora

FLEMISH AND SPANISH BAROQUE

c.1600–1700 ARTISTIC LINKS

▷ **The Horrors of War**
Sir Peter Paul Rubens c.1638
Palazzo Pitti, Florence, Italy
Pulsating with Baroque energy and
emotion, this picture comments on
the war-torn times in which Rubens
lived. He explained that the
"grief-stricken woman clothed
in black" is "the unfortunate Europe
who, for so many years now,
has suffered plunder, outrage,
and misery."

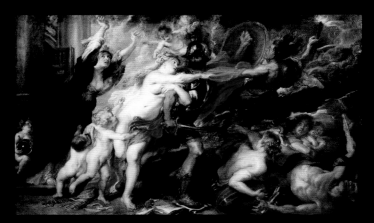

Spain and Flanders (a territory roughly equivalent to present-day Belgium) are widely separated in geographical terms, but there were powerful ties between them in the 17th century, since Flanders was part of Spain's extensive empire. There were strong artistic links too, not least because the supreme Flemish artist of the age—Peter Paul Rubens—twice visited Spain. On his second visit he befriended the greatest of Spanish painters, Diego Velázquez. Rubens exemplifies the Baroque style at its most dynamic and colorful. He was so vigorous, prolific, and versatile that he influenced a whole generation of his countrymen, including Anthony van Dyck, who worked for a time as his chief assistant. In Spain, there was great variety within the general trends of the time, from the somber grandeur of Francisco de Zurbarán to the lightness and exaltation of Bartolomé Esteban Murillo—both of them expressive of the country's religious fervor.

◎ CONTEXT

War and peace

In the 17th century the map of Europe differed greatly from the one we know now. Spain was declining from the peak of power it had enjoyed in the 16th century, but it still controlled widespread territories, including Flanders (sometimes called the "Spanish Netherlands") and parts of Italy. Spanish rule was often harsh, prompting discontent and rebellion. Flanders's northern neighbor, the Dutch Republic, won its freedom from Spain in 1609 after a bloody struggle, but Flanders itself remained a subject until 1713, when it became part of the Austrian empire.

Like Spain, Flanders was devoutly Catholic. Religious subjects were at the forefront of art in both countries, although other ones were becoming more prominent. Rubens was fortunate that he launched his career in

Antwerp at a time when a period of truce between Flanders and the Dutch Republic led to a spate of rebuilding and redecoration of churches that had been damaged in warfare.

Antwerp was one of the two leading art centers in Flanders (the other was Brussels, the home of the court of the Spanish governors). Although Antwerp had suffered grievous war damage in the later 16th century, the city recovered and in Rubens's time had become a major center of printing and the art market. In Spain, the capital Madrid—where Velázquez spent most of his career—was prominent in culture, but not overwhelmingly so. Several other Spanish cities were important centers of painting, notably Seville, which was the main port for the lucrative trade with Spain's colonies in the Americas.

KEY EVENTS

◎ Decline of an empire

▷ **1609** A 12-year truce begins between the Spanish Netherlands (Flanders) and the Dutch Republic.

▷ **1624** England declares war on Spain as part of the changing pattern of alliances of the Thirty Years War. At the end of the war in 1648, Spain's power is greatly reduced.

▷ **1649** In England, Charles I is executed during the English Civil War. Most of the king's famous art collection is sold, and some of the finest paintings are bought by the Archduke Leopold William, governor of the Spanish Netherlands.

▷ **1668** The Treaty of Lisbon ends a financially disastrous war (begun in 1640) between Spain and Portugal.

▷ **1700** Charles II of Spain dies. The country has declined in strength so much that Louis XIV of France is able to gain the throne for his own grandson, Philip V.

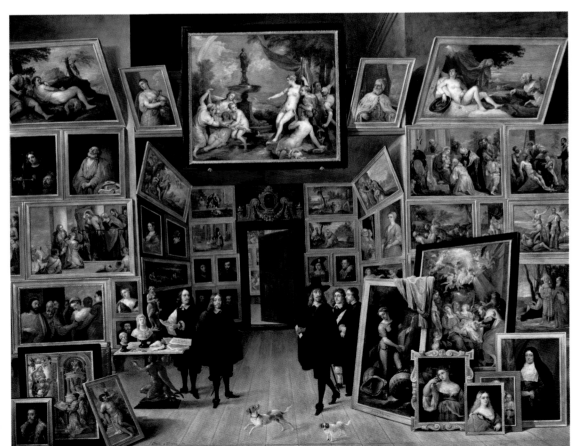

❝ GLORY TO THAT **HOMER OF PAINTING,** TO THAT **FATHER OF WARMTH** AND **ENTHUSIASM ❞**

1853 | Eugène Delacroix
French Romantic painter, on Rubens

The Archduke Leopold William in His Picture Gallery
Leopold William governed the Spanish Netherlands on behalf of Philip IV of Spain from 1646 to 1656. He formed one of the finest collections of paintings of the age.
c.1652, David Teniers the Younger, Prado, Madrid, Spain

◉ BEGINNINGS
YOUTHFUL ENDEAVOR

Rubens spent eight months in Spain in 1603–04 as part of a diplomatic mission from his employer, the Duke of Mantua, to King Philip III. At this time, painting in Flanders as well as Spain was still strongly influenced by the elegant, sophisticated, often rather artificial ideals of Mannerism. On his return to Flanders from Italy in 1608, Rubens was far and away the most important channel for introducing a more robust and modern style to his country. His work was influential in Spain too, but mainly after his second visit there in 1628–29. Baroque influence from Italy also found its way to Spain through the importing of paintings by Caravaggio and his followers.

◉ TURNING POINT

The Duke of Lerma on Horseback
Sir Peter Paul Rubens **1603** *Prado, Madrid, Spain*

When this portrait was painted, Francisco Gomez de Sandoval, 1st Duke of Lerma (1553–1625), was the most powerful man in Spain. The young monarch, Philip III, was a feeble, indolent character who left the business of government to his favorite, nicknamed "the king's shadow." Rubens probably painted the portrait at Valladolid, which had temporarily replaced Madrid as the capital of Spain. Lerma is depicted life-sized in a magnificent image of authority. He is coolly observant, although there is also a careworn or melancholic look about him that hints at his vulnerability and problems: his wife had recently died and he was under pressure from political opponents. Rubens was an accomplished horseman and he has clearly relished painting this superb specimen, with its flowing mane, alert ears, and almost soulful eyes. With this dynamic, youthful work Rubens set the tone for equestrian portraiture throughout the 17th century.

Sir Peter Paul Rubens

born Siegen, Germany, June 28, 1577;
died Antwerp, Flanders, May 30, 1640

Rubens was remarkably blessed by nature, having good looks, a fine brain, and a robust physique, as well as artistic genius. He made the best of these gifts, living a life of extraordinary success and achievement. He was even lucky in love, having two happy marriages that produced eight children. As befits the most famous painter of his time, he had an international career. He was born in Germany and lived mainly in Antwerp, but he spent an important formative period in Italy and visited the Dutch Republic, England, France, and Spain. With the help of a well-organized studio he produced a huge number and variety of paintings and designs. He also worked as a diplomat—putting his fluency in several languages to good use—and was knighted by the kings of both England and Spain for helping to negotiate peace between the countries.

BIOGRAPHY

◉ ARTISTIC INFLUENCES

Rubens was only 26 when he painted this portrait, but he had already studied more of the treasures of Italy than most artists of the time could hope to see in a lifetime. He was employed by the art-loving Duke of Mantua, who allowed him great freedom to travel. Thus, he was open to a wide range of influences.

Rubens first visited Florence in 1600, soon after arriving in Italy, and he passed through the city on the way to Spain in 1603. He would certainly have seen Giambologna's equestrian statue of Duke Cosimo I de Medici, recently erected in Florence's main square.

Equestrian statue of Cosimo I, 1587–94, by Giambologna, may have inspired Rubens. *Piazza di Signoria, Florence, Italy*

El Greco painted this famous picture for a chapel in Toledo. Rubens could not have seen the original, but the painting quickly became famous, and numerous copies were made.

St. Martin and the Beggar, c.1597, by El Greco has similarities to the Lerma portrait. *National Gallery of Art, Washington, DC*

In Madrid, Rubens saw Titian's famous equestrian portrait of the Holy Roman Emperor Charles V (*see p.116*) and painted a copy of the head. He must have seen other portraits of Charles, including perhaps this tapestry.

Charles V Reviewing His Troops, c.1550, by Jan Vermeyen. *Kunsthistorisches Museum, Vienna, Austria*

◎ TIMELINE

In the early part of the 17th century, several painters in Flanders and Spain were influenced by the somber art of Caravaggio, and dark tonality continued to be a striking feature of Zurbarán's work until the 1640s. Rubens was such a dominant figure in Flanders that few contemporary artists remained free of his influence—both van Dyck and Jordaens worked for him early in their careers. Spanish art had no similar fulcrum, and such individualistic painters as Murillo and Valdés Leal flourished together in Seville late in the century.

Peace and Plenty Binding the Arrows of War ▷
Abraham Janssen 1614
Wolverhampton Art Gallery, UK
Janssen was one of the leading contemporaries of Rubens in Antwerp, working in a solid, dignified style that reflected his knowledge of Italian art (he lived in Italy for several years around the turn of the 17th century). This allegorical painting was a prestigious commission from the Guild of Old Crossbowmen (Antwerp's chief group of volunteer citizen soldiers).

Landscape With Shepherds and Pilgrims ▷
Paul Bril c.1605
Pinacoteca Ambrosiana, Milan, Italy
Bril was a Flemish painter who spent most of his career in Rome. His charmingly artificial, exquisitely finished landscapes were popular with Italian collectors. His brother Matthew painted similar pictures.

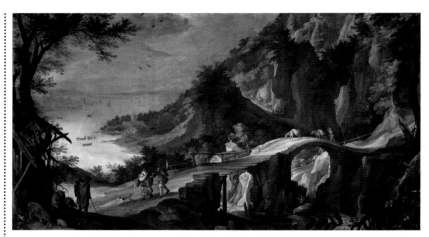

"The god of wood"
The great sculptor Juan Martínez Montañés, known as "the god of wood" because of his superlative skill as a carver, begins his celebrated *Christ of Clemency* for Seville Cathedral in 1603. It is finished in 1606.

1600	1603	1606	1609	1612	1615

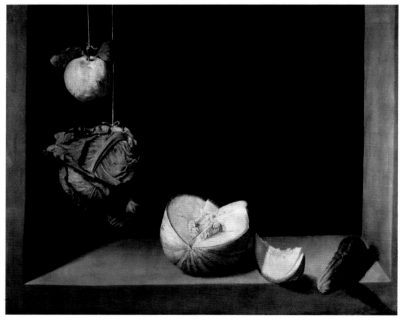

△ Still Life With Quince, Cabbage, Melon, and Cucumber
Juan Sánchez Cotán c.1600
San Diego Museum of Art, CA
Still life was a minor but distinctive speciality in Spanish art. Sánchez Cotán was mainly a religious painter and his still lifes have a rapt intensity that gives them a kind of mystical quality, in spite of the humble objects portrayed.

Court painter
Rubens returns from Rome to Antwerp in 1608 and is made court painter to the Spanish governors of Flanders the following year.

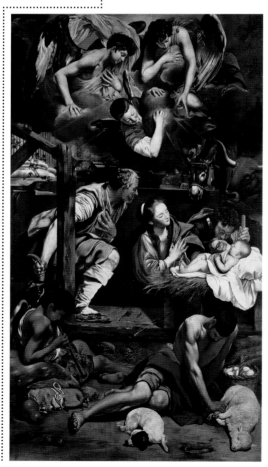

The Adoration of the Shepherds ▷
Juan Bautista Mayno 1612–13
Prado, Madrid, Spain
Mayno spent several years in Italy in the first decade of the century and was strongly influenced by Caravaggio, for example in his use of bold contrasts of light and shade and down-to-earth details. After taking holy orders in 1614, he painted only occasionally, notably producing a battle scene in the same series as Velázquez's (*see pp.176–77*).

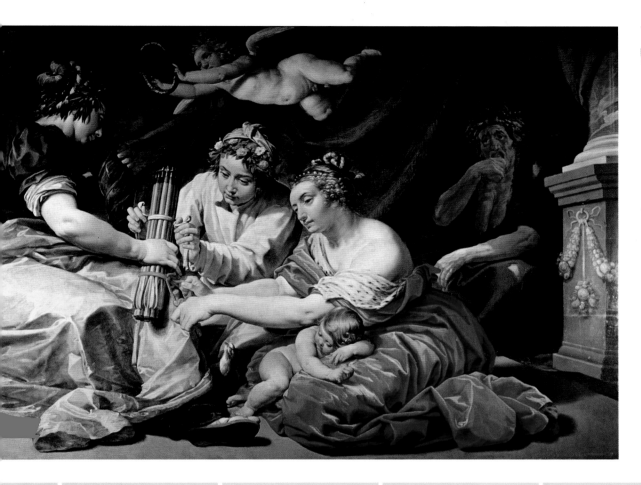

Van Dyck in England
In 1632 van Dyck moves from Antwerp to London, and is based there for the rest of his life as court painter to Charles I, although he makes lengthy visits to the Continent.

1618 **1621** **1624** **1627** **1630** **1633**

Diplomatic duties
Rubens is in England in 1629 and 1630 following a visit to Spain the previous year, negotiating peace between the countries. He is away from home for almost two years.

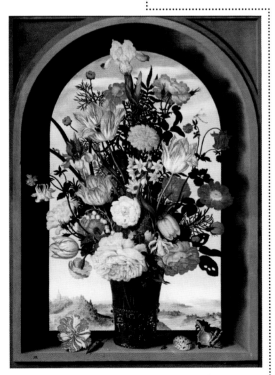

△ **Vase of Flowers**
Ambrosius Bosschaert c.1620
Mauritshuis, The Hague, Netherlands
The outstanding member of a family of painters, Bosschaert was a leading figure in establishing flower painting as an independent speciality. He was born in Antwerp but worked mainly in the Dutch Republic.

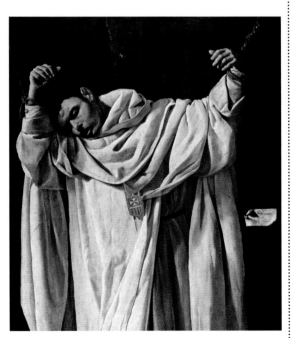

△ **St. Serapion**
Francisco de Zurbarán 1628
Wadsworth Atheneum, Hartford, CT
One of the most powerful religious painters of the age, Zurbarán is best known for austere, dramatic images of saints such as this. Serapion was a 12th-century monk who was killed by pirates.

Francisco de Zurbarán

baptized Fuente de Cantos, Spain, November 7, 1598;
died Madrid, Spain, August 27, 1664

Zurbarán spent most of his career in Seville, where he was the leading painter for several years, although he also worked for Philip IV in Madrid in 1634–35 and settled there late in life in 1658. His paintings were produced mainly for religious institutions including churches and monasteries, sometimes in the form of a series of images of saints. From the 1640s much of his work was exported to Spain's colonies in the Americas—in the 1650s he experienced financial problems when payments for his paintings were lost in naval warfare.

BIOGRAPHY

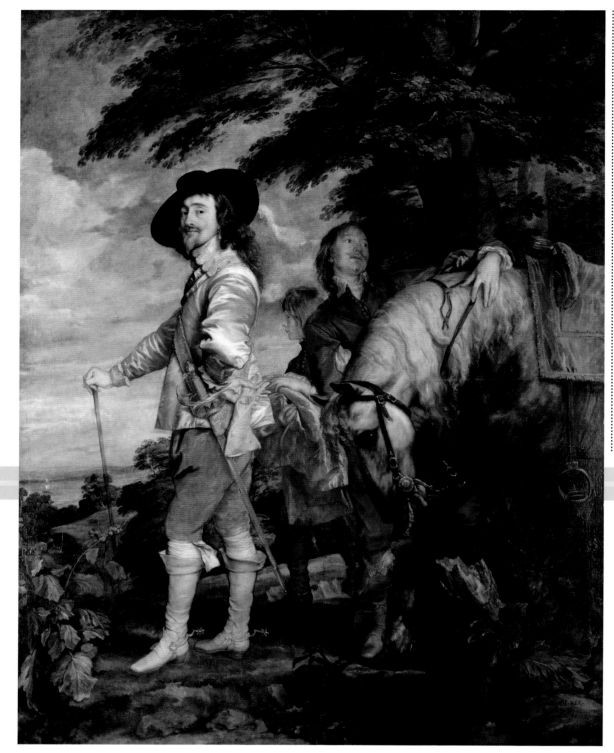

◁ **Charles I Out Hunting**
Sir Anthony van Dyck c.1635
Louvre, Paris, France
This is one of van Dyck's acknowledged masterpieces, showing all the aristocratic grace and refinement for which he is renowned. Charles was dignified but rather short; van Dyck uses a low viewpoint to help disguise this.

> **WITHOUT HIM** A CERTAIN STRAIN OF **MELANCHOLIC ELEGANCE** IS UNIMAGINABLE

1968 | Sir David Piper
British art historian, on van Dyck

Royal commission
Gianlorenzo Bernini completes a marble bust of Charles I in 1637. It is based on a portrait by van Dyck (showing three views of the head) sent to Bernini in Rome.

1634 **1637**

△ **Autumn Landscape With a View of Het Steen in the Early Morning**
Sir Peter Paul Rubens c.1636
National Gallery, London, UK
In 1635 Rubens bought a country house, the Château de Steen. It inspired him to produce some magnificent landscapes in which he showed his delight in the beauty and richness of nature.

BIOGRAPHY

Sir Anthony van Dyck

born Antwerp, Flanders, March 22, 1599;
died London, England, December 9, 1641

Van Dyck was a child prodigy and became Rubens's chief assistant when he was still in his teens. Like Rubens he had a glamorous international career, spending six years in Italy as a young man and most of the last decade of his life in England, as court painter to Charles I, who knighted him. He produced religious and mythological scenes, but he was primarily a portraitist—one of the greatest of all time. His work was an inspiration to later portraitists, especially in Britain.

▽ The King Drinks
Jacob Jordaens c.1640
Musées Royaux des Beaux-Arts, Brussels, Belgium
After Rubens died in 1640, Jordaens became Flanders's leading figure painter. His style was strongly influenced by Rubens, but was much more down to earth. This rollicking scene depicts a popular Flemish Twelfth Night festivity when one participant became "king for the night."

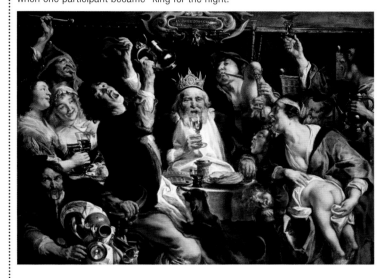

⊚ Diego Velázquez
baptized Seville, Spain, June 6, 1599; **died** Madrid, Spain, Aug 6, 1660

Velázquez spent most of his life working in Madrid as the favorite painter of the art-loving King Philip IV. He was mainly a portraitist, but also painted religious, mythological, and historical subjects, as well as—early in his career—superb everyday life scenes. He made two visits to Italy, on the second of which he had one of his greatest triumphs with a portrait of Pope Innocent X. The Pope thought it was so incisive in characterization that he called it "too truthful."

Portrait of Pope Innocent X, Galleria Doria Pamphili, Rome, Italy

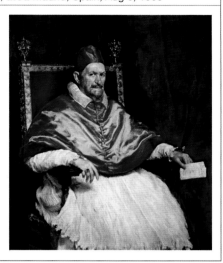

Art treatise
Francisco Pacheco's book *Art of Painting* is posthumously published in Seville in 1649. It is an important source of information on Spanish art of the time.

Court portrait
In 1656 Velázquez completes his most famous painting, *Las Meninas* ("The Maids of Honor"), a complex court group portrait that takes its name from a young princess's attendants.

1640 ⊙ **1643** **1646** **1649** **1652** **1655** ⊙ ⊙ **1658** ▶

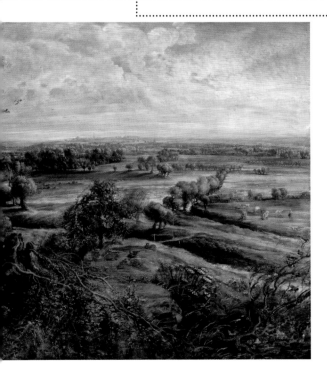

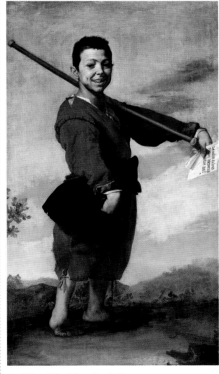

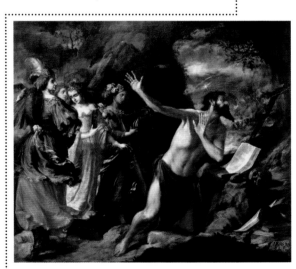

△ The Temptation of St. Jerome
Juan de Valdés Leal 1657
Museo de Bellas Artes, Seville, Spain
Valdés Leal specialized in religious subjects, which he treated in a highly personal style—nervous, energetic, and often with macabre elements. St Jerome's "temptation" shows the sexual hallucinations he endured.

△ The Clubfooted Boy
Jusepe de Ribera 1642
Louvre, Paris, France
This portrait of a Neapolitan beggar boy is one of Ribera's most famous works. It was painted on commission for an art dealer.

Bartolomé Esteban Murillo

baptized Seville, Spain, January 1, 1618;
died Seville, April 3, 1682

BIOGRAPHY

Murillo spent almost all his life in Seville, where he was the leading painter from the late 1640s until his death. His early work was influenced by the somber style of Zurbáran, but he developed a much lighter, freer, and more colorful manner. Throughout the 18th century and well into the 19th century, he was the most famous and admired of all Spanish painters. His reputation later declined and for many years he was generally dismissed as sentimental, but his status has risen again.

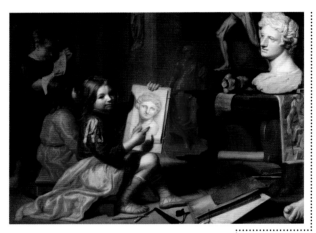

◁ The Painter's Studio
Jacob van Oost 1666
Groeningemuseum, Bruges, Belgium
Van Oost worked mainly in Bruges, where he was the leading painter of his time. He mainly painted religious works and portraits, but he sometimes ventured into other fields, as seen in this charmingly sentimental scene of child artists.

1660 **1665** ○ **1670**

Academy founded
Spain's first art academy is founded in Seville in 1660. Murillo is appointed joint president, together with Francisco Herrera the Younger, a painter and architect.

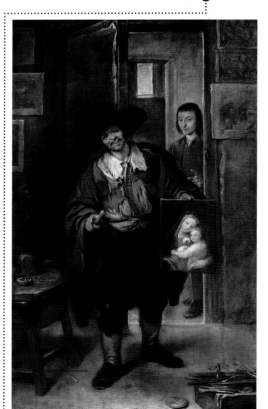

The Picture Dealer ▷
José Antolínez c.1670
Alte Pinakothek, Munich, Germany
Antolínez specialized in religious subjects, but his most distinctive painting is this highly unusual image of a poor artist (perhaps a mocking self-portrait) trying to sell his work.

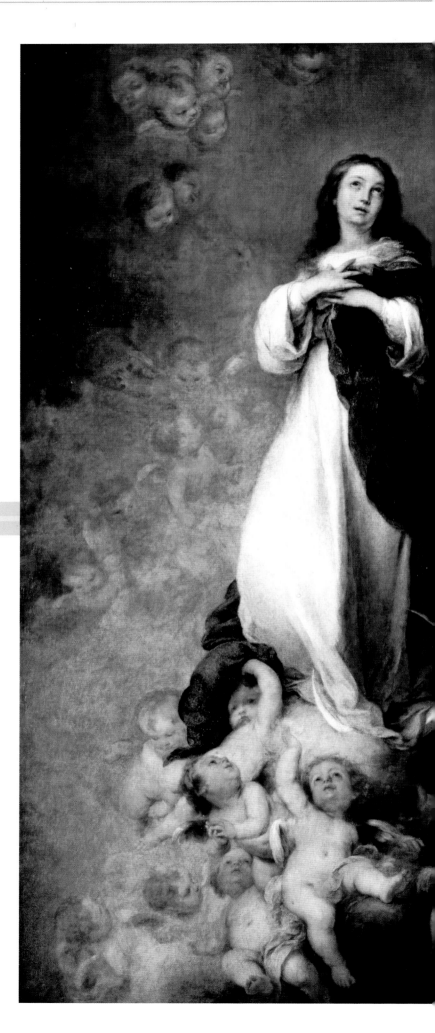

◁ **The Immaculate Conception**
Bartolomé Esteban Murillo c.1680
Louvre, Paris, France
This was Murillo's favorite subject, which he depicted numerous times. The Immaculate Conception is the name for the Catholic belief that the Virgin Mary—from the moment of being conceived in her mother's womb—was free of original sin, which was innate in all other human beings.

❝ [MURILLO] WAS **UNDOUBTEDLY** ONE OF THE **GREATEST RELIGIOUS PAINTERS** OF THE BAROQUE ERA ❞

1983 | Diego Angulo Iñiguez
Spanish art historian

◁ **Charles II Adoring the Host**
Claudio Coello 1685–90
Escorial, Madrid, Spain
Coello was the leading religious painter in Madrid in his period and this is his masterpiece—a huge altarpiece set in an elaborate architectural framework. It features about 50 portraits of members of the court.

Italian master
The Italian artist Luca Giordano is summoned to Madrid by Charles II in 1692. He becomes the leading decorative painter for the next decade, carrying out a huge amount of work.

1675 **1680** ○ **1685** ○ **1690** ○

Court portraitist
Juan Carreño de Miranda dies in Madrid in 1685. With the great exception of his friend Velázquez, he was Spain's best court portraitist of the time. He also painted religious works.

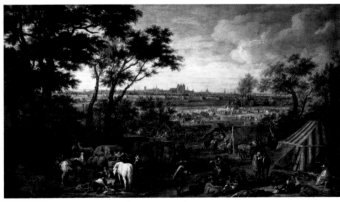

The Siege of Tournai △
Adam Frans van der Meulen 1684
Musées Royaux des Beaux-Arts, Brussels, Belgium
Van der Meulen was born in Brussels and spent most of his career in France, where he worked as a military painter for Louis XIV. His paintings, such as this example, were based on drawings made on the spot.

THE ESCORIAL

An enormous monastery-palace near Madrid, the Escorial is the burial place of most of Spain's monarchs. It was begun in 1563 and officially completed in 1584, although building work continued after this. Although externally the Escorial is overwhelmingly severe, internally it has extraordinarily lavish decoration, including a vast amount of painting in the form of frescoes, altarpieces, and other works.

Southern facade of the Escorial

CONTEXT

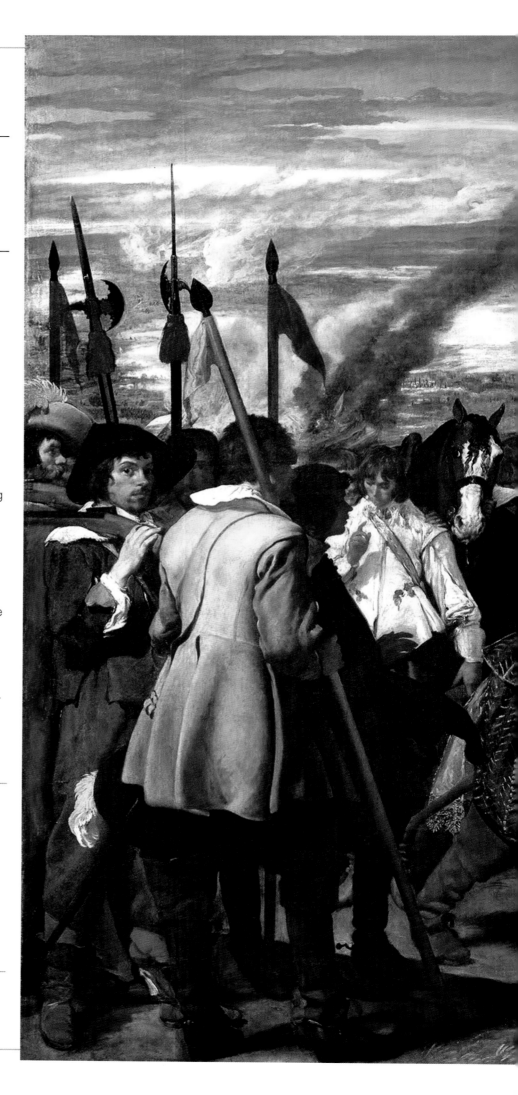

⊙ MASTERWORK

The Surrender of Breda

Diego Velázquez **1634–35**
Prado, Madrid, Spain

In 1630 Philip IV began building a new palace on what was then the outskirts of Madrid. It was designed to be a place of recreation away from the center of the city, hence its name—*Buen Retiro* (literally "good retreat"). The palace, which was almost totally destroyed in the 19th century, was lavishly adorned with art, including a series of 12 life-size paintings in the Hall of Kingdoms (the main state room) depicting the principal military victories of Philip's reign. This commission was divided among several of the leading Spanish artists of the day, among them Juan Bautista Mayno, Francisco de Zurbarán, and Diego Velázquez, who rose to the occasion with this work of 1634–35, one of his supreme masterpieces.

It depicts the Spanish general Ambrogio Spinola accepting the keys of Breda from his Dutch counterpart Justin of Nassau, after the Spaniards had captured the fortified city in 1625. Both generals were dead by the time Velázquez painted the picture. He had known Spinola fairly well, but he never met Justin, and he never went to Breda. He based his representation of the scene on engravings and descriptions, but he makes everything seem utterly real. The usual convention in such battle pictures was to show the defeated general on bended knee before his conqueror, but Velázquez creates a much more interesting and convincing human drama by depicting Justin merely bowing as the chivalrous Spinola places a consoling hand on his shoulder.

Breda was one of the last important victories of Philip's reign, and in 1637, only two years after Velázquez finished the painting, the Dutch retook the city.

❝❝ A PAINTER OF **HUMANITY IN THE CONCRETE**, A **SEARCHER** AFTER THE **POETRY OF LIFE** ❞❞

1943 | Enrique Lafuente Ferrari
Spanish art historian, on Velázquez

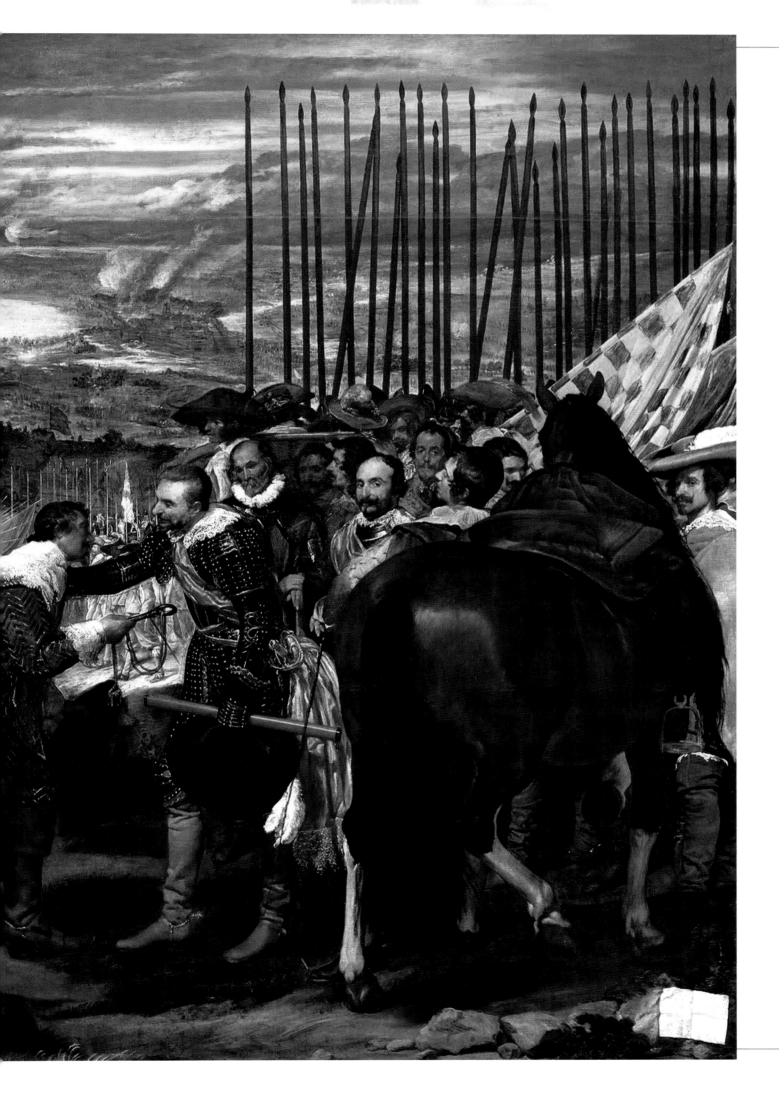

DUTCH BAROQUE

c.1600–1700 A GOLDEN AGE

▷ Self-portrait
Rembrandt c.1665
Kenwood House, London, UK
In this majestic self-portrait, Rembrandt—depicted with the tools of his trade—expresses the dignity of his profession. His early self-portraits had often been touched with Baroque flamboyance, but in his later work he was more concerned with inner life than outer show.

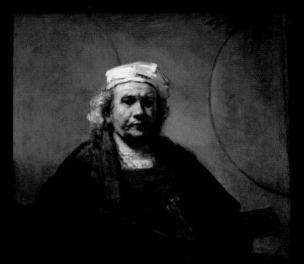

During the 17th century, Dutch painting burst into bloom in a way that has no parallel in the history of art. In the space of a few decades, the Dutch Republic (what we now call the Netherlands, or Holland) grew from an artistic backwater into the home of the most vigorous and varied school of painting in Europe. This remarkable transformation reflected the equally swift development of the country from a fringe state that was battling for its existence to a commercial giant with the best merchant navy in the world. Some Dutch paintings have strong Baroque features—the ostentation of Hals's *Laughing Cavalier*, for example, or the movement and passion of *The Blinding of Samson* by Rembrandt—but there is such diversity of subject and style among the artists of the period (contrast Brouwer with Vermeer, for example) that there is no clear overall trend.

◎ CONTEXT

A new republic

In 1578 a revolt began against Spanish rule in the Netherlands, and in 1579 seven provinces in the northern part of the territories joined together to form the Republic of the United Netherlands. This new country (also known at the time as both the United Provinces and the Dutch Republic) effectively gained its independence in 1609, when a truce was signed with imperial Spain, although the Spanish did not officially recognize the new status of their former territory until the end of the Thirty Years' War in 1648.

The long and bloody struggle for freedom helped to create a strong sense of national pride that is directly expressed in 17th-century Dutch art. In other countries, the main patrons of art were still the traditional ones—Church, royalty, and aristocracy—but in the Dutch Republic art was produced primarily for the middle classes, the kind of citizens who had created its stability and prosperity. They liked paintings that celebrated their achievements, possessions, and surroundings—portraits, landscapes, everyday life scenes, and so on.

The success of the city of Amsterdam summed up the success of the country. Between 1610 and 1640 its population tripled from about 50,000 to 150,000, and it became one of the world's leading centers of commerce and finance. Its huge new town hall (now the Royal Palace), built in 1648–55, was a triumphant symbol of the golden age.

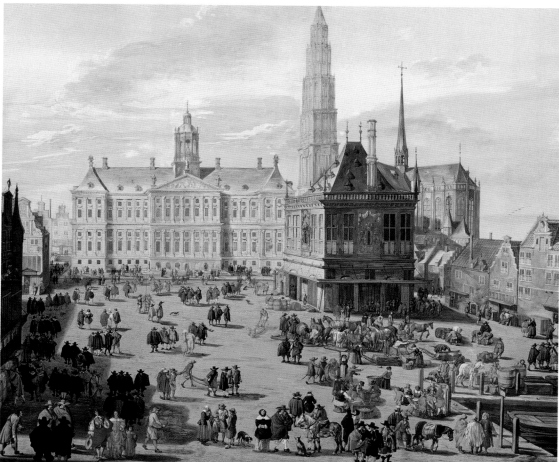

❝❝ PICTURES ARE **VERY COMMON HERE,** THERE BEING **SCARCE AN ORDINARY TRADESMAN** WHOSE HOUSE IS **NOT DECORATED WITH THEM ❞❞**

1641 | John Evelyn
English diarist, on the popularity of painting in the Dutch Republic

Dam Square, Amsterdam
Amsterdamers proudly called their new town hall "the eighth wonder of the world." In this painting of 1659 by Jacob van der Ulft, it dominates the city's bustling main square.
Musée Conde, Chantilly, France

◎ BEGINNINGS
FROM MANNERISM TO NATURALISM

Haarlem was one of the first cities in the new Dutch Republic to emerge as an important center of painting. In fact, its tradition of painting stretched back to the 15th century, but its art—like all other aspects of life—suffered grievously in the 1570s when the city was captured by the Spanish in 1573, and then partly destroyed in a great fire in 1576. However, Haarlem quickly recovered, and between about 1575 and 1625 its population doubled from 20,000 to 40,000. Several artists in the city were significant in this period of transition from Mannerism to a more forceful Baroque style, but Frans Hals was easily the most important of them. His portraits have a sense of spontaneity and informality that was fresh and invigorating. The sitters in his paintings do not pose stiffly, but seem at ease. In his group portraits, the figures interact with each other and engage with the spectator, through gestures, smiles, and glances. This liveliness is enhanced by Hals's bold, sweeping brushwork.

◉ ARTISTIC INFLUENCES

Haarlem was probably the most artistically stimulating city in the Dutch Republic in Hals's youth (its neighbor Amsterdam later became more important). Painters there were beginning to nurture the natural outlook on which Dutch art was founded. In addition to local influences, Hals could—like all artists of the time—have learned from engravings of foreign (particularly Italian) paintings.

Geertgen tot Sint Jans was the outstanding painter in Haarlem in the late 15th century. His skill in handling groups of figures looks forward to Hals, who certainly knew this painting, and may even have restored it.

The Burning of the Bones of St. John, c.1485, is depicted in this panel by Geertgen. *Kunsthistorisches Museum Vienna, Austria*

Group portraiture already had a distinct tradition in the region when Hals painted his first civic guards picture. Maerten van Heemskerck, who worked mainly in Haarlem, painted this example in about 1530.

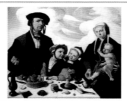

Pieter Jan Foppeszoon and His Family, 1530, Heemskerck, shows one of Haarlem's city council. *Gemäldegalerie, Kassel, Germany*

Karel van Mander is said to have been Hals's teacher. Certainly he was one of the leading art figures in Haarlem when Hals was growing up. He is best remembered for an art treatise published in 1604.

This engraved portrait of Karel van Mander was published in 1817, but it is based on a likeness from his own time. *Private Collection*

Biblical feast scenes provide a precedent for Hals's lively groups at a table. Hendrik Goltzius, who engraved this one, was a friend of van Mander and one of the outstanding printmakers of the period.

Christ at the Marriage at Cana, c.1553 is an engraving by Goltzius of a fresco by Francesco Salviati. *British Museum, London, UK*

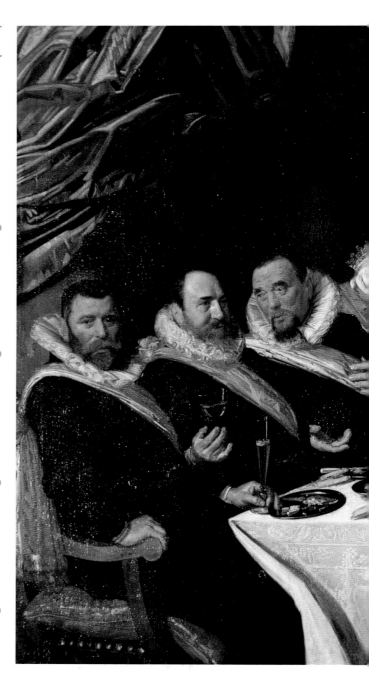

◎ TURNING POINT

Banquet of the Officers of the St. George Civic Guard Company of Haarlem

Frans Hals **1616** *Frans Halsmuseum, Haarlem, Netherlands*

This exultant group portrait is the first great landmark in Dutch painting, celebrating the vigor and self-confidence of the new republic. Civic guards were citizens who did military training in order to defend their homeland when the need arose. With peace and prosperity, their companies became more important as social clubs— their banquets were sumptuous affairs that sometimes went on for days. Hals was a member of the St. George Company; he knew these bold, burly men well and brings them vividly to life.

◎ **Frans Hals**

born Antwerp, Flanders 1582/83;
died Haarlem, Netherlands, August 29, 1666

Hals was the leading portraitist in Haarlem throughout his career (he rarely painted other subjects) and had many prestigious commissions, especially for group portraits, which were particularly popular in the Dutch Republic. In spite of his success (and continuing to work until the end of his long life), he often had financial problems, probably because he had a large family to support (he had at least ten children). It used to be thought that he was an alcoholic and wife beater, but it is now known that the unsavory person in question was a cousin with the same name.

BIOGRAPHY

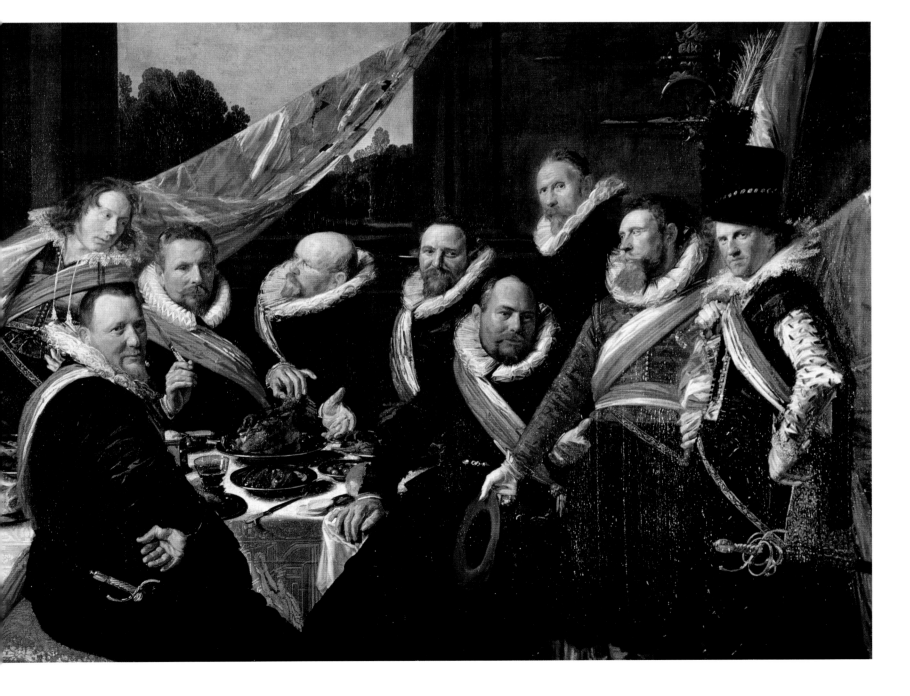

◎ TIMELINE

Early in the 17th century there was some distinct Italianate (especially Caravaggesque) influence in Dutch painting, and at the end of the century French influence—marked by suave elegance—became pervasive. For the most part, however, Dutch painting of the golden age is remarkable for its vigor, variety, and independence of spirit. Almost every type of painting flourished and most artists were specialists, concentrating on one or two types of picture. Rembrandt was the great exception.

◎ Hendrick Avercamp

baptized Amsterdam, Netherlands, January 25, 1585; **buried** Kampen, Netherlands, May 15, 1634

Avercamp spent most of his career in the provincial town of Kampen. Little is known of his life and he perhaps lived in seclusion, since he was deaf and mute—he was nicknamed "*de Stomme van Kampen*" ("the mute of Kampen"). He was an outstanding draftsman as well as a painter, producing tinted drawings as finished works. His nephew Barent Avercamp (1612–79) imitated his style.

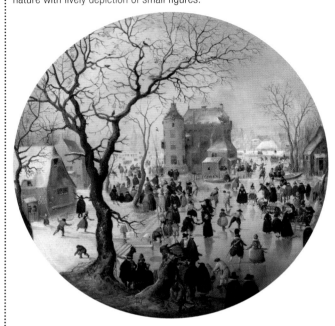

▽ Winter Scene with Skaters near a Castle
Hendrick Avercamp c.1610 *National Gallery, London, UK*
Avercamp was the first Dutch painter to specialize in winter landscapes—a type that became very popular. This example is typical of his work in combining sensitive observation of nature with lively depiction of small figures.

Book of Painters
In 1604 Karel van Mander's *Het Schilderboek* (*The Book of Painters*), an important source of art-historical information, is published in Haarlem.

Terbrugghen in Rome
Hendrick Terbrugghen arrives in Rome c.1605 and lives there for about a decade. After returning to Utrecht in 1614 he becomes—with Gerrit van Honthorst—one of the foremost Dutch exponents of Caravaggio's style.

1600 **1605** **1610** **1615**

Guild member
Frans Hals becomes a member of the painters' guild in Haarlem in 1610, the first documented date in his career. The guild is said to have been founded in the 1490s.

Adoration of the Shepherds △
Joachim Wtewael c.1605 *Ashmolean Museum, Oxford, UK*
The elegant artificiality of this scene is typical of Wtewael, who continued elements of the Mannerist style well into the 17th century. He worked in Utrecht, the main center of Catholicism (and religious painting) in a largely Protestant country.

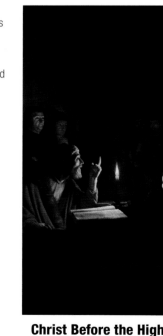

Christ Before the High Priest △
Gerrit van Honthorst c.1617
National Gallery, London, UK
Honthorst spent several years in Italy early in his career and was one of the leading Dutch followers of Caravaggio, although his style later became much lighter.

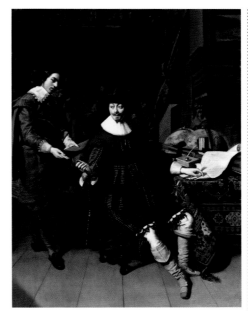

◁ The Laughing Cavalier
Frans Hals 1624
Wallace Collection, London, UK
The roguish smile and swaggering pose of this unknown man caught the imagination of the Victorian public—the misleading title (he is not laughing) was coined in about 1880. The brilliantly painted costume features various symbols that allude to the pleasures and pains of love.

◁ Constantijn Huygens and His Clerk
Thomas de Keyser 1627
National Gallery, London, UK
De Keyser was the leading portraitist in Amsterdam before Rembrandt eclipsed him in the early 1630s. Constantijn Huygens was one of his most distinguished sitters—a highly cultivated diplomat who served his country loyally for more than 60 years.

1620 **1625** **1630** **1635** ▶

Stately church
In 1620 work starts on building the Westerkerk (West Church) in Amsterdam, a major Protestant church (in which Rembrandt is later buried). It is designed by the architect and sculptor Hendrick de Keyser, father of the painter Thomas de Keyser.

Adriaen Brouwer

born Oudenaarde?, Flanders, c.1605;
buried Antwerp, Flanders, February 1, 1638

Brouwer was Flemish by birth and he spent the final years of his short life in Antwerp, but he worked in Haarlem for a significant part of his career and is consequently considered part of the history of Dutch as well as Flemish art. He is said to have been a pupil of Frans Hals. Their subjects are entirely different, but there is a kinship of spirit in their agile brushwork. Brouwer evidently led a dissolute life; certainly he was regularly in debt and he seems to have died a pauper.

BIOGRAPHY

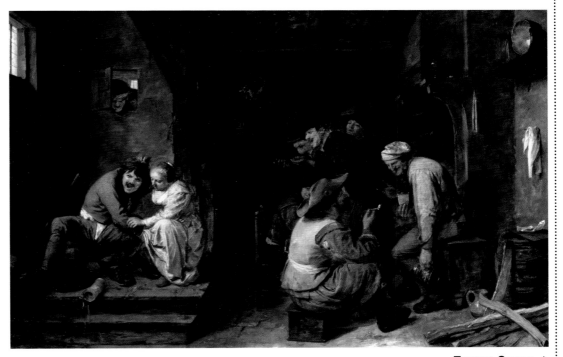

Tavern Scene △
Adriaen Brouwer c.1635 *National Gallery, London, UK*
Although he was only about 32 when he died, Brouwer played an important role in popularizing rowdy scenes of peasant life, such as this. His subject matter is often coarse, but his brushwork has a lovely sparkle and delicacy. His many admirers included Rubens and Rembrandt, both of whom owned examples of his work.

▽ The Blinding of Samson
Rembrandt 1636 *Städelsches Kunstinstitut, Frankfurt, Germany*
This is one of Rembrandt's most powerful and dramatic biblical scenes. The figures are
life-size and the blinding of the Israelite hero is shown with horrific directness. However,
the light streaming into the dark tent is depicted with wonderful sensitivity.

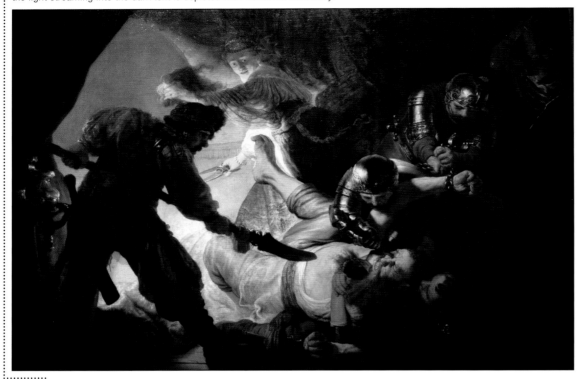

Rembrandt

born Leiden, Netherlands, July 15, 1606;
died Amsterdam, Netherlands,
October 4, 1669

Even in a golden age of Dutch art,
Rembrandt van Rijn stands out as a
colossus—revered for the depth of
feeling and technical mastery of his
work. Most of his paintings are
portraits or religious scenes, but he
tackled many other subjects and he
was also a superb draftsman and
printmaker. In addition, he was the
greatest art teacher of his day, with an
impressive list of distinguished pupils.

BIOGRAPHY

▶ 1635 1640 1645 1650 1655 1660

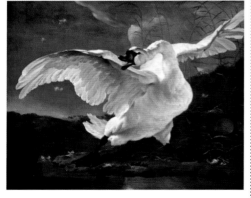

The Threatened Swan △
Jan Asselyn c.1640–50
Rijksmuseum, Amsterdam, Netherlands
Asselyn was mainly a landscapist, but his most
famous painting is this striking picture of an angry
bird. It was probably intended to have patriotic
symbolism—the swan (the Dutch Republic) defending
its nest against its enemies.

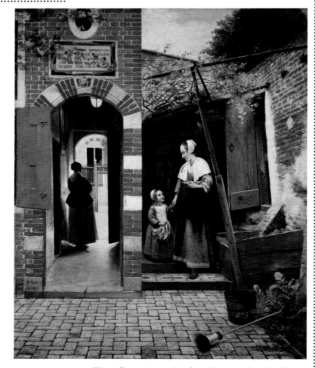

The Courtyard of a House in Delft △
Pieter de Hooch 1658
National Gallery, London, UK
Better than probably any other painter, De Hooch evokes a sense
of the peaceful, orderly well-being of Dutch society at the height
of its success. His best work, including this picture, was done in
Delft, where he lived from about 1655 to 1661.

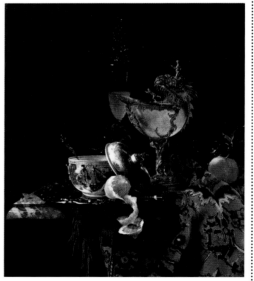

Still Life with a Chinese Bowl △
Willem Kalf 1662
*Museo Thyssen-Bornemisza,
Madrid, Spain*
Kalf was one of the greatest of all still-life
painters, with an exquisite feeling for color and
texture. This example shows the kind of exotic,
luxury objects that were imported into the Dutch
Republic through its worldwide trade.

Jan Vermeer

baptized Delft, Netherlands, October 31, 1632; **buried** Delft, December 16, 1675

BIOGRAPHY

Vermeer seems to have spent all his life in Delft, where he worked as a picture dealer as well as a painter. Only about three dozen paintings by him are known, and he must have been a slow-working perfectionist. When he died, aged 43, he left his widow and 11 children with heavy debts, partly caused by the disastrous effect of warfare (particularly the French invasion of 1672) on the art market. He was virtually forgotten for two centuries before his work was rediscovered in the mid-19th century.

The Mill at Wijk bij Duurstede ▽
Jacob van Ruisdael c.1670
Rijksmuseum, Amsterdam
Ruisdael was the greatest of all Dutch landscape painters—unrivaled in the variety, grandeur, and emotional depth of his work. Here, he adopts a low viewpoint so that the windmill looms majestically against the dramatic, cloud-laden sky.

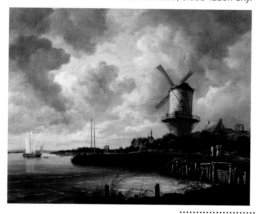

IN EVERYTHING THAT **VERMEER PAINTED** THERE LIES IN SUSPENSION... A **DREAMLIKE PEACE**, A **COMPLETE STILLNESS**

1941 | Johan Huizinga
Dutch historian

1665 **1670**

Final masterpieces
In 1664 Frans Hals, now in his 80s, paints group portraits of the regents and regentesses of the old men's almhouse in Haarlem—his last great works. Two years later he dies impoverished.

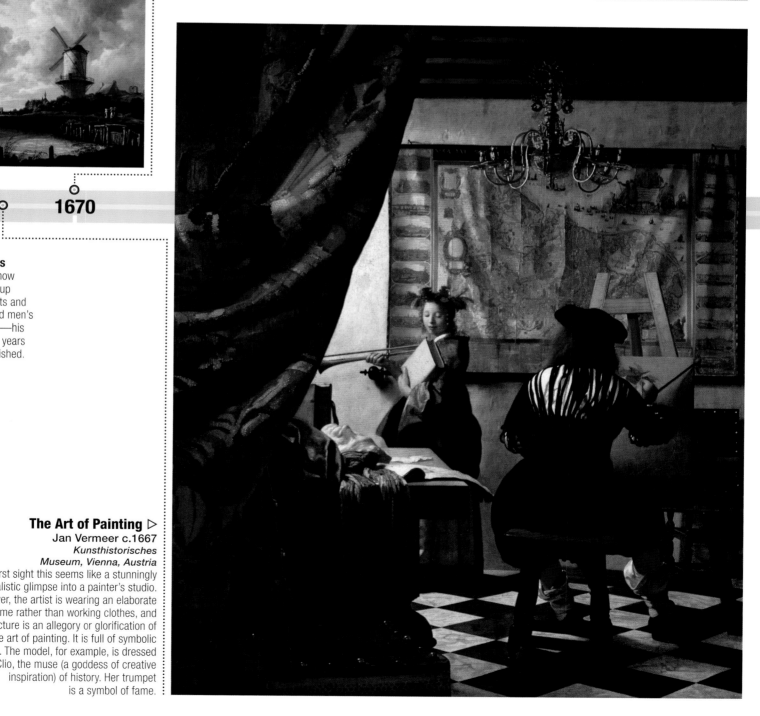

The Art of Painting ▷
Jan Vermeer c.1667
Kunsthistorisches Museum, Vienna, Austria
At first sight this seems like a stunningly realistic glimpse into a painter's studio. However, the artist is wearing an elaborate costume rather than working clothes, and the picture is an allegory or glorification of the art of painting. It is full of symbolic details. The model, for example, is dressed as Clio, the muse (a goddess of creative inspiration) of history. Her trumpet is a symbol of fame.

Willem van de Velde the Younger

baptized Leiden, Netherlands, December 18, 1633;
died London, England, April 6, 1707

BIOGRAPHY

Van de Velde is the most famous Dutch marine painter. He came from a nautical family and had a deep understanding of ships and the sea in all its moods, as well as an unerring gift for handsome and dramatic composition. In 1672–73 he and his father (the painter Willem van de Velde the Elder) settled in England, and he had a powerful influence on British marine painting. Turner greatly admired him.

▽ The Cannon Shot
Willem van de Velde the Younger 1680
Rijksmuseum, Amsterdam, Netherlands
This is perhaps van de Velde's masterpiece—one of the most majestic marine pictures ever painted. The ship is a man-of-war, but the cannon shot it fires is a salute as it sets sail rather than an attack on another vessel. Details of the ship are expertly observed, but never fussy.

Interior of the Grote Kerk ▷
Gerrit Berckheyde 1673
National Gallery, London, UK
Townscape and architectural painting was one of the distinctive specialities of Dutch art, and church interiors formed a subdivision within this category. Often the imposing Gothic churches were shown virtually empty, but here Berckheyde depicts a large congregation.

1670 **1675** **1680** **1685**

War at sea
The Anglo-Dutch Wars provided subjects for several paintings by Willem van de Velde the Younger, including—in 1686—one of his finest works, *The Gouden Leeuw at the Battle of Texel.*

◁ Merrymaking at an Inn
Jan Steen 1674
Louvre, Paris, France
Steen painted various types of pictures, but he is best known for boisterous scenes of everyday life such as this, in which he showed up human foibles and follies (drunkenness is a common theme). However, his moralizing tends to be lighthearted.

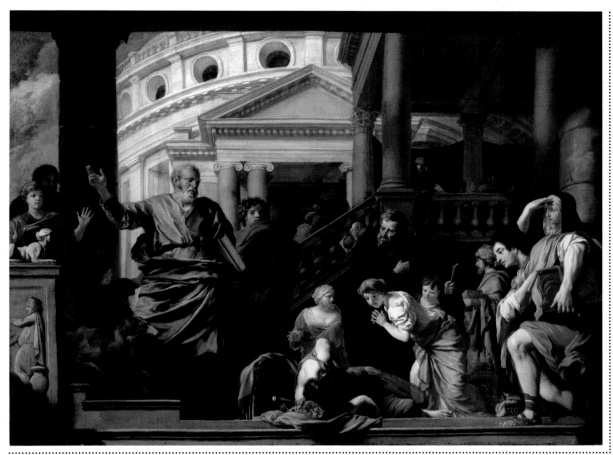

◁ The Death of Ananias
Gérard de Lairesse 1687
Gemäldegalerie, Kassel, Germany
This suave, handsome biblical scene exemplifies the Dutch influence that suffused French art in the later 17th century. Lairesse's contemporaries nicknamed him "the Dutch Poussin." He went blind in about 1690 and turned very successfully to lecturing and writing on art, his books being translated into several languages.

> " YOUR **BEAUTIFULLY VARIEGATED FESTOONS**, BOUQUETS, AND WREATHS... **PAINTED WITH A BRILLIANCE** FEW CAN MATCH "
>
> 1697 | Hieronymus Sweerts
> *Dutch poet, on Rachel Ruysch*

1690 **1695** **1700**

The Avenue △
Meindert Hobbema, 1689
National Gallery, London, UK
Hobbema was the only recorded pupil of Jacob van Ruisdael. He was strongly influenced by his master, but usually sunnier in mood. This, his most famous work, is generally regarded as the last great masterpiece of 17th-century Dutch landscape painting, beautifully balancing grandeur and intimacy.

Flowers on a Ledge △
Rachel Ruysch 1695
Private Collection
Flower painting was probably the only area in which the standards of 17th-century Dutch art were sustained—and perhaps even surpassed—in the 18th century. Remarkably, there was another Dutch flower painter of the time, Jan van Huysum (1682–1749), who rivaled Rachel Ruysch in international fame.

Rachel Ruysch

baptized The Hague, Netherlands, June 3, 1664; **died** Amsterdam, Netherlands, August 12, 1750

Ruysch specialized almost exclusively in paintings of flowers (and occasionally fruit). She was extremely successful in her lifetime: her wealthy international clientele was prepared to pay well for her extraordinarily polished technique, and contemporary poets sang her praises. She continued working well into her 80s, but her output was fairly small (there are about 100 known paintings by her), since her painstaking craftsmanship was so time-consuming. Her reputation as one of the greatest of all flower painters has endured.

BIOGRAPHY

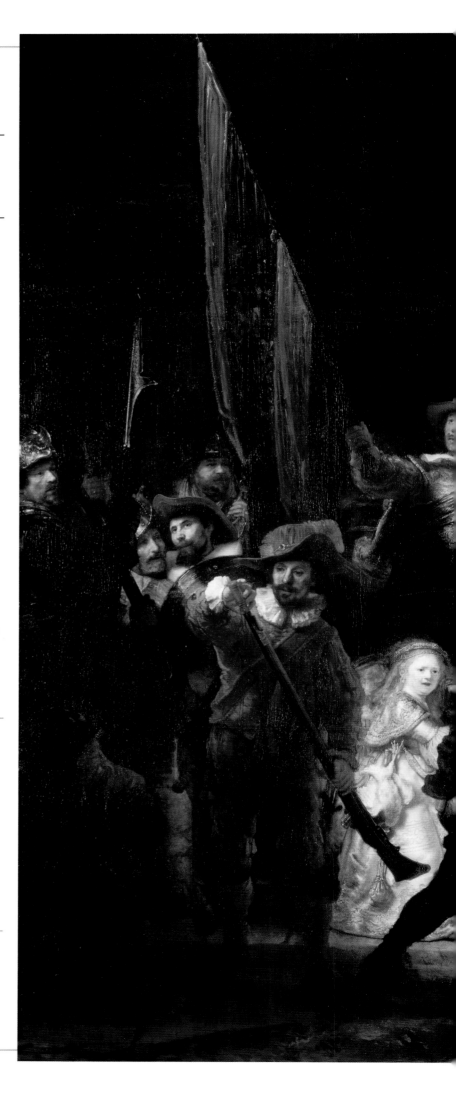

◎ MASTERWORK

The Night Watch

Rembrandt **1642**
Rijksmuseum, Amsterdam, Netherlands

In 1636 a new wing was added to a prominent building in Amsterdam, the Kloveniersdoelen—headquarters of a branch of the civic guard (the name can be loosely translated as "musketeers' meeting hall"). Between 1639 and 1645 the impressive great hall of the new wing was hung with a series of eight large group portraits of guards commissioned from some of the city's leading artists. Among them was Rembrandt, whose contribution to the design is now his most famous painting. Its familiar title was not used until the 19th century, when the picture was so darkened by old, dirty varnish that it looked like a nocturnal scene. It was cleaned soon after World War II, emerging as a daylight scene, but the name "The Night Watch" is now hallowed by usage. The more formal title is *The Militia Company of Captain Frans Banning Cocq and Lieutenant Willem van Ruytenburgh*. Captain Cocq is the figure in black in the center, giving an order to his lieutenant as their men prepare to march.

The Night Watch brings the Dutch tradition of civic guard portraiture to a rousing conclusion. Such paintings fell out of fashion soon afterward, since peace was now so firmly established. Rembrandt showed great originality in making a complex visual drama from a commonplace event. It is a popular myth that the guardsmen portrayed were dissatisfied with the painting—thinking they should all have been given equal prominence—and asked for their money back. In fact, contemporary comments suggest it was one of Rembrandt's most admired works. In 1678 his former pupil Samuel van Hoogstraten wrote that it was "so painterlike in thought, so ingenious in the varied placement of figures, and so powerful" that it made the other paintings in the great hall "look like packs of playing cards."

A THUNDERBOLT OF GENIUS ...ITS **FAME** RIVALS THAT OF **BEETHOVEN'S** *EROICA* OR MICHELANGELO'S **SISTINE CEILING** 〃

1948 | Jakob Rosenberg
German-American art historian

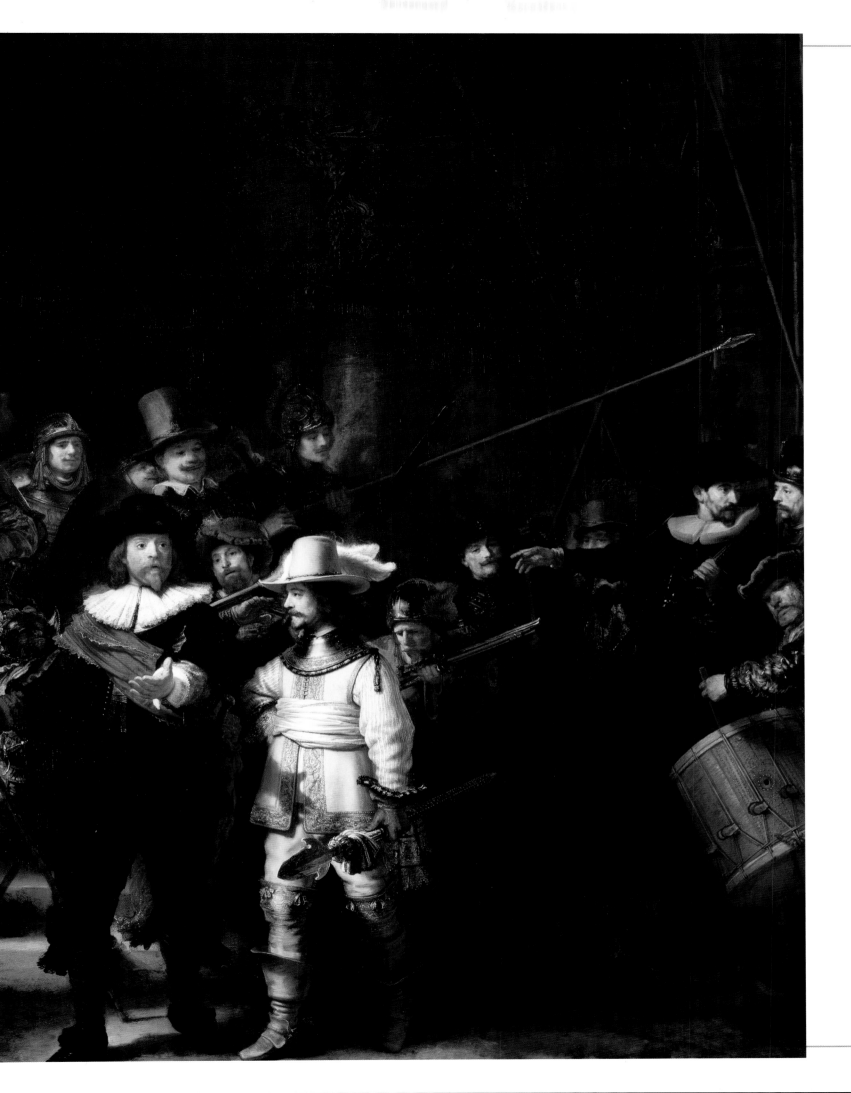

FRENCH BAROQUE

c.1600–1700 BAROQUE AND CLASSICISM

During the 17th century, France became the most powerful country in Europe and also began to challenge Italy for leadership in the visual arts. Elements of the dynamic Italian Baroque style were introduced to France by Simon Vouet, but they were tempered by a classical dignity that runs through so much of French art. A more flamboyant Baroque style emerged in the work of Vouet's pupil Charles Le Brun, who devoted much of his career to glorifying Louis XIV. A characteristic of Baroque art at its most full-blooded is the fusion of various arts to create an overwhelming effect, and this is seen in Louis' palace at Versailles, where painting, sculpture, architecture, and also the art of the gardener all work in harmony. However, the two most illustrious French painters of the time— Poussin and Claude—worked in a very different vein and mainly in Rome.

◎ CONTEXT

Royal patronage

In the late 16th century France endured a disastrous period of civil war that lasted intermittently for more than 30 years. When it finally ended in 1598, a strong king, Henry IV, began to restore stability and prosperity to the country. His reign saw significant handsome rebuilding in Paris, beginning its transition from a medieval to a modern city, but painting remained largely undistinguished.

However, painting was revitalized under Henry IV's son, Louis XIII, whose most inspired act of patronage was to summon Simon Vouet from Rome in 1627 to be his court painter. Louis' mother, Marie de Médicis, was also a notable art patron. She employed some of the outstanding French painters of the day, including Nicolas Poussin and Philippe de Champaigne, and most memorably commissioned Rubens to create a great cycle of pictures on her life for the Luxembourg Palace in Paris—works that had an enduring influence on French art.

The most important French patron of the 17th century was Louis XIV, who became king in 1643, aged four, and reigned for 72 years. His chief minister, Cardinal Mazarin, governed the country on his behalf until his death in 1661, whereupon Louis took control of affairs himself. Through a series of wars, he increased France's territory and prestige, although in the later part of his long reign the tide turned against him and his belligerence left the country financially exhausted.

Louis XIV was not a connoisseur of art, but he appreciated its value in promoting the power and glory of himself and his country, and he spent lavishly on it. His taste was for sheer magnificence, reflecting his image as the "Sun King" (he used the sun as his personal emblem). The greatest symbol of his wealth and prestige was the huge and immensely opulent palace of Versailles. Louis began his building campaign there in the 1660s and work went on into the 18th century, employing an enormous workforce.

France during the Baroque era

▷ **1598** End of the Wars of Religion; France is weakened and its art is at a low ebb.

▷ **1610** Henry IV is assassinated; his widow Marie de Médicis becomes the regent of France.

▷ **1624** Cardinal Richelieu becomes chief minister to Louis XIII and remains in office until his death in 1642; he is one of France's greatest statesmen and a notable patron of art and learning.

▷ **1648** The Royal Academy of Painting and Sculpture is founded in Paris. The Thirty Years' War comes to an end, with France emerging from the conflict more strongly than any other country.

▷ **1662** The Gobelins tapestry factory in Paris is taken over by the crown.

▷ **1682** Louis XIV makes the palace of Versailles his official residence and the seat of government.

▷ **1694** The Gobelins factory closes because of Louis XIV's financial difficulties; it reopens in 1699.

KEY EVENTS

Louis XIV Visiting the Gobelins Factory
The Gobelins factory was famous mainly for tapestries, but it produced many other kinds of luxury goods for royal palaces. This tapestry (c.1673) was designed by Charles Le Brun for the palace of Versailles.

> THE **HISTORY OF PAINTING** IN **FRANCE** UNDER **LOUIS XIV** IS THE HISTORY OF **ROYAL PATRONAGE** AND **LITTLE ELSE** ❞

1985 | Christopher Wright
British art historian

◎ BEGINNINGS
A GREAT REVIVAL

At the start of the 17th century, French painting was, in general, mediocre and provincial. However, as the country began to revive after a disastrous period of civil war, the arts too gained fresh life. The move away from tired Mannerism to a more vigorous Baroque style first distinctly appeared in the work of French artists working in Italy (such as Valentin and Vouet) and with foreign artists working in France. For example, the Italian painter Orazio Gentileschi worked in Paris in 1624–25, and Rubens made three visits to the city around this time. Also, by the end of the 1620s several accomplished Caravaggesque painters were active in various places in the French provinces, including Aix-en-Provence and Toulouse. However, it was Vouet's return from Rome to Paris in 1627 that really brought French painting into the artistic mainstream. After 14 years in Italy he was completely fluent in the language of Italian Baroque painting, but his work also has a suave gracefulness that can be considered distinctly French.

◎ Simon Vouet

born Paris, France, January 8, 1590;
died Paris, June 30, 1649

Vouet was the son of a painter and is said to have been active as an artist himself from his early teens—according to a biographer, he worked in England when he was just 14. From 1613 to 1627 he lived in Italy, where he achieved such a reputation that Louis XIII summoned him to Paris to be his court painter.

Vouet was versatile and prolific, working not only for the king but also for various other patrons and on a variety of subjects, sacred and secular. Unfortunately, most of his large decorative designs—a major part of his output—have been destroyed. He revitalized French painting not only through his own work, but also through teaching many of the leading artists of the next generation who trained in his studio.

BIOGRAPHY

◉ ARTISTIC INFLUENCES

The Baroque style was born in Italy, and it was mainly from Italy—through various channels—that it entered France. French artists of the time were inspired not only by contemporary painting in Rome (the main center of innovative ideas), but also particularly by earlier works from the Venetian Renaissance. Venice was often a side trip on the way to or from Rome.

The dynamism and warmth of Titian's early work was admired by French Baroque painters. Several of them copied or adapted this celebrated altarpiece commissioned by Jacopo Pesaro, and there are clear echoes of it in Vouet's *Presentation in the Temple*.

The Pesaro Altarpiece, 1519–26 was one of Titian's most influential works. *S. Maria dei Frari, Venice, Italy*

Annibale Carracci's wonderful draftsmanship was an inspiration to many artists who followed him. Vouet followed him in stressing the importance of drawing as the foundation of painting and urged his pupils "to set this study above all others."

Head of a girl, c.1585, exemplifies Annibale's sensitive observation and exquisite handling of red chalk. *Chatsworth House, Derbyshire, UK*

Caravaggio's dramatic use of light and shade was influential on French painters working in Rome (including Vouet) and also in some provincial areas of France. However, his style made comparatively little impact in Paris.

The Nativity, 1609, by Caravaggio was stolen from a church in Palermo, Sicily, in 1969 and has never been recovered.

Guido Reni's svelte, idealized forms influenced French Baroque painting. His work was admired in Paris, and Louis XIII's Italian-born mother, Marie de Médicis, invited him to work there in 1629 (he declined, but painted an altarpiece for her).

The Rape of Europa, c.1638, shows the grace of Guido Reni's style. *National Gallery, London, UK*

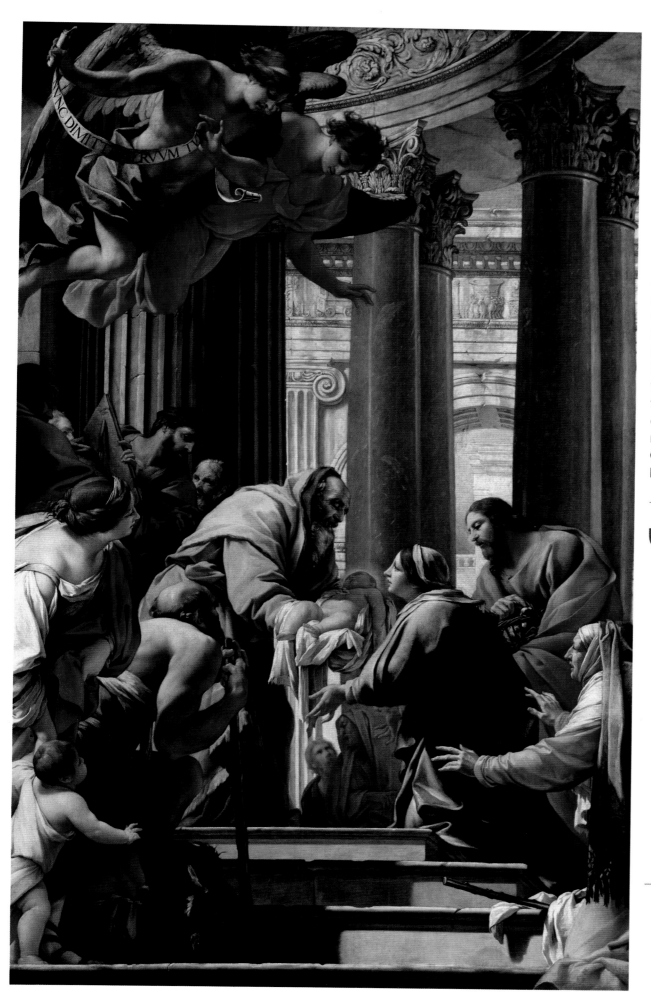

Presentation in the Temple

Simon Vouet **1641**
Louvre, Paris, France

This magnificent work was presented by Cardinal Richelieu to the newly built church of St. Paul and St. Louis, the first Jesuit church in Paris. It was originally only part of the church's huge—30ft (10m) in height—main altarpiece, but this was largely destroyed during the French Revolution. The qualities that made Vouet a success are clear: handsome, dignified composition; firm, graceful draftsmanship; a fluid sense of movement; glowing coloring; an overall harmony. He made predecessors, such as Georges Lallemant (*see p.194*), look cumbersome.

❝ HE WAS **SUPPLE**, **BRILLIANT**, **ADAPTABLE...** HE MANAGED TO **INSPIRE A GENERATION OF PUPILS** WHO WERE TO CARRY ON HIS WORK IN A **REMARKABLE WAY** ❞

1953 | Anthony Blunt
British art historian, on Vouet

◎ TIMELINE

Paris was far and away the most important art center in France during the 17th century, and most of the leading painters spent at least part of their careers there. However, painting was also produced at royal chateaus such as Fontainebleau and later at Versailles, and there were distinctive art traditions in some provincial areas, particularly Lorraine, where Georges de La Tour was the major figure. Several French painters worked mainly in Rome, including Valentin and later Claude and Poussin.

The Innocence of Susanna ▷
Valentin de Boulogne c.1625
Louvre, Paris, France
Valentin settled in Rome as a young man and spent all his documented career there, working with distinction in Caravaggio's style. In this biblical scene, the young prophet Daniel saves a woman who has been unjustly accused of adultery.

Paris rebuilt
The Place Royale (now the Place des Vosges) is begun in 1605. This very large and handsome square is the most imposing part of Henry IV's rebuilding campaign in Paris after a period of civil war.

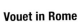

1600 **1610** **1620** **1630**

Vouet in Rome
In 1614 Simon Vouet arrives in Rome, where he is based for the next 13 years until being recalled to Paris by Louis XIII. He achieves great prestige in Rome, even being elected president of the Academy of St. Luke (a rare honor for a foreigner) in 1624.

St. Martin and the Beggar ▷
Georges Lallemant c.1630
Musée Carnavalet, Paris, France
Before the arrival of Vouet in 1627, Lallemant was probably the leading painter and art teacher in Paris. However, few of his paintings survive. The elongated figures in this altarpiece are still in the Mannerist tradition, but the sense of swagger is more Baroque.

**Hyante and Climene Offering
a Sacrifice to Venus** △
Toussaint Dubreuil c.1600
Louvre, Paris, France
This is one of the few surviving works from a series of 78 paintings Dubreuil and his assistants produced for one of Henry IV's residences, the Château Neuf at Saint-Germain-en-Laye, near Paris. The mythological subject matter comes from a poem by the 16th-century French writer Pierre de Ronsard.

The Penitent Magdalene ▷
Georges de La Tour c.1640
Louvre, Paris, France
This was La Tour's favorite subject, which he treated several times. Like many other artists of the period, he was inspired by Caravaggio's dramatic use of light and shade, but he used it in his own exquisitely sensitive, contemplative way. He is generally regarded as the greatest of all Caravaggio's followers.

Cardinal Richelieu ▷
Philippe de Champaigne
c.1637 *Sorbonne, Paris, France*
Champaigne was the leading French portraitist of the 17th century, combining grandeur with incisive characterization. He was the favorite painter of Cardinal Richelieu, who was virtually the ruler of France, and portrayed him numerous times.

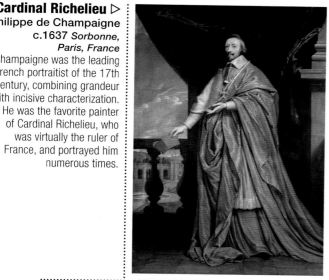

1640

A Peasants' Meal △
Le Nain brothers (Louis Le Nain?) 1642
Louvre, Paris, France
There were three Le Nain brothers: Antoine, Louis, and Mathieu. They sometimes signed their paintings, but only with the surname, and it has proved very difficult to separate their work into individual contributions. They painted various types of pictures, the best known of which are sober, dignified peasant scenes such as this.

BIOGRAPHY

Georges de La Tour

baptized Vic-sur-Seille, France, March 14, 1593; **died** Lunéville, France, January 30, 1652

La Tour spent all his known career in Lorraine, in northeast France. At this time it was an independent duchy, although France invaded it in 1633 and occupied it for much of the 17th century. He was the leading painter locally, and his work was also admired in Paris. However, after his death he was quickly forgotten and he was not rediscovered until the early 20th century. Only about 40 paintings by him are known. The most characteristic of these are meditative nocturnal scenes illuminated by candlelight or a flaming torch.

❝❝ THE **ISOLATION** OF LA TOUR **IN LORRAINE** HELPS TO EXPLAIN THE **ORIGINALITY** OF HIS **ARTISTIC LANGUAGE** ❞❞

2005 | Ann Sutherland Harris
American art historian

Landscape With the Nymph Egeria ▽
Claude Lorraine 1669 *Museo di Capodimonte, Naples, Italy*
Claude was the most famous, admired, and influential landscape painter of the 17th century. He specialized in "ideal landscapes," creating a serene, flawlessly beautiful vision of nature, with none of the imperfections of the real world.

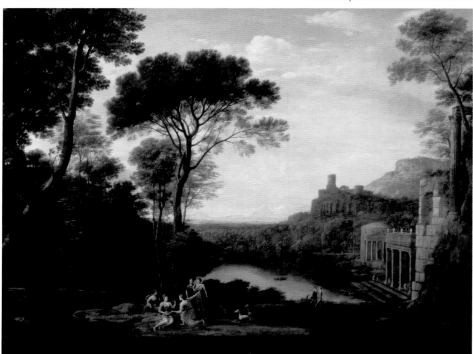

Louis XIV and his Family Dressed as Roman Gods ▽
Jean Nocret 1670
Château de Versailles, France
Louis XIV, the "Sun King," liked to compare himself with Apollo, the Roman god of light. Here, the idea is extended to his whole family, who are all dressed as Roman gods. The picture was commissioned by Louis XIV's younger brother, who sits to the left as Aurora, the morning star.

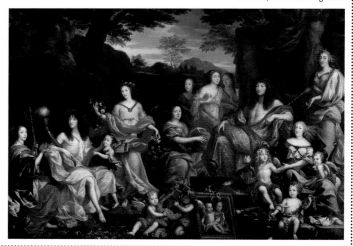

1650 **1660** **1670**

Gift of thanks
In 1662, Philippe de Champaigne paints one of his greatest works, a portrait of his daughter (a nun) and her mother superior. The painting was in thanks for his daughter's seemingly miraculous recovery from paralysis.

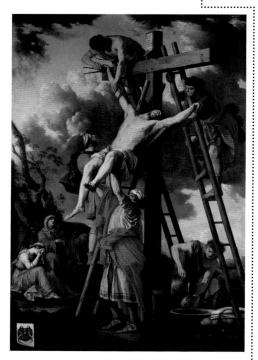

The Deposition △
Laurent de La Hyre 1655
Musée des Beaux-Arts, Rouen
La Hyre was one of the leading painters in Paris around the middle of the century. In his later works such as this, his style—solid and dignified—was strongly influenced by Poussin.

Alexander the Great's Triumphal Entry Into Babylon ▷
Charles Le Brun c.1662–68
Louvre, Paris, France
This huge, incident-packed painting—more than 23ft (7m) in width—is one of a series on the victories of Alexander the Great that Le Brun produced as designs for the Gobelins tapestry factory. They pay flattering tribute to Louis XIV, who saw himself as a great conqueror, like Alexander.

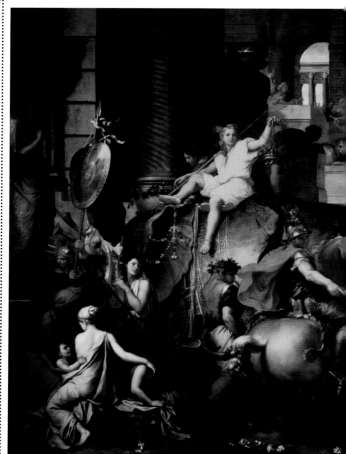

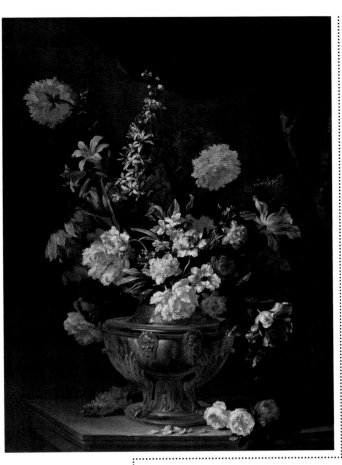

◁ Flowers in a Sculptured Vase
Jean-Baptiste Monnoyer c.1680
Towneley Hall, Burnley, UK
Monnoyer had a highly successful career painting opulent flower pieces. Many of them were painted for specific interiors in great houses, including royal palaces. Louis XIV owned about sixty of his paintings. Monnoyer spent his final years in England, where his work was much appreciated.

Le Brun portrait
In 1686, Nicolas de Largillière presents a magnificent portrait of his mentor Charles Le Brun as his "reception piece" when he becomes a member of the Royal Academy of Painting and Sculpture in Paris.

Nicolas Poussin

born Les Andelys, France, June 1594;
died Rome, Italy, November 19, 1665

Poussin's early years in France are fairly obscure, and his career did not properly flourish until he settled in Rome in 1624 at the age of 30. Apart from a two-year period from 1640–42, when he reluctantly submitted to pressure from Cardinal Richelieu and worked in Paris for Louis XIII, he lived in Rome for the rest of his life. The city played a huge part in shaping his art, for the dignified classical style that he developed was based on his love for the culture of the ancient world. In spite of his growing fame, Poussin lived a life of quiet dedication to his work.

BIOGRAPHY

> HE USED TO TAKE OUT **INTO THE COUNTRY** HIS **BRUSHES** AND HIS **PALETTE** READY **LOADED WITH COLORS**

Nicolas Desportes
French painter, on his uncle, Alexandre-François Desportes

1680 **1690** **1700**

Cardinal's tomb
In 1693, Antoine Coysevox completes the tomb of Cardinal Mazarin (Chapel of the Institut de France, Paris), one of the masterpieces of 17th-century French sculpture. It was begun in 1689.

Charles Le Brun

baptized Paris, France, February 24, 1619; **died** Paris, February 12, 1690

Le Brun was the leading artist during the central years of Louis XIV's reign, not just because of his own work, much of which glorified the king, but also through his role in organizing and supervising the work of others. He was director of both the Royal Academy of Painting and Sculpture and the Gobelins factory. His period of dominance came to an end in 1683 with the death of the king's chief minister Jean-Baptiste Colbert, who had been his protector.

BIOGRAPHY

△ Self-Portrait as a Hunter
Alexandre-François Desportes 1699
Louvre, Paris, France
Desportes was one of the greatest animal painters of his time, alongside the slightly younger Jean-Baptiste Oudry (*see p.205*). He based his work on loving study of nature: unusual for the time, he produced oil sketches in the open air.

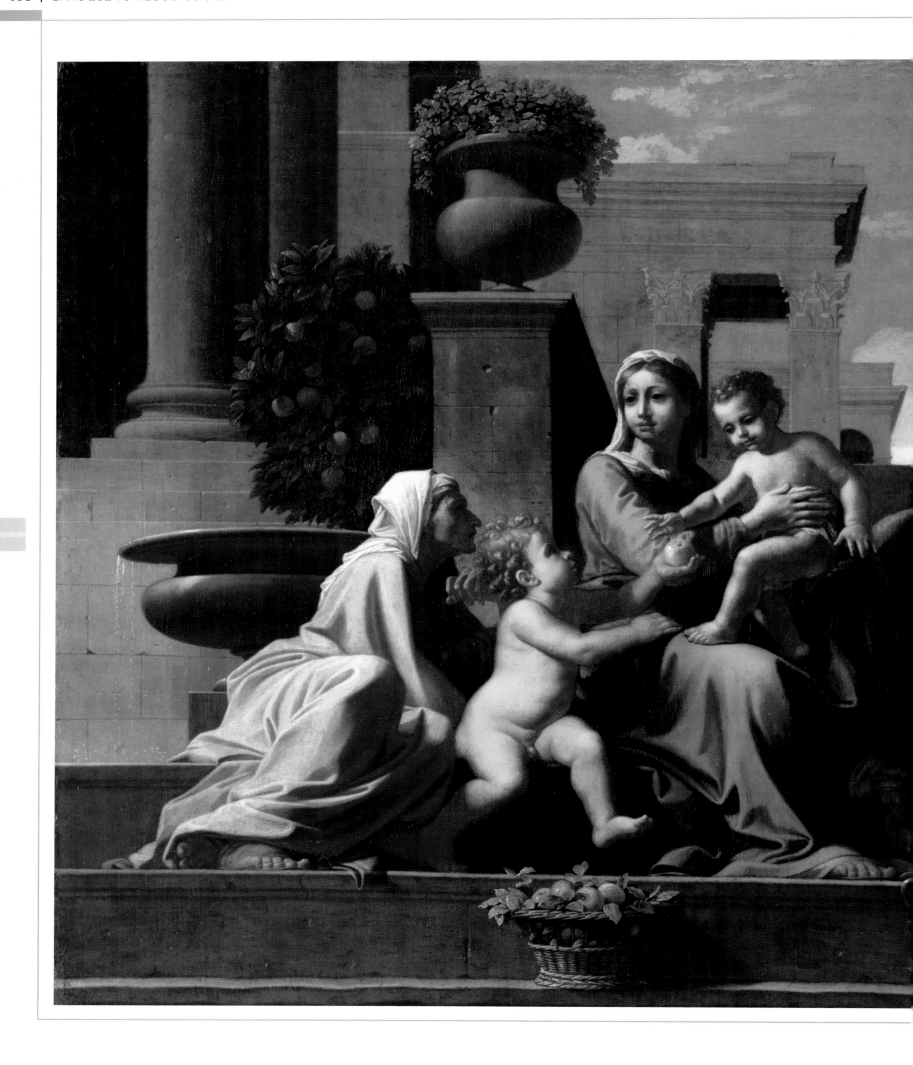

◎ MASTERWORK

The Holy Family on the Steps

Nicolas Poussin **1648**
Cleveland Museum of Art, OH

Although Poussin spent virtually his whole creative life in Italy, he became revered as a key figure in French painting, indeed in French culture in general. His approach to art was highly intellectual, and his paintings—with their unerring combination of lucidity and grandeur—were regarded by the Royal Academy of Painting and Sculpture in Paris as perfect embodiments of its ideals. The Academy, founded in the year in which this picture was painted, upheld the idea that art was not primarily a matter of self-expression but rather of the rational use of skills that can be taught and learned.

Poussin was extremely methodical in his working processes, making numerous preparatory drawings for his paintings and also arranging small wax figures on a miniature stage so he could study the effects of grouping and lighting. Unlike most leading painters of the time, he never employed assistants, preferring to work in solitude so no one would break his concentration. He was once asked how he achieved the amazing clarity and harmony of paintings such as this and replied, "I have neglected nothing." Most of his paintings were done for cultured patrons who shared his scholarly interests—generally people of only modest status and wealth. In spite of this and the fact that he led a fairly reclusive life, he was held in such awe that by the time of his death he was one of the most famous artists in Europe.

There is another version of this painting in the National Gallery of Art, Washington, DC. It was once thought to be the original, but it is now generally regarded as a very good contemporary copy.

 MY NATURE CONSTRAINS ME TO **SEEK** AND TO **LOVE** **WELL-ORDERED** THINGS 〟

1642 | Nicolas Poussin

FRENCH ROCOCO

▷ **Madame de Pompadour**
François Boucher 1758
*Victoria and Albert Museum,
London, UK*
The luxurious satin of the dress,
the casual elegance of the pose,
and the charming artificiality of
the setting sum up the glamour
of court life and the enchanting
lightness of spirit of Rococo art.
Madame de Pompadour was
Louis XV's best-known mistress.

At the turn of the 17th and 18th centuries, the sumptuous type of painting and ornament that was characteristic of the palace of Versailles began to go out of fashion and give way to a lighter, brighter style. This style, which is now known as Rococo, first appeared in the decorative arts—such as furniture and textiles —expressed in supple curves and a general feeling of delicate but spirited elegance. However, it soon spread to painting and sculpture, and to a more limited extent to architecture. Paris was the center of the style, and most of the outstanding French Rococo painters worked there. Watteau was the first great practitioner, followed by Boucher and Fragonard, who were the most illustrious figures at the style's peak. However, one of the greatest French painters of the time, Chardin, worked in a different, more sober vein.

◎ CONTEXT

The Age of Enlightenment

The Rococo period coincides fairly closely with the Age of Enlightenment or—as it is sometimes called—the Age of Reason. These terms describe a broad cultural and intellectual movement founded on the belief that human society could be advanced and improved through the application of knowledge and rational thought—in opposition to prejudice, superstition, and unquestioned traditions. The movement affected virtually all of Europe in one way or another and also spread to America (where Benjamin Franklin and Thomas Jefferson were leading figures), but it was in France that it found its fullest expression.

The intellectual leaders in France included three men of letters who wrote prolifically on a wide range of subjects: Denis Diderot, Jean-Jacques Rousseau, and Voltaire (the pseudonym of Francois-Marie Arouet). Diderot is particularly remembered as the chief editor of the great work that sums up Enlightenment ideals—*L'Encyclopédie*. This huge storehouse of universal knowledge was published between 1751 and 1772 in 17 volumes of text and 11 volumes of engraved illustrations (later supplements took the total up to 35 volumes). It contained about 20 million words in all, aiming both to summarize current knowledge in every field and—in Diderot's words—"to change the way people think." Censorship laws prevented it from openly attacking the Church or State, but it managed to do so by more subtle literary means, and its subversive ideas helped to create the conditions from which the French Revolution grew.

Enlightenment ideas affected the arts in various ways. They helped inspire in painters an interest in scientific subjects, for example, but they also increased interest in classical antiquity, thus contributing to the growth of Neoclassicism. More generally, the secular outlook of the Enlightenment was part of the move away from the long dominance of religious subjects in art. Rococo painters turned more often to love stories than to the Bible for their inspiration.

A royal progress toward revolution

KEY EVENTS

▷ **1715** Louis XIV dies after a reign of 72 years, and is succeeded by his five-year-old grandson, Louis XV.

▷ **1737** France's official art exhibition is held in the *Salon Carré* (Square Salon) of the Louvre palace for the first time, giving rise to the term Salon (previously the event had been held in other venues).

▷ **1745** Madame de Pompadour becomes Louis XV's official mistress; she is a noted patron of the arts, especially of François Boucher.

▷ **1753–75** Building of the Place Louis XV (now the Place de la Concorde), the largest square in Paris.

▷ **1756** The Vincennes porcelain factory transfers to specially designed premises at Sèvres, between Paris and Versailles. Boucher is among the artists who create designs for the factory.

▷ **1774** Louis XV dies and is succeeded by his grandson Louis XVI; the country is in economic chaos, leading to widespread unrest that culminates in the French Revolution.

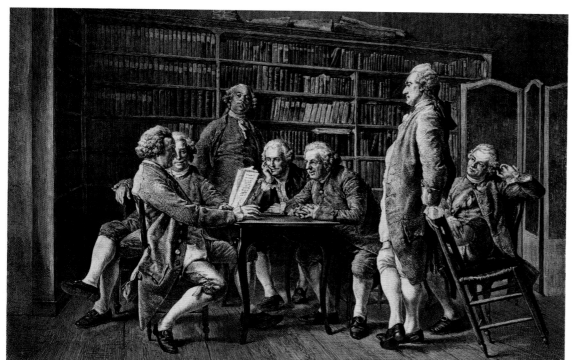

> BAROQUE **TAMED AND CUT DOWN** FOR A **MORE CIVILIZED** AGE, ONE WITH **A SENSE OF HUMOR** TOO

1966 | Sir Michael Levey
British art historian, on the Rococo style

Diderot and friends
This 19th-century reconstruction shows Denis Diderot in his library with a group of intellectual friends. His varied literary output included a good deal of art criticism. Chardin and Greuze were among the painters about whom he wrote perceptively.

◎ BEGINNINGS
CONTINUITY AND CHANGE

The grandiose tradition of late Baroque painting continued in France well into the 18th century, not least because several leading artists who had been born in the first half of the 17th century continued working productively into old age. An example is Charles de La Fosse (1636–1716). A pupil and assistant of Charles Le Brun—the dominant French artist of the time—he inherited a good deal of his master's weighty, learned style, but his work was freer, more colorful, and more graceful, and in this respect heralds the Rococo style. However, the true fountainhead of French Rococo painting was Antoine Watteau, an independent-minded individual who broke completely free of the Italian influence that had long permeated French art. Through his innovative choice of subjects and highly original treatment of them, he created a new visual realm. His freshness of vision and sensitivity of handling established a distinctive outlook—full of charm, elegance, and dreamy romance—that seems quintessentially Parisian.

◉ ARTISTIC INFLUENCES

Watteau's artistic education was patchy but varied. In his early years he did a good deal of hackwork, producing copies for picture dealers, which brought him into contact with a range of styles and types of work. However, his love of the theater was just as strong an influence on him as work by other painters.

Beautifully dressed young lovers in a garden or park setting is a tradition that ultimately goes back to medieval manuscripts. Music making features in this 15th-century miniature, as it does in much of Watteau's work.

The Fountain of Life, miniature from a 15th-century Italian manuscript. *Biblioteca Estense Universitaria, Modena, Italy*

Luxurious clothes and fabrics are often prominent in Rococo art. Veronese was a master at depicting their colors and textures. There is a kinship here with Watteau's liking for pink silks and satins.

Mars and Venus United by Love, c.1575, Paolo Veronese, shows his typical mastery of texture. *Metropolitan Museum of Art, New York City, NY*

Rubens was idolized by Watteau, who studied his work intently, making numerous drawings. This beautiful celebration of love and marriage was a direct inspiration for Watteau's depictions of courtship and flirtation.

The Garden of Love, c.1633, Sir Peter Paul Rubens, was a much copied and admired work. *Prado, Madrid, Spain*

Claude Gillot, Watteau's main teacher in Paris, had a strong interest in the theater—one that he shared with his great pupil. The highly artificial world of Watteau's paintings owes much to the stage.

Sketches of Costumes for the Commedia dell'Arte, c.1700, by Gillot. *Metropolitan Museum of Art, New York City, NY*

◎ TURNING POINT

Pilgrimage to the Isle of Cythera

Antoine Watteau **1717** *Louvre, Paris, France*

Watteau presented this picture to the Royal Academy of Painting and Sculpture in Paris to mark his membership. The subject, taken from a contemporary play, is a romantic pilgrimage to the island where Venus was born. The painting did not fit into conventional categories, so the Academy invented one for the occasion, describing Watteau as a painter of "*fêtes galantes*" (literally "amorous festivals," but often translated as "courtship parties"). In creating this new type of picture, Watteau showed a charm, sensuousness, and lightness of touch that set the tone for French painting for the next half century.

◎ Antoine Watteau

born Valenciennes, France, October 10, 1684;
died Nogent-sur-Marne, France, July 18, 1721

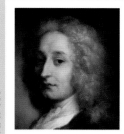

BIOGRAPHY

Watteau's short life was marred by illness, and his awareness of his own mortality is perhaps reflected in his art. Unlike most Rococo paintings, Watteau's often have a feeling of melancholy underneath the frivolous surface—a reminder that life's pleasures, however sweet, are fleeting. He had a difficult temperament but also many loyal and indulgent friends, and his work was in great demand. In 1720–21 he visited Dr. Richard Mead (a renowned physician and art collector) in London about his tuberculosis, but died soon afterward, aged 36.

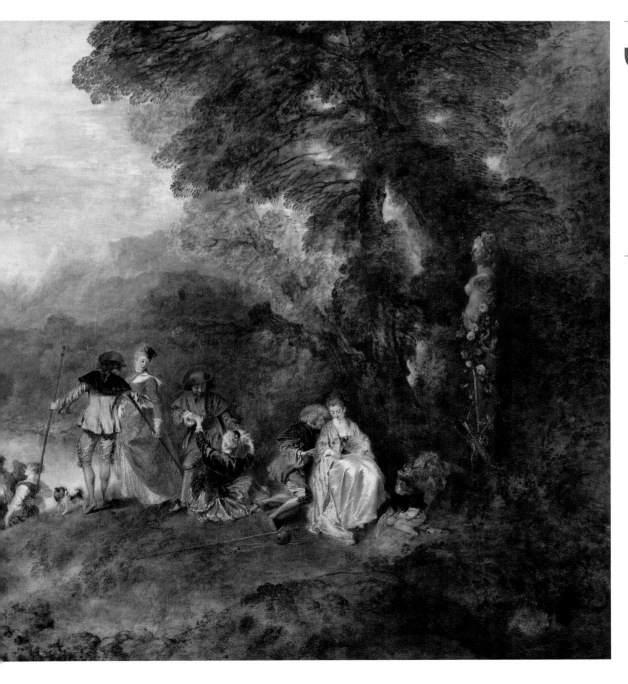

❝❝ THIS IS THE **MOST RENOWNED** OF WATTEAU'S PICTURES AND IN A SENSE THE **MOST PHILOSOPHICAL** ❞❞

1967 | Anita Brookner
British art historian and novelist

◎ TIMELINE

In the early years of the 18th century, elements of the Baroque and Rococo styles blended, but Watteau broke away decisively from old conventions, giving French painting a distinctive intimacy and sparkle. The Rococo style reached its peak of exuberance and (often gently erotic) charm around the middle of the century, particularly in the work of Boucher and his pupil Fragonard. By the 1770s, however, taste was beginning to turn away from frivolity and the new, sterner outlook would soon find expression in full-blooded Neoclassicism.

▽ **The Artist and His Family**
Nicolas de Largillière c.1710
Louvre, Paris, France
This painting, created for Largillière's own satisfaction, is more informal than his commissioned portraits. The artist shows himself as a country gentleman; his daughter sings to entertain her parents.

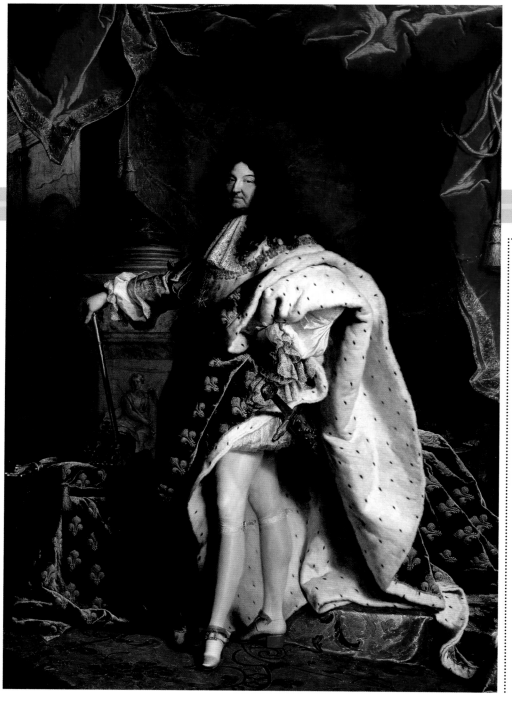

◁ **Louis XIV**
Hyacinthe Rigaud 1701 *Louvre, Paris, France*
Louis commissioned this portrait as a gift for his grandson, Philip V of Spain, but when he saw the finished work he was so pleased with this overwhelming image of royal power and pomp that he kept it for himself and ordered a copy for Philip.

1700 **1705** **1710**

A new master
Watteau leaves the studio of Claude Gillot in 1707–08 and becomes an assistant to Claude Audran, a specialist in decorative painting.

BIOGRAPHY

Hyacinthe Rigaud

born Perpignan, France, July 18, 1659;
died Paris, France, December 29, 1743

Together with his friend Nicolas de Largillière, Rigaud was the leading French portraitist of his period. The two artists tended to work for slightly different markets, Rigaud depicting aristocracy and royalty (including foreign visitors to the French court), while Largillière painted the wealthy middle classes. Rigaud ran a large and well-organized studio to meet the demand for his work. He kept detailed records, which provide valuable information about artistic practice in his day.

▽ Perseus and Andromeda
Francois Lemoyne 1723
Wallace Collection, London, UK
Lemoyne's suave, fluent, graceful style, as
exemplified in this picture, brought him great
success. However, he suffered from depression
and committed suicide when apparently at
the height of his career.

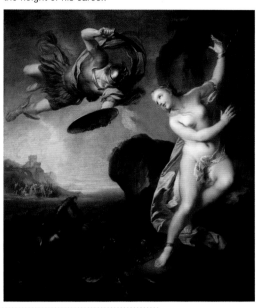

BIOGRAPHY

Jean-Siméon Chardin

born Paris, France, November 2, 1699; **died** Paris, December 6, 1779

Chardin stands apart from the mainstream of French painting
in the 18th century. He had no interest in glamorous subjects,
concentrating on modest still lifes and quiet scenes of everyday life.
However, his unerring sense of structure and balance, his sensitivity
of touch, and his avoidance of superficial or distracting elements give
his paintings a sense of deep seriousness and timeless dignity.
Appropriately, his life was one of unassuming dedication to his art.

The House of Cards ▷
Jean-Siméon Chardin c.1737
National Gallery, London, UK
Although it is first and foremost
a lovely depiction of childhood
innocence, pictures such as this
were—at the time—often given a
moralizing message. The fragility of
the house of cards in Chardin's
painting was made to stand for the
vulnerability of all human enterprise.

1715	1720	1725	1730	1735	1740 ▶

Tapestry designs
In 1736 François Boucher
makes his first designs for
tapestry—a type of work
that becomes an important
part of his huge output.
In 1755 he becomes
director of the Gobelins
tapestry factory.

The Dead Wolf △
Jean-Baptiste Oudry 1721
Wallace Collection, London, UK
Oudry was one of the most acclaimed animal painters of the
18th century. This picture is a superb demonstration of his
skills in painting not just animals—alive and dead—but also
various types of still-life detail.

△ Death of St. Scholastica
Jean Restout 1730
Musée des Beaux-Arts, Tours, France
Restout was one of the few French painters
of the time to concentrate on serious religious
paintings. Here the emotional force continues
the Baroque tradition, but the gracefulness is
Rococo in spirit.

The Miracle of St. Benedict ▷
Pierre Subleyras 1744
S. Francesca Romano, Rome, Italy
Subleyras spent most of his career in Rome, where the noble sobriety of his work—especially in religious subjects—was more valued than in France. St. Benedict, founder of the Benedictines, is said to have performed miracles, including reviving a dead child.

▽ Self-Portrait
Maurice-Quentin de La Tour 1751
Musée de Picardie, Amiens, France
Pastel portraiture had a great vogue in the 18th century, particularly in France, where La Tour was one of the leading specialists. He was renowned for his lively characterization, beautiful coloring, and ability to depict the textures of luxurious materials, such as silk and velvet.

Death of a disciple
Nicolas Lancret dies in Paris in 1743, aged 53. Lancret founded his successful career on imitating the style of Watteau, who may have briefly taught him.

1740 **1745** **1750** **1755** **1760**

François Boucher

born Paris, France, September 29, 1703; **died** Paris, May 30, 1770

Boucher was the most versatile, prolific, and successful master of French Rococo, with a long list of honors to his name, including being appointed first painter to the king in 1765. In addition to a large output of paintings of various types, he produced designs for tapestries, the stage, porcelain, and much else besides—even down to fashion items, such as fans. His style was charmingly artificial and sentimental, although underpinned by formidable prowess as a draftsman.

BIOGRAPHY

The Four Seasons: Summer ▷
François Boucher 1755
Frick Collection, New York City, NY
This is part of a series of four allegories of the seasons that Boucher painted for his eminent patron Madame de Pompadour. It was a fairly modest commission—the pictures are small—but he lavished great care on these exquisite confections, which rank among his loveliest creations.

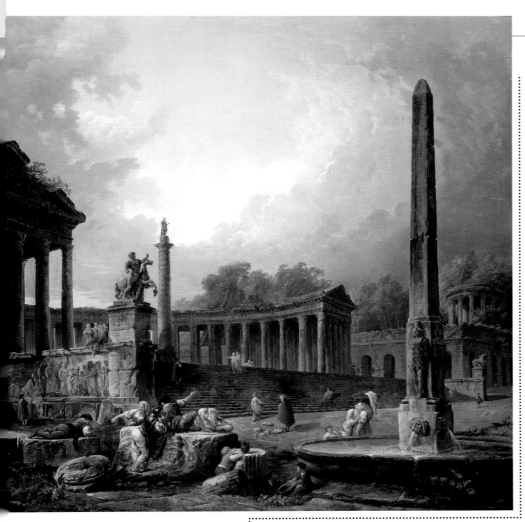

Hubert Robert

born Paris, France, May 22, 1733;
died Paris, April 15, 1808

Robert was nicknamed "Robert des Ruines," because he was the leading specialist in paintings depicting ruined buildings, both real and imaginary. His work combines grandeur of conception with delicacy of touch—indeed his lively, fluid brushwork recalls that of his friend Fragonard. Robert had a highly successful career, although he was imprisoned for a time during the French Revolution. He continued painting even when he was in prison, and worked until the end of his life.

◁ **Architectural Capriccio**
Hubert Robert 1768
Bowes Museum, Barnard Castle, UK
The term *capriccio* has various meanings in art, but it is most often applied to paintings such as this, in which real buildings and structures —Trajan's Column in Rome stands in the center—are combined with imaginary ones.

Pastel portraits
Chardin exhibits pastel portraits of himself and his wife at the Paris Salon in 1775. He took up pastels late in life after the lead in oil paints caused an eye ailment.

1765 ○ **1770** ○ **1775** ○ **1780**

> HER **FRESH-LOOKING** FACE IS AS **SOFT** AS THE SKIN OF A **PEACH**

1844 | Théophile Thoré
French art critic, on Fragonard's Young Girl Reading

△ **The Broken Pitcher**
Jean-Baptiste Greuze 1771
Louvre, Paris, France
At the peak of his career Greuze was widely admired for pictures such as this, which have a sentimental charm but are also mildly titillating (the broken pottery is an allusion to lost virginity). The French Revolution radically changed artistic tastes, and Greuze died in poverty.

Young Girl Reading ▷
Jean-Honoré Fragonard c.1776
National Gallery of Art, Washington, DC
As taste began to turn against Rococo lightheartedness, Fragonard experimented with other idioms to test the market. This young woman is just as lovely as those in earlier Fragonard paintings, but there is no hint of frivolity in her studious absorption in her book.

◎ MASTERWORK

The Swing

Jean-Honoré Fragonard **1767**
Wallace Collection, London, UK

The distinguished French art historian Pierre Rosenberg described Fragonard as the "fragrant essence" of the 18th century, and this painting—his most famous work—could be described as the fragrant essence of the Rococo style. All is enchantment as the beautiful girl, in her coral pink dress, gaily flies through the air—as light and graceful as a butterfly. For beauty of color, dexterity of brushwork, and vivaciousness of atmosphere, it is unsurpassed in the art of its time.

We are fortunate that we have a contemporary account—by the French poet Charles Collé—of how the painting came to be commissioned. Collé writes that a minor painter called Gabriel-François Doyen told him a "gentleman of the court" asked him to paint a picture showing his mistress on a swing being pushed by a bishop, whilst the gentleman himself should be placed "in such a way that I would be able to see the legs of the lovely girl." Doyen was "petrified" at this risqué idea and suggested it was much more suited to Fragonard, who accepted the commission. The "gentleman of the court" is never named by Collé, although he was perhaps the Baron de Saint-Julien.

Fragonard changed the bishop to an elderly man, who—it can be assumed—is the girl's husband. He is outwitted by her young lover, who reclines in the bushes, out of sight of the husband but enjoying an exciting view of the wife. Above the young man, a statue of Cupid (the god of erotic love) joins in the game, putting a finger to his lips to urge secrecy.

Another playful detail, easily overlooked, is the little dog who appears at the bottom right of the scene. Dogs were often used in art as symbols of fidelity, and this one yaps as if trying to warn the unfortunate husband that he is being cuckolded.

> ❝ FRAGONARD **TRANSFORMED** WATTEAU'S **WISTFUL SERENITY** INTO A **JOYFUL ABANDONMENT** TO THE **PLEASURES** OF THE **SENSES** ❞

1972 | Donald Posner
American art historian

◎ Jean-Honoré Fragonard

born Grasse, France, April 5, 1732;
died Paris, France, August 22, 1806

Fragonard trained under Boucher and in 1752 won the prestigious *Prix de Rome* art scholarship. This brought him a period of study at the French Academy in Rome from 1756 to 1761. After he returned to Paris, he tried to establish himself as a painter of large-scale heroic works, but he realized that this was not where his talent lay and turned to the intimate scenes of romance that won him fame. At the peak of his success he was one of the most admired artists in France. However, taste turned away from the lighthearted Rococo style and the French Revolution virtually ended his career, sweeping aside the frivolous aristocratic world he had catered to. By about 1792 he had given up painting. For a few years he worked as an administrator at the Louvre museum, then lived—and died—in obscurity.

BIOGRAPHY

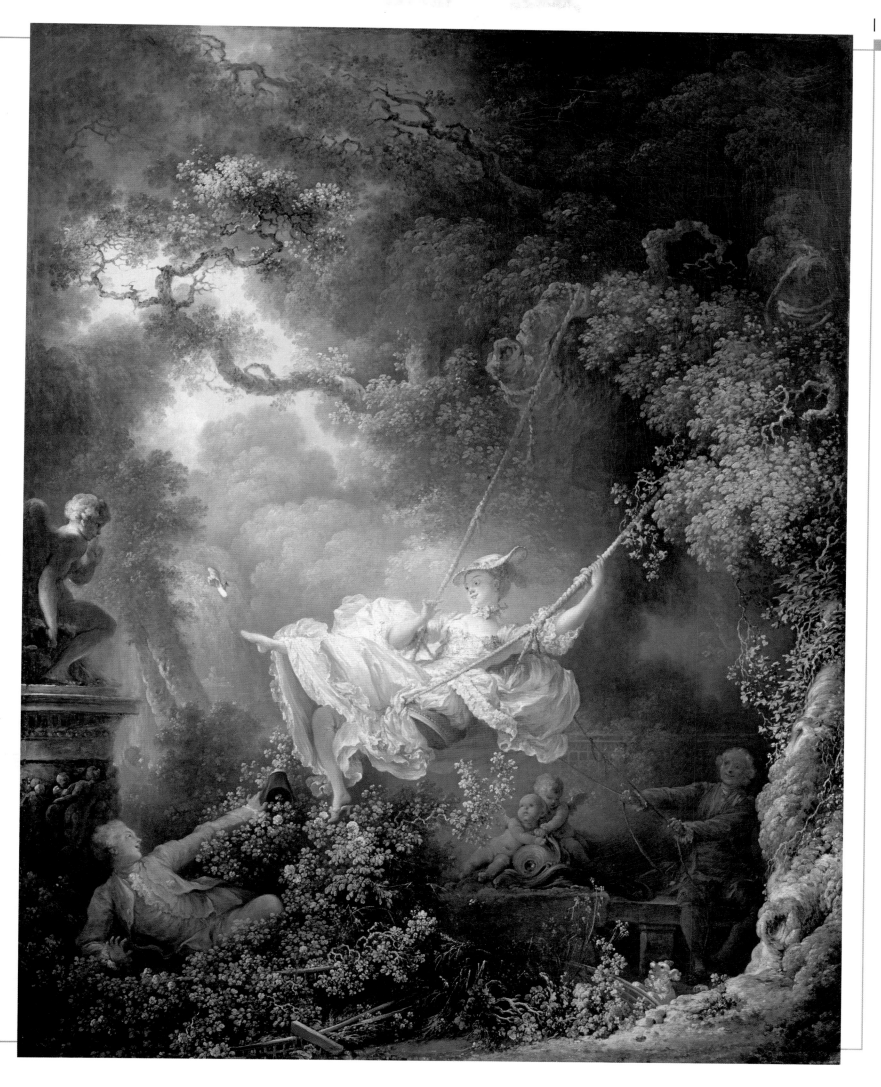

ROCOCO OUTSIDE FRANCE

▷ **The Artist's Wife**
Allan Ramsay c.1758–60
Scottish National Gallery,
Edinburgh, UK
Ramsay was well traveled and
cosmopolitan in spirit. He probably
painted this enchanting portrait
soon after returning from the
second of four visits to Italy
in 1757. His work—elegant
and sophisticated—helped
to acclimatize the Rococo
style in Britain.

The Rococo style spread from France in various ways—through the travels of artists, the international trade in art, and the publication of engravings and illustrated books. It became particularly popular in southern Germany and other parts of Central Europe, but it also reached as far afield as Russia and Portugal. In each country there were distinctive variations as the style merged with local traditions. Britain had a certain resistance to French frivolity, but nevertheless the Rococo had a major impact there in fields such as furniture and silverware, and in painting it is clearly reflected in the delicacy of artists including Allan Ramsay (*see above*) and Thomas Gainsborough. Some outstanding examples of the style were produced by painters from countries outside the established major centers of art—Jean-Étienne Liotard of Switzerland and the Swede Alexander Roslin, for example.

⊚ CONTEXT

Germany reborn

As the Rococo style spread outside France, it was expressed in various national and local idioms. Nowhere did it blossom more spectacularly than in Germany, which enjoyed a remarkable cultural resurgence during the 18th century. Throughout much of the Renaissance, it had been one of the leading artistic centers outside Italy, but its art was in decline by the end of the 16th century (partly because of the disturbances of the Reformation). Later, in the first half of the 17th century, Germany (a patchwork of states, great and small, rather than a unified country) was devastated by the Thirty Years War (1618–48). This was fought largely on German territory and it is estimated that during this time about 20 to 30 percent of the population died—from famine and plague as well as direct military action.

The recovery from this terrible period was slow, but by the beginning of the 18th century Germany was reviving, and it became home to some of the finest Rococo art. This was created mainly in southern Germany, which was largely Catholic, while the north was predominantly Protestant and more sober in its tastes. The best German Rococo art is not usually found in easel painting, but in other fields, including ceramics—the Meissen factory was Europe's first and greatest maker of porcelain—and church decoration. In France and other countries, the Rococo style was expressed mainly in secular art, but in the German lands it was compatible with a certain type of religious spirit—airy and uplifting, as in the wonderful churches of Vierzehnheiligen (*see below*) and Die Wies (*see p.216*).

⊚ 18th-century developments

KEY EVENTS

▷ **1703** As part of the modernization of his country, Peter the Great of Russia founds the city of St. Petersburg; many Western artists are attracted to work in what becomes a major cultural center.

▷ **1707** England and Scotland are united as the Kingdom of Great Britain.

▷ **1730** Clement XIII becomes pope. In his ten-year reign he enriches Rome with numerous building projects.

▷ **1740** In Vienna, Maria-Theresa becomes ruler of the Habsburg empire. She is a notable patron, with a taste for French art.

▷ **1760** George III becomes king of Great Britain. He is an important art collector, his acquisitions including an incomparable group of paintings by Canaletto.

▷ **1768** Foundation of the Royal Academy of Arts in London.

▷ **1775** Beginning of American Revolution against British rule.

> **THE FIRST IMPRESSION** ON ENTERING THIS **VAST, SOLITARY** PILGRIMAGE CHURCH IS ONE OF **BLISS AND ELEVATION.** ALL IS **LIGHT: WHITE, GOLD, PINK** 🙷

1960 | Sir Nikolaus Pevsner
German-born British art historian, on Vierzehnheiligen

Interior of the church at Vierzehnheiligen, Germany
The breathtaking church of Vierzehnheiligen (Fourteen Saints) was designed by Balthasar Neumann and built between 1742 and 1473. One of the greatest architects of the age, Neumann was also the main creator of the Residenz at Würzburg, decorated by Tiepolo.

◎ BEGINNINGS

COLOR AND PAGEANTRY

The Rococo style emerged first in ornament, rather than in the major visual arts, and it was in decorative details that it most quickly and easily spread across national boundaries from its heartland in France. These details were disseminated particularly in the form of engravings. They were sold by print dealers in cities throughout Europe, so a cabinetmaker in London and a silversmith in Lisbon, for example, could borrow an identical fashionable motif from a French design.

In painting, the transition from Baroque to Rococo was more gradual and less clear, especially in Italy, where the Baroque style was strongly established and cities had their own distinct traditions. It was expressed in such ways as the use of lighter, brighter colors, freer brushwork, and looser composition. In Venice, which became a leading center of Rococo painting, artists were inspired by the color and pageantry of their 16th-century predecessor Paolo Veronese—indeed, contemporaries described Giambattista Tiepolo as "Veronese reborn."

> HIS **PICTORIAL FLUENCY**, ELEGANT IN ITS DRAWING AND **FESTIVE IN ITS COLOR**, PROVIDED A **STIMULUS** FOR **ALL THE PAINTERS** OF THE NEXT GENERATION
>
> 1994 | Francesco Valcanover
> *Italian art historian, on Sebastiano Ricci*

◉ ARTISTIC INFLUENCES

Ricci's work in several countries helped to disseminate the Rococo style. In 1716, at about the time he painted *Bacchus and Ariadne*, he met Watteau and other leading French artists in Paris. However, he was more influenced by Italian predecessors than by French art. The lightness of spirit that characterizes Rococo art is also found in the work of certain Italian painters of the 16th and 17th centuries.

Titian's picture is the most famous of all interpretations of the story of Bacchus and Ariadne, and it was much copied and adapted by other artists. Ricci's picture shows a different moment in the narrative, but he has borrowed the detail of the vase in the foreground.

Bacchus and Ariadne, 1520–23, by Titian, is a work whose figures reveal the influence of the ancient sculpture *Laocoön*. *National Gallery, London, UK*

Veronese, with his lively spirit and shimmering colors and textures, was a major influence on Rococo painting in Venice. Painting in the city enjoyed a magnificent resurgence in the 18th century following a relatively fallow period in the 17th century.

The Muse of Painting, c.1560, by Paolo Veronese, exemplifies the artist's gracefulness and beauty of color. *Detroit Institute of Arts, Detroit, MI*

Annibale Carracci's Farnese Ceiling, one of the modern marvels of Rome, was greatly admired by many artists of the 17th and 18th centuries, including Ricci. Annibale's style is very solid, but the ceiling's exuberance looks forward to the Rococo era.

The Triumph of Bacchus and Ariadne, c.1597–1600, forms the central part of Annibale's Farnese Ceiling. *Palazzo Farnese, Rome, Italy*

Carlo Cignani was the leading painter in Bologna in the late 17th and early 18th century. He was much admired by fellow artists, and his sweet, graceful style influenced many of them. He helped to advance the young Ricci's career.

Head and Shoulders of the Virgin, c.1670, by Carlo Cignani, exemplifies his elegant draftsmanship. *Chatsworth House, Derbyshire, UK*

◎ TURNING POINT

Bacchus and Ariadne

Sebastiano Ricci **c.1716** *Schloss Weissenstein, Pommersfelden, Germany*

The classical myth of Bacchus and Ariadne was a favorite subject of Ricci's, which he treated several times during his career. This is perhaps his finest interpretation of the theme and indeed one of his most beautiful creations. Artists have depicted various points in the lovers' story (Titian memorably showed their first meeting), and here Ricci has chosen their wedding. The youthful winged figure standing between them is Hymen, the Greek god of marriage. Ricci absorbed a host of influences on his extensive travels, but his borrowings are rarely obvious, since he blended them into such a suave, mellifluous manner. The easy grace of his compositions belies the hard work Ricci put into them. He was a dedicated draftsman and made numerous preparatory studies for his paintings.

◎ Sebastiano Ricci

baptized Belluno, Italy, August 1, 1659;
died Venice, Italy, May 15, 1734

BIOGRAPHY

Ricci was one of the leading Italian painters in the period of transition between Baroque and Rococo. He spent a good deal of his career in Venice and he is generally regarded as a Venetian artist, but he worked in many other places in Italy and also in England, Belgium, France, and Germany. This itinerant career reflects not only the demand for his work (which made him a wealthy man), but also his stormy love life, which—in his early years—sometimes caused him to move in haste.

His travels helped to spread elements of the Rococo style. Ricci was versatile and prolific, painting various types of pictures (particularly on religious and mythological subjects) in oil and fresco. He sometimes collaborated with his nephew Marco Ricci (1676–1730), who was mainly a landscape painter.

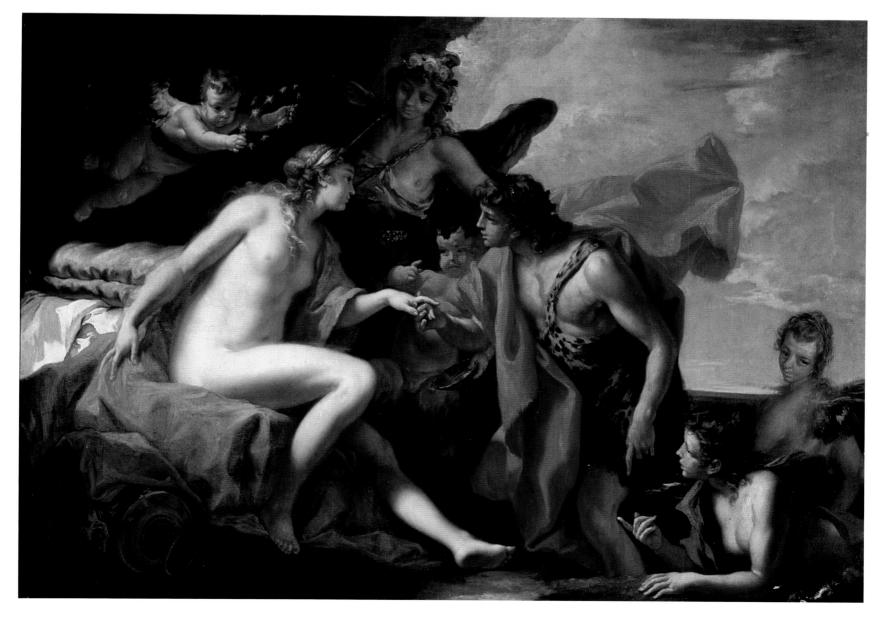

◎ TIMELINE

Although France could now claim leadership in the visual arts, Italy remained highly significant in painting during the 18th century. It attracted many wealthy artistic tourists (especially from Britain), and some of the finest Italian painters of the time— Batoni and Canaletto, for example—worked largely to supply their needs. By about 1780 the charm of Rococo was beginning to give way virtually everywhere to the severity of Neoclassicism. However, in some parts of Central Europe the Rococo style continued to flourish until virtually the end of the century.

◁ **Venus and Cupid**
Adriaan van der Werff 1718
Wallace Collection, London, UK
Van der Werff was the most acclaimed Dutch painter of his time, with an international reputation. His elegant, highly polished work shows how completely the naturalism of 17th-century Dutch art gave way to Rococo artifice in the early 18th century.

Artists' biographies
In Amsterdam in 1718, the painter and writer Arnold Houbraken publishes the first part of a three-volume collection of biographies of Dutch artists—an invaluable source of art-historical information.

Majestic monastery
In 1702, building starts on the monastery at Melk, Austria, designed by Jacob Prandtauer. It is decorated with some outstanding Rococo frescoes.

Military monument
Blenheim Palace is begun in Oxfordshire, England, in 1705. It is a gift of thanksgiving to the Duke of Marlborough for his victories over Louis XIV.

1700　　　　　**1705**　　　　　**1710**　　　　　**1715**　　　　　**1720**

Meissen porcelain
In 1710, the first porcelain factory in Europe is founded at Meissen, near Dresden, in Germany. It produced virtually every type of porcelain, practical and ornamental, including exquisite figurines in the Rococo style.

△ **Self-Portrait With a Portrait of Her Sister**
Rosalba Carriera 1709
Uffizi, Florence, Italy
Carriera was one of the first notable specialists in pastel portraiture. She was internationally renowned, and worked in Paris and Vienna as well as Italy. Her success helped to inspire the 18th-century vogue for pastel, especially among French artists.

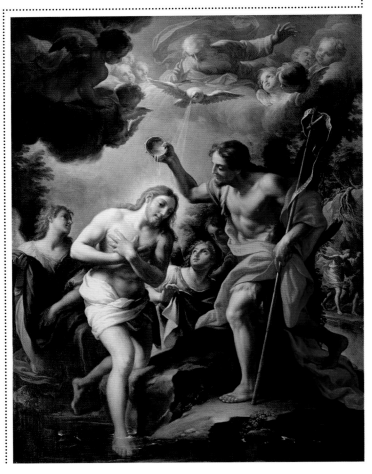

The Baptism of Christ ▷
Francesco Trevisani 1723
Leeds Art Gallery, UK
At the time he painted this picture, Trevisani was probably the most famous and successful artist in Rome, the successor to Carlo Maratta (*see p.162*). He continued the tradition of Maratta, but in a softer, sweeter, more intimate way.

◁ **The Stonemason's Yard**
Canaletto c.1727
National Gallery, London, UK
Early in his career Canaletto painted some vivid, informal scenes of Venice such as this, but he soon began to concentrate on views of the public face of his city—works that were especially popular with aristocratic British visitors to Italy.

Composer statue
In 1738, Louis-Francois Roubiliac, a French sculptor working in England, establishes his reputation with a brilliantly characterized seated statue of the composer Handel, commissioned for Vauxhall pleasure gardens in London.

1725　　　**1730**　　　**1735**　　　**1740** ▶

A Capriccio With Roman Ruins △
Giovanni Paolo Panini 1737 *Fitzwilliam Museum, Cambridge, UK*
Panini occupied a role in Rome similar to that of his contemporary Canaletto in Venice, specializing in detailed views of the city. Some are topographically accurate; others, such as this, are *capriccios*—arrangements of real and imaginary elements.

Tavern Scene from "A Rake's Progress" △
William Hogarth c.1735
Sir John Soane's Museum, London, UK
In about 1730, Hogarth invented the idea of using a sequence of paintings or engravings to tell a moral story. This is the third in a series of eight paintings about a character called Tom Rakewell, who wastes his inheritance on loose living and ends his days in an insane asylum.

❝ I HAVE...ENDEAVORED TO **TREAT MY SUBJECTS** AS A **DRAMATIC WRITER**: MY **PICTURE** IS **MY STAGE** ❞

William Hogarth

▽ The Chocolate Girl
Jean-Étienne Liotard 1743
Gemäldegalerie, Dresden, Germany
The Swiss painter Liotard worked in various European countries and also spent four years in Constantinople. He worked mainly in pastel, as in this, his most famous picture, which shows a Viennese maidservant.

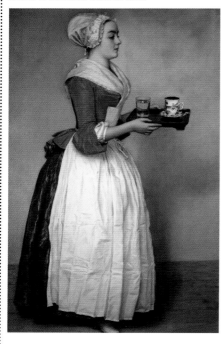

▽ The Last Judgment
Johann Baptist Zimmermann
c.1750–54 *Wieskirche,*
nr. Steingaden, Germany
This huge fresco covers the nave vault of the Wieskirche (White Church), designed by Dominikus Zimmermann, brother of the painter. The biblical Last Judgment has inspired some terrifying visions in art (most famously by Michelangelo in the Sistine Chapel), but here it is presented as a radiant, airy vision, in colors of a porcelainlike delicacy. Christ is shown seated on a rainbow.

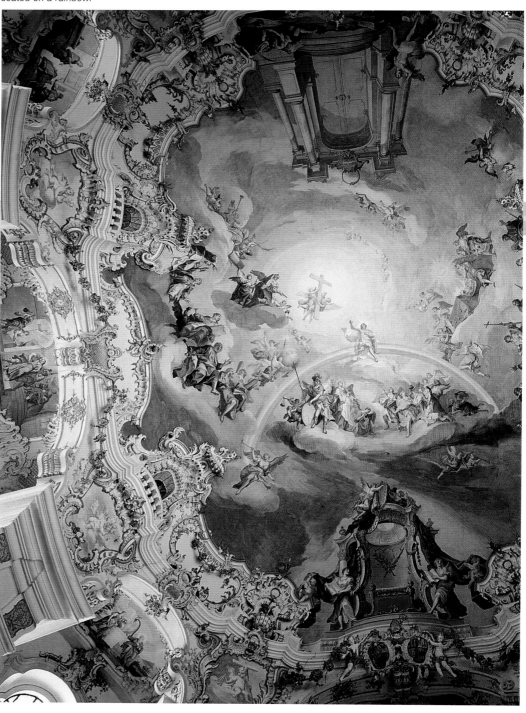

Johann Baptist Zimmermann

baptized Wessobrunn, Germany, January 3, 1680
died Munich, Germany, March 2, 1758

Zimmermann came from an artistic family and often collaborated with his architect brother Dominikus (1685–1766). Both brothers also worked in stucco—a type of plaster that can be used for sculpture and architectural enrichment, as in the extraordinarily elaborate Rococo surrounds to *The Last Judgment* (*see below*). Most of the brothers' work was for religious institutions in southern Germany (Johann Baptist painted altarpieces as well as frescoes), but they also carried out some secular commissions.

BIOGRAPHY

1745

1750

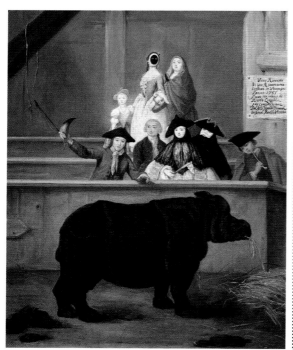

Exhibition of a Rhinoceros at Venice △
Pietro Longhi 1751
National Gallery, London, UK
Exotic animals were often shown at festivities such as the carnival in Venice, but a rhinoceros was a great rarity, and this one, Clara, became a celebrity. She arrived in Rotterdam from India in 1741 and toured extensively for 17 years before dying in London in 1758.

Portrait of Charles John Crowle ▷
Pompeo Batoni c.1762
Louvre, Paris, France
Batoni was the leading portraitist in Rome and his sitters included many foreign visitors to the city, such as this wealthy British traveler. His style has grandeur and dignity, but also a Rococo verve and charm.

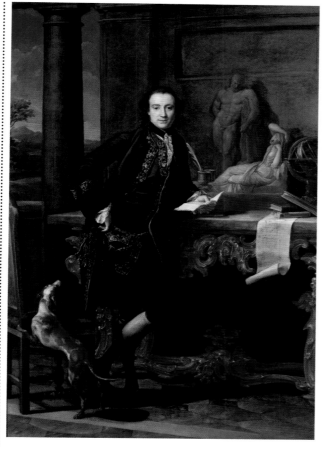

Gainsborough in Bath
In 1759, Gainsborough moves to the fashionable spa town of Bath, England, where he works for a wealthier clientele than in his native Suffolk. He lives there until 1774, when he settles in London.

◁ The Honourable Mrs. Graham
Thomas Gainsborough
1777 *Scottish National Gallery, Edinburgh, UK*
This portrait shows Gainsborough at his most gloriously glamorous. It consciously echoes the work of van Dyck, whom Gainsborough greatly admired, but the lightness of touch is entirely in the Rococo spirit.

1760 **1765** **1770** **1775** **1780**

Uffizi opens
In 1765, the Uffizi Palace opens as a public museum in Florence, showing art treasures collected over the centuries by the Medici family. Originally the building, designed by Giorgio Vasari, had been used as government offices (*uffizi* in Italian).

Copley's triumph
In 1778, the American-born painter John Singleton Copley achieves success at the Royal Academy in London with *Watson and the Shark*.

CONTEXT

CHINOISERIE

One of the most charming aspects of 18th-century European art is chinoiserie: the imitation or evocation, usually in a playful spirit, of Chinese motifs and patterns. Such imitation dates back to the Middle Ages (beautiful Chinese-style silks were produced in Italy in the 14th century, for example), but it was not until the late 17th century that it became a distinctive strain in European art, and it reached its heights of inventiveness and delicacy in the Rococo period. Chinoiserie affected virtually all kinds of applied and decorative art, including ceramics, furniture, and silverware, and it also found expression in painting, sculpture, and architecture. Garden buildings were often designed in Chinese style, notably the pagoda (1761) by Sir William Chambers at Kew Gardens, London.

◁ The Lady With a Fan
Alexander Roslin 1768
Nationalmuseum, Stockholm, Sweden
The model for this ravishing painting was the artist's wife, Marie-Suzanne Giroust, who was herself an accomplished pastel portraitist. Roslin spent his early years in his native Sweden and then had a busy international career, working mainly in France (where he met his wife) but also in Austria, Germany, Italy, Poland, and Russia.

◎ MASTERWORK

The Marriage of Frederick Barbarossa and Beatrice of Burgundy

Giambattista Tiepolo **1751–52**
Kaisersaal, Würzburg Residenz, Germany

Tiepolo was the supreme Italian painter of his age. His output was varied, but he is famous chiefly for his frescoes. He worked mainly in his native Venice and northern Italy, but he was admired throughout Europe. In 1750 he accepted a commission from Karl Philipp von Greiffenklau, the Prince-Bishop of Würzburg, and spent the next three years in his employment in Germany—the first time he had left Italy.

The prince-bishop was one of many minor rulers in Germany, but he was immensely wealthy, and his palace—the Residenz—is appropriately magnificent. Tiepolo decorated the Kaisersaal (Emperor's Hall), which was the state dining room, and the ceiling over the main staircase. These works mark the summit of his career. In the Kaisersaal he painted scenes from Würzburg's early history, including the marriage of the Emperor Frederick I (nicknamed Frederick Barbarossa because of his red beard). The wedding took place in 1156, but Tiepolo makes no attempt to evoke the 12th century, instead creating a fairy-tale image of the Middle Ages. The dominant figure in the composition is the bishop conducting the marriage ceremony, underlining the fact that Tiepolo's paintings are intended to glorify his patron and his predecessors as prince-bishop.

> ❝ HE IS **FULL OF SPIRIT**... WITH **BOUNDLESS FIRE**, SUPERB COLORS, AND AMAZING **SPEED OF HAND** ❞
>
> 1736 | Count Carl Gustav Tessin
> *Swedish diplomat and art patron, recommending Tiepolo to King Frederick I of Sweden*

NEOCLASSICISM

▷ **The Ancient Town of Agrigentum**
Pierre-Henri de
Valenciennes 1787
Louvre, Paris, France
Valenciennes visited many
archaeological sites in Italy and
was particularly impressed with
the Greek remains that he found
in Sicily. Here, he illustrates the
ancient local custom of sending
out slaves to greet visitors on
their approach to the city.

During the late 18th and early 19th centuries, Neoclassicism was the predominant style in Western art. The movement drew inspiration from the recent archaeological discoveries at Pompeii and Herculaneum in Italy, but it went beyond mere imitation. Some Neoclassical painters attempted to recapture the moral and spiritual values of Greece and Rome, while others tried to bring to life the words and deeds of their poets and heroes. There had been earlier classical revivals, of course, but in this instance there was a far greater emphasis on historical accuracy. At first glance, for example, Valencienne's *The Ancient Town of Agrigentum* (*above*) may appear reminiscent of one of Claude's nostalgic idylls (*see p.196*), but the artist aimed to depict a specific, ancient custom and to highlight the main surviving structure at Agrigentum (now Agrigento)—the Temple of Concord, in the middle distance.

◎ CONTEXT

Changing with the times

The development of Neoclassicism was affected by a much broader movement, the Enlightenment (*see p.201*), which helped to shape European culture during the course of the 18th century. Its leaders placed a very high value on the virtues of reason, philosophy, and scientific study, advocating their use in questioning every preconception about faith, tradition, and authority. The Neoclassical style—with its emphasis on order and clarity—was fully in tune with this outlook.

The high-minded attitudes of artists and thinkers helped to create a different vision of the classical world. The nymphs and cupids of Rococo art were replaced with serious themes from ancient history, and painters took pains to make these look as authentic as possible. The setting of Benjamin West's *Agrippina* (*see p.225*), for example, is based on Robert Adam's illustrations of the Roman ruins at Spalatro (now Split). Similarly, Joseph-Marie Vien's Neoclassical scenes often include detailed depictions of artifacts excavated at Herculaneum. Mythological themes were still acceptable, but tended to be heroic scenes from Homer, rather than the amorous interludes of the gods.

In France, many of the historical pictures that were produced in the 1780s related to the republican phase of Roman history. Inevitably, this has led to conjecture that these paintings were meant as political propaganda. This is understandable, given Jacques-Louis David's subsequent close involvement with the revolutionary government—he was a member of the National Convention and voted for the death of Louis XVI —but it remains debatable.

After the Revolution, however, there is no doubt that Neoclassical art was sometimes created with deliberate political intent. David's *Intervention of the Sabine Women* (1799) was clearly intended as a plea for reconciliation. Similarly, Pierre-Narcisse Guérin's *Return of Marcus Sextus* (*see p.227*) was meant to reflect the plight of the emigrés, although this episode of Roman history was actually an invention of the artist. The Neoclassical style could also be applied unequivocally to contemporary events, as in David's *Oath of the Tennis Court* (1791).

The trend continued into the reign of Napoleon, who commissioned numerous artworks to glorify his achievements, admiring the stirring and passionate qualities of the style. Naturally, though, the focus of Neoclassicism shifted at this point. Instead of portraying the virtues of republican Rome, artists were now expected to select themes relating to imperial Rome, with the emphasis on its power and grandeur.

◎ Revolution and empire

▷ **1738** Excavations begin at the site of Herculaneum in Italy. Finds are put on show at a nearby museum.

▷ **1748** The buried ruins of Pompeii are rediscovered. Major archaeological excavations take place in the 1760s.

▷ **1768** The Royal Academy is founded in London, with Joshua Reynolds as its first president.

▷ **1776** The Declaration of Independence is issued by American revolutionaries, formalizing the war against Britain.

▷ **1789** In Paris, rebels storm the Bastille, a hated symbol of royal power. Further violence erupts as the French Revolution gathers momentum.

▷ **1793** Louis XVI is executed in January. By the fall, the country has descended into the Terror—a bloodthirsty period when more than 20,000 French citizens are guillotined.

▷ **1804** Napoleon is crowned emperor by Pope Pius VII in Paris.

▷ **1814** At the Congress of Vienna, politicians revise the map of Europe as the Napoleonic era nears its end.

KEY EVENTS

> **LEARN** FROM THE **ANCIENTS** TO **SEE NATURE**...THEY ARE THEMSELVES **NATURE**; ONE MUST BE **NOURISHED** BY THEM... 🙶

c.1800 |
Jean-Auguste-Dominique Ingres

Revolutionary mood
The *Marseillaise* was both the national anthem and the rallying call of the French Revolution. This sculpture of the same name adorns the Arc de Triomphe, the triumphal arch commissioned by Napoleon in Paris, depicting the departure of volunteers for the French Revolutionary Wars in 1792.

◎ BEGINNINGS
REDISCOVERING THE PAST

The classical remains at Rome had long been recognized as one of the foundations of Western culture. The city had been the highlight of the Grand Tour since the 17th century, and the French had been rewarding their most promising young artists with the *Prix de Rome* since 1666. However, the discoveries at Herculaneum and Pompeii in the 1700s aroused fresh interest and were made all the more tantalizing because images of them were carefully controlled. The only official illustrations, published by the *Accademia Ercolanese*, had a limited circulation, and sketching at the site was prohibited. The archaeological discoveries coincided with influential publications in the 1750s. In addition to Winckelmann's books, there was Robert Wood's analysis of the ruins at Palmyra (1753) and Balbec (1757) in modern-day Syria and Lebanon, and the Comte de Caylus's exhaustive, 7-volume study of antiquities from Greece, Rome, and Egypt (1752–67). These inspired the first major Neoclassical paintings in the early 1760s.

> ❝ **MY MASTER** OR MY **FATHER**, IT IS **ONE AND THE SAME**; [VIEN] KNOWS MY **FAULTS** AND MY **UNCERTAINTIES** ❞

1785 | Jacques-Louis David
Neoclassical painter and former pupil of Vien

◉ ARTISTIC INFLUENCES

Rome was the immediate source for many aspects of Neoclassicism. Winckelmann worked there as librarian to Cardinal Albani, the wealthy patron who commissioned Mengs to paint his *Parnassus*. Visitors to the city would invariably take home examples of Piranesi's engravings as souvenirs of their tour, while his friend Robert Adam frequently incorporated details from the prints into his own designs.

Watercolor cakes were a convenient means of storing and using paint. In 1781, William and Thomas Reeves won the Silver Palette of the Society of Arts for devising the process. Early examples were hard and had to be grated.

Paintbox by William Reeves and John Inwood, who were art suppliers with a shop in London that specialized in "superfine Cake Colors."

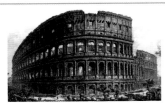

Giovanni Battista Piranesi found success with his influential series of *Vedute* ("Views") of Rome. He used an exaggerated sense of scale to make the ruins appear even grander than they actually were.

View of the Colosseum, 1761, by Piranesi makes the Roman landmark appear gigantic with its tiny figures and dramatic perspective. *Private Collection*

Robert Adam's architecture and interior design spread the taste for Neoclassicism in the US and UK. Much of his inspiration came from a close study of Diocletian's Palace at Spalatro—Split in modern-day Croatia—one of the last great surviving Roman monuments.

Syon House, renovated 1762–69 by Adam, contains a copy of the *Dying Gaul*, one of the most celebrated statues of antiquity. *Syon House, London, UK*

Johann Joachim Winckelmann (1717–68), a German archaeologist and art historian, exerted a huge influence on Mengs and his circle, through his study of ancient art: *Reflections on the Painting and Sculpture of the Greeks* (1755).

Portrait of the author, 1750s, German School, surrounded by the classical remains that had inspired his writings. *Royal Castle, Warsaw, Poland*

◎ TURNING POINT

The Cupid Seller

Joseph-Marie Vien **1763** *Château de Fontainebleau, France*

This is a landmark painting in Neoclassical art and is one of the first examples to take direct inspiration from the recent archaeological discoveries. It is based on a wall painting found near the Roman town of Herculaneum (*see p.39*). Vien used the only available visual source, an illustration published by the *Accademia Ercolanese*, but he modified it considerably, adding a more detailed setting with suitably classical trappings. Even so, the slightness of the theme and the prettiness of the figures still have Rococo overtones. Vien exhibited the painting in Paris in 1763, just a year before Jacques-Louis David enrolled in private classes with him.

◎ **Joseph-Marie Vien**

born Montpellier, France, June 18, 1716;
died Paris, France, March 27, 1809

BIOGRAPHY

Vien was a pioneer of the Neoclassical style in France and an influential teacher, with David among his pupils. He won the *Prix de Rome* in 1743 and spent six years in Italy. There, Vien was fascinated with Winckelmann's ideas and archaeological discoveries. He enjoyed incorporating classical elements into his work, but the results often seem charming rather than serious-minded. Even so, his career flourished: he became Director of the French Academy in Rome in 1775 and first painter to the king in 1789.

◎ TIMELINE

The initial focus of Neoclassicism was in Rome, where it was shaped by two dominant personalities. Winckelmann was the great theorist of the movement, while his friend Mengs managed to translate his ideas into a number of hugely influential paintings. At first, the main aim was to analyze and revive classical forms but, as the style spread, there was a growing emphasis on recapturing the values of the ancients. This trend was most evident in France, where Neoclassicism became associated with the Revolution and the rise of Napoleon.

▽ Jupiter Kissing Ganymede
Anton Raphael Mengs 1758–59
Galleria Nazionale d'Arte Antica, Rome, Italy
Mengs painted this pastiche of the Herculaneum frescoes as a private joke, hoping to fool his friend Winckelmann (who did indeed believe it to be an authentic Roman work). Mengs deliberately chose a theme that would appeal to Winckelmann's homosexual interests.

❝ TO TAKE THE **ANCIENTS** FOR **MODELS** IS OUR **ONLY WAY** TO BECOME **GREAT**, YES, **UNSURPASSABLE IF WE CAN** ❞

1755 | Johann Joachim Winckelmann
German art historian and archaeologist

Diderot's *Encyclopédie*
The first part of the 28-volume *Encyclopédie*, edited by Denis Diderot, is published in 1751. Its radical content will play a significant part in shaping the French Revolution.

The Ruins of Balbec
In 1757, the writer, traveler, and politician Robert Wood publishes his book on the Roman remains at Balbec (now Baalbek, Lebanon). Its illustrations prove highly influential for designers such as Robert Adam.

Mengs in Spain
In 1761, Mengs travels to Madrid, where he takes up the post of court painter to Charles III. He will not return to Rome until 1769.

1755 **1760**

◎ Gavin Hamilton

born Lanarkshire, Scotland, UK, 1723;
died Rome, Italy, January 4, 1798

The influential Scottish painter, picture dealer, and archaeologist Gavin Hamilton first traveled to Italy in 1748. He trained under Agostino Masucci and spent most of his career in Rome, where he became part of the circle around Mengs and Winckelmann, offering an important point of contact for visiting British artists. As a painter, Hamilton is best remembered for a series of heroic canvases based on Homer's *Iliad*. Gradually, though, he found it more lucrative to sell paintings to tourists, as well as antiquities from his own archaeological digs.

BIOGRAPHY

◁ The Death of Lucretia
Gavin Hamilton 1763–67
Yale Center for British Art, New Haven, CT
Also known as *The Oath of Brutus*, this is a scene from early Roman history. The virtuous Lucretia takes her own life after being raped while, on the right, her friends vow to avenge her. The picture may have influenced David's "oath" theme in *The Oath of the Horatii* (see pp.230–31).

Agrippina Landing at Brundisium With the Ashes of Germanicus ▽
Benjamin West 1768 *Yale University Art Gallery, CT*
Commissioned by the Archbishop of York, this austerely Neoclassical scene sealed West's reputation in England. Agrippina returns to confront the man who ordered her husband's death, and is greeted by crowds of sympathizers. The subject was drawn from an account by the Roman historian Tacitus.

THE GRAND TOUR

The Neoclassical movement coincided with the heyday of the Grand Tour. For most of the 18th century, young British aristocrats and gentlemen would complete their education by visiting cities of Europe. The highlight was Rome, where tutors would guide them around the classical remains.

British Gentlemen in Rome, Katharine Read, 1751, **Yale Center for British Art, CT**

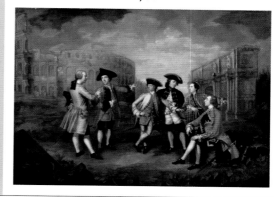

CONTEXT

Runciman at Penicuik
In 1772, the Scottish painter Alexander Runciman carries out his most ambitious project: the decoration of Penicuik House with scenes from Ossian and Scottish history.

1765 **1770** **1775**

△ Chamber of Roman Ruins
Charles-Louis Clérisseau c.1766
S. Trinità dei Monti, Rome, Italy
This extraordinary *trompe-l'oeil* fresco was designed to create the illusion of an ancient Roman ruin exposed to the elements. The furniture was in a similar vein—the desk was a damaged sarcophagus, while the table and chairs were formed from broken architectural fragments.

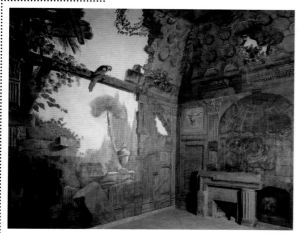

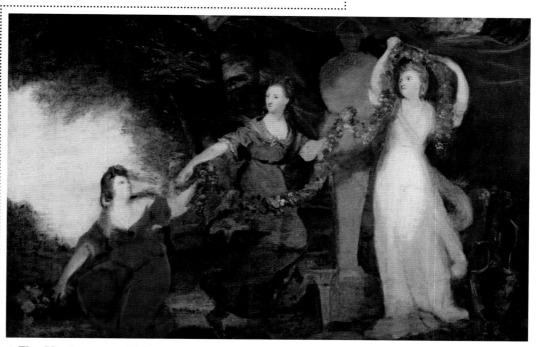

△ The Montgomery Sisters
Sir Joshua Reynolds 1773 *Private Collection*
This is a study for a portrait commissioned to mark the engagement of Elizabeth Montgomery (center). Her fiancé instructed the artist to paint the three sisters together, "representing some emblematical or historical subject." Reynolds chose an apt theme, showing them adorning a statue of Hymen, the Roman god of marriage.

The Death of Priam ▷
Jean-Baptiste Regnault 1785
Musée de Picardie, Amiens, France
The theme of regicide may seem politically charged in a work painted just before the French Revolution, but ironically this was a royal commission. Regnault was working in a highly Italianate style at this period, even signing his pictures as "Renaud de Rome."

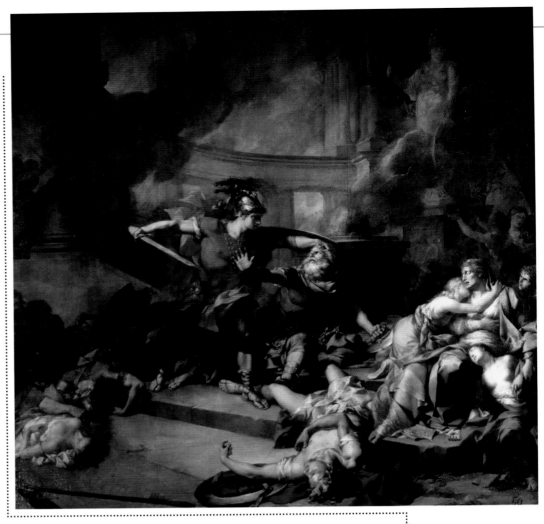

BIOGRAPHY

Jean-Baptiste Regnault

born Paris, France, October 1754;
died Paris, November 12, 1829

Trained by Jean Bardin and Nicolas-Bernard Lépicié, Regnault won the *Prix de Rome* in 1776. He spent four years in Rome, his stay coinciding with that of David, and he gained a series of prestigious royal commissions following his return to Paris. Regnault ran a flourishing studio—Guérin was one of his pupils—and he steered a successful course through the revolutionary period, receiving commissions from both the Republic and Napoleon. He built up a solid reputation with his polished mythological scenes, but he lacked the dramatic flair and originality of David.

1775　　　　　　　　　　**1780**　　　　　　　　　　**1785**

American Revolutionary War
On April 19, 1775, British and American forces clash at the Battles of Lexington and Concord. These skirmishes mark the start of the Revolutionary War—a conflict that will be formalized in the following year with the Declaration of Independence.

The Artist in the Character of Design △
Angelica Kauffmann c.1782 *Kenwood House, London, UK*
Kauffmann combined the decorative charm of the Rococo style with the lyrical trappings of classical art. In this allegorical self-portrait, she emphasizes her achievement as an independent female artist, fired with inspiration from the Muse of Poetry.

Goethe in the Roman Campagna △
Wilhelm Tischbein 1786–87
Städelsches Kunstinstitut, Frankfurt, Germany
This portrait of the celebrated German writer Johann Wolfgang von Goethe underlines his fascination with the classical world. The carved relief beside him relates to *Iphigenia in Tauris*, a tragedy by Euripides that Goethe had reworked several times, most recently in verse.

WEDGWOOD AND FLAXMAN

CONTEXT

The taste for the Neoclassical style was reflected in a range of media. Book illustrations by John Flaxman (1755–1826) proved influential, emphasizing the purity and simplicity of classical art. His inspiration came from Greek vase painting and, in this same field, his own designs were much admired. Early in his career, Flaxman worked for the potter Josiah Wedgwood (1730–95), creating a series of ceramic medallions and plaques for his wares.

The Apotheosis of Virgil
by John Flaxman, c.1776

Stubbs and the Turf Review
In 1790, George Stubbs becomes involved in the *Turf Review*, an illustrated history of horse racing since 1750. He produces several portraits of racehorses for this project.

The Return of Marcus Sextus ▷
Pierre-Narcisse Guérin 1797–99
Louvre, Paris, France
Marcus Sextus returns from exile to find his wife dead. Critics thought the painting had counterrevolutionary overtones, since it coincided with the return of the exiled royalists to France, but Guérin's actual intentions are unclear.

1790 **1795** **1800** ▶

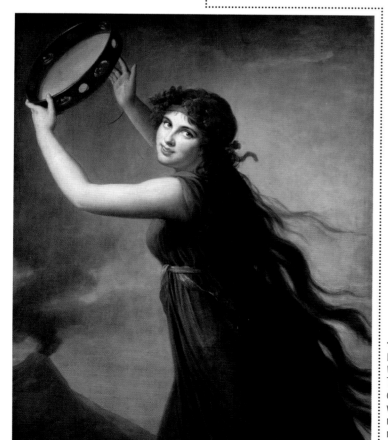

BIOGRAPHY

Elisabeth Vigée-Lebrun

born Paris, France, April 16, 1755;
died Paris, March 30, 1842

Before the French Revolution, Vigée-Lebrun enjoyed an outstanding career as a society portraitist. She was a favorite of Queen Marie-Antoinette, painting her on numerous occasions. In 1789, these royal associations placed her in danger, so she fled France. Her services remained in high demand, however, and she worked successfully in Italy, Russia, and England, returning to France only in her later years.

◁ Lady Hamilton as a Bacchante
Elisabeth Vigée-Lebrun c.1791
Walker Art Gallery, Liverpool, UK
The inclusion of Mount Vesuvius in the background confirms that this portrait was painted in Naples, where Emma Hamilton (famous as Lord Nelson's mistress) lived for several years after her marriage in 1791. She is pictured in the guise of a Bacchante—one of the wild, female followers of the wine-god Bacchus.

Thorvaldsen in Rome
After winning a scholarship from the Copenhagen Academy to study in Italy, the sculptor Bertel Thorvaldsen arrives in Rome on March 8, 1797. He subsequently describes this date as his "Roman birthday." Thorvaldsen will spend much of his career in the city.

> A MAN SHOULD **HEAR** A LITTLE **MUSIC, READ** A LITTLE **POETRY,** AND **SEE A FINE PICTURE EVERY DAY** OF HIS **LIFE**

1795–96 | Johann Wolfgang von Goethe
German writer

Anne-Louis Girodet

born Montargis, France, January 29, 1767;
died Paris, France, December 9, 1824

Girodet was one of David's most gifted, but erratic, pupils. After training briefly as an architect, he entered the master's studio in 1784 and five years later won the *Prix de Rome*. He was an outstanding portraitist and retained David's scrupulous technique throughout his career. However, some aspects of his work led to his association with Romanticism (*see pp.234–45*), notably his taste for highly imaginative subjects and his practice of painting at night, which produced some very unusual light effects. David was bemused by much of Girodet's work, but Napoleon was enthusiastic and offered him a number of commissions.

◁ **Ossian Receiving Dead Warriors into Valhalla**
Anne-Louis Girodet 1800–02
Château de Malmaison, Rueil-Malmaison, France
When renovating his home at Malmaison, Napoleon commissioned a pair of paintings to commemorate his favorite book—a collection of epic verse by a Celtic bard called Ossian. These poems were later discovered to be fraudulent but, at the time Ossian was regarded as the northern equivalent of Homer, creating a more local vision of the ancient world.

Vien dies
Joseph-Marie Vien dies in Paris in March 1809, a year after being raised to the nobility by Napoleon Bonaparte. He spent his final years on the task of writing his memoirs.

1800　　　　　　　　　　　**1805**　　　　　　　　　**1810**

David and Mme. Récamier
In 1800, David is working on his portrait of Madame Récamier, though a dispute soon arises. His pupil Ingres assists him, adding a Grecian lamp to the composition.

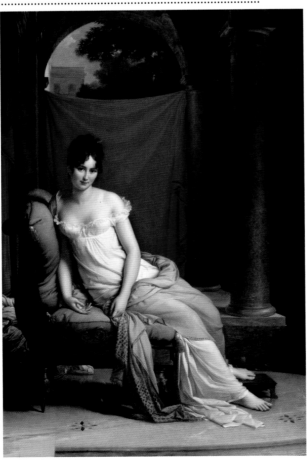

Portrait of Madame Récamier ▷
François Gérard 1805
Musée Carnavalet, Paris, France
One of David's favorite pupils, Gérard developed a softer, more graceful version of his master's style. The original commission for this portrait had gone to David, but the sitter disliked the results, so the job was passed to Gérard.

The Entry of Napoleon into Berlin △
Charles Meynier 1810 *Château de Versailles, France*
Napoleon commissioned a number of artworks to commemorate his successful Prussian campaign of 1806, when he led a triumphal procession through Berlin following his victory at the Battle of Jena. Meynier painted several friezelike canvases on patriotic themes and also produced designs for the sculptures and reliefs that were to adorn the Arc de Triomphe du Carrousel in Paris.

◁ Cupid and Psyche
Jacques-Louis David 1817
Cleveland Museum of Art, Cleveland, OH
After Napoleon's defeat and the restoration of the monarchy, David went into exile in Brussels. In his later paintings, he steered clear of political controversy. In this instance, he used an ancient tale by Lucius Apuleius for a moral allegory, contrasting the idealized beauty of Psyche with the coarse naturalism of Cupid.

❝ NOW **THEY WANT PAINTINGS** ONE COULD **WALK AROUND IN**; I DO NOT **GIVE A FIG** FOR THAT! ❞

c.1820 | Jean-Auguste-Dominique Ingres

1815

1820

The Battle of Waterloo
On June 18, 1815, the combined British and Prussian armies inflict a crushing defeat on the French at Waterloo. This finally shatters Napoleon's imperial ambitions. He abdicates and, in October, is exiled to the island of St. Helena.

Frankenstein published
Frankenstein, or the Modern Prometheus, is published anonymously in London on January 1, 1818. The author, 21-year-old Mary Shelley, was inspired by a dream that she had while staying near Geneva.

THE EMPIRE STYLE

The brand of Neoclassicism that prevailed in the Napoleonic era was not confined to painting, but also affected the applied arts. Furniture and other objects incorporated decorative details from ancient Greece, Rome, and Egypt. In some cases, the inspiration could come from modern, Neoclassical artworks. Here, the heroic figures of David's *The Oath of the Horatii* adorn an ornamental clock.

The Oath of the Horatii **clock, c.1810, Musée Carnavalet, Paris, France**

CONTEXT

△ Augustus Listening to the Reading of the Aeneid
Jean-Auguste-Dominique Ingres 1819
Musées Royaux des Beaux-Arts, Brussels, Belgium
Early in his career, Ingres opted for an austere version of the Neoclassical style. He based this on his superb draftsmanship, commenting that "a thing well drawn is always adequately painted." Here, the colors are muted, the figures are sculptural, and there is no interest in the setting.

◎ MASTERWORK

The Oath of the Horatii

Jacques-Louis David **1784**
Louvre, Paris, France

This is the most famous Neoclassical painting.
It brought David international renown, confirming his position as the most important artist in France. It also constitutes a perfect example of the style itself, its striking simplicity recalling a classical relief. In a single, breathtaking image, the artist has represented some of the noblest human qualities—courage, self-sacrifice, patriotism, strength in adversity—and conveyed them to the viewer in a clear but dramatic fashion.

The painting depicts an incident from Rome's early history. The city is at war with its neighbor, Alba, and the dispute is to be settled by a fight to the death between the three Horatii brothers of Rome and the three Curiatii brothers of Alba. Tragically, these families have ties of marriage and betrothal so that, before a single blow is struck, each of the women knows that she will lose a husband or a brother.

David probably drew his initial inspiration from *Horace*, a play by Pierre Corneille, although this particular incident does not feature in the text. He traveled to Rome to put himself in the right frame of mind to tackle the classical theme, and exhibited the picture there first, in July 1785. It was given a rapturous reception, and again when it was displayed in Paris, later in the year. Because it was completed just a few years before the French Revolution (1789–99), the picture is often seen as a symbolic call to arms for the French nation, but there is nothing to suggest that this was the artist's intention.

 TO **GIVE A BODY AND A PERFECT FORM** TO YOUR THOUGHT, **THIS ALONE** IS WHAT IT IS **TO BE AN ARTIST** 🙶

1796 | Jacques-Louis David

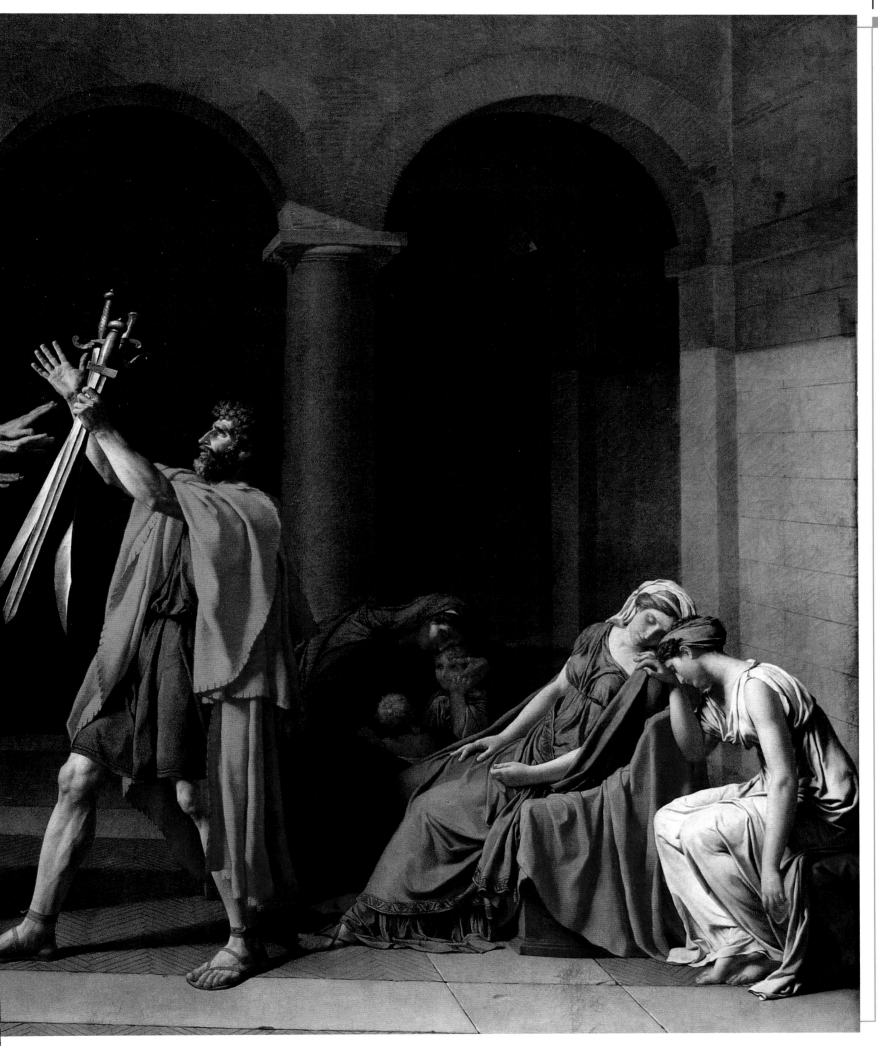

THE
19TH CENTURY

234 ROMANTICISM

246 ROMANTIC LANDSCAPE

256 PRE-RAPHAELITES

266 REALISM

276 IMPRESSIONISM

288 POST-IMPRESSIONISM

298 SYMBOLISM

At the beginning of the 19th century, art was dominated by Romanticism, which valued emotion, individuality, imagination, and the forces of nature above the rationalism and order promoted by the Neoclassicists. Many Romantic artists were fascinated by the Gothic style and medieval culture, and the British Pre-Raphaelites embraced these enthusiastically in their minutely detailed paintings. Realism, which emerged in the middle of the 19th century, focused on the contemporary world, and sought to convey the unvarnished reality of working-class life rather than celebrating heroic deeds from the past. The Impressionists also concentrated on the world around them, analyzing the optical effects in nature. Toward the end of the century, painters began to explore inner realms rather than external reality. The Post-Impressionists experimented with the expressive potential of line and color, while the Symbolists evoked mysterious worlds.

ROMANTICISM

▷ **The Death of Sardanapalus**
Eugène Delacroix 1827–28
Louvre, Paris, France
Inspired by Byron's poem *Sardanapalus* (1812), Delacroix's enormous canvas portrays an ancient Assyrian king who, as his palace is besieged by rebels, looks on impassively while his slaves and his mistresses are slaughtered, before his own suicide. Its Orientalist theme, emotionally charged subject matter, bravura brushwork, hot feverish palette, and wealth of exotic detail are all typical features of Romanticism.

Romanticism began as a reaction against the reason and order that lay at the heart of Neoclassicism. Romantic artists responded to the political upheavals of their day by rebelling against conservatism and moderation, giving priority to the anarchy of imagination and stressing the importance of the individual's experience. Orientalist subjects—with their promise of exoticism, novelty, passion, and cruelty—held wide appeal for them, as did the chivalric romances of the Middle Ages. Romantic art embraced a variety of styles: in France it typically meant the dashing bravura and heightened color of Delacroix and his fellow artists. In Germany it revealed itself in the religiously inspired, precisely finished canvases of Friedrich, Runge, and the Nazarenes. Spanish Romanticism was dominated by the dark fantasies of Goya, while in Britain, it found its most individual expression in the eccentric visions of William Blake.

◎ CONTEXT

An age of freedom

"Man is born free but is everywhere in chains," runs the opening sentence of *The Social Contract* (1761), written by the French philosopher Jean-Jacques Rousseau. The notion of freedom is a persistent theme in the art, literature, and music of the Romantic period. It underpins the era's most momentous political event—the French Revolution—which was ignited in 1789, when the French King Louis XVI attempted to raise taxes. The Estates General, an advisory body of elected representatives that had not met since 1614, was summoned to ratify his plans, but the members rebelled and demanded a new constitution. Against a background of hunger riots in Paris, the new Constituent Assembly abolished the old regime and issued the *Declaration of the Rights of Man*, enshrining every citizen's right to "Liberty, Equality, and Fraternity." The royal family was imprisoned

and the king and queen were eventually executed. Public buildings that were symbols of the old regime were sacked and vandalized, including the Bastille, where political prisoners had been incarcerated. A decade of unrest followed before a coup, led by an ambitious young general named Napoleon Bonaparte, ushered in a new era and a new Empire.

In Germany, which at the end of the 18th century was not yet a unified nation, a Romantic sensibility showed itself in music, philosophy, and literature. The writers Goethe and Schiller published a series of works that emphasized emotion, youth, faith, and spirituality. Perhaps the best known of these is Schiller's poem "Ode to Joy," originally called "Ode to Freedom" (1786), which celebrates the unity of mankind. It was used by Beethoven to form the rousing finale to his *Ninth Symphony* (1824), now one of the most revered of all musical works.

◎ Liberty and reform

KEY EVENTS

▷ **1793** French King Louis XVI and his Queen, Marie Antoinette, are executed.

▷ **1806** Two years after Napoleon declares himself Emperor of France, Ingres paints an imposing portrait of him seated on his Imperial throne.

▷ **1808–14** The Peninsular War in Spain leads Goya to create a series of prints depicting the horrors of the conflict.

▷ **1812–18** Lord Byron publishes *Childe Harold's Pilgrimage*, a poem describing the reflections of a world-weary young man who looks for distraction in foreign lands.

▷ **1821** The Greeks begin their War of Independence against Ottoman rule—a cause supported by artists and poets including Delacroix and Byron.

▷ **1830** The July Revolution in France succeeds in deposing King Charles X.

▷ **1834** A long campaign by the anti-slavery movement leads to the official abolition of slavery in the British Empire.

KEY EVENTS

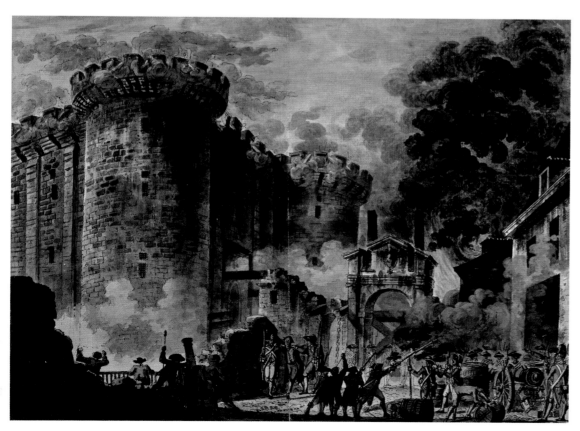

Storming of the Bastille
On July 14, 1789, crowds stormed the Bastille prison in Paris, to strike a blow against this hated symbol of royal authority, and to acquire the weapons stored there.

❝ **TO SAY** THE WORD **ROMANTICISM** IS TO SAY **MODERN ART**— THAT IS, **INTIMACY, SPIRITUALITY, COLOR**, ASPIRATION **TOWARD THE INFINITE** ❞

1846 | Charles Baudelaire
French poet and critic

◎ BEGINNINGS
EXTREME EMOTIONS

Romanticism began as a literary movement in late 18th-century Germany, but its ideas—particularly the stress it placed on individual emotion and intuition—soon spread to the visual arts, encouraging artists to produce highly imaginative, personal works. Rejecting the calm compositions typical of Neoclassical art, painters started to produce canvases that were often full of turmoil and ambiguity. They began to embrace melancholy and disturbing subject matter that underlined the fragility of mankind in the face of a hostile world that was in a state of flux. Theirs was a universe of extreme emotion, horror, and violence, of supernatural forces beyond human comprehension or control. But although they rebelled against the order and rationalism of Neoclassicism, the art produced by the early Romantic artists, such as Fuseli and his contemporaries, still made use of the art of antiquity, even if they exaggerated and distorted its forms to produce figures with improbable musculature and wildly dramatic gestures.

> **SPECTERS, DEMONS, AND MADMEN; PHANTOMS, EXTERMINATING ANGELS; MURDERS** AND ACTS OF **VIOLENCE**—SUCH ARE HIS **FAVORITE SUBJECTS**

Johann Casper Lavater
Swiss poet and physiognomist, on Fuseli

◉ ARTISTIC INFLUENCES

Early Romantic artists may have wanted to tear up the artistic rule book, but they nonetheless handpicked elements from past art, reassembling them to create arresting new images of great imaginative power. In Fuseli's *Nightmare*, for example, the sleeping girl is clad in the diaphanous robes sported by countless Roman statues, while her elongated limbs pay tribute to Mannerist art.

Classical sculpture provided a source of inspiration to many Romantic artists. Fuseli made several studies of the famous *Horse Tamers* on the Quirinial Hill in Rome, and the "mare" in *The Nightmare* bears more than a passing resemblance to the horses' heads.

The Horse Tamers are 4th-century CE Roman copies of Greek originals, and have stood on the Quirinal Hill in Rome since antiquity. *Rome, Italy*

Witchcraft is an age-old theme that has a particular resonance with the Romantic sense of man's powerlessness in the face of unseen forces. This well-known German print contains the basic elements of Fuseli's picture—victim, horse, and evil spirit.

Sleeping Groom and Sorceress, 1544, by Hans Baldung Grien, is a woodcut showing a bewitched stable groom. *The Israel Museum, Jerusalem, Israel*

Apparitions and dreams had long provided subjects for paintings. Here an actor on stage is trying to convey the sensation of seeing a ghost. Many Romantic artists later became adept at conveying the psychological horror of ghoulish visions.

David Garrick as Richard III, 1745, by William Hogarth, shows the king seeing the ghosts of those he murdered. *Walker Art Gallery, Liverpool, UK*

Sir Joshua Reynolds's subject paintings, which were often infused with moments of high drama, were widely admired by many contemporaries. Fuseli, who saw Reynolds's *Dido* while it was on the easel, produced *The Nightmare* in response.

Death of Dido, 1781, by Sir Joshua Reynolds, drawn from Virgil's *Aeneid*, depicts the suicide of the Queen of Carthage. *Royal Collection, UK*

◎ TURNING POINT

The Nightmare

Henry Fuseli **1781** *Detroit Institute of Arts, MI*

Fuseli's best-known work, this painting epitomizes the theatrical quality of Romanticism. It was so popular with the public that the artist made at least three other versions of it. He would have known of folktales of sleeping women being visited in the night by the devil, having intercourse with him, and later remembering the event in their dreams, but there may be a more personal story behind the picture. On the back of the canvas is a portrait of Anna Landholdt, with whom Fuseli was in love, but who had refused his proposal of marriage. The picture's eroticism tinged with sadism may reflect the artist's thwarted passion.

◎ Henry Fuseli

born Zurich, Switzerland, February 6, 1741;
died London, UK, April 16, 1825

BIOGRAPHY

Fuseli produced some of the most memorable images of the Romantic period. Swiss by birth, he spent most of his working life in England. During an eight-year stay in Rome (1770–78), he discovered Roman sculptures and the art of Michelangelo. Fuseli's art draws upon literary sources, and often depicts violent, tragic, or fantastic episodes. As Professor of Painting at the Royal Academy he taught the next generation of British artists, including Constable.

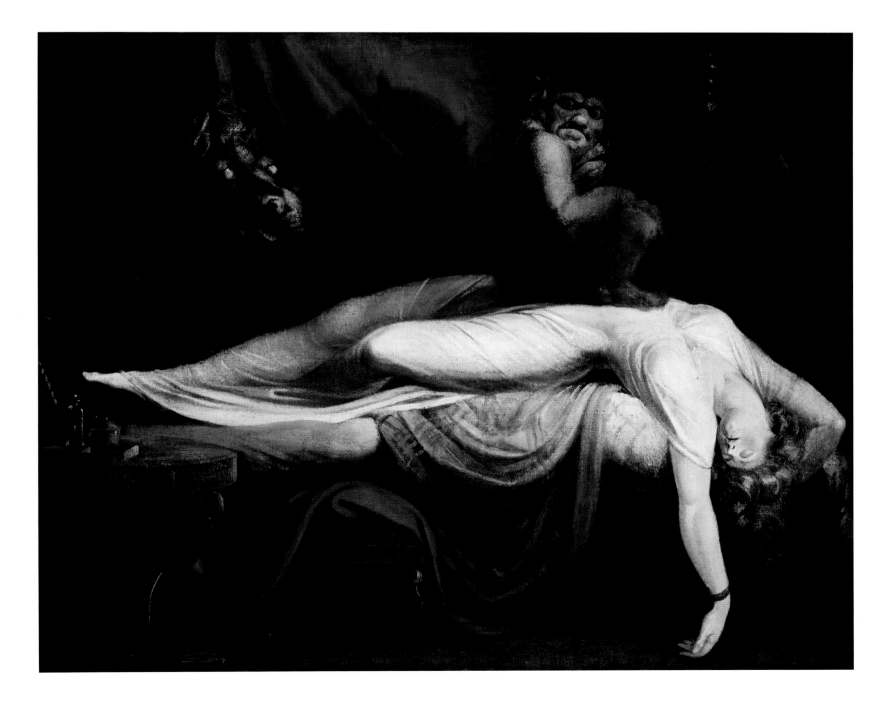

◎ TIMELINE

Romanticism in art began to take shape in the late 18th century, but found its fullest expression after 1800. In 19th-century France the art scene was often characterized as split between two camps—the Neoclassicists, led by Ingres, who emphasized line, and the Romantics, led by Delacroix, who stressed color. In reality, there was a great deal of overlap between the two groups, and both dealt with unattainable ideals of nobility and grandeur. Romanticism as a movement died out in the mid-19th century, but the Romantic spirit of antiestablishment rebellion has lived on into modern times.

Fuseli in London
Henry Fuseli settles in London in 1779. The deficiencies of his painting technique are initially criticized, but the power of his images is immediately recognized.

Royal patronage
Goya is appointed painter to the Spanish King Charles III in 1786, and goes on to produce a series of memorable portraits of the Spanish monarchy and aristocracy.

⊙ **1780** ⊙ **1785** ⊙

The Three Witches △
Henry Fuseli 1783
Royal Shakespeare Theatre, Stratford-upon-Avon, UK
Shakespeare's plays were a popular source of inspiration for Romantic artists, and here Fuseli depicts the three witches from Shakespeare's *Macbeth*. The composition relies for its theatrical effects on dramatic tonal contrasts, and on the fact that the figures are lined up in profile, their fingers pointing in unison.

◎ William Blake

born London, UK, November 28, 1757; **died** London, August 12, 1827

Blake is one of the key figures of the Romantic era. A nonconformist who believed passionately in the world of the spirit, he experienced visions from childhood, and developed his own highly personal mystical philosophy. He worked in print, tempura, and watercolor, disliking oil painting and traditional methods of teaching art. Around 1787, he developed a new method of printing his own illustrated poems in color, producing works in which text and illustration were interwoven. Seen by his contemporaries as an eccentric, Blake was rediscovered in the mid-19th century by another painter-poet, Dante Gabriel Rossetti.

BIOGRAPHY

❝ **IMAGINATION** IS THE **REAL AND ETERNAL WORLD** OF WHICH THIS **VEGETABLE UNIVERSE** IS BUT A FAINT SHADOW ❞

1804 | William Blake

Death on the Pale Horse ▽
Benjamim West 1796
Detroit Institute of Arts, MI
In this scene from the Apocalypse the figure of Death, seated upon a white horse, descends upon humanity, followed by a trail of demons. The animated composition, with its intertwined humans and beasts, owes a great deal to the example of Baroque painters such as Rubens.

1795 ○ ○ **1800** **1805** ○ ▶

God Judging Adam △
William Blake 1795
Tate Britain, London, UK
Blake's God is a stern tyrant seated on a fiery chariot drawn by horses. Adam cowers before him, reflecting the artist's negative attitude toward the God of the Old Testament. This is a relief etching printed from a copper plate and finished by hand; the figures are outlined in the hard linear style Blake adopted for his printed works.

Napoleon at Arcola △
Antoine-Jean Gros 1798
Louvre, Paris, France
Gros was present when Napoleon raised the French flag on the bridge at Arcola in Italy, following victory in battle. The artist was a student of Jacques-Louis David, but this fiery composition is a far cry from his teacher's severe Neoclassicism.

The Flood △
Anne-Louis Girodet c.1806
Louvre, Paris, France
Girodet had a foot in both the Neoclassical and Romantic camps. He followed the polished technique of his master Jacques-Louis David, but he often favored highly emotional subjects and lurid lighting. This dramatic picture had nothing to do with the biblical deluge but was intended to demonstrate the artist's originality.

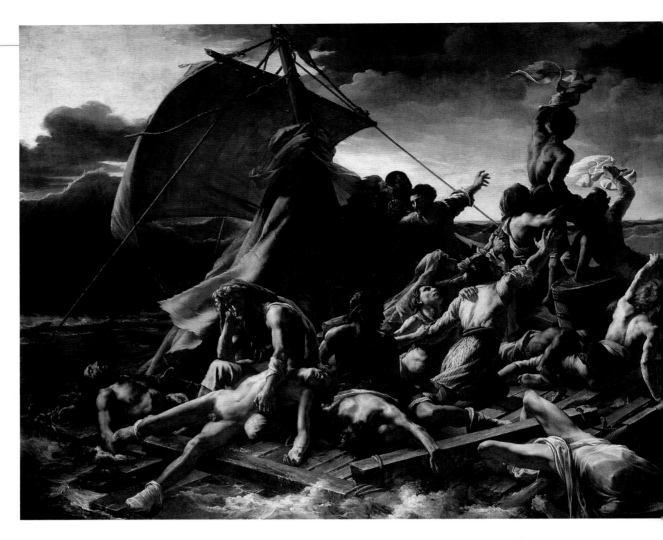

> WHAT **HANDS** AND **HEADS**! I CANNOT **EXPRESS** THE **IMAGINATION** IT **INSPIRES**. I FEEL A **LONGING** TO MAKE A SKETCH OF IT

1824 | Eugène Delacroix
Describing Géricault's Raft of the Medusa

Runge's altarpiece
In 1805, Philipp Otto Runge is commissioned to paint an altarpiece for a church in Greifswald. His *Rest on the Flight into Egypt* places Mary and Joseph in a luxuriant landscape with a tree full of angels.

1805 **1810** **1815**

Nazarenes in Rome
In 1810, a group of young Austro-German artists nicknamed the Nazarenes move from Vienna to Rome, where they live in an unoccupied monastery and paint pictures inspired by medieval art.

A momentous shipwreck
In 1816, the French ship *Méduse* runs aground off the coast of Senegal. The rescue is botched—140 lives are lost and there are only 15 survivors. The event inspires Géricault to create his most famous work.

◁ **The Child in the Meadow**
Philipp Otto Runge 1809
Hamburger Kunsthalle, Hamburg, German
Runge's baby is presented in the pose traditionally assumed by the Christ Child in scenes of the Nativity. Shorn of an obviously Christian context it has a wider significance, standing for all human babies and all new beginnings.

HAREM SCENES

While contemporary critics often saw French art as divided between Neoclassicism and Romanticism, the boundaries between the two tendencies were more blurred. For example, Ingres's *Grande Odalisque* (1814) exhibits the meticulous finish typical of French academic art, but the subject—a languid nude in an exotic setting—anticipates the harem scenes painted by Delacroix and his followers a few decades later.

Grande Odalisque, Ingres, 1814, Louvre, Paris, France

CONTEXT

Théodore Géricault

born Rouen, France, September 26, 1791;
died Paris, France, January 26, 1824

BIOGRAPHY

Théodore Géricault is known for a handful of dramatic works created in just over a decade, which present events or experiences in a grand manner inspired by the work of Rubens and Michelangelo. His best-known canvas is the epic *Raft of the Medusa*, but he also painted military subjects, horse races, and an extraordinary series of portraits of mental patients. Géricault's paintings exhibit the energetic handling of paint, dramatic compositions, and taste for the macabre that were characteristic of Romanticism.

◁ Raft of the Medusa
Theodore Géricault 1819
Louvre, Paris, France
An icon of French Romanticism, this enormous canvas depicts the starving and desperate survivors of the shipwrecked French frigate *Méduse*. In search of authenticity, Géricault visited morgues and hospitals to observe the appearance of the dead and dying.

▽ Disappointed Love
Francis Danby 1821
Victoria and Albert Museum, London, UK
Danby's painting explores the popular Romantic theme of melancholy. The woman is heartbroken—a miniature portrait of her lover lies beside her and a torn-up letter floats on the surface of the pond.

1820 **1825** **1830**

Goya in Bordeaux
Finding himself at odds with the Spanish political climate, Goya leaves Spain and goes to France, where he settles in Bordeaux in 1824. He dies there four years later.

◁ Saturn Devouring His Sons
Francisco de Goya 1819–23
Prado, Madrid, Spain
Between 1819 and 1823 Goya decorated his home with 14 murals on horrific themes. This one depicts the classical myth of the titan Saturn, who devoured his sons because of the prediction that one of them would overthrow him.

Mazeppa and the Wolves △
Horace Vernet 1826 *Private Collection*
Full of drama and action, Vernet's picture is based on a play by Lord Byron. It illustrates the story of a Polish page who was punished for having an affair with the queen by being strapped naked to a horse and driven into the woods.

1830

Liberty Leading the People △
Eugène Delacroix 1830
Louvre, Paris, France
Delacroix's large canvas enshrines the energy
and ideals of the 1830 July Revolution. The
allegorical figure of Liberty, more a woman of the
people than a goddess, leads the rebels—factory
workers, members of the bourgeoisie, artisans,
and peasants—over the barricades in a flurry of
dramatic action and bravura brushwork. The
bodies of the revolution's opponents lie
abandoned in the foreground.

> **ROMANTICISM IN ALL THE ARTS** IS WHAT REPRESENTS THE **MEN OF TODAY** AND NOT THE MEN OF THOSE **REMOTE, HEROIC TIMES**

Stendhal
19th-century French writer

BIOGRAPHY

Eugène Delacroix

born Charenton-Saint-Maurice, France,
April 26, 1798; **died** Paris, August 13, 1863

Delacroix's emotionally charged pictures have
led many critics to see him as the embodiment
of Romanticism in painting. He was a great
admirer of the work of Géricault—whose
influence can be seen in the turbulent canvases
he painted in the 1820s—and English artists
such as Constable, whose *Haywain* made a
great impression on him when it was shown in
Paris in 1824. In the 1830s, Delacroix discovered
a rich new area of Orientalist subject matter at
the same time that he received the first of several
commissions to decorate public buildings in
Paris. His expressive brushwork and exploration
of the optical effects of color later proved
inspirational to the Impressionists.

▽ The Execution of Lady Jane Grey
Paul Delaroche 1833
National Gallery, London, UK
One of the darker episodes in British history took place in 1554, when 16-year-old Lady Jane Grey, Queen of England for just nine days, was beheaded in the Tower of London. The picture has a Romantic subject, but the meticulous handling of paint is more characteristic of academic art.

▽ Portrait of Franz Liszt
Henri Lehmann 1839
Musée Carnavalet, Paris, France
Romantic portraiture often emphasizes the emotional state of the sitter. This portrait of the Hungarian pianist and composer Franz Liszt shows him turning toward the viewer, the expression on his face suggesting that he has been caught in a moment of intense creative concentration.

Delaroche's history paintings
Paul Delaroche continues his mission to create dramatic history paintings that communicate the emotional impact of events in his 1850 picture of a weary-looking Napoleon crossing the Alps on horseback.

1835 **1840** **1845** **1850**

Paints in tubes
In 1841, the American artist John G Rand invents the collapsible zinc paint tube, a convenient method of storing and transporting paint that is to have important artistic consequences.

△ Francesca da Rimini
Ary Scheffer 1835
Wallace Collection, London, UK
In this scene from Dante's *Inferno*, the doomed adulterous lovers Paolo and Francesca are shown in the second circle of Hell. Dante and his guide, the Roman poet Virgil, pause on their own journey through the underworld to view the tragic scene from the sidelines.

Desdemona Retiring to her Bed ▷
Théodore Chassériau 1849
Louvre, Paris, France
Much of Chassériau's early work marries elements of Neoclassicism and Romanticism, but he came increasingly under the influence of Delacroix, sharing with him a love of exoticism and rich color. This depiction of Shakespeare's heroine Desdemona exhibits the suggestive sensuality typical of many Romantic Orientalist scenes.

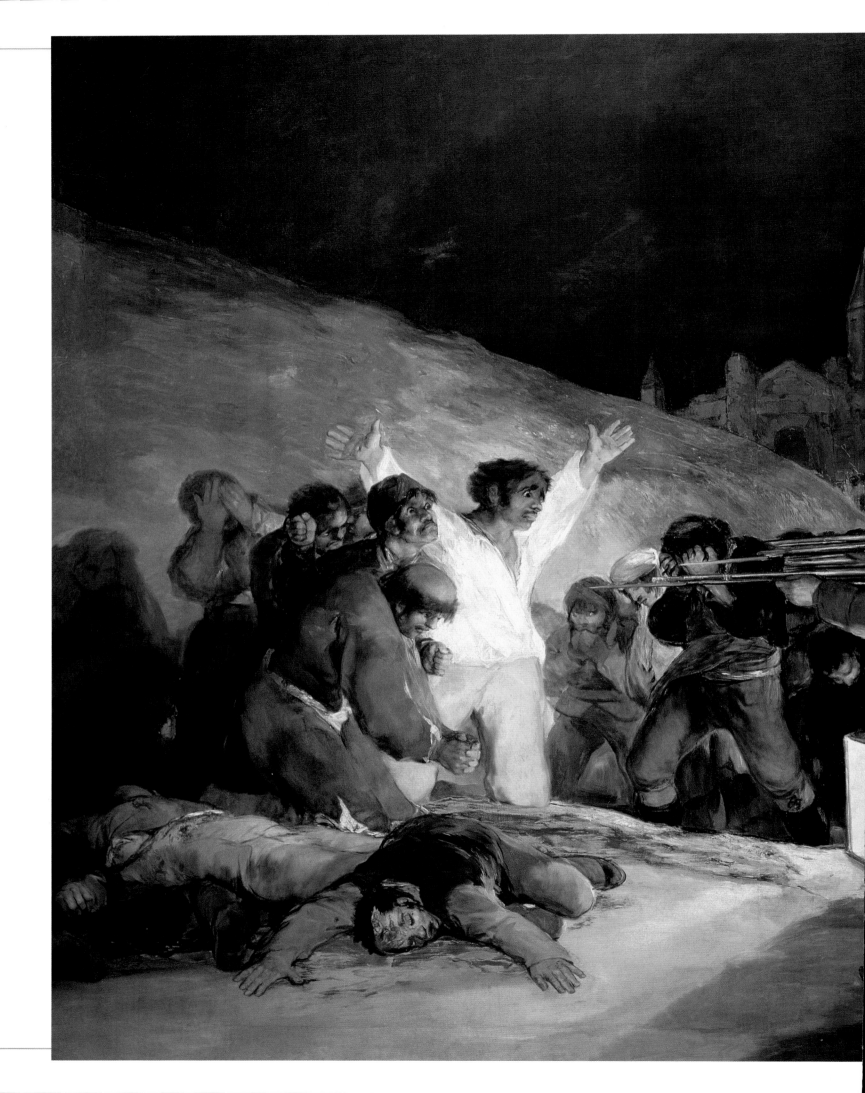

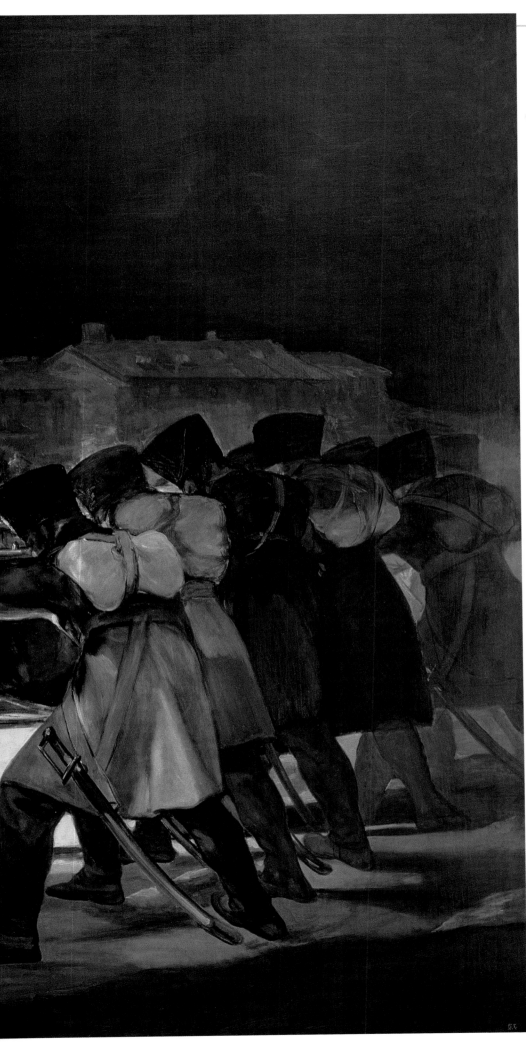

 MASTERWORK

The Third of May 1808

Francisco de Goya **1814**
Prado, Madrid, Spain

There are few more powerful images of the horrors of war than Goya's painting of Spanish rebels being shot by French soldiers for their attempt to resist France's occupation of Spain during the Peninsular War. The focal point of the picture is the man in the white shirt, his expression a mixture of disbelief and wide-eyed terror, his outstretched arms inevitably recalling Christ on the Cross. Beside him, a man stares at his executioners, while a monk gazes at the ground and clasps his hands in prayer. The next batch of victims trudge up the hill to meet their terrible fate. We do not see the faces of the soldiers in the firing squad; they are anonymous and move in unison like an efficient killing machine.

For dramatic effect, Goya shows the scene taking place at night (in fact, the killings were carried out during the day), using a limited range of black and brown tones relieved by splashes of bright color, such as the red of the blood and the brilliant white light of the lantern and shirt. The remarkably free handling of paint, which Goya applied with his fingers and knives as well as brushes, adds to the overall dynamism of the scene.

> I SEE **NO LINES OR DETAILS**...THERE IS **NO REASON** WHY **MY BRUSH** SHOULD **SEE MORE THAN I DO**

Francisco de Goya

ROMANTIC LANDSCAPE

c.1780–1850 THE MOODS OF NATURE

▷ **The Fighting Temeraire**
JMW Turner 1839
National Gallery, London, UK
The setting sun adds a typically Romantic sense of ending and loss to this scene showing the old battleship *Temeraire* being towed by a modern tug to be broken up. The *Temeraire* had played a crucial part in the British Royal Navy's victory over the French and Spanish fleets at the Battle of Trafalgar in 1805.

By the start of the 19th century, nature was increasingly seen by some artists as a powerful force that was not subject to the laws of man, yet was capable of conveying human thoughts and feelings and providing a connection with the spiritual. For certain painters, including Caspar David Friedrich and Samuel Palmer, God's creation—the natural world—was a religious act, and the landscape could reveal the Divine. Others developed a fascination with the various moods of nature for their own sake. Turner's animated canvases explored their most extreme manifestations—storms, sunrises and sunsets, and ships wrecked by angry seas—while Constable strove for a "pure and unaffected" way of painting to evoke the pastoral joys of the English countryside. American artists of the Hudson River School brought a Romantic sensibility to their own country, producing dramatic vistas of primeval forests, virgin lakes, and waterfalls.

◎ CONTEXT

Discovering natural wonders

Toward the end of the 18th century a number of leading European literary figures were encouraging readers to look at nature with fresh eyes. The French author Jean-Jacques Rousseau was advocating a return to nature to escape the artificiality of civilization. The German writers Johann Wolfgang von Goethe and Friedrich Schiller were pointing to parallels between human feelings and the moods of nature. Nature's power to encourage self-reflection also became a constant feature in the poems of William Wordsworth and his fellow poets of the English Lakes. Romantic authors cultivated sensitivity to nature, just as they also cultivated sensitivity to emotion. Great aesthetic debates were taking place about the nature of different types of beauty in landscape, which could vary from divine and awe-inspiring through quirky to classically serene.

The enthusiasm for landscape was underpinned by a growth in tourism and the idea of traveling for pleasure. Traveling was easier and safer than in previous centuries, and while in the early 18th century well-to-do northern European gentlemen on the Grand Tour had went straight for the culture and delights of Italian cities, a new generation saw Europe's natural wonders as worth the journey alone. The Rhine riverscape was deemed marvelous, and the Swiss Alps— once viewed as inconvenient obstacles—were now considered sublime. Seeing the Alps prompted poet Samuel Taylor Coleridge to wonder who could be an atheist when faced with such wonders, and Percy Bysshe Shelley was moved to compose an ode to Mont Blanc.

Almost continuous warfare put a temporary stop to tourism on mainland Europe between 1792 and 1815, forcing travelers to undertake journeys around their own countries. British tourists, for example, made for the south coast of England, the Lake District, and Scotland, all of which possessed a distinctive natural beauty captured in countless amateur sketches. But here, as elsewhere, it was a beauty under threat. Industrialization was beginning to change the face of landscape, leading to the destruction of large tracts of woods and fields and creating an unprecedentedly artificial environment. The people who lived in the new industrial towns were attracted to a Romantic vision of nature precisely because they were no longer immersed in the daily life of the countryside, and so could experience a nostalgic love for its vanishing attractions.

Searching for the sublime
The Matterhorn, a dramatic mountain peak in the Alps between France and Switzerland, inspired a sense of awe in tourists searching for sublime landscape.

A landscape popularized and accessible

KEY EVENTS

▷ **1781** William and Thomas Reeves invent the moist watercolor paint cake, which adds to the convenience of sketching scenes outside.

▷ **1792** Start of the French Revolutionary Wars, putting a halt to travel in Europe.

▷ **1802** The Peace of Amiens provides a temporary respite to hostilities, allowing a brief resumption of travel in Europe.

▷ **1815** The Duke of Wellington defeats Napoleon at Waterloo, ending the war. The way is now clear for a boom in European tourism.

▷ **1816** Percy Bysshe Shelley composes his *Mont Blanc: Lines Written in the Vale of Chamouni* in response to seeing the wonders of the Alps.

▷ **1842** French author Victor Hugo publishes a travelogue devoted to the Rhine, praising the river as "wild, but majestic."

▷ **1850** Wordsworth's epic poem *The Prelude*, decades in the making, is published in 14 books. It is the poet's reflection on his life and a meditation on man, nature, and society.

> ❝ **I NEED TORRENTS**, ROCKS, **FIRS**, **DARK WOODS**, MOUNTAINS, **STEEP ROADS** TO CLIMB OR DESCEND, **ABYSSES BEHIND ME** TO **MAKE ME AFRAID** ❞

Jean-Jacques Rousseau
French author, The Confessions, 1782–89

◎ BEGINNINGS

AWE-INSPIRING VISTAS

Romantic landscape covers a vast spectrum, from serene pastoral views to vistas of a stormy nature that inspire terror and awe. Many early Romantic works tended toward the spectacular, revealing the influence of ideas about the Sublime, or awe-inspiring (as opposed to the Beautiful, or serene), formulated by theorists including Edmund Burke. In 1757 Burke had identified terror as a suitable subject for painters, since it allowed viewers to feel secure in their own safety. This encouraged landscapists to opt for scenes of wild and rugged places that could evoke a degree of fear, or natural phenomena such as volcanoes, waterfalls, and avalanches, which induced similar feelings. The notion of the Picturesque, developed in the late 18th century, offered a slightly different approach. It favored roughness and irregularity, shunning the tranquility of the Beautiful and the drama of the Sublime, instead emphasizing interesting features, such as ruins. Both Turner and Constable were influenced by the Picturesque aesthetic in their early work.

> **DELIGHT MIGHT ARISE** FROM THE **CONTEMPLATION** OF A **TERRIFYING** SITUATION— **NATURAL, ARTISTIC,** OR **INTELLECTUAL** —THAT COULD NOT ACTUALLY **HARM** THE **SPECTATOR**

1757 | Edmund Burke
Irish philosopher and statesman

◉ ARTISTIC INFLUENCES

Painters of Romantic landscapes were naturally drawn to moments of high drama, such as volcanic eruptions, infernos, avalanches, and floods, all of which demonstrated the overwhelming power of nature. Joseph Wright's numerous paintings of Vesuvius reveal an enduring fascination with the volcano, and he drew upon various strands of past and contemporary art to help him portray its magnificence.

Moonlight features in a number of 16th- and 17th-century works by northern European artists, and later became part of the standard vocabulary of Romantic landscape. Its use adds a supernatural sense of mystery to many of Wright's nocturnal scenes.

The moon, detail from Adam Elsheimer's *Flight into Egypt*, 1609, gives off a ghostly light. *Alte Pinakothek, Munich, Germany*

Conflagrations had long been a regular feature of paintings of Hell and destruction, and they add a sense of doom and Satanic menace to many Romantic landscapes. The fire in Wright's painting of Vesuvius in full flow gives an unearthly red glow to the scene.

The Burning of Troy, detail, 17th century, attributed to Nicolas Poussin, depicts flames spreading across the skyline. *Private Collection*

Italy, with its spectacular countryside and Classical antiquities, proved highly attractive to a number of northern European artists in the 18th century. Jacob More, who met Wright in Italy, settled in Rome and specialized in dramatic landscapes and night scenes.

Naples from Posillipo, c.1780, Jacob More shows Vesuvius in a calmer mood. *Yale Center for British Art, Paul Mellon Collection, CT*

Spectators play an essential part in Romantic portrayals of nature's most extreme manifestations, and reveal a public fascination with natural disasters. Dwarfed by natural forces, tiny figures are reminders of the fragility of humanity and civilization.

Tourists admire the lava flowing from Vesuvius in this detail of a 1771 print by Pietro Fabris. *Stapleton Collection, UK*

◎ TURNING POINT

Vesuvius from Posillipo

Joseph Wright **c.1776–80** *Yale Center for British Art, New Haven, CT*

It is hard to imagine a more Romantic scene than this landscape, with its melodramatic subject, theatrical light effects, and its sense that nature is so much more powerful than humankind— represented by the diminutive figures in a boat. Wright toured Italy between 1773 and 1775, and stayed in Naples in the fall of 1774. Vesuvius was not in full eruption at the time, but since the volcano was constantly throwing out smoke and lava, the artist would have witnessed some volcanic activity. The scene fired Wright's imagination, and during his career he produced more than 30 much-admired views of the volcano erupting.

Joseph Wright of Derby

born Derby, UK, September 3, 1734; **died** Derby, August 29, 1797

BIOGRAPHY

Like a true Romantic artist, Joseph Wright was willing to challenge preconceived notions and try out new ideas. He trained as a portrait painter in London, but worked for most of his life in his native Derby. His most famous paintings reflect scientific and technical preoccupations, and he was the first painter to capture the spirit of the Industrial Revolution. Wright's later scenes of the Derbyshire landscape demonstrated how it was possible to truthfully observe natural phenomena, such as rock formations or light and atmosphere, without sacrificing beauty, drama, and composition.

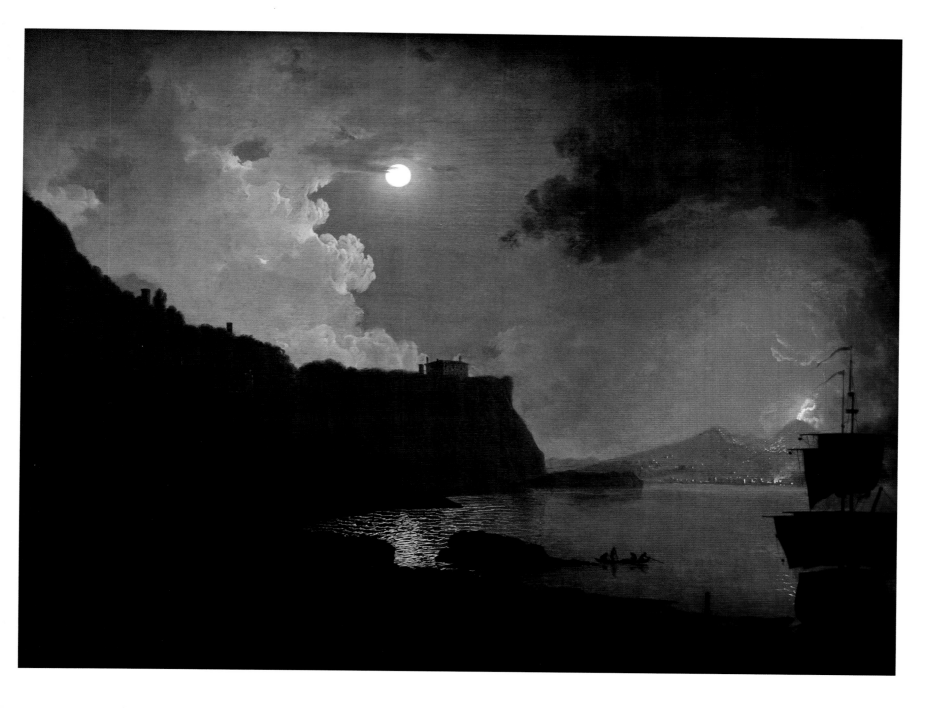

◎ TIMELINE

From as early as the 1760s British artists in particular were turning to wilder landscapes, storms, and scenes featuring Gothic architecture. By the early 19th century Caspar David Friedrich and JMW Turner were taking German and English landscape painting to the extremes of Romanticism. Turner conveyed nature's most violent moods in energetic brushwork, and Friedrich used a more highly finished style to present lone figures —or features including crosses—amidst huge landscapes, making them symbols of the transience of life.

The Eidophusikon
In London in 1781 De Loutherbourg—who had worked as a stage designer—opens his *Eidophusikon* ("Image of Nature"), a miniature mechanical theater imitating natural phenomena using lighting and moving pictures.

Tintern Abbey ▽
Thomas Girtin 1793
Blackburn Museum and Art Gallery, UK
Gothic ruins covered in foliage were a perfect fit with Picturesque taste, and many artists toured Britain in search of such scenes.

1780 ○ ○ **1785** **1790** ○ **1795**

Gilpin on the Picturesque
In 1782 William Gilpin publishes his *Observations on the River Wye and Several Parts of South Wales, etc. Relative Chiefly to Picturesque Beauty*, which defines the qualities important in a Picturesque scene.

❝ **PRECIPITOUS** ROCKS **THREATEN THE SKY** ...MAN PASSES THROUGH THE DOMAIN OF **DEMONS** AND **GODS** ❞

1767 | Denis Diderot
French Enlightenment philosopher, on the work of Claude-Joseph Vernet

◁ **Coastal Scene in a Storm**
Claude-Joseph Vernet 1782
Hamburg Kunsthalle, Germany
This is a typical tempest scene by Vernet, who excelled in animated marine pictures showing boats tossed around on the turbulent waves, set against stormy skies. The two figures bending into the wind seem fragile and threatened by the merciless power of the elements.

◁ Avalanche in the Alps
Philip James de Loutherbourg 1803
Tate Britain, London, UK
De Loutherbourg designed scenery and special effects for the theater, and this painting has all the drama of the stage. Terrified people in the foreground are overwhelmed by the avalanche's progress.

Gordale Scar ▽
James Ward 1813
Bradford Art Galleries and Museums, UK
Ward's depiction of the limestone cliffs near Settle, Yorkshire, is a defiantly national landscape with an almost primeval quality, symbolically defended by a white bull. The paint is applied in bold blocks appropriate to the monumental nature of the scene.

◉ PICTURESQUE SKETCHING

The craze for touring Britain in search of Picturesque sights was satirized in Thomas Rowlandson's print series *The Tour of Dr. Syntax, In Search of the Picturesque* (1812). In the pictured print, Dr. Syntax sketches in the Lake District as his horse grazes dangerously near to the water's edge, and tourists look on from a boat. Rowlandson himself went on several sketching tours around Britain and the Continent.

Dr. Syntax Sketching the Lake, 1812, from *The Tour of Dr. Syntax*, Thomas Rowlandson

CONTEXT

1800 ○ ○ **1805** **1810** ○ **1815** ▶

Girtin's painted panorama
Responding to the fashion for painted panoramas, in 1801 Girtin produces his *Eidometropolis*, a 360-degree view of London on an enormous canvas. Spectators pay to view it.

Turner's gallery
In 1804 Turner sets up a gallery on the first floor of his house in Harley Street, London, in which he can show his work to buyers.

◉ Claude-Joseph Vernet

born Avignon, France, August 14, 1714;
died Paris, France, December 4, 1789

The French artist Vernet trained in Rome, where he quickly made a reputation as a marine and landscape painter, producing pictures of quintessentially Picturesque sites, such as the Falls of Tivoli. His marine paintings fall into two contrasting types: calm and storm. The storm pictures depict ships either in danger or actually wrecked. The horror of the shipwrecks fitted perfectly with Edmund Burke's theory of the Sublime, since they offered the viewer the aesthetic pleasure of contemplating disaster and misfortune from a position of safety.

BIOGRAPHY

Gothic Church on a Cliff △
Karl Friedrich Schinkel 1815
Alte Nationalgalerie, Berlin, Germany
In the early 19th century there was a revival of interest in Gothic architecture, which was seen as more spiritual than classical styles. Schinkel's church silhouetted against the sky endows the landscape with a sense of transcendence.

John Constable

born East Bergholt, UK, June 11, 1776;
died Hampstead, London, UK, March 31, 1837

Constable is ranked with Turner as one of the giants of English landscape art. Both men were committed to the belief that landscape painting could be just as significant as history painting. However, most of Constable's landscapes—many of them featuring the Suffolk landscape of his childhood—were not heroic in a conventional sense; their power is based on the artist's fervent feelings about the countryside. Constable pursued what he called "a natural painture" —painting that conveys a truthful representation of nature. He based his finished paintings on oil studies made outdoors, which are remarkably fresh and freely rendered. His work was particularly admired by French Romantic painters.

▽ Dedham Lock and Mill
John Constable 1820
Victoria and Albert Museum, London, UK
Constable once said: "Painting is for me another word for feeling, and I associate my 'careless boyhood' with all that lies on the banks of the Stour." This picture shows the mill owned by his father, the sluice and lock gate on the River Stour, and the tower of Dedham church.

John Martin captures the public imagination
In 1816 John Martin achieves his first notable success at the Royal Academy in London with *Joshua Commanding the Sun to Stand Still*, which shows tiny human figures in a maelstrom.

1815 **1820** **1825** **1830**

Constable's success in Paris
In 1824 Constable's landscapes are exhibited at the Paris Salon, and critics and artists embrace his art as "nature itself." Delacroix is particularly impressed with his technique.

◁ The Bard
John Martin 1817
Laing Art Gallery, Newcastle upon Tyne, UK
Martin's painting illustrates a poem by Thomas Gray, which describes the destruction of the Welsh bards by Edward I. The last surviving bard is shown cursing the English troops below, before plunging to his death.

The Magic Apple Tree △
Samuel Palmer 1830
Fitzwilliam Museum, Cambridge, UK
Samuel Palmer left his native London as a young man to live in rural seclusion at Shoreham in Kent. Rich warm colors convey a vision of the countryside as a comfortable Arcadia blessed with abundant produce.

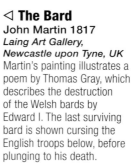

> I HAVE TO STAY **FULLY ALONE** IN ORDER TO **FULLY CONTEMPLATE** AND **FEEL NATURE**

Caspar David Friedrich

Kindred Spirits ▷
Asher B. Durand 1849
The Crystal Bridges Museum of American Art, Bentonville, AR
The American landscape offered its own Sublime vistas: here the painter Thomas Cole and poet William Cullen Bryant admire the wilderness of the Catskill Mountains.

The Stages of Life ▷
Caspar David Friedrich 1835
Museum der bildenden Künste, Leipzig, Germany
Friedrich's painting of a Baltic seaport is a meditation on mortality. The five figures on land are echoed by the five ships at different stages of their journey.

1835 **1840** **1845** **1850**

◁ **Rain, Steam, and Speed**
JMW Turner 1844
National Gallery, London, UK
Bravura brushwork conjures up a vortex of blinding rain as a steam train hurtles over a railway bridge. The picture is all about the excitement of speed, but it contains a puzzle. Is the hare, barely visible in the bottom right of the picture, running ahead of the train, or fleeing in terror?

JMW Turner

born London, UK, April 23, 1775;
died London, December 19, 1851

Joseph Mallord William Turner is one of the greatest of all landscape painters. Precociously gifted, he began making sketching tours of Picturesque sights while still in his teens. By the early 1800s he was a Royal Academician with a flourishing career, producing ambitious landscapes in the manner of Old Masters, such as Claude Lorrain. But his approach to landscape and seascape gradually became more dramatic and Romantic. He toured the Continent several times, painting in France, Germany, Switzerland, the Low Countries, and Italy. In the last two decades of his life his painting became increasingly free, at times almost abstract, with detail obliterated by color and light.

BIOGRAPHY

 MASTERWORK

The Oxbow

Thomas Cole **1836**
Metropolitan Museum of Art, New York City, NY

The English-born American artist Thomas Cole was a founder of the Hudson River School, acclaimed for its portrayals of the American landscape and wilderness. This majestic landscape—the artist's masterpiece—shows a bend on the Connecticut River as seen from Mount Holyoke in Northampton, Massachusetts. "The imagination can scarcely conceive Arcadian vales more lovely or more peaceful than the valley of the Connecticut," wrote Cole. But by the time he painted this view the place was not the idyll it had once been, and Mount Holyoke was attracting hordes of sightseers.

The artist made a habit of sketching out of doors, and in one drawing of this scene he added extensive notes on color. In the painting he deliberately used large masses of opposing dark and light tones to lead the eye through the farmland to the hill beyond. A violent sky and thunderclouds dominate the wilderness on the left, but the storm has passed in the valley below, and its cultivated fields are bathed in a gentler light. Almost hidden in the middle distance is the artist himself, who is painting the scene in front of him, his umbrella forming the only visual bridge between the two halves of the picture.

It is not clear whether Cole admired the cultivated land or lamented the disappearance of the American wilderness. On a hillside beyond the oxbow, he left a hidden message: the word Noah is roughly incised in Hebrew letters, a code that read upside down spells out Shaddai—the Almighty. Perhaps the artist was suggesting that the landscape be read as a holy text revealing the word of God.

> **TO WALK WITH NATURE AS A POET IS THE NECESSARY CONDITION OF A PERFECT ARTIST**
>
> Thomas Cole

PRE-RAPHAELITES

1848–1900 A REVOLUTIONARY BROTHERHOOD

▷ **Beata Beatrix**
Dante Gabriel Rossetti
c.1864–70
Tate Britain, London, UK
The Pre-Raphaelites explored a new kind of feminine beauty, centered around the "stunner"— a beautiful woman with a long neck and abundant hair. Rossetti's wife Elizabeth Siddal was a perfect example of the type—as well as an artist in her own right. Rossetti painted this visionary portrait of her after her suicide, presenting her in a state of ecstasy or spiritual transformation.

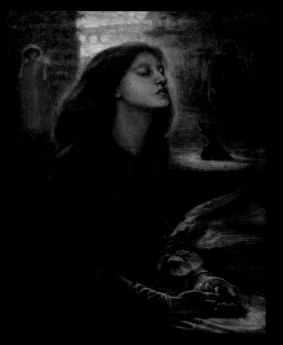

The Pre-Raphaelite Brotherhood was founded in 1848 by three young artists— John Everett Millais, Dante Gabriel Rossetti, and William Holman Hunt. They were soon joined by four others—the painter James Collinson, the sculptor Thomas Woolner, and art critics Frederic George Stephens and William Michael Rossetti. Dissatisfied with the ideals and teaching methods of the Royal Academy, the Pre-Raphaelites took their stylistic inspiration from Italian painting before the time of Raphael (1483–1520). The objects and people in their pictures were brilliantly colored and evenly lit, and nature was painstakingly observed in all its detail. They developed new ways of painting narratives from the Bible, mythology, literature, and world history, emphasizing accuracy of dress, accessories, and setting. The Pre-Raphaelites also engaged with pressing social issues, such as prostitution, religion, and emigration, and promoted a new kind of female beauty.

◎ CONTEXT

An age of change

The formation of the Pre-Raphaelite Brotherhood coincided with a period of rapid technological and social change in Britain. The country was industrializing at a fast pace, trade was growing, cities were expanding, and newly wealthy captains of industry formed a class of patrons excited to buy art. Prince Albert's enthusiasm for design, manufacturing, and art was reflected in a number of initiatives including the Great Exhibition—a massive international fair in 1851—and the creation of cultural and scientific institutions and museums in London.

The 1840s was also a turbulent decade, in which social concerns were beginning to be expressed. In 1848—the year that the Pre-Raphaelite Brotherhood was formed—the Chartists, members of a working-class labor movement, held a meeting in London to demand voting rights for all men over 21. Rebellion was in the air, and the British authorities feared that the revolutions that had engulfed much of Europe would spread to Britain. Some critics were beginning to ask whether life had been better in the pre-Industrial world. Architects such as AWN Pugin (1812–52) were designing buildings in a Gothic Revival style that offered a contrast to the perceived ugliness of the modern industrial city. The critic John Ruskin (1819–1900) argued that the ways of working in medieval society were preferable to those involved in modern manufacturing. William Morris would later build on such ideas to develop his own brand of socialism.

Revolutionary developments in the natural sciences, geology, botany, meteorology, and astronomy were changing perceptions of the natural world. Debates about evolution and the history of the earth coalesced in the publication of Darwin's *On the Origin of Species* (1859), which posed a direct challenge to religious teachings. Scientific inquiry and sectarian division were eroding the power of the established church, and the Pre-Raphaelites' revolutionary approach to religious painting—frequently labeled blasphemous—reflected a desire to create new ways of looking at faith.

The Great Exhibition
Held in Hyde Park in 1851, the Great Exhibition was a showcase for Victorian trade and industry. The exhibition attracted more than six million visitors.

> **I MEAN** BY A PICTURE A **BEAUTIFUL ROMANTIC DREAM** OF SOMETHING THAT **NEVER WAS, NEVER WILL BE** 〞

Edward Burne-Jones

 BEGINNINGS

BRILLIANT DETAILS

In the first volume of his book *Modern Painters* (1843) the influential critic John Ruskin argued that the artist's principal aim was "truth to nature." To begin with, the Pre-Raphaelites interpreted this notion literally, meticulously recording every detail of a scene, although this painstaking approach proved to be unsustainable in the long term. They adopted colors that were brilliant—even strident—by the standards of the day. Rejecting the conventional method of underpainting canvases in earth tones, they painted directly on to a bright background prepared with zinc white, which does not yellow over time. This allowed them to apply pigments in transparent layers for added luminosity. Rejecting the conspicuous brushwork of their predecessors, the Pre-Raphaelites aimed for a flat, even application of paint, frequently employing in oils the type of small brushes more usually used for watercolor. When their pictures were hung in public, they were often accused of "killing" surrounding works with their bright hues.

> GO TO **NATURE IN ALL HER SINGLENESS OF HEART**, AND WALK WITH HER **LABORIOUSLY** AND **TRUSTINGLY**... **REJECTING** NOTHING, **SELECTING** NOTHING AND **SCORNING** NOTHING
>
> 1843 | John Ruskin

⊙ ARTISTIC INFLUENCES

Many Pre-Raphaelite artists, including Ford Madox Brown, were initially drawn to subjects that featured dramatic moments from British history. They researched details of costume, furniture, architecture, and accessories to add authenticity to their scenes, looking to the art of the medieval and early Renaissance periods, as well as the more recent past, for inspiration.

The Gothic Revival style was fashionable at the time the Pre-Raphaelite Brotherhood formed. The best-known building in the style was the new Houses of Parliament, designed by Charles Barry with interiors by AWN Pugin, on which construction began in 1840.

Gothic Revival floor tiles with medieval motifs were designed by AWN Pugin for the new Houses of Parliament, London.

The Nazarenes, a group of Austro-German artists, were admired by the Pre-Raphaelites. They provided an important precedent for a brotherhood of artists who sought a return to early art, and rejected the soft and painterly styles of the Old Masters.

Franz Pforr, detail, c.1810, from a portrait by Nazarene painter Friedrich Overbeck. *Nationalgalerie, Berlin, Germany*

The hard, graphic style used by William Blake was an important source of inspiration for the Pre-Raphaelites. They initially shared Blake's idea that line signaled clarity, while oil paint was ambiguous, unclear, and manipulated the emotions of the observer.

Head of Job, detail from William Blake's *The Just Upright Man* (1826), is an example of Blake's linear style. *Ashmolean, Oxford, UK*

Pre-Renaissance art inspired the Pre-Raphaelites. They took their cue from the techniques employed by medieval manuscript illuminators, the smooth clear colors seen in 14th-century Italian painting, and the brilliance of stained glass.

Vivid colors used by Italian artists in the late 13th and 14th centuries can be seen in the work of the Pre-Raphaelites.

◎ TURNING POINT

John Wycliffe Reading his Translation of the Bible to John of Gaunt

Ford Madox Brown **1847–48** *Bradford Art Galleries and Museums, UK*

John Wycliffe (1328–84), who made the first complete English translation of the Bible, is shown reading his work to John of Gaunt (son of Edward III), John's wife and child, and the poets Geoffrey Chaucer and John Gower. Brown did a great deal of historical research for this picture, making sure that the period details of furniture, architecture, and costume were correct. His interest in history, use of brilliant pigments applied to a white background, and sharply outlined forms, had an impact on the early works of Pre-Raphaelite artists such as Rossetti.

◎ Ford Madox Brown

born Calais, France, April 16, 1821;
died London, UK, October 6, 1893

BIOGRAPHY

Ford Madox Brown belonged to a slightly older generation than the Pre-Raphaelite Brotherhood. He never joined the group, but was linked with it through his pupil Dante Gabriel Rossetti, and his work anticipates and reflects its artistic concerns. He also joined William Morris's design company, Morris, Marshall, Faulkner & Co., founded in 1861. Brown often engaged with social issues, and these were to become a major preoccupation of some of the Pre-Raphaelite artists who sought to find ways of representing modern life and its attendant darker sides—poverty and prostitution.

◎ TIMELINE

The Pre-Raphaelite Brotherhood began in 1848 as a secret society whose members inscribed the mysterious initials "PRB" on their pictures. The Brotherhood had virtually dissolved by 1853, with members going their separate ways, but its significance lived on for decades. From the end of the 1850s Rossetti attracted a set of new followers, including William Morris and Edward Burne-Jones. Their ideas became central to the emerging Aesthetic and Arts and Crafts movements.

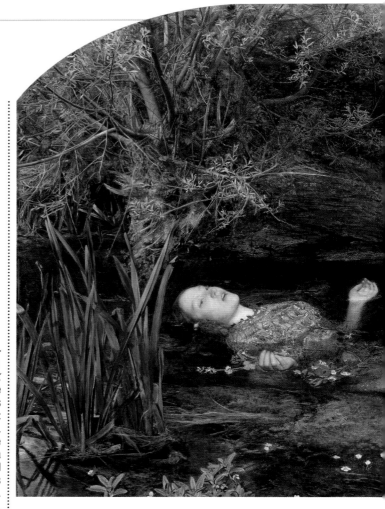

Dickens's attack
Millais's *Christ in the House of his Parents* is violently attacked in print by Charles Dickens in 1850 for its supposed ugliness.

Ophelia ▷
John Everett Millais 1851
Tate Britain, London, UK
Millais's picture of the drowning heroine from Shakespeare's *Hamlet* encapsulates the concerns of early Pre-Raphaelitism: truth to nature and poetic storytelling. The artist spent months painting the minutely detailed background by a stream in Ewell, Surrey. He then posed Elizabeth Siddal in a bath of water in his studio as a model for Ophelia.

Founding the Brotherhood
The Pre-Raphaelite Brotherhood meets for the first time in 1848, at Millais's London studio. The young artists are united in their admiration of early Italian art and dissatisfaction with the art establishment.

| 1848 | 1851 | 1854 | 1857 | 1860 |

Hunt's religious subjects
Holman Hunt finishes *The Light of the World* in 1852, showing Christ knocking on a door. Two years later he makes the first of four trips to the Holy Land, with the aim of painting biblical works in authentic settings.

△ The Girlhood of Mary Virgin
Dante Gabriel Rossetti 1848–49
Tate Britain, London, UK
This was the first Pre-Raphaelite work to be shown in public, at the National Institution. It draws on early Renaissance paintings and is loaded with religious symbolism.

Millais and Hunt on show
In 1849 Millais's *Isabella*, illustrating a poem by Keats, and Hunt's *Rienzi*, based on a Bulwer Lytton novel, are shown at the Royal Academy, where they stand out from the other works on display.

The Awakening Conscience
William Holman Hunt 1853
Tate Britain, London, UK
A kept woman rises from her lover's lap, suddenly struck by memories of past innocence prompted by the music she has been playing. Her gaze is directed toward a sundrenched garden, hinting at the light of salvation.

△ The Val d'Aosta
John Brett 1858
Private Collection
John Brett, who exhibited with the Pre-Raphaelites, was a friend of John Ruskin, sharing his interest in science and geology. Ruskin was with him in Italy when he painted this brilliantly lit vista, with its carefully delineated detail.

CONTEXT

WHISTLER'S AESTHETIC APPROACH

Although American-born artist James Whistler (1834–1903) was not a Pre-Raphaelite, many of his paintings from the 1860s show the preoccupation with loveliness that also obsessed Rossetti and his followers. This coalesced in the cult of beauty that became known as the Aesthetic movement. Whistler's 1862 *Symphony in White, No 1: The White Girl* exemplifies the sensuous "art for art's sake" philosophy of Aestheticism.

***Symphony in White, No 1: The White Girl** National Gallery of Art, Washington, DC*

A femme fatale
Edward Burne-Jones finishes *The Beguiling of Merlin*, a work commissioned by Liverpool shipping magnate Frederick Leyland, in 1872. It shows a scene from Arthurian legend and features a striking femme fatale.

Morris & Co.
William Morris reorganizes the artists' collective he founded in 1861 as Morris & Co., a company under his sole direction, in 1875. Rossetti and Brown cease to be partners.

1863 **1866** **1869** **1872** **1875**

> ❝ **THEIR FAITH** SEEMS TO CONSIST IN AN **ABSOLUTE CONTEMPT** FOR **PERSPECTIVE** AND THE KNOWN LAWS OF **LIGHT AND SHADE** ❞

1851 | Charles Dickens
English novelist and journalist

◁ **Work**
Ford Madox Brown 1852–63
Manchester Art Gallery, UK
Brown's ambitious painting is an allegory on different forms of labor: Irish workers dig a trench; a flower seller carries her basket; a group of orphaned children beg in the foreground. The philosopher Thomas Carlyle and the churchman Frederic Denison Maurice look on.

◁ The Wheel of Fortune
Edward Burne-Jones 1883
Musee d'Orsay, Paris, France
Burne-Jones's image of the wheel of
fortune, which ultimately claims and
crushes everyone, is a mature work in
which the artist's taste for classical
mythology is conveyed through figures
inspired by Michelangelo and Botticelli.

Dante Gabriel Rossetti

born London, UK, May 12, 1828;
died Birchington-on-Sea, Kent, UK, April 9, 1882

BIOGRAPHY

The son of an Italian professor, Rossetti was a poet as well
as a painter, and an enthusiast for Arthurian romance and
the poetry of Dante and Robert Browning. His most
characteristic works from the 1850s were jewel-like
watercolors of medieval subjects, and his main model was
Elizabeth Siddal, who later became his wife. In the 1860s
his art found a new direction, focused on the single female
figure and featuring his muses Fanny Cornforth, Alexa
Wilding, and Jane Morris.

Poetic inspiration
Around 1888 Holman
Hunt begins work on
The Lady of Shalott,
an illustration to
Tennyson's poem and a
classic Pre-Raphaelite
subject, which he turns
into a complicated
composition infused with
sexuality. He does not
finish it until 1905.

○**1878** **1880** ○ **1888**

Millais's exhibition
A large exhibition of
Millais's paintings is held
in 1886 at the Grosvenor
Gallery, London. Founded
in 1877, this grand
exhibition space favoring
Aesthetic and avant-garde
works is satirized in
Gilbert and Sullivan's
operetta *Patience* (1881)
as "greenery-yallery
Grosvenor Gallery."

❝ THE **MORE
MATERIALISTIC**
SCIENCE BECOMES,
THE **MORE ANGELS**
SHALL I PAINT.
**THEIR WINGS ARE
MY PROTEST** ❞

Edward Burne-Jones

Astarte Syriaca ▷
Dante Gabriel Rossetti 1877
Manchester Art Gallery, UK
This large painting, which Rossetti regarded as
his "most exalted performance," shows the
Syrian goddess of love Astarte flanked by two
acolytes. The model was Jane Morris, William
Morris's wife, with whom Rossetti had a long and
passionate relationship, but Rossetti transformed
her into a mysterious being with an almost
masculine physique.

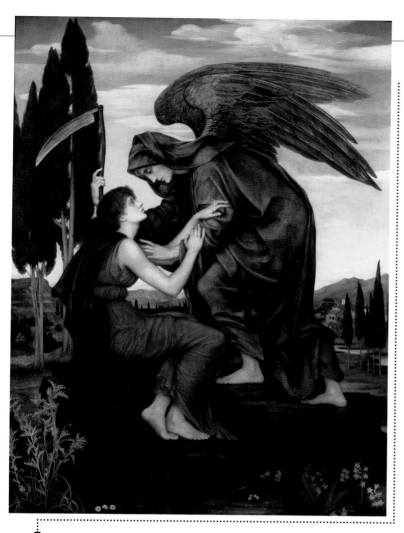

◁ The Angel of Death
Evelyn De Morgan 1890
De Morgan Centre,
London, UK
Evelyn De Morgan, the wife of the ceramic artist William De Morgan, was a prolific painter of figures in a late Pre-Raphaelite style, inspired by Burne-Jones and Botticelli. This work also demonstrates her interest in spiritualism.

Destiny ▽
JW Waterhouse 1900 *Towneley Hall Art Gallery and Museum, Burnley, UK*
Waterhouse is one of the later artists who revived the literary themes popularized by the original Pre-Raphaelites. Despite the period dress and setting, the girl here is drinking a libation to British soldiers fighting in the Boer War.

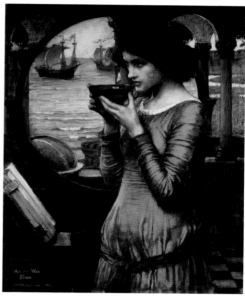

Pre-Raphaelites in Venice
Works by Hunt, Millais, and Burne-Jones are exhibited in a group show at the Venice Biennale in 1895, representing the best British art. Italian viewers are particularly interested in the Pre-Raphaelite pictures, which have received extensive press coverage.

1890 **1892** **1894** **1896** **1898** **1900**

Millais recognized
By now a successful and prosperous painter and a baronet, Millais is elected President of the Royal Academy in 1896 a few months before his death from throat cancer.

Pre-Raphaelite revival
Around the turn of the 20th century a phase of Pre-Raphaelite revival occurs in the work of younger artists, such as Eleanor Fortescue-Brickdale, Frank Cadogan Cowper, and John Byam Shaw.

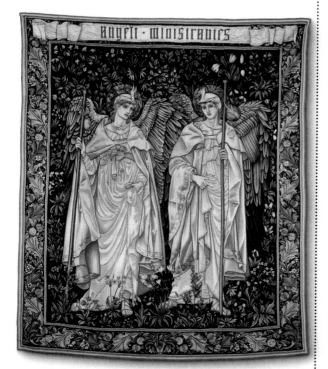

Angeli Ministrantes △
Edward Burne-Jones and William Morris 1894
Private Collection
This tapestry was woven by Morris & Co. at its Merton Abbey workshop, from figures originally drawn by Burne-Jones for stained-glass windows at Salisbury Cathedral. Burne-Jones was the firm's main figure designer, while Morris designed the patterns.

CONTEXT

KELMSCOTT PRESS

William Morris sought to unite art and craftsmanship, believing that a designer must not only understand his materials, but also derive pleasure from his labor. While his firm Morris & Co. produced furniture, tile, embroidery, stained glass, and tapestry, he devoted the last decade of his life to the art of the book. He founded the Kelmscott Press in 1891, devising the typography, ornamental borders, and page layout himself, and overseeing the printing and binding. Morris's own literary works, including the prose romance *News from Nowhere*, were printed by the press.

News from Nowhere, 1890, frontispiece

◎ MASTERWORK

Autumn Leaves

Sir John Everett Millais **1855–56**
Manchester Art Gallery, UK

When John Ruskin saw this picture at the Royal Academy, he wrote that it would "rank in future among the world's best masterpieces." It is certainly one of Millais's finest works. He painted it in the garden of a house he was renting in Scotland with his new wife Effie Gray (who had formerly been married to John Ruskin). Four girls have been raking up fallen leaves and collecting them in a basket, and now they are about to burn them on a bonfire. The girls are, from left to right, Effie's sisters Alice and Sophie, and two local children, Matilda Proudfoot and Isabella Nicol.

Millais had visited the poet Alfred Lord Tennyson at his home on the Isle of Wight in 1854, and helped to rake up and burn dead leaves. While he worked on the picture he was reading Tennyson's poem "The Princess" (1847), which contains the lines:

Tears, idle tears, I know not what they mean.
Tears from the depth of some divine despair
Rise in the heart, and gather to the eyes,

In looking on the happy Autumn-fields,
And thinking on the days that are no more.

The poem's melancholy mood is reflected in the girls' mournful expressions and the darkening sky. By the time he painted the canvas, Millais had moved away from the high-key color and sharp focus of his earlier works, toward a softer style. The subject is not immediately obvious, and contemporary critics found the meaning of the painting obscure. Effie described it as "a picture full of beauty and without subject."

However, Millais wrote that he "intended the picture to awaken by its solemnity the deepest religious reflection." The painting certainly contains many references to the transience of life, particularly in the autumnal setting, the barely visible reaper in the background, and the apple—a traditional symbol of temptation and loss of innocence—held by Isabella, the youngest girl. The spire of St. John's church, Perth, is also just visible in the background, against the sunset.

> ❝ I HAVE BEEN GOING THROUGH A KIND OF **CROSS EXAMINATION WITHIN MYSELF** LATELY AS TO A MANNER OF **PRODUCING BEAUTY** ❞

1855 | Sir John Everett Millais

◎ Sir John Everett Millais

born Southampton, UK, June 8, 1829;
died London, UK, August 13, 1896

An artistic prodigy, Millais was only 11 when he joined the Royal Academy Schools in London. There he became friendly with William Holman Hunt and, together with Dante Gabriel Rossetti, they formed the Pre-Raphaelite Brotherhood in 1848. Millais was criticized for the disturbing realism of his early works, but began to enjoy critical acclaim in the 1850s. In 1853 he fell in love with John Ruskin's wife Effie Gray, and her divorce and marriage to Millais provoked a scandal. The financial demands of his growing family meant that he needed to produce more paintings, so the time-consuming detail of the earlier works was gradually replaced with a broader style. Millais's portraits, and landscapes proved very popular, bringing him wealth and eventually the presidency of the Royal Academy that he had once despised.

BIOGRAPHY

REALISM

▷ **The Gleaners**
Jean-François Millet 1857
Musée d'Orsay, Paris, France
Millet's picture explores one of
Realism's central themes: the
working lives of the poor. Gleaners
went around fields at sunset,
picking up ears of corn missed
by harvesters. The three figures,
who bend over, pick up the corn,
and straighten up again, convey
the gruelingly repetitive nature
of the task.

Realism emerged in France in the wake of the 1848 Revolution and in reaction to the Romanticism of the previous generation of painters. The Realists believed that the only proper subject for an artist was the world in which he lived. Led by the charismatic Gustave Courbet, painters rebelled against the traditional historical, mythological, and religious subjects of French art, favoring scenes of modern life painted with an uncompromizing directness. Humble people—peasants, stone breakers, beggars, prostitutes, laundresses, and ragpickers—took center stage in their canvases. Although Realist paintings are not characterized by a single style, they are often infused with a robustness and energy, conveyed through bold lines, strong tonal contrasts, broad handling of paint, and a somber palette. Realist depictions of working men and women going about their business could be distinctly unpretty. Many viewers criticized such pictures as lacking in poetry and imagination, while other critics applauded them as a more democratic form of art in keeping with the times. From the mid-1850s, the ideas of the French Realists began to influence artists elsewhere in Europe, the UK, and the US.

◎ CONTEXT

The age of the people

Realist art reflects the politically turbulent times in which it was created. At the end of February 1848, Paris experienced an uprising that escalated into a revolution with Europe-wide repercussions, sparking similar rebellions in the German states, Italy, Austria, Hungary, and Bohemia. In France, recession, unemployment, and serious food shortages fueled the anger of the working classes and the dispossessed. This discontent fed into a long-running campaign by the lower and middle classes for the universal male suffrage that would give them some way to participate in government. After days of street fighting, King Louis-Philippe abdicated, and a provisional government was declared. A summer of further discontent culminated in the notorious "June Days," when government troops massacred demonstrators in the Parisian streets—an event commemorated in Meissonier's shocking depiction of bloody corpses strewn over the cobblestones.

Ironically, although all adult French men did get the vote, they ended up with a dictator rather than an egalitarian democracy. Napoleon's nephew Louis-Napoleon stepped into the breach in the chaos that followed the 1848 uprising. Initially the president of the Second Republic, in 1851 he staged a military coup, declaring himself Emperor Napoleon III a year later, and the Second Republic became the Second Empire. While the new Emperor tried to implement reforms that would help the lower classes, they did not have much impact on working lives. However, he did succeed in modernizing and beautifying Paris (*see p.277*).

Napoleon III's foreign policy led to his downfall, when France was defeated in the Franco-Prussian War of 1870–71. The two-month Commune that followed was an attempt by the working classes to create a democratic republic in Paris. But the government exiled in Versailles violently suppressed the revolution, the Third Republic was established, and the monarchy was abolished.

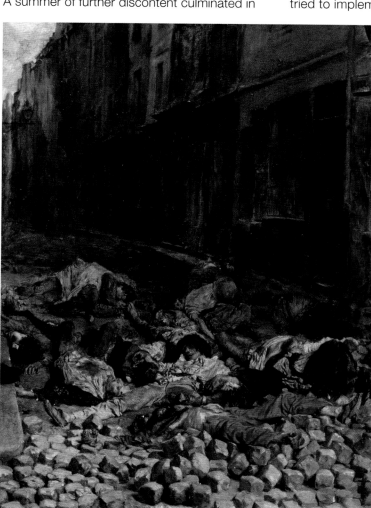

Barricade in the Rue de la Mortellerie
Meissonnier depicts a scene he observed in Paris after the National Guard stormed a barricade during the riots of 1848. Realistic detail adds to the sense of shock. *Ernest Meissonier, 1848, Louvre, Paris, France*

◎ Revolution and expansionism

KEY EVENTS

▷ **1848** Karl Marx's *Communist Manifesto* is published.

▷ **1852** Louis-Napoleon, nephew of Napoleon Bonaparte, declares himself Emperor of France.

▷ **1862** Publication of Victor Hugo's *Les Misérables*, a major novel that reflects the author's ideas of politics and social injustice.

▷ **1867** The Paris Exposition Universelle hosts a major show of Millet's work, including *The Gleaners* and *The Angelus*.

▷ **1871** The German states are finally united as a single Empire, and Wilhelm I is declared German Emperor.

▷ **1881** Tsar Alexander II is assassinated by anarchists, against a background of unrest and demands for the abolition of serfdom in Russia.

▷ **1889** The Paris Salon is dominated by canvases that are painted in a natural-looking style, including several works from the Nordic countries.

> **PAINTING** IS AN ESSENTIALLY **CONCRETE ART** THAT CAN ONLY CONSIST OF THE **REPRESENTATION OF THINGS** WHICH ARE **REAL** AND WHICH **EXIST** 🙶

1861 | Gustave Courbet

◎ BEGINNINGS
PAINTING REAL LIFE

During the 1840s many French artists were painting scenes of rural life that extolled its picturesque qualities, although the Barbizon artists, who worked in the Forest of Fontainebleau, were adopting a less prettified, more naturalistic approach to landscape. However, when Gustave Courbet burst upon the art scene there was a profound change. His distinctly unidyllic images of the countryside, particularly *The Stone Breakers* (1849) and *Peasants of Flagey Returning From the Fair* (1850–55), emphasized the hardship and boredom of rural life. Although Courbet had studied the Old Masters, he also emulated the naivety and rough-hewn quality of folk art and popular prints in his deliberately awkward compositions, many of which were large—on the type of scale previously used for historical or religious pictures. Courbet and fellow Realist Jean-François Millet were intimately involved in the widespread debate about the lives of the underclass, and both invested their humble subjects with a new heroism.

◎ Gustave Courbet

born Ornans, France, June 10, 1819;
died La Tour-de-Peilz, Switzerland, December 31, 1877

The unconventional self-appointed leader of the Realists, Courbet was the son of prosperous farmers from eastern France. Although he claimed to be self-taught, he had some formal training and learned much from copying 17th-century paintings in the Louvre. He is most celebrated for his paintings from the late 1840s to 1850s depicting laborers or peasants, their densely impastoed surfaces showing extensive use of a palette knife in deliberate disdain for the fine finish of academic art. In 1855 Courbet set up a "Realist Pavilion" at the Paris International Exhibition, intending to spread Realism internationally. He painted several landscapes and hunting scenes from the mid-1850s, and spent his final four years as an exile in Switzerland. Courbet's rejection of idealization and belief that painting should focus only on tangible reality had a profound effect on 19th-century art.

BIOGRAPHY

◎ TURNING POINT

The Bathers

Gustave Courbet **1853** *Musée Fabre, Montpellier, France*

Courbet's picture, with its anti-classical and anti-Romantic flavor, is almost a manifesto of Realism. Such was the scandal when he exhibited it at the Paris Salon in 1853 that the inspector in charge almost removed it from display. Viewers were amazed by the enormous and unidealized rear of the naked woman emerging from a pool, which was far removed from the refined forms seen in conventional academic paintings of bathers. Many Salon visitors, including the painter Delacroix, were puzzled by the picture's apparent meaninglessness, and the extravagant gestures of the two women, which are more typical of mythological figures than real flesh-and-blood creatures with dirty feet. The composition is deliberately unconventional, almost clumsy. Paint is applied in broad sweeps, and there are startling transitions between light and shade.

◉ ARTISTIC INFLUENCES

Realist painters wanted to portray the modern world just as they saw it, unencumbered by notions of classical beauty. But their view of that world was inevitably shaped by the art of the past. They admired the dramatic Baroque compositions of the 17th century, and the work of those artists who had in their own day produced pictures that aimed for truthfulness, rather than some unattainable ideal.

Photography was in one sense the most Realist of all the arts—it had the potential to fulfill the aim of unidealized and objective observation that lay at the heart of the Realist agenda.

Nude Study, c.1853, by Julien Vallou de Villeneuve is typical of the kind of photograph Courbet is known to have kept as reference material. *Private Collection*

Rembrandt was much admired by Courbet. The naturalism, broad handling of paint, and rich shadows in this tender portrait of Hendrickje Stoffels, Rembrandt's common-law wife, are features of Courbet's work.

Woman Bathing in a Stream, 1654, by Rembrandt is a tender but unsentimental interpretation of an ancient theme. *National Gallery, London, UK*

Caravaggio's dramatic lighting inspired Courbet, who would have seen *The Death of the Virgin* in the Louvre. Glaring, almost stagelike lighting gives Mary prominence against the dark background.

The Death of the Virgin, 1605–06, by Caravaggio is a stark and powerful treatment of the subject. *Louvre, Paris, France*

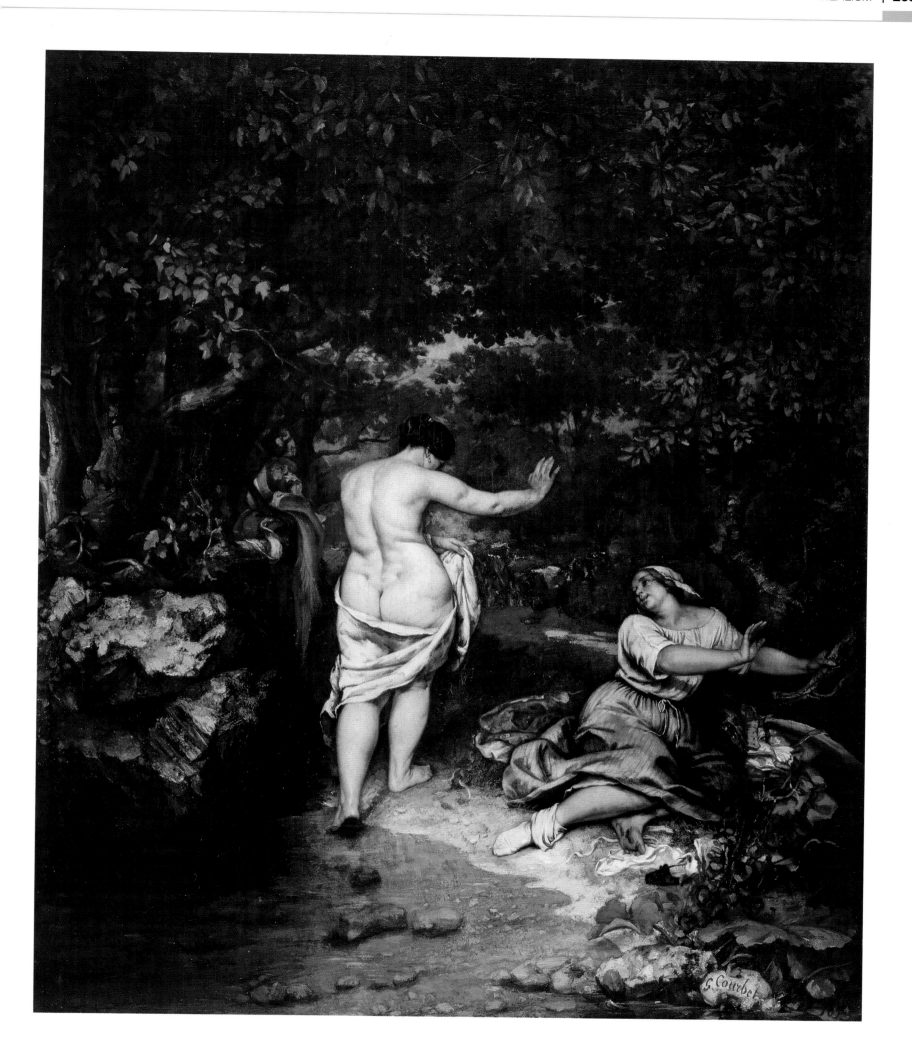

◎ TIMELINE

Realism was born in France in the late 1840s in the work of Courbet, Millet, and Daumier. Courbet's art was influential in Germany from the 1860s, the decade when Dutch artists of the Hague School were also beginning to paint landscapes and genre scenes in a Realist style. During the 1870s a group of Russian artists called the Wanderers took up the challenge of painting the more disturbing aspects of society, and Realist ideas engaged major American painters, including Thomas Eakins.

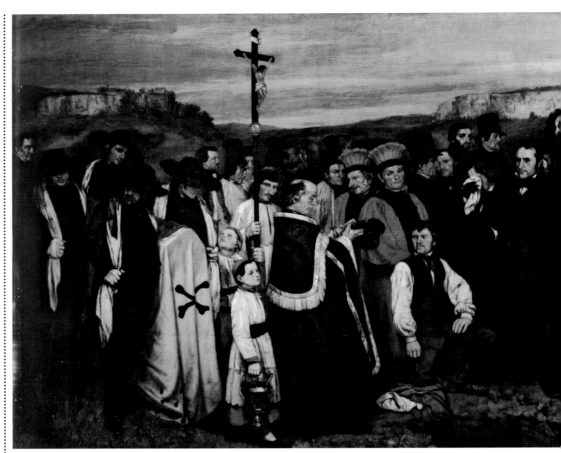

A Burial at Ornans ▷
Gustave Courbet 1850–51
Musée d'Orsay, Paris, France
Courbet's monumental canvas depicting a middle-class burial in the French provinces was shown at the Paris Salon in 1851. He was criticized for glorifying a mundane subject and for the awkwardness of the figures; other commentators, however, praised the "democratic" composition in which each figure has equal importance.

1850 1855 1860

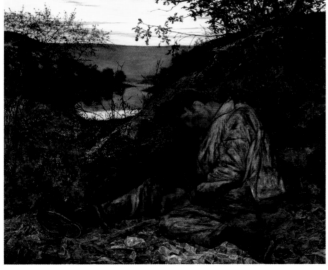

The Stone Breaker △
Henry Wallis 1857
Birmingham Museum and Art Gallery, UK
In mid-Victorian Britain, able-bodied paupers were forced to endure long hours of backbreaking toil to qualify for workhouse lodgings and food. The setting sun, the man's slumped posture, and the fact that the hammer has slipped from his hand reveal that he is dead rather than sleeping.

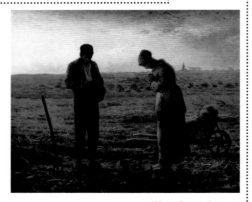

The Angelus △
Jean-François Millet c.1857–59
Musée d'Orsay, Paris, France
A farmer and his wife have stopped digging potatoes to recite the Angelus prayer at sunset. This image of rustic piety was sent on a tour of the US in 1889, when it was billed as the most famous painting in the world.

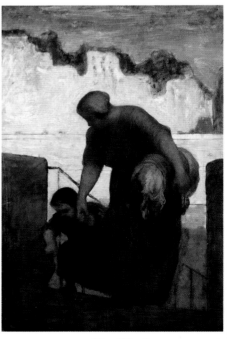

The Washerwoman △
Honoré Daumier c.1863
Musée d'Orsay, Paris, France
Daumier analyzed the plight of city workers, including laundresses, who worked hard for a pittance. The painting's somber tones convey a sense of weariness and resignation, and the generalized features of the mother and child underline the dehumanizing effects of such labor.

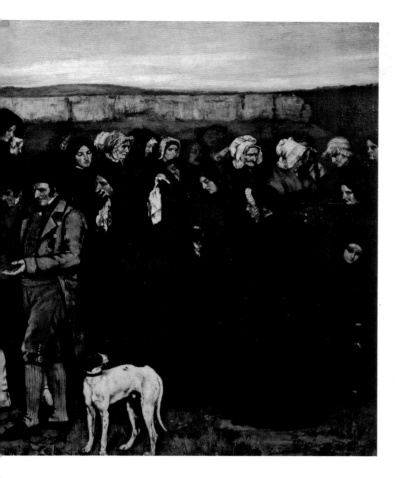

> ## NOBODY COULD DENY THAT A STONE BREAKER IS AS WORTHY A SUBJECT IN ART AS A PRINCE

Charles Perrier
French critic, on the themes of Courbet's work

The Iron Rolling Mill, or Modern Cyclops I ▽
Adolph Menzel 1872–75
Nationalgalerie, Berlin, Germany
Menzel's carefully observed painting shows men at work in a factory producing railway tracks, but it appears to celebrate modern manufacturing rather than offering the kind of social critique found in Courbet's work.

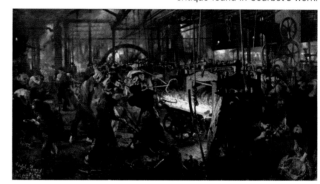

Courbet incarcerated
In Paris the Vendôme Column—a monument to Napoleon Bonaparte's military victories—is torn down in 1871. For his role in this, Gustave Courbet is imprisoned and ordered to pay rebuilding costs.

1865 **1870** **1875**

Realism spreads
Works by Russian artists are presented at the Paris Universal Exhibition in 1867, including a number by Vasily Perov showing scenes of rural hardship. These reveal that the influence of French Realism, particularly the works of Millet and Courbet, is spreading far and wide.

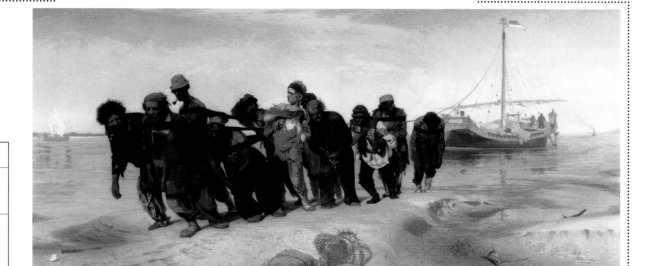

Barge Haulers on the Volga △
Ilya Repin 1873
Russian Museum, St. Petersburg, Russia
Repin had witnessed the hardships of boat haulers during his youthful travels through Russia. The men, dressed in rags and bound with leather harnesses, are almost collapsing with exhaustion, but a young man in the center raises his head and pulls against his straps as though to break free.

BIOGRAPHY

Ilya Repin

born Chuguyev, Ukraine, July 24 [August 5], 1844; **died** Kuokkala, Finland, September 29, 1930

Repin trained as an icon painter, and later became involved with the Wanderers, a group of Russian artists who believed that art should represent real life and encourage social reform. His *Barge Haulers on the Volga* earned him instant international fame and praise from Dostoevsky, who shared his concern for the lives of the poor. In the 1880s Repin turned away from Realist subject matter and toward themes from Russian history, but in the 20th century he became a model for Soviet Socialist Realist artists.

Sir James Guthrie

born Greenock, Scotland, UK June 10, 1859;
died Rhu, Scotland, UK September 6, 1930

Guthrie was the leader of a group of Scottish painters known as the Glasgow Boys. A visit to France in 1882 exposed him to the work of French Realist Jules Bastien-Lepage, whose influence is apparent in the rustic scenes Guthrie began painting. He wanted to immerse himself in the village life of the Scottish countryside. By 1884 he had settled in Cockburnspath, a farming village in Berwickshire, where he was joined by fellow artists who were also committed to painting outdoors. In later years, Guthrie became a society portraitist and President of the Royal Scottish Academy.

A Hind's Daughter ▷
Sir James Guthrie 1883
Scottish National Gallery, Edinburgh, UK
Guthrie's broad, square brushstrokes reveal the influence of French artist Bastien-Lepage, while the earthy palette also pays tribute to French Realist art. The girl is the daughter of a skilled farm laborer. The position of her head at the intersection of the horizontal horizon line and the vertical of the trees reinforces her as the focus of the composition.

Naturalism encapsulated
Jules Bastien-Lepage's *Hay Making* proves popular at the Paris Salon in 1878. A scene of two weary peasants resting in a field, French writer Emile Zola hails it as the masterpiece of naturalism in painting.

1875

1880

◁ **London Shoeshine Boy**
Jules Bastien-Lepage 1882
Musée des Arts Décoratifs, Paris, France
Although most of his subjects were rural, in the 1880s the French artist Bastien-Lepage produced a series of paintings of urban children forced to make a living on the street.

◁ **Three Women at Church**
Wilhelm Leibl 1882
Kunsthalle, Hamburg, Germany
One of Germany's greatest Realist painters, Leibl spent more than three years working on this picture, striving for a harmonious depiction of three generations of women. The expressions of piety in the face of each woman impressed van Gogh.

WE **STUDIED THE STREETS** AND THE **FIELDS** MORE **DEEPLY**; WE ASSOCIATED OURSELVES WITH THE **PASSIONS AND FEELINGS** OF THE **HUMBLE**

Jules Breton

▽ End of the Working Day
Jules Breton 1887
Brooklyn Museum of Art, New York City, NY
Jules Breton was one of a number of artists (including
Bastien-Lepage) who produced rustic scenes painted
outdoors that portrayed peasant life, but lacked the savage
social criticism of early Realist pictures. His workers are
returning home after a hard day's digging in the fields,
but the setting sun casts a serene light over the image.

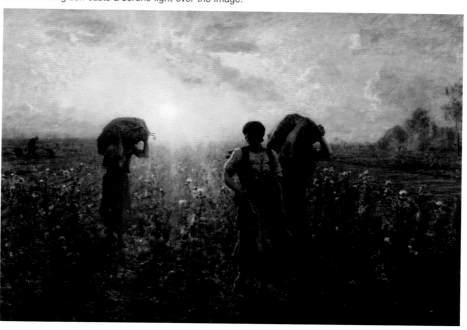

Realist sculpture
The sculptor Jules Dalou, fired
by his socialist convictions, begins
work in 1897 on an ambitious Worker's
Monument to be erected in Paris.
Intended to be 105ft (32m) in height
and crowned by the figure of a
peasant, it is never completed.

▽ The Larener Woman With Goat
Anton Mauve 1885
Gemeentemuseum, The Hague, Netherlands
Dutch artist Anton Mauve is remembered as
a painter of peasants in fields and flocks of
sheep. He was one of the Hague School of artists,
who were influenced by the French practice of
painting rural scenes outdoors. Mauve was a
cousin-in-law of van Gogh, and significantly
influenced his early work.

1885 **1890** **1895**

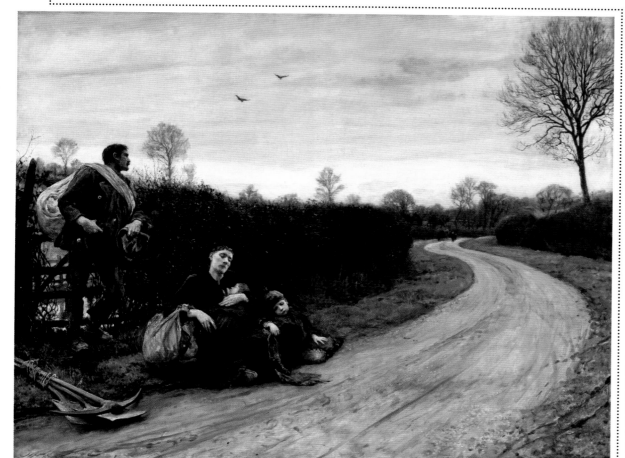

Jules Breton
born Courrières, France,
May 1, 1827;
died Paris, France, July 5, 1906

Breton became one of the most
famous painters of peasant life in
Second Empire France. Although
he sided with the liberals in the
1848 Revolution, and was
concerned with social causes, he
gradually abandoned attempts to
convey the miserable plight of rural
laborers in favor of an idyllic,
picturesque vision of the world in
which the workers appear noble
rather than downtrodden. This led
to critical success at home and in
the US, and patronage from the
French government.

BIOGRAPHY

◁ Hard Times
Sir Hubert von Herkomer 1885
Manchester Art Gallery, UK
Herkomer's humble background gave him a natural
sympathy with the poor and disadvantaged. He
was inspired to paint this picture after meeting a
family of itinerant laborers near his home, but the
scene was posed in the studio and members of a
local family were employed as models.

◎ MASTERWORK

The Gross Clinic

Thomas Eakins **1875**
Philadelphia Museum of Art and Pennsylvania Academy of The Fine Arts, PA

This enormous canvas, measuring 8 x 6½ ft (2.5 x 2 m), has been described as the most important American painting of the 19th century. It depicts Professor Samuel Gross lecturing to medical students at Jefferson Medical College, Philadelphia, as he conducts an operation to remove some diseased bone from a leg. The identity of the patient is hidden since we can only see the left thigh, buttocks, and feet. Eakins does not shirk from portraying the gory details of the incision and the surgical instruments cutting into flesh, or the blood on Dr. Gross's fingers. The surgeons go about their business in a matter-of-fact way, but the picture is full of drama. A female figure, who may perhaps be the patient's mother, shields her eyes from the spectacle at its center, adding a melodramatic touch. The students in the surgical amphitheater could almost be ordinary theatergoers; dramatic lighting from an overhead skylight gives the whole scene the air of a stage set. The artist included his own portrait among the spectators—a barely visible figure sketching or writing to the right of the railing leading out from the tunnel. The man seated behind Dr. Gross is a clerk taking notes about the operation. Because this episode is taking place in an era before modern knowledge of hygiene, the surgeons are operating in their lab coats rather than scrubs.

The picture had obvious antecedents in Rembrandt's paintings of anatomy lessons and in 19th-century group portraits of French surgeons preparing for dissection. The pronounced tonal contrasts and dashing brushwork may also owe something to Eakins's admiration for the work of the Spanish painters Velázquez and Ribera, which he had seen in Madrid. The canvas was rejected by the art jury of the Philadelphia Centennial Exhibition in 1876, but was finally hung in the medical section—an unintentional tribute to Eakins's accuracy of observation.

> ❝ ONE OF THE MOST **POWERFUL, HORRIBLE,** YET **FASCINATING PICTURES** THAT HAS BEEN PAINTED ANYWHERE THIS CENTURY ❞

1876 | New York Tribune
On The Gross Clinic

◎ Thomas Eakins

born Philadelphia, PA, July 25, 1844
died Philadelphia, June 25, 1916

Now considered one of America's greatest painters, Eakins was best known for his portraits, which often show his sitters in an unflattering but truthful light. He had a long-standing interest in anatomy, which he studied at Jefferson Medical College in Philadelphia, and attended dissections while studying in Paris in the 1860s.

Eakins was appointed Director of the Pennsylvania Academy of the Fine Arts in 1882, when he placed great emphasis on drawing from life, but he was forced to resign in 1886 because he had used a nude male model in a mixed drawing class. Eakins was also interested in photography, assisting English photographer Eadweard Muybridge in his study of people and animals in motion in 1884, and he later conducted his own photographic and motion studies. Despite the controversy surrounding his resignation, he achieved recognition as a great master toward the end of his life.

BIOGRAPHY

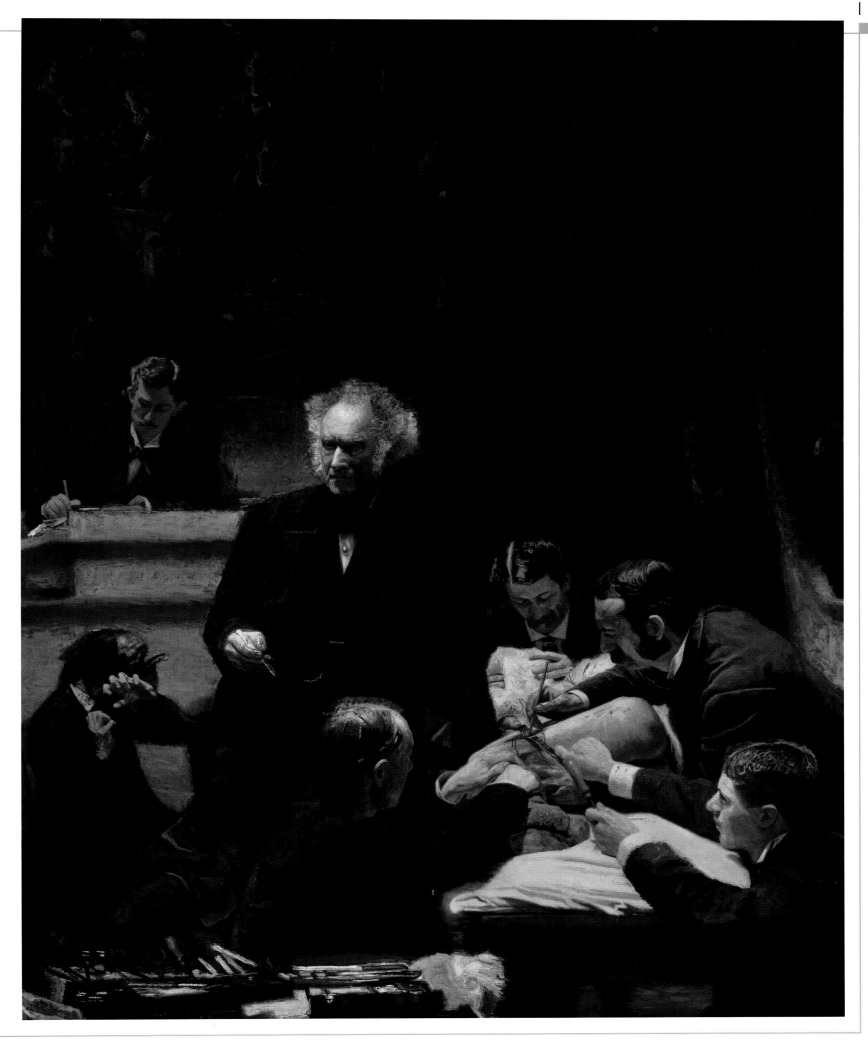

IMPRESSIONISM

c.1860–1900 CAPTURING THE MOMENT

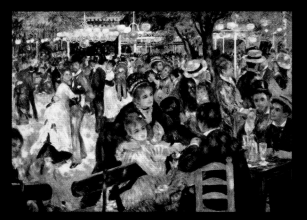

▷ **Dance at the Moulin de la Galette**
Pierre-Auguste Renoir 1876
Musée d'Orsay, Paris, France
Renoir's depiction of a Sunday afternoon in a popular Montmartre dance garden conveys the movement of the crowd and effects of natural sunlight and artificial light through the broken brushstrokes, blurred forms, and vibrant color that were characteristic of Impressionism. Many of his friends posed as models.

In the late 1860s a number of artists in Paris came together to form a group with a revolutionary agenda. What they shared was not a unified style, but a desire to break free from the constraints of academic art, a wish to show their work outside the official exhibitions of the Paris Salon, and a passion for portraying contemporary life. Their urban landscapes, sun-dappled scenes of leisure, and views of the countryside and coast captured what the eye sees in a fleeting moment with flickering brushstrokes and dabs of brilliant, often unmixed, color. The central figures in the group were Bazille, Cézanne, Degas, Manet, Monet, Morisot, Pissarro, Renoir, and Sisley, but it had a fluid membership over the course of the eight exhibitions it organized between 1874 and 1886. Impressionist ideas soon spread beyond France to artists in the rest of Europe and the US.

◎ CONTEXT

An age of renovation

By the mid-1860s France was undergoing an extensive program of public works, which had been instigated by Napoleon III. The country was modernizing and industry was expanding—a development reflected in the railway bridges, industrial waterways, and factories that appear in several Impressionist landscapes. Paris was also being given a massive facelift, supervised by civil servant Baron Georges Haussmann. This ambitious renovation project swept away the capital's winding, medieval streets and replaced them with grand, tree-lined boulevards wide enough to accommodate pavement cafes, public buildings, and apartment houses. The newly installed gas lanterns in the streets lit up the city at night, encouraging nightlife and attendance at the opera, ballet, theatre, concerts, and dance halls.

A series of World Fairs held in Paris in 1855, 1867, 1878, 1889, and 1900 asserted France's position in the world and celebrated the arts and industry. The annual Salon—where artists exhibited their work under the aegis of the Académie des Beaux-Arts—was still a fixture in the social calendar, but the private art market was expanding and dealers such as Paul Durand-Ruel were beginning to sell works by living artists, not just the Old Masters. Although the siege of Paris by Prussian forces in 1870–71 caused damage and temporarily halted the building program, there is little reflection of this national humiliation in Impressionist canvases.

New railway lines radiated out of Paris, bringing the suburbs and countryside within easy reach of the city. Some artists, including Monet and Pissarro, even chose to base themselves in the nearby countryside—finding a wide selection of new subjects to paint— but retained their links with the capital. Trains provided easy access for day-trips from Paris and holidays on the Normandy coast, with its newly fashionable resorts. Railway stations themselves were also a source of fascination as places of movement, steam, smoke, speed and—above all—modernity.

Haussmann's Paris
The intersection of Boulevard Magenta and rue de Maubeuge in Paris's 10th district. The main thoroughfares formed a link between the city's railway stations.

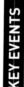 **IMPRESSIONIST PAINTERS…PAINT REALITY AND… PRESUME TO RENDER THE VERY IMPRESSION OF NATURE** 〃

1877 | Emile Zola
French novelist, journalist, and critic

◎ BEGINNINGS
PAINTING EN PLEIN AIR

Impressionism had its immediate roots in the French traditions of Realism and naturalism that had developed in the 1840s in the art of painters such as Gustave Courbet and the Barbizon artists, who worked in the Forest of Fontainebleau. The young Impressionists were influenced by Courbet's insistence that the artists' own experience and scenes from daily life were suitable subjects for art. They were also inspired by Barbizon painters, such as Millet, who showed that it was possible to produce a landscape without historical associations, but also to depict it so that it was rooted in a particular season, time, and place. Encouraged by the Barbizon artists' example of frequently painting *en plein air*—outdoors—the Impressionists left their studios and ventured out into the countryside and town. At the same time, they moved away from the earthy palette favored by the previous generation, adopting pure, intense colors and smaller, more fragmented brushstrokes to record the momentary effects of light.

◉ ARTISTIC INFLUENCES

While Impressionism was not one single unchanging style, Impressionist painters all wanted to convey the sensation they felt in front of nature. They were inspired by art from the recent past, contemporary habits and fashion, and—most importantly—the idea of painting outdoors to capture the fleeting moment.

New inventions, such as collapsible easels and pre-mixed paints stored in lead tubes, rather than pigs' bladders, meant that artists could easily take their materials outdoors. New pigments expanded their palettes.

Portable and collapsible easels were among the mid-19th century inventions that helped artists to paint *en plein air*.

Marine scenes by 17th-century Dutch masters, such as Willem van de Velde the Younger, profoundly influenced Boudin. Van de Velde specialized in paintings of the sea and coast, featuring big skies and scudding clouds.

Dutch Vessels Inshore and Men Bathing, detail, 1661 is characteristic of van de Velde's work. *National Gallery, London, UK*

Outdoor painting was practiced by Barbizon artists, such as Charles-François Daubigny, who had a studio boat. Boudin and the Impressionists were inspired by his example, and Monet sometimes used a boat.

The River Seine at Mantes, detail, c.1856 by Daubigny is a typical outdoor scene. *Brooklyn Museum of Art, New York, US*

The vigorous brushwork that characterizes many Impressionist works can be seen in coastal scenes by the Dutch artist Johan Barthold Jongkind. They were much admired by both Boudin and Monet.

Seascape With Ponies on the Beach, detail, 19th century features Johan Barthold Jongkind's brushwork. *Private Collection*

◎ TURNING POINT

Beach Scene at Trouville

Eugène Boudin **c.1873** *National Gallery, London, UK*

Boudin's paintings at Trouville record a new feature of contemporary life in the sketchy manner that was soon adopted by other Impressionist painters. Individual details are subordinated to the overall impression of atmospheric freshness, while light tones convey the effects of bright sunlight filtered through clouds. Vacationers had begun to flock to the new seaside resorts of Trouville and neighboring Deauville, and Boudin uses the reds and whites of their clothes to add splashes of color to the muted blues and browns of sand and sea. Monet, who also painted here, probably owned two of Boudin's many paintings of this type.

◎ Eugène Boudin

born Honfleur, France, July 12, 1824;
died Deauville, France, August 8, 1898

BIOGRAPHY

Boudin, who was largely self-taught, initially ran a picture-framing business in Le Havre. This brought him into contact with several artists, including Millet, who encouraged his artistic ambitions. The son of a sailor, Boudin had an instinctive feel for the moods of the sea, and he came to specialize in Normandy beach scenes. He advocated painting in the open air—a habit that he passed on to the young Monet, who often worked beside him. Boudin's bright and breezy seascapes formed one of the crucial links between the Barbizon painters and the Impressionists.

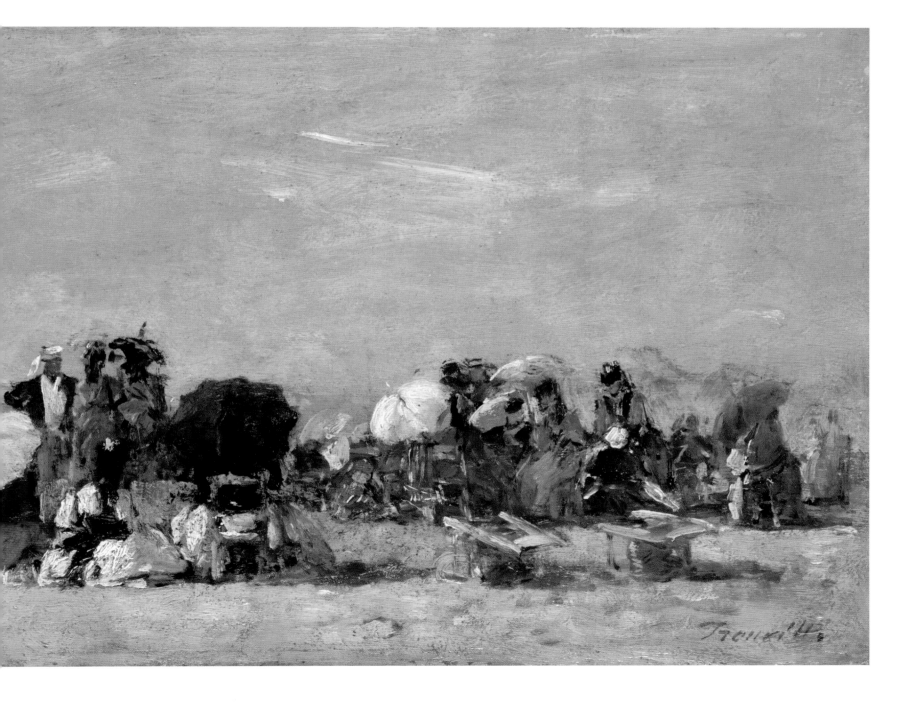

◎ TIMELINE

The idea of an exhibition venue to serve as an alternative to the Paris Salon was first discussed among a group of avant-garde artists at the Café Guerbois in Paris in the late 1860s. It was not until 1874 that the first exhibition took place, sparking the term "Impressionism," used disparagingly, from an attending art critic. A further seven shows followed, the last taking place in 1886. Pissarro was the only artist who exhibited in all eight shows, while Degas and Morisot participated in seven.

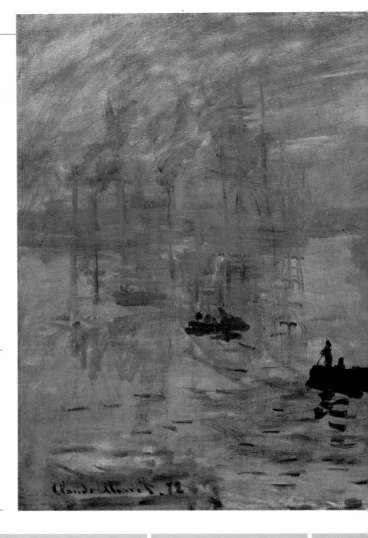

Pissarro moves to the country
In 1866 Camille Pissarro moves to Pontoise, a town within easy reach of Paris, where life is cheaper and there are rural subjects to paint.

Manet provokes a storm
Edouard Manet exhibits *Olympia*, his painting of a brazen prostitute and her maid, at the Paris Salon in 1865. This modern reworking of the traditional theme of a female nude creates a furor.

❝❝ THEY DO NOT **RENDER A LANDSCAPE**, BUT THE **SENSATION PRODUCED** BY THE LANDSCAPE ❞❞

1874 | Jules-Antoine Castagnary
French art critic, on the first Impressionist show

1865	1866	1867	1868	1869	1870

Family Reunion △
Frédéric Bazille 1867
Musée d'Orsay, Paris, France
Bazille shows his family gathered together on the terrace of their home near Montpellier in the south of France. Although the work is quite stiffly painted, it succeeds in conveying the light and bright colors of the Mediterranean, and the sense of soft sunshine filtered through foliage.

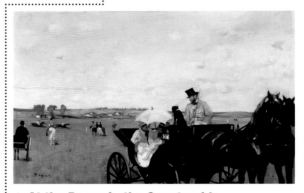

△ **At the Races in the Countryside**
Edgar Degas 1869 *Museum of Fine Arts, Boston, MA*
This scene, shown at the first Impressionist exhibition in 1874, depicts Degas's friend Paul Valpinçon and his family at the races. The apparently casual composition resembles a spontaneous snapshot, revealing the influence of photography.

◎ Frédéric Bazille

born Montpellier, France, December 6, 1841; **died** Beaune-la-Rolande, France, November 28, 1870

Born into a wealthy southern French family, Bazille studied medicine in Paris in 1862, but took up painting. He admired Manet and was close to Renoir and Monet, particularly liking their open-air work. His death in combat during the Franco-Prussian War was a tragic loss to Impressionism.

BIOGRAPHY

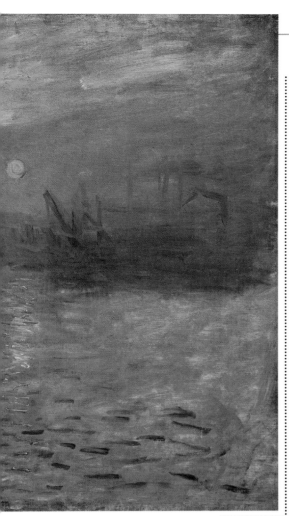

◁ Impression Sunrise
Claude Monet 1872
Musée Marmottan, Paris, France
Monet's loose brushstrokes suggest sunrise over the harbor in this scene at Le Havre. When it was shown at the first "independent art show" in 1874, the critic Louis Leroy coined the hostile term "Impressionist," inadvertently naming the new art movement.

◁ The Cradle
Berthe Morisot 1874
Musée d'Orsay, Paris, France
Berthe Morisot was the first woman to show with the Impressionist group in 1874, and motherhood became one of her favorite subjects. This tender picture, painted in soft silvery tones, shows her sister Edma gazing at her sleeping daughter, Blanche.

First Impressionist show
The first Impressionist exhibition is organized in 1874 at the Paris studio of the photographer Nadar. Thirty artists take part, but the show is greeted with derision from critics and is a financial flop.

Second Impressionist show
The second Impressionist exhibition is staged in 1876 at the gallery of art dealer Paul Durand-Ruel. There are twice as many canvases on display as at the exhibition two years earlier, but only 19 artists take part.

1871 1872 1873 1874 1875 1876 ▶

Gare Saint-Lazare △
Edouard Manet 1873
National Gallery of Art, Washington, DC
The Paris station of Saint Lazare was a popular subject for the Impressionists, not least because they themselves used it to board trains for the suburbs and Normandy. Manet shows his favorite model, Victorine Meurent, and a little girl looking across the railway cutting.

Landscape, Ile de France ▷
Armand Guillaumin 1874
Private Collection
In the early 1870s, Guillaumin painted alongside Pissarro at Pontoise. Like Pissarro, Guillaumin presents a cultivated, working landscape. Two men labor in the fields, and choppy brushstrokes suggest the movement of the clouds on an overcast day.

BIOGRAPHY

Armand Guillaumin
born Paris, France, February 16, 1841;
died Orly, nr. Paris, June 26, 1927

Overshadowed by his more famous Impressionist contemporaries, Guillaumin was a friend of Cézanne, Pissarro, and Vincent van Gogh and his brother Theo. He exhibited works in six of the eight Impressionist exhibitions and specialized in scenes of the countryside around Paris. His work is characterized by brilliant colors and often contains uncompromisingly modern features, such as smoking factory chimneys.

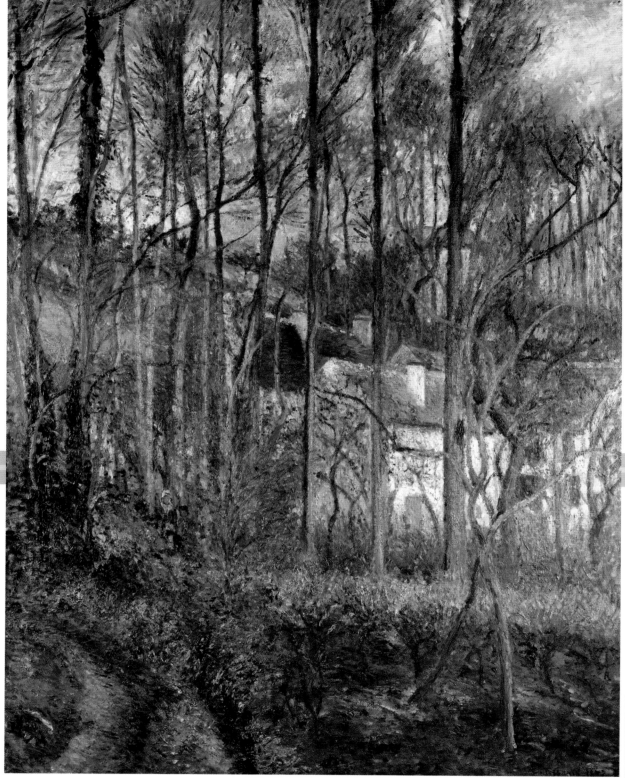

The Côte des Bœufs at L'Hermitage △
Camille Pissaro 1877
National Gallery, London, UK
Pissarro aimed to paint the hillside near his home in Pontoise as though he was actually immersed in the scene himself, creating a sense of intimacy between the landscape and the spectator. He built up the picture using dabs of broken color to create a heavily textured surface.

▽ **Rainy Day**
Gustave Caillebotte 1877
The Art Intstitute of Chicago, IL
The smart new boulevards of Baron Haussmann's Paris, and those who strolled along them, are recorded in Caillebotte's scene of the Place de Dublin. The influence of photography can be seen in the apparently casual composition and the severe cropping of the figures.

1878

❝ EVERYTHING PAINTED ON THE SPOT HAS **A STRENGTH, A POWER, A VIVIDNESS** ❞

1888 | Eugène Boudin

▽ A Bar at the Folies-Bergère
Edouard Manet 1882
Courtauld Gallery, London, UK
Parisians flocked to the Folies-Bergère music hall to see circus acts and ballet, and to pick up prostitutes. Manet focuses on Suzon, one of the barmaids, showing her aloof from the crowd, lost in thought as she serves a customer. Manet mocked up the bar in his studio, painting the background from memory; the relationship between the reflections in the mirror and the objects and model in the foreground is inconsistent.

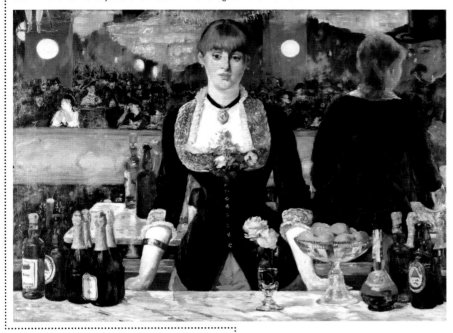

PHOTOGRAPHY

The photographic process was first developed in the 1830s, and by the time the Impressionist group formed, portrait and landscape photography had become thriving commercial businesses. Though they did not always admit it, many artists used photographs as a basis for their compositions—as can be seen in the abrupt crops, unusual perspectives, and varied focus of some works. Eadweard Muybridge's photographic studies of animals in motion in the 1870s also inspired artists including Degas.

Early camera and tripod

CONTEXT

Development of Divisionism
Pissarro meets Georges Seurat and Paul Signac in fall 1885, becoming a convert to their new way of painting. Small dots of contrasting colors are painstakingly applied to the canvas to blend in the eye of the viewer.

Last Impressionist show
The last Impressionist exhibition takes place in 1886. Most of the core members of the group are developing new, individual styles or have formed lucrative arrangements with dealers, causing a disruption to the group's tenuous unity.

1880 1882 1884 1886 1888 ►

Renoir's experiment
Renoir finishes *The Large Bathers* in 1887, a work showing evenly lit figures with hard contours. It reflects his worry that he has reached the end of his experiment with Impressionism, but he soon reverts to a softer manner.

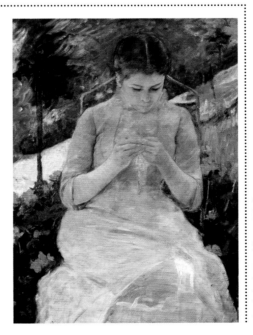

◁ Young Woman Sewing in a Garden
Mary Cassatt 1880–82
Musee d'Orsay, Paris, France
The American artist Mary Cassatt produced several scenes of well-to-do women—often her family members or friends—engaged in domestic tasks. The monumental and precisely delineated figure dominates the picture space.

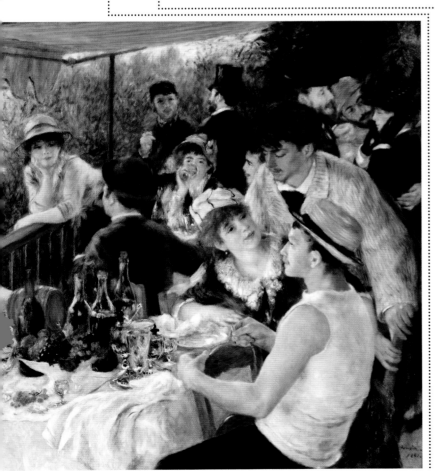

◁ Luncheon of the Boating Party
Pierre-Auguste Renoir 1880–81
The Phillips Collection, Washington, DC
Renoir's friends enjoy lunch at the Maison Fournaise restaurant, overlooking the Seine at Chatou. Light streams in from the balcony opening and is reflected off the white tablecloth and the vests worn by the men.

Snow Scene at Moret ▽
Alfred Sisley c.1894 *Private Collection*
Snow scenes appealed to Impressionist artists, including Sisley and
Monet, because they offered the opportunity to study subtle variations
in light and to use different tonal ranges. In this canvas, the snow has
created discreet color harmonies in the winter landscape.

▽ Paul Helleu Sketching With his Wife
John Singer Sargent 1889
Brooklyn Museum of Art, New York, NY
This study, which exhibits the broad handling typical
of many Impressionist works, is both a record of the
practice of *plein-air* painting and a testament to
Sargent's friendship with the French artist Paul Helleu.

1889	1890	1891	1892	1893	1894

**Pissarro abandons
Divisionism**
In 1890 Pissarro gives up
painting in the Divisionist style
developed by Seurat, finding
that it hampers his spontaneity.

Philip Wilson Steer

born Birkenhead, UK,
December 28, 1860; **died** London,
UK, March 18, 1942

The British artist Philip Wilson
Steer studied in Paris in the early
1880s, and his work from around
1887 to 1894 reveals the
influence of the Impressionists—
particularly Monet—and also of
Whistler, in its sparkling colors,
freshness, and free brushwork.
In 1886, he became a founder
member of the New English Art
Club, a group of fellow artists
who had also studied in Paris and
were aware of the latest trends in
French art. In 1889, Steer took
part in an exhibition entitled
"The London Impressionists."

BIOGRAPHY

Children Paddling,
Walberswick ▷
Philip Wilson Steer 1891–92
*Fitzwilliam Museum,
Cambridge, UK*
By the time he painted this picture,
Steer was England's leading
follower of French Impressionism.
The Suffolk beach scene shows
his debt to Monet and Sisley in its
use of flecked brushstrokes to
apply pure, unmixed color
directly to the canvas.

Childe Hassam

born Dorchester, MA, October 17, 1859; **died** East Hampton, NY, August 27, 1935

Childe Hassam was an American artist who came into contact with the work of Monet, Pissarro, and Sisley when he spent three years painting in Paris in the late 1880s. After he settled in New York in 1889 he continued painting in his own version of Impressionism, marrying broken brushstrokes and a light palette with a formality of composition. Hassam and his fellow artists helped to spread Impressionist ideas in the US through their exhibiting society known as "The Ten."

◁ Blue Dancers
Edgar Degas 1899 *Pushkin Museum, Moscow, Russia*
Dancers in rehearsal or waiting in the wings were one of Degas's favorite motifs. In this luminous pastel he captures them adjusting their costumes just before they go on stage, their poses interweaving to create a harmonious rhythm.

Monet's study of light
In 1895 Monet shows 20 paintings of the facade of Rouen Cathedral in different light conditions at Durand-Ruel's Paris gallery, to a mixed critical reception.

Monet paints London
In three trips to London between 1899 and 1901, Monet produces several views of Charing Cross Bridge and Waterloo Bridge in the fog. To capture the effects of light, smog, and mist, he works on many canvases simultaneously, moving between them as the atmosphere changes.

1895 **1896** **1897** **1898** **1899** **1900**

△ The Boulevard Montmartre on a Winter Morning
Camille Pissarro 1897
Metropolitan Museum of Art, New York, NY
In the late 1890s Pissarro, who had previously concentrated on rural scenes, painted a series of views of the Parisian boulevards seen from a hotel window. Here he conveys a silvery light with feathery brushstrokes.

Sisley's seascapes
Alfred Sisley visits south Wales in 1897. He produces a series of subtly innovative paintings of the coastline at Penarth and Langland Bay. His only seascapes, they are among his final works.

△ Late Afternoon, New York
Childe Hassam c.1900
Brooklyn Museum of Art, New York, NY
Hassam's atmospheric urban scenes convey his belief that New York was the most beautiful city in the world. Here, the trees, buildings, horse-drawn carriages, and figures journeying along a New York street almost dissolve in a blizzard of snow.

◎ MASTERWORK

The Waterlily Pond Green Harmony

Claude Monet **1899**
Musée d'Orsay, Paris, France

Monet's paintings of waterlilies are the culminating achievement of his career. For much of the last 33 years of his life, he devoted himself to translating the moods and reflections of his beloved pond into images of transcendent beauty.

He had always painted the gardens of the houses where he lived, and when he bought the house he was renting in Giverny in 1890, he finally had the chance to create a garden entirely to his own taste. He laid out the flower garden in a series of beds ablaze with colorful blooms, and then created a tranquil water garden. He filled the pond with special hybrid waterlilies, and installed an arched wooden bridge, inspired by those he had admired in Japanese prints.

Monet visited his water garden at least three times a day to study the changing light. He also recorded it obsessively—this is one of 12 canvases painted from the same vantage point during the same year. They were produced shortly after the death of Monet's stepdaughter Suzanne, and represent a peaceful paradise that offers solace in the face of desolation.

The eye is drawn to the mirrorlike surface of the pond and the way the plants and bridge are reflected in the water. Horizontal brushstrokes delineating the waterlilies are interrupted by the vertical strokes of lighter green, showing the reflected vegetation above the pond. It is a hermetically sealed world in which there is barely any suggestion of sky, and as serene and harmonious as the painting's title suggests. Monet continued to paint his waterlily pond until his death, eventually creating almost abstract canvases without reference to the banks or bridge, where the entire subject is the surface of the water.

MY **EYES WERE OPENED** AT LAST, AND I REALLY **UNDERSTOOD NATURE**

1888 | Claude Monet

Claude Monet

Born in Paris, Monet grew up in the coastal town of Le Havre, where his friendships with landscape painters Johann Barthold Jongkind and Eugène Boudin encouraged him to become an artist. During the mid-1860s he tried and failed to make his mark at the Paris Salon with monumental works painted partly outside, and toward the end of the decade he became a key figure in the group of painters who later became known as the Impressionists. After a spell in London during the Franco-Prussian War, Monet returned to France, making his home in a succession of suburban towns near Paris before settling in Giverny in 1883. Throughout his long career, Monet remained faithful to the Impressionist aim of exploring the changing quality of light and color in landscape. His series of paintings of grainstacks, Rouen Cathedral, and waterlilies depict specific sites under differing light and weather conditions.

POST-IMPRESSIONISM

▷ **The Harvest**
Vincent van Gogh 1888
Van Gogh Museum,
Amsterdam, Netherlands
The brilliant palette of van Gogh's
painting is typical of many
Post-Impressionist pictures.
Working at a feverish pace, in
one week in June 1886 van Gogh
produced ten paintings on the
theme of the harvest. The dazzling
colors give a vivid impression of
wheat fields under the blazing sun,
while the composition, with its
horizontal bands, has a sense
of structural solidity.

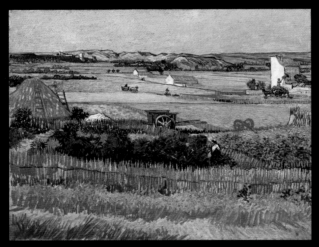

At the last Impressionist exhibition in 1886 one of the works that caused a stir was a large landscape by Georges Seurat created with tiny dots of paint— *A Sunday Afternoon on the Island of La Grand Jatte (see p.292)*. Unlike the Impressionists, who sought to capture the fleeting moment, Seurat attempted to convey a sense of monumental timelessness. He was one of a number of artists who were becoming convinced that they should do more than simply record the scene in front of them. Cézanne, Gauguin, and van Gogh, who had all started out painting in the Impressionist manner, were each reacting to it in different ways. Cézanne was beginning to explore geometrical form and reworking the conventions of Western perspective, while Gauguin and van Gogh were moving toward an art that was less naturalistic and more concerned with evoking feelings and emotions.

◎ CONTEXT

New horizons

The 1880s were marked by a scramble among Western nations to annex territory in the non-Western world. Although Britain was the most successful nation in this land grab, France made substantial gains too, presenting its colonial project as a mission to civilize the "inferior races." The 1889 Universal Exhibition, held in Paris and intended by its chief organizer to be "the point of departure, for the entire world, of a new era," was marked by an extended coverage of the non-Western world. Displays were mounted on the Far East, the Middle East, and North Africa, as well as what was seen as the "primitive" world—Central Africa and Polynesia. Living "natives" were imported to the exhibition to act out their daily routines.

The section devoted to Paris, which was dominated by the brand new Eiffel Tower, was placed at the center of the exhibition as a beacon of civilization. But for some thinkers and artists, the veneer of civilization was wearing increasingly thin. The last few years of the century may have been characterized as *La Belle Epoque*—a beautiful era when the arts, music and theater flourished—but these pleasures were not available to everyone. Indeed, some commentators saw the luxury of the period as almost decadent. The French capital had become increasingly polarized between the "haves"—the wealthy citizens who could enjoy restaurants, beautiful clothes, fine entertainment, and vacations in the fashionable coastal resorts—and the "have-nots."

Progressive artists tended to belong to the latter category. Although some of their Impressionist colleagues were becoming steadily richer through the activities of their commercially minded dealers, slightly younger painters were struggling to establish themselves. They were also beginning to cast their eyes beyond the capital, seeking to escape to the more "primitive" areas in France itself, such as Brittany, Provence, or the Languedoc, or even—in the case of Gauguin—to the islands of Polynesia that he had glimpsed at the Universal Exhibition.

Entertaining times

▷ **1886** Emile Zola publishes his novel *L'Oeuvre* ("The Masterpiece"), a story of a painter that he based on his friend Paul Cézanne and other artists.

▷ **1886** The Folies-Bergère stages its first music-hall *revue*, a new form of show for which it becomes famous.

▷ **1889** The Moulin Rouge opens in Paris. It is the birthplace of the bawdy can-can dance commemorated in many paintings and posters from the period.

▷ **1894** Alfred Dreyus, a military officer of Jewish origin, is wrongly accused of selling military secrets to the Germans. The affair sharpens political divisions in France and inflames anti-Semitism.

▷ **1889** The *Revue Blanche* is founded. A progressive literary and artistic journal, it runs articles on political topics—such as anarchism and colonialism—and promotes avant-garde art.

▷ **1900** The Paris Universal Exhibition opens, receiving more than 50 million visitors in seven months.

▷ **1903** France leads the way in the spread of automobiles, manufacturing over 30,000—half the world's production.

KEY EVENTS

> I WANTED TO MAKE OF **IMPRESSIONISM** SOMETHING **SOLID AND ENDURING**, LIKE THE **ART IN MUSEUMS** "

Paul Cézanne

The Universal Exhibition
This colored engraving from the Musée Carnavalet, Paris, presents a bird's-eye view of the 1889 Universal Exhibition, dominated by the Eiffel Tower.

 BEGINNINGS

MASTERS OF COLOR

The term "Post-Impressionist" was coined by English art critic Roger Fry in 1910, when he was organizing an exhibition of modern French art in London. The artists who fall under its umbrella pursued different paths, all of which had their origins in Impressionism. In the mid-1880s Gauguin and van Gogh were taking their cues from a diverse range of artistic sources—including Japanese prints, stained-glass windows, and the art of "primitive" peoples—in order to produce pictures loaded with feeling and symbolism.

Cézanne, who had recently painted alongside Pissarro in Pontoise, was now working in isolation in his native Provence, experimenting with landscapes, still lifes, and portraits constructed from broken planes of color. Georges Seurat and his followers—the "Neo-Impressionists"—were going beyond Impressionism, turning its broken brushwork into something more rigorous through a scientific method of applying paint in countless dots, inspired by theories about the optical and emotional effects of different colors.

> **I LOVE BRITTANY.** I FIND THE **SAVAGE,** THE **PRIMITIVE** THERE. WHEN MY **CLOGS RESOUND ON THE GRANITE SOIL,** I HEAR THE **MUFFLED, DULL, POWERFUL TONE** THAT I'M AFTER IN PAINTING

1888 | Paul Gauguin

◉ ARTISTIC INFLUENCES

By the 1860s a number of artists were traveling to the Breton village of Pont-Aven to paint, attracted by picturesque customs and inexpensive lodgings. Gauguin stayed there for long periods in 1886 and 1888. Among his fellow artists was Emile Bernard, whose simplified style of painting involving flat areas of color surrounded by dark borders seemed to point the way forward.

The art of non-Western cultures had always fascinated Gauguin. He particularly admired Japanese prints, and probably knew Hiroshige's orchard scene. Many other artists shared Gauguin's enthusiasm for Hiroshige—van Gogh copied this print in 1887.

Plum Estate, Kameido, 1857, by Ando Hiroshige is a bold composition bisected by a tree trunk, with a brilliant red background. *Brooklyn Museum, New York, NY*

Japanese fighting couples by printmaker Hokusai were the basis for Gauguin's pose of Jacob and the angel. Gauguin had also observed traditional Breton wrestling contests—the cow in *The Vision of the Sermon* was a prize awarded to the winner.

Sumo Wrestlers, one of thousands of sketches showing sumo wrestlers in the 15-volume *The Hokusai Manga*, published from 1814. *Private Collection*

Cloisonnism, a painting style partly inspired by stained-glass decoration that featured large, flat areas of bold color contained by dark outlines, was adopted by Gauguin after he abandoned the Impressionist-influenced fractured brushwork of his earlier paintings.

Circus Scene, detail, 1887, by Louis Anquetin is an example of the Cloissonist style that inspired Gauguin. *Private Collection*

Breton folklore and religious practices— which included elaborate pilgrimages and "pardons" (saints' feast-days)—began to attract artistic interest in the second half of the 19th century. German artist Otto Weber was among the first to portray local customs.

A Church in Brittany, detail, 1864, by Otto Weber shows a family returning from a religious service. *Musée des Beaux-Arts, Lille, France*

◎ TURNING POINT

The Vision of the Sermon

Paul Gauguin **1888** *Scottish National Gallery, Edinburgh, UK*

This painting was inspired by a scene of women in a church, which Gauguin witnessed while he was staying at Pont-Aven in Brittany. The women in traditional Breton costume have been listening to a sermon based on a passage in the Bible in which Jacob spends a whole night wrestling with a mysterious angelic figure. With its distorted forms and unnatural color the work is not a literal transcription of an event, but an attempt to convey the intense religious experience of the women, who are physically separated from their imaginative vision by a tree trunk.

◎ **Paul Gauguin**

born Paris, France, June 8, 1848;
died Atuona, Marquesas Islands, May 8, 1903

BIOGRAPHY

Gauguin's early childhood in Peru (his mother's native country) left him with a taste for the exotic. A successful stockbroker who painted as a hobby, he formed a friendship with Pissarro, produced works in a muted Impressionist style, and exhibited in the first Impressionist exhibition in 1874. By 1883 Gauguin had lost his job and was painting full-time, much to his family's dismay. Between 1886 and 1890 he was the unofficial leader of the artists' colony at Pont-Aven, Brittany. In 1891 he left France for French Polynesia, where he spent most of the rest of his life.

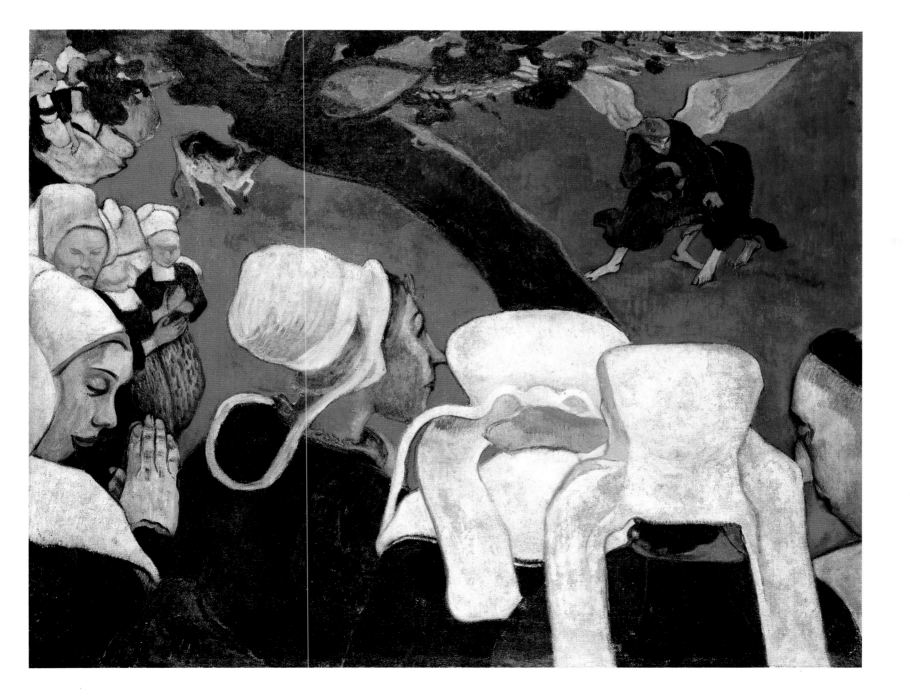

◎ TIMELINE

At the time of the last Impressionist exhibition in 1886 it was becoming apparent that new strands were emerging in avant-garde French art. In the south of France, Cézanne produced canvases that played with structure and perspective. In Brittany, Gauguin and Bernard were painting bold compositions with symbolic resonance. In the Netherlands, van Gogh was preparing for a move to France, where he would produce a series of intensely expressive canvases.

▽ Street Scene, at Five in the Afternoon
Louis Anquetin 1887
Wadsworth Atheneum, Hartford, CT
This night scene is a perfect example of the Cloisonnist method of painting that Anquetin devised with Emile Bernard, which was characterized by strong black lines enclosing flat areas of color.

◁ Breakfast
Paul Signac 1886–87
Rijksmuseum Kröller-Müller, Netherlands
Signac met Seurat in 1884 and, under his influence, started to paint using scientifically juxtaposed small dots of pure color. Although this painting depicts a solidly bourgeois family, Signac was actually an anarchist.

Birth of the Nabis
Paul Sérusier paints a small panel, *The Talisman*, under Gauguin's influence in 1888. This almost abstract arrangement of colors impresses fellow painters, including Maurice Denis and Pierre Bonnard, who form themselves into a new group—the Nabis (Hebrew for "Prophets").

1885　　**1886**　　**1887**　　**1888**　　**1889**

Van Gogh's peasants
In 1885 van Gogh paints his first major work, *The Potato Eaters*, a darkly expressive picture showing poor Dutch peasants eating their evening meal.

A Sunday Afternoon on the Island of La Grande Jatte ▷
Georges Seurat 1884–86
Art Institute of Chicago, IL
Seurat spent two years working on his most famous work, composed of tiny dots of contrasting or complementary color intended to fuse in the viewer's eye for a vibrant effect. The picture was unusual in showing people belonging to different social classes frequenting the same park on an island in the Seine.

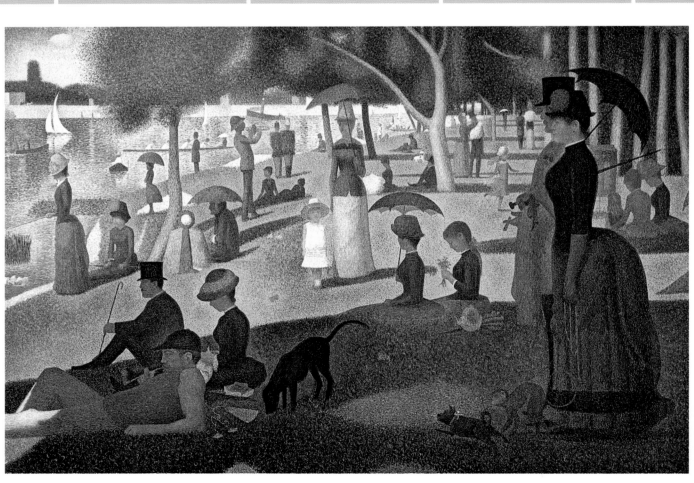

Breton Women With Umbrellas ▽
Emile Bernard 1892 *Musée d'Orsay, Paris, France*
Bernard admired what he saw as the authenticity of Pont-Aven, but he gradually moved away from realism in his depictions of its daily life, to concentrate on the abstract qualities of form and color. The meaning of this picture is obscure, but its atmosphere is poetic.

ROUSSEAU'S NAÏVE EXOTICISM

Henri Rousseau does not fit neatly into any artistic movement, but his naïve and expressive paintings were widely admired by the avant-garde artists who were his contemporaries, such as Picasso, and by later artists, including the Surrealists. He had no formal artistic training, and made his living as a toll collector, which earned him the nickname of Le Douanier ("the Customs Officer"). Many of his pictures are of exotic jungle scenes, but he probably never set foot outside France.

Surprised! **1891, National Gallery, London, UK**

1890 **1891** **1892** **1893** **1894** ▶

Inspiration from Provence
Cézanne begins work in 1890 on the first of five paintings of card players, which show Provençal workmen immersed in a card game. The models are local farmhands.

Gauguin leaves "civilization"
Gauguin leaves France for Polynesia in 1891, in search of "ecstasy, calm, and art." He settles in Tahiti, and is initially disappointed to find it tainted by European colonialism.

Toulouse-Lautrec's low-life views
In 1892 Toulouse-Lautrec begins a series of paintings giving an insider's view of Paris brothels. He produces 50 such works over the next three years.

Georges Seurat

born Paris, France, December 2, 1859; **died** Paris, March 29, 1891

Seurat's career was short but influential. His early works were monochrome drawings exploring the properties of tone, but from the early 1880s he began to deploy his researches into optical and color theory, and used his divisionist (or "pointillist") technique to paint life in the Paris suburbs. His last works depict views of the Normandy coast and scenes of urban entertainment. Seurat's ideas were taken up by his followers, who included Signac, van Rysselberghe, and Cross.

The Muses ▷
Maurice Denis 1893
Musée d'Orsay, Paris, France
Denis's picture gives the age-old subject of the Muses a modern interpretation. Its decorative nature illustrates his view that "a picture, before being a battle horse, a nude woman, or some anecdote, is essentially a flat surface covered with colors."

▽ Still Life With Plaster Cast
Paul Cézanne c.1895
Courtauld Gallery, London, UK
In Cézanne's late still life, all the objects on the studio floor and the table top appear as though tipped up against the picture plane, or viewed from different angles. This radical distortion of conventional perspective prefigures Cubism.

A Gauguin masterpiece
In 1897 Gauguin paints an enormous canvas, *Where Do We Come From? What Are We? Where Are We Going?* A meditation on the evolution of man from birth to death, it is set in Tahiti.

Paul Cézanne
born Aix-en-Provence, France, January 19, 1839;
died Aix-en-Provence, October 23, 1906

A native of Provence, Cézanne trained in Paris, where he met fellow Impressionist painters. He abandoned his early dark and violently expressive manner of painting, tried unsuccessfully to exhibit at the Salon, and showed in some of the Impressionist group shows. In the 1880s he became increasingly uneasy with Impressionism's lack of solidity and structure and began to place more emphasis on mass and construction in his work, and to interpret rather than merely record what he saw. From the mid-1880s he divided his time between Aix-en-Provence and Paris, producing a large number of landscapes depicting the great Provençal mountain, Mont Sainte-Victoire.

BIOGRAPHY

1895 **1896** **1897**

Henri de Toulouse-Lautrec
born Albi, France, November 24, 1864;
died nr. Langon, France, September 9, 1901

Aristocratic and wealthy, Lautrec inherited a genetic disorder that left him with stunted growth. He based himself in Montmartre, Paris, and enjoyed a bohemian life, frequenting nightspots such as the Moulin Rouge, cafes, and brothels. Perhaps because of his own bizarre appearance, he was sensitive to the vulnerabilities of the prostitutes and entertainers he portrayed. His work sold well, and he was commissioned to design posters for several cabarets and dance halls, but he died early from alcoholism.

BIOGRAPHY

The Female Clown Cha-U-Kao ▷
Henri de Toulouse-Lautrec 1895
Musée d'Orsay, Paris, France
Cha-U-Kao, who appeared at the Moulin Rouge, was one of Toulouse-Lautrec's favorite models. Here she is shown in a private moment backstage, fastening a yellow frill around her waist. The man reflected in the mirror could be a friend or admirer.

Seated Woman ▷
Edouard Vuillard 1901 *Private Collection*
Vuillard, who was associated with the Nabis group, always aimed to capture the essence rather than the literal appearance of a scene. His intimate interiors possess a psychological intensity.

" SUBJECTING **COLOR** AND **LINES** TO THE **EMOTION HE HAS FELT**, THE **PAINTER** WILL **DO THE WORK OF A POET** "

1899 | Paul Signac

Toulouse-Lautrec on show in London
The largest show of Toulouse-Lautrec's work in his lifetime is held in 1898 at the Goupil Gallery in London. Some critics dismiss the works as immoral, but others are enthusiastic.

▽ In the Shade
Henri-Edmond Cross 1902
Private Collection
Cross adopted and developed the divisionist style initiated by Seurat in the 1880s, taking it forward into the 20th century. His landscapes of the south of France proved inspirational for Fauvist painters, including Matisse and Derain.

1898 1899 1900 1901 1902 1903 1904

Gauguin on Hiva Oa
In 1901 Gauguin leaves Tahiti for the island of Hiva Oa in the Marquesas, hoping to find a primitive world less contaminated by Europe. He builds himself a house decorated with wooden reliefs.

A Walk on the Beach △
Theo van Rysselberghe 1901
Private Collection
The Belgian artist van Rysselberghe was bowled over when he saw Seurat's *Grande Jatte* at the eighth Impressionist exhibition in 1886, and took up painting in the Neo-Impressionist style. The dashes of paint in this beach scene successfully evoke shimmering seaside light.

Barbaric Tales ▷
Paul Gauguin 1902
Museum Folkwang, Essen, Germany
Different cultures converge in this scene of storytelling. The redheaded man has the features of Gauguin's Dutch artist friend Meyer de Haan; the Asian-looking figure in the center adopts a Buddhist pose; and the woman on the right embodies Gauguin's fascination with Polynesia.

◎ MASTERWORK

Self-Portrait With Bandaged Ear

Vincent van Gogh **1889**
Courtauld Gallery, London, UK

In this unforgettable portrait, van Gogh stares out at the viewer, revealing his soul with an almost unbearable honesty. It is a painting that presents a particularly raw and personal artistic statement.

In February 1888 van Gogh had taken the train from Paris to Arles in the south of France. He was intent on founding a utopian artists' colony there—a "studio in the south"—and was hoping that Paul Gauguin and Emile Bernard would come and join him. Gauguin arrived later that year in October, but the amicable set-up soon turned sour, and the pair quarreled. At Christmas, after a particularly vicious disagreement, van Gogh threatened Gauguin with a razor blade before cutting off part of his own ear and presenting it to one of the prostitutes in the local brothel. He was taken to hospital suffering his first serious attack of insanity, and Gauguin left Arles, never to return.

This self-portrait was one of the first works that van Gogh painted after the incident, in the hope that taking up painting again would help restore his stability. He shows himself standing in front of an easel that supports a canvas bearing some vague daubs. On the wall is a Japanese print. Van Gogh had previously explained in a letter to his brother Theo that he hoped his life in the south of France would be like a Japanese painter's, but the happiness he sought eluded him, so the print is a poignant reminder of a lost vision of paradise. Van Gogh turns his head to display his bandaged ear in a deliberate reference to his act of self-mutilation. He seems to shrink inside his heavy overcoat, and his sallow complexion and thin face shorn of its red beard make it clear that he is unwell. The coarse brushstrokes, laid on in rigid lines in some areas, add to the overall sense of unease and melancholy, creating an image of arresting power.

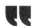

❝ AN AWFUL LOT OF PAINTERS **GO MAD**, IT'S A LIFE **WHICH MAKES YOU DISTRACTED**, TO SAY THE LEAST **❞**

1889 | Vincent van Gogh

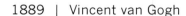

◎ Vincent van Gogh

born Zundert, Netherlands, March 30, 1853;
died Auvers-sur-Oise, France, July 29, 1890

Van Gogh worked as an art dealer and a lay preacher before deciding to become a painter of peasant life, inspired by the example of artists such as Jean-François Millet of the Barbizon school. He received little formal artistic education and was largely self-taught. In 1886 he moved to Paris, and was introduced to Impressionist artists by his art-dealer brother Theo, who sold some of their works. He began to paint in a style based on Seurat's divisionist technique and, like many contemporaries, fell in love with the bold colors and designs of Japanese prints. In 1888 he moved to Arles, where he produced some of his best-loved works, but attacks of mental illness caused him to seek periodic refuge in an asylum at nearby St.-Remy. The last months of his life were spent at Auvers-sur-Oise, where a fresh bout of depression led to his suicide at the age of 37. Van Gogh's life is exceptionally well documented through the vast number of letters he wrote to his brother.

BIOGRAPHY

SYMBOLISM

▷ **The Poor Fisherman**
Pierre Puvis de Chavannes
1881 *Musée d'Orsay,*
Paris, France
Puvis de Chavannes evokes a
typically Symbolist mood of
desolation by placing his narrative
in a bleak landscape setting. The
destitute widower trying to support
his motherless children is a
Christlike figure, the mast of his
boat subtly recalling the Cross.

Toward the end of the 19th century Symbolist writers and artists reacted against the materialism and rationalism of the modern world, and the way these were reflected in art, by producing works that prioritized imagination and the emotions. They drew upon a complicated mix of mystical thought, the occult, and psychology, seeking to make invisible worlds visible. Despite the name of their movement, they did not use a ready-made set of symbols, preferring to communicate ideas through subtle suggestion. Their art expressed ecstasy, ambiguity, melancholy, mystification, and revelation. Common themes included sleep, dreams, silence, stillness, and the troubling power of female sexuality. Symbolist art had its roots in France in the work of such painters as Gustave Moreau and Pierre Puvis de Chavannes, but it found followers throughout Europe, especially in Britain, Belgium, Austria, and Scandinavia.

◎ CONTEXT

The age of Art Nouveau

In the last two decades of the 19th century the very prosperity that Symbolist artists and writers found so distasteful encouraged architecture and the decorative arts to flourish, as well as the development of a radical new design style. Art Nouveau, as it was known in France, signaled a determination to break with the past in favor of what was modern. It was characterized by sinuous, asymmetrical lines based on organic shapes, and drew upon sources including William Morris's Arts and Crafts products and the art and artifacts of Japan. A milestone in its development was the opening in 1895 of Siegfried Bing's Parisian store and showroom of contemporary design, Maison de l'Art Nouveau ("House of New Art"), where shoppers could see tasteful interiors devised by leading designers.

Art Nouveau architecture
This elaborate entrance was designed in 1901 for a residence at 29 Avenue Rapp in Paris. With its curving lines, plantlike tendrils, and female figures, it epitomizes the flamboyant sensuality of Art Nouveau.

Pictorial posters produced by graphic artists including Alphonse Mucha and Toulouse-Lautrec also furthered the craze for the new style, which soon spread beyond the capital to other cities in France and the rest of Europe.

Art Nouveau was concerned with the world of appearances, but even if they adopted some of its aesthetic features, Symbolist artists wanted to look beyond the visible and penetrate the depths of the human psyche. It is no coincidence that psychiatry and psychoanalysis were developing at precisely the same time. In his Paris clinic the famous French neurologist Jean-Martin Charcot was exploring hypnosis as a way of treating patients. His pupils included the Viennese analyst Sigmund Freud, whose probing of the unconscious and the meaning of dreams resonates with Symbolist concerns. There was also a general reawakening of interest in spirituality, and both conventional Catholicism and unconventional esoteric cults flourished during this period. Rosicrucianism, said to have originated in the writings of a 15th-century visionary, was revived in France by occultists including Sâr Joséphin Péladan, who even set up a new exhibiting society, the Salon de la Rose+Croix. Music and literature were also vehicles for this fresh inquiry into the soul, with its emphasis on subtlety, mood, and imagination conveyed through experimental forms, repeated sounds, and cadences. For those brave enough to experiment with innovative ways of living, there were some new trends that flew in the face of conservative society, such as vegetarianism, meditation, and naturism.

 NOTHING IN ART IS DONE **THROUGH THE WILL ALONE**, EVERYTHING IS DONE BY **DOCILE SUBMISSION** TO THE **ARRIVAL OF THE SUBCONSCIOUS** 🙿

1898 | Odilon Redon

◎ BEGINNINGS
IMAGINATIVE VISIONS

Symbolism reached its peak in the last two decades of the 19th century (its aesthetic program was expressed in a manifesto in 1886), but its origins can be traced back to the paintings that Gustave Moreau and Pierre Puvis de Chavannes were producing in France in the 1860s and 1870s. Both artists were drawn to the Romantic subjects that had been painted a generation earlier—to work that prioritized emotion and allusion, and favored subjectivity over objectivity. What they and other Symbolist artists shared was a mood rather than a style. While Moreau created theatrical compositions with richly decorative surfaces and a multiplicity of detail, Puvis de Chavannes produced works with monumental simplified forms and muted colors. Odilon Redon, another of the early Symbolists, worked almost exclusively in black and white until he was in his fifties, creating a repertoire of weird subjects influenced by the writings of Edgar Allan Poe.

◎ Gustave Moreau

born Paris, France, April 6, 1826;
died Paris, France, April 18, 1898

Gustave Moreau was one of the founding fathers of Symbolist painting in France. He came into his own as a painter after a two-year stay in Italy from 1857, when he studied Renaissance masters including Mantegna and Leonardo and became convinced of the spiritual value of art. His first major work, *Oedipus and the Sphinx* (1864), established his lasting preoccupations with the opposition between good and evil, male and female, and physicality and spirituality. His favorite subjects were ancient civilizations or mythological themes, which he portrayed in densely worked, encrusted canvases. In the 1870s Moreau's style changed to become softer and more full of contrast between light and shade, often featuring small figures in elaborate settings. In 1892 he became a professor at the Ecole des Beaux-Arts, where his pupils included Georges Rouault and Henri Matisse.

BIOGRAPHY

◎ TURNING POINT

The Apparition
Gustave Moreau **1876** *Fogg Art Museum, Harvard University, Cambridge, MA*

Gustave Moreau's picture portrays the young Judean princess Salome, who bewitched her stepfather Herod with her dancing and demanded the head of John the Baptist as a reward. The saint's haloed head appears before her in an apparition, after the act of decapitation, while the executioner with his hands on his sword stands impassively in the background. J.-K. Huysmans wrote a long commentary on the painting in his novel *A Rebours* ("Against Nature").

◉ ARTISTIC INFLUENCES

Symbolist painters were stirred by imaginative tales of sex, death, violence, and the supernatural, and the theme of the femme fatale was especially popular. Some artists drew their subjects from poems or novels, such as Flaubert's *Salammbô*, which Moreau used for *The Apparition*.

Macabre imagery is a feature of many Symbolist paintings. Moreau first saw the bronze statue of Perseus by the Italian Renaissance sculptor Benvenuto Cellini when he was 15, and he would have viewed it again when he spent two years in Italy in 1857–59.

Medusa, detail from *Perseus Beheading Medusa*, 1545–54, by Cellini is an image of startling ghoulishness. *Loggia dei Lanzi, Florence, Italy*

Orientalist subjects by artists who traveled to the Middle East and North Africa from the 1830s played their part in shaping Symbolism. Delacroix painted a number of Arab subjects on his return from Algeria and Morocco.

The sultan, detail from Delacroix's *Mulet Abd-ar-Rhaman, the Sultan of Morocco*, 1845. *Musée des Augustins, Toulouse, France*

Female sensuality is evident in Moreau's work. He was familiar with the compositions of Théodore Chassériau, whose *Susanna and the Elders* shows a woman who unwittingly inflames the lust of two older men.

Susanna and the Elders, detail, 1856 by Chassériau depicts a consequence of female allure. *Louvre, Paris, France*

Elaborate ornament is a hallmark of paintings by Moreau and other Symbolist artists. The decoration of Herod's palace, with its unusual capitals, is directly inspired by the columns inside the Alhambra Palace in Granada.

Exotic decoration seen on the columns of the Alhambra Palace, Granada, provided inspiration for Moreau's work.

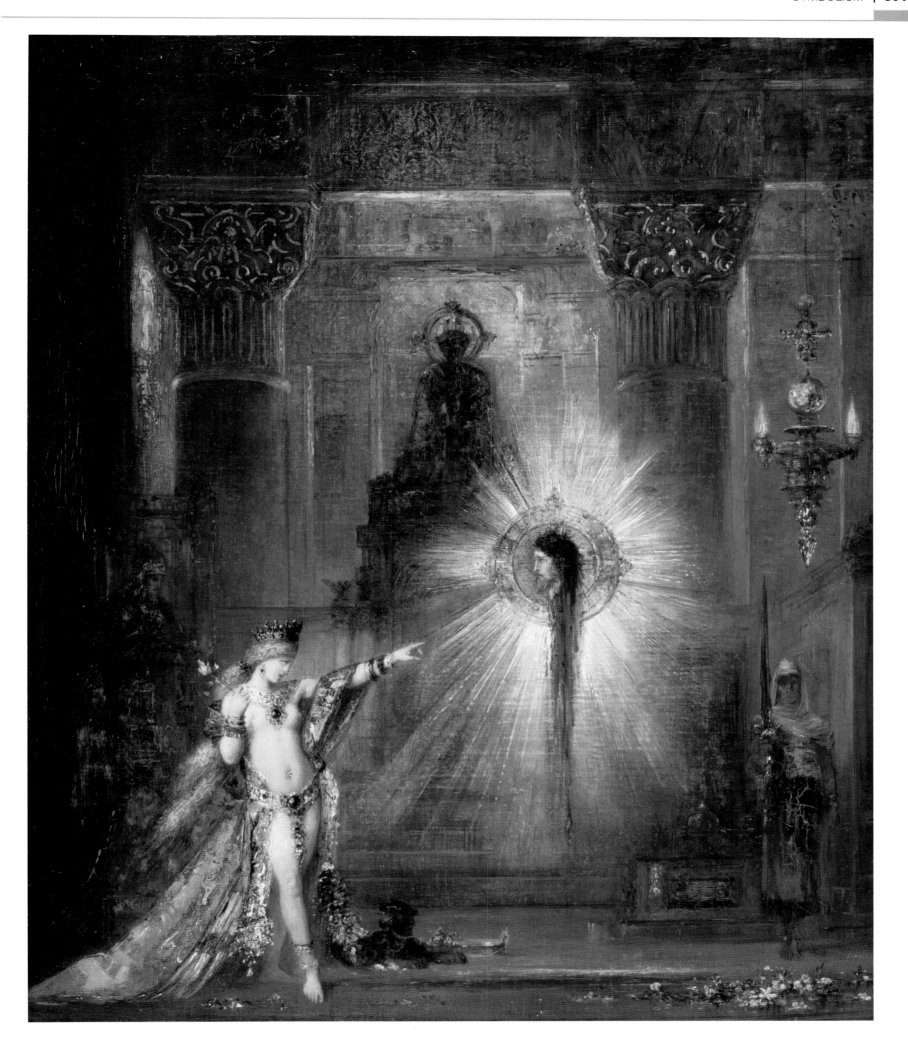

◎ TIMELINE

Symbolism really emerged as a coherent art movement around 1885, though its origins can be traced back a decade or so earlier. In the later 1880s and 1890s, Symbolist preoccupations could also be seen in Post-Impressionist works by artists such as Gauguin and Emile Bernard. Recognizably Symbolist works were being produced well into the 20th century, and by that time Symbolist ideas had spread well beyond Paris to Brussels, London, Glasgow, Vienna, Oslo, and St. Petersburg.

Redon joins the Symbolists
Odilon Redon moves to Paris in 1876 to pursue a career as an artist. He soon becomes one of the most important members of the Symbolist avant-garde.

Sculpting the emotions
In 1875 Auguste Rodin produces his *Age of Bronze*, a sculpture that embodies feeling and emotion purely through the pose of the body rather than relying on conventional props used in allegorical works.

Desire ▷
Max Klinger 1878
Private Collection
The German artist Max Klinger, who admired the work of Arnold Böcklin, is best known for his series of prints. His *Glove* cycle, for which this is a preparatory drawing, presents an odd combination of reality and dream, echoing the contemporary beginnings of psychoanalysis.

▽ **The Prodigal Son**
Pierre Puvis de Chavannes 1879
National Gallery of Art, Washington, DC
Puvis's shivering figure in a bleak landscape reflects the artist's melancholy character, one that was shared by many Symbolists. He confessed that he preferred "rather mournful aspects to all others, low skies, solitary plains, discreet in hue."

1875 **1876** **1877** **1878** **1879** **1880**

Praise for Moreau
Gustave Moreau is discovered at the 1880 Salon by J.-K. Huysmans, who praises him as "unique, an extraordinary artist." He later waxes lyrical about Moreau's work in his novel *A Rebours*.

❝ FOR WE **WISH FOR THE NUANCE STILL, NOT COLOR, ONLY THE NUANCE!** ❞

1874 | Paul Verlaine
French Symbolist poet

◁ **The Island of the Dead**
Arnold Böcklin 1880
Kunstmuseum, Basle, Switzerland
This is the first of Böcklin's many versions of this picture. All of them show a boat bearing a mysterious white figure and a coffin approaching a rocky island, commonly interpreted as a cemetery.

AGAINST NATURE

CONTEXT

Joris-Karl Huysmans's 1884 novel *A Rebours* ("Against Nature") sums up the atmosphere of Symbolism. Its hero is Des Esseintes, a disillusioned aesthete who withdraws into a private world where he celebrates all that is artificial and unnatural, surrounding himself with works by Gustave Moreau and Odilon Redon. The novel helped to form the popular perception of Symbolism.

Joris-Karl Huysmans

Belgian avant-garde
The avant-garde exhibiting society Les XX (Les Vingt) is formed in Brussels in 1883. Over the next ten years it promotes the work of avant-garde artists, including Symbolists Fernand Khnopff and James Ensor.

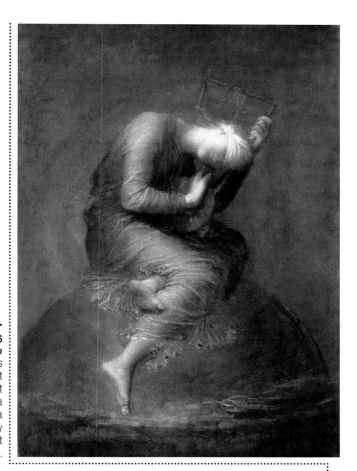

Hope ▷
George Frederic Watts 1886
Private Collection
The British painter GF Watts's declaration "I paint ideas, not things" chimes with Symbolist thought. His depiction of Hope as a blindfolded figure plucking at a single string on a broken lyre may be deliberately ambiguous, but it has inspired many people.

1881 **1882** **1883** **1884** **1885** **1886** ▶

Redon's monsters
Odilon Redon produces a startling black-and-white Symbolist drawing, *The Smiling Spider*, in 1881. A nightmarish vision of a giant arachnid, it is one of many similar drawings he created showing hybrid monsters.

Symbolist manifesto
The poet Jean Moréas publishes a Symbolist manifesto in the newspaper *Le Figaro* on September 18, 1886. It declares that the essence of hidden or true reality can only be communicated through art or poetry.

BIOGRAPHY

Arnold Böcklin

born Basle, Switzerland, October 19, 1827;
died San Domenico, Italy, January 16, 1901

Böcklin was one of the most important artists in the German-speaking world in the 1880s and 1890s, although he spent much of his career in Italy. The country awakened in him a love of Renaissance art, and he painted several works on a mythological theme. His style changed in the 1880s, becoming darker and infused with mystical content as he became aware of Symbolism. A request from a female patron for a picture to induce dreams resulted in his masterpiece, *The Isle of the Dead* (1880), which drew upon memories of visiting the Italian island of Ischia.

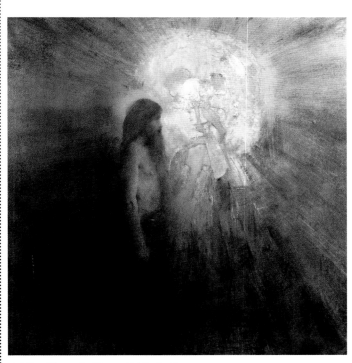

△ **The Temptation of St. Anthony**
Fernand Khnopff 1883
Private Collection
Gustave Flaubert's novel *The Temptation of St. Anthony* (1874) helped popularize the subject of the saint tormented by lust. Khnopff's picture, with its disembodied head, clearly recalls Moreau's *Apparition*.

Punishment of Lust ▽
Giovanni Segantini 1891
Walker Art Gallery, Liverpool, UK
This painting belongs to a series on the theme of bad mothers, created by the Italian artist Segantini. The painter condemned those women who refused the responsibilities of motherhood through abortion or neglect; the souls of two of them are shown floating against a snowy background resembling the Alps, where Segantini spent much of his life.

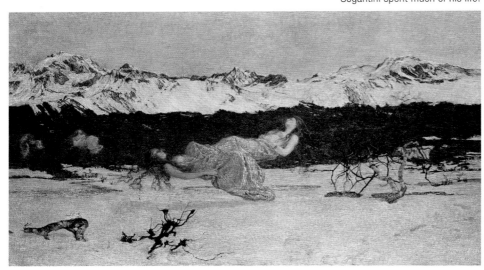

SYMBOLIST SCULPTURE

While avant-garde artists opened up new possibilities for painting at the end of the 19th century, Rodin was doing the same for sculpture. He struggled to establish himself in the face of hostility, but works such as *The Burghers of Calais* (1884–89), *The Kiss* (1889), and *The Thinker* (1902), successfully convey ideas and emotions through poses and bold composition.

The Kiss, 1889, Auguste Rodin

Salon de la Rose+Croix
In August 1891, Sâr Joséphin Péladan, a Rosicrucian and art critic who claims descent from Babylonian kings, founds the Salon de la Rose+Croix in Paris for artists who share his ideals.

Defining Symbolism
In his 1892 essay *The Symbolists*, the poet and critic Albert Aurier defines Symbolist art as "the painting of ideas," stating that it is essentially decorative.

1887 **1888** **1889** **1890** **1891** **1892**

Gauguin's influence
Gauguin's *Vision of the Sermon* (*see pp.290–91*), painted in 1888, is a milestone in the development of an art that communicates a sense of mystery rather than seeking to transcribe reality.

Ferdinand Hodler

born Berne, Switzerland, March 14, 1853;
died Geneva, Switzerland, May 19, 1918

A Swiss painter from a poor family, Hodler began by depicting artisans at work and light-filled landscapes, but around 1890 he turned his back on naturalism. At that time he came into contact with the French Symbolists, and he showed at the first Salon de la Rose+Croix in Paris in 1892. Under the influence of Symbolism, Hodler began to focus on representing states of mind, and themes such as sleep, dreams, death, and eroticism, although he also received a number of commissions for history paintings. His mature canvases are characterized by simplified flat figures arranged in rhythmic repetitive patterns.

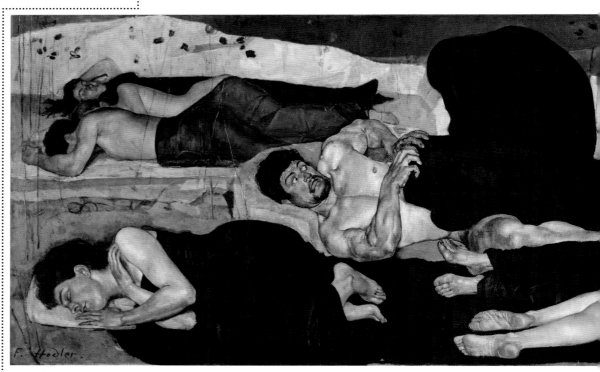

△ Night
Ferdinand Hodler 1889–90
Berne Kunstmuseum, Switzerland
Hodler portrays himself as having been rudely awakened by the figure of death, while all around him lie the entwined bodies of sleeping men and women. He intended the work to have a universal, symbolic meaning: it does not represent a specific moment, but evokes the essence of night and death.

▽ Orpheus
Jean Delville 1893 *Private Collection*
The Belgian Symbolist Jean Delville embraced
Rosicrucianism and Theosophy, producing
works inspired by Gustave Moreau. His *Orpheus*
is a disembodied head modeled on his wife,
resting on his lyre and lapped by waves.

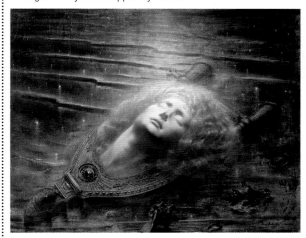

◁ Madonna
Edvard Munch 1894–95
*Munch Museet,
Oslo, Norway*
Munch's ambivalent attitude
toward women comes
across in this picture, which
presents the Madonna as
both sacred and sensual.
Munch worked in Oslo and
Berlin, but his time in Paris
exposed him to Symbolism
and Post-Impressionism.
His obsession with female
sexuality was shared by
many Symbolist artists.

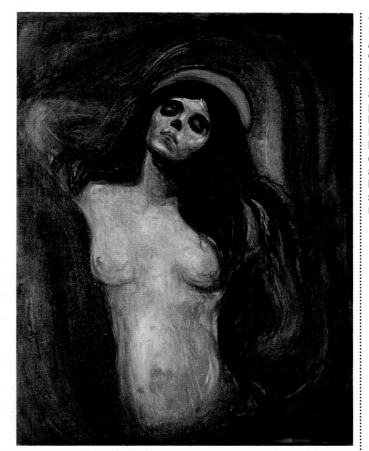

The lone genius
Rodin completes his
monument to Balzac in
1898. In keeping with
the Symbolist worship
of creative genius, it
represents the French
author as an isolated
figure, defiant against
the world—like
Rodin himself.

1893	**1894**	**1895**	**1896**	**1897**	**1898**

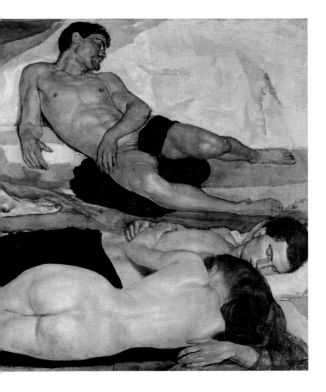

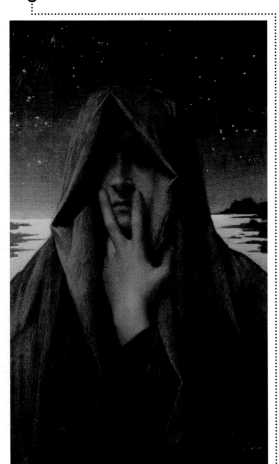

Viennese Secession
In Vienna in 1897 a group
of 19 artists, including Gustav
Klimt, break away from existing
artists' societies to form their
own exhibiting group, the
Secession, aiming to revitalize
Austrian art.

> ❝ **ARTIST**, YOU ARE **A
> PRIEST**: ART IS **THE
> GRAND MYSTERY** ❞

1897 | Sâr Joséphin Péladan
Rosicrucian "high priest" and art critic

◁ Silence
Lucien Levy-Dhurmer 1895
Private Collection
Levy-Dhurmer's woman presents an enigma.
It is hard to read her expression, interpret her
mysterious gesture, or divine the reason
behind her melancholy mood. Stripped of
context, the work is purely Symbolist in mood.

▽ Pallas Athena
Franz von St.uck 1898
Private Collection
Like Arnold Böcklin, the German artist Franz von Stuck took his inspiration mainly from mythology, giving his subjects a distinctively Symbolist twist. His *Pallas Athena* is bold and alluring.

▽ Murdered Dmitry Tsarevitch
Mikhail Nesterov 1898–99
Russian Museum, St. Petersburg, Russia
The youngest son of Ivan the Terrible, who died in mysterious circumstances, resembles a martyr with his head framed by a halo. A member of the World of Art group, Nesterov was also a devout believer in Russian Orthodox Christianity.

The Kiss ▷
Gustav Klimt 1907
Österreichischer Galerie Belvedere, Vienna, Austria
Vienna was the birthplace of Sigmund Freud, and a feeling of psychological intensity—as well as an obsession with sex and death—pervades the work of Gustav Klimt and other artists of the Vienna Secession. The robes of the couple locked in an intimate embrace are decorated with patterns influenced by Art Nouveau and Byzantine designs.

Klimt and Schiele
In 1907, Gustav Klimt becomes mentor to the 17-year-old Egon Schiele, introducing him to the work of Munch and other European avant-garde artists and freeing him to explore eroticism and death in his own work.

1898 **1900** **1902** **1904** **1906**

Symbolism in Russia
In 1898 the World of Art group is formed in St. Petersburg, aiming to promote artistic individualism and strongly influenced by Symbolism and Art Nouveau. Many adherents, including Alexandre Benois and Léon Bakst, become stage designers.

Lake Keitele ▷
Akseli Gallen-Kallela 1905
National Gallery, London, UK
The Finnish artist Gallen-Kallela studied in Paris, and on his return to his native country produced a number of Symbolist-influenced paintings illustrating Finland's mythical origins. His evocation of a Finnish lake presents a vast expanse of melancholy emptiness typical of many Symbolist landscapes, and its simplified forms reveal the influence of Gauguin.

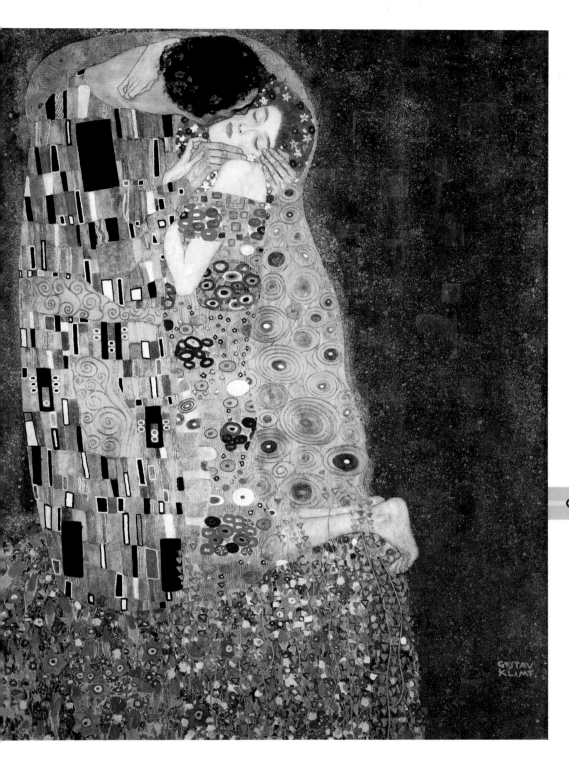

Gustav Klimt

born Baumgarten, Austria, July 14, 1862;
died Vienna, Austria, February 6, 1918

Klimt's early academic style won him success and official commissions, but in the 1890s he was drawn to the avant-garde art that was developing elsewhere in Europe, and began to shape his own eclectic style, fusing Symbolist subject matter with elements of Impressionism and Art Nouveau. A desire to create a new type of art put him at the forefront of the artists who formed the breakaway Secession group in 1897. Klimt was a great womanizer, and often depicted erotic subjects, his portrayals of nudity leading to accusations of pornography.

Symbolist cycle
In 1908 Edvard Munch suffers a mental collapse, having produced a large number of paintings over many years as part of his *Frieze of Life* cycle, which revolves around typically Symbolist subjects: death, sex, and anguish.

1908 **1910**

△ Ophelia Among the Flowers
Odilon Redon 1905–08 *Tate Modern, London, UK*
Redon shows Shakespeare's doomed heroine in a richly colored fantasy world, surrounded by the flowers she has been picking before she drowns. Redon wrote: "I love nature in all her forms...the humble flower, tree, ground, and rocks, up to the majestic peaks of mountains...I also shiver deeply at the mystery of solitude."

❝❝ MEN DREAM, AND THEIR DREAMS OPEN UP VISTAS OF A NEW WORLD TO THEM ❞❞

1875 | Stanislaw Przybyszewski
Polish novelist, writer, and dramatist

Odilon Redon

born Bordeaux, France, April 20, 1840;
died Paris, France, July 6, 1916

Redon's first successful works were black-and-white charcoal drawings, which evoke a mysterious and melancholic fantasy world peopled by bizarre hybrid creatures. In the 1880s and 1890s he brought his fantastic compositions to a wider audience through a series of lithographs. By 1886 he was being cited as a major Symbolist artist. He turned to color in about 1890, producing vibrant dreamscapes in oil and pastel.

◎ MASTERWORK

I Lock My Door Upon Myself

Fernand Khnopff **1891**
Neue Pinakothek, Munich, Germany

Fernand Khnopff was in contact with the English art world from the mid-1880s, developing a close friendship with the Pre-Raphaelite artist Edward Burne-Jones. He was particularly struck by a poem "Who Shall Deliver Me?" (1876) by Christina Rossetti, sister of the painter Dante Gabriel Rossetti—also a Pre-Raphaelite—and derived the title of this painting from its third verse:

I lock my door upon myself,
And bar them out; but who shall wall
Self from myself, most loathed of all?

Khnopff's picture expresses the intensely melancholy flavor of Rossetti's poem—the musings of a woman wrapped up in her own dreams. With her abundant red hair and strong features, the woman in the painting resembles a Pre-Raphaelite "stunner." The space she occupies seems almost abstract, giving only tantalizing glimpses of a world beyond. The picture is enigmatic and eludes precise interpretation, though a number of symbolic objects may offer clues as to the woman's circumstances and state of mind. A sculpture of Hypnos, the Greek god of sleep, sits on a shelf. Hypnos was an important figure to Khnopff—he installed a bust of the god on an altar in his home, declaring that "Sleep was the most perfect thing in life." Sleep, or oblivion, is also suggested by the poppy beside the statue. White lilies are traditionally linked with purity, but the three in the foreground are red and fading, adding to the gloomy atmosphere. An arrow—generally associated with pain or love—lies in front of the woman, pointing toward her. The dark cloth calls to mind a coffin covering. Isolation and introspection are the prevailing themes, with hypnotism and the occult suggested by the bust of Hypnos and the golden ornament dangling from a chain in front of the woman. Spiritualism and the use of mediums to contact the dead while in a hypnotic trance were popular in the 1890s, and Khnopff may be alluding to the practice.

> **ART** IS IN ESSENCE **AN IDEALISM**: THE **DEEPEST DREAMS** RECEIVE THE **MOST PERSONAL INTERPRETATION**

Fernand Khnopff

Fernand Khnopff

born Grembergen, Belgium, September 12, 1858; **died** Brussels, Belgium, November 12, 1921

Fernand Khnopff was at the forefront of the Symbolist movement in Belgium, and was admired internationally by artists such as Edvard Munch and Gustav Klimt. In his early twenties he went to Paris, where he discovered the work of Gustave Moreau and Edward Burne-Jones. This had a profound influence on his art, leading him to turn toward otherworldly subjects, and to paint pale, soulful-looking women. Khnopff's pictures are permeated by the moods of silence, isolation, and reverie. He was obsessed with the beauty of his sister Marguerite, and his frequent practice of using her as a model adds a sinister incestuous undertone to some of his work. Khnopff's art was widely admired by fellow European artists, especially those in Belgium, England, and Austria.

BIOGRAPHY

THE
MODERN AGE

312 EXPRESSIONISM

322 CUBISM

332 BIRTH OF ABSTRACT ART

340 DADA AND SURREALISM

350 ABSTRACT EXPRESSIONISM

358 POP AND OP ART

366 RECENT ABSTRACTION

374 THE FIGURATIVE TRADITION

Since the beginning of the 20th century, art has changed more radically than at any other time. A succession of innovative styles and movements not only overthrew the predominant idea that painting and sculpture were about representing natural appearances, but also questioned the social role of art, and even its validity. The term "modernism" is sometimes used to characterize the beliefs and concepts underlying these developments, although they are so varied that it is hard to find a consistent ideology: the decade from 1905 to 1915 alone witnessed the birth of Fauvism, Cubism, abstract art, and Dada. Some movements, like abstract art, still flourish today, while others have become part of history. And all through the cultural upheaval of the modern age, figurative painting has continued to develop in the rich tradition that can be traced back to the earliest human cultures.

EXPRESSIONISM

▷ **The Port of Collioure**
André Derain 1905
Musée National d'Art Moderne, Paris, France
Two of the original Fauve artists, André Derain and Henri Matisse, spent the summer of 1905 painting together in Collioure, a small harbor on the Mediterranean coast. The fresh, bold work that they produced there set the movement's tone.

While Impressionism was essentially about artists interpreting the world through their own eyes, in Expressionism they communicated intense feeling through their work. To do this, they made use of vivid colors—often used directly from the tube rather than mixed—quirky distortion, and vigorous brushstrokes. In the years before World War I, the world was changing quickly—populations migrated to industrialized cities, wars were being fought, and new technologies impacted every area of life. Feeling increasingly alienated, some artists moved away from realistic representations of what they saw and looked to their own personalities for inspiration. The Fauves, who were among the first Expressionists, were a small, distinct unit led by French painters Henri Matisse and André Derain. The wider Expressionist movement was a more diffuse concept that, while influenced by Fauvism, grew up mainly in Germany—its main figures included Ernst Ludwig Kirchner, Franz Marc, Paul Klee, and Erich Heckel, but its reach extended to Russian-born Wassily Kandinsky and Marc Chagall, and Lithuanian-born Chaim Soutine, among others.

◎ CONTEXT

A world of change

Radical technology was sweeping the world toward the end of the 19th century, when many earlier inventions were becoming increasingly common and accessible. Railways began to cross Europe, North America, and further afield, electricity was being installed in homes, and people were beginning to be aware of the telephone, at a time when its predecessor—the telegraph—still seemed relatively new.

These breakthroughs encouraged people to share ideas, information, and experiences, but they also contributed to a general impression of rapid, uncontrollable change. Even if newer discoveries—such as the automobile, gramophone, radio transmission, moving pictures, powered flight, and radioactivity—did not impact on most people's daily lives, they provided a glimpse of the exciting, but also quite frightening, future.

This was also a time of widespread political change and instability around the world. In Africa, wars were being waged to gain land and natural resources, Greece and Turkey fought each other ferociously, and the US was battling for power in Cuba, Puerto Rico, and the Philippines. In Russia, thousands of workers went on strike, launching their first revolution against the Tsar and the ruling class.

Even countries that were not at war, or under threat, were dealing with enormous social change—education was available to many people who had never had access to learning, the class system was starting to break down, and women were beginning not only to seek a life outside the home, but to campaign for the vote so they could play an equal part in society.

Painting, like all forms of art, often responds to and reflects upheaval. The early 20th century produced an unprecedented number and variety of revolutionary artistic theories, personalities, techniques, and movements. The basic philosophy behind Expressionism was particularly enduring—its stamp can be seen in the work of some of the early abstract painters, several Surrealists, and virtually the entire Abstract Expressionist movement.

KEY EVENTS

◎ Waves of progress and uprising

▷ **1900** Gare d'Orsay railway station—the world's first electric urban rail terminal—opens in Paris to allow access to the 1900 World's Fair.

▷ **1901** The first transatlantic radio signal is transmitted from Cornwall in England to Signal Hill, Newfoundland, Canada, paving the way for a convenient form of long-distance communication.

▷ **1903** On a beach in Kitty Hawk, NC, Orville and Wilbur Wright fly a powered airplane for the first time.

▷ **1904** Construction begins on the Panama Canal, which will connect the Atlantic and Pacific oceans and dramatically reduce international travel times.

▷ **1905** Russian workers launch a revolution that eventually leads to Communism and the overturn of the old order in Eastern Europe.

▷ **1907** Color photography is invented by Auguste and Louis Lumiére.

▷ **1910** The periodical *Der Sturm* (*The Assault*) is founded in Berlin. A major voice in Expressionist art, it is often associated with coining the movement's name.

" WE WERE ALWAYS **INTOXICATED WITH COLOR**...AND WITH THE **SUN** THAT MAKES **COLORS LIVE** "

André Derain

Technological advances
At the turn of the 20th century, the Parisian cityscape reflected huge advances in technology, such as this electric train built for the 1900 World's Fair.

◎ BEGINNINGS
MASTERS OF COLOR

Toward the end of the 19th century, a number of artists were moving away from traditional naturalism in order to achieve the effects they wanted. In much of his later work, Vincent van Gogh communicated his inner turmoil using pure, bright colors and dramatic, almost violent, brushstrokes. In the same way, Paul Cézanne interpreted traditional still-life subjects in rich hues and textured paint, and Paul Gauguin portrayed exotic peoples and landscapes using tropical hues in solid blocks.

But true Modernism in art is usually dated from the 1905 Salon d'Automne in Paris, where a few young painters exhibited even bolder, brighter works. The art critic Louis Vauxelles noticed them displayed near a traditional sculpture, and commented that it was like seeing a Donatello *parmi les fauves* ("among the wild beasts"). Although Fauvism was short-lived (lasting only two or three years at full power), it had a huge influence on the Expressionist movement and beyond.

 MY CHOICE OF **COLORS** DOES NOT REST ON ANY **SCIENTIFIC THEORY** —IT IS BASED ON **OBSERVATION**, ON **SENSITIVITY**, AND ON **FELT EXPERIENCE** 🙶

1908 | Henri Matisse

◉ ARTISTIC INFLUENCES

Fauve and Expressionist artists, including Matisse, absorbed influences from a wide range of places and eras. Art and design from other cultures helped to inspire their love of rich color and pared-down shapes, and the work of earlier artists helped them to develop new ways of seeing. In painting, as in all disciplines, their teachers passed on not only skills, but also ideas, values, and enthusiasms.

Orientalism inspired the Fauves and Expressionists, becoming popular in the late 19th century as part of the Aesthetic Movement. With its obsession for all things Japanese—shapes, colors, subjects—this craze featured strongly across the worlds of art and fashion.

19th-century Japanese fan with floral motifs, adorned with Expressionist-like blocks of strong color.

Gustave Moreau, the French Symbolist, influenced several Fauve artists, including Matisse. Moreau used paint in a fluid, sensual way that inspired his students. But his biggest influence was ideological, and he encouraged Matisse to "simplify painting."

The Peacock Complaining to Juno, 1881, reveals Moreau's sensuous style. *Musée National Gustave Moreau, Paris, France*

John Peter Russell, the Australian Impressionist, introduced Matisse to the work of Vincent van Gogh. As a result of Russell's influence, Matisse changed his style completely, and later in his life revealed that Russell "explained color theory to me."

Mrs. Russell Amongst the Flowers at Belle Isle, 1927, is one of Russell's late works that illustrates his use of color. *Musée Rodin, Paris, France*

Matisse's mother worked in the family shop, which sold house paint. Matisse also saw his mother painting porcelain and making hats, so he was involved with color from an early age. When he began to paint, she urged him to express what he felt and not to follow rules.

Anna Heloise, Henri Matisse's mother, was adored by her son. Matisse always claimed: "She loved everything I did."

◎ TURNING POINT

Luxe, Calme, et Volupté

Henri Matisse **1904** *Musée National d'Art Moderne, Paris*

During the summer of 1904, Matisse went to stay with his friend, the painter Paul Signac, on the French Riviera. It was there that he produced *Luxe, Calme, et Volupté*, ("*Luxury, Calm, and Pleasure*"), a picture that was highly influenced by Signac's pointillism. Although Matisse soon discarded the style, it was with this painting that he began to explore the pure, intense color palette that came to define his work and influence so many other artists and movements. The title comes from Charles Baudelaire's poem "Invitation to a Voyage." In it, Baudelaire describes an imaginary haven where "all is order and beauty, luxury, calm, and pleasure."

◎ Henri Matisse

born Le Cateau-Cambrésis, France, December 31, 1869;
died Nice, France, November 3, 1954

BIOGRAPHY

Henri Matisse was the son of a merchant. He became a lawyer to please his parents, but took drawing classes in his own time. At 21, while he recovered from appendicitis, his mother gave him a set of paints to keep him amused—with these he discovered what he later called "a kind of paradise." He gave up law to study art in Paris and went on to become one of the most influential painters of the 20th century, as well as a brilliant theater designer and illustrator.

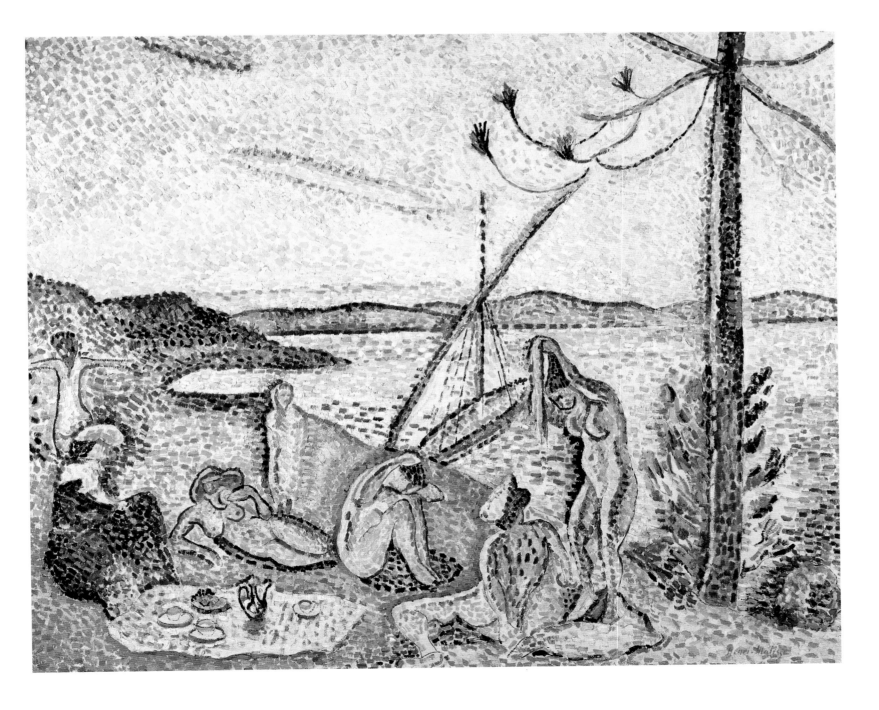

◎ TIMELINE

In 1905, the same year that Fauvism was born, a group of artists including Erich Heckel and Ernst Ludwig Kirchner launched the first German Expressionist group, Die Brücke (The Bridge). A few years later, in 1911, a second German association, Der Blaue Reiter (The Blue Rider) was established by a group of artists including Wassily Kandinsky and Franz Marc. These artists all had very individual styles, and some came to be linked with other movements—Kandinsky and Paul Klee, for example, were also leading abstract painters.

◎ Wassily Kandinsky

born Moscow, Russia, December 4, 1866;
died Neuilly-sur-Seine, France, December 13, 1944

A Russian-born painter, printmaker, designer, teacher, and writer, Wassily Kandinsky was one of the most important figures in Modernism. While teaching law as a young man, he was so moved by an exhibition of French Impressionists that he took up painting himself, working first in an Expressionist style before becoming an early abstract artist. From 1922 to 1933, he taught at the Bauhaus school of design in Germany. In 1934, he settled in the Paris suburb of Neuilly-sur-Seine, where he lived until his death.

Vienna Secession
Formed in 1897, a group of Austrian artists known as the Vienna Succession was at its peak by 1900. The work of some of its members—like Post-Impressionist painter Gustav Klimt—portrayed turbulent emotion in a style that looked forward to Expressionism.

Death of van Gogh
On July 29, 1890, Vincent van Gogh dies near Paris. Although he was virtually unknown in his lifetime, his work had a major influence on the Fauves and Expressionism in general.

Art Nouveau
Also flourishing at the turn of the century is Art Nouveau, a decorative style based on sinuous plant and floral forms.

◁ Murnau Street With Women
Wassily Kandinsky 1909
Private Collection
From 1908 to 1914, Kandinsky spent holidays in the town of Murnau in the Bavarian Alps, painting its streets and its people in exuberant Expressionist manner. Even then, his geometric forms and blocks of color hint at a developing abstract style.

1890 **1895** **1900** **1905** **1910**

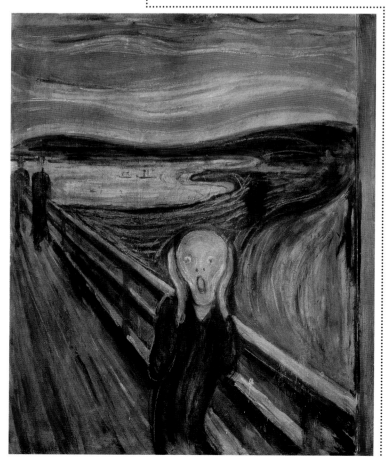

Horse in a Landscape ▷
Franz Marc 1910
Museum Folkwang, Essen, Germany
Marc loved to paint animals, believing them to be supremely beautiful and, in some ways, superior to humans. In his work, he used a very personal color symbolism—blue was male and spiritual, yellow was female and gentle, and red suggested violence, fear, or danger.

◁ The Scream
Edvard Munch 1893
Munch Museet, Oslo, Norway
Many years prior to the recognition of Expressionism as a movement in its own right, the Norwegian painter Edvard Munch produced one of the most famous images in art (Munch made four versions). Its vibrant colors and distorted shapes epitomized the Expressionist spirit and went on to influence many 20th-century artists.

 NATURE IS NOT ONLY ALL THAT IS **VISIBLE TO THE EYE**...IT ALSO INCLUDES THE **INNER PICTURES** OF THE **SOUL** 〝〝

Edvard Munch

Arnold Schoenberg ▽
Egon Schiele 1917
Private Collection
In his portrait of the avant-garde composer Arnold Schoenberg, the Austrian artist Egon Schiele pays homage to a fellow Expressionist. In addition to music, Schoenberg produced accomplished paintings, drawings, and poems.

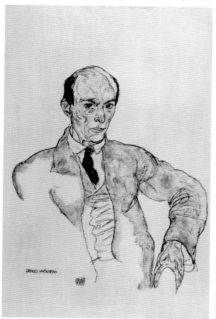

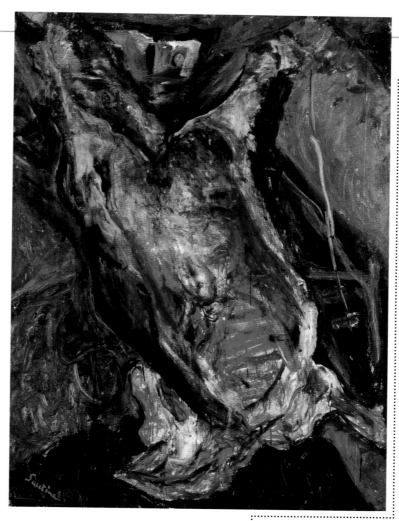

◁ Carcass of Beef
Chaim Soutine 1925
Albright-Knox Art Gallery, Buffalo, NY
Lithuanian-born, Soutine moved to France in 1913, and with his friend Marc Chagall became a leading Expressionist. Soutine was inspired by great artists of the past, particularly Rembrandt, whose *Flayed Ox* (1655), depicting an animal carcass, particularly fascinated him. For his own painting, Soutine moved a real side of beef into his studio—the neighbors were so appalled by the smell they informed the police.

Art for all
The *Exposition des Arts Décoratifs* is held in Paris in 1925. This event showcases the finest decorative arts of the age, whose style eventually becomes known as Art Deco.

1915 1920 1925 1930

Looking back
In 1924, The Ny Carlsberg Glyptotek in Copenhagen, Denmark, mounts a huge retrospective exhibition of Henri Matisse's work.

Just reward
André Derain is given the Carnegie Prize in 1928, a mark of international recognition awarded by the Carnegie Museum of Art in Pittsburgh.

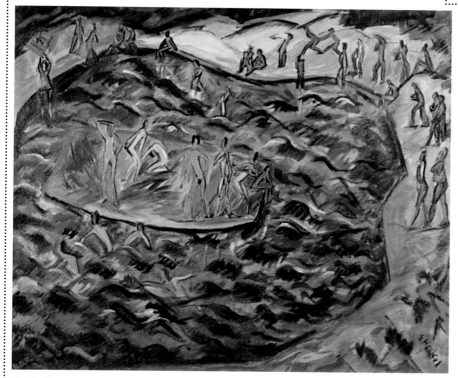

△ Bathers
Erich Heckel 1913 *St. Louis Art Museum, MO*
In this bird's-eye view, Heckel illustrates the then current trend for *Freikörperkultur* (free body culture), which was an appreciation of the experience of nature and sometimes nudity. In typical Heckel style, many of the lines—in the water, the land, and the figures—are jagged and angular.

Erich Heckel

born Döbeln, Germany, July 31, 1883;
died Radolfzell, Germany, January 27, 1970

Erich Heckel studied architecture in Dresden, where he helped to found the Expressionist group Die Brücke in 1905. He continued to work as an architect until 1909, when he took up painting full time. In 1913, the year Die Brücke disbanded, he was given a solo exhibition in Berlin. During World War I, declared unfit for service, he volunteered to work as a medical orderly, going on to produce powerful images reflecting the conflict. Throughout his career, Heckel worked with woodcut engravings—he particularly enjoyed color woodcuts, despite the laborious process involved in cutting different blocks of wood for each of the colors he used.

BIOGRAPHY

◁ **Conjuring Trick**
Paul Klee 1927 *Philadelphia Museum of Art, PA*
Paul Klee was one of the most respected figures in 20th-century art. Klee was obsessed with color, and early in his career confessed that "color possesses me." In this typically quirky, yet slightly disturbing, image—sometimes called *Prestidigitator*—disembodied eyes, nose, and mouth float against a shimmering red background.

Pierrot ▷
Georges Rouault 1938–39
Fondation Georges Rouault, Paris, France
The *commedia dell'arte* figure of Pierrot was a favorite theme for Rouault. In much of his work, he portrayed the clown as sad and disillusioned.

1930 **1935** **1940** **1945** **1950**

From figurative to abstract
In 1930, Henri Matisse finishes a series of four bronze bas-relief sculptures, *Back 1–Back 4*, each featuring a different view of the human figure, from conventionally figurative to near abstract.

War on art
On August 2, 1934, Adolf Hitler becomes Führer (head of state) in Germany. Under Hitler, the Nazi party declares much Expressionist work to be "degenerate" and removes it from display in public buildings, or has it destroyed.

Death of Soutine
On August 9, 1943, Chaim Soutine dies in German-occupied Paris during an emergency operation for a stomach ulcer.

The Fiancés ▷
Marc Chagall 1927–35
Private Collection
Chagall grew up in a provincial Russian town before World War I. Throughout his long life, he took inspiration from memories of that time, and the folk tales he grew up with—musicians and lovers, for example, appear in many of his paintings, all of which reflect his passion for color.

Matterhorn I ▷
Oskar Kokoschka 1947
Fondation Oskar Kokoschka, Vevey, Switzerland
An Austrian-born Expressionist, Kokoschka was known for portraiture early in his career, but a period of travel during the 1920s focused his interest on the natural world. Kokoschka loved Switzerland and eventually settled there, producing stunning images of its landscape.

Georges Rouault

born Paris, France, May 27, 1871;
died Paris, February 13, 1958

BIOGRAPHY

The son of an artisan, Rouault began his career as an apprentice to a stained-glass painter. Like Matisse, he was taught by Gustav Moreau, and he was influenced by his teacher's work as well as by his own fascination with medieval art. To create his distinctive style, Rouault favored the rich colors of stained glass, applying them with thick paint in an effect called impasto. Throughout his career, he continued to work in stained glass, as well as ceramics, tapestry, stage design, and illustration.

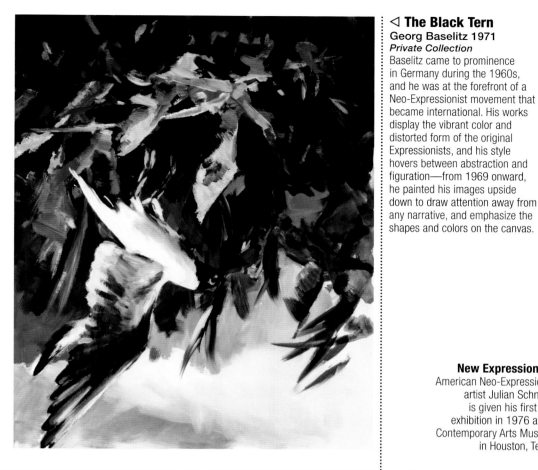

◁ **The Black Tern**
Georg Baselitz 1971
Private Collection
Baselitz came to prominence in Germany during the 1960s, and he was at the forefront of a Neo-Expressionist movement that became international. His works display the vibrant color and distorted form of the original Expressionists, and his style hovers between abstraction and figuration—from 1969 onward, he painted his images upside down to draw attention away from any narrative, and emphasize the shapes and colors on the canvas.

Power of the spirit
In February 1958, Georges Rouault dies in Paris and is given a state funeral. His devout Catholic faith had given much of his work a deeply spiritual quality.

New Expressionism
American Neo-Expressionist artist Julian Schnabel is given his first solo exhibition in 1976 at the Contemporary Arts Museum in Houston, Texas.

1955 **1960** **1965** **1970** **1975**

❝ **OPEN YOUR EYES** AT LAST AND SEE…NOW I WILL **OPEN THE BOOK OF THE WORLD** FOR YOU ❞

Oskar Kokoschka

EXPRESSIVE DANCE

CONTEXT

While Expressionist paintings were exploring new territory, modern dance was also focusing on self-expression. Rejecting the qualities that define classical ballet—precise technique, storytelling, and elaborate designs—the new style involved bare feet, simple draped costumes, lack of plot, and free movement inspired by emotion. Some Modernists, such as the German pioneer Mary Wigman (*right*), occasionally danced without music.

Mary Wigman

 MASTERWORK

The Street

Ernst Ludwig Kirchner **1908**
MoMA, New York, NY

Crowded city streets were a favorite subject for Die Brücke (German for "The Bridge"), the early German Expressionist group founded in 1905 with Kirchner as its leader. The original members—Kirchner, Erich Heckel, Fritz Bleyl, and Karl Schmidt-Rottluff—were Dresden architecture students who had turned to painting, and wanted to break away from the academic tradition. They shared a fascination with 19th-century philosopher Friedrich Nietzsche, from whose writing they took their name: "The great thing about man is that he is a bridge and not a goal."

Kirchner's Dresden scenes portray the isolation and anxiety he felt in the midst of impersonal city life. Everything about this image is jarring—the colors are harsh and clashing, the street has an unnatural slope, the pavement is crowded, and escape is blocked by a trolley car in the background. With its masklike, vacant faces and lonely figures, *The Street* perfectly embodies what Kirchner referred to as "agonizing restlessness"—the defining quality of so many Expressionist works.

Kirchner's alienation increased when he left provincial Dresden in 1911 for Berlin. Between 1913 and 1915, he produced seven street scenes that expressed the even more profound isolation he felt in the huge, anonymous city. In 1918 he suffered a breakdown and moved to an alpine farmhouse in Switzerland, where he painted peaceful mountain scenes. In 1937, the Nazis declared Kirchner's work "degenerate" and removed all examples from public collections. The following year, he took his own life.

> **❝** THE **GOAL** OF MY WORK HAS ALWAYS BEEN TO **DISSOLVE MYSELF COMPLETELY** INTO THE **SENSATIONS** OF THE **SURROUNDINGS** ... **❞**
>
> 1917 | Ernst Ludwig Kirchner

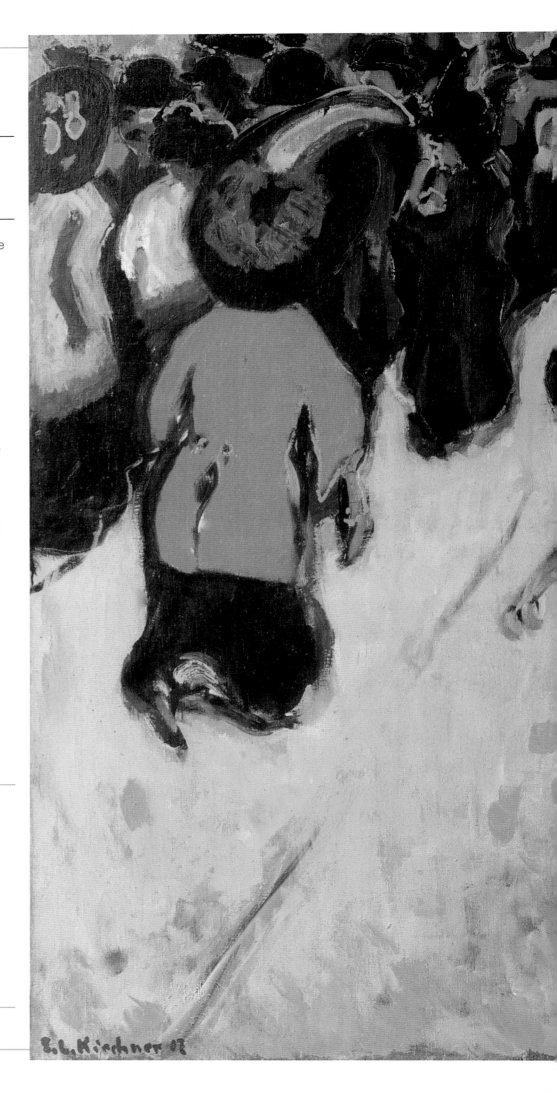

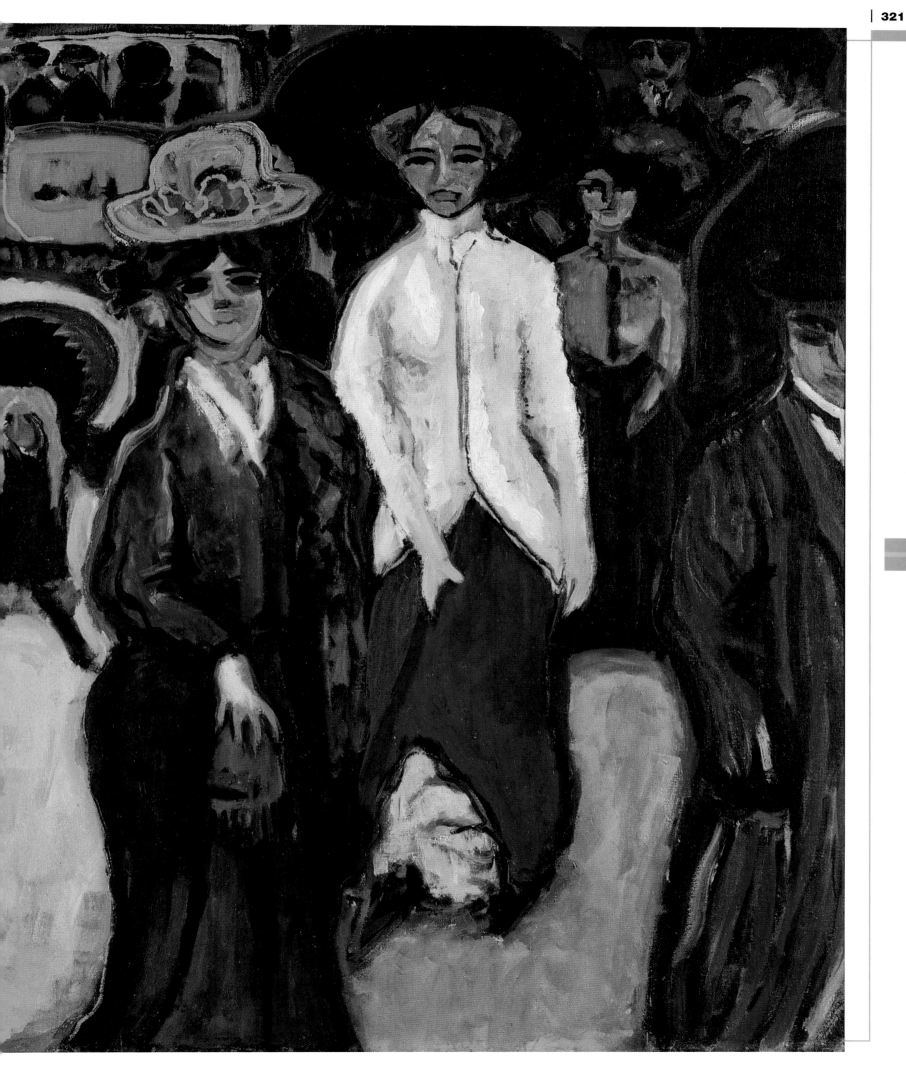

CUBISM

▷ **The Smoker**
Juan Gris 1913
Museo Thyssen-Bornemisza,
Madrid, Spain
In this affectionate portrait of the
American art patron Frank Haviland,
Gris separated various elements
of the face and reordered them
geometrically. The use of strong
color is a feature of later
Cubism—early examples are
almost monochromatic.

Cubism—like Expressionism—developed in an age that produced automobiles, airplanes, cinema, and the widespread adoption of photography. The growth of photography was crucial, because it meant that painting was no longer tied to its traditional role of reproducing people, places, and objects realistically. Instead, painters could explore new ways of looking at subjects, sometimes from different angles at the same time, as in Juan Gris's *The Smoker* (*left*). Cubism, which began around 1907, initially involved the work of only two artists, Pablo Picasso and Georges Braque. But by 1911 it had become popular among other progressive artists in Paris, including Gris, Marcel Duchamp, Fernand Léger, Robert and Sonia Delaunay, and Jean Metzinger. From there, it spread widely—to Italy, Britain, and Russia, for example, and also to the United States, notably in the work of Charles Sheeler.

◎ CONTEXT

A new way of seeing

At the turn of the 20th century, the boundaries of science, technology, travel, and communication were being extended almost beyond imagination. Albert Einstein was revolutionizing the world of physics, fingerprint evidence was used for the first time to solve a murder, and radio (wireless telegraphy) equipment was installed in offices and on ships. Pablo Picasso and Georges Braque changed art in a way that was equally revolutionary.

There was an upheaval in other art forms as well. Igor Stravinsky, for example, had been commissioned to compose *The Rite of Spring*, to be performed by Serge Diaghilev's Ballet Russes. On its opening night in Paris in 1913, the audience were so appalled by the avant-garde nature of both the music and Vaslav Nijinsky's angular choreography that there was a near-riot in the theater. Contemporary paintings had a similar capacity to inspire violent reaction. At the time, it was fashionable to read into Cubism an attempt to comment on, or interpret, advanced doctrines of science and philosophy, but Picasso and Braque never made this link, and they had no time for those who did. A climate of change certainly nurtured the new style, but as Picasso made clear: "Cubism has kept itself within the limits and limitations of painting, never pretending to go beyond it." Picasso and Braque never turned to revolutionary thought or technology for their subject matter—however extreme the style they invented, they chose to paint landscapes, people, musical instruments, and still-life studies with bowls of fruit, just as artists had always done. Both artists had the luxury of financial support from their dealer, so they could afford to play repeatedly with the same subjects. In contrast, fellow Cubists had to sell their work on the open market to survive, so they often chose more eye-catching subjects, and offshoots of Cubism such as Futurism and Vorticism were inspired by themes including aviation.

The outbreak of World War I ended the close and fertile collaboration between Picasso and Braque, but the movement they established went on to be one of the most important and influential in modern art.

Camera Cubism
Vorticism, a British development from Cubism, was expressed in photography as well as painting. Alvin Langdon Coburn used a triangular arrangement of mirrors over his lens to create geometric forms in images that were called vortographs.

Modernism manifest

KEY EVENTS

▷ **1905** Einstein's Special Theory of Relativity is published, revolutionizing the accepted laws of physics in the way that Cubism was to revolutionize art. Spanish artist José Gonzáles adopts the pseudonym Juan Gris.

▷ **1907** Picasso paints *Les Demoiselles d'Avignon*, often described as the first Cubist work. Braque is initially shocked by the painting, but subsequently responds with a large Cubist nude of his own.

▷ **1908** The art critic Louis Vauxelles makes his first reference to cubes in describing Braque's work, suggesting the movement's name for the first time.

▷ **1912** Albert Gleizes and Jean Metzinger publish *On Cubism*, the first book dealing with the subject. Picasso and Braque introduce the technique of collage—the addition of non-artistic materials such as paper fragments to their images.

▷ **1914** World War I is declared. Braque's enlistment in the French Army ends his close artistic partnership with Picasso.

> EVEN **A PART OF AN OBJECT** HAS VALUE. A WHOLE **NEW REALISM** RESIDES IN THE WAY ONE **ENVISAGES AN OBJECT**, OR **ONE OF ITS PARTS**

Fernand Léger

◎ BEGINNINGS

BUILDING BLOCKS OF MODERNISM

The most revolutionary of all modern art movements, Cubism was the creation of the artists Pablo Picasso and Georges Braque. The critic Louis Vauxelles inadvertently christened the movement when, commenting on exhibitions in 1908 and 1909, he used the terms "*cubes*" and "*bizarreries cubiques*" (cubic eccentricities). Soon, more painters began to work in the style, and Cubism provided inspiration for related movements elsewhere—Futurism in Italy, Vorticism in Britain, Constructivism in Russia, and Precisionism in America.

◉ ARTISTIC INFLUENCES

Picasso and Braque had very different personalities, but for a time they shared the same vision in their work. Instead of reproducing exactly what they saw, they experimented with fragmenting and rearranging their subjects, appearing to look at them from more than one vantage point at the same time.

African art fascinated Picasso and other Cubists. Like many progressive artists, they were excited by its vibrant, expressive qualities. Some collected African tribal masks, which were common and cheap in Paris curio shops.

Ceremonial mask from Gabon, late 19th or early 20th century, is typical of the style of African art that influenced Cubists.

Cézanne was a key influence. He did not try to create depth with traditional perspective, and viewed his subjects from shifting positions. His works are less windows on the world as flat surfaces with their own integrity.

Mont Sainte-Victoire, c.1904, illustrates how Cézanne used color to suggest form. *Kunsthaus, Zürich, Switzerland*

Daniel-Henry Kahnweiler was the art dealer who brought Picasso and Braque together. He promoted Cubism, and represented Fernand Léger, Juan Gris, and Fauve artists André Derain and Maurice de Vlaminck.

Daniel-Henry Kahnweiler was a German-born dealer and critic working in Paris. He was the first to show Cubist work.

Paul Gauguin inspired the Cubists in his use of simple, flat shapes, with his fascination for "primitive" cultures (Polynesian rather than African), and through the freedom from inhibition that characterizes much of his work.

Woman Holding a Fruit, 1893, shows Gauguin's lush, uninhibited style. *Hermitage Museum, St. Petersburg, Russia*

◎ TURNING POINT

Les Demoiselles d'Avignon

Pablo Picasso **1907** *MoMA, New York, NY*

This startling work is seen as not only heralding the birth of Cubism, but as a key landmark in the entire history of painting. Overthrowing conventional ideas about form, color, and perspective, it broke away from traditional art so radically and ferociously that even some of Picasso's closest friends and associates were baffled and shocked by it. The painting was not shown in public until 1916. The five women in the painting are prostitutes—the title is a reference to Barcelona's Carrer d'Avinyo (Avignon Street), which was notorious for its brothels. Picasso made hundreds of preparatory drawings for this painting, indicating that he originally intended to create a more detailed and explicit brothel scene that included one or more male figures.

◎ **Pablo Picasso**

born Málaga, Spain, October 25, 1881;
died Mougins, France, April 8, 1973

The most famous artist of the modern age, Pablo Picasso was the son of a painter and art teacher who showed him how to draw when he was a small child. He studied at art schools in Barcelona and Madrid, but soon outgrew them, and had his own studio by the time he was 16. In 1900, he began visiting Paris, where he settled in 1904. Soon, his work became popular with discerning patrons such as Gertrude and Leo Stein, and by the end of World War I, he was wealthy and firmly established as a leading artist. For the rest of his life, Picasso was extraordinarily prolific—not only as a painter, but also as a sculptor, printmaker, ceramicist, and stage designer—and he was still working within hours of his death at the age of 91.

BIOGRAPHY

◎ TIMELINE

Once Picasso and Braque joined forces, their collaboration was close, intense, and hugely productive. They met regularly to discuss their work and for a time they produced paintings so similar that experts still find it difficult to tell their work apart. Soon, other avant-garde Paris-based artists adopted the conventions they had established, and variations of Cubism went on to spring up in other countries. Cubist ideas were also adopted and adapted in sculpture, the decorative arts, and to a lesser extent, architecture.

❝ IN THE **EVOLUTION** OF THE **NEW ART**, THE CONTRIBUTIONS OF **PICASSO** AND **BRAQUE** ARE…OFTEN **HARDLY DISTINGUISHABLE** ❞

1920 | Daniel-Henry Kahnweiler
Art dealer and critic, writing in The Rise of Cubism

◁ **Viaduct at L'Estaque**
Georges Braque 1908
Musée National d'Art Moderne, Paris, France
This is one of the paintings that gave rise to the term Cubism. The name continued to be used, even though Braque and Picasso soon moved away from the blocklike forms seen here, and later Cubism has nothing to do with cubes.

1907 **1908**

Birth follows death
Following Cézanne's death, a commemorative exhibition of his work is mounted in Paris in 1907, inspiring many progressive artists and playing a part in the birth of Cubism.

Marcel Duchamp

born Blainville, France, July 28, 1887;
died Neuilly-sur-Seine, France, October 2, 1968

Although he had a huge impact on 20th-century art, Marcel Duchamp actually produced comparatively little of it. Like many artists of the time, he was drawn to the work of Paul Cézanne, and around 1910 he began to paint in the Cubist style. By 1917, he was experimenting with Dada, and later he was involved with Surrealism. Producing pieces that were often characterized by humor, Duchamp shifted attention from the appearance of works of art to the ideas that lay behind them—a revolutionary notion that is still enormously influential in the 21st century.

BIOGRAPHY

▽ The Town No.2
Robert Delaunay 1910
Musée National d'Art Moderne, Paris, France
Born in Paris, Delaunay was essentially self-taught, and worked in both Impressionist and Post-Impressionist styles before turning to Cubism. Here, the extreme fragmentation of a townscape hints at his move toward total abstraction.

The Knife Grinder ▽
Kasimir Malevich 1912–13
Yale University Art Gallery, New Haven, CT
Malevich experimented with a number of Modernist movements. The style of this painting, which combines elements of Cubism and Futurism, is sometimes called Cubo-Futurist. Its subtitle is "Principle of Glittering."

Dynamism of a Soccer Player ▽
Umberto Boccioni 1913
MoMA, New York, NY
Boccioni was one of the leading exponents of Futurism, an Italian development from Cubism. This work portrays the athletic energy of a ballplayer through his interaction with the flickering atmosphere around him.

1909 **1910** **1911** **1912** **1913** ▶

Looking to the future
Futurism is officially launched when the *Futurist Manifesto* is published by Filippo Tommaso Marinetti in Paris in February 1909.

Gothic inspiration
In the spring of 1909, Robert Delaunay begins work on his *Saint-Severin* series of seven paintings. These portray in fragmented Cubist style the interior of a small Gothic church near his studio.

Nude Descending a Staircase, No. 2 ▷
Marcel Duchamp 1912
Philadelphia Museum of Art, PA
Duchamp's semiabstract nude, with its extraordinary sense of movement, attracted considerable negative criticism when it was exhibited at the Armory show in New York (1913). One commentator likened it to "an explosion in a shingles factory"—the resulting publicity made Duchamp a celebrity in the United States.

The Conquest of the Air △
Roger de La Fresnaye 1913
MoMA, New York, NY
La Fresnaye produced distinctive work that was strongly influenced by Cubism. His best-known painting shows the artist and his brother relaxing outdoors, with a large balloon in the background.

Making history
During February and March 1913, the Armory Show in New York (a huge exhibition of modern art) introduces Cubism to the American public.

Still Life ▷
Jean Metzinger 1916
Private Collection
One of the first artists to be won over to Cubism, Metzinger tended to apply its principles in a more decorative way than some of his associates. With Albert Gleizes, he wrote the first book on the subject, *On Cubism* (1912).

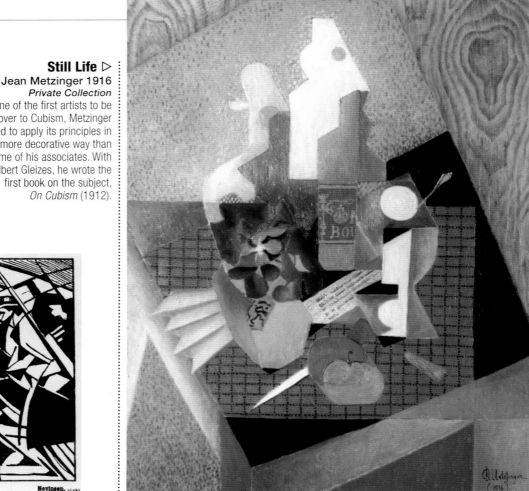

▽ On the Way to the Trenches
CRW Nevinson 1915
Nevinson created this woodcut for *Blast*, the short-lived journal of Vorticism in Britain. As an official war artist, he witnessed the full horror of battle, and the work he produced reflected his experience.

On the way to the Trenches. Nevinson. XXVI

1914 1915 1916 1917 1918

The world at war
In July 1914, war breaks out in Europe and later affects countries around the world. Artists of every discipline portray the conflict (*see above*), and many others die in the fighting.

<div style="writing-mode: vertical">BIOGRAPHY</div>

Amedeo Modigliani

born Livorno, Italy, July 12, 1884;
died Paris, France, January 24, 1920

Modigliani was the ultimate bohemian artist. Born into a Jewish Italian family, he studied art in Florence and Venice before settling in 1906 in Paris, where he met Chaim Soutine, Juan Gris, and the Cubist sculptor Jacques Lipchitz, and pursued a life of exuberant excess. While not involved directly with Cubism (or any other movement), Modigliani had great respect for Picasso, he socialized in the group's orbit, and many of his portraits display mild Cubist distortion. During his life, Modigliani had little commercial success, and he died when he was only 35, yet within a few years he was acknowledged as one of the most original artists of his time.

◁ Portrait of Hanka Zborowska
Amedeo Modigliani 1917
Galleria Nazionale d'Arte Moderna, Rome, Italy
Like the early Cubists, Modigliani was fascinated by African masks, and his expressionless portraits reflect this. Here, he portrays the wife of his art dealer Léopold Zborowski. Toward the end of the artist's life the couple allowed him to use their house as a studio.

Bargeman ▷
Fernand Léger 1918
MoMA, New York, NY
Léger's brand of Cubism was particularly distinctive, and by 1912, he was using it to explore his fascination with technology. *Bargeman* depicts a river craft against a background of houses—in the upper left section, the title figure grips his wheel with clawlike hands on the end of huge tubular arms.

SHAPING AN AGE

Inspired by the 1925 Exposition des Arts Décoratifs in Paris, the Art Deco style dominated applied arts in the late 1920s and 1930s. Several factors shaped its distinctive look: the designs of Léon Bakst and Alexandre Benois for the Ballets Russes, the discovery of Tutankhamun's tomb and the resulting fashion for all things Egyptian, and the singular style of Léger-brand Cubist painting, as seen in the work of Deco potter Clarice Cliff.

Clarice Cliff
Art Deco
coffee pot

Expert opinion
Daniel-Henry Kahnweiler's book *The Rise of Cubism* is published in 1920. Never a commercial success, it soon became an authoritative source work, and it is still used in this way today.

Death of Modigliani
In January 1920, Amedeo Modigliani dies in Paris of tubercular meningitis brought on by poverty, overwork, and addiction to alcohol and drugs.

▽ Pertaining to Yachts and Yachting
Charles Sheeler 1922
Philadelphia Museum of Art, PA
A photographer as well as a painter, Sheeler was the leading exponent of Precisionism, an American variation of Cubism. He portrayed urban and industrial subjects in a smooth, linear style—here, several large vessels appear to skim across the ocean's surface.

1919	1920	1921	1922	1923 ▶

Friends together
In 1921, Pablo Picasso produced two similar Cubist paintings entitled *Three Musicians*. Experts believe that the artist is one of these, and his friends, poets Guillaume Apollinaire and Max Jacob, are the others.

> **❝ ABOVE ALL**, IT IS A MATTER OF **LOVING ART**, NOT **UNDERSTANDING** IT **❞**

Fernand Léger

Fernand Léger

born Argentan, France, February 4, 1881;
died Gif-sur-Yvette, France, August 17, 1955

Originally apprenticed to an architectural draftsman, Léger supported himself in this trade while he attended art school, and went on to become a major figure in Cubism. After serving in World War I, he established a distinctive style in which he portrayed cityscapes and technology in strong colors and geometric shapes. During World War II, he lived and worked in the United States, returning permanently to France in 1945. A giant of 20th-century art, Léger also produced stunning stained glass, mosaics, tapestries, and ceramics.

◎ MASTERWORK

Le Portugais (the Emigrant)

Georges Braque **1911**
Kunstmuseum, Basel, Switzerland

In the classic Cubist manner, Braque produced this sepia-hued portrait of a musician by analyzing the subject's form, breaking the image into multiple fragments, then arranging them to reflect a number of different angles and different moments in time—and also to suggest light and shadow. Here, the effect is so complete and complex that it is difficult at first for the viewer to make out what is being portrayed, although the central figure, the curtain and its tasseled cord, and the still-life image on the wall reveal themselves fairly readily. The top-hatted subject is a Portuguese guitar player the artist had once seen in a Marseilles bar.

After working together on Cubism for several years, Braque and Picasso began to experiment with stenciling and collage. In doing this, they extended the scope of Cubism even further by challenging the process of painting as well its treatment of subjects. At first,

blended into the composition, these techniques had no particular function. Here though, across the fragmented central image, Braque stenciled selected letters and numbers in order to enhance the nature of the painting's surface as a subject of interest in its own right, rather than an object on which to create a representational image. At the same time, the realism of these elements highlights the painting's abstract nature. At top right, the stenciled fragment from a poster announcing a *GRAND BAL* (a dance) not only serves the painting's intricate composition, it also adds a bohemian café atmosphere.

Le Portugais was painted during the summer that Braque spent working with Picasso in Céret in France, a picturesque town at the foot of the Pyrenees near the Spanish-French border. Céret attracted many writers, musicians, and artists of the time, including Expressionist painters Henri Matisse and André Derain.

> ❝ AS PART OF A **DESIRE** TO COME **AS CLOSE AS POSSIBLE** TO A **CERTAIN KIND OF REALITY**, IN 1911 **I INTRODUCED LETTERS** INTO MY PAINTINGS ❞

Georges Braque

◎ Georges Braque

born Argenteuil, France, May 13, 1882;
died Paris, France, August 31, 1963

The son and grandson of house painters, Braque took up the family trade, but chose to study painting at the same time. In 1900, he moved to Paris to train as a master decorator, but also attended art schools. Early paintings show a strong Impressionist influence, but after seeing the work of the Fauves in 1905, he adopted their style. Then, from the time he met Picasso in 1907, he focused on developing the form that became known as Cubism. They worked together until 1914, when Braque went to fight in World War I, during which he suffered a serious head wound. After the conflict, his style became less angular, featuring subtle, muted colors and a more realistic interpretation of nature. He continued to work in Paris for the rest of his life, even during World War II. As well as paintings, Braque produced theatrical designs, lithographs, engravings, book illustrations, sculptures, stained-glass windows, and jewelry designs. In 1961, he became the first living artist to be exhibited in the Louvre.

BIOGRAPHY

◎ BEGINNINGS
MOVING TOWARD THE FUTURE

Toward the end of the 19th century and at the beginning of the 20th, painting began to move away from the idea that the accurate reproduction of reality was one of its inherent functions. Fauvism and Expressionism developed this concept further, then Cubism finally opened the door to pure abstraction by treating paintings as surfaces on which artists create a response to the world, rather than as windows through which they view a part of it. Some abstract art—like the Kupka painting pictured opposite—is based, however obliquely, on the world around us, but pure abstraction, sometimes called nonobjective art, portrays no concrete reality at all, as seen in the work of Theo van Doesburg, Kazimir Malevich, Ben Nicholson, and Piet Mondrian.

The first abstract works appeared a little after 1910, and images in this idiom continued to flourish throughout the rest of the 20th century, and beyond. Now, in the first decades of the 21st century, abstract art is still a vibrant, and often challenging, vein of modernism.

◎ František Kupka

born Opocno, Bohemia, September 23, 1871;
died Puteaux, Paris, France, June 24, 1957

BIOGRAPHY

Born in Bohemia (now part of the Czech Republic), Kupka studied at the Academies of Fine Arts in both Prague and Vienna. In 1896, he settled in Paris and began his career producing illustrations and satirical caricatures. His early paintings displayed Fauve influences, and he developed a fascination with color that led him to abstraction as a way of exploring its spiritual symbolism, and using it to create effects like those of music. When World War I was declared, Kupka enlisted in the French Army and fought in the Battle of the Somme. Later, he went on to become a teacher, developing a more geometrical style in his own work. Kupka's role as a pioneer of abstract art began to be generally appreciated only after his death in 1957. The following year a major exhibition of his work opened at the Musée National d'Art Moderne in Paris.

◉ ARTISTIC INFLUENCES

As they shifted toward abstraction, the movement's pioneers explored a wide range of influences that offered enrichment and delight solely through the employment of line, pattern, texture, and color. Sometimes they were drawn to the work of other painters—even those from earlier, profoundly conventional, disciplines—but folk-art techniques and effects made possible by new technology also had much to offer.

James McNeill Whistler prefigured abstraction by emphasizing the arrangement of form and color, rather than the subject. (His famous "Whistler's Mother" is actually titled *Arrangement in Grey and Black No. 1*.) In this dramatic firework scene, he plays with color, form, and light.

Nocturne in Black and Gold: The Falling Rocket, 1875, by Whistler has a title alluding to the link between painting and music. *Detroit Institute of Arts, MI*

Multiple-exposure photographs by the French scientist Etienne-Jules Marey depicting the movement of the bodies of people and animals fascinated some early abstractionists. This technique became known as chronophotography.

Record of the Several Phases of a Jump, 1886, Etienne-Jules Marey, shows how multiple-exposure photography creates rhythmic patterns.

Maurice Denis, the French Symbolist painter and theorist, believed in suggestion rather than literal representation. His work has strongly abstract qualities, a concept he wrote about: "A picture is … essentially a flat surface covered with colors arranged in a certain order."

The Green Christ, 1890, Maurice Denis, clearly portrays Jesus, but the painting is more about colors and shapes. *Private Collection*

The Bohemian tradition of adorning traditional wooden cottages with hand-painted squares, arrows, dots, and zig-zags influenced Kupka as he grew up in the Bohemian countryside. They also encouraged his fascination with line and pattern.

Simple motifs adapted by local women from their needlework designs decorate cottages in the area of Bohemia where Kupka was born.

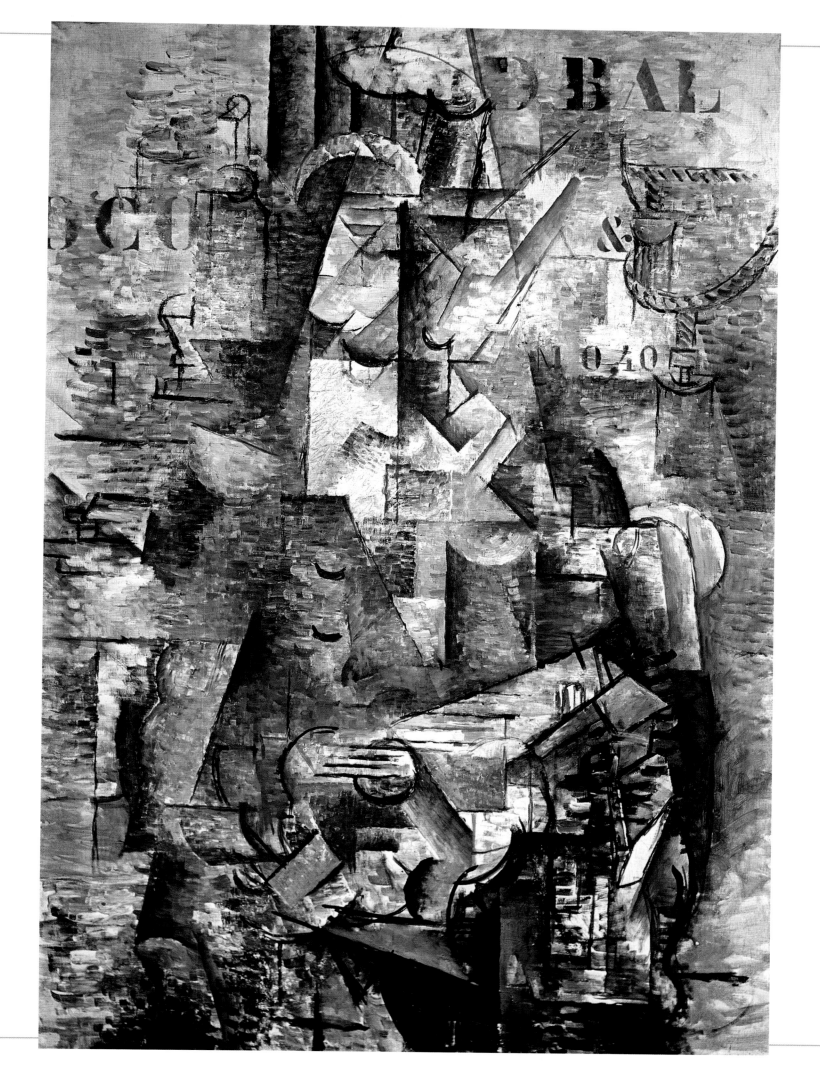

BIRTH OF ABSTRACT ART

1910–1940s SETTING THE CANVAS FREE

Of all the new art forms and movements to emerge during the 20th century, abstract art is perhaps the most enduring. Any work of art that does not depict the recognizable, visual world can be described as abstract. Some abstract paintings, like this study by Sonia Delaunay, distort the figures or objects being portrayed without disguising their nature altogether. Certain Cubist paintings, such as Marcel Duchamp's 1912 *Nude Descending a Staircase, No. 2* (*see p.327*) also follow the same principle. At the most extreme extent of abstraction however, there is no attempt to reproduce or even to suggest nature—paintings explore the power of line, color, and form for their own sake in order to bypass literal perception and access unconscious awareness. Leading abstractionists of the time included František Kupka, Wassily Kandinsky, Theo van Doesburg, Kazimir Malevich, Ben Nicholson, and Piet Mondrian.

◎ CONTEXT

The art of freedom

Early abstract art grew out of the same rapidly changing culture as Expressionism and Cubism. It developed slightly later, though, so it also reflected a world of increased political activity and widespread social upheaval.

In the years leading up to World War I, the birth of abstract art was very much an international phenomenon that emerged more or less at the same time in the work of artists in various countries. In their different ways, all discovered the limitless potential of color and form divorced from representation. Pioneers included the Russian Kasimir Malevich; Wassily Kandinsky, also a Russian, working in Germany; František Kupka, a Czech living in Paris; Dutch painter and writer Theo van Doesburg; and Piet Mondrian, a Dutchman, who spent vital years of his career in Paris. For such artists, this was not simply a new style, but a revolutionary idiom, uniquely suited to portraying their feelings, and appropriate to a new world view. Kandinsky once claimed that the impact of the acute angle of a triangle on a circle produces an effect that is just as powerful as Michelangelo's "finger of God touching the finger of Adam."

World War I changed the structure of society across Europe and beyond. When it was over, servants who had enlisted or undertaken war work had little desire to return to domestic service, and the women who had toiled in offices and factories to take the place of men conscripted for military service would never again be content to stay at home—the rigid but familiar class system that had been in place for hundreds of years began to crumble. The postwar decades brought more upheaval in the form of a devastating worldwide depression in the 1930s, and the rise of the Nazi party in Germany, which led to another World War. Eventually, abstraction not only came to dominate modern art, but also represent the victory of western freedom over the totalitarianism of Nazi Germany and Soviet Russia, both of which had banned it.

A world in turmoil

▷ **1917** Start of the Russian Revolution, during which Tsar Nicholas II and his family are killed. This event leads to the creation of the communist Soviet Union.

▷ **1918** World War I ends. For a few years after the war the American economy flourishes, making it an international financial capital and a center for the arts.

▷ **1929** The New York stock market crashes, contributing to an international depression. This encourages a patriotic type of figurative painting in the US.

▷ **1932** In the Soviet Union, Socialist Realism is decreed the only acceptable type of art. Abstraction (along with Expressionism and Cubism) is outlawed.

▷ **1933** Adolf Hitler, leader of the Nazi party, is declared Germany's Chancellor. Most modern art is labeled as "degenerate" and much is destroyed.

▷ **1936** During preparations for the Cubism and Abstract Art exhibition at the Museum of Modern Art, New York, 19 sculptures are denied entry from Europe because US Customs define sculpture as "imitations of natural objects."

KEY EVENTS

❝❝ **ABSTRACTION** IS **REAL**, PROBABLY **MORE REAL THAN NATURE**. I PREFER TO **SEE WITH CLOSED EYES** ❞❞

Josef Albers
German-American artist and educator

Horrors of war
Having suffered appallingly under the Tsar, the Russian people still endured terrible conditions after the Revolution, including starvation. Some regions fought for their independence—to escape carnage in Latvia in 1917, these peasants fled into the woods near Riga.

◎ BEGINNINGS

MOVING TOWARD THE FUTURE

Toward the end of the 19th century and at the beginning of the 20th, painting began to move away from the idea that the accurate reproduction of reality was one of its inherent functions. Fauvism and Expressionism developed this concept further, then Cubism finally opened the door to pure abstraction by treating paintings as surfaces on which artists create a response to the world, rather than as windows through which they view a part of it. Some abstract art—like the Kupka painting pictured opposite—is based, however obliquely, on the world around us, but pure abstraction, sometimes called nonobjective art, portrays no concrete reality at all, as seen in the work of Theo van Doesburg, Kazimir Malevich, Ben Nicholson, and Piet Mondrian.

The first abstract works appeared a little after 1910, and images in this idiom continued to flourish throughout the rest of the 20th century, and beyond. Now, in the first decades of the 21st century, abstract art is still a vibrant, and often challenging, vein of modernism.

◎ František Kupka

born Opocno, Bohemia, September 23, 1871; **died** Puteaux, Paris, France, June 24, 1957

Born in Bohemia (now part of the Czech Republic), Kupka studied at the Academies of Fine Arts in both Prague and Vienna. In 1896, he settled in Paris and began his career producing illustrations and satirical caricatures. His early paintings displayed Fauve influences, and he developed a fascination with color that led him to abstraction as a way of exploring its spiritual symbolism, and using it to create effects like those of music. When World War I was declared, Kupka enlisted in the French Army and fought in the Battle of the Somme. Later, he went on to become a teacher, developing a more geometrical style in his own work. Kupka's role as a pioneer of abstract art began to be generally appreciated only after his death in 1957. The following year a major exhibition of his work opened at the Musée National d'Art Moderne in Paris.

BIOGRAPHY

◉ ARTISTIC INFLUENCES

As they shifted toward abstraction, the movement's pioneers explored a wide range of influences that offered enrichment and delight solely through the employment of line, pattern, texture, and color. Sometimes they were drawn to the work of other painters—even those from earlier, profoundly conventional, disciplines—but folk-art techniques and effects made possible by new technology also had much to offer.

James McNeill Whistler prefigured abstraction by emphasizing the arrangement of form and color, rather than the subject. (His famous "Whistler's Mother" is actually titled *Arrangement in Grey and Black No. 1*.) In this dramatic firework scene, he plays with color, form, and light.

Nocturne in Black and Gold: The Falling Rocket, 1875, by Whistler has a title alluding to the link between painting and music. *Detroit Institute of Arts, MI*

Multiple-exposure photographs by the French scientist Etienne-Jules Marey depicting the movement of the bodies of people and animals fascinated some early abstractionists. This technique became known as chronophotography.

Record of the Several Phases of a Jump, 1886, Etienne-Jules Marey, shows how multiple-exposure photography creates rhythmic patterns.

Maurice Denis, the French Symbolist painter and theorist, believed in suggestion rather than literal representation. His work has strongly abstract qualities, a concept he wrote about: "A picture is … essentially a flat surface covered with colors arranged in a certain order."

The Green Christ, 1890, Maurice Denis, clearly portrays Jesus, but the painting is more about colors and shapes. *Private Collection*

The Bohemian tradition of adorning traditional wooden cottages with hand-painted squares, arrows, dots, and zig-zags influenced Kupka as he grew up in the Bohemian countryside. They also encouraged his fascination with line and pattern.

Simple motifs adapted by local women from their needlework designs decorate cottages in the area of Bohemia where Kupka was born.

◎ TURNING POINT

Study For Amorpha: Fugue in Two Colors II

František Kupka **1910–11**
Cleveland Museum of Art, OH

No image can be singled out as the first to be purely abstract, but this painting is certainly among the movement's key pioneering works. One of a series that preoccupied Kupka between 1909 and 1912, it was inspired when the artist watched his stepdaughter running with a ball. Based on his belief that rhythmic forms in pure colors reflect cosmic energy, Kupka interpreted his memory in abstract mode. In abstraction, he found a parallel with the musical fugue, "where the sounds evolve like veritable physical entities, intertwine, come and go."

❝ THE **CREATIVE ABILITY** OF **AN ARTIST** IS MANIFESTED ONLY IF HE **SUCCEEDS IN TRANSFORMING** NATURAL PHENOMENA INTO **ANOTHER REALITY** ❞

František Kupka

◎ TIMELINE

Soon after 1910 Kandinsky, Kupka, and a few others began to produce the first examples of pure abstract art. In the years that followed, a number of artists such as Piet Mondrian and Theo van Doesburg used the revolutionary new idiom to create their own distinctive styles. Eventually, during the early 1940s, abstraction led to the birth of the first major art movement of the American avant-garde—Abstract Expressionism.

Upward ▷
Wassily Kandinsky 1929
Peggy Guggenheim Collection, Venice, Italy
This abstracted head is composed of geometric planes and non-naturalistic colors, accentuated by barlike shapes. Two forms in the painting (in the head's base, and at top right) suggest the letter E, which may refer to the work's original title in German, *Empor* (Upward).

Composition ▷
Theo van Doesburg 1925
Private Collection
In 1917, along with Piet Mondrian and others, van Doesburg founded the group De Stijl ("The Style"). By the time he produced this painting though, he was moving away from the strict horizontals and verticals associated with it.

Superior shapes
The Suprematist movement is launched in 1915 by Kasimir Malevich at an exhibition of avant-garde art in Petrograd (now St. Petersburg), Russia.

1915 ○ **1920** **1925** **1930** ○

❝ THE **ARTIST CREATES** SOMETHING THAT THE MOST **INGENIOUS** AND **EFFICIENT TECHNOLOGY** WILL **NEVER** BE ABLE TO CREATE ❞

Kasimir Malevich

◁ **Suprematist Composition**
Kasimir Malevich 1916
Private Collection
After his Cubist period, Malevich developed a style he called Suprematism, in which he aimed to show "the supremacy of pure form." This austere discipline eventually led him to paint a picture of a white square on a white background.

△ **Female Torso**
Joan Miró 1931
Philadelphia Museum of Art, PA
Miró's work does not slot easily into a single movement—like many artists of his time, he was influenced by Fauvism and Cubism, and he is widely associated with the Surrealists, but some of his work—like this naïve, playful painting—is pure abstraction.

End of an era

Founded in 1919, the Bauhaus was a German design school dedicated to bringing all the visual arts together. Kandinsky was one of the many distinguished teachers. It flourished until 1933, when it was closed under pressure from the Nazis.

▽ 1938 (painting)

Ben Nicholson 1935 *Private Collection*

A leading figure in British avant-garde art, Nicholson began as a figurative painter, then experimented with Cubism until he established his own style of abstraction. After meeting Mondrian in 1934, he began to paint geometric shapes in neutral and primary colors.

▽ Trafalgar Square

Piet Mondrian 1939–42
MoMA, New York, NY

The originator of a severe type of abstraction called Neo-Plasticism, Mondrian reduced his paintings to horizontal and vertical lines, and used only primary colors, plus black and white. *Trafalgar Square*, painted in London, is one of a series he named in honor of cities that had offered him hospitality.

THE ART OF FASHION

In 1965, fashion designer Yves St. Laurent adapted Piet Mondrian's blocks of bold color for a collection of couture dresses that became symbols of the decade. St. Laurent realized that Mondrian's work would adapt perfectly to the straight lines of the then-fashionable "shift" style. As a dressmaker, his skill lay in concealing each garment's subtle body shaping in the grid of fine seams.

Robe Mondrian
by Yves St Laurent

CONTEXT

1935 **1940**

Degeneracy on display

The Nazi party labeled abstract and other avant-garde art "degenerate" and outlawed it. But in 1937 they mounted a propaganda exhibition of such banned art in Munich, in which works were hung chaotically and derided on explanatory labels. The exhibition traveled around several German cities.

Ben Nicholson

born Denham, UK, April 10, 1894;
died London, UK, February 6, 1982

A pioneer of modern British art, Nicholson attended the Slade School of Art (London) before traveling extensively in Europe, where he absorbed a wide range of influences—throughout his life he produced both figurative and abstract work. Particularly known for austere geometric paintings, he also created images in relief—many small, but a few large. With his second wife, sculptor Barbara Hepworth, he was at the center of the St. Ives group of artists who lived and worked in Cornwall, UK.

BIOGRAPHY

◎ MASTERWORK

Composition VI

Wassily Kandinsky **1913**
Hermitage Museum, St. Petersburg, Russia

Wassily Kandinsky considered music to be a superior art form to painting because of its inherently abstract nature, and his close friendship with the avant-garde composer Arnold Schoenberg inspired much of his work. In 1910 he began planning a series of paintings called *Compositions*—a term that is common to the languages of both music and art. Kandinsky claimed that when he saw color he heard music, and he believed passionately that art could have the same emotional power as music. He painted ten *Compositions*—all monumental in size; all carefully planned using preliminary studies; and all powerful celebrations of abstraction.

Composition VI takes the biblical Deluge as its theme, and its wild colors and swirling forms clearly suggest elemental forces. The artist wrote more fully about this painting than about any of his other works. Initially, he identified two centers: on the left, a "tender, pink, somewhat diffuse center with weak shaky lines in the middle;" and on the right, a little higher, "a coarse red-blue center, somewhat discordant, with sharp, strong, very precise and rather malevolent lines." He then mentioned a third center between them, closer to the left—while noting that this is less obvious than the others, he called it "the main center." Here, he described "pink and white froth" that seems to be "floating in air, surrounded by vapor."

Kandinsky's first three *Compositions* were destroyed during World War II, but black-and-white photographs of the completed works survive, along with some of his studies.

> ❝ I APPLIED **STREAKS** AND **BLOBS OF COLOR**... AND I **MADE THEM SING** WITH **ALL THE INTENSITY I COULD**... ❞
>
> Wassily Kandinsky

DADA AND SURREALISM

▷ **The Human Condition**
René Magritte 1933
*National Gallery of Art,
Washington, DC*
In explaining *The Human Condition*,
Magritte wrote: "In front of a
window seen inside a room, I
placed a painting covering exactly
that portion of the landscape
covered by the painting. Thus, the
tree in the picture hides the tree
behind it, outside the room. For the
spectator it is both inside the room
within the painting, and outside in
the real landscape." Although he
refers to the real landscape as
opposed to the painting, there is
actually nothing real here—Magritte
is toying with reality in true
Surrealist fashion.

Dada, a movement without governing principles, appeared around 1915 as a revolt against the civilization that had engulfed the world in war. The Dadaists sought to embody the absurd in their work on the basis that absurd art reflects an absurd society. Its leading exponents included Marcel Duchamp, Francis Picabia, and George Grosz. Dada was short-lived though, and during the 1920s, its ideas were absorbed into Surrealism, a linked movement that also questioned the status quo and the accepted notions of reality, as Magritte demonstrated in *The Human Condition* (*above left*). Surrealism concentrated less on random absurdity than Dada, and more on the fertility of the unconscious mind and its ability to forge a superior, or "*sur,*" reality. Magritte was a leading artist of the movement, along with Man Ray, Max Ernst, Salvador Dalí, and later practioners including Frida Kahlo.

◎ CONTEXT

The world turned upside down

World War I had a profound effect on most artists of the time, but more than any other movement, Dada was a direct reaction to the slaughter, propaganda, and inanity of the conflict and—by extension—to the society that allowed it to happen. The Dadaists were connected not by an artistic style, but by their rejection of what they saw as an uncontrolled fervor of idealism, nationalism, capitalism, and progress. They were also rebelling against tired artistic conventions, so they turned to unorthodox forms of expression. In an early Dadaist gesture, Marcel Duchamp developed the concept of the "ready-made"—an existing mass-produced object declared to be a work of art. One of his earliest and best-known ready-mades was a urinal, which he called *Fountain* (1917). In a sense, the founders of Dada saw themselves as non-artists creating non-art in a society where art was meaningless.

The Dada movement began to fall apart during the early 1920s at a time when it started to become acceptable, but some of its practitioners went on to become involved with Surrealism, which shared many of its frustrations, and played with reality in a similar way. Its founder, the French writer and poet André Breton, wanted to create a movement across the arts that was wider and more structured than the chaos of Dada. In 1924, he published his *Manifesto of Surrealism*, in which he described a movement that could "express…the actual functioning of thought." To this end, he focused largely on Sigmund Freud's study of the unconscious mind, as well as on his fascination with dreams. Freud himself had no sympathy with Surrealism, and had no wish to be connected with the movement. His ideas differed from those of the artists in one critical way—the key to Freud's obsession with dreams was his belief that, with sufficient skill and experience, psychoanalysts could interpret them to provide patients with profound insight and healing. For the Surrealists, dreams were a rich and complex source of artistic imagery in themselves.

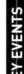

An era of global turmoil

▷ **1899** In his groundbreaking treatise *The Interpretation of Dreams*, Sigmund Freud sets out his theories of the unconscious mind. The book takes many years to gain respect, but later has a powerful influence on André Breton's *Manifesto of Surrealism*.

▷ **1914** World War I breaks out. Artists and intellectuals react to the scale of the carnage and destruction of the four-year conflict with a sense of alienation.

▷ **1918** A pandemic of Spanish flu spreads across the world, killing between 20 and 50 million people, including the Austrian painter Egon Schiele and the French poet and art critic Guillaume Apollinaire.

▷ **1925** John Logie Baird transmits the first television image in London, England. His invention leads to the most powerful mass-communication medium in history.

▷ **1933** The Nazi regime in Germany establishes a Culture Chamber under Joseph Goebbels. Only groups that are members of this chamber are allowed to be "productive in our cultural life."

▷ **1939** The UK, France, New Zealand, and Australia declare war on Germany, marking the beginning of World War II.

KEY EVENTS

❝ **THE SURREAL** IS BUT **REALITY** THAT HAS **NOT BEEN DISCONNECTED** FROM **ITS MYSTERY** ❞

René Magritte

Treating the unconscious mind
Austrian-born neurologist Sigmund Freud was the founder of psychoanalysis, the science of treating mental illness by exploring the relationship between the conscious and unconscious mind. Regular conversations between patient and psychoanalyst were key to this process—during his last years, Freud conducted such sessions in this London consulting room.

◎ BEGINNINGS
THE PATH TO ABSURDITY

Emerging from the horrors of World War I —"the war to end all wars"—Dada was the invention of a group of painters and poets who frequented the Cabaret Voltaire in Zurich. According to one theory, the name Dada was inspired by two Romanian artists who repeatedly expressed agreement by saying "*da, da*" ("yes, yes"). But some think Dada was just a suitably babyish word for a movement that embraced nonsense—it means "hobbyhorse" in French. However it got its name, the new movement soon spread to Berlin and further afield, embracing literature, theater, and graphic design, as well as art and poetry. Surrealism, Dada's successor, was a more rational expression of similar artistic and political sympathies, and its influence extended in the same way to include not only literature and drama, but also film, music, and political theory.

◎ TURNING POINT

Celebes
Max Ernst **1921** *Tate Modern, London, UK*

Produced during the transition period from Dada to Surrealism, *Celebes* is considered one of the first Surrealist paintings. The title comes from a childish German poem beginning, "The elephant from Celebes has sticky, yellow bottom grease." Ernst was fascinated by collage, with which he altered existing images and arranged bizarre juxtapositions. In this picture though, he used *trompe l'oeil* to create the impression of collage with his brush—the sinister elephant was inspired by a photograph of a huge, boilerlike Sudanese corn bin, and the portrayal of a living creature in this mechanical form makes it particularly disturbing. Setting it alongside a headless woman and an eyeless horned head gives the painting both the absurd qualities of Dada and the dream imagery of Surrealism. Ernst's first large canvas, *Celebes* was bought by a friend, the poet Paul Eluard.

◉ ARTISTIC INFLUENCES

While Dada and Surrealism took absurdity to an extreme degree, artists have always experimented with reality to create work that is rich in imagination and fantasy. Early in the 20th century, practioners of both movements found inspiration in works created by earlier masters of strangeness, from the disturbing Renaissance fantasies of Hieronymus Bosch, through to more contemporary oddities, such as Henri Rousseau's picture-book jungle scenes and Georgio de Chirico's strange, quasi-classical, landscapes.

◎ Max Ernst

born Brühl, Germany, April 2, 1891;
died Paris, France, April 1, 1976

Born into a middle-class family of nine children, Max Ernst learned about painting from his father, but he never had formal training. After studying psychology and philosophy in college, he fought in the German army during World War I —the horrors of his experience had a profound effect on his work, which often depicted absurd or apocalyptic scenes. In 1922, Ernst moved to France, becoming a leader of the Surrealist movement, and developing the technique of frottage (rubbing paper with a pencil over a textured surface) as a random device for exploring the unconscious mind. During World War II, he escaped to New York, where he did much to inspire and shape the American avant-garde movement that became Abstract Expressionism. In 1953, he returned to France, where he lived until his death.

BIOGRAPHY

Hieronymus Bosch has been called the original Surrealist, but he was more a painter of nightmares than of dreams, as illustrated in his ambitious triptych *The Garden of Earthly Delights*.

Detail from Bosch's *The Garden of Earthly Delights*, c.1500, is part of a panel thought to portray Hell. *Museo del Prado, Madrid, Spain*

Henri Rousseau's paintings of exotic landscapes have a dreamlike quality that appealed to the Surrealists. Rousseau never saw a real jungle, only tropical plants in a botanical garden.

The Assault of the Jaguar, 1910, by Rousseau features a fairy-tale horse under attack in fantasy foliage. *Pushkin Museum of Fine Arts, Moscow, Russia*

Giorgio de Chirico invented Metaphysical Painting, which had a strong influence on Surrealism. *The Soothsayer's Recompense* is one of a series with a lone statue in a classical piazza.

The Soothsayer's Recompense, 1913, by de Chirico, uses a steam train to play with the concept of time. *Philadelphia Museum of Art, PA*

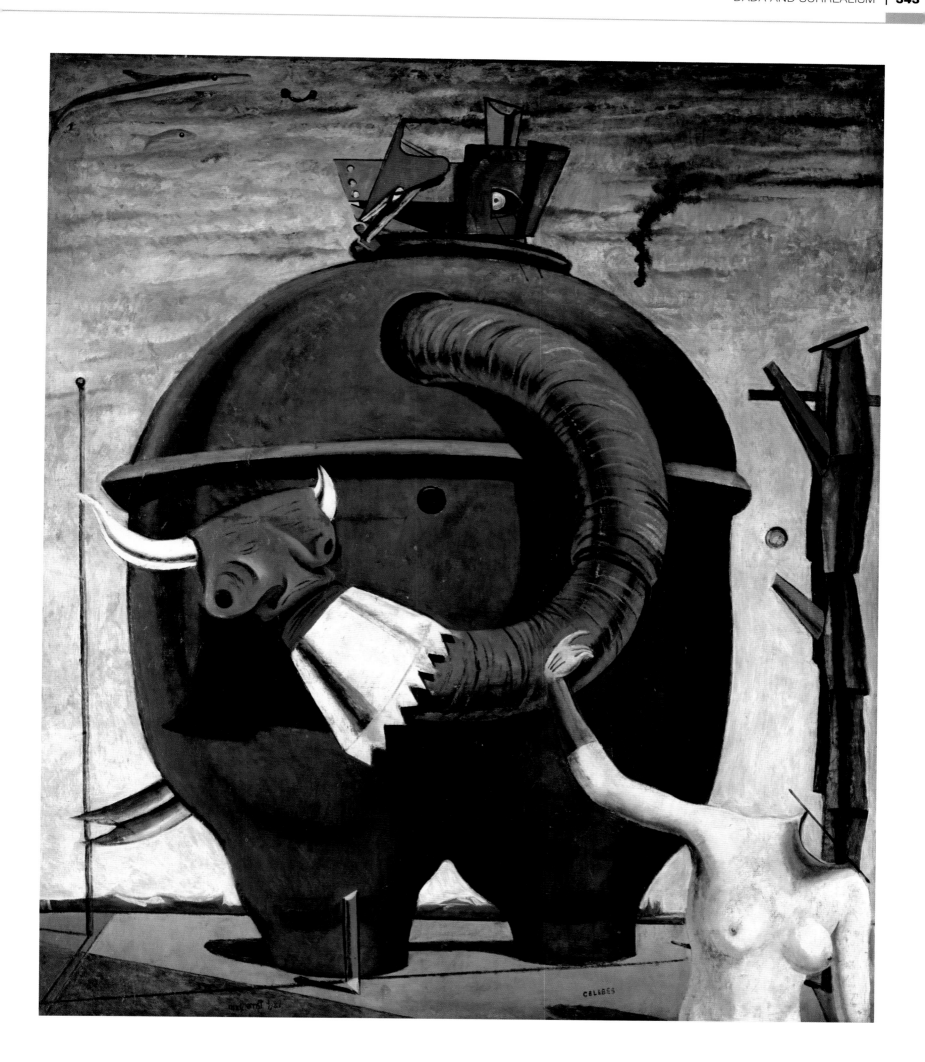

◎ TIMELINE

The Dada movement was extreme, but short-lived. It started around 1915—a year before German writer and performer Hugo Ball read out a *Dada Manifesto* in Zurich. The movement lasted until the early 1920s, when many of its proponents turned to the more positive concept of Surrealism. Centered in Paris, Surrealism spread further than Dada, and it lasted longer. As an organized movement, it did not survive much longer than World War II, but its influence endured. In particular, the work of the Surrealists directly influenced the birth of Abstract Expressionism.

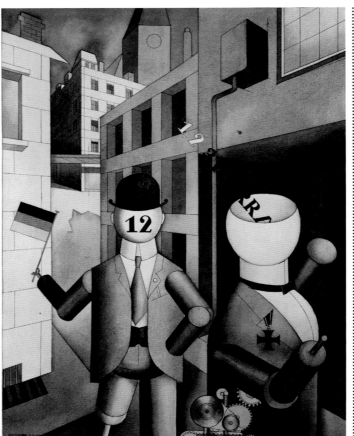

◁ **Republican Automatons**
George Grosz 1920
MoMA, New York City, NY
Grosz was a leading member of the Berlin Dada group. He produced images of acute social and political satire that feature faceless figures with hooks for hands and gears for souls. In *Republican Automatons*, one figure wears a bowler hat, the other an Iron Cross.

Traveling show
In 1918, German writer Richard Huelsenbeck founds a Dada group in Berlin, and in April, publishes a second *Dada Manifesto*.

New blood
The Zurich Dada group, reinforced by the arrival of Francis Picabia in 1919, carries on attracting attention and making headlines for another year.

The end of nonsense
By 1923, Dada activity, concentrated in Paris, is dying out—Picabia has abandoned it, and many other Dada artists are increasingly attracted to the new movement being formed by André Breton—Surrealism.

1917 **1919** **1921** **1923**

A wave of change
In 1922, in Barcelona, André Breton makes a speech denouncing Dada as "insolent in its negation" and "offensive in its style."

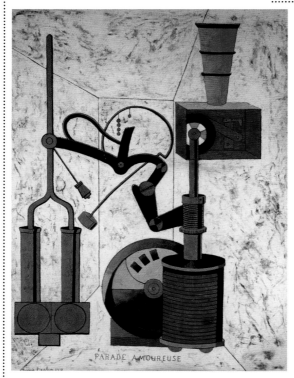

△ **Parade Amoureuse**
Francis Picabia 1917 *Private Collection*
Born in Paris, Picabia experimented with several artistic styles before taking up Dada at its outset. This work dates from his "machinist" or "mechanomorphic" period. He later rejected Dada and, in turn, Surrealism.

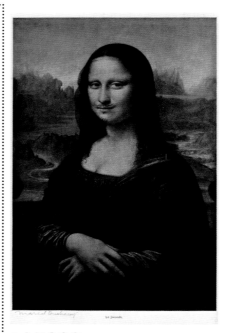

△ **L.H.O.O.Q.**
Marcel Duchamp 1919
Private Collection
This "rectified ready-made" is a postcard of Leonardo's *Mona Lisa* with added moustache, beard, and inscription. In English, the letters of its title spell "Look" phonetically, while in French, reading the letters out loud forms a lewd sentence.

◎ Joan Miró

born Barcelona, Spain, April 20, 1893; **died** Palma de Mallorca, Spain, December 25, 1983

Born in Catalonia, Miró studied art in Barcelona, and from 1919 he spent much of his time in Paris. Although he signed the 1924 Surrealist manifesto, he never allied himself with this, or any other, movement. During the Spanish Civil War (July 1936–April 1939), Miró designed posters for the anti-Franco forces, and during the 1940s he began to work in the fields of sculpture and ceramics, creating a number of murals including, in 1958, *Wall of the Sun* and *Wall of the Moon* for the UNESCO Building in Paris. In 1972, he opened the Joan Miró Foundation in Barcelona, donating a huge body of work including around 240 paintings, 175 sculptures, and 8,000 drawings.

BIOGRAPHY

MOVIE MAGIC

The Surrealists were fascinated by cinema, a medium in which the world could be refashioned inside a darkened room. Funded by wealthy patrons, a few enduring Surrealist films were created, such as Luis Buñuel and Salvador Dalí's *Un Chien Andalou* (1929) and Jean Cocteau's *The Blood of a Poet* (1932).

In this scene from *The Blood of a Poet*, photographer Lee Miller plays a statue that comes to life.

Deutschland Deutschland über Alles ▷
John Heartfield 1929
Private Collection
A photomontage artist strongly influenced by Dada, John Heartfield (born Helmut Herzfeld in Berlin) produced this anti-Nazi cover illustration for a volume of pictorial satire by the Jewish journalist Kurt Tucholsky.

Dream dog
Over a period of ten days in March 1928, filmmaker Luis Buñuel and artist Salvador Dalí shoot the first Surrealist film, a plotless dream narrative called *Un Chien Andalou*. It was released the following year.

A new reality
In 1924, André Breton publishes his first *Manifesto of Surrealism*, setting out principles intended to apply to both art and life in general.

Words and pictures
In 1927, René Magritte publishes an essay entitled "The Word and the Image," in which he explains their relationship using simple sketches. From this time, he begins to incorporate words into his paintings.

1925 **1927** **1929**

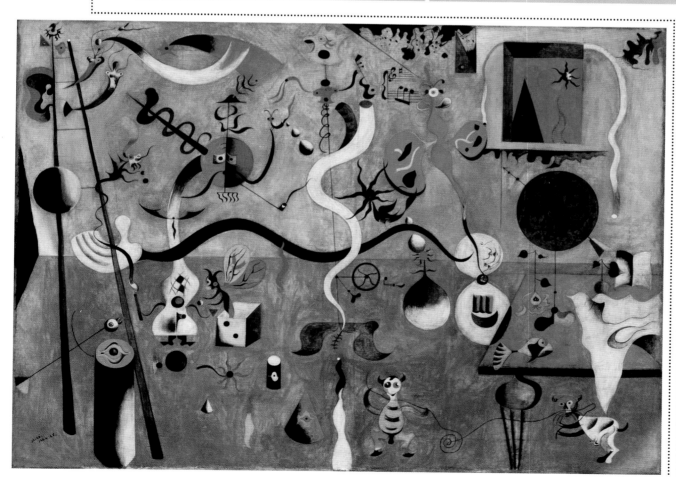

> ❝ **THE WORKS** MUST BE **CONCEIVED WITH FIRE** IN THE **SOUL**, BUT **EXECUTED WITH CLINICAL COOLNESS** ❞
>
> Joan Miró

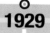

◁ Carnival of Harlequin
Joan Miró 1924–25
Albright-Knox Art Gallery, Buffalo, NY
In this portrayal of the *commedia dell'arte* clown, Miró paints him as a guitar, with a signature diamond motif on his body, and an admiral's hat on his head. All around him, strange creatures and inanimate objects are dancing, jumping, singing, and generally celebrating the Mardi Gras festival of the title. According to Miró, the black triangle seen through the window represents the Eiffel Tower.

Frida Kahlo

born Coyoacán, Mexico, July 6, 1907;
died Coyoacán, July 13, 1954

Born to a German-Jewish father and a Spanish-American Indian mother, Kahlo contracted polio when she was six years old. At the age of 18, she was involved in a bus accident—her spine was broken, her legs and pelvis were shattered, and a railing pierced her abdomen. She spent the rest of her life in pain, enduring grueling operations. During her initial recovery, Kahlo discovered painting, and she turned for advice to the respected muralist Diego Rivera. In 1929, they entered into a troubled on-off marriage, during which Kahlo produced a series of disturbing self-portraits, all reflecting profound physical or emotional pain. During their time together, Rivera was much better known than his wife, but during the 1980s she emerged from his shadow and gained international recognition of her own.

The Two Fridas ▷
Frida Kahlo 1939
Museo de Arte Moderno, Mexico City, Mexico
Kahlo's images are often based on her dreams, and many of them involve the physical damage and heartbreak she suffered throughout her life. In this double self-portrait, both hearts are exposed—the left one is broken and bleeding from her recent divorce, while the right one is whole, as if her husband still loved her.

Defeated by war
The outbreak of World War II in 1939 marked the effective breakup of the Surrealist movement, since many of its leading figures escaped the conflict by taking up residence in the United States.

> ❝ I PAINT **BECAUSE I NEED TO**, AND I PAINT **WHATEVER PASSES THROUGH MY HEAD** WITHOUT **ANY OTHER CONSIDERATION** ❞
>
> Frida Kahlo

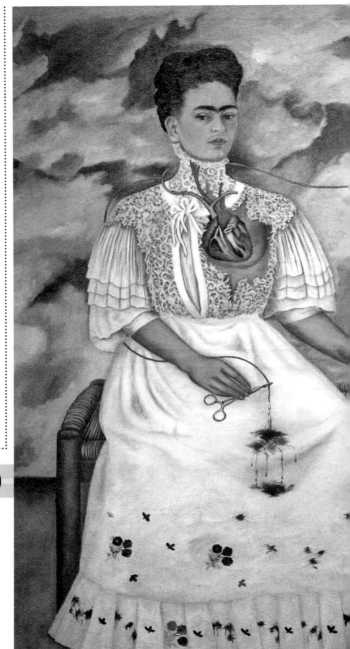

1930 **1935** **1940**

Art and life
In 1932, André Breton publishes a book called *Communicating Vessels*, in which he attempts to explain how Surrealist ideas could be used to aid recovery from depression.

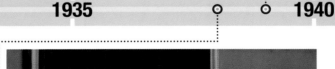

Time Transfixed ▷
René Magritte 1938
Art Institute of Chicago, IL
Magritte had a particularly disturbing talent for placing the commonplace next to the strange. In this domestic setting, a mantel clock sets the theme of passing time, while, barreling out of the wall, a steam engine freezes in motion.

René Magritte

born Lessines, Belgium, November 21, 1898;
died Brussels, Belgium, August 15, 1967

Born in rural Belgium, Magritte studied at the Académie Royale des Beaux-Arts in Brussels. Under the influence of Giorgio de Chirico, he began to work in the Surrealist style and produced his first important painting, *The Menaced Assassin*, in 1926. From 1927 to 1930, he worked with the Surrealists in Paris, but fell out with André Breton and returned to Brussels, where he remained for the rest of his life, producing an impressive body of Surrealist work.

▽ Difficult
Kurt Schwitters 1942–43
Albright-Knox Art Gallery, Buffalo, NY
A Dada-like artist flying solo long after
the movement had died, German-born
Schwitters is best known for creating
collages—pictures made from torn paper,
bus tickets, cigarette wrappers, string,
and other often discarded materials.
He gave his work a special name, *Merz*,
derived from a fragment of printed words
he used in one of these images.

THE FACE OF SURREALISM

Having become a Surrealist in 1929,
Salvador Dalí continued to engage
enthusiastically with popular culture,
designing jewelry, books, and furnishings in
that idiom throughout his life. One of his most
iconic pieces, dating from the late 1930s, is
a sofa called *Mae West's Lips*, inspired by
the Hollywood actress, Mae West.

Mae West's Lips, **a sofa designed by
Salvador Dalí**

Merz no more
In January 1948, Kurt Schwitters dies in
England, where he had fled to escape
the war. The day before his death, he
was granted British citizenship.

1945 **1950**

Rude reference
As an antidote to the grimness of
occupied Europe in 1943, René Magritte
finds unlikely inspiration in the work of
Auguste Renoir, producing the pastoral
Ocean, a vaguely obscene homage to
Renoir's *Young Shepherd in Repose*.

Death of a Surrealist
In 1944, Felix Nussbaum, a German-Jewish
Surrealist, dies in Auschwitz concentration
camp. He and his wife had taken refuge
from the Nazis in Belgium, but they were
eventually arrested and imprisoned.

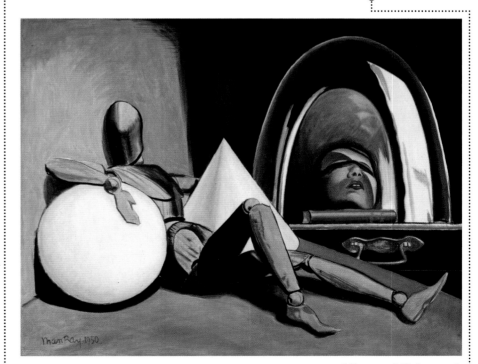

Aline and Valcour △
Man Ray 1950 *Private Collection*
Painter, photographer, and filmmaker Man Ray was the only
American to be involved with both Dada and Surrealism.
Named after an erotic novel by the Marquis de Sade, this
image features motifs from the artist's past work, including
the unsettling figure of the jointed mannequin, the geometric
forms, and the severed, blindfolded head.

◎ MASTERWORK

The Persistence of Memory

Salvador Dalí **1931**
MoMA, New York City, NY

Possibly the most famous of all Surrealist paintings, *The Persistence of Memory* takes time as its theme, featuring melting pocket watches that symbolize flowing eternity. Ants crawling on one of the watches convey the idea of decay and death, while the rocks and cliffs (modeled on those near Dalí's home in Catalonia, Spain) suggest life's hard reality. The monstrous face is drawn from the artist's own profile.

Dalí deliberately rendered his fantastical visions with exquisite precision and clarity—he called his paintings "hand-painted dream photographs." Yet he never clearly explained their meaning—when he was asked to comment on one critic's view that this work alludes to Einstein's Theory of Relativity, he replied that it was actually a Surrealist vision of Camembert cheese melting in the heat of the Sun.

Dalí's talent for flamboyance and self-publicity— in 1936, he appeared in a diving suit at the opening of the London Surrealist Exhibition—brought him fame far beyond the world of art. As well as paintings, he produced work in the fields of sculpture, book illustration, jewelry and furniture design, and filmmaking. He also wrote a novel, *Hidden Faces* (1944), and produced several volumes of exuberant autobiography. In Dalí's hometown of Figueras in Spain, a museum devoted to his work has become a major tourist attraction, and there are several other Dalí museums around the world, including a large one in St. Petersburg, Florida.

> WHAT IS **IMPORTANT** IS TO **SPREAD CONFUSION**, NOT ELIMINATE IT 🙿
>
> Salvador Dalí

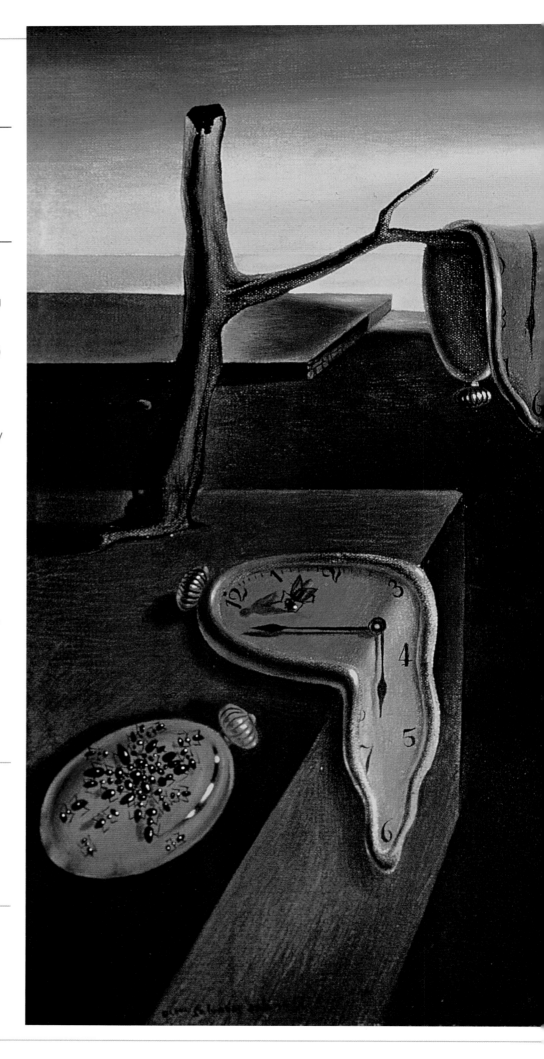

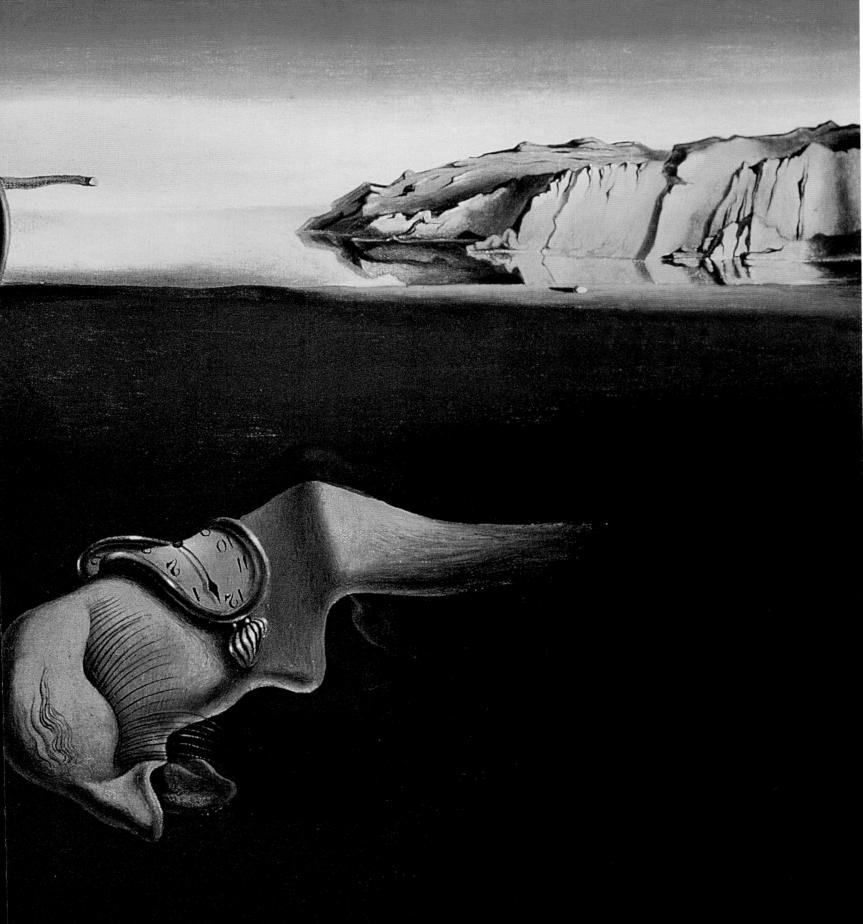

ABSTRACT EXPRESSIONISM

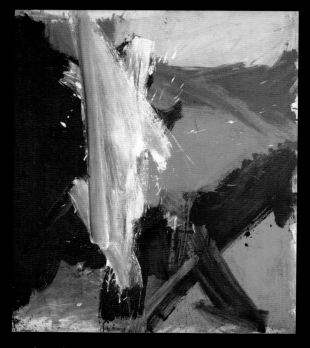

‣ Merritt Parkway
Willem de Kooning 1959
Detroit Institute of Arts, MI
Unlike many Abstract
Expressionists, Dutch-born de
Kooning found inspiration in the real
world—the Merritt Parkway is a
scenic thoroughfare that runs
through Long Island in New York
state, where he was living at the
time. The straight, slashing
brushstrokes suggest speed, while
his limited color palette represents
sky, sun, grass, earth, and water.

Abstract Expressionism is not always abstract, nor necessarily expressive. The name was applied to it by the American critic Robert Coates in 1946, several years after the movement appeared (though the term had been used as early as 1919 in relation to the work of Wassily Kandinsky). The Abstract Expressionists themselves preferred "New York School" as a group name, largely because they were united not by one cohesive style, but by a general attitude—their work was heavy with moral themes and profound emotions, and they placed a high value on individuality, freedom of expression, and spontaneous improvisation, often interpreted on huge canvases. Despite the movement's name, the influence that most shaped it was Surrealism, with its emphasis on intuition and universal themes. The major figures involved, among whom were the first generation of American artists to achieve worldwide acclaim, include Willem de Kooning (his powerful *Merritt Parkway* is shown *above left*), Mark Rothko, Jackson Pollock, Barnett Newman, Arshile Gorky, and Clyfford Still.

◎ CONTEXT

The age of America

Many of the Abstract Expressionists were born in the US around the time of World War I, and grew up during the Great Depression in the 1930s. Some began their careers as figurative painters working in the vein known as Social Realism, the main subject of which was the hardship and suffering so many Americans endured at that time. Most were even supported by the US government's Works Progress Administration (WPA), which funded a special program, the Federal Art Project (FAP). Later though, in the early 1940s, these artists wanted a new form of expression—one that was profound, meaningful, and original, yet free of politics and provincialism.

At the same time, the US (and particularly New York City, where many artists lived) was attracting leading figures in European modernism escaping from World War II. Among these were Salvador Dalí, Max Ernst, André Masson, Piet Mondrian, and Fernand Léger.

Another immigrant of major importance was the painter and teacher Hans Hofmann, who had arrived earlier, in 1932. Also in New York City, the work of modern artists was exhibited increasingly widely, so American painters were able to learn from it and to be inspired in their search for a new idiom.

By the second half of the 1940s, the US had played a decisive role in two world wars, it was rich in natural resources, it had a huge labor pool to draw on that was enhanced by constant immigration, and its economy was stable and strong. The country was emerging as a great world superpower at the same time that Abstract Expressionism—the first truly American avant-garde idiom—was born. The new movement became one of the most important artistic developments of the postwar era, and it helped New York to replace Paris as the world center of contemporary art—a position that it still maintains.

◎ Fall and rise of a superpower

▷ **1929** The US stock market has become increasingly inflated, and on Black Tuesday—October 29, 1929—stock prices plummet and prices collapse, contributing to the Great Depression.

▷ **1935** Established by President Franklin D. Roosevelt, the US government's Works Progress Administration (WPA) creates jobs in huge quantities for the unemployed.

▷ **1939** The Museum of Non-Objective Art opens in New York City to display the collection of philanthropist Solomon R. Guggenheim. It reopens in 1959 in a new building designed by Frank Lloyd Wright that bears the name of its benefactor.

▷ **1945** Peace is declared at the end of World War II. US involvement in the Allied victory later helps it to become a world superpower in the postwar era.

▷ **1950** US involvement in the war against communism in North Korea—which leads to the death of 5,000,000 people—inspires a sense of profound alienation in many Americans, including the morally conscientious Abstract Expressionists.

KEY EVENTS

 I PAINT THE WAY I DO BECAUSE I CAN **KEEP ON** PUTTING **MORE AND MORE THINGS** IN —LIKE **DRAMA**, PAIN, **ANGER**, LOVE, **A FIGURE**, A HORSE, **MY IDEAS OF SPACE** 🙶

Willem de Kooning

Inspired by suffering
During the 1930s, poor farming practices and drought in the American Midwest led to the Dust Bowl period. One of the causes of the Great Depression, it inspired works of art including Social Realist paintings and John Steinbeck's classic novel *The Grapes of Wrath*.

 BEGINNINGS

BROTHERS IN ART

During the late 1930s, many American artists working in New York felt almost overwhelmed by their exposure to modern European art. By the 1940s, though, a few of them had gained the confidence to develop a new language of painting that reflected the United States. Although they shared a common purpose, each member of the group had his own style: Jackson Pollock developed his drip technique; Mark Rothko worked in large, soft-edged blocks of color; and Arshile Gorky explored fluid, organic shapes.

In 1950, a group of them wrote to the Metropolitan Museum of Art in New York City, protesting against its anti-abstraction bias. In the next year they posed for a photograph in *Life* magazine, in which they were labelled "the Irascibles."

Clement Greenberg, a leading American art critic of the postwar era, was an enthusiastic champion of the new movement, and he coined a name for it that highlights its essentially New-World character—"American-Type Painting." Abstract Expressionism, however, was the name that stuck.

> WHEN SOMETHING IS **FINISHED, THAT MEANS IT'S DEAD**, DOESN'T IT? I BELIEVE IN **EVERLASTINGNESS**. I **NEVER FINISH A PAINTING**—I JUST **STOP WORKING ON IT FOR A WHILE**

Arshile Gorky

◉ ARTISTIC INFLUENCES

Living in New York during the 1930s, the painters who became known as Abstract Expressionists were hungry for exposure to the best of modern European art, which was increasingly on show in the city. While most of these artists had begun their careers producing figurative work, they were inspired to forge a new movement by their exposure to Cubism, Expressionism, and most of all, Surrealism.

Social Realism is a broad term for art that comments on social conditions. Many Abstract Expressionists began by creating work in this figurative idiom, illustrated in the work of the Mexican painter José Clemente Orozco, who specialized in bold murals.

The Epic of American Civilization, detail, 1932–34, from Orozco's 24-panel fresco. *Dartmouth College, Hanover, NH*

Carl Jung believed in a collective unconscious —a pool of instincts and archetypes that is universal, and common to all humans. This concept was central to the Surrealists, and later to Abstract Expressionists, who used such symbols in their work.

Swiss psychologist and psychiatrist Carl Jung (1875–1961), photographed here in 1922, five years after developing his theory of the collective unconscious.

Surrealism had a strong influence on the Abstract Expressionist movement. The bright colors and organic forms in Roberto Matta's paintings are evident in the work of Gorky in particular, and Matta also worked with Jackson Pollock.

Psychological Morphology, 1938, by Matta depicts the fantasy scenes and biomorphic shapes typical of many Surrealist works. *Private Collection*

Hans Hofmann, a German-born painter and teacher, was one of the major postwar influences on American art. In Paris, he had known Picasso, Matisse, and Braque, and acquired a profound understanding of their work that he passed on to his students.

Landscape, 1940, by Hofmann displays exuberant color and brushstrokes that echo Expressionism and look to Abstract Expressionism. *Private Collection*

◎ TURNING POINT

Water of the Flowery Mill

Arshile Gorky **1944** *MoMA, New York City, NY*

During the early 1940s, Gorky evolved a painting style that combined the watery, organic abstraction of Surrealism with the powerful brushwork of Abstract Expressionism; the visible drips in *Water of the Flowery Mill* reflect the way the Surrealists cultivated accident and randomness as a key to the unconscious. The image was inspired by the remains of an old mill and bridge on the Housatonic River in Connecticut.

◎ Arshile Gorky

born Khorkom, Armenia [now in Turkey], c.1902;
died Sherman, CT, July 21, 1948

Born Vosdanig Adoian in an Armenian province of Turkey, Gorky arrived in the US in 1920. Although he attended art school in New York, he was largely self-taught, taking inspiration from Cézanne, Picasso, and Miró. Later, he met Surrealists André Breton and Roberto Matta, both of whom influenced his mature style. During the mid-1940s, Gorky suffered a series of personal tragedies that led him to commit suicide.

BIOGRAPHY

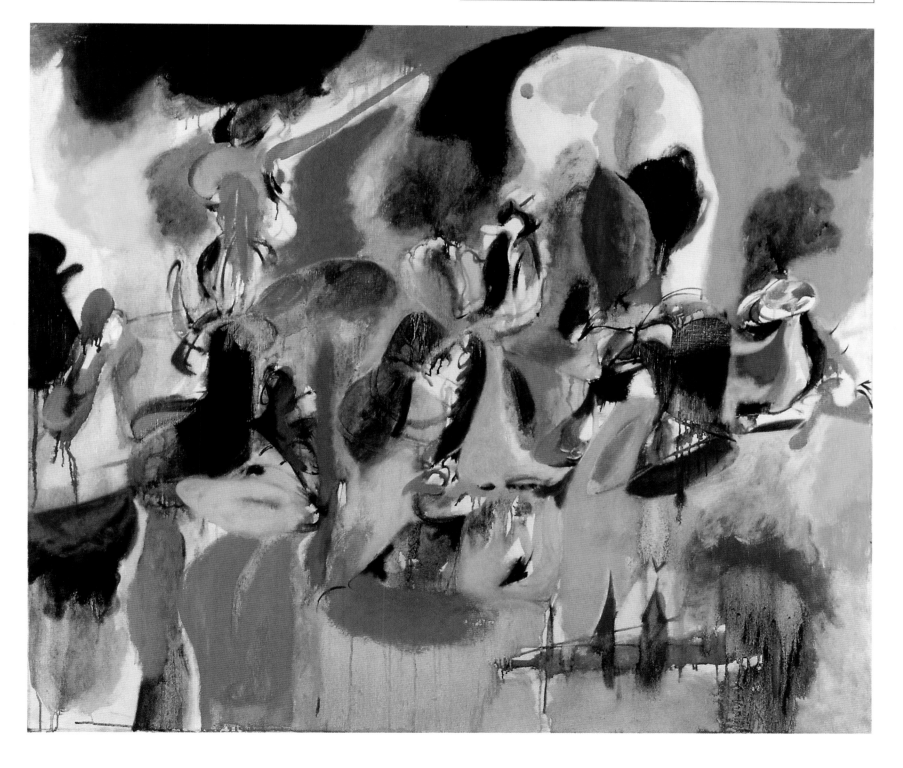

◎ TIMELINE

The Abstract Expressionists
painted powerful, large-scale works of art that were inspired by personal experience and emotions. By the late 1950s, however, the movement was no longer at the center of the art world, and its concepts were failing to inspire the new generation of artists. Nevertheless, important work in this idiom continued to be produced, and many experts consider Abstract Expressionism to be the most significant art movement since World War II.

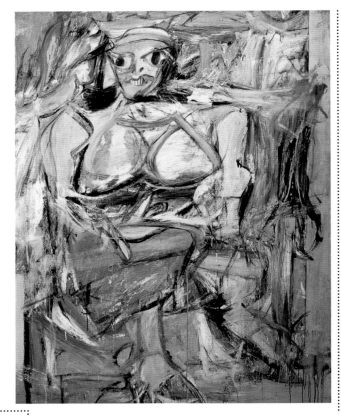

❝ I'M **NOT INTERESTED** IN THE RELATIONSHIP OF **COLOR**, OR **FORM**, OR **ANYTHING ELSE**. I'M INTERESTED **ONLY IN EXPRESSING BASIC HUMAN EMOTIONS** ❞

1956 | Mark Rothko

◁ **Woman 1**
Willem de Kooning 1950–52
MoMA, New York City, NY
De Kooning's shifts between abstraction and figuration show that the distinction between them was becoming less important. Featuring his typically aggressive brushwork and dramatic colors, this intimidating image—it measures about 6 x 5ft (190 x 150cm)—reflects eternal male ambivalence between reverence for women and fear of them.

Flying high
During 1936 and 1937, under the US Federal Art Project program, Arshile Gorky produces a series of ten mural panels documenting the history of aviation for Newark Airport in New Jersey. Today, only two survive.

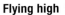

1930 **1935** ○ **1940** **1945** ○ ○ **1950** ○

The eyes of babes
In 1929, Mark Rothko takes a part-time job teaching in a Jewish school in New York (a position he holds until 1952). He later claimed to learn a great deal from children's ability to communicate in simple visual terms.

Onement 1 ▷
Barnett Newman 1948
MoMA, New York City, NY
Originally an amateur figurative artist, Newman gave up painting in his thirties, but a few years later, inspired by Surrealism, he took it up again. *Onement 1*, his breakthrough work, established his signature device—a vertical band, or zip that both divides and unites the composition.

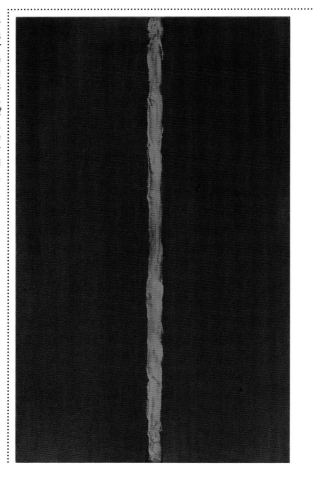

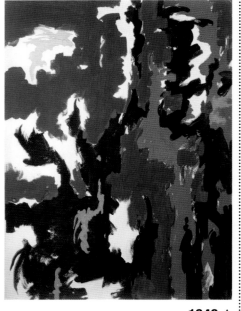

1949 △
Clyfford Still 1949
Private Collection
A pioneer of Abstract Expressionism, Still ground his own pigments, applying them thickly to the canvas in jagged forms using both a palette knife and a brush. Although he claimed, "I paint only myself, not nature," his images often suggest primordial landscapes.

◎ Barnett Newman

born New York City, NY, January 29, 1905;
died New York, July 4, 1970

The son of Polish immigrants, Newman attended classes at the Art Students League in New York, but also earned a degree in philosophy at City College. After college, he worked at several jobs before taking up painting again in 1944. In 1950 he had his first one-man show at the Betty Parsons Gallery, but did not achieve major success until the final decade of his life. As well as paintings, Newman also produced lithographs and sculptures, and wrote perceptively about modern art.

BIOGRAPHY

Violet Center ▷
Mark Rothko 1955
Private Collection

One of the foremost artists of his generation, Russian immigrant Mark Rothko produced canvases defined by formal elements such as shape, color, balance, depth, composition, and scale. Like many of his mature works, *Violet Center* expresses intense emotion using stacked, soft-edged rectangles of pure, luminous color.

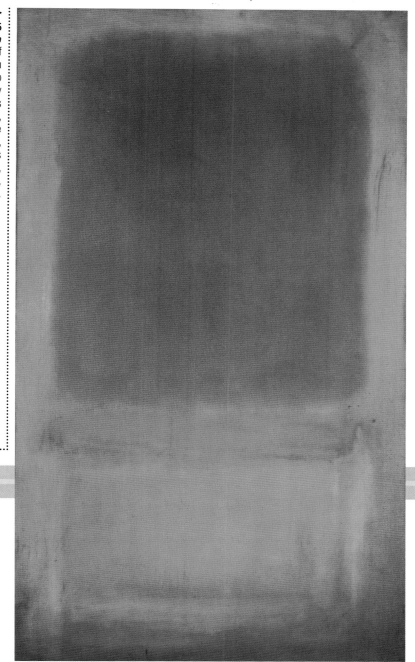

Bastos ▽
Robert Motherwell 1975 *National Gallery of Australia, Canberra, Australia*

American-born Motherwell was an inventive printmaker as well as a painter. In this lithograph (based on a collage) he creates a dynamic composition around a Corsican cigarette packet.

1955

1970

1975

Art for the few
In 1958, Mark Rothko agrees to create a series of paintings for a restaurant in New York's Seagram Building. He later withdrew, declaring the luxury space to be inappropriate for his art.

△ Gray Scramble (Single)
Frank Stella 1969
Private Collection

In his very early work, Stella was an Abstract Expressionist, but he moved into a linked style known as "Post-Painterly Abstraction," which rejected emotional gesture in favor of emphasizing paintings as "flat surfaces—nothing more." Early examples of his concentric squares (which echo the contemporary Op-art idiom) feature either colors or tones of gray—here he scrambles them.

FIRST SHOWING

In October 1942, art patron and dealer Peggy Guggenheim opened her Art of This Century gallery in New York. The gallery exhibited many works by artists in her own collection, including Cubists, Surrealists, and abstract painters. It was also one of the first galleries to champion Abstract Expressionism. The interior design (by gallery architect Frederick Kiesler) was unique, with concave walls and canvases that protruded into the interior as if they were floating in space.

A model of the Art of This Century gallery, created for an exhibition at London's Victoria and Albert Museum in 2007

CONTEXT

◎ MASTERWORK

Number 1 (Lavender Mist)

Jackson Pollock **1950**
National Gallery of Art, Washington DC

Born in Wyoming in 1912, Pollock moved to New York in 1929 and studied there at the Art Students League. He began as a figurative painter, and figurative elements reappear later in his career, but for several years Pollock created and explored a unique abstract style that assured his place as the leading figure in Abstract Expressionism.

During the Great Depression, Pollock was employed by the Federal Art Project along with Rothko, de Kooning, Gorky, and others. (At various times, they all worked on large murals, which may have inspired the vast scale of much Abstract Expressionist work.) In 1943, Peggy Guggenheim arranged his first one-man show at her Art of This Century gallery (*see p.355*), but Pollock did not develop his signature drip technique until 1947. This radical innovation involved laying a canvas on the floor, then using sticks and brushes to throw, dribble, and splatter paint onto it in complex threads and layers, with no discernible focal point or formal composition. Although this process appeared random and spontaneous, it was very controlled. "There is no accident," Pollock insisted.

Number 1 (Lavender Mist) is one of Pollock's most important and impressive works, considered a landmark in the history of Abstract Expressionism. Its powerful visual rhythms and ravishing atmosphere were created by the intricate marbling of enamel paint in black, white, and subtle hues of gray and salmon pink.

Pollock was married to the painter Lee Krasner, and settled with her on Long Island, New York, where he was killed in a car accident in 1956.

❝ **THE PAINTING** HAS A **LIFE OF ITS OWN**. I TRY TO **LET IT COME THROUGH** ❞

1947–48 | Jackson Pollock

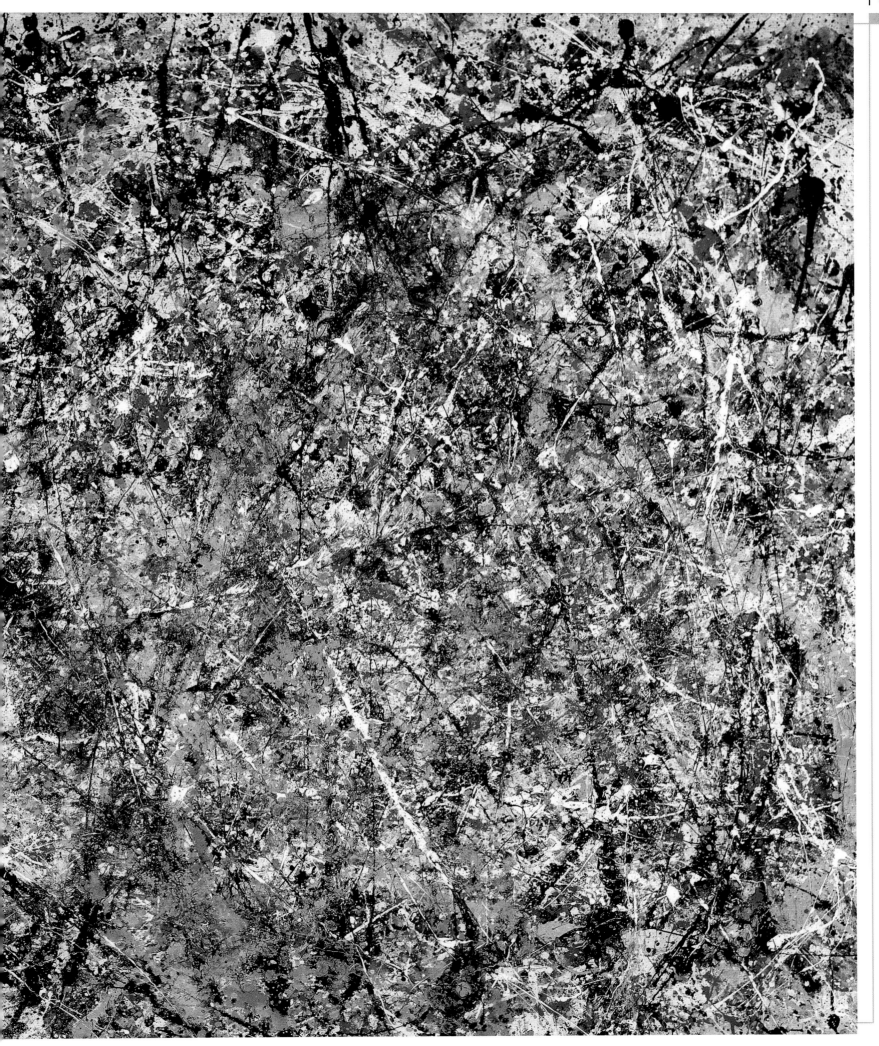

POP AND OP ART

▷ **Gallery Gasper**
Allen Jones 1966–68
Private Collection
A leading figure in the development of Pop art, Allen Jones specialized in hyper-glamorous female figures, often posing in high-heeled shoes. Drawing on the precise, linear style of illustrations from the 1940s and '50s, he created his own distinctive, provocatively erotic style within the Pop-art movement.

Pop artists set out to dismantle the barriers between fine art and popular culture. Emerging in the mid-1950s, they drew on all the exciting images that appeared after World War II—in films, magazine and book illustrations, comics, packaging, and advertising. The Pop-art movement originated in Britain, with a group of artists that included Richard Hamilton, Eduardo Paolozzi, and Allen Jones (best known for his provocative female subjects in the style of advertising graphics—*see above*), who broadened the scope of art to include work that was not formal and academic, but bright, fresh, and accessible. As the 1960s dawned, American Pop art emerged, with its emphasis on technology and mass production. Leading figures such as Roy Lichtenstein and Andy Warhol not only used consumer items as their subjects, but also used mechanically made prints as a major medium. Op art was a term coined in 1964 to describe a kind of abstraction that sought to dazzle or create the effect of movement. Both Pop and Op art reached a wide audience and exerted a strong influence on the worlds of design and fashion.

◎ CONTEXT

Swinging toward the future

Pop art was rooted in postwar prosperity and optimism. Although it began in the 1950s, the movement flowered in the social revolution of the 1960s, when fashion and music dominated a culture that was soon labeled as "swinging," particularly in London, where the movement first flourished. Wartime rationing had ended, the economy was booming, and everything was oriented toward youth: teenagers and young adults were no longer waiting to grow up to join the mainstream—they *were* the mainstream. And, more than at any other time, this new elite came from every class—high-born socialites mixed with actors and musicians, and fashionable artists and photographers were just as likely to be working-class as titled—barriers of every kind were beginning to be broken down.

On both sides of the Atlantic, greater affluence brought increased access to popular culture in the form of television sets as standard household items; newsstands stacked with colorful magazines; supermarkets piled high with alluring packaging; and cinemas showing a seemingly endless stream of glossy films with even glossier, picture-perfect stars. In this new economic and cultural democracy, popular images saturated everyday life to such an extent that the images themselves were now displayed as art, ready to compete with Old Masters for public attention.

In his famous 1957 definition of what Pop art meant to him, the influential British artist Richard Hamilton, one of the movement's pioneers, clearly drew a link with the thrilling new world it inhabited: "Popular (designed for a mass audience); transient (short-term solution); expendable (easily forgotten); low cost; mass produced; young (aimed at youth); witty; sexy; gimmicky; glamorous; and last but not least, Big Business."

◎ A changing, popular culture

▷ **1954** Bill Haley and His Comets release "Rock Around the Clock." This was not the first rock and roll record, but it is widely acknowledged as the one that brought rock and roll into the international mainstream, ushering in the youth culture of the 1950s and '60s.

▷ **1958** A best-selling book, *The Hidden Persuaders*, by American journalist and social critic Vance Packard, exposes the psychological manipulation involved in all forms of advertising.

▷ **1958** The importance of television in popular culture is underlined when Pope Pius XII names Clare of Assisi as the medium's patron saint.

▷ **1960** A Woolworth's lunch counter in North Carolina agrees to serve a black customer. This marks an early milestone in the demolition of another cultural boundary.

▷ **1963** After the American president John F. Kennedy is assassinated, Andy Warhol responds by creating an iconic Pop-art portrait of his wife, Jackie.

KEY EVENTS

A world of dreams
In the ideal kitchens of 1950s' advertisements, décor was fashionably modern, food was plentiful, equipment was sleek and labor-saving, and housewives were perfectly groomed at all times.

❝ **I LOVE** LOS ANGELES. I LOVE **HOLLYWOOD.** **EVERYBODY'S PLASTIC,** BUT **I LOVE PLASTIC.** I WANT TO **BE PLASTIC** ❞

Andy Warhol

◎ BEGINNINGS
INDEPENDENT SPIRITS

In the dowdy postwar London of 1952, a group of artists, architects, and writers met occasionally at the Institute of Contemporary Arts (ICA) to discuss the effect developments in science and technology had on contemporary art—they called themselves the Independent Group. From these discussions, they developed the interest in mass culture that inspired the beginnings of the Pop-art movement. The group disbanded in 1955, but one of its members, writer and critic Lawrence Alloway, is often credited with coining the term Pop art.

◎ TURNING POINT

Just What is it that Makes Today's Homes So Different, So Appealing?
Richard Hamilton **1956** *Kunsthalle, Tübingen, Germany*

In 1956, architect and writer Theo Crosby—with former members of the Independent Group—organized an exhibition at London's Whitechapel Art Gallery called "This is Tomorrow." Taking modern living as its theme, the event showcased artworks and installations that involved collaboration between artists and architects. One image that featured in the catalog and on an exhibition poster was Richard Hamilton's collage, *Just What is it that Makes Today's Homes So Different, So Appealing?*, widely considered the first fully fledged work of Pop art. Taking its title from an American magazine advertisement, it references virtually all the elements of popular culture that inspired the movement. The work depicts a living room full of cardboard cutout people and furnishings, a comic book, packaging, television and advertising graphics, and modern appliances. Visible through the window can be seen a cinema showing the first film talkie, *The Jazz Singer,* starring Al Jolson.

Richard Hamilton

born London, UK 24 February 1922;
died London 13 September 2011

A highly influential painter, printmaker, teacher, and writer, Hamilton began his career as an illustrator, then went on to study first at London's Royal Academy and then at the Slade School of Fine Art. In 1952, he was one of the founders of the Independent Group, which laid the groundwork for the Pop-art movement.

Although he worked largely with collage, Hamilton stepped outside his usual style and medium in 1968 to design the cover for The Beatles' "White Album" (actually named *The Beatles*). Hamilton's design was so astonishingly simple it gave the album its popular name. In later life, Hamilton's fascination with consumer culture was often tinged with political satire.

BIOGRAPHY

⦿ ARTISTIC INFLUENCES

Both the original British Pop artists and their American counterparts were fascinated by the colorful, sophisticated, and surprisingly powerful images that surrounded them. These could be found on billboards, in consumer publications and packaging, and on the moving screen—the small one in the corner of the living room, or the glorious wide-screen version at the local cinema.

Stars of the silver screen became idols to millions of people, and their images were everywhere. With his series of legendary screen-print portraits, Andy Warhol made the point that celebrities had virtually become consumer products themselves.

Stars like Elizabeth Taylor posed for publicity photographs to be used in fan magazines, product endorsements, and interviews.

Comic-book graphics were cheap, bright, punchy, and very widely available. With a few bold strokes, they brought to life a wide range of well-loved characters, from brave superheroes to wasp-waisted glamour girls and appealingly grubby children.

Eagle Comics hero Dan Dare was a space pilot. Eagle has another place in Pop-art history—David Hockney, as a teenager, had his first work published there.

Victor Vasarely was a Hungarian/French artist who experimented with optical illusion in a number of different media during the 1930s. His work had a major influence on the Op-art movement that flourished alongside Pop.

Zebra, c.1938 is a two-tone image by Victor Vasarely that takes the form of a handwoven tapestry. *Private Collection*

◎ TIMELINE

Although Pop art didn't become a movement until around 1960, it was closely linked with the work of two American artists, Jasper Johns and Robert Rauschenberg, who were associated with a slightly earlier idiom known as Neo-Dada. Johns in particular prefigured Pop with paintings that, for him, referenced "things the mind already knows." In both the US and Britain, Pop practitioners turned the familiar into art, but British artists tended to adapt their sources more, introducing satire or political comment. At the same time, Op art elevated the status of complex optical illusions from intriguing patterns to exhibits on gallery walls.

◎ David Hockney

born Bradford, UK, July 9, 1937

BIOGRAPHY

The most famous British artist of his generation, Hockney attended Bradford School of Art and the Royal College of Art in London. A star of British Pop art in swinging London, he began to make regular visits to Los Angeles in the mid-1960s, before settling there in 1976. In 2005, he returned to live in Yorkshire, England, and continued to work prolifically —in addition to paintings, Hockney has produced book illustrations, stage designs, and photographic collages.

◁ **Wittgenstein in New York**
Sir Eduardo Paolozzi 1965
Pallant House Gallery, Chichester, UK
This is one in a series of prints entitled "As Is When," inspired by the work of Austrian-British philosopher Ludwig Wittgenstein. The images feature text from his writings combined with collagelike elements, all produced in bright Pop-art colors.

Fertile ground
In 1950, London's Institute of Contemporary Arts (ICA) launches its inaugural exhibition. It is at the ICA that the Independent Group meet to discuss ideas that nurtured the Pop-art movement.

1950 **1953** **1956** **1959** **1962**

△ **Flag**
Jasper Johns 1955
MoMA, New York City, NY
Taking as his theme one of the "things the mind already knows," Johns built up this collage using paint, fabric, plywood, and scraps of newsprint that are faintly visible under the stars and stripes. His image portrays the American flag at a time when there were only 48 states.

Early Warhol
In February 1956, an exhibition of Andy Warhol's early work opens at New York's Bodley Gallery. Although it was called "Studies for a Boy Book," no book was ever published.

Campbell's Soup Can Tomato ▷
Andy Warhol 1962
MoMA, New York City, NY
Originally, Warhol created a collective work entitled *Campbell's Soup Cans* —32 individual silk-screened images, one for each variety in the company's range. When first exhibited, they were arranged in four rows of eight, like cans on supermarket shelves.

◁ A Bigger Splash
David Hockney 1967
Tate Modern, London, UK
Hockney spent considerable time working in Los Angeles before he settled there. The resulting images often feature himself and his friends, but *A Bigger Splash* showcases his most common California theme—the glamorous swimming-pool culture—without visible figures.

▽ Sheng-Tung
Bridget Riley 1974
Private Collection
London-born Riley is a leading Op artist who typically produces images that have a dazzling, disorienting effect on the eye. Her early work is all black and white, but later she experimented with the shimmering effects of color.

> **FOR ME, NATURE IS NOT A LANDSCAPE, BUT THE DYNAMISM OF VISUAL FORCES**
>
> Bridget Riley

1965		1968		1971		1974		1977

Landmark album
In 1967, The Beatles release *Sgt. Pepper's Lonely Hearts Club Band*, with its legendary Pop-art collage cover by Peter Blake.

BIOGRAPHY

Andy Warhol

born Pittsburgh, PA, August 6, 1928; **died** New York City, NY February 22, 1987

Born to Slovakian immigrants, Warhol graduated in Pictorial Design from the Carnegie Institute for Technology, Pittsburgh, before moving to New York City in 1949. After working as a successful commercial illustrator, he turned to Pop art in 1961, documenting consumer goods and celebrities, from Marilyn Monroe to Mao Zedong. In 1964 he opened a print-producing studio called The Factory, and went on to produce books and films—he even appeared on television, popular culture's signature medium.

△ Double Metamorphosis III
Yaacov Agam 1968–69
Musée National d'Art Moderne, Paris, France
Israeli born, Paris-based artist Yaacov Agam was a pioneer of optical and kinetic art. In the latter idiom, he produced a series of *Double Metamorphosis* paintings on raised slats, so the image changes as the viewer moves across it. His aim was to "transcend the visible."

◎ MASTERWORK

Whaam!

Roy Lichtenstein **1963**
Tate Modern, London, UK

Based on an image from *All-American Men of War*, published by DC Comics in 1962, *Whaam!* was subtly adapted by Lichtenstein from the original, then blown-up to a huge scale—together, its two

panels measure around 175 x 400 cm (70 x 160 in)—to produce a powerful, stylized, and emblematic work of Pop art. The artist often drew on commercial sources—such as comic books, cartoons, and commercial illustrations—because the way they depicted emotional content using simple, graphic techniques allowed him to present highly charged subjects in an apparently superficial way. Lichtenstein also favored the comic-book color palette of bright red, yellow, blue, and green, often outlined in black. As well as referencing popular culture, his chosen style was an ironic comment on what he saw as the trivialization of culture in American life.

Lichtenstein was a major pioneer of the American Pop-art movement. An only child, he was born in New York City and grew up with a love of comics, science, and drawing. Like many famous artists, he attended

the Art Students League in the city, then went on to study for a degree in fine art at Ohio University. While he was there, he was drafted to fight in World War II, but he returned to finish his undergraduate degree, followed it with a master's, and went on to become a teacher.

As an artist, Lichtenstein was always fascinated by American culture, and he spent his early career depicting historical scenes involving famous battles or tales of the Far West. He started experimenting with Pop art in the early 1960s, turning to his early love of comics as the inspiration for *Whaam!*, which is both his best-known work and a milestone in American art. Direct inspiration is said to have come when one of his children held up a comic and challenged him: "I bet you can't paint as good as that."

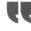 **POP ART** ... DOESN'T LOOK LIKE A **PAINTING OF SOMETHING**, IT LOOKS LIKE THE THING ITSELF

Roy Lichtenstein

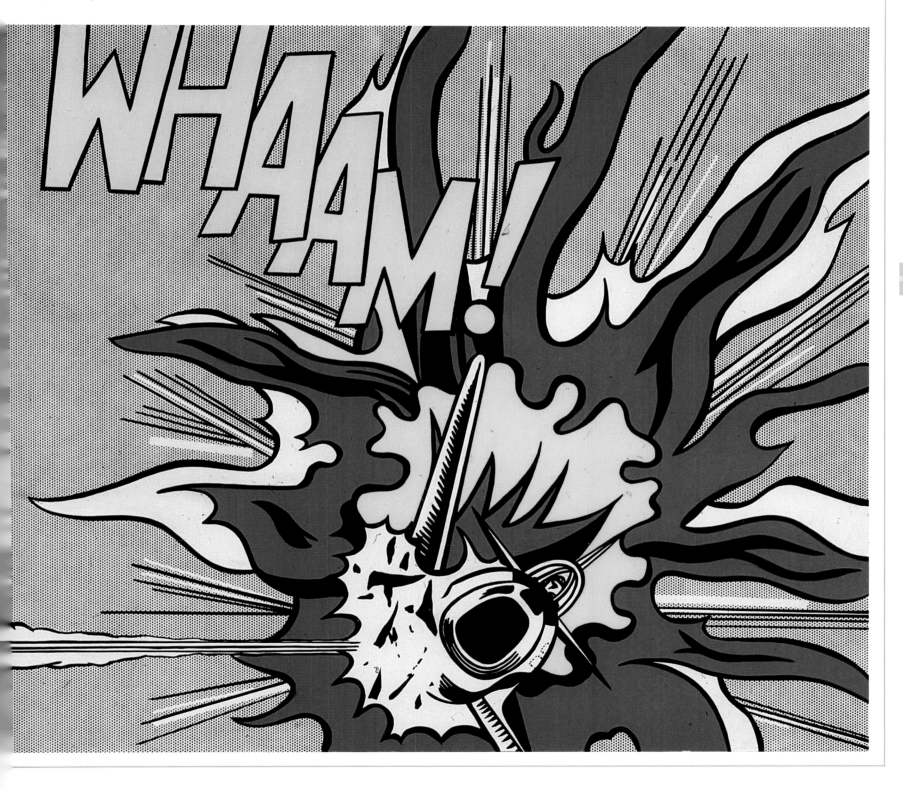

RECENT ABSTRACTION

▷ **Red Yellow Blue Painting Number 1**
Brice Marden 1974
Albright-Knox Art Gallery, Buffalo, NY
This is one of a series of similarly named works, each of which features different shades of the three primary colors arranged in different orders. For all of them, Marden developed a technique of mixing melted beeswax with oil paint to make it less shiny and to enhance the texture of the painted surface.

Nurtured during the uneasy years prior to World War I, abstract art was one of the most momentous developments in the history of art. At first it shocked or baffled many people, and for a long time it was appreciated only by a minority, but in the generation after World War II it won public acceptance and indeed came to occupy a central position in contemporary art. At this time, in the wake of the persecution of modernist art in Nazi Germany and Stalinist Russia, abstraction had the significant attraction—especially in the US—of being considered an expression of Western freedom of thought. In more recent years, abstract painting has no longer been at the forefront of artistic developments, but it has continued to thrive in different ways into the 21st century. Notable practitioners include Karel Appel, Cy Twombly, Howard Hodgkin, Brice Marden (with his bright, bold compositions, *see above left*), Gerhard Richter, and Damien Hirst.

◎ CONTEXT

Freedom and flexibility

Most of today's artists are working in societies that have not been touched by world war, crippling depression, or political upheaval, and ones that are less and less restricted by rules and conventions. One aspect of this situation is the blurring or abandoning of traditional boundaries and categories in art. Rather than thinking in terms of media (painting, sculpture, printmaking, and so on) or stylistic "isms," commentators now often concern themselves more with the issues that art addresses or the themes with which the artists engage. Photography was once a clearly distinct field, but since the 1960s it has routinely been used in various artistic contexts, and modern technology enables large-scale color prints to compete with the visual presence of paintings.

Although there have been artists in every age who are difficult to classify in terms of styles and movements, modern painters express themselves with greater flexibility and freedom from conventions than ever before. In particular, they feel no need to be defined as either mainstream figures or rebellious outsiders, and some leading artists produce acclaimed work in both abstract and figurative idioms.

Ancient and modern
In April 2010, the Louvre unveiled a new acquisition—the ceiling of its classical Salle des Bronzes gallery had become a giant abstract painting. Marrying dramatically contrasting styles and periods, Cy Twombly's abstract creation features a sweep of Aegean blue with huge discs floating near the edges, and the inscribed names of ancient Greek sculptors. "It's that simple," Twombly declared.

Landmarks of a modern age

KEY EVENTS

▷ **1959** The US goes to war in Vietnam, supporting rebel nationalists against the communist regime. The devastation and ultimate failure of this conflict (which ends in 1973) inspired widespread horror, and led to the disaffection and disillusionment of many Americans, including some artists in every field.

▷ **1969** In July, as part of the Apollo space program (named after the Greek god of light, music, healing, and prophecy), astronaut Neil Armstrong becomes the first man to walk on the moon.

▷ **1975** Bill Gates and Paul Allen establish computer-software company Microsoft, leading the way for the computer revolution that will transform modern life.

▷ **1990** East and West Germany are reunited after the fall of the Berlin Wall. The same year, Mikhail Gorbachev's reforms in Russia begin to sweep communism from Eastern European states and bring an end to the Cold War.

▷ **2001** On September 11, a group of Muslim extremists launch a series of suicide attacks, including the destruction of New York's World Trade Center. In all, more than 3,000 people die.

> ❝ IT'S **HARD TO LOOK AT PAINTINGS**. YOU HAVE TO BE ABLE TO **BRING ALL SORTS OF THINGS TOGETHER** IN YOUR **MIND**, YOUR **IMAGINATION, IN YOUR WHOLE BODY** ❞

Brice Marden

◎ BEGINNINGS
PICTURES AND WORDS

The early work of American artist Cy Twombly—one of the world's most revered contemporary abstractionists—was nourished by his connection with a number of outstanding American artists. During his student days in New York, he shared a studio with Neo-Dadist Robert Rauschenberg, and later he was taught by the leading Abstract Expressionists Franz Kline and Robert Motherwell. Twombly began his career as an Abstract Expressionist, and he has been called "the heir to Jackson Pollock." His move to Italy in 1957,

however, signaled a shift away from this dominant modern American art movement and toward a wider, looser idiom, sometimes rich with color. Twomby's work is usually defined by disparate, sometimes intricate shapes, and—in particular—by writing: words, or scraps of words, signatures, swirls, quotations, numbers, and motifs. Blurring traditional distinctions between painting and drawing, brush and pencil, and images and words, Twombly created a mysterious world of iconography, metaphor, and myth.

> **POSTMODERN ART** REQUIRES KNOWLEDGE MUCH LIKE A **CRYPTIC CROSSWORD**, WHERE **COMPREHENSION** COMES FROM **SOLVING THE PUZZLE**

Cy Twombly

◉ ARTISTIC INFLUENCES

From early in his career, and particularly after his move to Italy, Twombly was profoundly influenced by European culture and history in general, and in particular the classical world—its history, its landscape, its mythology, its art, and its poetry. This obsession colored much of his work: not only his images, but also his characteristic scribbles and graphic effects.

Catalan-American artist Pierre Daura, one of Twombly's first teachers, was a great influence on his early work. They both revered Paul Cézanne. Daura lived in Paris before settling in Virginia, but returned regularly to France.

Church at St. Cirq, 1955–65, records the French town where Daura kept a house. *Daura Gallery, Lynchburg College, VA*

Lake Bolsena near Rome gave its name to all Twombly's works in this series. When he was creating them, he stayed at a 19th-century, classically styled palazzo on the lake shore, where there has been a settlement since pre-Roman times.

The largest volcanic lake in Italy, Bolsena has attracted country dwellers and summer visitors for millennia.

The lyric poetry of Sappho, a Greek poet born in the 7th century BCE, appears as fragments in a number of Twombly's works, including some paintings in the Bolsena series. Sappho's lyric poetry was widely admired in ancient times.

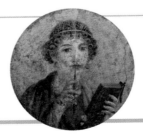

Dating from about 50 CE, this fresco from Pompeii is thought to portray the poet with a writing stylus and wax tablet. *Museo Archeologico Nazionale di Napoli, Italy*

German Expressionism was of great interest to Twombly as a young man. Franz Marc, a founder of Der Blaue Reiter (*see p.316*), shared Twombly's fascination with Greece. Like Twombly, Marc used line and symbol, but he used them in a very different way.

The Fox, 1913, illustrates Marc's symbolic use of color—red stands for brutality and danger. *Kunstmuseum, Düsseldorf, Germany*

◎ TURNING POINT

Untitled (Bolsena)

Cy Twombly **1969** *Private Collection*

During the summer of 1969, Twombly produced a series of 14 works in oil-based house paint, crayon, and pencil on canvas. Part painting, and part graphic art, the Bolsena images feature carefully drawn shapes, calligraphy, and measurements (some of which reflect his obsession with the Apollo space mission) scattered across a cream background. Combining these with seemingly random swirls, scratches, and other expressive gestures, Twombly created his own distinctive, highly recognizable style.

◎ Cy Twombly

born Lexington, VA, April 25, 1928;
died Rome, Italy, July 5, 2011

BIOGRAPHY

In 1953, after studying at the Museum of Fine Arts School in Boston, the Art Students League in New York, and Black Mountain College in North Carolina, Twombly traveled through Europe and North Africa on a grant from the Richmond (Virginia) Museum of Fine Arts. He then lived in New York City before spending time in the army (where he worked on codes) and later, teaching. After settling in Italy, he continued to produce paintings and sculptures until his death.

◎ TIMELINE

After the dramatic dominance of Abstract Expressionism in the 1940s and '50s, abstract painting opened up and became more varied, and artists working in a number of different styles came to prominence. From the angst-ridden Expressionism of Karel Appel and the dark symbolism of Anselm Kiefer to the rhythmic geometry of Simon Hantaï and Damien Hirst and the simple colored panels of Ellsworth Kelly and Gerhard Richter, abstract painters in the modern age express astonishing individuality within their common artistic idiom.

CONTEXT

PLASTIC COLOR

Developed during the 1940s, acrylic paints were intended for use in decorating. Containing pigments suspended in acrylic polymer (a type of plastic), the new paints were quick-drying and could be thinned with water, yet they were water-resistant when dry. By the 1960s, a version suitable for artists was widely available, and the acrylic paints used by contemporary artists have changed little since then. Easy to use, compatible with other materials (like chalk, pastel, or even sand), and suitable for use on most surfaces, acrylic paints are now available in matte, gloss, or silk (semimatte) finishes.

Acrylic paint

◁ **Tabula**
Simon Hantaï 1974
Musée d'Art et d'Industrie, Saint-Étienne, France
Hungarian-born, Hantaï lived and worked in France until his death in 2008. A rebel and a recluse, he produced huge canvases, rich with saturated color punctuated by pure white. To create works such as this, he folded and tied the canvas before applying the paint —a process known as *pliage*.

Hirst born
On June 7, 1965, Damien Hirst—one of the most influential (and commercially successful) artists of his generation—is born in Bristol, UK.

Eastern influence
During the mid-1980s, Brice Marden began to find inspiration in eastern calligraphy. Between 1985 and 1987, he produced a series of 25 images, *Etchings to Rexroth*, in which he referenced Chinese symbols.

| 1965 | 1970 | 1975 | 1980 | 1985 |

△ **Angry Landscape**
Karel Appel 1967 *Private Collection*
A Dutch-born painter and sculptor, Appel lived and worked in Paris, New York, and Monaco, producing— on the whole—strongly Expressionistic images characterized by thick, swirling paint, violent colors, and aggressive brushstrokes. Although powerfully abstract, they often feature human forms.

△ **Das Wölund-Lied (Wayland's Song)**
Anselm Kiefer 1982
Saatchi Collection, London, UK
Inspired by the culture of his native Germany (from the Rhine legends to the Third Reich), Kiefer often layers references and media in his work. This image incorporates oil paint, emulsion, straw, a photograph, and a lead wing. Wayland is a Norse blacksmith.

◁ **Ferrocene**
Damien Hirst 2008
Private Collection
Best known for installations and
sculptures, Hirst is also a prolific
painter. *Ferrocene*, one of his signature
Spot Paintings (there are around
1,400), features rows of 4in (10 cm)
dots executed in household gloss,
each of which is a slightly different
color. The title, like many in the
series, was chosen randomly from
a chemical company catalog.

Bridging the centuries
In June 2011, the Dulwich
Picture Gallery in London
mounts an exhibition called
"Twombly and Poussin:
Arcadian Painters." A week
after its opening, Cy Twombly
dies in Rome.

1990	1995	2000	2005	2010

Gerhard Richter

born Dresden, Germany,
February 9, 1932

One of the most acclaimed
artists of his generation,
Richter is a versatile figure
who produces work that
encompasses various styles
and approaches. His own
brand of Superrealism utilizes
news-type images, blurred like
photographs taken from a
moving car, often resembling
his abstract paintings. Richter
spent his childhood under an
oppressive regime in a country
at war, but he went on to study
art at Academies in Dresden
and Düsseldorf. He lives and
works in Cologne.

BIOGRAPHY

△ **Abstract Painting (812)**
Gerhard Richter 1994
Art Gallery of New South Wales, Sydney, Australia
Born in eastern Germany, Richter showcases paint in his
abstract work—not as a medium, but as a substance of
interest in its own right. To create this image, he dragged
buttery yellow oil color across a previously painted canvas,
highlighting the wooden stretcher bars underneath.

△ **Grey Space (distractor)**
Julie Mehretu 2006
St. Louis Art Museum, MO
Born in Ethiopia, Julie Mehretu lives and works in
the US. Her distinctive technique employs elements
of drawing, collage, and painting to create complex
images that suggest landscape, architecture, and
consumer culture. *Grey Space (distractor)* uses
bold sweeps of color and intricately entangled lines
to evoke the urgency and constant movement of
an increasingly complex world.

◎ MASTERWORK

Small Tree Near Cairo

Sir Howard Hodgkin **1973–77**
Private Collection

Born in London in 1932, Howard Hodgkin determined at the age of five that he was going to be a painter. In 1940, following the outbreak of World War II, he moved with his mother and sister to Long Island, and exposure to the Museum of Modern Art (MoMA) in nearby New York City reinforced his early ambition. Settled back in England after the war, he studied at both Camberwell School of Art in London and Bath Academy of Art, and later traveled widely in Europe, India, and North Africa.

Hodgkin's images consist largely of simple shapes on a small surface—this work was painted on a wooden panel 11¼ x 15¾in (28.5 x 40cm) in size— yet he is regarded as one of the greatest colorists in contemporary art. While his brushstrokes may appear casual, hurried, and almost childlike, he often takes years of painstaking labor to finish a painting; his images may look like pure abstraction, but his work is rooted in reality, in personal experience, and in memory. The flat colors and decorative border that characterize *Small Tree Near Cairo*, for example, reflect his love of Indian miniatures, which he collects.

A trustee of several major galleries in the UK, where he still lives, Hodgkin was knighted in 1992.

❝ I WANT **MY PICTURES** TO BE **THINGS**. I WANT THEM TO BE **MADE UP OF MARKS** THAT ARE **PHYSICALLY** AND **INDIVIDUALLY** SELF-SUFFICIENT ❞

Sir Howard Hodgkin

THE FIGURATIVE TRADITION

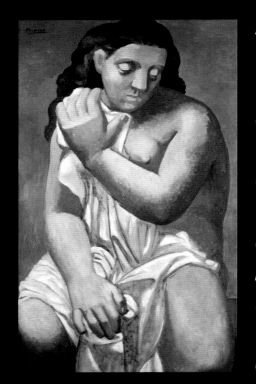

▷ **Large Nude
With Drapery**
Pablo Picasso 1920–21
*Musee de l'Orangerie,
Paris, France*
In the early 1920s Picasso painted
a number of pictures featuring
massively imposing figures, either
nude or with "timeless" draperies.
These works clearly show the
influence of classical antiquity,
and they are part of a trend in
which certain avant-garde artists
reacted against the revolutionary
experimentation of the prewar
period with a quest for clarity
and stability.

Added to the art-historical lexicon as a response to the concept of abstraction, the term "figurative" describes art that is recognizably based on the visible world. Some figurative painters have been strongly opposed to abstraction and avant-garde art in general, but others have embraced both modern and traditional ideas—as Picasso did in his "Neoclassical" phase in the 1920s (*see left*). Similarly, Balthus has strong links with Surrealism, and Tamara de Lempicka with Art Deco. A few painters—Gerhard Richter, for example—have achieved distinction in both abstract and figurative styles (*see pp.371 and 381*). Richter's work shows particularly clearly the influence of photography, which has left an indelible mark on the way in which we see the world. Other outstanding figurative painters in the modern age include John Singer Sargent, Augustus John, Edward Hopper, Paula Rego, and Lucian Freud.

◎ CONTEXT

New challenges

During the last two centuries, artists have developed myriad ways of expressing themselves that move away—to a greater or lesser extent—from the basic concept of reproducing the world around them. The results include Impressionism, Expressionism, Cubism, Abstraction, Dada, Surrealism, and Pop, as well as—since the 1960s—newer forms of art, such as installation, video, and performance art. These new artistic expressions have had such an impact on contemporary art that some commentators no longer consider painting to be a clearly distinct category. Rather, painting is regarded by many as just part of the varied spectrum of activities in which artists engage. Some even see painting as an anachronism. Nevertheless,

figurative painting continues to have many devoted adherents. Political or ideological concerns have often been the motivation for modern figurative painting. In the repressive Soviet Union, this meant the compulsory—and usually banal—glorification of the State, although an artist as gifted as Aleksandr Dejneka was able to rise above the restrictions to create images of vigor and dignity (*see p.379*). A more personal standpoint is seen in the work of Paula Rego, whose paintings comment with subtlety on power and gender (feminism has become a major theme in the art of recent years). Some painters, however, have eschewed such issues: Matisse's career embraced two world wars, but he aimed for "an art of balance, purity, and serenity."

Ways of seeing

KEY EVENTS

▷ **1870s** The development of the dry plate negative means that handheld cameras can be used. As a result, photography becomes more widely accessible.

▷ **1915** D.W. Griffith's film *Birth of a Nation* is released, and the cinema begins to take over from painting as the principal medium for visual narrative.

▷ **1923** The German critic Gustav Hartlaub coins the phrase "New Objectivity" to describe a type of realist painting that heralds a return to "matter of factness," after Expressionism and Dada.

▷ **1933** Socialist Realism, which combines unproblematic naturalism with political conformity, is declared the official artistic doctrine of Stalin's Soviet Union. Hitler's Nazi Germany also rejects modernism.

▷ **1955** The exhibition *The Family of Man* at MoMA implies that photography—rather than painting—is the visual medium that most illuminates the human condition.

▷ **2005** The Royal Academy of Arts in London, once regarded as a bastion of tradition, allows photography and video in its annual Summer Exhibition.

❝ WE ARE ALL **HUNGRY** AND **THIRSTY** FOR **CONCRETE** IMAGES. **ABSTRACT ART** WILL HAVE BEEN **GOOD FOR ONE THING**: TO **RESTORE FIGURATIVE ART** TO ITS **EXACT VIRGINITY** ❞

Salvador Dalí

Henri Matisse drawing with a bamboo stick
Matisse is often bracketed with Picasso as the preeminent painter of the 20th century. Throughout his career he closely studied the human figure, but he freely distorted forms for expressive effect. Here—with a charcoal-tipped stick—he outlines gloriously lithe and energetic dancers for a huge mural.

◎ BEGINNINGS

THE VAN DYCK OF OUR TIMES

Figurative painting, the dominant idiom for millennia, encompasses a vast range of different styles and subjects. In the modern age, one of its greatest interpreters is John Singer Sargent. His career as a portraitist covered the period when Expressionism, Cubism, and abstract art came into being, yet his style reflects the work of early masters such as Rembrandt and Velázquez. The sculptor Auguste Rodin described him as "the Van Dyck of our times." At the height of his fame, he virtually gave up portraiture. During World War I he became a war artist, and it was then that he produced *Gassed*, perhaps his greatest masterpiece.

> ❝ I DON'T **DIG BENEATH THE SURFACE** FOR THINGS THAT **DON'T APPEAR** BEFORE **MY OWN EYES** ❞

John Singer Sargent

◉ ARTISTIC INFLUENCES

Sargent's mother Mary was an enthusiastic amateur artist who encouraged him to draw, and the family's extensive travels in Europe furnished him with plentiful subject matter. His passion was always the painterly tradition of the Old Masters, and when he arrived in Paris, he sought out a teacher who shared these values.

Pieter Bruegel's *The Parable of the Blind* suggested the basic composition of *Gassed*. In both images, sightless figures move in a line, each touching the shoulder of the man in front for guidance.

The Parable of the Blind, detail, c.1568, by Bruegel, conveys—like *Gassed*—sympathy rather than pity. *Museo di Capodimonte, Naples, Italy*

Diego Velázquez was the painter most admired by Sargent, many of whose portraits echo the fluid brushwork, slightly angled postures, and strong impression of personality typical of the Spaniard's work.

Lady With a Fan, c.1640, by Diego Velázquez, depicts a sitter who has never been identified with certainty. *Wallace Collection, London, UK*

Carolus-Duran was a fashionable Parisian portraitist when Sargent became his pupil in 1874. He encouraged his students to paint from life, and the immediacy of Sargent's work reflects this principle.

The Woman With the Glove, detail, 1869, by Carolus-Duran, portrays the artist's wife. *Musée d'Orsay, Paris, France*

Sargent's *Madame X* created a scandal in Paris that inspired his move to London. At first, his notoriety discouraged British patrons, but during the 1890s, he became the country's leading society portraitist.

Madame X (Madame Pierre Gautreau), 1883–84, by Sargent, has a provocative pose that shocked Parisian society. *Metropolitan Museum of Art, New York City, NY*

◎ TURNING POINT

Gassed

John Singer Sargent **1919** *Imperial War Museum, London, UK*

In 1918, the British government commissioned Sargent to produce a memorial to those who died in World War I. Asked to take as his theme "Anglo-American cooperation," he chose instead to portray the horrors of mustard gas as a chemical weapon. In this gruesome scene, which Sargent witnessed after an attack on the Western Front, two lines of soldiers make their way to a dressing station (its guy ropes lead off to the right). Their eyes burned and bandaged, each victim holding on to the one in front, they are led past comrades, similarly injured, lying on the ground in untended heaps.

In portraying both their suffering and their heroic dignity, Sargent highlights the appalling horrors of war and the obscene waste of life it entails. A telling detail is the football game in the background, between the fourth and fifth soldiers. Its inclusion provides a dramatic contrast between the maimed soldiers and the strong, vital sportsmen, and may also allude to the notion of killing as a form of sport. The enormous power of *Gassed* is enhanced by its vast size—it measures around 9 x 20ft (2.75 x 6m).

◎ John Singer Sargent

born Florence, Italy, January 12, 1856;
died London, UK, April 15, 1925

BIOGRAPHY

Born to wealthy Americans living in Europe, Sargent had little conventional education, yet he spoke several languages and he was an accomplished pianist. In 1873, he enrolled at the Accademia di Belle Arte, Florence, and the next year his father sent him to Paris, where he studied at the École des Beaux-Arts and in the studio of Carolus-Duran—an early painting of his teacher established his skill as a portraitist and inspired commissions for further portraits.

After the *Madame X* scandal in 1884, Sargent settled permanently in London. His first major success came in 1887, when *Carnation Lily, Lily Rose*, an exquisite study of two little girls in a garden, was exhibited at the Royal Academy. At the height of his fame, he took on more than a dozen portrait commissions a year, his sitters including Robert Louis Stevenson and Theodore Roosevelt. In 1907, he abandoned portraiture as his main occupation and devoted himself to murals and watercolors. In his later years he often visited the United States, and traveled widely in Europe and the Middle East.

After Sargent died, his work was discredited for decades, but since the 1970s, he has regained his position as one of the great figurative painters of his age.

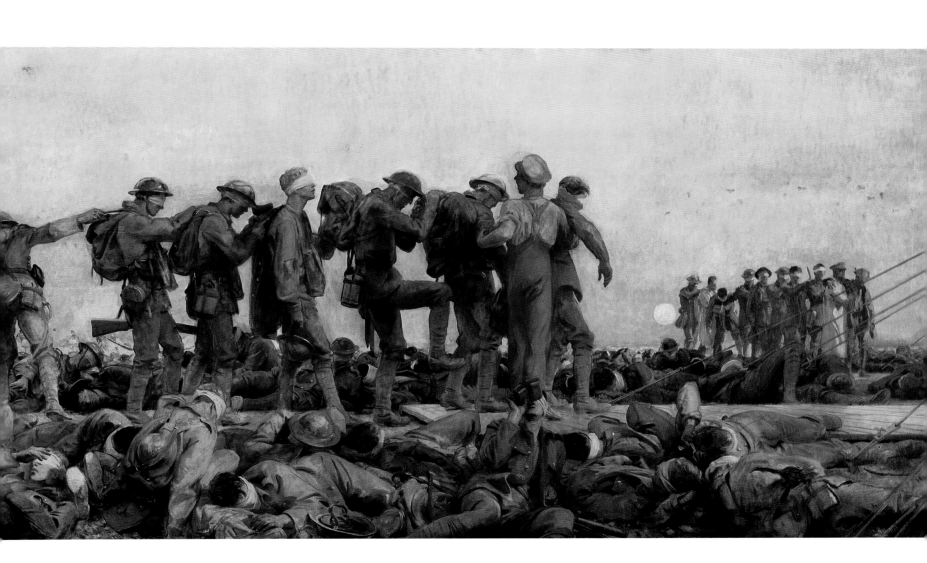

◎ TIMELINE

For millennia, human beings have drawn and painted what they can see or imagine—around 15,000 years ago, on cave walls in Lascaux, France, for example, hunter-gatherers created an astonishing collection of animal images that still fascinate us today (*see pp. 12–21*). Whether representational pictures are created as forms of worship, entertainment, decoration, status, or record keeping, they have formed an integral part of almost every known civilization. Throughout the 20th century and beyond, alongside the burgeoning of countless new art forms, styles, and media, mankind's need to preserve, manipulate, and invent elements of the world around them in the form of pictures has continued to inspire great works of art.

Living link
In 1903, Gwen John visited France with her friend, Dorelia McNeill. During their travels, John made three portraits of Dorelia including the celebrated *Dorelia in a Black Dress.*

Ultimate accolade
In 1906, the Uffizi Gallery in Florence asked John Singer Sargent to paint himself for their collection of self-portraits. He agreed, but the following year he turned away from portraiture to focus his energy on other subjects.

1900

1910

1920

▽ David and Dorelia in Normandy
Augustus John 1908
Fitzwilliam Museum, Cambridge, UK
Augustus John, the embodiment of a bohemian with his long beard, weakness for alcohol, and complex emotional life, studied at London's Slade School, where there was a strong emphasis on figure drawing. This study features his son by his first wife, Ida, alongside Dorelia, his long-time mistress and second, common-law wife. John met Dorelia though his sister Gwen, a fine painter in her own right.

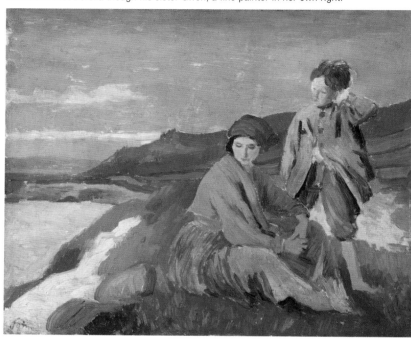

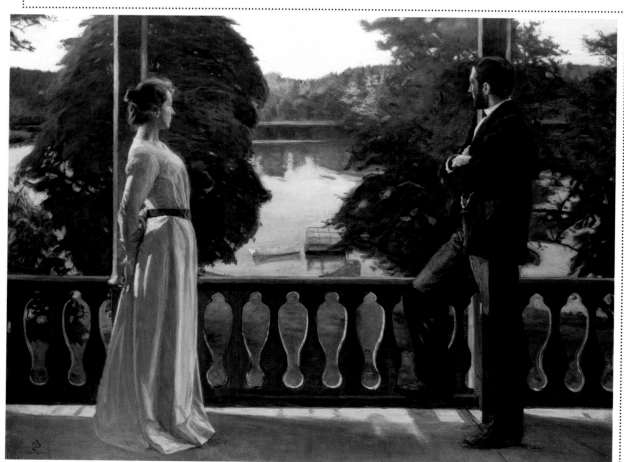

> **A GREAT MAN OF ACTION INTO WHOSE HANDS** THE FAIRIES HAD **PLACED A PAINTBRUSH** INSTEAD OF **A SWORD**

Wyndham Lewis
English Vorticist painter and writer, on Augustus John

◁ Nordic Summer Evening
Richard Bergh 1900
Museum of Art, Gothenburg, Sweden
Making a feature of the distinctive Scandinavian twilight, this romantic image suggests not only the relationship between man and woman, but the link between people and nature. The painter, who was also a writer on art theory and politics, used two friends as models—Prince Eugen of Sweden and the opera singer Karin Pyk.

◁ American Gothic
Grant Wood 1930
Art Institute of Chicago, IL
Painted with a precise realism redolent of northern Europe in the 15th century, *American Gothic* communicates the strong Puritan character typical of the American Midwest (or does it suggest intolerance and rigidity?). Portraying a farmer and his spinster daughter, the painting takes its name from the style of the prominent gable window.

Relay Race Around the Streets of Moscow ▽
Aleksandr Dejneka 1947
Tretyakov Gallery, Moscow, Russia
Highly regarded in the Soviet Union and beyond, Dejneka was an acclaimed painter, graphic artist, sculptor, and mosaicist. According to the contemporary doctrine of Socialist Realism, it was the responsibility of artists to portray a positive view of their society—in this work, Dejneka interprets the message with honesty and humanity.

1930　　　　　　　　　　　**1940**　　　　　　　　　　　**1950** ▶

One-way ticket
In 1933, Tamara de Lempicka married her patron and lover, Baron Raoul Kuffner. When war threatened a few years later, the couple fled Europe for the United States, where they settled.

△ Tamara in the Green Bugatti
Tamara de Lempicka 1925
Private Collection
A quintessential Art-Deco work, Lempicka's stylized self-image features a tight composition; sophisticated colors; and a strong sense of speed, chic, and decadence. A painter of Polish or Russian birth who was active in Paris, Los Angeles, and New York, she portrays herself as an ambitious, willful, and very modern woman.

BIOGRAPHY

Edward Hopper

born Nyack, NY, July 22, 1882;
died New York City, NY, May 15, 1967

Born in upstate New York, Hopper lived in New York City for most of his life, but traveled widely in the United States. Trained as a commercial artist, he earned his living as an illustrator before taking up full-time painting in 1924. A leading exponent of American Scene Painting, he never sought to express emotion in his paintings, yet their powerful commentary on modern life soon established him as one of the leading exponents of the figurative tradition. Hopper has also been described as the greatest American etcher of the 20th century.

△ Compartment C, Car 293
Edward Hopper 1938
IBM Collection, Armonk, NY
The main theme running through Hopper's work is urban alienation—the loneliness of city life—and many of his paintings feature lone women in stark settings.

The stage is set

In 1950, having studied drawing at night school, and supported himself by painting both commercial signs and theatrical sets, Gerhard Richter decides to become a professional artist.

▽ Interior

Bernard Buffet 1950
Musée National d'Art Moderne, Paris, France
The leading French figuratist of the 1950s, Buffet produced portraits, still lifes, and cityscapes as well as domestic scenes. With its linear black shapes and somber tones, this image documents a collection of contemporary design classics—tiled floor, painted shutters, and café-style bentwood seating.

West Interior ▷

Alex Katz 1979
Philadelphia Museum of Art, PA
Born in Brooklyn, Katz studied at Manhattan's Cooper Union art school. Although his early career coincided with the height of Abstract Expressionism, he remained a figurative painter, using fields of flat color years before they featured in Pop art. This is Katz's wife Ada.

Friends at home

As well as a being a Pop artist, David Hockney has also worked in a more traditional figurative manner. One of his best-known works, *Mr. and Mrs. Clark and Percy* (1970–71) is a portrait of the artist's friends, designers Ossie Clark and Celia Birtwell.

1950 **1960** **1970** **1980**

❝ **PAINTING** IS THE PASSAGE FROM THE **CHAOS OF THE EMOTIONS** TO THE **ORDER OF THE POSSIBLE** ❞

Balthus

◁ Katia Reading

Balthus 1968–76
Private Collection
Born in Paris of Polish-French descent, Balthus (Balthazar Klossowski de Rola) had no formal training. Working in a simplified figurative style, he often portrayed adolescent girls in a slightly voyeuristic way, and he could take years to complete one of his paintings. Believing that art should be experienced, not discussed, this enigmatic artist always refused requests for biographical information.

S With Child ▷
Gerhard Richter 1995
Hamburger Kunstalle,
Hamburg, Germany
One of a series of eight portraits Richter made of his wife (the artist Sabine Moritz) and their baby son, this achingly tender image—among the most intimate of his entire body of work—contrasts strikingly with his uncompromising abstraction.

Dame Paula Rego

born Lisbon, Portugal, January 26, 1935

Raised in a country dominated by military dictatorship and the Catholic Church, Rego was sent by her parents to study in London in 1951. The following year she enrolled at the Slade School of Fine Art, where she later taught. When she first gained critical recognition during the early 1960s, she was working in a semiabstract style, but later turned to the stylized, elusively narrative figuration for which she is best known. In addition to painting, Rego is a respected exponent of print and collage, and a powerful female voice in the art world.

1990 **2000**

Eternal rhythm
In 1989, London's Tate Gallery acquires Paula Rego's *The Dance* (1988), an allegorical study in which a village folk celebration symbolizes passage though the stages of womanhood from youth to old age—the dance of life.

◁ The Cadet and His Sister
Paula Rego 1988
Private Collection
Much of Rego's work deals with folklore, childhood, and fantasy, sometimes with dark, disturbed overtones. Like many of her images, this one is slightly unsettling, with overtones of incest, female domination, and loss.

△ Standing Nude
John Currin 1993
Private Collection
Currin is best known for producing work that is both deeply traditional and completely contemporary—*Standing Nude* portrays a hyperrealistic middle-aged woman, her sinewy body and lined face set off mercilessly against a stark black background. With works such as this, John Currin helped to bring figurative painting back into fashion.

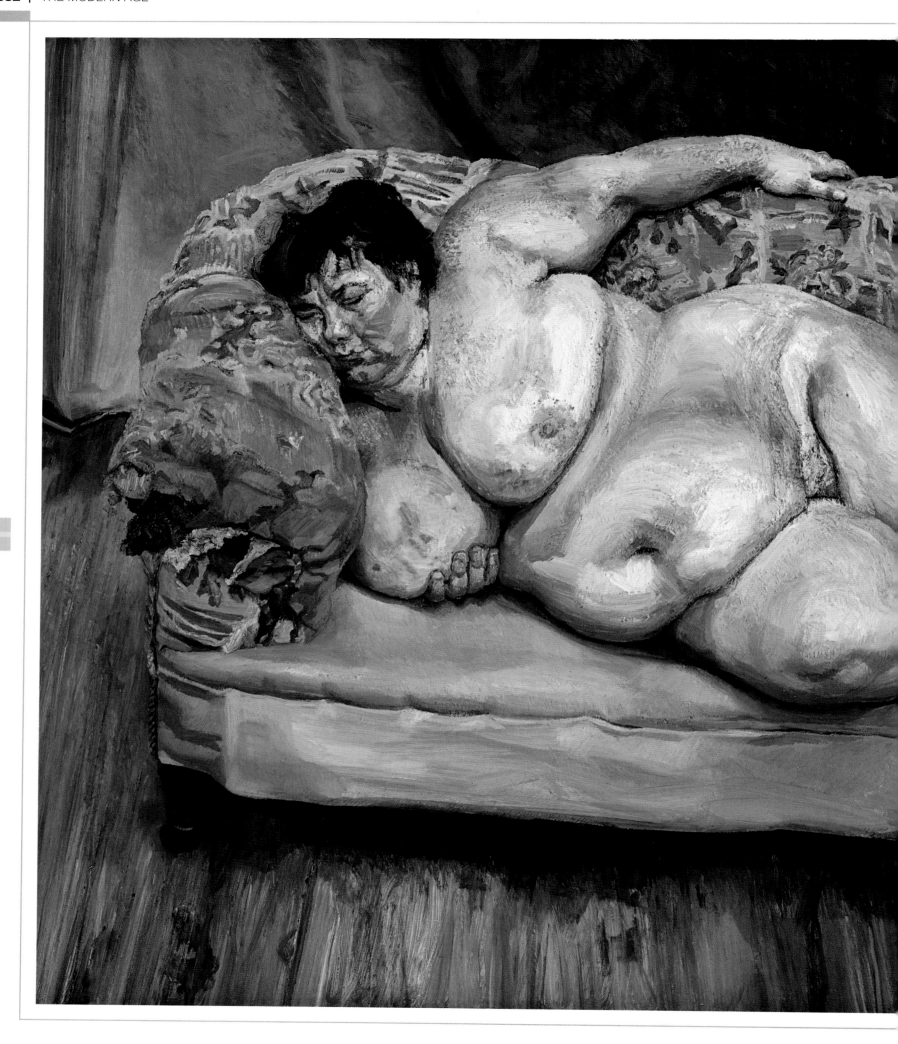

◎ MASTERWORK

Benefits Supervisor Sleeping

Lucian Freud **1995**
Private Collection

A grandson of Sigmund Freud, Lucian was born
in Berlin, but settled in Britain with his family in 1933,
when he was a child. He always loved drawing and in
1939 he began to study at the East Anglian School of
Painting and Drawing, attending on and off until 1942.
After that, he established a home and a studio in
Paddington, the shabby London district he inhabited
for the rest of his life.

Freud's passion was the human form—portraits and
nudes executed with vigorously textured brushstrokes
and muted, yet rich, coloration that express the frailty
of his sitters as well as their humanity; the prevailing
mood is one of alienation. As subjects, he preferred
people who were close to him—his friends, his
daughters, and his mother, whom he drew even after
her death. This is the second of his four paintings of
benefits supervisor Sue Tilley—for the first, she was
positioned on the studio floor, but she complained
so much that he provided the sofa on which she
relaxes here so completely.

Freud operated within an art world dominated by
abstraction and experimentation, yet he produced
works of searing realism and complex atmosphere—in
1987, critic Robert Hughes declared him "the greatest
living realist painter." Intense in both his work and his
personal relationships (he fathered a large number of
children by different women), he worked ferociously
until his death in 2011 at the age of 88.

❝ I'VE ALWAYS WANTED TO
CREATE DRAMA IN MY
PICTURES, WHICH **IS WHY
I PAINT PEOPLE**. THE
SIMPLEST GESTURES
TELL **STORIES** ❞

Lucian Freud

GLOSSARY

A

Abstract art Art that does not recognizably represent things from the visible world. Instead, it involves the use of colors and forms arranged for their own decorative or expressive value.

Abstract Expressionism A type of painting that emerged in New York in the mid-1940s and dominated American art in the 1950s. Abstract Expressionists usually worked on large canvases and employed varying degrees of abstraction with strong expressive content.

Acrylics A type of paint in which a synthetic acrylic resin forms the medium. First used by artists in the 1940s, acrylics have become a versatile alternative to oil paints. Most types of acrylic paint are soluble in water; they can be used on a variety of supports and dry more quickly than oil paint.

Aesthetic Movement An artistic movement that flourished in the late 19th century—especially in the 1880s—in Britain and elsewhere, and included literature as well as painting and the decorative arts. Adherents believed the arts should above all give pleasure and rejected the notion that they should necessarily have a social or moral purpose.

Altarpiece A painting or other work of art designed to be set on, above, or behind an altar in a Christian church. It usually represents scriptural episodes or sacred people.

Art Deco A style of design and interior decoration that developed in the 1920s and 1930s in the United States and Europe, and was characterized by bold colors and smooth geometrical or stylized forms. It takes its name from the Exposition Internationale des Arts Décoratifs et Industriels Modernes, an exhibition held in Paris in 1925 that featured items of the new style.

Art Nouveau A decorative style that became popular in the United States and Europe at the end of the 19th century and in the first decade of the 20th century. It was characterized by sinuous asymmetrical lines and shapes derived from plant stems, flames, waves, and flowing hair. The name was taken from La Maison de l'Art Nouveau, a shop that opened in Paris in 1895.

Arts and Crafts movement An influential late social and aesthetic movement, chiefly in architecture and the decorative arts, originating in Britain in the late 19th century. It championed craftsmanship and simplicity of design. The movement's adherents produced works that involved traditional skills and demonstrated an "honesty" in quality of materials and design.

Avant-garde A term applied to artists (or their works) who were considered to be innovative or experimental, seemingly ahead of their time.

B

Baroque A movement in European art and architecture that was dominant in the 17th century, between the Mannerist and Rococo periods. Baroque paintings are often characterized by dynamic movement, emotional intensity, and theatrical effects.

Bauhaus A modernist school of art and design founded by architect Walter Gropius in Weimar, Germany, in 1919 and noted for its refined, functionalist approach to architecture and industrial design. The school moved to Dessau in 1925 and to Berlin in 1932, but was closed by the Nazis in 1933. Many distinguished painters taught at the Bauhaus, which is regarded as the most important and influential art school of the 20th century.

Der Blaue Reiter A loose association of Expressionist artists, based in Munich, who were active from 1911 to 1914. The name is German for "The Blue Rider." The work of the members was varied, but it tended toward semiabstract forms and bright colors.

Die Brücke A group of German Expressionist artists formed in Dresden in 1905 and disbanded in Berlin in 1913. Artists in the group typically produced figure compositions and landscapes with strong colors and angular forms. The name is German for "The Bridge."

Byzantine art Art and architecture of the Byzantine (Eastern Roman) Empire or areas under its cultural influence. Most Byzantine art is religious and deeply serious in spirit. Mosaics and icons are typical forms.

C

Chiaroscuro An Italian term meaning "bright-dark" that is used to describe the effects of light and dark in a painting, especially when they are strongly contrasting. It originated primarily in the work of Leonardo, but is particularly associated with 17th-century artists, notably Caravaggio and Rembrandt.

Classical, classicism Terms describing the spirit of order and harmony associated with the art and architecture of Greek and Roman antiquity. In its broadest sense, classicism is the opposite of Romanticism, valuing shared ideals and standards over individual expression.

Constructivism An art movement that originated in Russia around 1914, characterized by the use of industrial materials such as glass and metal components arranged in abstract forms. Following the Revolution of 1917, Constructivist art was closely linked with politics and was intended to be socially useful.

Cubism A revolutionary and highly influential style of painting created by Braque and Picasso, who worked together closely in Paris from 1907 to 1914. The use of perspective with a traditional fixed viewpoint was abandoned, and forms were fragmented and rearranged on the picture surface. The pictorial freedom this created was enhanced when Braque and Picasso introduced collage elements into their paintings.

D

Dada A deliberately meaningless name chosen by the adherents of an early 20th-century movement in art, literature, music, and film. It originated in 1915 in Zurich, Switzerland, and spread to other European countries during and immediately after World War I; there were also Dada activities in New York. The movement mocked artistic and social conventions and was characterized by an anarchic spirit of revolt against traditional values. Instead of conventional media, it favored such means of expression as montage, collage, and the ready-made.

Diptych A painting or other work of art made up of two equal-sized parts facing one another like the pages of a book. A popular format for medieval religious art, the diptych often featured a hinge between the two parts so that the work could be folded for transport.

Disegno An Italian word for drawing or design. In the context of Renaissance art, however, the word also has a broader meaning, suggesting the intellectual and creative capacity of the artist.

Distemper A water-based paint that uses glue as a binder instead of an oil base. Inexpensive but impermanent, it is especially suited to temporary work, such as stage scenery.

E

Encaustic A painting technique in which pigments are mixed with hot wax. The term derives from a Greek word meaning "burnt in." It was one of the principal painting techniques employed in the ancient world.

Engraving A word that can be used as a general term for the various processes of making prints or applied more specifically to one of these processes—sometimes known more exactly as line engraving. In line engraving the design is cut into a smooth metal (usually copper) plate, which is inked and passed through a press. From the early 16th century to the early 19th century, line engraving played a highly important role as a means of reproducing other works of art.

Etching A method of printmaking in which acid is used to create a design on a metal (usually copper) plate. The plate is first covered with a waxy acid-resistant substance, which is drawn upon with a steel etching needle. The plate is then immersed in an acid bath, which bites the lines exposed by the needle, creating furrows to hold the ink. After the waxy coating is cleaned off, the etched plate is inked and printed in the same manner as an engraving.

Expressionism An approach to art in which the artist or writer seeks to express the subjective world of emotion rather than observed reality. Distortion and exaggeration are used for emotional effect. More specifically, Expressionism refers to the dominant force in German art at the beginning of the 20th century, particularly in the work of two groups: Die Brücke and Der Blaue Reiter.

F

Fauvism An early 20th-century movement in painting characterized by vivid expressionistic and nonnaturalistic use of color that briefly flourished in Paris from 1905 to about 1907. The name Fauves, French for "wild beasts," was coined by critic Louis Vauxcelles in 1905.

Figurative art Art that recognizably depicts figures, objects, or scenes, as opposed to abstract art.

Fresco A technique of painting on a surface of wet plaster using a mixture of powdered pigments and water. As the paint dries, it bonds with the plaster, making the picture an integral part of the wall (or ceiling), producing an exceptionally permanent result. The word "fresco" is Italian for "fresh," referring to the freshly applied plaster on which the artist paints.

Frottage A technique of reproducing an image of a rough surface—for example, grained wood—by laying a piece of paper over it, then rubbing the paper with a crayon or pencil until an impression of the surface appears. The name is French for "rubbing." Max Ernst invented the technique in 1925, and it was adopted by several other Surrealist artists.

Futurism An Italian avant-garde art movement founded in 1909 by the Italian writer Filippo Tommaso Marinetti. The Futurists celebrated the modern world, especially its machines and technology. They worked in various fields, but the main exponents were painters.

G

Gothic A term applied to the architecture and art prevalent in most of Europe in the late Middle Ages, and by extension to the art of this period (mid-12th century to early 16th century). Gothic architecture is characterized by pointed arches, rib vaults, and flying buttresses. Gothic art is less precise in its meaning, but painting and sculpture of the period often feature figures that have a swaying gracefulness. See also International Gothic.

Gouache An opaque version of watercolor, also called body color, in which the pigments are bound with glue.

Grand Tour An extensive tour of parts of Continental Europe, especially Italy, undertaken by young aristocrats and gentlemen, particularly from Britain. The objective of the Tour, which was at its peak during the 18th century, was to complete the individual's education through seeing firsthand the masterpieces of classical and Renaissance art and architecture.

Ground A coating applied to a surface to prepare it for painting or other artistic use. In Renaissance painting, a common ground was gesso (a mixture of powdered chalk and glue), which heightened the intensity of the colors. In etching, the ground is the waxy coating spread on the metal plate.

I

Icon An image depicting Christ, the Virgin Mary, a saint, or other holy person. The term is especially used to describe the sacred panel paintings of the Byzantine, Russian, and Greek Orthodox Churches.

Illuminated manuscript An ornamented handwritten book characteristic of the Middle Ages. Adorned with images and various kinds of decoration, often in gold and rich colors, manuscripts were usually written on parchment (made from animal skin) or vellum (a fine kind of parchment).

Impasto Thickly applied opaque paint showing the marks made by the brush or knife. Many of Rembrandt's paintings have distinctive impasto.

Impressionism A movement in painting that began in France in the 1860s, and went on to have a huge influence on avant-garde art throughout Europe and elsewhere. The Impressionists rebelled against the formal type of painting promoted by the academies and were concerned with depicting the visual impression of the moment, especially in terms of shifting effects of light and color.

International Gothic A style in painting and other arts flourishing in various European countries from c.1375 to c.1425. The style was marked by aristocratic elegance (it developed mainly in courtly environments) and the use of delicate naturalistic detail.

L

Lithography A technique, invented in 1798, in which prints are made by drawing directly on a slab of stone (or more recently, metal or plastic) with a greasy crayon. The stone is wetted and ink is applied. The ink is repelled by wet areas but adheres to the greasy drawing, and the design is affixed to paper in a press.

M

Mannerism A term originally applied to the sophisticated (and often rather artificial) style characteristic of much Italian art in the period c.1520–1600, and later extended to cover the art of other countries in this period.

"Master of …" An invented name given to an unidentified artist for convenience in discussing the works attributed to him. The Master of Flémalle (now generally thought to be Robert Campin) is probably the most famous personality created in this way.

Medium The material or form of expression with which artists create their work: painting, drawing, and printmaking, for example, are three different media. In painting, it also refers to the substance with which the pigment is mixed to make paint. For instance, in oil painting the medium is an oil such as linseed oil, and in watercolor the medium is gum arabic.

Miniature A very small painting, particularly a type of portrait that was popular in Europe from the 16th century to the early 19th century. Miniatures were originally painted in watercolor or gouache on vellum, ivory, or card.

Modernism A very broad term for the beliefs and attitudes underlying the radical developments in art from about 1900.

N

Nabis A group of painters active in Paris in the 1890s who were inspired by the work of Paul Gauguin, particularly his expressive use of color and pattern. The name Nabis derives from the Hebrew word for "prophets," reflecting the zealousness with which the group propagated the style and teachings of Gauguin and also their interest in mystical ideas.

Neoclassicism A movement in art and architecture that spread throughout Europe in the late 18th and early 19th centuries. Inspired by the order, reason, and high-mindedness of ancient Greek and Roman art and architecture, Neoclassicism was partly a reaction to the frivolities of the Rococo style.

Neo-Expressionism A style of painting (and —to a much smaller degree—sculpture) that flourished particularly in the late 1970s and 1980s, notably in the US, West Germany, and Italy. Neo-Expressionist paintings are typically large and aggressively raw in feeling.

Neoimpressionism A movement in painting that emerged in France in the 1880s as a development from and reaction against Impressionism. The most significant Neoimpressionist was Georges Seurat, who aimed to make the Impressionist treatment of color and light more rational and scientific.

Neo-Plasticism A term coined by Piet Mondrian to describe his austere style of geometrical abstract art, in which he limited himself to straight lines, rectangles, and a small number of colors. Mondrian believed that art should be purely abstract and not attempt to represent the natural world.

O

Oil painting Painting in which an oil—such as linseed, walnut, or poppyseed—is used as the medium that binds the pigment.

Op art A type of abstract art that uses certain optical phenomena to create images that appear to pulsate or flicker. It was highly popular in the 1960s.

P

Panel In painting, a support made from wood, metal, or other rigid material. Until canvas was introduced in the 15th century, nearly all portable paintings in Europe were painted on wood.

Performance art An art form that combines various aspects of visual art, drama, dance, and music. It became popular in the 1960s.

Perspective Method of giving a sense of three-dimensional depth on a two-dimensional surface: objects appear smaller the further away they are from the viewer, and parallel lines appear to converge with increasing distance.

Pop art Movement in art based on modern popular culture and mass media, using images from comic books, advertisements, consumer products, television, and movies. Pop Art emerged in the US and Britain in the late 1950s and flourished particularly in the 1960s.

Postimpressionism Term coined by British critic and artist Roger Fry to describe various developments from and reactions against Impressionism, particularly in France, in the period from about 1880 to 1905. Fry used the term as the title of an exhibition, "Manet and the Postimpressionists," he organized in London in 1910. The exhibition included numerous paintings by Cézanne, Gauguin, and van Gogh, who are now regarded as the fathers of Postimpressionism.

Pre-Raphaelite Brotherhood The name adopted by a group of young British painters who came together in 1848 in reaction against what they considered to be the formulaic painting characteristic of the Royal Academy in London. They painted in a style that aimed to capture the sincerity and directness of Italian art before the time of Raphael.

R

Ready-made Name given by Marcel Duchamp to a type of artwork he invented consisting of an ordinary, everyday object removed from its usual functional context and displayed instead as a work of art. Duchamp exhibited his first ready-made in 1913.

Realism A movement in 19th-century art (particularly French painting) in which scenes of contemporary urban and rural life were presented in an unidealized, often earthy way.

Renaissance A revival of the arts and learning that began in Italy in the 14th century and spread to other parts of Europe during the 15th and 16th centuries. It drew upon the classical cultures of Rome and Greece, and was informed by scientific developments, including those in perspective and anatomy.

Rococo A style of art and architecture characterized by lightness and playfulness that succeeded Baroque in the early 18th century, initially in France and then throughout Europe. In the second half of the 18th century it gradually gave way to Neoclassicism.

Romanesque The dominant style of architecture and art in most of Europe during the 11th and 12th centuries. It is characterized mainly in terms of the massive, round-arched buildings of the period. Romanesque painting is often powerfully nonnaturalistic, sometimes with almost expressionistically distorted figures.

Romanticism A movement in the arts in the late 18th and early 19th centuries that reacted against the reason and formality of Neoclassicism and the Enlightenment. Instead, Romantic artists celebrated individual experience and expression and often looked to nature for inspiration.

S

Screenprinting A printmaking technique in which ink is pressed through a fine mesh screen by a rubber blade and onto a surface of paper or other suitable material below. The design can be created on the screen in various ways (including the transference of photographic images). Separate screens are generally used to apply different colors.

Sfumato An Italian term, literally meaning "faded away," used in painting to describe an extremely subtle blending of tones, which melt into one another as imperceptibly as smoke disappearing in the air. The technique was used to great effect by Leonardo.

Socialist Realism The type of art officially promulgated in the Soviet Union from the late 1920s (and subsequently in other communist countries). Socialist Realism celebrated Soviet cultural and technological achievements, generally in a stereotyped way that reflected the repressive control of the arts by the state. Subjects included industrial and urban landscapes and scenes on collective farms.

De Stijl A group of artists (mainly Dutch) founded in 1917. Their name, Dutch for "The Style," was also the title of a magazine published intermittently from 1917 to 1928 in which they promoted their austere abstract art. Piet Mondrian and Theo van Doesburg were the leading members of the group, which embraced sculpture, architecture, and design as well as painting.

Support The material—such as wood, canvas, paper, or even a wall—on which a painting or drawing is made.

Suprematism A Russian abstract art movement lasting from about 1915 until 1918, involving the use of simple geometrical forms such as squares, triangles, and circles. Kasimir Malevich was the creator and main exponent of this very austere form of abstraction.

Surrealism A movement in art, literature, and ideas, officially founded by the poet André Breton in Paris in 1924, although it had been emerging for some time before this. It was the most widespread and influential avant-garde movement of the 1920s and 1930s, and its ideas continued to echo long after this. In its unconventionality and love of the bizarre, Surrealism was closely related to its predecessor Dada, but it was more positive in outlook, seeking to release the creative potential of the unconscious mind.

Symbolism An artistic and literary movement flourishing in the late 19th and early 20th centuries. Adherents rejected the naturalistic ideals of Realism and Impressionism, favoring subjective, poetic representations of the world, often influenced by mystical ideas.

T

Tempera A term that can be applied to any paint using an organic gum or glue as the medium, but which almost invariably refers to the most common paint of this type, egg tempera. This was the chief technique for panel painting in Europe until oil paints began to take over in the 15th century.

Triptych A picture or relief carving on three panels, often hinged together, with the outer sections capable of being folded over the central part. As with the diptych, this format was often used in small, portable altarpieces, although some triptychs are very large.

Trompe-l'oeil A painting (or a part of a painting) done with such skillful illusionism that it initially deceives viewers into believing they are looking at a real object rather than a two-dimensional depiction of it. The term is French for "deceives the eye."

V

Vorticism A short-lived British avant-garde art and literary movement that was launched in 1914 and broken up by World War I. Influenced by Italian Futurism and French Cubism, Vorticism aggressively expressed the dynamism of modern life, reacting against the perceived complacency of British society at the time.

W

Watercolor A type of paint bound with a medium—usually gum arabic—soluble in water. Watercolor of various kinds has been employed in many times and places, but is best known for use by British landscape painters in the 18th and 19th centuries.

Woodcut A printmaking technique in which the design is created on a block of wood sawn along the grain (as in a plank). It was first used in Europe around 1400 and was the chief means of creating prints until it was gradually superseded by line engraving during the 16th century.

Wood engraving A printmaking technique in which the design is created on a hardwood block sawn across the grain—rather than along the grain of a softer wood, as in woodcut. The harder, smoother surface and the use of finer tools means that wood engravings are usually more precise and detailed than woodcuts, although they can look very similar. The technique was developed in England in the 18th century and was often used for book illustrations in the 19th century.

INDEX OF ARTISTS

In this index, page numbers in **bold type** indicate main references, including biographical boxes, while numbers in *italic type* refer to illustrations.

For dates in Russia before 1918, both Julian (Old Style) and Gregorian (New Style) calendar dates are given when known; the Julian date (used in Russia) is listed first, with the equivalent Gregorian date (used almost everywhere else) following in square brackets. Other conventions are fairly standard: a question mark indicates that the date or place is probable but not absolutely certain; c. (for circa) indicates an approximate date that is known to be accurate, based on the best available evidence.

A

Aachen, Hans von 143, *151*
born Cologne, Germany, 1552;
died Prague, Bohemia [now Czech Republic], March 4, 1615

Abate, Niccolò dell' 144, **148**, *148*
born Modena, Italy, c.1510;
died Fontainebleau?, France, 1571

Agam, Yaacov 363
born Rishon-le-Zion, Palestine, May 11, 1928

Albers, Josef 333
born Bottrop, Germany, March 19, 1888;
died New Haven, CT, March 25, 1976

Allori, Alessandro *138*, 140
born Florence, Italy, May 31, 1535;
died Florence, September 22, 1607

Altdorfer, Albrecht 128
born Amberg?, Germany, c.1480;
died Regensburg, Germany, February 12, 1538

Altichiero 84
active Verona and Padua, Italy, 1370s and 1380s

Andrea da Firenze 84
died Florence?, Italy, 1378?

Angelico, Fra 85, 88, 90, **91**, *91*, 93
born nr. Vicchio, Italy, c.1395;
died Rome, Italy, February 18, 1455

Anquetin, Louis 290, 292
born Étrépagny, France, January 26, 1861;
died Paris, France, August 19, 1932

Antolínez, José *174*
baptized Madrid, Spain, November 7, 1635;
died Madrid, May 30, 1675

Antonello da Messina 95, 112, **114**
born Messina, Italy, c.1430;
died Messina, February 14–25, 1479

Apelles 36, **37**, *37*
born Colophon, Ionia [now Turkey];
active 4th century BCE

Apollodorus 36
active Athens, Greece, late 5th century BCE

Appel, Karel 366, 367, 370, *370*
born Amsterdam, Netherlands, April 25, 1921;
died Zurich, Switzerland, May 3, 2006

Arcimboldo, Giuseppe 143, *149*
born Milan?, Italy, c.1527; **died** Milan, July 11, 1593

Asselyn, Jan *184*
born Dieppe, France, c.1615;
buried Amsterdam, Netherlands, October 3, 1652

Audran, Claude 204
born Lyons, France, August 25, 1658;
died Paris, France, May 28, 1734

B

Avercamp, Barent 182
born Kampen, Netherlands, 1612;
buried Kampen, October 24, 1679

Avercamp, Hendrick 182, *182*
baptized Amsterdam, Netherlands, January 25, 1585;
buried Kampen, Netherlands, May 15, 1634

Bakst, Léon 306, 329
born Grodno, Russia, April 28 [May 10], 1866;
died Paris, France, December 27, 1924

Baldovinetti, Alesso *94*
born Florence, Italy, 1425?;
died Florence, August 29, 1499

Baldung Grien, Hans *128*, 236
born Schwäbisch Gmünd, Germany, 1484/85;
died Strasbourg, Germany, September 1545

Balthus 374, *380*
born Paris, France, February 29, 1908;
died Rossinière, Switzerland, February 18, 2001

Bardin, Jean 226
born Montbard, France, October 31, 1732;
died Orléans, France, October 6, 1809

Barocci, Federico 136, **139**, *139*
born Urbino, Italy, 1535?;
died Urbino, September 30, 1612

Bartolommeo, Fra 89, *105*, 106
born Florence, Italy, March 28, 1472;
died Florence, October 31, 1517

Baselitz, Georg *319*
born Deutschbaselitz, Germany, January 23, 1938

Bassano, Jacopo *116*
born Bassano, Italy, c.1515;
died Bassano, February 13, 1592

Bastien-Lepage, Jules 272, *272*, 273
born Damvillers, France, November 1, 1848;
died Paris, France, December 10, 1884

Batoni, Pompeo 214, *217*
born Lucca, Italy, January 25, 1708;
died Rome, Italy, February 4, 1787

Bazille, Frédéric 276, **280**, *280*
born Montpellier, France, December 6, 1841;
died Beaune-la-Rolande, France, November 28, 1870

Bellini, Gentile 111, *114*
born Venice, Italy, c.1430–35;
buried Venice, February 23, 1507

Bellini, Giovanni 110, *110*, 111, 112, *112–13*, **113**, 114, 118
born Venice, Italy, c.1430–35;
died Venice, November 29, 1516?

Bellini, Jacopo 85, 112, *112*, 114
born Venice, Italy, c.1400; **died** Venice, 1470/71

Benois, Alexandre 306, 329
born St. Petersburg, Russia, April 21 [May 3], 1870;
died Paris, France, February 9, 1960

Berckheyde, Gerrit *186*
born Haarlem, Netherlands, June 6, 1638;
died Haarlem, June 10, 1698

Bergh, Richard 378
born Stockholm, Sweden, December 28, 1858;
died Storängen, Sweden, January 29, 1919

Bernard, Emile 290, 292, *293*, 296
born Lille, France, April 28, 1868;
died Paris, France, April 16, 1941

Bernini, Gianlorenzo 157, *157*, **161**, *161*, 162, 172
born Naples, Italy, December 7, 1598;
died Rome, Italy, November 28, 1680

Blake, Sir Peter 363
born Dartford, UK, June 25, 1932

Blake, William 234, **238**, *238–9*, 258, *258*
born London, UK, November 28, 1757;
died London, August 12, 1827

Bleyl, Fritz 320
born Zwickau, Germany, October 8, 1880;
died Bad Iburg, Germany, August 19, 1966

Boccioni, Umberto *327*
born Reggio di Calabria, Italy, October 19, 1882;
died Sorte, nr. Verona, Italy, August 17, 1916

Böcklin, Arnold 302, *302*, **303**
born Basle, Switzerland, October 19, 1827;
died San Domenico, Italy, January 16, 1901

Bonnard, Pierre 292
born Fontenay-aux-Roses, France, October 3, 1867;
died Le Cannet, France, January 23, 1947

Bosch, Hieronymus 124, 126, *126–7*, 342, *342*
born 's-Hertogenbosch?, Netherlands, c.1450;
buried 's-Hertogenbosch, August 9, 1516

Bosschaert, Ambrosius *171*
baptized Antwerp, Flanders, November 18, 1573;
died The Hague, Netherlands, 1621

Botticelli, Sandro 88, 89, 92, 94, 97, **98**, *98–9*, 102, *102*, 262
born Florence, Italy, c.1445;
buried Florence, May 17, 1510

Boucher, François 200, *200*, 201, 204, 205, **206**, *206*
born Paris, France, September 29, 1703;
died Paris, May 30, 1770

Boudin, Eugène 278, *278–9*, **279**, 287
born Honfleur, France, July 12, 1824;
died Deauville, France, August 8, 1898

Bouts, Dirk *125*
born Haarlem?, Netherlands, c.1420;
died Louvain, Flanders, May 6, 1475

Bramante, Donato *101*, 108
born Monte Asdrualdo [now Fermignano]?, Italy, c.1444;
died Rome, Italy, April 11, 1514

Braque, Georges 322, 323, 324, 326, *326*, **330**, *331*
born Argenteuil, France, May 13, 1882;
died Paris, France, August 31, 1963

Breton, Jules **273**, *273*
born Courrières, France, May 1, 1827;
died Paris, France, July 5, 1906

Brett, John 260
born Bletchingley, UK, December 8, 1831;
died London, UK, January 7, 1902

Bril, Paul *170*
born Antwerp, Flanders, c.1554;
died Rome, Italy, October 7, 1626

Broederlam, Melchior 122, *122*
born Ypres, Flanders, c.1350;
died Ypres, c.1411

Bronzino, Agnolo 132, *132*, 133, 134, 138, *140*, *141*
born Monticelli, nr. Florence, November 17, 1503;
died Florence, November 23, 1572

Brouwer, Adriaen 178, **183**, *183*
born Oudenaarde?, Flanders, c.1605;
buried Antwerp, Flanders, February 1, 1638

Brown, Ford Madox 258, **259**, *259*, 261, *261*
born Calais, France, April 16, 1821;
died London, UK, October 6, 1893

Bruegel, Pieter 124, **129**, *129*, 376, *376*
born nr. Breda?, Netherlands, c.1525;
died Brussels, Flanders, 1569

Brunelleschi, Filippo 89, 90
born Florence, Italy, 1377;
died Florence, April 15, 1446

Buffet, Bernard *380*
born Paris, France, July 10, 1928;
died Tourtour, France, October 4, 1999

Burne-Jones, Sir Edward 257, 260, 261, 262, 263, *263*, 308, 309
born Birmingham, UK, August 28, 1833;
died London, UK, June 16/17, 1898

C
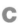

Caillebotte, Gustave *282*
born Paris, France, August 18, 1848;
died Gennevilliers, France, February 21, 1894

Campin, Robert 122, 124
born c.1375; **died** Tournai, Flanders, April 26, 1444

Canaletto 211, 214, *215*
born Venice, Italy, October 17, 1697;
died Venice, April 19, 1768

Caravaggio 156, **158**, *159*, 160, 168, 170, 192, *192*, 195, 268, *268*
baptized Milan, Italy, September 30, 1571;
died Porto Ercole, Italy, July 18, 1610

Carolus-Duran 376, *376*, 377
born Lille, France, July 4, 1837;
died Paris, France, February 18, 1917

Carpaccio, Vittore 114
born Venice, Italy, c.1460;
died Venice, 1525/26

Carracci, Annibale 139, 156, 158, 160, *160*, 192, *192*, 212, *212*
baptized Bologna, Italy, November 3, 1560;
died Rome, Italy, July 15, 1609

Carreño de Miranda, Juan 175
born Avilés, Spain, March 25, 1614;
died Madrid, Spain, October 3, 1865

Carriera, Rosalba 214
born Venice, Italy, January 12, 1673;
died Venice, April 15, 1757

Cassatt, Mary *283*
born Allegheny City, PA, May 22, 1844;
died Le Mesnil-Théribus, France, June 14, 1926

Castagno, Andrea del 93
born Castagno, Italy, c.1418;
buried Florence, August 19, 1457

Cavallini, Pietro 80, *80*
active Rome and Naples, Italy, c.1270–1330

Cellini, Benvenuto 143, **147**, 300, *300*
born Florence, Italy, November 3, 1500;
died Florence, February 13, 1571

Cézanne, Paul 276, 288, 289, 290, 292, 293, **294**, *294*, 314, 324, *324*, 326
born Aix-en-Provence, France, January 19, 1839;
died Aix-en-Provence, October 23, 1906

Chagall, Marc 312, *318*
born Vitebsk, Russia [now Vitsyebsk, Belarus], July 7, 1887;
died Saint-Paul-de-Vence, France, March 28, 1985

Champaigne, Philippe de 191, *195*, 196
baptized Brussels, Flanders, May 26, 1602;
died Paris, France, August 12, 1674

Chardin, Jean-Siméon 200, *205*, *205*, 207
born Paris, France, November 2, 1699;
died Paris, December 6, 1779

Chassériau, Théodore 243, 300, *300*
born Sainte-Barbe de Samano, Santo Domingo [now Dominican Republic], September 20, 1819;
died Paris, France, October 8, 1856

Chirico, Giorgio de 342, *342*, 346
born Volos, Greece, July 10, 1888;
died Rome, Italy, November 20, 1978

Christus, Petrus 120, *120*, 122
born Baerle-Duc [now Baarle-Hertog]?, Flanders, c.1410;
died Bruges, Flanders, 1475/76

Cignani, Carlo 212, *212*
born Bologna, Italy, May 15, 1628;
died Forlì, Italy, September 6, 1719

Cimabue 80, *80*
born c.1240;
died Pisa, Italy, 1302?

Claude Lorraine 148, 190, 194, *196*, 220, 253
born Chamagne, France, 1604/05?;
died Rome, Italy, November 23, 1682

Clérisseau, Charles-Louis 225
baptized Paris, France, August 28, 1721;
died Auteuil, France, January 19, 1820

Clouet, François 149, *149*, 152
born Tours?, France, c.1510;
died Paris, France, September 22, 1572

Cocteau, Jean 345
born Maisons-Laffitte, France, July 5, 1889;
died Milly-la-Forêt, France, October 11, 1963

Coello, Claudio 175
born Madrid, Spain, March 2, 1642;
died Madrid, April 20, 1693

Cole, Thomas 253, 254, *254–5*
born Bolton, UK, February 1, 1801;
died Catskill, NY, February 8, 1848

Collinson, James 256
born Mansfield, UK, May 9, 1825;
died London, UK, January 24, 1881

Constable, John 237, 242, 248, **252**, *252*
born East Bergholt, UK, June 11, 1776;
died Hampstead, London, UK, March 31, 1837

Copley, John Singleton 217
born Boston, MA, July 3, 1738;
died London, UK, September 9, 1815

Cornelis van Haarlem *150*, 180
born Haarlem, Netherlands, 1562;
died Haarlem, November 11, 1638

Correggio 106, **107**, *107*
born Correggio, Italy, c.1490;
died Correggio, March 5, 1534

Cortona, Pietro da 156, 157, 160, *161*, 164
born Cortona, Italy, November 1, 1596;
died Rome, Italy, May 16, 1669

Courbet, Gustave 266, 267, **268**, 269, 270, *270–1*, 271, 278
born Ornans, France, June 10, 1819;
died La Tour-de-Peilz, Switzerland, December 31, 1877

Cowper, Frank Cadogan 263
born Wickham, UK, October 16, 1877;
died Cirencester, UK, November 17, 1958

Coysevox, Antoine 197
born Lyons, France, September 29, 1640;
died Paris, France, October 10, 1720

Cranach, Lucas 142, *146*
born Kronach, Germany, 1472;
died Weimar, Germany, October 16, 1553

Crivelli, Carlo 97
born Venice?, Italy, c.1430–35;
died Ascoli Piceno, Italy, 1493/95

Cross, Henri-Edmond 293, *295*
born Douai, France, May 20, 1856;
died Le Lavandou, France, May 16, 1910

Currin, John 381
born Boulder, Colorado, September 19, 1962

D

Daddi, Bernardo *83*
died Florence?, Italy, 1348

Dalí, Salvador 340, 345, **347**, 348, *348–9*, 351, 375
born Figueras, Spain, May 11, 1904;
died Figueras, January 23, 1989

Dalou, Jules 273
born Paris, France, December 31, 1838;
died Paris, April 15, 1902

Danby, Francis *241*
born Common, Ireland, November 16, 1793;
died Exmouth, UK, February 10, 1861

Daubigny, Charles-François 278, *278*
born Paris, France, February 15, 1817;
died Paris, February 19, 1878

Daumier, Honoré 270, *270*
born Marseilles, France, February 26, 1808;
died Valmondois, France, February 10, 1879

Daura, Pierre 368, *368*
born Menorca, Spain, February 21, 1896;
died Rockbridge Baths, VA, January 1, 1976

David, Jacques-Louis 221, 222, 223, 226, 228, 229, *229*, *230*, *230–1*, 239
born Paris, France, August 30, 1748;
died Brussels, Flanders, December 29, 1825

de Kooning, Willem 350, *350*, 351, *354*, 356
born Rotterdam, Netherlands, April 24, 1904;
died East Hampton, NY, March 19, 1997

De Morgan, Evelyn 263
born London, UK, August 30, 1855;
died London, May 2, 1919

Degas, Edgar 276, 277, 280, *280*, 285
born Paris, France, July 19, 1834;
died Paris, September 27, 1917

Dejneka, Aleksandr 375, *379*
born Kursk, Russia, May 8 [20], 1899;
died Moscow, Russia, June 12, 1969

Delacroix, Eugène 167, *234*, 235, 238, 240, 242, *242*, 243, 252, 268, 300, *300*
born Charenton-Saint-Maurice, France, April 26, 1798; died Paris, France, August 13, 1863

Delaroche, Paul 243, *243*
born Paris, France, July 17, 1797;
died Paris, November 4, 1856

Delaunay, Robert 322, 327, *327*
born Paris, France, April 12, 1885;
died Montpellier, France, October 25, 1941

Delaunay, Sonia 322, 332, *332*
born Gradizhsk, Ukraine, November 14, 1885;
died Paris, France, December 5, 1979

Delville, Jean *305*
born Louvain, Belgium, January 19,1867;
died Brussels, Belgium, January 19, 1953

Denis, Maurice 292, *293*, 334, *334*
born Granville, France, November 25, 1870;
died Paris, France, November 13, 1943

Derain, André 295, 312, *312*, 313, 317, 324, 330
born Chatou, France, June 17, 1880;
died Garches, France, September 8, 1954

Desportes, Alexandre-François 197
born Champigneulle, nr. Varennes, France, February 24, 1661;
died Paris, France, April 20, 1743

Dioskurides of Samos 38, *38*
born Samos?, Asia Minor;
active c.1st century BCE

Doesburg, Theo van 332, 333, 334, 336, *336*
born Utrecht, Netherlands, August 30, 1883;
died Davos, Switzerland, March 7, 1931

Domenichino 156, *160*
born Bologna, Italy, October 21, 1581?;
died Naples, Italy, April 6, 1641

Domenico di Bartolo *93*
born Asciano, Italy, c.1400;
died Siena, Italy, c.1445

Domenico Veneziano *93*
born Venice?, Italy;
buried Florence, Italy, May 15, 1461

Donatello 87, 90, *90*, 94
born Florence, Italy, c.1386;
died Florence, December 13, 1466

Dossi, Dosso *106*
born Tramuschio?, nr. Ferrara, Italy, c.1485?;
died Ferrara, 1541/42

Doyen, Gabriel-François 208
born Paris, France, May 20, 1726;
died St. Petersburg, Russia, March 13, 1806

Dubreuil, Toussaint 194
born Paris?, France, c.1561;
died Paris, November 22, 1602

Duccio di Buoninsegna 78, 80, 82, *82*, 83
died Siena, Italy, 1318/19

Duchamp, Marcel 322, **326**, *327*, 332, 340, 341, *344*, 375
born Blainville, France, July 28, 1887;
died Neuilly-sur-Seine, France, October 2, 1968

Durand, Asher B 253
born Jefferson Village [now Maplewood], NJ, August 21, 1796;
died Jefferson Village, September 17, 1886

Dürer, Albrecht 115, 120, *121*, 124, 127, *127*, 128, 134, 146
born Nuremberg, Germany, May 21, 1471;
died Nuremberg, April 6, 1528

Dyck, Sir Anthony van 166, 170, 171, **172**, *172*, 217
born Antwerp, Flanders, March 22, 1599;
died London, England, December 9, 1641

E

Eakins, Thomas 270, **274**, *275*
born Philadelphia, PA, July 25, 1844;
died Philadelphia, June 25, 1916

Elsheimer, Adam *248*
baptized Frankfurt, Germany, March 18, 1578;
buried Rome, Italy, December 11, 1610

Ensor, James 303
born Ostend, Belgium, April 13, 1860;
died Ostend, November 19, 1949

Ernst, Max 340, **342**, *343*, 351
born Brühl, Germany, April 2, 1891;
died Paris, France, April 1, 1976

Eworth, Hans 143, *147*
born Flanders?, c.1520?;
died London?, England, 1574?

Exekias 35, *35*
active Athens, Greece, c.550–520 BCE

Eyck, Hubert van 122
died 1426?

Eyck, Jan van 120, **122**, *123*, 124
born Maaseik?, Flanders, c.1390;
died Bruges, Flanders, June 1441

F

Fabris, Pietro 248
active Naples, Italy, 1756–84

Fanzago, Cosimo 162
baptized Clusone, Italy, October 13, 1591;
died Naples, Italy, February 13, 1678

Flaxman, John 227
born York, UK, July 6, 1755;
died London, UK, December 7, 1826

Floris, Frans 142, 148, *148*
born Antwerp, Flanders, 1519/20;
died Antwerp, October 1, 1570

Fortescue-Brickdale, Eleanor 263
born Upper Norwood, UK, Jan 25, 1872;
died London, UK, March 10, 1945

Fouquet, Jean 125, *125*
born Tours, France, c.1420; died Tours, c.1481

Fragonard, Jean-Honoré 200, 204, 207, *207*, **208**, *208*
born Grasse, France, April 5, 1732;
died Paris, France, August 22, 1806

Freud, Lucian 374, *382–3*, **383**
born Berlin, Germany, December 8, 1922;
died London, UK, July 20, 2011

Friedrich, Caspar David 234, 246, 250, *253*
born Greifswald, Germany, September 5, 1774;
died Dresden, Germany, May 7, 1840

Fuseli, Henry 236, **237**, *237*, 238, *238*
born Zurich, Switzerland, February 6, 1741;
died Putney, London, UK, April 16, 1825

G

Gainsborough, Thomas 210, 217, *217*
baptized Sudbury, UK, May 14, 1727;
died London, UK, August 2, 1788

Gallé, Emile 299
born Nancy, France, May 4, 1846;
died Nancy, September 23, 1904

Gallen-Kallela, Akseli *306*
born Pori, Finland, April 26, 1865;
died Stockholm, Sweden, March 7, 1931

Gauguin, Paul 288, 290, *291*, *291*, 292, 293, 294, 295, *295*, 296, 304, 314, 324, *324*
born Paris, France, June 7, 1848;
died Atuona, Marquesas Islands, May 8, 1903

Gaulli, Giovanni Battista *156*
born Genoa, Italy, May 8, 1639;
died Rome, Italy, April 2, 1709

Geertgen tot Sint Jans 180, *180*
born Leiden?, Netherlands, 1460?;
died Haarlem?, Netherlands, 1490?

Gentile da Fabriano 85, *85*, 87, 94, 112, 114
born Fabriano, Italy, 1385?; died Rome, Italy, 1427

Gentileschi, Artemisia 160, *160*
born Rome, Italy, July 8, 1593;
died Naples, Italy, 1654?

Gentileschi, Orazio 192
baptized Pisa, Italy, July 9, 1563;
died London, England, February 7, 1639

Gérard, François 228
born Rome, Italy, May 4, 1770;
died Paris, France, January 11, 1837

Géricault, Théodore 240, *240–1*, **241**, 242
born Rouen, France, September 26, 1791;
died Paris, France, January 26, 1824

Ghiberti, Lorenzo 92
born Florence, Italy, c.1380;
died Florence, December 1, 1455

Ghirlandaio, Domenico 89, *97*, 105
born Florence, Italy, c.1449;
died Florence, January 11, 1494

Giambologna 168, *168*
born Douai, Flanders, 1529;
died Florence, Italy, August 13, 1608

Giampietrino *144*
active Milan, Italy; **died** c.1550

Gillot, Claude 202, *202*, 204
born Langres, France, April 27, 1673;
died Paris, France, May 4, 1722

Giordano, Luca 160, *162*, 175
born Naples, Italy, October 18, 1634;
died Naples, January 3, 1705

Giorgione 106, 110, *115*, 118
born Castelfranco, Italy, c.1477;
died Venice, Italy, October 1510

Giotto di Bondone 78, *78*, 79, 80, *80–1*,
81, 82, 83, 87
born Colle di Vespignano?, Italy, c.1270;
died Florence, Italy, January 8, 1337

Giovanetti, Matteo *72*
born Viterbo?, Italy, c.1300;
died Rome, Italy, 1368/69

Girodet, Anne-Louis 228, *228*, *239*
born Montargis, France, January 29, 1767;
died Paris, France, December 9, 1824

Giroust, Marie-Suzanne *217*
born Paris, France, March 9, 1734;
died Paris, August 31, 1772

Girtin, Thomas 250, *250*, 251
born London, UK, February 18, 1775;
died London, November 9, 1802

Giulio Romano *137*
born Rome, Italy, 1499?;
died Mantua, Italy, November 1, 1546

Gleizes, Albert 323, 328
born Paris, France, December 8, 1881;
died Avignon, France, June 23, 1953

Goes, Hugo van der 126, *126*
born Ghent?, Flanders, c.1440?;
died Rode Klooster, Flanders, 1482

Goltzius, Hendrick 180, *180*
born Mühlbracht, Flanders,
January/February 1558;
buried Haarlem, Netherlands, January 1, 1617

Gorky, Arshile 350, 352, **353**, *353*, 354, 356
born Khorkom, Armenia [now Turkey], c.1902;
died Sherman, CT, July 21, 1948

Gossaert, Jan (Mabuse) 146, *146*
born Maubeuge?, Flanders, c.1478;
died Veere?, Flanders, October 1, 1532

Goya, Francisco de 234, 238, 240,
244–5, **245**
born Fuendetodos, Spain, March 30, 1746;
died Bordeaux, France, April 16, 1828

Gozzoli, Benozzo *94*
born Florence, Italy, c.1421;
died Pistoia, Italy, October 4, 1497

Greco, El 142, 146, *150–1*, **151**, 168, *168*
born Candia [now Iraklion], Crete, c.1541;
died Toledo, Spain, April 7, 1614

Greuze, Jean-Baptiste *207*
born Tournus, France, August 21, 1725;
died Paris, France, March 21, 1805

Gris, Juan 322, *322*, 323, 324, 328
born Madrid, Spain, March 23, 1887;
died Boulogne-sur-Seine, France, May 11, 1927

Gros, Antoine-Jean *239*
born Paris, France, March 16, 1771;
died Meudon, France, June 25, 1835

Grosz, George 340, *344*
born Berlin, Germany, July 26, 1893;
died West Berlin, Germany, July 6, 1959

Grünewald, Mathis 121, 124, *127*
born Würzburg?, Germany, c.1475–80;
died Halle, Germany, August 30/31, 1528

Guercino 164, *164–5*
baptized Cento, Italy, February 8, 1591;
died Bologna, Italy, December 22, 1666

Guérin, Pierre-Narcisse 221, 226, *227*
born Paris, France, March 13, 1774;
died Rome, Italy, July 16, 1833

Guillaumin, Armand 281, *281*
born Paris, France, February 16, 1841;
died Orly, nr. Paris, June 26, 1927

Guthrie, Sir James 272, *272*
born Greenock, Scotland, UK, June 10, 1859;
died Rhu, Scotland, UK, September 6, 1930

H

Hals, Frans 178, 180, **181**, *181*, 182, *183*, 185
born Antwerp, Flanders, 1582/83;
died Haarlem, Netherlands, August 29, 1666

Hamilton, Gavin 224, *224*
born Murdieston House, Lanarkshire,
Scotland, UK, 1723;
died Rome, Italy, January 4, 1798

Hamilton, Richard 358, 359, **360**, *361*
born London, UK, February 24, 1922;
died London, September 13, 2011

Hantaï, Simon 370, *370*
born Bia, Hungary, December 8, 1922;
died Paris, France, September 11, 2008

Hassam, Childe 285, *285*
born Dorchester, MA, October 17, 1859;
died East Hampton, NY, August 27, 1935

Heartfield, John *345*
born Berlin, Germany, June 19, 1891;
died East Berlin, Germany, April 26, 1968

Heckel, Erich 312, 316, **317**, *317*, 320
born Döbeln, Germany, July 31, 1883;
died Radolfzell, Germany, January 27, 1970

Heemskerck, Maerten van 142, 146,
148–9, **149**, 180, *180*
born Heemskerck, Netherlands, 1498;
died Haarlem, Netherlands, October 1, 1574

Helleu, Paul 284
born Vannes, France, December 17, 1859;
died Paris, France, March 23, 1927

Hepworth, Dame Barbara 337
born Wakefield, UK, January 10, 1903;
died St. Ives, Cornwall, UK, May 20, 1975

Herkomer, Sir Hubert von 273
born Waal, Germany, May 26, 1849;
died Budleigh Salterton, UK, March 31, 1914

Herrera, Francisco the Younger 174
baptized Seville, Spain, June 28, 1627;
buried Madrid, Spain, August 25, 1685

Hilliard, Nicholas 143, 150, *150*, 151,
152, *153*
born Exeter, England, c.1547;
buried London, England, January 7, 1619

Hiroshige, Ando 290, *290*
born Edo [now Tokyo], Japan, 1797;
died Edo, October 12, 1858

Hirst, Damien 366, 370, *371*
born Bristol, UK, June 7, 1965

Hobbema, Meindert 187
baptized Amsterdam, Netherlands,
October 31, 1638;
died Amsterdam, December 7, 1709

Hockney, David 362, *363*, 380
born Bradford, UK, July 9, 1937

Hodgkin, Sir Howard 366, **372**, *372–3*
born London, UK, August 6, 1932

Hodler, Ferdinand 304, *304–5*
born Berne, Switzerland, March 14, 1853;
died Geneva, Switzerland, May 19, 1918

Hofmann, Hans 351, 352, *352*
born Weissenburg, Germany, March 21, 1880;
died New York City, NY, February 17, 1966

Hogarth, William 215, 236
born London, England, November 10, 1697;
died London, October 25/26, 1764

Hokusai, Katsushika 290, *290*
born Edo [now Tokyo], Japan, October 1760;
died Edo, May 10, 1849

Holbein, Hans the Younger 120, 121,
130–1, *130–1*, 150
born Augsburg, Germany, 1497;
died London, UK, October/November 1543

Honthorst, Gerrit van 182, *182*
born Utrecht, Netherlands, November 4, 1592;
died Utrecht, April 27, 1656

Hooch, Pieter de *184*
baptized Rotterdam, Netherlands,
December 20, 1629;
buried Amsterdam, Netherlands, March 24, 1684

Hoogstraten, Samuel van 188
born Dordrecht, Netherlands, August 2, 1627;
died Dordrecht, October 19, 1678

Hopper, Edward 374, **379**, *379*
born Nyack, NY, July 22, 1882;
died New York City, NY, May 15, 1967

Houbraken, Arnold 214
born Dordrecht, Netherlands, March 28, 1660;
died Amsterdam, Netherlands, October 14, 1719

Hunt, William Holman 256, 260, *260*, 262,
263, 264
born London, UK, April 2, 1827;
died London, September 7, 1910

Huysum, Jan van 187
born Amsterdam, Netherlands, April 15, 1682;
died Amsterdam, February 7/8, 1749

I

Ingres, Jean-Auguste-Dominique 221,
229, 238, 240
born Montauban, France, August 29, 1780;
died Paris, France, January 14, 1867

J

Janssen, Abraham 170–1
born c.1575;
buried Antwerp, Flanders, January 25, 1632

John, Augustus 374, *378*
born Tenby, Wales, UK, January 4, 1878;
died Fryern Court, Hampshire, UK,
October 31, 1961

John, Gwen 378
born Haverfordwest, Wales, UK, June 22, 1876;
died Dieppe, France, September 18, 1939

Johns, Jasper 362, *362*
born Augusta, GA, May 15, 1930

Jones, Allen 358, *358*
born Southampton, UK, September 1, 1937

Jongkind, Johan Barthold 278, *278*, 287
born Lattrop, Netherlands, June 3, 1819;
died La-Côte-Saint-André, France,
February 9, 1891

Joos van Ghent 95
active Flanders and Italy, c.1460–80

Jordaens, Jacob 170, *173*
born Antwerp, Flanders, May 19, 1593;
died Antwerp, October 18, 1678

K

Kahlo, Frida 340, *346*, **347**
born Coyoacán, Mexico City, Mexico,
July 6, 1907;
died Coyoacán, July 13, 1954

Kalf, Willem *184*
born Rotterdam, Netherlands, 1619;
died Amsterdam, Netherlands, July 31, 1693

Kandinsky, Wassily 312, 316, *316*,
332, 333, *336*, 337, **338**, *338–9*, 350
born Moscow, Russia,
November 22 [December 4], 1866;
died Neuilly-sur-Seine, France,
December 13, 1944

Katz, Alex 380
born New York City, NY, July 24, 1927

Kauffmann, Angelica 226
born Chur, Switzerland, October 30, 1741;
died Rome, Italy, November 5, 1807

Kelly, Ellsworth 370
born Newburgh, NY, May 31, 1923

Keyser, Hendrick de 183
born Utrecht, Netherlands, May 15, 1565;
died Amsterdam, Netherlands, May 15, 1621

Keyser, Thomas de 183
born Amsterdam?, Netherlands, c.1597;
buried Amsterdam, June 7, 1667

Khnopff, Fernand 303, *303*, **308–9**, *308–9*
born Grembergen, Belgium,
September 12, 1858;
died Brussels, Belgium, November 12, 1921

Kiefer, Anselm 370, *370*
born Donaueschingen, Germany, March 8, 1945

Kirchner, Ernst Ludwig 312, 316, **320**,
320–1
born Aschaffenburg, Germany, May 6, 1880;
died Frauenkirch, Switzerland, June 15, 1938

Klee, Paul 312, 316, *318*
born Munchenbuchsee, Switzerland,
December 18, 1879;
died Muralto, Switzerland, June 29, 1940

Klimt, Gustav 305, 306, *306–7*, **307**, 309, 316
born Baumgarten, Austria, July 14, 1862;
died Vienna, Austria, February 6, 1918

Kline, Franz 368
born Wilkes-Barre, PA, May 23, 1910;
died New York City, NY, May 13, 1962

Klinger, Max 302
born Leipzig, Germany, February 18, 1857;
died Grossjena, Germany, July 5, 1920

Kokoschka, Oskar *318–19*
born Pöchlarn, Austria, March 1, 1886;
died Montreux, Switzerland,
February 22, 1980

Krasner, Lee 356
born New York City, NY, October 27, 1908;
died New York City, June 19, 1984

Kupka, František 332, 333, **334**, **335**, *335*
born Opocno, Bohemia [now Czech Republic], September 22, 1871;
died Puteaux, Paris, France, June 24, 1957

L

La Fosse, Charles de 202
born Paris, France, June 15, 1636;
died Paris, December 13, 1716

La Fresnaye, Roger de 327
born Le Mans, France, July 11, 1885;
died Grasse, France, November 27, 1925

La Hyre, Laurent de 196
born Paris, France, February 26, 1606;
died Paris, December 29, 1656

La Tour, Georges de 194, *195*, *195*
baptized Vic-sur-Seille, France, March 14, 1593;
died Lunéville, France, January 30, 1652

La Tour, Maurice-Quentin de *206*
born Saint-Quentin, France, September 5, 1704;
died Saint-Quentin, February 17, 1788

Lairesse, Gérard de *187*
born Liège, Flanders, September 11, 1640;
buried Amsterdam, Netherlands, July 28, 1711

Lallemant, Georges 193, *194*
born Nancy, France, c.1575;
died Paris, France, 1636

Lancret, Nicolas 206
born Paris, France, January 22, 1690;
died Paris, September 14, 1743

Largillière, Nicolas de 197, 204, *204–5*
born Paris, France, October 10, 1656;
died Paris, March 20, 1746

Le Brun, Charles 190, *191*, *196–7*, 197, 202
baptized Paris, France, February 24, 1619;
died Paris, February 12, 1690

Le Nain, Louis 195
born Laon?, France, c.1600;
died Paris, France, May 23, 1648

Léger, Fernand 322, 323, 324, *328–9*, **329**, 351
born Argentan, France, February 4, 1881;
died Gif-sur-Yvette, France, August 17, 1955

Lehmann, Henri 243
born Kiel, Germany, April 14, 1814;
died Paris, France, March 30, 1882

Leibl, Wilhelm 272
born Cologne, Germany, October 23, 1844;
died Würzburg, Germany, December 4, 1900

Lemoyne, François *205*
born Paris, France, 1688;
died Paris, June 4, 1737

Lempicka, Tamara de *379*
born Moscow?, Russia, c.1895?;
died Cuernavaca, Mexico, March 18, 1980

Leonardo da Vinci 97, 100, 101, **102**, *103*, 104, *104*, 106, 108, 134, 150, 158, *158*, 300, *344*
born Anchiano or Vinci, Italy, April 15, 1452;
died nr. Amboise, France, May 2, 1519

Lépicié, Nicolas-Bernard 226
born Paris, France, June 16, 1735;
died Paris, September 14, 1784

Levy-Dhurmer, Lucien 305
born Algiers, Algeria, September 30, 1865;
died Le Vésinet, France, September 24, 1953

Lewis, Wyndham 378
born At sea, off Nova Scotia, Canada, November 18, 1882;
died London, UK, March 7, 1957

Lichtenstein, Roy 358, **364–5**, *364–5*
born New York City, NY, October 27, 1923;
died New York City, September 29, 1997

Limbourg brothers 73, *73*
died Bourges, France, 1416

Liotard, Jean-Étienne 210, *216*
born Geneva, Switzerland, December 22, 1702;
died Geneva, June 12, 1789

Lipchitz, Jacques 328
born Druskieniki, Lithuania, August 10 [22], 1891;
died Capri, Italy, May 26, 1973

Lippi, Fra Filippo 94
born Florence, Italy, c.1406;
died Spoleto, Italy, October 10, 1469

Longhi, Pietro 216
born Venice, Italy, November 15, 1701;
died Venice, May 8, 1785

Lorenzetti, Ambrogio 79, *82–3*, **83**
active Siena, Italy, 1319–48

Lorenzetti, Pietro 79, 83
active Siena, Italy, 1320–45

Lorenzo Monaco 84, 87
born c.1370;
died Florence?, Italy, c.1425

Lotto, Lorenzo 116, *116*
born Venice, Italy, c.1480;
died Loreto, Italy, 1556/57

Loutherbourg, Philip James de 250, *250–1*
born Strasbourg, France, October 31, 1740;
died Chiswick [now in London], UK, March 11, 1812

Lucas van Leyden 128
born Leiden, Netherlands, 1494?;
died Leiden, May–August 1533

M

Magritte, René 340, *340*, 341, 345, **346**, *346*, 347
born Lessines, Belgium, November 21, 1898;
died Brussels, Belgium, August 15, 1967

Maître de Flore 152
active France, c.1555–70

Malevich, Kasimir 327, 332, 333, 334, 336, *336*
born nr. Kiev, Russia, February 11 [23], 1878;
died Leningrad, Russia, May 15, 1935

Man Ray 340, *347*
born Philadelphia, PA, August 27, 1890;
died Paris, France, November 18, 1976

Mander, Karel van 129, 180, *180*, 182
born Meulebeke, Flanders, 1548;
died Amsterdam, Netherlands, September 11, 1606

Manet, Edouard 276, 277, 280, 281, *283*
born Paris, France, January 23, 1832;
died Paris, April 30, 1883

Mantegna, Andrea 88, 92, 94, *94*, 97, 112, *112*, 164, 300
born Isola di Carturo?, Italy, c.1431;
died Mantua, Italy, September 13, 1506

Maratta, Carlo 162, *162*, 214
born Camerano, Italy, May 15, 1625;
died Rome, Italy, December 15, 1713

Marc, Franz 312, 316, *316*, 368, *368*
born Munich, Germany, February 8, 1880;
died nr. Verdun, France, March 4, 1916

Marden, Brice 366, *366*, 370
born Bronxville, NY, October 15, 1938

Marinetti, Filippo Tommaso 327
born Alexandria, Egypt, December 22, 1876;
died Bellagio, Italy, December 2, 1944

Martin, John 252, *252*
born Haydon Bridge, UK, July 19, 1789;
died Douglas, Isle of Man, UK, February 17, 1854

Martini, Simone 78, 79, 82, 90, *90*
born Siena?, Italy, 1284?;
died Avignon, France, July/August 1344

Masaccio 78, 79, *86–7*, *86–7*, 88, 90, 91, 92, 94
born Castel San Giovanni [now San Giovanni Valdarno], Italy, December 21, 1401;
died Rome, Italy, June 1428/29?

Masolino di Panicale 85, 86, 92
born Panicale?, Italy, c.1383;
died 1435–40?

Masson, André 351
born Balagny, France, January 4, 1896;
died Paris, France, October 28, 1987

Massys, Quentin *127*, 128
born Louvain, Flanders, c.1466;
died Antwerp, Flanders, April/September 1530

Master of Flémalle 122, *122*, **124**, *124*
see also Robert Campin

Masucci, Agostino 224
born Rome, Italy, 1690;
died Rome, October 19, 1768

Matisse, Henri 295, 300, 312, 314, **315**, *315*, 317, 318, 330, 375
born Le Cateau-Cambrésis, France, December 31, 1869;
died Nice, France, November 3, 1954

Matta, Roberto 352, *352*, 353
born Santiago, Chile, November 11, 1911;
died Civitavecchia, Italy, November 23, 2002

Mauve, Anton *273*
born Zaandam, Netherlands, September 18, 1838;
died Arnhem, Netherlands, February 5, 1888

Mayno, Juan Bautista *170*, 176
born Pastrana, Spain, January 1578;
died Madrid, Spain, April 1, 1641

Mehretu, Julie 371
born Addis Ababa, Ethiopia, 1970

Meissonier, Ernest 267, *267*
born Lyons, France, February 21, 1815;
died Paris, France, January 31, 1891

Memling, Hans 102, *102*, *126*
born Seligenstadt, Germany, c.1430/40;
died Bruges, Flanders, August 11, 1494

Memmi, Lippo *82*, 90
active Siena, Italy, 1317–47

Mengs, Anton Raphael 222, 224, *224*
born Aussig, Bohemia [now Ústí nad Labem, Czech Republic], March 12, 1728;
died Rome, Italy, June 29, 1779

Menzel, Adolph *271*
born Breslau [now Wrocław], Poland, December 8, 1815;
died Berlin, Germany, February 9, 1905

Metzinger, Jean 322, 323, *328*
born Nantes, France, June 24, 1883;
died Paris, France, November 3, 1956

Meulen, Adam Frans van der *175*
baptized Brussels, Flanders, January 11, 1632;
died Paris, France, October 15, 1690

Meynier, Charles *228*
born Paris, France, November 25, 1768;
died Paris, September 6, 1832

Michael Damaskenos *44*
born Candia [now Iraklion], Crete;
active 1555–91

Michelangelo 89, 96, 100, 101, 104, **105**, *105*, 106–8, *107*, 116, 125, 132, *133*, 134, *134*, 137, *137*, 138, 144, 146, 148–50,
216, 237, 241, 262, 333
born Caprese, Italy, March 6, 1475;
died Rome, Italy, February 18, 1564

Millais, Sir John Everett 256, 260, *260–1*, 263, **264**, *265*
born Southampton, UK, June 8, 1829;
died London, UK, August 13, 1896

Millet, Jean-François 266, 267, 268, 270, *270*, 271, 278, 279, 296
born Gruchy, France, October 4, 1814;
died Barbizon, France, January 20, 1875

Miró, Joan 336, **344**, *345*
born Barcelona, Spain, April 20, 1893;
died Palma de Mallorca, Spain, December 25, 1983

Modigliani, Amedeo 328, *328*, 329
born Livorno, Italy, July 12, 1884;
died Paris, France, January 24, 1920

Mondrian, Piet 332, 333, 334, 336, *337*, 351
born Amersfoort, Netherlands, March 7, 1872;
died New York City, NY, February 1, 1944

Monet, Claude 276, 277, 278, 279, *280–1*, 284, 285, **286–7**, *286–7*
born Paris, France, November 14, 1840;
died Giverny, France, December 5, 1926

Monnoyer, Jean-Baptiste *197*
baptized Lille, France, January 12, 1636;
died London, England, February 16, 1699

Montañés, Juan Martínez 170
baptized Alcalá la Real, Spain, March 16, 1568;
died Seville, Spain, June 18, 1649

Mor, Anthonis 129
born Utrecht, Netherlands, c.1517/20;
died Antwerp, Flanders, 1576/77

Morales, Luis de 150
born Badajoz?, Spain, c.1520?;
died Badajoz, c.1586

More, Jacob 248, *248*
born Edinburgh, Scotland, UK, 1740;
died Rome, October 1, 1793

Moreau, Gustave 298, 300, *300*, *301*, 305, 309, 314, *314*, 319
born Paris, France, April 6, 1826;
died Paris, April 18, 1898

Morisot, Berthe 276, 280, *281*
born Bourges, France, January 14, 1841;
died Paris, France, March 2, 1895

Moroni, Giovanni Battista *138*
born Bondo Petello, Italy, c.1520/24;
died Albino, Italy, February 5?, 1578

Morris, William 257, 259, 260, 261, 263, *263*, 299
born Walthamstow, UK, March 24, 1834;
died London, UK, October 3, 1896

Motherwell, Robert 355, 368
born Aberdeen, WA, January 24, 1915;
died Provincetown, MA, July 16, 1991

Mucha, Alphonse 299
born Ivancice, Moravia [now Czech Republic], July 24, 1860;
died Prague, Czechoslovakia, July 14, 1939

Munch, Edvard 305, 307, 309, *316*
born Løten, Norway, December 12, 1863;
died Oslo, Norway, January 23, 1944

Murillo, Bartolomé Esteban 166, 170, **174**, *174–5*
baptized Seville, Spain, January 1, 1618;
died Seville, April 3, 1682

Myson 37
active Athens, Greece, 5th century BCE

N

Natoire, Charles-Joseph 223
born Nîmes, France, March 3, 1700;
died Castel Gandolfo, Italy, August 23–29, 1777

Nesterov, Mikhail 306
born Ufa, Russia, May 19 [31], 1862;
died Moscow, Russia, October 18, 1942

Nevinson, CRW 328
born London, UK, August 13, 1889;
died London, October 7, 1946

Newman, Barnett 350, **354**, *354*
born New York City, NY, January 29, 1905;
died New York City, July 4, 1970

Nicholson, Ben 332, 334, **337**, *337*
born Denham, UK, April 10, 1894;
died London, UK, February 6, 1982

Nocret, Jean *196*
born Nancy, France, December 26, 1615;
died Paris, France, November 12, 1672

Nussbaum, Felix 347
born Osnabrück, Germany, December 11, 1904;
died Auschwitz, Poland, August 9, 1944

O

Oost, Jacob van *174*
baptized Bruges, Flanders, July 1, 1603;
died Bruges, 1671

Orcagna, Andrea *83*
born Florence, Italy, 1320?;
died Florence, 1368?

Orozco, José Clemente 352, *352*
born Zapotlán el Grande [now Ciudad Guzmán],
Mexico, November 23, 1883;
died Mexico City, Mexico, September 7, 1949

Oudry, Jean-Baptiste 197, *205*
born Paris, France, March 17, 1686;
died Beauvais, France, April 30, 1755

Overbeck, Friedrich 258
born Lübeck, Germany, July 3, 1789;
died Rome, Italy, November 12, 1869

P

Palma Vecchio 111, *116*
born Serina, Italy, c.1480;
died Venice, Italy, July 30, 1528

Palmer, Samuel 246, *252*
born London, UK, January 27, 1805;
died Redhill, UK, May 24, 1881

Pan Painter 37, *37*
active Athens, Greece, c.480–450 BCE

Panini, Giovanni Paolo 215
born Piacenza, Italy, June 17, 1691;
died Rome, Italy, October 21, 1765

Paolozzi, Sir Eduardo 358, *362*
born Leith, Edinburgh, Scotland, UK,
March 7, 1924;
died London, UK, April 22, 2005

Parmigianino *137*, 148
born Parma, Italy, January 11, 1503;
died Casalmaggiore, Italy, August 24, 1540

Parrhasius 36
active Ephesus, late 5th century BCE

Patinir, Joachim 128, *128*
born Dinant or Bouvignes?, Flanders, c.1480;
died Antwerp, Flanders, 1524

Perov, Vasily 271
born Tobolsk, Russia, December 21, 1833
[January 2, 1834];
died Kuz'minki [now in Moscow], Russia,
May 29 [June 10], 1882

Perugino, Pietro 92, **96**, 97, *97*, 106
born Castello della Pieve
[now Città della Pieve], Italy, c.1450;
died Fontignano, Italy, February/March 1523

Picabia, Francis 340, 344, *344*
born Paris, France, January 22, 1879;
died Paris, November 30, 1953

Picasso, Pablo 293, 322, 323, 324, *324–5*,
325, 326, 328, 329, 330, *374*, 375
born Málaga, Spain, October 25, 1881;
died Mougins, France, April 8, 1973

Piero della Francesca 88, 89, **95**, *95*
born Borgo San Sepolcro [now Sansepolcro],
Italy, c.1415;
died Borgo San Sepolcro, October 12, 1492

Piero di Cosimo *97*
born Florence, Italy, January 2, 1462;
died Florence, April 12, 1522

Piranesi, Giovanni Battista 222, *222*
born Mogliano, Italy, October 4, 1720;
died Rome, Italy, November 9, 1778

Pisanello *84*, 85
born Pisa?, Italy, c.1394;
died Rome?, Italy, 1455?

Pisano, Andrea 83
born Pontedera?, Italy, c.1290;
died Orvieto?, Italy, 1348/49?

Pisano, Giovanni 80
born Pisa, Italy, c.1245–50;
died Siena, Italy, 1314–19

Pisano, Nicola 80, *80*
born Apulia, Italy, c.1220;
died Pisa?, Italy, 1278–84

Pissarro, Camille 276, 277, 280, *282*,
283, 284, *285*, 291
born Charlotte Amalie, Virgin Islands, July 10,
1830; died Paris, France, November 13, 1903

Pollaiuolo, Antonio 92, *96*
born Florence, Italy, c.1432;
died Rome, Italy, February 4, 1498?

Pollaiuolo, Piero *96*
born Florence, Italy, c.1441;
died Rome, Italy, c.1496

Pollock, Jackson 350, 352, **356**, *356–7*, 368
born Cody, WY, January 28, 1912;
died East Hampton, NY,
August 11, 1956

Pontormo 134, 135, *135*, 140
born Pontormo, Italy, May 26, 1494;
died Florence, Italy, December 31, 1556

Poussin, Nicolas 148, 161, 190, *190*, 191,
194, *197*, *198–9*, *199*, 248
born Les Andelys, France, June 1594;
died Rome, Italy, November 19, 1665

Pozzo, Andrea 163, *164*
born Trento, Italy, November 30, 1642;
died Vienna, Austria, August 31, 1709

Primaticcio, Francesco 143, *143*, 144, 146,
147, *147*, 148
born Bologna, Italy, 1504/05;
died Paris, France, March/September 1570

Procaccini, Camillo 139
born Bologna, Italy, c.1555;
died Milan, Italy, August 21, 1629

Puvis de Chavannes, Pierre 298, *298*, 300
born Lyons, France, December 14, 1824;
died Paris, France, October 24, 1898

R

Ramsay, Allan 210, *210*
born Edinburgh, Scotland, UK, October 2, 1713;
died Dover, UK, August 10, 1784

Raphael 96, 97, 100, *100*, 104, **106**, *106*, 108,
108–9, 132, 134, *136*, 144, 146, 256
born Urbino, Italy, March 28 or April 6, 1483;
died Rome, Italy, April 6, 1520

Rauschenberg, Robert 362, 368
born Port Arthur, TX, October 22, 1925;
died Captiva Island, FL, May 12, 2008

Read, Katharine 225, *225*
born Dundee, Scotland, UK, February 3, 1723;
died At sea, December 15, 1778

Redon, Odilon 299, 300, **307**, *307*
born Bordeaux, France, April 20, 1840;
died Paris, France, July 6, 1916

Regnault, Jean-Baptiste 226, *226*
born Paris, France, October 30, 1843;
died Buzenval [now in Paris], France,
January 19, 1871

Rego, Dame Paula 374, 375, **381**, *381*
born Lisbon, Portugal, January 26, 1935

Rembrandt 178, *178*, 182, 183, **184**, *184*,
188, *188–9*, 268, *268*, 274, 317, 376
born Leiden, Netherlands, July 15, 1606;
died Amsterdam, Netherlands, October 4, 1669

Reni, Guido 156, 157, 160, *161*, 192, *192*
born Bologna, Italy, November 4, 1575;
died Bologna, August 18, 1642

Renoir, Pierre-Auguste 276, *276*, *282–3*,
283, 347
born Limoges, France, February 25, 1841;
died Cagnes-sur-Mer, France, December 3, 1919

Repin, Ilya 271, *271*
born Chuguyev, Ukraine, July 24 [August 5], 1844;
died Kuokkala, Finland [now Repino, Russia],
September 29, 1930

Restout, Jean *205*
born Rouen, France, March 26, 1692;
died Paris, France, January 1, 1768

Reynolds, Sir Joshua 221, 225, 236, *236*
born Plympton, UK, July 16, 1723;
died London, UK, February 23, 1792

Ribera, Jusepe de *173*, 274
baptized Játiva, Spain, February 17, 1591;
died Naples, Italy, September 3, 1652

Ricci, Marco 213
born Belluno, Italy, June 5, 1676;
died Venice, Italy, January 21, 1730

Ricci, Sebastiano 212, *213*, *213*
baptized Belluno, Italy, August 1, 1659;
died Venice, May 15, 1734

Richter, Gerhard 366, 370, *371*, *371*,
374, 380, *381*
born Dresden, Germany, February 9, 1932

Rigaud, Hyacinthe 204, *204*
born Perpignan, France, July 18, 1659;
died Paris, France, December 29, 1743

Riley, Bridget 363
born London, UK, April 24, 1931

Rivera, Diego 347
born Guanajuato, Mexico, December 13, 1886;
died Mexico City, Mexico, November 24, 1957

Robert, Hubert *206–7*, **207**
born Paris, France, May 22, 1733;
died Paris, April 15, 1808

Rodin, Auguste 302, **304**, *304*, 305, 376
born Paris, France, November 12, 1840;
died Meudon, France, November 17, 1917

Rosa, Salvator 160, *162*
born Arenella, Italy, July 21 [or possibly June 20],
1615; died Rome, Italy, March 15, 1673

Roslin, Alexander 210, *217*
born Malmö, Sweden, July 15, 1718;
died Paris, France, July 5, 1793

Rossetti, Dante Gabriel 238, 256, *256*, 259,
260, *260*, 261, **262**, *262*, 264
born London, UK, May 12, 1828;
died Birchington, UK, April 9, 1882

Rosso Fiorentino 134, *134*, *136*, 143, *143*,
144, *144*, 146, 147, 150
born Florence, Italy, March 8, 1494;
died Fontainebleau or Paris, France,
November 14, 1540

Rothko, Mark 350, 352, 354, 355, *355*, 356
born Dvinsk, Russia [now Daugavpils, Latvia],
September 25, 1903;
died New York City, NY, February 25, 1970

Rouault, Georges 300, *318*, **319**
born Paris, France, May 27, 1871;
died Paris, February 13, 1958

Roubiliac, Louis-François 215
born Lyons, France, August 31, 1702;
died London, UK, January 11, 1762

Rousseau, Henri 293, *293*, 342, *342*
born Laval, France, May 21, 1844;
died Paris, France, September 2, 1910

Rowlandson, Thomas 251, *251*
born London, UK, July 14, 1756/57;
died London, April 21, 1827

Rubens, Sir Peter Paul 118, 166, *166*, 167,
168, *169*, 170, 171, 172, *172–3*, 191, 192, 202,
202, 239, 241
born Siegen, Germany, June 28, 1577;
died Antwerp, Flanders, May 30, 1640

Rublev, Andrei 42, 52, *52–3*
born Russia, c.1360?;
died Moscow, Russia, 1430

Ruisdael, Jacob van *185*, 187
born Haarlem, Netherlands, 1628/29?;
died Amsterdam?, Netherlands; buried Haarlem,
March 14, 1682

Runciman, Alexander 225
born Edinburgh, Scotland, UK, August 15, 1736;
died Edinburgh, October 21, 1785

Runge, Philipp Otto 234, 240, *240*
born Wolgast, Pomerania [now in Germany],
July 23, 1777;
died Hamburg, Germany, December 2, 1810

Russell, John Peter 314, *314*
born Sydney, Australia, June 16, 1858;
died Sydney, April 22, 1930

Ruysch, Rachel 187, *187*
baptized The Hague, Netherlands, June 3, 1664;
died Amsterdam, Netherlands, August 12, 1750

Rysselberghe, Théo van 293, *295*
born Ghent, Belgium, November 23, 1862;
died Saint-Clair, Côte d'Azure, France,
December 13, 1926

S

Sánchez Cotán, Juan *170*
baptized Orgaz, Spain, June 25, 1560;
died Granada, Spain, September 8, 1627

Sansovino, Jacopo 111
baptized Florence, Italy, July 2, 1486;
died Venice, Italy, November 27, 1570

Sargent, John Singer 284, 374, 376,
376–7, **377**, 378
born Florence, Italy, January 12, 1856;
died London, UK, April 15, 1925

Sarto, Andrea del *106*, 134, *134*
born Florence, Italy, July 16, 1486?;
died Florence, September 28/29, 1530

Sassetta 90, *92*
born Siena or Cortona?, Italy, c.1400;
died Siena, Italy, April 1, 1450

Savoldo, Giovanni Girolamo 158, *158*
active Venice, Italy, 1506–48

Scheffer, Ary *243*
born Dordrecht, Netherlands, February 10, 1795;
died Argenteuil, France, June 15, 1858

Schiele, Egon 306, *317*, 341
born Tulln, Austria, June 12, 1890;
died Vienna, Austria, October 31, 1918

Schinkel, Karl Friedrich *251*
born Neuruppin, Germany, March 13, 1781;
died Berlin, Germany, October 9, 1841

Schmidt-Rottluff, Karl 320
born Rottluff, Germany, December 1, 1884;
died West Berlin, Germany, August 10, 1976

Schnabel, Julian 319
born New York City, NY, October 26, 1951

Schwitters, Kurt 347, *347*
born Hanover, Germany, June 20, 1887;
died Kendal, UK, January 8, 1948

Scorel, Jan van 142, 146, *147*, 149
born Schoorl, Netherlands, August 1, 1495;
died Utrecht, Netherlands, December 6, 1562

Sebastiano del Piombo *106*
born Venice?, Italy, c.1485;
died Rome, Italy, June 21, 1547

Segantini, Giovanni *304*
born Arco, Italy, January 15, 1858;
died Schafberg, Switzerland, September 28, 1899

Sérusier, Paul *292*
born Paris, France, November 9, 1864;
died Morlaix, France, October 6, 1927

Seurat, Georges 209, 283, 284, 288, *292*, **293**, 295, 296
born Paris, France, December 2, 1859;
died Paris, March 29, 1891

Shaw, John Byam *263*
born Madras, India, November 13, 1872;
died London, UK, January 26, 1919

Sheeler, Charles 322, *329*
born Philadelphia, PA,
July 16, 1883;
died Dobbs Ferry, NY,
May 7, 1965

Siddal, Elizabeth 256, 260, 262
born London, UK, July 25, 1829;
died London, February 11, 1862

Signac, Paul 283, *292*, 293, 315
born Paris, France, November 11, 1863;
died Paris, August 15, 1935

Signorelli, Luca *104*
born Cortona, Italy, c.1440–50;
died Cortona, October 23/24, 1523

Sisley, Alfred 276, 277, 284, *284*, 285
born Paris, France, October 30, 1839;
died Moret-sur-Loing, France,
January 29, 1899

Sluter, Claus 122, *122*
born Haarlem, Netherlands, c.1350;
died Dijon, France, 1405/6

Soutine, Chaim 312, *317*, 318, 328
born Smilovitchi, Russia [now Belarus], 1893;
died Paris, France, August 9, 1943

Spinello Aretino *84*
born Arezzo, Italy, c.1350;
died Arezzo, 1410/11

Spranger, Bartholomeus 143, *150*
born Antwerp, Flanders, March 21, 1546;
died Prague, Austria, 1611

Steen, Jan *186*
born Leiden, Netherlands, 1625/26;
buried Leiden, February 3, 1679

Steer, Philip Wilson 284, *284–5*
born Birkenhead, UK, December 28, 1860;
died London, UK, March 21, 1942

Stella, Frank *355*
born Malden, MA, May 12, 1936

Still, Clyfford 350, *354*
born Grandin, ND, November 30, 1904;
died Baltimore, MD, June 23, 1980

Stuck, Franz von *306*
born Tettenweis, Germany,
February 23, 1863;
died Munich, Germany, August 30, 1928

Subleyras, Pierre *206*
born Saint-Gilles-du-Gard, France,
November 25, 1699;
died Rome, Italy, May 28, 1749

Tassi, Agostino 164
born Rome, Italy, 1578;
died Rome, February 1644

Teniers, David the Younger *167*
born Antwerp, Flanders, December 15, 1610;
died Brussels, Flanders, April 25, 1690

Terbrugghen, Hendrick 182
born The Hague?, Netherlands, 1588?;
died Utrecht, Netherlands, November 1, 1629

Tibaldi, Pellegrino *137*, 139
born Puria di Valsolda, Italy, c.1527;
died Milan, Italy, May 27, 1596

Tiepolo, Giambattista 117, *211*, 212, *218–19*, *219*
born Venice, Italy, March 5, 1696;
died Madrid, Spain, March 27, 1770

Tintoretto 114, 116, *117*, 151
born Venice, Italy, 1518?;
died Venice, May 31, 1594

Tischbein, Wilhelm *226*
born Haina, Germany, February 15, 1751;
died Eutin, Germany, June 26, 1829

Titian 97, 106, 110, 111, 114, *115*, 116, *116*, 118, *118–19*, 151, 168, 192, *192*, 212, *212*, 213
born Pieve di Cadore, Italy, c.1485;
died Venice, Italy, August 27, 1576

Tomaso da Modena *83*
born Modena, Italy, c.1325;
died c.1379

Toulouse-Lautrec, Henri de 293, **294**, *294*, 295, 299
born Albi, France, November 24, 1864;
died nr. Langon, France, September 9, 1901

Trevisani, Francesco *214*
born Capodistria, Italy [now Koper, Slovenia],
April 9, 1656;
died Rome, Italy, July 30, 1746

Turner, JMW 246, *246*, 248, 250, 251, 252, 253, *253*
born London, UK, April 23, 1775;
died London, December 19, 1851

Twombly, Cy 366, *367*, *368–9*, *369*, 371
born Lexington, VA, April 25, 1928;
died Rome, Italy, July 5, 2011

Uccello, Paolo 89, *92–3*, **93**, 96
born Florence, Italy, c.1397;
died Florence, December 10, 1475

Ulft, Jacob van der *179*
baptized Gorinchem, Netherlands,
March 26, 1621;
died Nordwijk, Netherlands,
November 18, 1689

Valdés Leal, Juan de 170, *173*
baptized Seville, Spain, May 4, 1622;
buried Seville, October 15, 1690

Valenciennes, Pierre-Henri de 220, *220*
born Toulouse, France, December 6, 1750;
died Paris, France, February 16, 1819

Valentin de Boulogne 192, 194, *194*
baptized Coulommiers, France,
January 3, 1591?;
died Rome, Italy, August 18/19, 1632

Vallou de Villeneuve, Julien 268
born Boissy-Saint-Léger, France,
December 12, 1795;
died Paris, France, May 4, 1866

Van Gogh, Vincent 272, *288*, 290, 292, **296**, *297*, 314, 316
born Zundert, Netherlands, March 30, 1853;
died Auvers-sur-Oise, France, July 29, 1890

Vasarely, Victor 360, *360*
born Pécs, Hungary, April 9, 1906;
died Paris, France, March 15, 1997

Vasari, Giorgio 98, 100, 104, **107**, 111, 132, 133, 135, **138**, *138*, 146, 217
born Arezzo, Italy, July 30, 1511;
died Florence, Italy, June 27, 1574

Velázquez, Diego 118, 166, 167, 170, **173**, *176*, *176–7*, 274, 376, *376*
baptized Seville, Spain, June 6, 1599;
died Madrid, Spain, August 6, 1660

Velde, Willem van de the Elder 186
born Leiden, Netherlands, 1611;
buried London, England, December 16, 1693

Velde, Willem van de the Younger 186, *186*, 278, *278*
baptized Leiden, Netherlands,
December 18, 1633;
died London, UK, April 6, 1707

Vermeer, Jan 178, 185, *185*
baptized Delft, Netherlands, October 31, 1632;
buried Delft, December 16, 1675

Vermeyen, Jan Cornelisz. *168*
born Beverwijk, Netherlands, c.1504;
died Brussels, Flanders, c.1559

Vernet, Claude-Joseph 250, *251*
born Avignon, France, August 14, 1714;
died Paris, France, December 4, 1789

Vernet, Horace *241*
born Paris, France, June 30, 1789;
died Paris, January 17, 1863

Veronese, Paolo 111, 114, **117**, *117*, 202, *202*, 212, *212*
born Verona, Italy, 1528?;
died Venice, Italy, April 19, 1588

Verrocchio, Andrea del 102, *102*
born Florence, Italy, c.1435;
died Venice, Italy, June/July 1488

Vien, Joseph-Marie 221, **223**, *223*, 228
born Montpellier, France, June 18, 1716;
died Paris, France, March 27, 1809

Vigée-Lebrun, Elisabeth **227**, *227*
born Paris, France, April 16, 1755;
died Paris, March 30, 1842

Vlaminck, Maurice de 324
born Paris, France, April 4, 1876;
died Rueil-la-Gadelière, France, October 11, 1958

Vouet, Simon 190, 191, **192**, **193**, *193*, 194
born Paris, France, January 8, 1590;
died Paris, June 30, 1649

Vuillard, Edouard *295*
born Cuiseaux, France, November 11, 1868;
died La Baule, France, June 21, 1940

Wallis, Henry *270*
born London, UK, February 21, 1830;
died Croydon, UK, December 20, 1916

Ward, James *251*
born London, UK, October 23, 1769;
died Cheshunt, UK, November 16, 1859

Warhol, Andy 358, 359, 360, 362, *362*, **363**
born Pittsburgh, PA, August 6, 1928;
died New York City, NY, February 22, 1987

Waterhouse, J.W. *263*
born Rome, Italy, January 1849;
died London, UK, February 10, 1917

Watteau, Antoine 200, 202, *202–3*, **203**, 204, 206, 212
baptized Valenciennes, France,
October 10, 1684;
died Nogent-sur-Marne, France, July 18, 1721

Watts, George Frederic *303*
born London, UK, February 23, 1817;
died London, July 1, 1904

Weber, Otto 290, *290*
born Berlin, Germany, October 17, 1832;
died London, UK, December 23, 1888

Werff, Adriaan van der *214*
born Kralingen, Netherlands, January 21, 1659;
died Rotterdam, Netherlands, November 12,
1722

West, Benjamin 221, *225*, 239
born Springfield [now Swarthmore], PA,
October 10, 1738;
died London, UK, March 11, 1820

Weyden, Rogier van der 122, **124**, *124–5*, 125, 126
born Tournai, Flanders, 1399?;
died Brussels, Flanders, June 18, 1464

Whistler, James McNeill 261, 284, 334, *334*
born Lowell, MA, July 11, 1834;
died London, UK, July 17, 1903

Wood, Grant *379*
born nr. Anamosa, IA, February 13, 1891;
died Iowa City, IA, February 12, 1942

Wright (of Derby), Joseph 248, **249**, *249*
born Derby, UK, September 3, 1734;
died Derby, August 29, 1797

Wtewael, Joachim *182*
born Utrecht, Netherlands, 1566;
died Utrecht, August 13, 1638

Zeuxis 36
born Heraclea, Italy; **active** late 5th century BCE

Zimmermann, Johann Baptist 216, *216*
baptized Wessobrunn, Germany,
January 3, 1680;
buried Munich, Germany, March 2, 1758

Zuccaro, Federico 139, *139*
born Sant'Angelo in Vado, Italy, April 18,
1540/41;
died Ancona, Italy, 1609

Zurbarán, Francisco de 166, 170, **171**, *171*, 176
baptized Fuente de Cantos, Spain,
November 7, 1598;
died Madrid, Spain, August 27, 1664

GENERAL INDEX

Bold page numbers indicate main references; numbers in *italic* refer to illustrations; numbers in ***bold italic*** refer to Turning Points and Masterworks. Page references for artists are included in the Index of Artists (*see pp.386–91*).

1938 (painting) (Nicholson) *337*
1949 (Still) *354*

A

Aberdeen Bestiary 71
Abraham and the Sacrifice of Isaac (Aelfric Hexateuch) *68*
Abstract Painting (812) (Richter) *371*
Académie des Beaux-Arts, Paris 277
Accademia del Disegno, Florence 133, 138, 140
Accademia Ercolanese 222, 223
acrylic paints 370, *370*
Adam, Robert 221, 222, 224
Adam Naming the Animals (Aberdeen Bestiary) *71*
The Adoration of the Magi (J. Bellini) *112*
Adoration of the Magi (Gentile da Fabriano) 85, 94
Adoration of the Magi (Giotto) *79*
Adoration of the Name of Jesus (Gaulli) *156*
The Adoration of the Shepherds (Maratta) *162*
The Adoration of the Shepherds (Mayno) *170*
Adoration of the Shepherds (Procaccini) *139*
Adoration of the Shepherds (Wtewael) *182*
Adrian VI, Pope 133
Aelfric of Eynsham 68
Aelfric Hexateuch 68
Aeneas's Flight from Troy (Barocci) *139*
Aethelwold of Winchester 66, *66*
African art 13, 16, 18, 19, 324, *324*, 328
Age of Bronze (Rodin) *302*
The Agony in the Garden (G. Bellini) ***112–13***
The Agony in the Garden (Mantegna) 112, *112*
Agrigentum 220, *220*
Agrippina (West) 221
Agrippina Landing at Brindisium With the Ashes of Germanicus (West) *225*
Ahmose, Pharaoh 23
Aidan 58
Aix-en-Provence 294
Akhenaten, Pharaoh 23, 26, 28
Albani, Cardinal 222
Albert, Prince Consort 257
Albizzi family 89
The Aldobrandini Wedding (Roman) *39*
Alexander II, Tsar 267
Alexander VI, Pope 101
Alexander VII, Pope 157
Alexander the Great 33, 38, *128*
Alexander the Great as Zeus (Roman) *37*
Alexander the Great's Triumphal Entry into Babylon (Le Brun) *196–97*

Alexandria 29, 44
Alfred the Great, King of Wessex 60, 66
Alfred Jewel 66, *66*
Algeria 18–19, 300
Alhambra Palace, Granada 300
Aline and Valcour (Man Ray) *347*
Allegorical Portrait of Sir John Luttrell (Eworth) *147*
Allegory of Good and Bad Government (Lorenzetti) 79, *82–83*
Allegory of Water or Allegory of Love (Fontainebleau School) 142, *142*
An Allegory With Venus and Cupid (Bronzino) ***140–41***, 146
Allen, Paul 367
Alloway, Lawrence 360
Alps 247, *247*
Altamira cave 14, *15*
The Ambassadors (Holbein) 121, ***130–31***
American Gothic (Wood) *379*
Amsterdam 179, *179*, 180, 183, 188
anamorphic perspective 130
The Ancient Town of Agrigentum (Valenciennes) 220, *220*
Andrew of Crete, St 44
The Angel Battles the Beast (Apocalypse of Beatus) *68*
The Angel of Death (De Morgan) *263*
Angeli Ministrantes (Burne-Jones and Morris) *263*
The Angelus (Millet) *270*
Anglo-Saxons 55, 65, 66, 67
Angry Landscape (Appel) *370*
The Annunciation (Fra Angelico) ***90–91***
The Annunciation (Lotto) *116*
The Annunciation (Simone Martini) 82, 90, *90*
The Annunciation With St. Emidius (Crivelli) *97*
The Annunciation With Six Saints (Fra Bartolommeo) *105*
Antioch 44
Antony, Mark 23, 29, 33
Antwerp 127, 128, 148, 167, 170
Apocalypse of Beatus 68
Apollinaire, Guillaume 329, 341
Apollo Belvedere (Roman) *101*
The Apotheosis of Virgil (Flaxman) *227*
The Apparition (Moreau) ***300–01***, *303*
Arc de Triomphe, Paris *221*
The Archangel Michael Vanquishing Satan (Reni) *161*
Archangels Michael and Gabriel (icon) *49*
The Archduke Leopold William in His Picture Gallery (Teniers) *167*
Architectural Capriccio (Robert) *206–7*
Ardèche Valley 14
Arena Chapel, Padua 78–82, *78, 80, 81*
Arezzo 88
Aristotle 108
Arles 296
Armory show, New York (1913) 327
Armstrong, Neil 367
Arnold Schoenberg (Schiele) *317*
The Arnolfini Portrait (van Eyck) ***122–23***
Arrangement on Grey and Black No. 1 (Whistler) *334*

Art of Painting (Pacheco) 173
The Art of Painting (Vermeer) *185*
Art of This Century gallery, New York 355, *355*, 356
The Arte of Limning (Hilliard) 151, 152
Artemis and Actaeon Bell Krater (Greek) *37*
Arthur, King 58
The Artist and His Family (Largillière) *204–05*
The Artist in the Character of Design (Kauffmann) *226*
The Artist's Wife (Ramsay) *210*
"As is When"—I Went to New York (Paolozzi) *362*
The Ascension (Rabbula Gospels) *44*
Ascoli 97
The Assault of the Jaguar (Rousseau) *342*
Assumption of the Virgin (Correggio) 106
The Assumption of the Virgin (Titian) *115*
Astarte Syriaca (Rossetti) *262*
At the Races in the Countryside (Degas) *280*
Athelstan, King of Wessex 61
Athens 33
Augsburg 111, 116
Augustine of Canterbury, St 55, 56, 61
Augustulus, Romulus, Emperor 55
Augustus, Emperor 33
Augustus Listening to the Reading of the Aeneid (Ingres) *229*
Aurier, Albert 304
Aurignacian industry 13
Aurora (Guercino) ***164–65***
Australia
 prehistoric art 13, 16, *18*
Austria
 Rococo 214
 Vienna Secession 305, 306, 307, 316
Autumn Landscape With a View of Het Steen in the Early Morning (Rubens) *172–73*
Autumn Leaves (Millais) ***264–65***
Avalanche in the Alps (Loutherbourg) *250–51*
The Avenue (Hobbema) *187*
Avignon 65, 68, 79, 84, 101
The Awakening Conscience (Hunt) *260*

B

Bacchus and Ariadne (Giordano) *162*
Bacchus and Ariadne (Ricci) 212, ***213***
Bacchus and Ariadne (Titian) 97, ***118–19***, 212, *212*
Bacchus, Ceres and Cupid (Hans von Aachen) *150–51*
Back 1—Back 4 (Matisse) *318*
Baird, John Logie 341
Balbec 222, 224
Ball, Hugo 344
Ballets Russes 323, 329
Balzac, Honoré de 305
Bangor, County Down 60

Banquet of the Officers of the St. George Civic Guard Company of Haarlem (Hals) ***180–81***
The Baptism of Christ (Piero della Francesca) 88, *88*
The Baptism of Christ (Trevisani) *214*
Baptistery, Florence 92
A Bar at the Folies-Bergère (Manet) *283*
Barbaric Tales (Gauguin) *295*
Barbarossa Pays Homage to Pope Alexander III (Zuccaro) *139*
Barbizon school 268, 278, 279, 296
Barcelona 325
The Bard (Martin) *252*
Barge Haulers on the Volga (Repin) 271, *271*
Bargeman (Léger) *328–29*
Barricade in the Rue de la Mortellerie (Meissonier) *267*
Barry, Charles 258
Basil I, Emperor 48
Bastille, Paris 221, 235, *235*
Bastos (Motherwell) *355*
Bath, England 217
The Bathers (Courbet) ***268–69***
Bathers (Heckel) *317*
Battle of Cascina (Michelangelo) 138
The Battle of Issus (Altdorfer) *128*
Battle of San Romano (Uccello) 93
Baudelaire, Charles 235, 271, 315
Bauhaus 316, 337
Bayeux Tapestry 64, *64*
Beach Scene at Trouville (Boudin) ***278–79***
Beata Beatrix (Rossetti) *256*
The Beatles 360, 363
Beatus of Liebana 68
Beaune 125
Bede, Venerable 59, 60
Beethoven, Ludwig van 235
The Beguiling of Merlin (Burne-Jones) 261
Bellini, Nicolosia 114
Benedict, St. 206
Benedictional of St. Aethelwold 66, *67*
Benefits Supervisor Sleeping (Freud) ***382–83***
Berlin 228, 320, 342, 344
Bernard of Clairvaux 65
Bernardino of Siena 93
Bernhardt, Sarah 299
Berry, Jean, Duc de 73
Berzé-la-Ville 65
bestiaries 71
The Betrayal of Christ (Giotto) ***80–81***
Bible 56, 57, 121
A Bigger Splash (Hockney) *363*
Bing, Siegfried 299
Birtwell, Celia 380
Bison (cave painting) **15**
The Black Tern (Baselitz) *319*
Blast 328
Der Blaue Reiter 316, 368
Blavatsky, Madame Helena 299
Blenheim Palace, Oxfordshire 214
The Blinding of Samson (Rembrandt) 178, *184*
The Blood of a Poet (film) 345, *345*

Blue Dancers (Degas) 285
Boethius Diptych 47
Bohemia 143, 334, *334*
Bologna 139, 160, 164
Bolsena, Lake 368, *368*
The Book of the Dead (Egyptian) 29
Book of Durrow 58
Book of Kells 55, 57, **62–63**
Books of Hours 65
Borghese, Cardinal Scipione 157
The Boulevard Montparnasse on a Winter Morning (Pissarro) 285
Bradshaw, Joseph 18
Bradshaw figures *18*
Brancacci Chapel, Florence 86, 90, 92
Brandon, Robert 152
Breakfast (Signac) 292
Breda 176
Breton, André 341, 344, 345, 346
Breton Women With Umbrellas (Bernard) *293*
Breuil, Henri 15, *15*, 17, 20
Britain
 Mannerism 143
 Pop art and Op art **358–65**
 Pre-Raphaelite Brotherhood **256–65**
 Rococo 210
 Romanticism 234, 246–47, 250–53
 Vorticism 323, 324, 328
 Winchester School 65, 66–67
British Empire 235
British Gentlemen in Rome (Read) 225
Brittany 289, 290, 291, 292
The Broken Pitcher (Greuze) 207
Browning, Robert 262
Die Brücke 316, 317, 320
Bruges 120, 122, 126, 174
Brunel Deschamps, Éliette 13, 14, 16
Brussels 167, 302, 303
Bryant, William Cullen 253
Buen Retiro, Madrid 176
The Building of the Tower of Babel (Romanesque) *69*
Buñuel, Luis 345
The Burghers of Calais (Rodin) 304
A Burial at Ornans (Courbet) *270–71*
Burke, Edmund 227, 248, 251
The Burning of the Bones of St. John (Geertgen tot Sint Jans) *180*
The Burning of Troy (Poussin) 248
Bury St. Edmunds 66
Bushmen 13
Byron, Lord 234, 235, 241
Byzantine art **42–53**, 66, 79, 80, 82, 112, 306

C

Cabaret Voltaire, Zurich 342
The Cadet and His Sister (Rego) 381
Café Guerbois, Paris 280
Cambyses II, King of Persia 23
Camera Picta (Mantegna) *94*
Campbell's Soup Can Tomato (Warhol) 362
Candamo Cave 16
The Cannon Shot (van de Velde) *186*
Canterbury 66
Canterbury Codex Aureus 58, *60*, 62
The Canterbury Tales (Chaucer) 65
Canute, King of Denmark and England 68
Capet, Hugh, King of France 61

Capetian dynasty 61
Capponi, Ludovico 132, *132*
A Capriccio With Roman Ruins (Panini) 215
capriccios 207, 215
Carcass of Beef (Soutine) 317
The Card Players (Lucas van Leyden) *128*
Cardinal Richelieu (Champaigne) 195
The Care of the Sick (Domenico di Bartolo) *93*
Carlyle, Thomas 261
Carnation, Lily, Lily, Rose (Sargent) 377
Carnival of Harlequin (Miró) 345
Carolingian dynasty 66
Carthage 38
Carthusian Order 65
Cassiodorus 56
Castiglione, Baldassare 106, 143
El Castillo cave 18
catacombs, Rome 44, *46*
Cathach of St. Columba 56
Catherine de Médicis 143, 148
Catholic Church 121, 133, 157, 158, 162
Catullus 118
cave paintings **12–21**, 378
Caylus, Comte de 222
Celebes (Ernst) **342–43**
Celts 55, 56, 62, 64
Céret 330
Cerveteri 34, 36
Chamber of Roman Ruins (Clérisseau) 225
Chambers, Sir William 217
Charcot, Jean-Martin 299
Charlemagne 66
Charles I, King of England 160, 167, 171, 172, *172*
Charles I Out Hunting (Van Dyck) *172*
Charles II, King of Spain 162, 167, 175
Charles II Adoring the Host (Coello) *175*
Charles III, King of Spain 238
Charles V, Emperor 101, 107, 111, *116*, 118, 127, 133, 168, *168*
Charles V on Horseback (Titian) *116*, 168
Charles V Reviewing His Troops (Vermeyen) *168*
Charles VII, King of France 125
Charles VIII, King of France 89, 101, 111
Charles IX, King of France 148
Charles X, King of France 235
Charles the Bold, Duke of Burgundy 126
Charon Crossing the Styx (Patinir) *128*
Chaucer, Geoffrey 65, 259
Chauvet, Jean-Marie 14
Chauvet Cave 14, *14*, 16
Chephren, Pharaoh 23
Un Chien Andalou (film) 345
Chigi, Agostino 96, 105
The Child in the Meadow (Runge) 240
Children Paddling, Walberswick (Steer) *284–85*
Chinese Horse (prehistoric) 13, **20–21**
chinoiserie 217
The Chocolate Girl (Liotard) *216*
Christ and Abbot Mena (Coptic) 44, *46*
Christ at the Marriage at Cana (Goltzius) *180*
Christ Before the High Priest (Honthorst) *182*
Christ Driving the Traders from the Temple (El Greco) *150–51*
Christ in Majesty (Romanesque) *70*
Christ in the House of His Parents (Millais) 260
Christ of Clemency (Montañes) 170

Christ's Entry into Jerusalem (Benedictional of St. Aethelwold) **66–67**
Christianity **42–53**, 54–59, 79, 80–81
Church at St. Cirq (Daura) 368
A Church in Brittany (Weber) 290
The Church Militant and the Church Triumphant (Andrea da Firenze) *84*
Church of England 121
cinema 345, 360, 375
cinnabar 34, *34*
Circus Scene (Anquetin) 290
Cistercian Order 65, 69
Clare of Assisi, St 359
Clark, Ossie 380
Clement VII, Pope 133
Clement XIII, Pope 211
Cleopatra, Queen of Egypt 23, 29, 33
Cliff, Clarice 329, *329*
Clovis I, King of the Franks 58
The Clubfooted Boy (Ribera) *173*
Coastal Scene in a Storm (Vernet) *250*
Coates, Robert 350
Coburn, Alvin Langdon 323
Codex Amiatinus 56, 59
Codex Euricianus 56
Codex Manesse 72
Codex Rossanensis 44
Codex Vigilanus 61
Colbert, Jean-Baptiste 197
Coleridge, Samuel Taylor 247
collage 330, 342, 347, 360, 362
Collé, Charles 208
Collioure 312
Cologne 66
color versus line 116
Colosseum, Rome 39
Columba, St. 56, *57*
Columbus, Christopher 101, 121
Comgall, St 60
comic books 360, *360*, 364, 365
commedia dell'arte 202, 318, 345
Commynes, Philippe de 111
Compartment C, Car 293 (Hopper) *379*
Composition (Van Doesburg) *336*
Composition VI (Kandinsky) **338–39**
Conjuring Trick (Klee) *318*
The Conquest of the Air (La Fresnaye) 327
Constantijn Huygens and His Clerk (Keyser) *183*
Constantine the Great, Emperor 42, 43, 46
Constantinople 43, *43*, 50, 111
contrapposto poses 134, 144
Copernicus, Nicolaus 133
Coptic Church 44, *46*
Corinth 33, 36
Corneille, Pierre 230
Cornforth, Fanny 262
Coronation of Alexander III (Aretino) *84*
Coronation of the Virgin (Lorenzo Monaco) *84*
Cosquer, Henri 17
Cosquer Cave *17*
The Côte des Boeufs at L'Hermitage (Pissarro) *282*
The Courtyard of a House in Delft (de Hooch) *184*
Crassus, Marcus 39
Crete 19, 34
Cromwell, Thomas 131
Crosby, Theo 360
The Crucifixion (Altichiero) *84*

Crucifixion (early Christian) 48
The Crucifixion (Evesham Psalter) *71*
The Crucifixion (Grünewald) *127*
The Crucifixion (Pisano) *80*
Crucifixion With Eight Saints (Daddi) *83*
The Crucifixion With the Virgin, St. John, St. Jerome, and St. Mary Magdalene (Perugino) *97*
cumdach 61
Cupid and Psyche (David) 229
Cupid Complaining to Venus (Cranach) *146*
The Cupid Seller (Vien) **223**
Cuthbert, St 59

D

Dam Square, Amsterdam (Van der Ulft) *179*
The Damned Consigned to Hell (Signorelli) *104*
Danaë (Gossaert) *146*
Danaë Receiving the Shower of Gold (Primaticcio) *147*
dance, Expressionism *319*
The Dance (Rego) *381*
Dance at the Moulin de la Galette (Renoir) *276*
Dante Alighieri 79, 243, 262
Darwin, Charles 257
David and Dorelia in Normandy (A. John) *378*
David Garrick as Richard III (Hogarth) *236*
The Dead Wolf (Oudry) *205*
Death and the Maiden (Baldung Grien) *128*
The Death of Ananias (Lairesse) *187*
Death of Dido (Reynolds) 236, *236*
The Death of Eurydice (Niccolò dell'Abate) *148*
The Death of Lucretia (Hamilton) *224*
Death of Meleager (Roman) *134*
Death on the Pale Horse (West) *239*
The Death of Priam (Regnault) *226*
Death of St. Scholastica (Restout) *205*
The Death of Sardanapalus (Delacroix) *234*
The Death of the Virgin (Caravaggio) *268*, *268*
Deauville 279
Dedham Lock and Mill (Constable) *252*
Delft 184, 185
della Rovere, Giuliano 139
Delphic Sibyl (Michelangelo) *134*
Les Demoiselles d'Avignon (Picasso) 323, **324–25**
The Deposition (La Hyre) *196*
The Deposition of Christ (Pontormo) 134, **135**, 140
Descent from the Cross (van der Weyden) *124–25*
Desdemona Retiring to her Bed (Chassériau) *243*
Desire (Klinger) *302*
Destiny (Waterhouse) *263*
Detail of Wrestlers (Etruscan) *36*
Deutschland Deutschland über Alles (Heartfield) *345*
Diaghilev, Serge 323
Diana of Versailles (Roman) *144*
Diana the Huntress (Fontainebleau School) **144–45**
Diana the Huntress (Giampetrino) *144*
Diane de Poitiers 143, 144, 149

Dickens, Charles 260, 261
Difficult (Schwitters) *347*
Dijon 122
Dijon Altarpiece (Broederlam) 122, *122*
Dinteville, Jean de 130
Diocletian, Emperor 50
Diocletian's Palace, Split 222
Dionysus Cup (Exekias) **34–35**
Diptych of Maartin van Nieuwenhove
 (Memling) *126*
diptychs *47*, 84
Disappointed Love (Danby) *241*
disegno 116
Disputa (Raphael) 101, 107, 108
Disrobing of Christ (El Greco) 150
The Doge Leonardo Loredan (Giovanni
 Bellini) *110*
Dominican Order 83, 84
Dorelia in a Black Dress (G. John) *378*
Double Metamorphosis III (Agam) *363*
Drakensberg 19
Dresden 320
Dreyfus, Alfred 289
The Duke of Lerma on Horseback
 (Rubens) **168–69**
Dunstan, St. 66
Durand-Ruel, Paul 277, 281
Dutch art *see* Netherlands
Dutch Republic 167, 178–80
Dutch Vessels Inshore and Men Bathing
 (Van de Velde the Younger) *278*
Dying Gaul (Roman) *222*
Dynamism of a Soccer Player
 (Boccioni) *327*

E

Eadfrith, Bishop of Lindisfarne 59
easels 278, *278*
Eastman Company 277
Ebbo Gospels 66
Echternach Gospels 59
Ecole des Beaux-Arts 300
Ecole de Nancy 299
Edfu 29
Edmund, King of England 74
Edward I, King of England 252
Edward the Confessor, King of England
 74
*The Effect of Good Government in the
 City* (Lorenzetti) 79, *82–83*
Egyptian art **22–31**, 33
Eiffel Tower, Paris 277, 289, *289*, 345
Einstein, Albert 323, 348
Elizabeth I, Queen of England 143, 152
Ellesmere Chaucer 65
Eluard, Paul 342
Emperor Justinian and his Entourage
 (Byzantine) *47*
*Emperor Nicephorus III Botaneiates
 between St. John Chrysostom and the
 Archangel Michael* (Byzantine) *49*
en plein air painting 278
L'Encyclopédie (Diderot) 201, 224
End of the Working Day (Breton) *273*
Engels, Friedrich 257
England *see* Britain
The Entombment (Bouts) *125*
The Entombment (Campin) 124
The Entry of Napoleon into Berlin
 (Meynier) *228*

The Epic of American Civilization
 (Orozco) *352*
Equestrian Statue of Cosimo I
 (Giambologna) 168, *168*
Erasmus 131
Eric Bloodaxe 61
Erik the Red 68
Escorial, Madrid 139, 175, *175*
Essex, Robert Devereux, 2nd Earl of 152
Este, Alfonso d', Duke of Ferrara 97, 118
Este, Isabella d' 97, *97*
Este family 88, 106
Etchings to Rexroth (Marden) *370*
Ethelbert, King of Wessex 60
Etruscans 33, 34, 36
Euclid 108
Eugen, Prince of Sweden 379
Euric, king of the Visigoths 56
Euripides 226
Evesham Psalter 71, 74
Exarchate of Africa 46
The Execution of Lady Jane Grey
 (Delaroche) *243*
Exhibition of a Rhinoceros at Venice
 (Longhi) *216*
Exposition des Arts Décoratifs, Paris (1925)
 317, 329
Ezekiel's Vision in the Valley of Dry Bones
 (Byzantine) *48*
Ezra (*Codex Amiatinus*) 56, *59*

F

The Factory 363
Falconry (Giovanetti) *72*
Fall of the Rebel Angels (Floris) *148*
Family Reunion (Bazille) *280*
fashion 337
Fayum portraits 29, 44
Federal Art Project (FAP) 351, 354, 356
The Female Clown Cha-U-Kao (Toulouse-
 Lautrec) *294*
Female Torso (Miró) *336*
Ferdinand I, Emperor 149
Ferrara 88, 106
Ferrocene (Hirst) *371*
"fêtes galantes" 203
The Fiancés (Chagall) *318*
The Fighting Temeraire (Turner) *246*
Finland 306
Flag (Johns) *362*
Flanders 122–28
Flaubert, Gustave 300, 303
Flayed Ox (Rembrandt) *317*
Flemish art 122–28, 142, **166–75**
Flight into Egypt (Elsheimer) *248*
The Flood (Girodet) *239*
Florence 78, 79, 83, 84, 88–93, *89*,
 101, 107, 111, 133, 138, 160, 161,
 168, 217
Florus and Laurus (Novgorod School) *51*
Flowers in a Sculptured Vase
 (Monnoyer) *197*
Flowers on a Ledge (Ruysch) *187*
Fontainebleau 136, 140, 147, 148, 194,
 268, 278
Fontainebleau School **142–46**, *142*, *143*,
 145, 152
Foscari, Doge Francesco 114
Foundling Hospital, Florence *90*
Fountain (Duchamp) 341, 375

The Fountain of Life (Italian miniature) *202*
Four Horsemen of the Apocalypse
 (Dürer) *121*
The Four Seasons: Summer (Boucher) *206*
The Fox (Marc) *368*
France
 Age of Enlightenment 201
 Art Nouveau 299
 Baroque **190–99**, 202
 cave paintings 14, 16–18, 20, *20–21*
 Cubism **322–31**
 Fauvism 312, 314–15, 330
 Impressionism **276–87**
 Mannerism 142–44
 Neoclassicism 221, 222–5, 230, 238
 Postimpressionism **288–97**
 Realism **266–73**
 Rococo **200–209**
 Romanticism 234, 235, 238
 Surrealism 344
 Symbolism 298
Francesca da Rimini (Scheffer) *243*
Francis I, King of France 102, 106, 140,
 143, 144, *144*, 146, 147
Francis II, King of France 148
Francis of Assisi, St 79, 80
Franciscan Order 80
Franklin, Benjamin 201
Franks 58
Frederick I, Emperor 219
Frederick II, Emperor 71
Frederick the Wise of Saxony 146
French Academy, Rome 208
Freud, Sigmund 299, 306, 341, *341*
Friedländer, Max J 146
Frieze of Life (Munch) *307*
Fry, Roger 290

G

Gallery Gasper (Jones) *358*
Game Pass Shelter, Drakensberg 19
The Garden of Earthly Delights (Bosch)
 126–27, 342, *342*
The Garden of Love (Rubens) *202*
Gare Saint-Lazare (Manet) *281*
Gassed (Sargent) *376*, **376–77**
Gates, Bill 367
Gebelein murals 23, *26–27*
Genoa 162
George, St 50, *73*
George III, King of England 211
Germany
 Bauhaus 337
 Der Blaue Reiter 316, 368
 Die Brücke 316, 317, 320
 Expressionism **312–21**, 368
 Mannerism 142
 Nazis 318, 320, 333, 337, 341, 345,
 366, 375
 Northern Renaissance 120–21, 124
 Rococo 210, 211
 Romanticism 234–36, 250–51
Gesù, Rome 162, *162*
Ghent 126
Ghent Altarpiece (Van Eyck) 122
Gilbert and Sullivan 262
Gilpin, William 250
The Girlhood of Mary Virgin (Rossetti) *260*
Giverny 286, 287
Glasgow Boys 272

glass, Venetian 112, *112*
The Gleaners (Millet) 266, *267*
*The Glory of St. Ignatius Loyola and
 the Missionary Work of the Jesuits*
 (Pozzo) *163*
Gobelins tapestry factory 191, *191*, 196,
 197, 205
God Judging Adam (Blake) *238–39*
Goebbels, Joseph 341
Goethe, Johann Wolfgang von 226, 227,
 235, 247
Goethe in the Roman Campagna
 (Tischbein) *226*
Gogh, Theo van 296
Goldsmith in His Shop (Christus) 120, *120*
Gonzaga family 88
Gonzaga, Federico II 107
Gonzaga, Ludovico 94
Gorbachev, Mikhail 367
Gordale Scar (Ward) *251*
Gospel Book of St. Augustine 55, 56
Gospel Books 54–62, *54*, *56–63*
Gothic Church on a Cliff (Schinkel) *251*
Goupil Gallery, London 295
Granada 300
Grand Tour 222, 225, 247
Grande Odalisque (Ingres) *240*
Gravettian industry 13
Gray, Effie 264
Gray, Thomas 252
Gray Scramble (Single) (Stella) *355*
The Great Harris Papyrus *28–29*
Greek art **32–39**, 55
The Green Christ (Denis) *334*
Greenberg, Clement 352
Greenland 68
Gregory I, Pope 60
Gregory XI, Pope 65
Gregory XV, Pope 164
Greiffenklau, Karl Philipp, Prince-Bishop of
 Würzburg 219
The Gresley Jewel (Hilliard) *150*
Grey Space (distractor) (Mehretu) *371*
The Gross Clinic (Eakins) **274–75**
Grosvenor Gallery, London 262
Guarini, Guarino 163
Guggenheim, Peggy 355, 356
Guggenheim, Solomon R 351
Guimard, Hector 299
Gutenberg, Johann 121
Guthrum 55

H

Haarlem 150, 180–81, 182, 185
The Hague 124
Hague School 270, 273
Haley, Bill and His Comets 359
Halley's Comet 79
Handel, George Frederic 215
Hannibal 33
Hard Times (Herkomer) *273*
The Harrowing of Hell (Byzantine) *50–51*
The Harvest (Van Gogh) *288*
Hatshepsut, Queen of Egypt 28
Haussmann, Baron Georges 277, 282
Hautvillers 55
Haviland, Frank 322
The Haywain (Constable) *242*
Head and Shoulders of the Virgin
 (Cignani) *212*

Head of a Girl (Carracci) *192*
Head of Job (Blake) *258*
Head of a Woman (Verrocchio) 102, *102*
The Heavenly Ladder 50
Hell 69
Henry II, King of France 143, 144, 148, 149
Henry IV, King of France 149, 191, 194
Henry V, King of England 73
Henry VIII, King of England 121
Herculaneum 220, 221, 222, 223
Hierakonopolis 24
hieroglyphs, Egyptian *24*, 26
Hillaire, Christian 14
A Hind's Daughter (Guthrie) *272*
Hitler, Adolf 318, 333
Hodegon Monastery, Constantinople 44
The Holy Family on the Steps (Poussin) **198–99**
Holy Roman Empire 66, 68
Holy Trinity With the Virgin, St. John, and Donors (Masaccio) *90*
Homer 221, 224, 228
Homilies of St. Gregory 48
The Honourable Mrs. Graham (Gainsborough) *217*
Hope (Watts) *303*
Horace (Corneille) 230
The Horrors of War (Rubens) *166*
Horse in a Landscape (Marc) *316*
The Horse Tamers (Roman) 236, *236*
The House of Cards (Chardin) *205*
Houses of Parliament, London 257, 258, *258*
Hudson River School 246, 254
Huelsenbeck, Richard 344
Hughes, Robert 383
Hugo, Victor 247, 267
The Human Condition (Magritte) 340, *340*
Hunters in the Snow (Bruegel) *129*
Huygens, Constantijn 183
Huysmans, Joris-Karl 300, 302, 303, *303*
Hyante and Climene Offering a Sacrifice to Venus (Dubreuil) *194*

I

I Lock My Door Upon Myself (Khnopff) **308–09**
icons 42–53
Ignatius Loyola, St. 163
Ignudo (Rosso Fiorentino) 144, *144*
Imago Hominis 58, *59*
The Immaculate Conception (Murillo) *174–75*
Impression Sunrise (Monet) *280–81*
In the Shade (Cross) *295*
Independent Group 360, 362
The Innocence of Susanna (Valentin de Boulogne) *194*
Institute of Contemporary Arts (ICA) 360, 362
Interior (Buffet) *380*
Interior of the Grote Kerk (Berckheyde) *186*
Intervention of the Sabine Women (David) 221
Iona 55, *55*, 57
The Iron Rolling Mill, or Modern Cyclops I (Menzel) *271*
Isabella (Millais) 260
Isenheim Altarpiece (Grünewald) *127*

The Island of the Dead (Böcklin) *302*
Italy
 Baroque art **156–65**, 212
 birth of the Renaissance **78–87**
 flowering of the Renaissance **88–99**
 Futurism 323, 324, 327
 High Renaissance **100–109**
 Mannerism **132–41**, 144
 Neoclassicism 222–25
 Romantic landscape 248–49
 Venetian Renaissance **110–19**
Iti, tomb of *27*

J

Jacob, Max 329
Jacob's Dream (Rosa) *162*
James I, King of England 152
Japan 286, 290, 296, 299, 314
Jarrow 55
The Jaws of Hell Fastened by an Angel (Winchester Psalter) *69*
Jefferson, Thomas 201
Jerusalem 44, 46
Jesuit Order 156, 162, 163
Jesus and the Samaritan Woman (early Christian) *46*
Jesus Before Pilate and the Repentance of Judas 44
Joan of Arc 73
John XII, Pope 68
John of Bavaria, Count of Holland 124
John Klimakos, St 50
John Wycliffe Reading his Translation of the Bible to John of Gaunt (Brown) ***259***
Jolson, Al 360
Joseph in Egypt (Pontormo) 140, *140*
Joshua Commanding the Sun to Stand Still (Martin) *252*
Judith (Palma Vecchio) *116*
Judith Beheading Holofernes (Gentileschi) *160*
Julius II, Pope 100, 101, 104, 108
Jung, Carl 352, *352*
Jupiter and Io (Correggio) *107*
Jupiter Kissing Ganymede (Mengs) *224*
Just What is it that Makes Today's Homes So Different, So Appealing? (Hamilton) **360–61**
Justin of Nassau 176
Justinian, Emperor 43, 47, 48

K

Kahnweiler, Daniel-Henry 324, *324*, 326, 329
Kamares 19
Katia Reading (Balthus) *380*
Keats, John 260
Kells 55
Kelmscott Press 263
Kennedy, Jackie 359
Kennedy, John F. 359
Kew Gardens, London 217
Khaemwaset, Prince *23*
Khafre, Pharaoh 26
Khnumhotep II, Pharaoh *27*
Khufu, Pharaoh 26
Kiesler, Frederick 355
Kindred Spirits (Durand) *253*

King David Playing the Harp (Vespasian Psalter) *60*
The King Drinks (Jordaens) *173*
Kings and Scribes (Codex Vigilanus) *61*
The Kiss (Klimt) **306–07**
The Kiss (Rodin) *304*
The Kiss of Judas (Romanesque) *69*
The Knife Grinder (Malevich) *327*
Knossos 34
Kodak 277
Kristan von Hamle Visits His Lover (Codex Manesse) *72*
Kublai Khan 72
Kuffner, Baron Raoul 379

L

La Cosa, Juan de 101
Laas Gaal 19
Lady Hamilton as a Bacchante (Vigée-Le Brun) *227*
A Lady in her Bath (Clouet) *149*
The Lady of Shalott (Hunt) *262*
The Lady With a Fan (Roslin) *217*
Lady With a Fan (Velázquez) *376*
Lake District 247, 251
Lake Keitele (Gallen-Kallela) *306*
Lamentation (Heemskerck) *148–49*
The Lamentation of Christ (Giotto) *78*
Landholdt, Anna 237
Landscape (Hofmann) *352*
Landscape, Ile de France (Guillaumin) *281*
Landscape With the Nymph Egeria (Claude Lorraine) *196*
Landscape With Shepherds and Pilgrims (Bril) *170*
Languedoc 289
Laocoön (Roman) 101, *104*, 118
The Larener Woman With Goat (Mauve) *273*
The Large Bathers (Renoir) *283*
Large Nude With Draperie (Picasso) *374*
Lascaux cave paintings 12, *12*, 13, *14*, 16, *16*, *17*, 20, *20–21*, *378*
The Last Judgment (Cavallini) *80*
Last Judgment (Michelangelo) *137*, 148
Last Judgment (Van der Weyden) *125*
The Last Judgment (Zimmermann) *216*
The Last Supper (Tintoretto) *117*
The Last Supper (Veronese) *117*
Late Afternoon, New York (Hassam) *285*
The Laughing Cavalier (Hals) 178, *183*
Laurentian Library, Rome 133, *133*
Le Havre 281, 287
Leo V, Emperor 48
Leo X, Pope 101, 133
Leopold William, Archduke 167, *167*
Lerma, 1st Duke of 168, *169*
Leroy, Louis 281
L.H.O.O.Q. (Duchamp) *344*
Liber Sacramentorum *61*
Liberty Leading the People (Delacroix) *242*
Lichfield Gospels 58, *59*
Licinius 46
The Light of the World (Hunt) *260*
Lindisfarne 55, 58
Lindisfarne Gospels 54, *54*, 55, 56, 59, *59*
Lombards 55, 60
London 250, 251, 257, 285, 302, 337, 359, 360

London Shoeshine Boy (Bastien-Lepage) *272*
Loredan, Doge Leonardo *110*, 111
Loreto 116
Lorraine 195
Los Angeles 362, 363
Louis IX, King of France 71
Louis XIII, King of France 191, 192, 194
Louis XIV, King of France 157, 162, 167, 175, 190, 191, *191*, 196, *196*, 197, 201, *204*, 214
Louis XIV (Rigaud) *204*
Louis XIV and His Family Dressed as Roman Gods (Nocret) *196*
Louis XIV Visiting the Gobelins factory (Le Brun) *191*
Louis XV, King of France 200, 201
Louis XVI, King of France 201, 221, 235
Louis-Philippe, King of France 267
Louvre, Paris 144, 201, 208, 268, 330, *367*
Ludovisi family 164
Luke, St. *44*, 59, 138
Lumière, Auguste and Louis 277, 313
Luncheon of the Boating Party (Renoir) *282–83*
Luther, Martin 101, 107, 121, 133
Luxe, Calme, et Volupté (Matisse) **315**
Lytton, Bulwer 260

M

MacDurnan Gospels *61*
Macgregol 55
McNeill, Dorelia 378, *378*
Madame de Pompadour (Boucher) *200*
Madame X (Sargent) *376*, *376*, 377
Madonna (Munch) *305*
Madonna and Child Enthroned (Cimabue) *80*
Madonna and Child With a Distaff (Morales) *150*
Madonna of the Harpies (Andrea del Sarto) *106*
Madonna of the Quail (Pisanello) *84*
The Madonna Standing With the Child and Angels (Massys) *127*
Madonna With the Long Neck (Parmigianino) *137*
Madrid 139, 167, 168, 173, 175, 176
Madrid Codex 68
Mae West's Lips (Dalí) *347*
Maestà (Duccio) *82*
Maestà (Simone Martini) *82*
Magdalenian industry 13
The Magic Apple Tree (Palmer) *252*
Manesse family 72
Manetho 26
Mantua 88, 94, 97, 107, 137
Mantua, Duke of 168
Manuel II, Emperor 51
manuscript painting 54–62, *54*, *56–63*, 65–72, *66–72*
Mao Zedong 363
Marey, Etienne-Jules 334, *334*
Margaret Valois 149
Maria-Theresa, Empress 211
Marie Antoinette, Queen of France 227, 235
Marie de Médicis 191, 192
Mariette, Auguste 25, *25*
Mark, St. *66*
Marlborough, Duke of 214

The Marriage of Frederick Barbarossa and Beatrice of Burgundy (Tiepolo) **218–19**
The Marriage of the Virgin (Rosso Fiorentino) 136
Mars and Venus United by Love (Veronese) 117, 202
Marseillaise 221
Martin I, Pope 47
Martin V, Pope 101
The Martyrdom of St. Erasmus (Poussin) 161
The Martyrdom of St. Peter (Caravaggio) **158–59**
The Martyrdom of St. Sebastian (Pollaiuolo) 96
Marx, Karl 257, 267
Mary Magdalene Approaching the Sepulchre (Savoldo) 158
masks, shamanism 18
Massacre of the Innocents (Cornelis van Haarlem) 150
Mastaba of Ty (Egyptian) **24–25**
Matisse, Anna Heloise 314
Matterhorn I (Kokoschka) 318–19
Matthew, St. 54, 59
Maurice, Emperor 46
Maurice, Frederic Denison 261
Maximilian II, Emperor 143, 149, 150
Mazarin, Cardinal 191, 197
Mazeppa and the Wolves (Vernet) 241
Mead, Dr. Richard 203
Medici, Cosimo de' 89
Medici, Duke Cosimo I de' 133, 138, 140, 168, *168*
Medici, Francesco de', Grand Duke of Tuscany 138
Medici, Giuliano de' 96
Medici, Lorenzo de' (Lorenzo the Magnificent), 89, 96, 98, 133
Medici, Lorenzo di Pierfrancesco de' 98
Medici, Piero de' 89, 94
Medici family 89, 97, 98, 101, 138, 161, 217
Mehmed II, Sultan 111, 114
Meier-Graefe, Julius 299
Meissen porcelain 211, 214
Melissa (Dossi) 106
Melk 214
Melun Diptych (Fouquet) 125
Memphis 26, 29
The Menaced Assassin (Magritte) 346
Las Meninas (Velázquez) 173
Menkaure, Pharaoh 26
Mentuhotep II, King of Egypt 27
The Mérode Altarpiece (Master of Flémalle) 122, 124
Merritt Parkway (de Kooning) 350, *350*
Merrymaking at an Inn (Steen) 186
Merton Abbey 263
Metochites, Theodore 50
Metropolitan Museum of Art, New York 352
Meurent, Victorine 281
Michael VII Dukas, Emperor 49
Michael VIII, Emperor 50
Microsoft 367
Mieszko I, King of Poland 55
Milan 79, 139
The Millat Wijk bij Duurstede (Ruisdael) 185
Miller, Lee 345
miniatures 150, 152, *153*

Minoans 19, 33, 34
The Miracle of the Icon 51
Miracle of the Relic of the True Cross (Carpaccio) 114
The Miracle of St. Benedict (Subleyras) 206
Mr. and Mrs. Clark and Percy (Hockney) 380
Modern Painters (Ruskin) 258
Mona Lisa (Leonardo da Vinci) *104*, 144, 344
Mongols 51
Monogram Page (Book of Kells) **62–63**
Monroe, Marilyn 363
Mont Sainte-Victoire 294
Mont Sainte-Victoire (Cézanne) *324*
Montefeltro, Federigo da, Duke of Urbino 88, 89, 95
The Montefeltro Altarpiece (Piero della Francesca) 95
The Montgomery Sisters (Reynolds) 225
More, Sir Thomas 131
Moréas, Jean 303
Morris, Jane 262
Morris & Co. 261, 263
Morris, Marshall, Faulkner & Co. 257, 259
Mosaic of Street Musicians (Dioskurides of Samos) 38
Moses and the Daughters of Jethro (Rosso Fiorentino) 134
Moulin Rouge, Paris 289, 294
Mozarabic art 61, 68
Mummy Cartonnage of Nespanetjerenpere (Egyptian) 29
Murdered Dmitry Tsarevitch (Nesterov) 306
Murnau Street With Women 316
The Muse of Painting (Veronese) 212
The Muses (Denis) 293
Museum of Modern Art, New York 333
Muybridge, Eadweard 274, 283
Mycenaeans 33, 34

N

Nabis 292, 295
Nadar 281
Nagada culture 24
Nancy 299
Naples 79, 160, 162, 249
Naples from Posillipo (More) 248
Napoleon I, Emperor 221, 224, 226, 227, 228, *228*, 235, *239*, 243, 247, 271
Napoleon III, Emperor 267, 277
Napoleon at Arcola (Gros) *239*
The Nativity (Byzantine) 49
Nativity (Caravaggio) 192
Nazarenes 234, 240, 258
Nebamun Hunting in the Marshes 23, 24, **30–31**
Nectanebo I, Pharaoh 29
Nefertiabet, Princess 26
Neferu, Queen of Egypt 27
Nelson, Horatio 227
Netherlands 292
 Dutch Baroque **178–89**
 Mannerism 142
 Netherlandish School 122, 124, 127
Neumann, Balthasar *211*
New English Art Club 284
New Minster Charter 65
New York City 285, 351, 352, 367
New York School 350

News from Nowhere 263, *263*
Niaux Cave 18
Niccolò da Tolentino 93
Nicholas II, Tsar 333
Nicolas V, Pope 93
Nietzsche, Friedrich 320
Night (Hodler) 304–05
The Night Watch (Rembrandt) **188–89**
The Nightmare (Fuseli) 236, **237**
Nijinsky, Vaslav 323
Nocturne in Black and Gold: The Falling Rocket (Whistler) 334
Noli Me Tangere (Duccio) 82
Nordic Summer Evening (Bergh) 378
Normandy 277, 279, 281, 293
Normans 50, 64–65
Notre Dame, Paris 65
Novem Codices 56
Novgorod School 50, 51
Nude Descending a Staircase, No. 2 (Duchamp) *327*, 332
Nude Study (Villeneuve) 268
Number 1 (Lavender Mist) (Pollock) **356–57**
Nuremberg 120
Nuremberg Chronicle 43
Ny Carlsberg Glyptotek, Copenhagen 317

O

The Oath of the Horatii (David) **230–31**
The Oath of the Horatii clock 229
Oath of the Tennis Court (David) 221
Ocean (Magritte) 347
Odo, Bishop of Bayeux 64
The Odyssey (Tibaldi) 137
Oedipus and the Sphinx (Moreau) 300
An Old Man and a Boy (Ghirlandaio) 97
Old Testament Trinity (Rublev) **52–53**
Olympia (Manet) 280
On the Way to the Trenches (Nevinson) 328
Onement I (Newman) 354
Ophelia (Millais) 260–61
Ophelia Among the Flowers (Redon) 307
Orpheus (Delville) 305
Ossian Receiving Dead Warriors into Valhalla (Girodet) 228
Ostrogoths 47, 55
Otto I, Emperor 68
Ottoman Turks 51, 111, 235
Ottonian dynasty 66
Ovid 118
The Oxbow (Cole) **254–55**

P Q

Pacheco, Francisco 173
Padua 78–82, *78*, *80–81*, 112
The Painter's Studio (Van Oost) *174*
paints
 acrylic paints 370, *370*
 pigments 14, 112, *112*
 in tubes 243
 ultramarine 118
 watercolors 247
Palaeolithic art **12–21**
Palais Garnier, Paris 277
Palermo 50
Palette of Narma (Egyptian) 27

palettes, Egyptian 27
Pallas Athena Von Stuck) 306
Palmyra 222
Papal States 79
The Parable of the Blind (Bruegel) 376, *376*
Parable of the Sower (Bassano) 116
Parade Amoureuse (Picabia) 344
Paris 162, 191, 192–94, 200, 221, 267, 276–77, *277*, 289, 299, 313, *313*, 322–23
Paris Salon 201, 252, 267, 268, 270, 276, 277, 280, 287
Parma 106, 107
Parnassus (Mengs) 222
Parthenon, Athens 33, 37
Passion of Christ (Memling) 102
pastels 206, 207
Patience (Gilbert and Sullivan) 262
Paul, St. 158
Paul III, Pope 137
Paul IV, Pope 144
Paul V, Pope 157, 160
Paul Helleu Sketching With his Wife (Sargent) 284
Pazzi family 96, 97
Peace and Plenty Binding the Arrows of War (Janssen) 170–71
The Pearl Fishers (Allori) 138
Peasants of Flagey Returning From the Fair (Courbet) 268
A Peasants' Meal (Le Nain brothers) 195
Peche Merle Cave 17
Péladan, Sâr Joséphin 299, 304, 305
Pembroke, Earls of 74
La Peña de Candamo 16
Penicuik House 225
The Penitent Magdalene (La Tour) 195
Pennsylvania Academy of the Fine Arts 274
Pepin II, King of the Franks 59
Perseus and Andromeda (Lemoyne) 205
The Persistence of Memory (Dalí) **348–49**
perspective 89, 90, 92, 102
Pertaining to Yachts and Yachting (Sheeler) 329
Perugia 96
The Pesaro Altarpiece (Titian) 192, *192*
Peter, St. 47, 158
Peter the Great, Tsar 211
Philip II, King of Spain 118, 129, 139
Philip III, King of Spain 168
Philip III (Philip the Good), Duke of Burgundy 121, 122, 124
Philip IV, King of Spain 171, 173, 176
Philip V, King of Spain 167, 204
Philip of Macedon 37
photography 268, 277, 283, 322, 334, 367, 375
Picts 56, *56*, 57
The Picture Dealer (Antolínez) *174*
Pierrot (Rouault) 318
Pieter Jan Foppeszoon and His Family (Heemskerck) *180*
pigments 14, 112, *112*
Pilgrimage to the Isle of Cythera (Watteau) **203**
Pitti Palace, Florence *161*
Pius VII, Pope 221

Pius XII, Pope 359
Place Royale, Paris 194
Plato 108
plein air painting 278
Pliny the Elder 34, 37
Plum Estate, Kameido (Hiroshige) 290
Poe, Edgar Allan 300
Poitiers 73
Polo, Marco 72
Polynesia 289, 291, 293, 295, 324
Polyphemus Attacking Acis and Galatea
 (Carracci) 160
Pompadour, Madame de 200, 201, 206
Pompeii 33, 36, *37, 38*, 39, *40–41*, 220,
 221, 222, *368*
Pont-Aven 290, 291, 293
Pontinari, Tommaso 126
Pontinari Altarpiece (Van der Goes) *126*
Pontoise 280, 281, 282, 290
The Poor Fisherman (Puvis de
 Chavannes) 298
The Port of Collioure (Derain) *312*
Portrait of Baldassare Castiglione
 (Raphael) *106*
Portrait of Charles John Crowle
 (Batoni) *217*
Portrait of a Dominican Friar (Tomaso da
 Modena) *83*
Portrait of Don Gabriel de la Cueva y Giron
 (Moroni) *138*
Portrait of Francis I, King of France
 (Clouet) *144*
Portrait of Franz Liszt (Lehmann) *243*
Portrait of Hanka Zborowska
 (Modigliani) *328*
Portrait of a Lady (Baldovinetti) *94*
Portrait of Ludovico Capponi (Bronzino)
 132, *132*
Portrait of Madame Récamier
 (Gérard) *228*
Portrait of a Man (Antonello da
 Messina) *114*
Portrait of Pope Innocent X
 (Velázquez) *173*
portrait miniatures 150, 152, *153*
Le Portugais (Braque) **330**, *331*
Portugal 210
The Potato Eaters (Van Gogh) 292
Prague 143, 150
Prandtauer, Jacob 214
Pre-Raphaelite Brotherhood **256–65**,
 308–09
Prehistoric art **12–21**
The Presentation in the Temple (Vouet) 192,
 193
Primavera (Botticelli) 88, **98–99**,
 102, *102*
printing 121
Prix de Rome 208, 222, 223, 226, 228
Procession of the Magi (Gozzoli) *94*
The Prodigal Son (Puvis de
 Chavannes) *302*
Provence 289, 290
*Psalter of St. Louis and Queen
 Blanche* 71
Ptolemaic dynasty 29
Ptolemy III, Pharaoh 29
Pugin, AWN 257, 258, *258*
Punishment of Lust (Segantini) *304*
Pyk, Karin 379
Queen Mary I (Mor) *129*

R

Rabbula Gospels 44, *44*
Raedwald 58
Raft of the Medusa (Géricault) 240–41
Rahotep and Nofret (Egyptian) 26, *26*
Rain, Steam, and Speed (Turner) 253
Rainy Day (Caillebotte) *282*
The Raising of Lazarus (Sebastiano del
 Piombo) *106*
A Rake's Progress (Hogarth) *215*
Ramesside dynasty 23
Ramses III, Pharaoh 28–29
Rand, John G 243
Rape of Europa (Reni) *192*
Ravenna 43, 47, 60
Rebecca at the Well (Byzantine) *46*
Record of the Several Phases of a Jump
 (Marey) *334*
Red Yellow Blue Painting Number 1
 (Marden) *366*
Reeves, William and Thomas 222, *222*, 247
Reichenau 66
Relay Race Around the Streets of Moscow
 (Dejneka) *379*
Republican Automatons (Grosz) *344*
Rest on the Flight into Egypt (Runge) 240
The Return of Marcus Sextus (Guérin)
 221, *227*
Revue Blanche 289
Rhine, River 247
Richard II, King of England 73, 74, *74*
Richelieu, Cardinal 191, 193, *195*, 197
Rienzi (Hunt) 260
The Rite of Spring (Stravinsky) 323
The River Seine at Mantes
 (Daubigny) *278*
Robe Mondrian (St. Laurent) *337*
Robert of Molesme 69
rock paintings **12–21**
Roger II, King of Sicily 50
Rolin, Nicholas 125
Roman art **32–41**, 55
Le Roman de la Rose 72
Rome 44, *46*, 101, 104, 133, 156–58, 194,
 197, 221, 222, 224, 225, 240
Ronsard, Pierre de 194
Roosevelt, Franklin D. 351
Roosevelt, Theodore 377
Rosenberg, Pierre 208
Rosetta Stone 29
Rosicrucianism 299, 304, 305
Rossetti, Christina 308–09
Rousseau, Jean-Jacques 201, 235, 247
Royal Academy of Arts, London 211, 217,
 221, 252, 256, 260, 263, 264, 375
Royal Academy of Painting and Sculpture,
 Paris 191, 199, 203
Rudolf II, Emperor 139, 143, 149,
 150, 151
The Ruins of Balbec (Wood) 224
Ruskin, John 257, 258, 260, 264
Russia
 abstract art 333
 Constructivism 324
 icons 43, 46, 52
 Realism 271
 Rococo 210
 Stalinist 366
 Suprematism 336
 Wanderers 270, 271

S

S With Child (Richter) *381*
Sade, Marquis de 347
Sahara, cave paintings 18, 19
St. Catherine's Monastery, Sinai 44, 47, 48,
 48, 49
St. Francis and Angels 80
St. Francis Renounces His Earthly Father
 (Sassetta) *92*
St. George and the Dragon (Novgorod
 School) *50*
St. Ives group 337
St. Jérôme in His Study (Antonello da
 Massina) *95*
St. John's Gospel 61
Saint-Julien, Baron de 208
St. Laurent, Yves 337
St. Lucy Altarpiece (Domenico
 Veneziano) *93*
St. Luke Painting the Blessed Virgin
 (Michael Damaskenos) *44*
St. Luke Painting the Virgin (Vasari) *138*
St. Martin, Nohant-Vic 69
St. Martin and the Beggar (El Greco)
 168, *168*
St. Martin and the Beggar (Lallemant) *194*
St. Paul and the Viper (Romanesque) 66,
 71
St. Peter (icon) 44, *47*
St. Peter's, Rome 101, 108, 157, *157*,
 161, 164
St. Petersburg 302, 306, 336
Saint-Savin Abbey *69*
St. Serapion (Zurbarán) *171*
Saint-Séverin series (R. Delaunay) *327*
Sala dei Giganti (Giulio Romano) *137*
Salon d'Automne exhibition, Paris
 (1905) *314*
Salon de la Rose+Croix 299, 304
Salt cellar With Neptune and Tellus
 (Cellini) *147*
Sant'Ignazio, Rome *163*
Santa Maria Maggiore, Rome 160
Santa Maria Novella, Florence 90
Santa Maria del Popolo, Rome 158
Sappho *368*, 368
Saqqara 24, *24–25*, 25, 26
Saturn Devouring His Sons (Goya) *241*
A Satyr Mourning Over a Nymph (Piero di
 Cosimo) *97*
Savonarola, Girolamo 89
Schilderboek (Van Mander) 182
Schiller, Friedrich 235, 247
Schoenberg, Arnold 317, 338
The School of Athens (Raphael) **108–09**
Scotland 247, 272
The Scream (Munch) *316*
*A Scribe, an Astronomer With an Astrolabe,
 and a Mathematician* (Psalter of St. Louis
 and Queen Blanche) *71*
Scrovegni, Enrico 82
Scythian Women Besieging Their Enemies
 (Acre) *72*
Seascape With Ponies on the Beach
 (Jongkind) *278*
Seated Scribe (Gentile Bellini) *114*
Seated Woman (Vuillard) *295*
Sefar 18
Self-Portrait (La Tour) *206*
Self-Portrait (Poussin) *190*

Self-Portrait (Rembrandt) *178*
Self-Portrait as a Hunter (Desportes) *197*
Self-Portrait With Bandaged Ear (Van Gogh)
 296–97
Self-Portrait With Gloves (Dürer) *127*
Self-Portrait With a Portrait of Her Sister
 (Carriera) *214*
Selves, Georges de 130
Sennefer, tomb of *28*
*The Sermon, Arrest, and Martyrdom of
 St. James* (Van Scorel) *147*
Seville 167, 170, 174
Sèvres 201
sfumato 102, 107, 150
Shakespeare, William 74, 238, 243,
 260, 307
shamanism 13, 14, 18
Shelley, Mary 229
Shelley, Percy Bysshe 247
Sheng-Tung (Riley) *363*
A Sibyl (Domenichino) *160*
Sicily 50, 157
The Siege of Tournai (Van der Meulen) *175*
Siena 78, 79, *79*, 82–83, 84, 88, 90,
 92–93
Silence (Levy-Dhurmer) *305*
Sistine Chapel, Rome 101, 104, *104–05*,
 137, 216
Sistine Madonna (Raphael) 100, *100*
Sixtus IV, Pope 101
*Sketches of Costumes for the Commedia
 dell'Arte* (Gillot) *202*
Sleeping Groom and Sorceress (Baldung
 Grien) 236, *236*
Small Tree Near Cairo (Hodgkin) **372–73**
The Smoker (Gris) 322, *322*
Snow Scene at Moret (Sisley) *284*
The Social Contract (Rousseau) 235
Society of Arts 222
Soiscél Molaise 61
Somalia 19
The Soothsayer's Recompense (de Chirico)
 342, *342*
South Africa 19
Soviet Union 333
 Socialist Realism 375
Spain
 Baroque **166–77**
 cave paintings 15, 16, 18, 19
 Mannerism 139, 142, 146
 Peninsular War 245
 Romanticism 234
Spartacus 39
Spinola, Ambrogio 176
Split 221
Spring (Arcimboldo) *149*
The Stages of Life (Friedrich) *253*
Standing Nude (Currin) *381*
Stanza della Segnatura, Vatican 104, 108
Stein, Gertrude 325
Stein, Leo 325
Steinbeck, John 351
Stevenson, Robert Louis 377
De Stijl 336
Still Life (Metzinger) *328*
Still Life With a Chinese Bowl (Kalf) *184*
Still Life With Plaster Cast (Cézanne) *294*
*Still Life With Quince, Cabbage, Melon, and
 Cucumber* (Sánchez Cotán) *170*
Stoffels, Hendrickje 268
The Stonebreaker (Wallis) *270*

The Stonebreakers (Courbet) 268
The Stonemason's Yard (Canaletto) 215
The Story of Adam (Ashburnham Pentateuch) 58
Stravinsky, Igor 323
The Street (Kirchner) **320–21**
Street Scene, at Five in the Afternoon (Anquetin) 292
Strong, Sir Roy 152
Strozzi, Palla 85
Strozzi family 89
Study for Amorpha: Fugue in Two Colours II (Kupka) **335**
Study of Hands (Andrea del Sarto) 134
Der Sturm 313
A Sunday Afternoon on the Island of La Grand Jatte (Seurat) 288, *292*, 295
Sung dynasty 20
Suprematist Composition (Malevich) 336
Surprised! (Rousseau) 293
Surrealist Landscape (Matta) 352, *352*
The Surrender of Breda (Velázquez) **176–77**
Sutton Hoo 58
The Swing (Fragonard) **208**, *209*
Switzerland 247, 342, 344
Symbols of the Gospel Writers (Book of Durrow) **56–57**
Symphony in White, No. 1 (Whistler) 261
Syon House, London *222*

T

Tabula (Hantaï) *370*
Tacitus 225
The Talisman (Sérusier) *292*
Tamara in the Green Bugatti (de Lempicka) *379*
Tamburlaine the Great 51
Tango (S. Delaunay) *332*
Tanis 28
Tara Brooch 55
Tarkovsky, Andrei 52
Tarquinia 34, 36
Tassili n'Ajjer Plateau 19
Tavern Scene (Brouwer) *183*
tempera 112
The Tempest (Giorgione) *115*
Tempietto, Rome *101*
Temple of Zeus, Olympia 37
The Temptation of Adam and Eve (Masolino di Panicale) 92
The Temptation of St. Anthony (Khnopff) *303*
The Temptation of St. Jerome (Valdés Leal) *173*
"The Ten" 285
Tennyson, Alfred, Lord 262, 264
Thamar Painting 122
Theodora, Empress 47
Theophanes the Greek 52
The Thinker (Rodin) 304
The Third of May 1808 (Goya) **244–45**
Thoré, Théophile 207, 272
The Threatened Swan (Asselyn) *184*
Three Musicians (Picasso) 329
The Three Witches (Fuseli) *238*
Three Women at Church (Leibl) *272*
Time Transfixed (Magritte) *346*
Tintern Abbey (Girtin) *250*
Toledo 150, 168
The Tour of Doctor Syntax, In Search of the Picturesque (Rowlandson) 251

Tournai 124
The Town No. 2 (R. Delaunay) *327*
Trafalgar Square (Mondrian) *337*
Trajan's Column, Rome 39, 207
The Transfiguration (Raphael) 106, *136*
Très Riches Heures du Duc de Berry (Limbourg brothers) 73, *73*
Tribute Money (Masaccio) 79, **86–87**, 92
Trier 66
The Triumph of Bacchus and Ariadne (Carracci) *212*
Triumph of Death (Orcagna) *83*
Triumph of Galatea (Raphael) 105
trompe l'oeil 32, 38, 225, 342
Trouville 279
Turin Shroud 163
Tuscany 111
Tutankhamun, Pharaoh *22, 23,* 329
The Two Fridas (Kahlo) *346–47*

U

Uffizi Palace, Florence 217, 378
United States of America
 Abstract Expressionism 336, 342, 344, **350–57**
 Age of Enlightenment 201
 American Scene Painting 379
 Hudson River School 246, 254
 Impressionism 285
 Pop art and Op art **358–65**
 Precisionism 324, 329
 Realism 270, 274
 Romanticism 246, 254
Untitled (Bolsena) (Twombly) **369**
Upward (Kandinsky) *336*
Urban II, Pope 69
Urban VIII, Pope 157
Urbino 88, 95, 106, 139
The Ustyug Annunciation (icon) *50*
Utrecht 182
Utrecht Psalter 55

V

The Val d'Aosta (Brett) *260*
Valladolid 168
Valpinçon, Paul 280
Vase of Flowers (Bosschaert) *171*
Vatican 101, 104, 108
Vauxelles, Louis 314, 323, 324
vellum 66, *66*
Vendôme Column, Paris 271
Venice 79, **110–19**, 192, 215, 263
Venus and Adonis (Spranger) *150*
Venus and Cupid (Van der Werff) *214*
Venus figurines 13
Venus of Willendorf 16
Verdi, Giuseppe 25
Verlaine, Paul 299
Versailles 190, 191, 194, 200, 267
Vespasian Psalter 60
Vesuvius, Mount 248–49, *248–49*
Vesuvius from Posillipo (Wright) **249**
Vézelay 70
Viaduct at L'Estaque (Braque) *326*
Victoria, Queen of England 257
Victoria and Albert Museum, London 257
Vienna Genesis 46
Vienna Secession 305, 306, 307, 316

Vierzehnheiligen 211, *211*
View of the Colosseum (Piranesi) *222*
Vigila 61
Vikings 55, 56, *56*, 60, 61, 62
Villa Farnesina, Rome 101, 105
Villa of Livia 32
Villa of the Mysteries Frescoes (Roman) **40–41**
Vincennes porcelain 201
Les XX (Les Vingt) 303
Violet Center (Rothko) *355*
Virgil 236, 243
The Virgin and Child Accompanied by the Apostles (Coptic) 44
Virgin and Child With Scenes from the Life of St. Anne (Lippi) 94
Virgin Enthroned with Two Saints **44–45**
Virgin Hodegetria 44
The Virgin in the Garden of Paradise (German School) 73
The Virgin Mary Appearing to St. Philip Neri (Maratta) *162*
Virgin of Humility Adored by a Prince of the House of Este (Jacopo Bellini) *114*
The Virgin of the Rocks (Leonardo) **102–03**, 104, *158*
The Virgin of Vladimir (Circle of Andrei Rublev) 42, *42*
Visigoths 55, 56, *56*
The Vision of the Sermon (Gauguin) 290, **291**, 304
Vitruvius Pollio 40
Vladimir of Kiev 43, 49
Voltaire, François Marie Arouet de 201

W

Wales 285
A Walk on the Beach (Rysselberghe) *295*
Wanderers 270, 271
Warrior Vase (Mycenaean) *34*
The Washerwoman (Daumier) *270*
Water of the Flowery Mill (Gorky) **353**
The Waterlily Pond Green Harmony (Monet) **286–87**
Watson and the Shark (Copley) *217*
Wearmouth 55
Wedgwood, Josiah 227
The Well of Moses (Sluter) *122*
Wellington, Duke of 247
Wernigerode Gospels 66
West, Mae 347, *347*
West Interior (Katz) *380*
Whaam! (Lichtenstein) **364–65**
The Wheel of Fortune (Burne-Jones) *262*
Where Do We Come From? What Are We? Where Are We Going? (Gauguin) 294
Whitechapel Art Gallery, London 360
Wieskirche 211, *216*
Wigman, Mary 319, *319*
Wilding, Alexa 262
Wilhelm I, Kaiser 267
Willendorf 16
William the Conqueror 64, 65
Wilton Diptych **74–75**, 84
Winchester Bible 70
Winchester Psalter 69
Winchester School 65, *66–67*
Winckelmann, Johann 222, *222*, 223, 224
Winter Scene With Skaters near a Castle (Avercamp) *182*

Wittenberg 121
Das Wölund-Lied (Wayland's Song) (Kiefer) *370*
Woman I (de Kooning) *354*
Woman Bathing in a Stream (Rembrandt) 268
Woman Holding a Fruit (Gauguin) *324*
Woman Playing a Kithara (Roman) *39*
Woman selling Cupids (Roman) *39*
The Woman With the Glove (Carolus-Duran) *376*
Wood, Robert 222, 224
Woolner, Thomas 256
Wordsworth, William 247
Work (Brown) *261*
Works Progress Administration (WPA) 351
World of Art group 306
Wright, Frank Lloyd 351
Wright, Orville and Wilbur 313
Würzburg 219

Y

Young Girl Reading (Fragonard) *207*
Young Man Among the Roses (Hilliard) 142, **152–53**
Young Shepherd in Repose (Renoir) *347*
Young Woman Sewing in a Garden (Cassatt) *283*
The Youthful David (Castagno) *93*

Z

Zborowska, Hanka *328*
Zebra (Vasarely) *360*
Zimmermann, Dominikus 216
Zola, Emile 277, 289
Zurich 342, 344

ACKNOWLEDGMENTS

Cobalt id would like to thank the following for their invaluable help: Ian Chilvers for the generous bestowal of advice on a range of editorial matters large and small, and for his consummate dedication to maintaining the historical accuracy and artistic integrity of this book. Hilary Bird for indexing, and Louise Thomas at Cashou for her outstanding professionalism and consistent attention to detail (www.cashou.com).

The authors would like to thank the following for their assistance: Meghan Acker, Harry Aldwinckle, Petrina Beaufoy Helm, Graham Dalik, Emmie Francis, Sally Jacobs, Ramuntcho Matta, Deirdre Morrow, Malcolm Procter, Tim Rock, Katy Rogers, Rebekah Standing, and Dr Claudia Stumpf.

The publisher would like to thank the following for their kind permission to reproduce their photographs:

Key: a - above; b - below/bottom; c - center; l - left; r - right; t - top
BAL - The Bridgeman Art Library; **DEA** - De Agostini Picture Library;
GI - Getty Images

1 GI: AFP / Luis Acosta / © 2013. Banco de México Diego Rivera Frida Kahlo Museums Trust, Mexico, D.F. / DACS. **2 GI:** Imagno. **5 Corbis:** The Art Archive / Alfredo Dagli Orti / © ADAGP, Paris and DACS, London 2013. **6 British Museum,** London (tc). **GI:** APIC (tr). **7 GI:** AFP / Stan Honda / © Succession Picasso / DACS, London 2013 (tr); DEA (tl); UIG / Mondadori Portfolio (tc). **8–9 BAL:** Giraudon © Succession H. Matisse / DACS 2013. **12 Corbis. 13 Corbis:** All Canada Photos / Alexandra Kobalenko. **14 BAL:** Giraudon (br). **Corbis:** (crb); Frans Lanting (cr). **GI:** AFP / Direction Regionales des Affaires Culturelles (cra). **15 Corbis:** (b). **GI:** Time Life Pictures / Dmitri Kessel (tr). **16 Dorling Kindersley:** Courtesy of the Natural History Museum, London (br). **GI:** AFP / Lionel Bonaventure (bl); Gamma-Rapho / Raphael Gaillarde (ca). **17 BAL:** Index (bl). **GI:** Gamma-Rapho / Fanny Broadcast (br). **18 BAL:** Omniphoto / UIG (tl). **Corbis:** Sebastien Cailleux (br). **GI:** Gamma-Rapho / Raphael Gaillarde (tr). **19 Corbis:** Liba Taylor (bl); Visuals Unlimited / Tim Hauf (tr). **GI:** DEA / G. Dagli Orti (br); Photographer's Choice / Thomas Schmitt (tl) **20–21 BAL. 22 GI:** AFP / Khaled Desouki. **23 GI:** DEA / G. Dagli Orti. **24 Corbis:** Burstein Collection (ca); Sandro Vannini (cb); Gianni Dagli Orti (bc). **GI:** DEA (c) **25 BAL:** Archives Charmet (tr). **Corbis:** Sygma / Frederic Soltan (tl). **26 GI:** DEA / A. Jemolo (bl); DEA / G. Dagli Orti (tr). **26–27 GI:** DEA / G. Dagli Orti (tc). **27 BAL:** Cincinnati Art Museum, Ohio / Gift of Mrs Joan Stark in memory of Louise J. Roth (bl). **Corbis:** Sandro Vannini (br). **GI:** DEA / G. Sioen (cr). **28 akg-images:** Erich Lessing (br). **BAL:** (tl). **GI:** UIG / Werner Forman (tl). **29 Brooklyn Museum of Art, New York / Charles Edwin Wilbour Fund** (tl). **GI:** DEA (tr); Universal History Archive (br). **30–31 BAL:** British Museum, London. **32 GI:** DEA / G. Dagli Orti. **33 Corbis:** SOPA / Bruno Cossa. **34 Corbis:** Wolfgang Kaehler (ca); Visuals Unlimited / Scientifica (ca). **GI:** DEA / G. Nimatallah (cb); National Geographic / O. Louis Mazzatenta (c). **35 Corbis:** Heritage Images (l, tc). © **Marie-Lan Nguyen/Wikimedia Commons:** Musée Louvre, Paris (br). **36 Corbis:** The Art Archive / Alfredo Dagli Orti (tr); Burstein Collection (c). **GI:** DEA / G. Dagli Orti (tc, br). **37 GI:** (br); Museum of Fine Arts, Boston / James Fund and by Special Collection (tl). **38 Corbis:** Werner Forman (bc); Araldo de Luca (tr). **39 BAL:** DEA (bl); Giraudon / Museo Archeologica Nazionale, Naples (cb). **GI:** AFP / Alberto Pizzoli (ca); AGE Fotostock / Wojtek Buss (tr). **40–41 Corbis:** Frederic Soltan **42 BAL:** State Russian Museum, St. Petersburg. **43 Corbis:** Historical Picture Archive. **44 Corbis:** Araldo de Luca (crb). **GI:** DEA / G. Dagli Orti (cra); DEA (cr, br). **45 SuperStock:** (bl). **GI:** Ancient Art and Architecture Collection Ltd. **46 BAL:** DEA (br). **GI:** DEA (tc, br). **47 The Art Archive:** Boistesselin / Kharbine-Tapabor (l). **GI:** DEA (tr, br). **48 Corbis:** Radius Images (tr). **GI:** DEA (l, br). **49 BAL:** Bibliothèque Nationale, Paris (br); Private Collection (tl). **GI:** DEA (b). **50 BAL:** State Russian Museum, St. Petersburg (br); Tretyakov Gallery, Moscow (bl). **Corbis:** Roger Wood (ca). **51 BAL:** Tretyakov Gallery, Moscow (crb). **Corbis:** (bc). **GI:** DEA (tl). **52 Alamy Images:** Grzegorz Gajewski. **53 BAL:** Tretyakov Gallery, Moscow. **54 GI:** Robana / British Library, London. **55 GI:** Iconica / Macduff Everton. **56 Corbis:** Homer Sykes (cb). **GI:** DEA (c); UIG / Prisma (ca); UIG / Werner Forman (bc). **56–57 Corbis:** Stapleton Collection (b). **57 BAL:** Neil Holmes (tr). **58 Alamy Images:** The Art Gallery Collection (tr). **GI:** DEA (bc). **59 BAL:** Bibliothèque Nationale, Paris (tl); British Library, London (cb); Lichfield Cathedral, Staffordshire (br). **GI:** DEA (tr). **60 BAL:** British Library, London (bl); Royal Library, Stockholm (tc). **61 Boltin Picture Library / National Museum of Ireland,** Dublin (tr); Lambeth Palace Library, London (cb). **GI:** DEA / A. Dagli Orti (br); UIG / Prisma (cr). **62, 63 BAL:** The Board of Trinity College, Dublin. **64 BAL:** UIG / Universal History Archive. **65 Corbis:** adoc-photos. **66 BAL:** British Library, London (bl). **GI:** BAL / Ashmolean Museum, Oxford (cr); DEA (cra, crb). **The Royal Library, Copenhagen:** (br). **67 BAL:** British Library, London. **68 BAL:** British Library, London

(br). **GI:** DEA (tc, bl). **69 BAL:** British Library, London (br); Giraudon (tl). **Corbis:** Sylvain Sonnet (bl). **70 BAL:** Winchester Cathedral, Hampshire (br). **GI:** Cover / JMN (l). **71 BAL:** Aberdeen University Library, Scotland (br); British Library, London (tr). **GI:** The Bridgeman Art Libry / Canterbury Cathedral, Kent (br); UIG / Photo12 (tl). **72 BAL:** Bibliothèque Nationale, Paris (tl); Musée Condé, Chantilly (bl). **GI:** DEA (tr, br). **73 BAL:** Buyenlarge (tl); DEA (br). **74–75 BAL:** National Gallery, London. **78 BAL:** Scrovegni (Arena) Chapel, Padua. **79 Corbis:** SOPA / Maurizio Rellina. **80 BAL:** Giraudon (ca). **Corbis:** Araldo de Luca (cb); Summerfield Press (c). **GI:** DEA / G. Nimatallah (bc). **81 BAL:** Private Collection (crb). **GI:** APIC (l). **82 GI:** DEA (tr, bl, br). **83 BAL:** Samuel Courtauld Trust, The Courtauld Gallery, London (bl). **Corbis:** Elio Ciol (br). **GI:** DEA (ca). **84 Alamy Images:** The Art Archive (br). **BAL:** Capella di San Giacomo, Padua (bl); Santa Maria Novella, Florence (tr). **GI:** Alinari Archives, Florence / Pietro Aldi (tr). **85 Corbis:** Summerfield Press. **86–87 Corbis:** Sandro Vannini. **88 GI:** DEA. **89 GI:** BAL. **90 BAL:** (crb); DEA / G. Nimatallah (tr). **91 Corbis:** Sandro Vannini (tc). **DEA** (b). **92 BAL:** National Gallery, London (tr). **Corbis:** Sandro Vannini (bl). **GI:** DEA (br). **93 Corbis:** The Art Archive / Alfredo Dagli Orti (tl); Summerfield Press (tr). **Courtesy National Gallery of Art, Washington, D.C.:** (br). **94 BAL:** National Gallery, London (br). **Corbis:** Alinari Archives, Florence (br). **GI:** DEA (tl, br). **95 Corbis:** The Art Archive / Alfredo Dagli Orti (tl); National Gallery, London (br). **96 Corbis:** National Gallery, London. **97 Corbis:** National Gallery, London (tr). **GI:** DEA (clb, crb, br). **Courtesy National Gallery of Art, Washington, D.C.:** (cla). **98–99 BAL:** Galleria degli Uffizi, Florence. **100 Staatliche Kunstsammlungen, Dresden. 101 GI:** Lonely Planet Images / Robert McGrath. **102 BAL:** British Museum, London (cr); Galleria degli Uffizi (br). **Corbis:** Bettmann (cl). **GI:** SuperStock (tr). **103 Photo SCALA, Florence. 104 BAL:** Giraudon (bl). **Corbis:** Sandro Vannini (ca). **GI:** Gamma-Rapho / Eric Vandeville (br). **105 BAL:** Giraudon (crb). **GI:** The Image Bank / Mark Harris (l). **106 BAL:** DEA / A. Dagli Orti (br). **Corbis:** Musée du Louvre, Paris (tl); Summerfield Press (bc). **GI:** DEA (tc). **107 BAL:** Kunsthistorisches Museum, Vienna (tl). **Corbis:** Alinari Archives, Florence (bl). **108–109 GI:** Universal History Archive. **110 BAL:** National Gallery, London. **111 GI:** AWL Images / Alan Copson. **112 Musée du Louvre, Paris** (c); Museo Vetrario, Murano (ca). **Corbis:** National Gallery, London (bc). **Dorling Kindersley:** Courtesy of Winsor & Newton (cb). **113 BAL:** Musée Condé, Chantilly (tc). **GI:** Universal History Archive (bl). **114 BAL:** Isabella Stewart Gardner Museum, Boston (cr). **GI:** BAL (tc); DEA (bl, bc). **115 Corbis:** Arte & Immagini srl (cla). **GI:** DEA (r). **116 Corbis:** Gianni Dagli Orti (ca); Summerfield Press (cla). **GI:** DEA (bl, br). **117 BAL:** Cameraphoto Arte Venezia (b). **GI:** DEA (t). **118 Library Of Congress, Washington, D.C.:** (c). **119 GI:** Universal History Archive. **120 Corbis:** The Metropolitan Museum of Art, New York. **121 GI:** Time & Life Pictures / Mansell. **122 Alamy Images:** Archivart (clb). **BAL:** Giraudon (cra). **Corbis:** Francis G. Mayer (crb). **BAL:** (tl). **123 Corbis:** National Gallery, London. **124 Corbis:** The Metropolitan Museum of Art, New York (ca). **GI:** BAL (br). **125 Corbis:** Gemaldegalerie, Berlin (tl). **GI:** DEA (tr, br). **126 BAL:** Groeningemuseum, Bruges (br); Prado, Madrid (tl). **GI:** DEA (bc); Universal History Archive (tr). **127 BAL:** Samuel Courtauld Trust, The Courtauld Gallery, London (tc); Musée d'Unterlinden, Colmar (br). **GI:** Imagno (bl). **128 BAL:** Collection of the Earl of Pembroke, Wilton House, Wiltshire (clb); Kunstmuseum, Basel (tr). **Corbis:** Francis G. Mayer (cr). **BAL:** (br). **129 BAL:** Prado, Madrid (bc). **GI:** DEA (t). **130–131 Corbis:** National Gallery, London. **131 Corbis:** Arte & Immagini srl (crb). **132 Corbis:** Frick Collection, New York. **133 BAL:** Biblioteca Medicea-Laurenziana, Florence. **134 akg-images:** Erich Lessing (cra). **Arti Doria Pamphilj s.r.l.:** (br). **BAL:** Giraudon (cr). **Corbis:** Alinari Archives, Florence (bl). **GI:** DEA (cl). **135 GI:** DEA. **136 BAL:** San Lorenzo, Florence (cra). **GI:** DEA / G. Nimatallah (l). **137 akg-images:** Electa (tr). **BAL:** Alinari Archives, Florence / Palazzo Poggi, Bologna (br). **Corbis:** Massimo Listri (bl); Summerfield Press (bc). **138 BAL:** Santissima Annunziata, Florence (br). **Corbis:** Massimo Listri (bc). **GI:** DEA (cla). **139 BAL:** Alinari Archives, Florence / Pinacoteca Nazionale, Bologna (cra); Cameraphoto Arte Venzia (tl). **Corbis:** Alinari Archives, Florence (br). **140 BAL:** National Gallery, London. **141 Corbis:** National Gallery, London. **142 BAL:** Giraudon / Musée du Louvre, Paris. **143 Corbis:** Eurasia Press / Steven Vidler. **144 Alamy Images:** Tomas Abad (br). **BAL:** Devonshire Collection, Chatsworth; Reproduced by permission of Chatsworth Settlement Trustees (bc). **Corbis:** The Art Archive / Alfredo Dagli Orti (bl). **GI:** DEA / G. Dagli Orti (tc). **145 GI:** DEA. **146 Alamy Images:** INTERFOTO (br). **Corbis:** Bettmann (bl). **147 BAL:** Château of Fontainebleau, Seine-et-Marne (tl); Samuel Courtauld Trust, The Courtauld Gallery, London (br); Giraudon / Musée de la Chartreuse, Douai (crb). **Corbis:** Ali Meyer (br). **148 GI:** Giraudon (tl). **GI:** DEA (bl). **148–149 Alamy Images:** Peter Horree (tc). **149 BAL:** Fitzwilliam Museum, Cambridge (tc); Giraudon / Musée du Louvre, Paris (cr). **GI:** DEA (bl). **150 BAL:** Hermitage, St. Petersburg (bl); Private Collection (tc). **GI:** DEA (cra, br). **151 GI:** DEA (tl, crb). **152 BAL:** The Stapleton

Collection. **153 BAL:** Victoria & Albert Museum, London (l, r). **156 GI:** BAL. **157 Corbis:** Heritage Images. **158 GI:** Galleria degli Uffizi, Florence (crb). **Corbis:** Design Pic / Ken Welsh (cl); The Gallery Collection (br). **GI:** Universal History Archive (cr). **159 GI:** BAL. **160 Corbis:** Alinari Archives, Florence (bl); Summerfield Press (cra). **GI:** DEA / G. Dagli Orti (br). **161 BAL:** Alinari Archives, Florence / Santa Maria della Concezione, Rome (bl). **Corbis:** Vanni Archive (r). **GI:** BAL (crb). **162 BAL:** Devonshire Collection, Chatsworth; Reproduced by permission of Chatsworth Settlement Trustees (cla); Palazzo Pitti, Florence (br). **Corbis:** Arcaid / David Clapp (bc). **GI:** DEA / L. Pedicini (cra). **163 Corbis:** Sylvain Sonnet. **164–165 GI:** DEA. **166 Corbis:** Arte & Immagini srl. **167 GI:** BAL. **168 Alamy Images:** PjrTravel (cr). **GI:** BAL (cl); DEA (crb, br). **169 GI:** Cover / Gotor. **170 GI:** DEA / Veneranda Biblioteca Ambrosiana (ca); DEA (bl, br). **171 BAL:** Wolverhampton Art Gallery, West Midlands (t). **Corbis:** Francis G. Mayer (bl, bc). **172 BAL:** National Gallery, London (br). **GI:** BAL (tl). **173 Corbis:** Alinari Archives, Florence (cr). **GI:** BAL (bc); DEA (cla); Cover / Gotor (br). **174 BAL:** Lukas - Art in Flanders VZW (cla). **GI:** Cover / Gotor (r); DEA (bc). **175 GI:** Giraudon (tr). **Corbis:** SOPA / Pietro Canali (br). **GI:** DEA (c). **176–177 GI:** Universal History Archive. **178 BAL:** English Heritage Photo Library. **179 Corbis:** The Art Archive. **180 BAL:** Museumslandschaft Hessen Kassel (c). **GI:** DEA (ca); Universal History Archive (cb). **Hendrik Goltzius,** Christ at the Marriage of Cana, **after Francesco Salviati, 1590–1617:** (bc). **181 BAL:** The Clowes Fund Collection, Indianapolis Museum of Art (tc). **GI:** DEA (b). **182 BAL:** Ashmolean Museum, Oxford (bl); National Gallery, London (cra). **183 BAL:** National Gallery, London (br); Wallace Collection, London (tl). **GI:** BAL (ca). **184 Corbis:** Rijksmuseum, Amsterdam (br). **GI:** DEA (bc, br); Gamma-Rapho / Francis Demange (tl). **185 GI:** DEA (cla); Imagno (br). **186 Corbis:** Rijksmuseum, Amsterdam (cra). **GI:** DEA (bl); Universal History Archive (ca). **187 BAL:** Museumslandschaft Hessen Kassel (tc); Private Collection (cb). **Corbis:** Lebrecht Music & Arts / Derek Bayes (clb). **188–189 GI:** DEA. **190 GI:** DEA. **191 GI:** Giraudon / Château de Versailles. **192 BAL:** Cameraphoto Arte Venezia / Santa Maria Gloriosa dei Frari, Venice (cra); Devonshire Collection, Chatsworth; Reproduced by permission of Chatsworth Settlement Trustees (cra); Modadori Electa / Oratory of San Lorenzo, Palermo (cla). **Corbis:** Historical Picture Archive (cla). **GI:** Alinari Archives, Florence (br). **193 BAL:** Giraudon / Musée du Louvre, Paris. **194 Musée du Louvre, Paris** (tl); Musée Carnavalet, Paris (br). **GI:** DEA (cla). **195 BAL:** Archives Charmet / La Sorbonne, Paris (cla). **GI:** DEA (tr); Hulton Fine Art Collection (clb). **196 BAL:** Giraudon / Musée des Beaux-Arts, Rouen (bl). **Corbis:** Alinari Archives, Florence (tl); The Art Archive (br). **197 BAL:** Towneley Hall Art Gallery and Museum, Burnley (tl). **GI:** BAL (br). **198–199 BAL:** Cleveland Museum of Art, Ohio / Leonard C. Hanna, Jr. Fund. **200 Corbis:** Stapleton Collection. **201 Alamy Images:** Mary Evans Picture Library. **202 Corbis:** Museum of Fine Arts, Boston (cl). **GI:** BAL (cb); DEA (ca); Time Life Pictures / Rob Crandall (bc). **203 BAL:** Musée du Louvre, Paris (bl). **GI:** DEA / G. Fini (tc). **204 Corbis:** Francis G. Mayer (tr). **GI:** Universal History Archive (bl). **205 BAL:** Wallace Collection, London (bl). **Corbis:** Lebrecht Music & Arts / Derek Bayes (tr). **GI:** DEA / G. Dagli Orti (br); DEA (br). **206 Corbis:** Frick Collection, New York (br). **GI:** DEA (tc, tr). **207 BAL:** The Bowes Museum, Barnard Castle, County Durham (tl); National Gallery of Art, Washington, D.C. (br). **GI:** DEA (bl). **208 BAL:** Giraudon / Musée Fragonard, Grasse. **209 BAL:** Wallace Collection, London. **210 GI:** DEA. **211 Corbis:** Arcaid / Florian Monheim. **212 BAL:** Detroit Institute of Arts; Gift of Mr. and Mrs. Edgar B. Whitcomb (cr); Devonshire Collection, Chatsworth; Reproduced by permission of Chatsworth Settlement Trustees (cra). **GI:** DEA (bl); Universal History Archive (cra). **213 BAL:** Collection Michael Burden (tc); Kunstsammlungen, Pommersfelden (b). **214 BAL:** Leeds Museum and Art Galleries / Temple Newsam House (br); Wallace Collection, London (tr). **Corbis:** Arte & Immagini srl (bl). **215 BAL:** Fitzwilliam Museum, Cambridge (br); National Gallery, London (cr). **Corbis:** Lebrecht Music & Arts / Derek Bayes (bl). **216 BAL:** Wieskirche, Wies (br). **GI:** DEA (tl, bl). **217 BAL:** Giraudon / Musée du Louvre, Paris (tl); National Gallery of Scotland, Edinburgh (tl); Nationalmuseum, Stockholm (tr). **218–219 BAL:** Sandro Vannini. **220 GI:** BAL. **221 Alamy Images:** The Art Gallery Collection. **222 BAL:** Museum of London (cra); Royal Castle, Warsaw / Maciej Bronarski (br). **Corbis:** PoodlesRock (cr). **GI:** Hulton Archive / Christopher Simon Skyes (tc). **223 akg-images:** Erich Lessing (tc). **GI:** DEA (tl). **224 Corbis:** Yale Center for British Art / Paul Mellon Collection (bl). **GI:** DEA (ca). **225 BAL:** Arthur Ackermann Ltd. (br); Yale Center for British Art / Paul Mellon Collection (tr). **Corbis:** Massimo Listri (bl); Philadelphia Museum of Art (tl). **226 BAL:** Musée de Picardie, Amiens (tr); Staedel Museum, Frankfurt-am-Main (br). **Corbis:** Lebrecht Music & Arts / Derek Bayes (bl). **227 BAL:** Giraudon / Musée du Louvre, Paris (tr); Harris Museum and Art Gallery, Preston (tl); Walker Art Gallery, National Museum Liverpool (bl). **228 GI:** DEA (tl); Universal History Archive (bl); Imagno (br). **229 Corbis:** Bettmann (tl).

GI: DEA (br). **TopFoto.co.uk:** Musée Carnavalet, Paris / Philippe Ladet (bl). **230–231 GI:** APIC. **234 GI:** Universal History Archive. **235 GI:** DEA. **236 BAL:** The Royal Collection © 2011 Her Majesty Queen Elizabeth II (br). **GI:** Time Life Pictures / Mansell (cr); UIG / Prisma (cra); Universal History Archive (tr). **237 Corbis:** Bettmann (tc). **GI:** Universal History Archive (br). **238 GI:** DEA (cl, tr). **239 BAL:** Detroit Institute of Arts (tr); Hermitage, St. Petersburg (bc); Musée Girodet, Montargis / Peter Willi (br). **240 Alamy Images:** The Art Gallery Collection (t). **BAL:** Hamburger Kunsthalle, Hamburg (bl). **241 Alamy Images:** The Art Gallery Collection (tr). **GI:** DEA (bl, br). **242 GI:** Universal History Archive. **243 BAL:** Giraudon / Musée du Louvre, Paris (br); Wallace Collection, London (bl). **Corbis:** National Gallery, London (tl). **GI:** Imagno (tr). **244–245 BAL:** Prado, Madrid. **246 GI:** DEA. **247 Corbis:** SuperStock. **248 BAL:** Private Collection / Yale Center for British Art / Paul Mellon Collection (crb). **Corbis:** Stapleton Collection (br). **GI:** DEA (cra). **249 BAL:** Yale Center for British Art / Paul Mellon Collection (tc). **GI:** Universal History Archive (br). **250 BAL:** Blackburn Museum and Art Gallery, Lancashire (tc); Hamburger Kunsthalle, Hamburg (bl). **GI:** DEA (tr). **251 BAL:** Victoria & Albert Museum, London (tr). **Corbis:** Alte Nationalgalerie, Berlin (br). **GI:** BAL (tc). **252 BAL:** Fitzwilliam Museum, Cambridge (tc); Laing Art Gallery, Newcastle-upon-Tyne (bl). **GI:** DEA (tr). **253 Corbis:** Francis G. Mayer (tr). **GI:** BAL (tl); Imagno (bl). **254–255 Photo SCALA, Florence:** Art Resource / The Metropolitan Museum of Art, New York. **256 Alamy Images:** Archivart. **257 GI:** BAL. **258 BAL:** Fitzwilliam Museum, Cambridge (cra); Victoria & Albert Museum, London (cra). **Dorling Kindersley:** Trish Gant (br). **GI:** DEA (cr). **259 BAL:** Bradford Art Galleries and Museums, West Yorkshire (b). **Corbis:** Hulton-Deutsch Collection (tc). **260 BAL:** Private Collection (br). **GI:** DEA (tl); SuperStock (bl). **260–261 Corbis:** Tate Britain, London (tc). **261 BAL:** Manchester Art Gallery (bc). **GI:** Universal History Archive (tr). **262 BAL:** Giraudon / Musée d'Orsay, Paris (tl); Manchester Art Gallery (c). **263 BAL:** Private Collection (tl); Towneley Hall Art Gallery and Museum, Burnley (br). **Corbis:** The Print Collector (br). **GI:** BAL (tl). **264 Corbis:** Arte & Immagini srl. **265 BAL:** Manchester Art Gallery. **266 GI:** Universal History Archive. **267 GI:** DEA. **268 Alamy Images:** The Art Gallery Collection (crb). **BAL:** Giraudon / Musée du Louvre, Paris (br); Hulton Archive (cl). **Photo SCALA, Florence:** Art Resource / The Metropolitan Museum of Art, New York (cr). **269 GI:** DEA. **270 BAL:** Musée d'Orsay, Paris (tr). **Corbis:** Musée d'Orsay, Paris (bc). **GI:** BAL (br); DEA (tl). **271 Corbis:** Alte Nationalgalerie, Berlin (cr). **GI:** Universal History Archive (br). **272 BAL:** Musée des Arts Décoratifs, Paris (bc); National Gallery of Scotland, Edinburgh (tr). **GI:** DEA (bl). **273 BAL:** Haags Gemeentemuseum, The Hague (tl); Manchester Art Gallery (bl). **Corbis:** Brooklyn Museum (tr). **GI:** adoc-photos (cr). **275 BAL:** Philadelphia Museum of Art, Pennsylvania (br). **276 BAL.** **277 GI:** Roger Viollet. **278 BAL:** Brooklyn Museum of Art, New York / Gift of Cornelia E. and Jennie A. Donnellon (cb); National Gallery, London (c); Private Collection (bc). **Dreamstime.com:** Yuriy Chaban (c). **279 akg-images:** National Gallery, London (b). **BAL:** Giraudon / Archives Larousse, Paris (tc). **280 BAL:** Museum of Fine Arts, Boston (br). **GI:** BAL (bl); DEA (tr). **281 Corbis:** Francis G. Mayer (bl); Private Collection (br). **GI:** BAL (ca). **282 Corbis:** Burstein Collection (cra); National Gallery, London (l). **283 BAL:** Musée d'Orsay, Paris (bc). **Corbis:** Courtauld Institute of Art, London (tl). **Dorling Kindersley:** Guy Ryecart (tr). **GI:** DEA (bl). **284 BAL:** Brooklyn Museum of Art, New York (tr); Private Collection (tr); Fitzwilliam Museum, Cambridge (tl). **285 Alamy Images:** Tomas Abad (bc). **Corbis:** Brooklyn Museum (br). **GI:** BAL (tc). **286–287 GI:** UIG / Mondadori Portfolio (c). **287 Corbis:** Bettmann (cb). **288 GI:** DEA. **289 GI:** BAL. **290 Corbis:** Brooklyn Museum (cra); Private Collection (cr). **GI:** BAL (crb, br). **291 Corbis:** adoc-photos (tc). **GI:** DEA (b). **292 BAL:** The Art Institute of Chicago (bc). **Corbis:** Francis G. Mayer (tl). **GI:** BAL (tr). **293 BAL:** Musée d'Orsay, Paris / © ADAGP, Paris and DACS, London 2013 (br); National Gallery, London (tr). **Corbis:** The Art Archive (tl). **294 GI:** BAL (br); DEA (tl). **295 BAL:** Private Collection (tr). **Corbis:** Fine Art Photographic Library (bl); The Gallery Collection (tc). **GI:** BAL (br). **296 Corbis:** Bettmann. **297 GI:** Universal History Archive. **298 GI:** BAL. **299 Corbis:** Radius Images (b). **300 BAL:** Giraudon / Archives Larousse, Paris (cl); Giraudon / Musée des Augustins, Toulouse (cr); Giraudon / Musée du Louvre, Paris (crb). **Corbis:** Atlantide Phototravel (cra); Adam Woolfitt (bl). **301 BAL:** Fogg Art Museum, Harvard University / On Loan to the Hamburger Kunsthalle, Hamburg (tc). **GI:** DEA (bl). **302–303 GI:** DEA (tl). **303 BAL:** Giraudon / Private Collection (bc); Private Collection (tr). **GI:** Hulton Archive (tc). **304 GI:** BAL (tr, br); DEA (tl). **305 BAL:** Giraudon / Private Collection / © DACS 2013 (tl); Private Collection / Courtesy Musée d'Orsay, Paris (bc). **Corbis:** Burstein Collection / © The Munch Museum / The Munch - Ellingsen Group, BONO, Oslo / DACS, London 2013 (tr). **306 akg-images:** National Gallery, London (bc). **Corbis:** Global Look (tc); Ali Meyer (tl). **307 Corbis:** Francis G. Mayer (tl). **GI:** DEA (tr). **308 GI:** DEA. **309 Alamy Images:** Mary Evans Picture Library (cr). **312 BAL:** Giraudon / Musée d'Art Moderne, Centre Pompidou, Paris / © ADAGP, Paris and DACS, London 2013. **313 Corbis. 314 BAL:** Giraudon / Musée Rodin, Paris (crb). **GI:** BAL (cr); DEA (cra). **Succession H. Matisse:** (br). **315 BAL:** Giraudon / © Succession H. Matisse / DACS 2013 (b). **Library Of Congress, Washington, D.C.:** Van Vetchen Collection (tc). **316 BAL:** Nasjonalgalleriet, Oslo / © The Munch Museum / The Munch - Ellingsen Group, BONO, Oslo / DACS, London 2013. (bl); Private Collection / © ADAGP, Paris and DACS,

London 2013 (ca). **GI:** BAL (br). **317 akg-images:** Erich Lessing (tl). **Corbis:** Albright-Knox Art Gallery / © ADAGP, Paris and DACS, London 2013 (tc); Francis G. Mayer / © DACS 2013 (bl). **318 BAL:** Giraudon / Private Collection / Chagall ® / © ADAGP, Paris and DACS, London 2013 (bc). **Corbis:** Christie's Images / © ADAGP, Paris and DACS, London 2013 (tr); Philadelphia Museum of Art (tl). **319 BAL:** Private Collection / © Fondation Oskar Kokoschka / DACS 2013 (bl). **Corbis:** Bettmann (br); Christie's Images / © 2012 Georg Baselitz (tc). **320–321 GI:** DEA. **322 GI:** DEA. **323 GI:** Alvin Langdon Coburn / © George Eastman House, International Museum of Photography and Film. **324 Corbis:** Werner Forman Archive (ca). **GI:** BAL (bc); DEA (c). **Lebrecht Music and Arts:** Rue des Archives / PVDE (cb). **325 GI:** AFP / Stan Honda / © Succession Picasso / DACS, London 2013 (l); Apic (tr). **326 GI:** DEA / © ADAGP, Paris and DACS, London 2013. **327 BAL:** DEA / G. Nimatallah / Nazionale d'Arte Moderna, Rome (br); Giraudon / Musée National d'Art Moderne, Centre Pompidou, Paris (tl); RIA Novosti / Yale University Art Gallery, New Haven, CT (tc). **Corbis:** Francis G. Mayer (tr); Francis G. Mayer / © Succession Marcel Duchamp / ADAGP, Paris and DACS, London 2013 (bc). **328 BAL:** Private Collection / © ADAGP, Paris and DACS, London 2013 (tr). **Corbis:** Stapleton Collection / The Estate of C.R.W. Nevinson (tl). **GI:** DEA (bc). **329 BAL:** Bonham's London / Private Collection / Courtesy of Wedgwood, Clarice Cliff is a registered trademark of WWRD (Waterford Wedgwood Royal Doulton) (tl). **Corbis:** Francis G. Mayer / © ADAGP, Paris and DACS, London 2013 (bl); Philadelphia Museum of Art (tr). **330 Corbis:** Bettmann. **331 BAL:** Öffentliche Kunstsammlung, Basel / © ADAGP, Paris and DACS, London 2013. **332 © Pracusa 2012009. 333 GI:** Hulton Archive. **334 BAL:** Detroit Institute of Arts / Gift of Dexter M. Ferry, Jr. (cra); Giraudon / Private Collection / © ADAGP, Paris and DACS, London 2013 (crb). **Corbis:** adoc-photos (cr). **GI:** AFP / Joe Klamar (br); DEA / © ADAGP, Paris and DACS, London 2013. (cl). **335 BAL:** Cleveland Museum of Art, Ohio / © ADAGP, Paris and DACS, London 2013. **336 BAL:** Private Collection (ca). **Corbis:** The Art Archive / Alfredo Dagli Orti / © ADAGP, Paris and DACS, London 2013 (tr); Stedelijk Museum, Amsterdam (bl); Philadelphia Museum of Art / © Succession Miro / ADAGP, Paris and DACS, London 2013 (br). **337 Alamy Images:** INTERFOTO (tr). **BAL:** Agnew's, London / Private Collection / © Angela Verren Taunt 2013. All rights reserved, DACS (cla). **Photo SCALA, Florence:** Digital image, The Museum of Modern Art, New York / © 2013 Mondrian/Holtzman Trust c/o HCR International USA (br). **338–339 BAL:** Hermitage, St. Petersburg / © ADAGP, Paris and DACS, London 2013. **340 BAL:** Giraudon / National Gallery of Art, Washington, D.C. / © ADAGP, Paris and DACS, London 2013. **341 Corbis:** Peter Aprahamian. **342 Corbis:** DPA / Ana Riwkin (cl); Philadelphia Museum of Art / © DACS 2013 (br). **GI:** BAL (cr); SuperStock (crb). **343 Corbis:** Lebrecht Music & Arts / Derek Bayes / © ADAGP, Paris and DACS, London 2013. **344 BAL:** Alinari Archives, Florence / Galleria Pictogramma, Rome / © Succession Marcel Duchamp / ADAGP, Paris and DACS, London 2013 (bc); Museum of Modern Art, New York / © DACS 2013 (tc); Private Collection / © ADAGP, Paris and DACS, London 2013 (bl). **345 BAL:** Private Collection / © The Heartfield Community of Heirs / VG Bild-Kunst, Bonn and DACS, London 2013 (tr). **Corbis:** Albright-Knox Art Gallery / © Succession Miro / ADAGP, Paris and DACS, London 2013 (b); Hulton-Deutsch Collection (tl). **346 BAL:** Art Institute of Chicago, Illinois / © ADAGP, Paris and DACS, London 2013 (bc). **347 BAL:** Private Collection / © Man Ray Trust / ADAGP, Paris and DACS, London 2013 (br). **Corbis:** Albright-Knox Art Gallery / © DACS 2013 (tc); EPA / Robert Vos / © Salvador Dali, Fundació Gala-Salvador Dali, DACS, 2013 (tr). **GI:** AFP / Luis Acosta / © 2013. Banco de México Diego Rivera Frida Kahlo Museums Trust, Mexico, D.F. / DACS (tl). **348–349 BAL:** Museum of Modern Art, New York / © Salvador Dali, Fundació Gala-Salvador Dali, DACS, 2013. **350 BAL:** Detroit Institute of Arts / Gift of W. Hawkins Ferry / © The Willem de Kooning Foundation, New York / ARS, NY and DACS, London 2013. **351 Corbis:** PhotoQuest / Sloan. **352 BAL:** Phillips, Fine Auctioneers, New York / Private Collection / © ARS, NY and DACS, London 2013 (br). **Corbis:** Bettmann (cr); Science Faction / Macduff Everton / © DACS 2013 (cra); Geoffrey Clements / © ADAGP, Paris and DACS, London 2013 (clb). **353 Corbis:** Francis G. Mayer / © ADAGP, Paris and DACS, London 2013 (b). **GI:** Time Life Pictures / Gjon Mili (tc). **354 BAL:** Giraudon / Museum of Modern Art, New York / © The Willem de Kooning Foundation, New York / ARS, NY and DACS, London 2013 (tc); Private Collection / Courtesy Clyfford Still Museum, Clyfford Still, 1949, PH-519, 1949, gouache on paper, 76 x 56 cm. © Clyfford Still Estate (br). **Photo SCALA, Florence:** Digital Image, The Museum of Modern Art, New York / © 2013 The Barnett Newman Foundation, New York / DACS, London (bc). **355 BAL:** Christie's Images / Private Collection / © 1998 Kate Rothko Prizel & Christopher Rothko ARS, NY and DACS, London (bl); Mayor Gallery, London / Private Collection / © ARS, NY and DACS, London 2013 (crb). **Corbis:** Christie's Images / © Dedalus Foundation, Inc. / DACS, London / VAGA, New York 2013 (tr). **GI:** AFP / Chris Young (bc). **356–357 BAL:** National Gallery of Art, Washington, D.C. / © The Pollock-Krasner Foundation ARS, NY and DACS, London 2013. **358 Corbis:** Christie's Images / Copyright Allen Jones. **359 GI:** Retrofile / Tom Kelley Archive. **360 Alamy Images:** Antiques & Collectables / reproduced by kind permission of the Dan Dare Corporation Limited (crb). **BAL:** Phillips, Fine Art Auctioneers, New York / Private Collection / © ADAGP, Paris and DACS, London

2013 (br). **Corbis:** Christopher Felver (cl). **GI:** Silver Screen Collection (cr). **361 BAL:** Kunsthalle, Tubingen / © R. Hamilton. All Rights Reserved, DACS 2013. **362 BAL:** Pallant House Gallery, Chichester / © Trustees of the Paolozzi Foundation, Licensed by DACS 2013 (tc); Saatchi Collection, London / © The Andy Warhol Foundation for the Visual Arts, Inc. / DACS, London, 2013. Trademarks Licensed by Campbell Soup Company. All Rights Reserved. (br). **GI:** DEA / © Jasper Johns / VAGA, New York / DACS, London 2013 (bl). **363 BAL:** Giraudon / Musée National d'Art Moderne, Centre Pompidou, Paris / © ADAGP, Paris and DACS, London 2013 (br). **Corbis:** Christie's Images / © Bridget Riley 2013. All rights reserved, courtesy Karsten Schubert, London (cra). © **Tate, London 2013:** David Hockney, *A Bigger Splash*, 1967, Acrylic on canvas, 96 x 96 inches © David Hockney (tl). **364–365 The Art Archive:** Tate Gallery, London / Eileen Tweedy / © The Estate of Roy Lichtenstein / DACS 2013. **366 Corbis:** Albright-Knox Art Gallery / © ARS, NY and DACS, London 2013. **367 GI:** Paris Match / Hubert Fanthomme / © Cy Twombly Foundation. **368 BAL:** Kunstmuseum, Dusseldorf (br). **Corbis:** Sandro Vannini (cr). **Collection of the Daura Gallery, Lynchburg College, Virginia:** (cra). **GI:** DEA (crb). **369 BAL:** Christie's Images / Private Collection / © Cy Twombly Foundation (b). **Corbis:** STR / Keystone (tr). **370 BAL:** Christie's Images / Private Collection / © Karel Appel Foundation / DACS 2013. (bl); Giraudon / Musée d'Art Moderne, St Etienne / © ADAGP, Paris and DACS, London 2013. (ca). **Dorling Kindersley:** Steve Gorton (t). © **Anselm Kiefer / courtesy White Cube:** Anselm Kiefer, *Wölundlied*, 1982, Oil, emulsion and straw on canvas with lead wing and gelatin silver print on projection paper, 109 x 149 inches (br). **371 © Damien Hirst and Science Ltd. All rights reserved, DACS 2013:** Photographed by Prudence Cuming Associates (t). © **Julie Mehretu / courtesy White Cube:** Julie Mehretu, *Grey Space (distractor)*, 2006, Ink and acrylic on canvas, 72 x 96 inches; Photo: Erma Estwick (br). © **Gerhard Richter, 2013:** (bc). **372–373 Corbis:** Christie's Images / © Howard Hodgkin. **374 BAL:** Giraudon / Musée de l'Orangerie, Paris / © Succession Picasso / DACS, London 2013. **375 BAL:** The Barnes Foundation, Merion, Pennsylvania / © Succession H. Matisse / DACS 2013. **376 BAL:** DEA / The Metropolitan Museum of Art, New York (bc); Giraudon / Musée d'Orsay, Paris (cb). **GI:** DEA (c); Imagno (ca). **377 Alamy Images:** Lebrecht Music and Arts Photo Library (b). **Corbis:** (tc). **378 Alamy Images:** The Art Gallery Collection (bl). **BAL:** © The Estate of Augustus Edwin John (tr). **379 BAL:** Private Collection / © ADAGP, Paris and DACS, London 2013. (bl); Tretyakov Gallery, Moscow (tr). **Corbis:** Geoffrey Clements (br). **GI:** Apic (bl). **380 BAL:** Musée National d'Art Moderne, Centre Pompidou, Paris / © ADAGP, Paris and DACS, London 2013. (tl); Philadelphia Museum of Art, Pennsylvania / © Alex Katz, DACS, London / VAGA, New York 2013. (tr); Private Collection / © ADAGP, Paris and DACS, London 2013. (bl). **381 BAL:** Private Collection / © Paula Rego (bl). © **John Currin. Courtesy Gagosian Gallery:** (br). © **Gerhard Richter, 2013:** (tr). **382–383 BAL:** © The Lucian Freud Archive.